DICTIONARY OF
Chinese and Japanese Art

Hugo Munsterberg

HACKER ART BOOKS
New York 1981

For
Seymour Hacker
friend and publisher

PREFACE

This work is dedicated to Seymour Hacker, for it was he who urged me to produce a book of this kind. Originally, it is true, the idea was to offer the reader an updated English version of Weber's famous *Ko-ji Ho-ten* of 1923, which its author described as a "Dictionnaire à l'Usage des Amateurs et Collectionneurs." However, as the translation progressed, it was felt increasingly that the original publication, although valuable in its own day, was very outdated, not only in its factual information, but also in its entire emphasis and point of view, which was that of a turn-of-the-century French amateur rather than of a modern scholar. It was therefore decided to rewrite the book completely, using only some of Weber's entries and adding many new ones, and vastly expanding the Chinese material. In doing so the author drew not only upon his own knowledge, gained in a lifetime of study and teaching, but on the scholarly information gathered from hundreds of different sources, far too numerous to list here. Some, such as Siren's monumental history of Chinese painting and Werner's *Dictionary of Chinese Mythology*, Hackin's volume on *Asiatic Mythology*, the Tokyo National Museum staff's *Pageant of Japanese Art*, Robinson's study of Japanese swords, and the Pelican volumes on Chinese and Japanese art, were particularly useful. To all these, and to countless others, the author wishes to express his thanks and indebtedness. Finally, he wishes to thank his research assistant, Miss Angela Pao, who, with painstaking care and infinite patience, helped in assembling the material and preparing the manuscript for publication.

ABCDEFGHIJ
KLMNOPQR
STUVWXYZ

A-fang Palace Famous palace built by the emperor Shih Huang-ti of the Ch'in Dynasty. It was constructed with the help of 700,000 prisoners and criminals near the capital Hsien-yang at the beginning of the 3rd century B.C. The Japanese name for this palace is Abokyu. It is said that the central gallery of this gigantic building could hold 10,000 people and that banners over 60 feet long could hang freely from the ceiling. Although the building itself does not survive, it is often represented in Chinese painting.

Abe family Name of a daimyo family originating in Mikawa. Its founder was Masakatsu (1541-1600), a vassal of Tokugawa Ieyasu.

Abe-no-Nakamaro One of the 36 celebrated poets of Japan. He was sent to China in 716 in order to attempt to bring back the secrets of the Chinese calendar. Legend has it that the Chinese, who distrusted him, attempted to starve Nakamaro to death by removing the staircase of the pagoda in which he was staying. He wrote, with the blood of his fingers, the following poem on the walls of the building: "When I see before me the celestial plain, I think myself in Kasuga, contemplating the moon which rises above the summit of Mikasa." He is often represented in art, notably by Hokusai who shows him seated on a terrace contemplating the moon.

Abe-no-Yasuna Legendary figure who is said to have encountered a white fox who was being hunted in Sama park. The animal asked for his protection which he generously offered. Some time later, he met and married a beautiful girl who turned out to be no other than the reincarnation of that very fox he had saved. It is said that she wrote the following verse on the side of the Abe mansion: "If you are in love, go into the forest of Shinoda in Izumi; seek and you will find a kuzu leaf," for her name was Kuzunoha. The fox writing lines of verse on a wall is a subject sometimes represented in Japanese art.

Abhaya mudra One of the mudras or symbolic hand gestures used in both Buddhist and Hindu art. The hand is raised with the fingers upward and

1

the palm facing outward. It symbolizes fearlessness, indicating that the worshipper should approach the deity without fear. It is commonly found in the Buddhist sculpture and painting of both China and Japan.

Abura-akango　A ghost having only one eye, a long neck and an enormous tongue. It subsists on lantern oil which it licks during the night. This creature is sometimes represented in Japanese art, notably in the prints of Hokusai.

Academy of Painting　See Imperial Academy of Painting.

Acala　Also spelled Achala. Originally a form of the Hindu god Shiva, but incorporated into the Buddhist pantheon, where he is known as Putung in Chinese or Fudo Myo-o in Japanese. He is often represented in Japanese art. See also Fudo Myo-o.

Adachigahara　Aged sorceress and cannibal of Japanese legend. She is usually represented as an emaciated woman holding an enormous bread knife, sometimes preparing to slit the throat of a young child, or else killing a woman. It is said that she magically transforms herself into a monster and at night steals children, whose blood she uses for curing the mysterious ailments of a young prince in her charge, and whose bodies she then devours. She is portrayed in Japanese folk theatre and in popular paintings and prints.

Adi Buddha　Primordial Buddha who is seen as the source and originator of all things and who plays an important role, especially in Nepalese and Tibetan Buddhist art. He manifests himself as Vairocana, the Cosmic Buddha, known as Dainichi in Japan. This deity can be recognized by his hand gesture in which the index finger of the right hand is clasped by the five fingers of the left hand, symbolizing the union of the Womb World and Diamond World, or the phenomenal world and the world of ultimate essences, in his being.

Agano　Place in northern Kyushu which, beginning with the 17th century, was an important center of ceramic production. It was founded by the Korean potter Senkai and manufactured Korean-style wares. It was patronized by the tea masters, notably Kobori Enshu, and wsa known for its tea caddies or cha-ire. Old Agano ware has a hard pale grey paste and a reddish brown glaze, while during the 18th century, wares with a porous glaze resembling an orange peel known as tachibanahadayaki were produced. In the 19th century, much of the Agano ware resembled Raku pottery.

Agni Deva　Hindu god of fire and one of the chief deities in the Vedic pantheon of ancient India, who was incorporated into the Buddhist pantheon as one of the devas. He is sometimes represented in the art of China and especially of Japan. In Japanese his name is Kwaten and he is seen as one of the Juni-ten or Twelve Devas.

Ainu　Aborigines of Japan who at one time, it is believed, inhabited the entire Japanese archipelago. Today they have almost died out: only a few thousand live on a reservation in Hokkaido, Japan's northernmost

island, and the small island chain to the north of it. In contrast to the Japanese people, the Ainu were of Caucasian stock and related to the indigenous people of Siberia. They worshipped the forces of nature and especially the bear, and lived on a neolithic level of civilization. The Japanese referred to them as Ebisu, or barbarians, and pushed them gradually northward over a period of many centuries. It is believed by many scholars that it was their ancestors who produced the Jomon culture of prehistoric Japan, one of the most remarkable neolithic cultures the world has known. See Jomon.

Aizen Myo-o Japanese name for a Buddhist deity who in Sanskrit is called Raga-vidyaraja. He is seen as the god of love and a manifestation of Dainichi (Sanskrit - Vairocana) and is often represented in the art of the Heian and Kamakura periods. His body is red, he has three faces, and six arms in which he holds a bow and arrow used to shoot down passions that bind men to the phenomenal world.

Aizu A type of Japanese folk pottery made in the Hongo kilns of Iwate prefecture. Although the wares produced here are coarse and intended for ordinary use, they are much admired by modern Mingei enthusiasts for their honesty and simple beauty of shape and glaze.

Aizu-nuri A type of lacquer produced in the Aizu district of northern Honshu. This industry dates from the late 16th century and excels in utilitarian lacquers, often decorated with bright colors and gold powder.

Akahada A Japanese kiln site located at Koriyama in Nara prefecture. The early wares produced here were tea wares in the tradition of Kobori Enshu, the famous tea master of the Momoyama period. However, the more characteristic productions were made during the 19th century under Mokuhaku in the manner of Ninsei and the Kyoto School. Particularly fine are his tea bowls with depictions of Horai, the Taoist Land of Immortals, and water jars decorated with charming little pictures in a primitive style.

Akasaka Section of Tokyo which during the Edo period was well known for its metalworkers, who were renowned for their iron sword guards and who took on the name of this district as their family name. Its founder was Shozaemon Tadamasa, who worked in the middle of the 17th century. He was succeeded by a long line of masters who flourished during the entire Edo period and were well known for the cutout patterns of the ironwork which they produced. Their decorative designs represented flowers, leaves, plants and animals shown in silhouette in a stylized manner.

Akashagharbha Literally meaning "Womb of the Void," the name of a Boddhisattva who embodies the idea that the ultimate nature of the world consists of emptiness. He is thought of as a personification of wisdom and compassion. He rarely occurs in the art of China, but is found in the esoteric Buddhist art of Japan where he is known as Kokuzo.

Akshobya The second of the Dhyani Buddhas, called A-ch'u in Chinese

and Ashuku in Japanese. He is usually represented seated in meditation with one hand in the dhyana mudra, the gesture of meditation, and the other in the bhumisparsa mudra, the gesture of calling the earth as a witness that he is a true Buddha.

Album The album of paintings or calligraphy is a format commonly used in the pictorial arts of China and Japan. The albums usually have wood or brocade covers and rarely measure more than 18 inches in height or width. They usually consist of eight, ten or twelve pages, although occasionally there may be more. A single album may include both paintings and calligraphy, often presenting both illustrations and poems on facing leaves. While many of the albums were executed by one particular artist illustrating some poems or working around some central theme, others might be the collaborative effort of a number of painters or calligraphers, or represent a collection of various works by different artist assembled by a collector. Some of the greatest masterpieces of Chinese and Japanese painting, such as the paintings of Ma Yüan and Hsia Kuei, the landscape sketches of Shih-t'ao, and the illustrations of the *Ise Monogatar* by Sotatsu, take the form of album leaves.

Altar of Earth and Harvests One of the chief places of worship of Imperial China, located in Peking, not far from the Imperial Palace. It takes the form of a white stone terrace surrounded by low walls with four gates. It is divided into five sections, each filled with earth of a different color: white for the west, green for the east, black for the north, yellow for the south, and red for the center. The earth was brought from the four corners of the empire to symbolize that all of the earth under the sun was subject to the emperor. Sacrifices performed by the Son of Heaven himself took place in the spring in order to obtain a good crop, and in the fall after the harvest. A hall of prayer built in the beginning of the Ming Dynasty stands north of the altar.

Altar of Heaven Part of the Temple of Heaven, located south of Peking, where the emperor of China performed the ceremonies and rituals to the deity of Heaven. See Temple of Heaven.

Ama-no-hashidate One of the scenic beauty spots of Japan which is considered one of the three outstanding views or sankei. The name means, literally, the "bridge of heaven," a term taken from Shinto mythology, but it specifically refers to a sand bar 2 miles long and 200 feet wide, covered with pine groves which have been bent into fantastic shapes by wintry storms. It is located in Kyoto prefecture not far from Miyazu. This famous site has often been represented in Japanese art, notably in an ink painting by the great Muromachi master Sesshu and in the colored woodcut prints of Hiroshige.

Amado Sliding wooden shutters placed over the windows in Japanese houses to protect them against rain, storms or thieves, especially at night. They are usually removed during the daytime.

Amakurikara amaryo Literally "rain dragon encircling a sword blade."

This motif is often engraved on Japanese sword blades or represented on sword guards. It is derived from Buddhism and symbolizes the union of the essential principles of life.

Amaterasu Shinto goddess and the most popular figure in the Japanese religious pantheon. She is goddess of the sun, born of the left eye of Izanagi. She is the legendary ancestress of the Japnaese ruling family, the present emperor Hirohito being regarded as the 124th in the line of descent. Many shrines in Japan are dedicated to the cult of the goddess. The main one is situated in the province of Ise where thousands of pilgrims migrate each year. Upon their return they are recognizable by small packages of charms wrapped in oil paper and worn hanging from cords around their necks. Amaterasu is also called Ohirume Muchi no Mikoto, Daijingu and Shimmei.

Amateur painter The Chinese pictorial tradition is very unique in regarding the painter who is not a professional, but rather a scholar, official or man of letters who does not live by his painting, as superior to the professional artist who sells his work. Although this idea did not exist in ancient China, it has played a great role in Chinese art criticism, at least since Ming times when the idea that the amateur or literati painter was superior to those who made their living from painting arose. The division of Chinese artists into the so-called Southern and Northern Schools, often rather arbitrarily applied especially in regard to earlier painters, is based on the notion that the former were all amateurs in this elevated sense of the term, while the latter were professionals. To this day many well-known Chinese painters and calligraphers look upon themselves as amateurs by this definition of the term.

Ameya Korean potter who became a naturalized Japanese citizen. He was active in Kyoto during the early 16th century and there established a ceramic kiln. He is primarily important for being the father of the famous potter Chojiro, who was the founder of the Raku school of pottery.

Amida See Amitabha.

Amida Sanzon A Buddhist trinity formed by the Buddha Amida flanked by the Bodhisattvas Kannon and Seishi. It is often represented in Japanese art, notably in the wall paintings of the Kondo at Horyuji and the famous Tachibana Trinity in the same temple.

Amitabha Fourth of the great Dhyant Buddhas, the Buddha of Endless Light, residing in the Western Paradise to which he welcomes all the faithful who call upon him. His Chinese name is A-mi-t'o-p'o, while in Japan he is known as Amida. He is frequently represented in both the sculpture and the painting of China and especially Japan, where the Pure Land or Jodo sect venerates him above all other Buddhist deities. The most famous of his images in Japan is that of the Great Buddha of Kamakura.

Amogha Vajra Hindu priest who lived from 704 to 774. In 733 he came to China and became one of the patriarchs of the Tantric sect. His Chinese

name is Fu-kung and the Japanese call him Fuku Kongo. He invented a new alphabet for the transcription of the Sanskrit language and published many books, several of them translations of Indian texts. He is sometimes represented in Japanese painting, especially that of the Esoteric School.

An-hua A type of ceramic decoration, known as "secret" or "hidden" decoration in English, which first appeared on Yung-lo bodiless ware in the 15th century and is found on many wares dating from subsequent periods. There are two varieties of an-hua decoration. It may consist of either a very fine engraving on the body, or a fine slip applied before glazing. In both forms, the design is hardly visible unless the piece is held up to the light.

An-yang City in northern Honan province of China where the remains of the Later Shang period capital were excavated in a series of digs starting in 1929 and continuing to 1937, and then resumed in 1950 during the postwar period. Many important tombs containing inscribed bones, bronzes, pottery, marble and jade carvings were discovered there. It is believed to have been occupied from 1350–1027 B.C.

Ananda Chief disciple of the Buddha Sakyamuni. His Chinese name is A-nan-t'o, his Japanese name, Anan or Tamon. He was entrusted by the Historical Buddha with spreading his teachings and is traditionally credited with having compiled some of the sacred writings or sutras. He is represented as a monk with a shaven head, dressed in monk's garments, and is sometimes paired with Kasyapa, another of the Buddha's chief disciples. He is often represented in the sculpture and painting of China and Japan.

Ancestor worship In both China and Japan, filial piety was regarded as a supreme virtue, and the spirits of the ancestors were worshipped in temples, at funeral shrines and at domestic altars. While it was Confucius, the great Chinese philosopher of the Late Chou period, who emphasized this cult, there can be no doubt that already in Shang times, 1,000 years earlier, the cult of the ancestors played a great role, for it was believed that if proper respect was not shown to them, the spirits of the dead would avenge themselves upon the descendants who had neglected them. Offerings of food and wine were given to them and special festivals honoring the dead were celebrated. In Japan this cult also is found already in prehistoric times, for the native religion of Japan, Shintoism, emphasized the worship of ancestral spirits and many of the great Shinto shrines are dedicated to the deified spirits of the great men of the past. In terms of the visual arts, this cult is reflected in the splendid shrines and tombs; erected for the ancestors and in the ancestral portraits which were often painted, notably in Ming and Ch'ing China.

Anchi See Kaigetsudo.

Ando Family name of the famous Japanese printmaker, Horishige, who was the last great master of Ukiyo-e and outstanding for his numerous landscape prints. See Hiroshige. It was also the artist name of one of the early

18th-century Ukiyo-e masters of the Kiagetsudo School, although the second character in the name was written differently. See Kaigetsudo.

Andon Portable lantern used inside Japanese dwellings where it fulfills the same function as our table lamps. The shapes of these lanterns can be varied—cylindrical, round, square, multisided or twisted. It is always open on top and made of paper stuck to a framework of thin wooden sticks. It is usually supported by one or two wooden shafts, 60 to 80 cm. or 23 to 31 in. in height, fixed to a solid base which sometimes contains a small drawer for lighting accessories, such as spare wicks or snuffers. The actual lamp is a small clay dish filled with vegetable oil in which the wick is soaked.

Anhui Chinese province which during the Ch'ing period was a center of a school of painting, of which the so-called Four Masters of Anhui, Hsiao Yung-tsung, Hung-jên, Ch'a Shih-piao, and Mei Ch'ing were the outstanding members. The work of these artists was characterized by the highly individual styles of the painters. See separate entries under artists' names.

Animal Caricatures Series of famous scrolls executed during the Heian and Kamakura periods, which are traditionally attributed to Toba Sojo. See Toba Sojo.

Animal combat motif Decorative motif associated with the art of the nomadic tribes of the Ordos Desert. It consists of two animals of fairly equal stature, for example a stag and a lion or a tiger and an eagle, locked in combat. Particularly fine examples of these fighting animals are to found in the form of harness plaques. See also Ordos.

Anjali mudra Hand gesture used in both Buddhist and Hindu art. It is a form of salutation and adoration, similar to hands folded in prayer in Christian ritual.

Annam Ancient kingdom of Indochina, now comprising part of Vietnam, which for many centuries, notably from the Late Han to the T'ang period, was dominated by the Chinese empire and stood under Chinese cultural influence.

Ao A Japanese word meaning green or of a green color. It is applied to a certain type of Kutani ware known as Ao-Kutani, which is the most characteristic and beautiful of all of the Japanese porcelains made at the Kutani kilns. Another use of the term is Ao Oni, or Green Devil, one of the mythological creatures of Japanese legend.

Aodo Denzen Japanese painter and printmaker of the Edo period who lived from 1747–1822. He was born in Sukagawa in Fukushima prefecture and served the Lord Matsudaira as a painter. His true name was Nagata Zenkichi, but he took on the artist's name Aodo Denzen. He first studied Nanga painting under Gessen, but later took up Western-style painting, which he had learned from Kokan and a Dutchman in Nagasaki. He is today primarily remembered for his Western-style paintings and copper plate prints representing landscapes.

Aoi Japanese name for the mallow whose leaves are often used as decorative motifs on sword guards and also figure prominently on Japanese family crests.

Aoki Family name of the famous Edo period Nanga painter, Mokubei. See Mokubei.

Apple green Type of Chinese porcelain, known in China as p'ing-kuo-ch'ing, which was made during the Ch'ing Dynasty at Ching-tê-chên in southern China. It is decorated with a copper green glaze, referred to by European collectors as apple green, which is applied over a white or grey crackled body. The finest of these were made during the rule of the emperor K'ang-hsi during the late 17th and early 18th centuries.

Apsara Sanskrit word for heavenly beings corresponding to angels in Christian legend. They are often represented in Japanese art as winged beings, flying to the sky and surrounding a Buddha. Among the most famous of these representations are the Chinese relief sculptures often decorating the ceilings of the Buddhist cave temples and the Japanese painted representations at the Konoo of Horyuji. In Japan they are referred to as tennin.

Arhat Buddhist holy men called Lohan in Chinese and Rakan in Japanese. They are creatures who have attained perfection, but have not entered the Nirvana and become Buddhas. They enjoyed a great popularity in both China and Japan and are often represented in the sculpture and painting of these countries. It is said that originally there were sixteen Arhats, but the number was later expanded to five hundred, which are portrayed in both Chinese and Japanese painting.

Arita Town in Saga prefecture of Kyushu, the southernmost island of Japan. It has been the great center of Japanese porcelain production ever since the 17th century, when large supplies of porcelain clay were discovered there. The early Arita wares were blue and white porcelains influenced by those of Korea and China, but later on many colors as well as gold were used in the decoration of the Arita wares. Among the outstanding productions of the Arita kilns are the refined Kakiemon wares, the Nabeshima wares produced for the local daimyo, and the Imari wares, so-called after the port from which they were exported all over Japan and to Europe. Arita continues to be an important center of Japanese porcelain manufacture to the present day. See also Imari, Kakiemon, Nabeshima.

Asagao Japanese term for the morning glory, a very popular flower in Japan where it symbolizes the shortness of life's span. It is often represented in Japanese painting and is regarded as one of the Seven Plants of Autumn.

Asahi Sho Ivory carver of the second half of the 19th century. He also bore the name of Noboru and worked in Tokyo. His two sons, Meido and Kodo, were also talented sculptors and worked toward the end of the 19th century. They were both pupils of Ishikawa Komei.

Asai Chu Japanese painter of the Meiji period who lived from 1856–1907. Born in Chiba prefecture, he moved to Tokyo, where he first studied

Japanese painting under Kunisawa Shinkuro and then Western-style art under the Italian artist Antonio Fontanesi at the Tokyo Art School. He became one of the leading Western-style painters of Japan and was appointed professor, first at the Tokyo Art School and later at the Technological School in Kyoto. In 1900 he went to Europe, where he had the opportunity to study current French painting. He specialized in oil painting, especially landscapes, which were executed in a realistic style derived from 19th-century French painting.

Asakusa A district of Tokyo situated on the banks of the Sumida River, which contained the red light district of Edo and was the site of a great Kannon temple. Scenes from Asakusa are often represented in Japanese prints, especially those dealing with the so-called greenhouses and the life of the courtesans. In addition, the district also contained ceramic factories which produced all kinds of wares. The Asakusa ningyo, small figurines used as netsuke, were made by Fukushima Chikayaki in the Asakusa district during the middle of the 19th century.

Asano A daimyo family originating in Owari, which was founded by the general Nagamasa (1546-1610), who was the brother-in-law of Hideyoshi. In 1619, the Asano were made princes, and the town of Hiroshima became their residence. They played a prominent role in the history of Japan, and were great patrons of art. The Asano collection, containing some of the most famous Japanese paintings, is to this day one of the outstanding collections of Japan.

Ashikaga Celebrated feudal family which was descended from the Minamoto. It played a great role in Japanese history, with the Ashikaga becoming the shoguns or military rulers of the country from 1333-1573. Its most important members were Yoshimitsu and Yoshimasa, who were great patrons of art during the Muromachi period. See also Yoshimitsu and Yoshimasa.

Asuka A region of Japan in Nara prefecture where the first Buddhist temple was constructed during the late 6th century. The temple was completely destroyed in the fire of 1196, but a Buddha image made by the most famous early Buddhist sculptor, Tori Busshi, survives in damaged condition. The first historical period of Japan, lasting from 552-650, is today referred to as the Asuka period. See also Tori Busshi.

Asura Originally the demon king in Hindu mythology who is perpetually engaged in a bitter battle with the gods. As with so many figures of Hindu mythology, he found his way into Buddhist legend as well, and is sometimes represented in Far Eastern art, the most famous example being the Asura image from Kofukuji in Nara.

Atsuita Japanese term used to describe the costume which is the basic garment for a male role in a noh play. There are two main types of atsuita, one decorated with a design in large blocks, the other in a latticework pattern. In both cases the design is woven into the fabric.

Aureole See Nimbus and Halo

Autumn Festival Important Chinese popular celebration which falls on the 9th day of the 8th lunar month, corresponding to the end of September in the Western calendar, and usually coinciding with the autumnal equinox. It marks the middle of the autumn season and is celebrated by eating moon cakes and admiring the full moon. It sometimes is represented in Chinese painting, but played a lesser role than the Spring and Dragonboat Festivals.

Avalokitesvara Most famous of all Buddhist Bodhisattvas or saints, called Kuan-yin in Chinese and Kannon in Japanese. The name literally means the "lord who looks on." He is seen as the Bodhisattva of mercy and compassion and the spiritual son of Amitabha. He is usually represented as an Indian prince with a crown, jewels and skirt, and sometimes holds a fly whisk or a bottle of heavenly nectar. At other times he is shown with the lotus, symbol of purity, and as such is known as Padmapani. In his Tantric form, he may also be shown with eleven heads, and at times with as many as a thousand arms. In China, after the Sung period, the deity is usually represented in female form and thought of as a goddess of mercy. He enjoyed great popularity both in China and Japan, and is often represented in both painting and sculpture.

Avatar Sanskrit term referring to the different incarnations of the Hindu gods who may manifest themselves in multiple forms, taking on both human and animal shapes. The great god Vishnu, for example, may manifest himself as a gracious cowherd, Krishna, or as a boar or lion, and the beautiful goddess Parvati may also manifest herself as the haggard and repulsive goddess of pestilence, Kali.

Awaji Island in Japan's inland sea which is best known, in terms of art, for the pottery kiln which was established in Igano, a village in the extreme north of the island. It was built around 1830 by a rich merchant, and under Kasu Mimpei produced brilliant wares decorated with yellow and green enamels in imitation of Chinese wares, as well as wares decorated in gold and silver in imitation of the Ninsei wares of Kyoto. Mimpei was succeeded by his son, Rikita, and his nephew, Sanpei, who carried on the work but it is believed that the early works coming from the Late Edo period are the best productions of the kiln.

Awate Type of pottery manufactured in the Awate district of Kyoto. It is a ware similar to Satsuma ware, employing enamel colors and gold on a soft body. It enjoyed considerable popularity during the late 19th century in Europe and America, and the Awate kilns are still active today.

Aya or **Ayaginu** Japanese term literally meaning "figured silk." As it is presently used, the term simply refers to a twill weave, but historically speaking only those silks in which the twill was used sectionally to produce intricate patterns or figures can be classified as aya. The material is characterized by the delicacy of its designs, which contrast with the richness of the nishiki or brocade patterns. The twill weave was one of the

most widely used methods during the Nara period, when its development was second only to that of brocade.

Azuchi Site of a famous castle built on the shores of Lake Biwa in 1576 by the Momoyama-period military dictator, Oda Nobunaga. It was seven stories high and framed for its splendid buildings and magnificent paintings. However, it was destroyed and nothing of it remains today at this site except for the tomb of Nobunaga.

ABCDEFGHIJ KLMNOPQR STUVWXYZ

Badger The badger, called tanuki in Japanese, is an animal that is believed to be gifted with supernatural and magical powers and plays a great role in Japanese legend. He is said to be able to disguise himself as a pilgrim or a priest, or is shown wearing a lotus leaf with a flower serving as headgear and holding a sake bottle. He is considered a mischievous animal who does a great deal of harm if the opportunity presents itself, always ready to molest peasants, fishermen and travelers. Numerous legends are told about his escapades, which are often represented in the popular art of Japan.

Bamboo A very common and much-beloved plant in both China and Japan, where it is used for many purposes, such as for the construction of houses, in the garden and farmyard, and the making of a great many utensils. It is also looked upon as a symbol of long life, constancy and fideltiy, with the Confucian scholar often said to resemble a bamboo which bends in the wind but does not break. There is an entire category of painting which, especially in China, enjoyed tremendous popularity, devoted to the depiction of bamboo.

Ban Japanese term used to describe a banner, in particular those used to decorate Buddhist temples. Although the term usually designates a cloth banner, it may also be used in reference to sheet metalwork which is hung in the manner of a banner or streamer.

Banko Name of a ceramic ware, literally meaning "10,000 years old," produced in Mie prefecture. The kiln was established in the 18th century by a well-to-do merchant by the name of Gonzaemon and produces fine-grained stoneware decorated with bright enamel colors.

Bat The bat, called fu in Chinese, plays a great role in Chinese legend and is often represented in Chinese art. It is referred to as the flying rat or a form of mouse, and is looked upon as an auspicious creature, an emblem of happiness and longevity. The reason for this is probably that the

12

character for bat and that for happiness, although written with different pictograms, are both pronounced "fu."

Batik An Indonesian method of hand-printing textiles which consists of coating parts of the fabric with wax to resist the dye, dipping it in a cold dye solution, boiling off the wax, and repeating the process for each color used. A similar technique was employed in both China and Japan. Excellent examples may be found in the Shosoin in Nara, which date from the 8th century and probably came from T'ang China. This technique was widely used in Japan, especially for Okinawan folk textiles, and is in Japan referred to as rokechi.

Bazan Famous netsuke carver of the Meiji period who was born in Gifu in 1834 and died in 1897. He excelled in carving a great variety of netsuke in wood, never repeating the same design twice. His style is very realistic and he usually engraved his name on his carvings.

Bear An animal which plays an important role in the folklore of both China and Japan, and was probably imported from Siberia, where the bear cult had a central position in the religious and magic life of Shamanism. It is often represented in the art of ancient China, where sculptures in stone, jade, and bronze in the shape of bears were common and were believed to be protective charms, since the bear represented bravery and strength. In Japan, the bear cult is particularly important among the Ainu people of Hokkaido, who to this day worship the bear as a sacred deity and represent it in their carving.

Benizuri-e Literally "crimson prints." Early Japanese prints which were printed in crimson and green with yellow also added sometimes. They are similar to beni-e or "crimson pictures," which were produced somewhat earlier, but differ in that the color was applied by hand in beni-e and by the printing process in benizuri-e.

Begging bowl Buddhist monks, as part of their vow of poverty, were required to beg for alms for their sustenance. In doing so they employed a bowl whose top curves inward, which is referred to as a begging bowl. This form was employed by Chinese potters throughout the ages as one of the standard ceramic forms, and it is also referred to as an alms bowl.

Beni-e Literally "crimson pictures", a type of early Japanese prints in which a crimson red applied by hand was the dominant color with yellow and green sometimes used as subsidiary colors. See also Beni-zuri-e.

Benkei Hero of Japanese history and legend who lived during the 12th century. After a wild childhood he became the perfect model of a fighting monk, and is often portrayed with a shaven head, wearing a small skullcap. It is said that he grew to a height of 8 feet and was immensely strong. Among his many celebrated exploits was the theft of the Miidera bell, which he carried on his shoulders. Another episode relating to him is the one in which he collected swords by seizing them from passers by on the Gojo Bridge in Kyoto. Having acquired 999 fine specimens, he was,

however, defeated by Yoshitsune, whose retainer he thereupon became. From then on the two became inseparable companions and underwent many adventures together. Episodes from his life are frequently represented in Japanese art. See also Yoshitsune.

Benten Japanese form of the Hindu deity Sravasti, the wife of Brahma and goddess of eloquence and learning. She enjoyed great popularity in Japan, where she was regarded as one of the Seven Gods of Good Luck, the only female of that group. She is particularly popular as a patroness of literature and music, but is also connected with the sea, and is sometimes referred to as the daughter of the Dragon King. Numerous famous temples are dedicated to her, notably the shrine at Enoshima near Kamakura. She is also frequently represented in Japanese painting and sculpture.

Bentobako Box often decorated with lacquer and consisting of several superimposed compartments. It is used to contain food to be carried on outings.

Benwa Japanese name for the Chinese god of jewellers. See Pien-ho.

Benzaiten See Benten.

Bhaishajyaguru See Yakushi.

Bhumisparsa mudra Hand gesture made by the Buddha during his temptation by Mara, the Evil One. It consists of touching the earth, thereby calling upon the earth goddess as witness that he is the true Buddha. It sometimes occurs in the sculpture and painting of China and Japan.

Bijinga Literally the "painting of beautiful women," it is a category of the Japanese pictorial tradition which goes back to the Edo period and which has enjoyed great popularity among modern Japanese style painters. Among the most famous artists working in this genre were Kaburagi Kiyokata and Ito Shinsui. See Kiyokata and Shinsui.

Bimbo Gami The god of poverty in Japan, whose presence in a household is betrayed by the clicking sound made by the insect known in the West as the "death watch" beetle. This deity is considered to be the shadow of Fuku-no-Kami, the god of wealth. A copper coin sealed in a bamboo tube and used as a whistle in a special ceremony is believed to be an effective means of keeping out this undesirable spirit.

Bird and flower painting Category of Chinese painting first established during the T'ang period. It played a prominent role in the art of the Sung, Yuan and Ming Dynasties. The first two famous artists who worked in this genre were the 10th-century masters Huang Ch'üan and Hsü Hsi; however, no paintings which can with certainty be attributed to them have survived. The most famous bird and flower painter of the Sung period was the emperor Hui-tsung, while the most celebrated of all bird and flower painters was the Late Sung and Early Yuan painter Ch'ien Hsüan, of whose work many examples have come down to us. Of Ming painters working in this genre, the best known was Lü Chi who is celebrated for his decorative scrolls. Among more recent bird and flower

painters, the most original were Chu Ta, a painter of the Eccentric School, and Ch'i Pai-shih, the great 20th-century master. The term "bird and flower" is used rather loosely to include paintings wholly devoted to flowers, flowering branches, insects, butterflies and similar subjects.

Birds Both magical and naturalistic birds play a great role in the mythology and art of China and Japan. Already in the Shang bronzes many species of birds are represented, among which the owl, a symbol of night and darkness, and the pheasant, standing for light and sun, are the two most important. In later times the sun is shown containing a raven, and the symbol of the south takes the form of a solar bird and is often represented as such as Chinese wall paintings and decorative designs. Among the imaginary birds it was the fêng-huang, usually translated as "phoenix," which plays the greatest role. This bird is associated with the empress and is often shown on the garments and ornaments worn by the ladies of the Chinese court. In Japan numerous birds were shown, especially in the painting and among the decorative designs employed by Japanese craftsmen throughout the ages. Particularly popular were hawks and eagles represented on the screen paintings, but many other birds occur throughout the history of Japanese art.

Birodo Japanese term for the fine velvets which were introduced from China during the late 16th century. Japanese weavers began manufacturing these fabrics and eventually developed the beautiful birodoyuzen in which the velvet provides a ground for pictures in soft colors produced by a combination of cutting and dyeing processes. A colored picture is affixed by the yuzen process to the birodo, which is then given to the cutter, who will clip the looped threads at varying depths to enhance the design.

Bishamonten Japanese form of the Indian god Kubera, the Vedic god of wealth, who is the protector of the treasures of the earth and the guardian of the north. He is looked upon as one of the Seven Gods of Good Luck who insure prosperity. He is usually represented as a warrior dressed in armor, holding weapons and wearing a fierce expression on his face. Numerous representations of him are found in Japanese painting and sculpture. Many of these representations show him as one of the Four Heavenly Guardians who protect temples. In this form, he can usually be recognized by a small pagoda which he carries in his hand.

Biwa Name of a lake near Kyoto in Shiga prefecture. It is so called because its shape is like that of a Japanese musical instrument resembling a mandolin which is called biwa. It is celebrated in Japanese literature and art and regarded as one of the beauty spots of Japan. Following the Chinese custom of representing eight views of some famous landscape, Japanese painters have often represented the eight views of Lake Biwa in their art.

Bizen District of Japan in Okayama prefecture where very beautiful pottery has been made from Kamakura times to the present day. Traditionally regarded as one of the six ancient kilns, it initially was purely utilitarian, but after being discovered by the tea masters during the Momoyama

period it became one of the most important centers for the production of tea ware. The jars, pitchers, bowls and dishes have a reddish-brown body and are unglazed. It is probably the most characteristically Japanese of the Japanese ceramic productions, and is to this day admired by the tea masters as giving expression to the very essence of the Japanese tea taste. Two of the great modern masters of Bizen, Kaneshige Toyo and Fujiwara Kei, have been designated living cultural treasures of the Japanese nation.

Black ware Type of prehistoric Chinese pottery first discovered at a site near Lung-shan in Shantung, and therefore also often referred to as Lung-shan ware. It is believed to date from between 2500–1700 B.C. The shapes, consisting largely of dishes, beakers and tall stemmed cups, are very similar to wares made earlier in Iran. It is well thrown and finely made with a glossy black surface. See also Lung-shan and Ch'eng-tzu-yai.

Blanc de Chine Type of Chinese porcelain developed during the Ming period, which had a very pure white body and was covered with a white glaze. In addition to the usual ceramic shapes, many of these white wares took the form of figurines, derived from Buddhist or Taoist legend. The center of their manufacture was Tê-hua in Fukien province.

Blue and green painting A style of Chinese landscape painting employing azurite blue and malachite green, which in Chinese is referred to as ch'ing-lü. Itwas particularly popular during the T'ang period and was used by Li Ssu-hsün and Li Chao-tao and their followers, who are usually associated with the Northern School of Chinese painting.

Blue and white ware Type of Chinese porcelain which was decorated in cobalt blue under the glaze on a pure white porcelain body. The style was probably originally introduced from the Islamic Near East, but became popular in China during the Yuan and Ming periods, and has been used in China, Korea and Japan ever since. Imitations of Chinese blue and white were also made in Europe, especially at Delft.

Boar The boar, in ancient China, was looked upon as an animal symbolizing the wealth of the forest and was one of the twelve animals in the zodiacal cycle. Along with the domesticated pig, its flesh was much esteemed, and it was used in the sacrifices to the spirits. Its hair was used in the manufacture of paint brushes and also for thread in the sewing of leatherwork. It is sometimes represented in Chinese art, especially in pictorial representations of the twelve sacred animals of the duodenary cycle.

Boccaro Portuguese word to describe a Chinese stoneware of a dark color made at the I-hsing kilns. See I-hsing.

Bodhi Tree The tree under which the Buddha achieved Enlightenment, derived from "bodhi," a Sanskrit word meaning "enlightenment." It was located in the village of Bodhgaya in the Bihar state of northeastern India.

Bodhidharma Indian monk who is regarded as the founder of Ch'an or, in Japanese, Zen Buddhism. He is known as P'u-t'i-ta-mo or Ta-mo in Chinese and Daruma in Japanese. He supposedly arrived in China in 520,

bringing with him the new Buddhist doctrine, but some modern scholars have questioned his historical existence. He is commonly represented in both Chinese and Japanese painting. See also Daruma.

Bodhisattva A Buddhist saint who is on the road to Buddhahood, but has chosen to remain on earth to bring salvation to suffering mankind. Although the Sanskrit term is usually employed in reference to him, the Chinese word used is P'u-sa and the Japanese term is Bosatsu. He is represented wearing a crown, jewels, a scarf and skirt like those of an Indian prince, since the Historical Buddha Sakyamuni is thought of as having been a Bodhisattva before reaching Buddhahood. There are numerous Bodhisattvas of whom Avalokitesvara, Maitreya, Kshitigarbha, Manjusri and Samantabhadra are the most important. They are all frequently represented in the Buddhist art of both China and Japan. See entries under names of individual Bodhisattvas.

Bodiless porcelain Translation of the Chinese term t'o-t'ai, referring to white porcelains potted with a paper thinness so that the vessel appears to consist of nothing but glaze. The finest of these were made during the Yung-lo period of the Ming Dynasty, but other examples were produced during the Ch'ing reign as well.

Bokuseki Japanese term used for the calligraphy executed by distinguished Chinese Ch'an priests. Such works were greatly esteemed by Japanese Zen monks and tea masters, and were often displayed in the alcove of the chashitsu or tea room.

Bompo Japanese painter of the Muromachi period who lived from 1344 to 1420. He was a priest at the Nanzenji Temple in Kyoto. His work was based on Chinese ink painting of the Sung period, specializing in the depiction of orchids.

Bon Festival or **Bon Matsuri** A Buddhist festival celebrated every year in honor of the dead between the 13th and 16th of July. It is believed that the souls of the dead return to earth during these days and visit their family home. The houses are cleaned for this occasion and food and drink are set out in front of the family altar. Lanterns are placed everywhere in the evening, especially at the seashore and lakes and rivers, to welcome the dead. Dances are performed at the local temples and shrines throughout rural Japan, which are referred to as bon odori. After the festival is over the dead are conducted back to the spirit world.

Bone carving Bone, along with bronze clay, wood and metal, was one of the artistic media employed by the artists of ancient China. It is particularly important for the inscriptions in an archaic script which were found on some of the bones, and it is through these inscribed bones, which were traditionally referred to as dragon bones and sold in Chinese apothecaries, that the attention of archaeologists was drawn to the remains of the Shang Dynasty. Other bones might be employed for stylized animal designs of a magical or symbolical nature and yet others in connection with divination. See also Oracle bones.

Bone writing Term used for the most ancient of Chinese scripts, which was in use during the Shang Dynasty beginning with the 16th century B.C. It is known as chia-ku-wên, literally shell-bone script, in Chinese. The earliest examples of this style have been preserved in the form of characters engraved on animal bones, tortoise shells, and bronzes which were uncovered by excavations in Honan province. The style is highly pictorial and linear in nature with the strokes forming well-composed patterns, although lacking fixed standards at this time. While this script is crude and archaic, it is basically that used by the Chinese today. Modern calligraphers have returned to the study of this ancient style for inspiration for new methods of treatment.

Boneless painting A method of Chinese painting, known as mo-ku-hua in Chinese, in which no outlines are employed, only colors and washes.

Bonkei A small tray on which a miniature garden is created with mud, peat, many-colored sands and other materials. The tray is often decorated with black lacquer.

Bonsai Japanese term used to describe the art of cultivating dwarf trees or plants in pots for their aesthetic beauty. Although often very old, these cherry trees or pines are artificially kept small and are handed down from generation to generation. Picturesque examples of such dwarf trees are greatly prized and bring high prices.

Bonten Japanese name for the creator god of the Hindu religion, Brahma, who was incorporated into the Buddhist pantheon. He is often represented as one of the Twelve Devas in Japanese painting and sculpture. See Brahma.

-bori Japanese suffix meaning to engrave, to chisel, to sculpt, which is often added to words describing lacquer work or metalwork, such as Kamakura-bori, sukashi-bori, chinkin-bori, etc.

Bosatsu Japanese word for Bodhisattva. See Bodhisattva.

Boys' Festival The Boys' Festival, which is celebrated in Japan on the 5th day of the 5th month, or May 5th, is referred to as Shobu-no-sekku or Tango-no-sekku in Japanese. It is the equivalent of the Girls' Festival which is celebrated on the 3rd day of the 3rd month. On this day leaves of the iris are put on display because they are said to resemble the blade of a sword, and in the houses of the well-to-do an arrangement of dolls representing famous feudal generals with their armor and weapons are placed on display. A cloth or paper streamer in the form of a carp is flown from a wooden pole in the yard or garden, one for each boy in the family.

Brahma Also known as Fan-t'ien Wang in Chinese and Bonten in Japanese. Hindu deity who is looked upon as the first member of the Hindu trinity and the creator god. He is usually represented with four heads and is often shown seated on a swan or goose. He is rarely represented in Chinese art, but is more commonly found in Japan, where he occurs as one of the deities in the Shingon pantheon or as an attendant deity to a Buddha or Bodhisattva.

Brocade A rich oriental silk fabric with raised patterns embroidered in gold and silver threads. This technique was highly developed in China, where it was known as chin. Examles of such silk brocade textiles, dating from as early as the Han period, have survived, and it is recorded that the Chinese emperor sent rolls of brocades with dragon designs to the Japanese court as early as the 3rd century A.D. These fabrics also enjoyed great popularity in the Islamic world and medieval Europe.

Broken ink See P'o-mo.

Bronze Bronze, an alloy of copper and tin with sometimes a small addition of zinc, ever since the Shang Dynasty, which was founded during the middle of the 2nd millenium B.C., served as a major artistic medium in China. It was introduced into Japan from the continent during the Yayoi period around 200 B.C. via Korea, where it was also widely employed. In ancient China it was indeed the most important of all artistic media, with the ritual vessels for the worship of the spirits of nature and the ancestors made of this material, either with the aid of molds or by the lost-wax process. During the later periods, especially under Buddhist inspiration, bronze was employed in China and Japan for the making of religious images which were also often gilded. Among the most famous of these Buddhist bronzes are the numerous sculptures from the Six Dynasties and T'ang period of China, and those of the Nara and Kamakura periods in Japan, notably the Daibutsu at Todaiji and Kamakura. At the same time, bronze continued to be used throughout the history of both Chinese and Japanese art for all kinds of utilitarian objects and in the decorative arts. See also Ritual vessels and entries under individual shapes.

Brush The brush, known as pi in Chinese and fude in Japanese, is the most important tool of the Chinese or Japanese painter or calligrapher. The artist usually employs an assortment of brushes which are kept in a special brush pot. The handle of the brush is usually made of wood, but the bristles consist of the hair of various animals, most commonly rabbit or hare. However, for coarser work, sheep or goat or other hair such as fox, sable, badger, camel and deer may be employed.

Brushwork The quality of brush painting is, in the eyes of Chinese and Japanese critics, the most important single criterion for excellence in painting and calligraphy. The chief medium used for brush drawing is usually ink, but a limited pallet of colors may also be employed. The brush itself is usually soft but resilient and can be shaped to a fine point. See Brush.

Buddha The term used for Saki yamuni after achieving Enlightenment. While the Sanskrit word is usually employed to refer to this divine being, the Chinese term is Fo-t'o or Fo and the Japanese term is Butsu. While originally there was only the Historical Buddha, who is also known as Gautama, in later Buddhism, especially of the Mahayana sect, there are a host of Buddhas among whom Vairocana—the Cosmic Buddha, Amitabha—the Buddha of the Western Paradise, Maitreya—the Buddha of the Future, and the Dhyari Buddhas are the most important.

Buddhist cave temples Among the most important artistic monuments of Buddhist China are the cave temples which, in imitation of Indian models, were hollowed out of the living rock. The most outstanding of these date from the Six Dynasties and T'ang periods, notably the 5th, 6th, and 7th centuries of the Christian era. They were used for religious devotion, to house the monks, and as places of pilgrimage, and were decorated with sculptures and wall paintings. The best known of them are Yün-kang, Lung-mên, T'ien-lung Shan and Tun-huang, the last particularly important in containing a large number of Buddhist murals dating from the late Six Dynasties and T'ang periods. See also entries under the names of specific cave temples.

Bugaku A Japanese dance and music performance which was introduced from China. It is primarily of importance in the study of the visual arts for its use of highly expressive masks, many of them with movable parts, and magnificent colorful garments, the finest of which were made during the Heian period. Bugaku was performed at the imperial court as well as in Buddhist temples and Shinto shrines.

Bull The bull plays an important role in both the legend and art of China and, to a lesser extent, of Japan. With its crescent-shaped horns, it is believed to have had lunar associations and played a great role in the ceremonial and agricultural life of the people. The bull motif was a popular one already in the art of the Shang and Chou periods, and occurs in painting and sculpture throughout the history of Chinese art. In Japan bulls were used to pull carts during the medieval period and were often represented in Japanese painting.

Bunchin Japanese term for a weight used to prevent the paper from rolling up while it is being written on. It often takes the form of a small bronze figurine of an animal or mythological or legendary origin. They are also referred to as okimono.

Buncho Japanese printmaker of the Ukiyo-e School who lived from c.1725 to 1794. His family name was Moru and he used the pseudonym Ippitsusai. He specialized in prints of Kabuki actors. His early work was influenced by Harunobu, while his later work is close to that of Shunsho, with whom he collaborated in 1770 in a famous book called *Ehon Butai Ogi* or *Picture Book of Stage Fans*.

Buncho Japanese painter of the Eco period who lived from 1765 to 1842. His family name was Tani and he is not to be confused with the Ukiyo-e printmaker Ippitsusai Buncho, whose name is written with one different Japanese character. He was a pupil of Bunrei and Kangan who was well-versed in both Japanese- and Chinese-style painting and also learned the European technique of rendering perspective. He served the Lord Tayasu and was much admired for his painting during his lifetime. He is usually regarded as a member of the Nanga School, which he introduced to Edo. However, he also worked in the Kano and Yamato-e traditions. His output was huge, comprising landscapes, figures, portraits and birds and

flowers, but was extremely uneven. He was called the greatest painter in Edo in his time, but his reputation has not stood up too well. Examples of his work may be seen in the Tokyo National Museum.

Bundai Small low table used by the Japanese for writing. It is generally made of lacquered wood and often forms part of an entire set of writing utensils.

Bunjinga School of Japanese painting in which there was a great emphasis upon the artists being gentlemen painters and amateurs in the best sense of the word. It roughly corresponds to the so-called Southern or Nanga School of painting, which played an important role in Japanese painting of the Edo period. See also Literati painting, Amateur paint, Gentlemen painters, and Wên-jên hua.

Bunsei Japanese painter of the Muromachi period who flourished during the middle of the 15th century. He was a Zen monk attached to Daitokuji Temple in Kyoto. He worked in the suiboku school of ink painting in the Chinese manner and was strongly influenced by Shubun. He painted both landscapes and religious figures. Good examples of work attributed to him may be found in the Boston Museum and the Yamato Bunkakan in Nara.

Buson Japanese painter of the Bunjinga (art of literary men) School who lived from 1716 to 1783. His original name was Taniguchi, but he substituted Yosa as an expression of his admiration for Chinese art. He was one of the most celebrated haiku poets and did not take up painting until he was forty. His work shows a spontaneous and abstract style in rendering a landscape and is based on Chinese painting of the Nanga or Southern School.

Butsu Japanese word for Buddha. See Buddha.

Butsudan A Japanese term for the family altar containing the tablets of the deceased which are found in all Buddhist households. They also often contain small statuettes of divinities, candles, incense burners and small shrines. Offerings of food and wine are presented here, incense burned and prayers said.

Butterfly The butterfly, which was considered a type of bird in ancient China, enjoyed great popularity and was often referred to in poetry and depicted in painting. It was an emblem of joy, a symbol of summer and a sign of conjugal felicity. It is frequently shown as a decorative motif in the embroidery and porcelain of the Ming and Ch'ing periods. There are also some charming painted scrolls in which the butterfly is rendered in a delicate and poetic manner.

Byobu Japanese term for screen painting, which originated in China, but enjoyed particular popularity in Japan beginning with the Nara period. It may contain as few as two and as many as twelve leaves, with sets containing two six-leaved screens the most common. They are used extensively in Japanese houses, temples and palaces for decorative purposes, to create a certain atmosphere, as room dividers and as protection against drafts.

Some of the most famous of all Japanese paintings were executed in the form of such byobu. They are generally made of very strong paper glued on to frames of light wood which are decorated either in black and white or in bright colors, sometimes with gold leaf. The finest of these screens are believed to be those made during the Momoyama and Early Edo periods.

Byodoin One of the most famous of Japanese Buddhist temples, located at Uji near Kyoto. It was originally built as a villa for the prime minister Fujiwara-no-Michinaga, and was converted into a temple in 1052. The main hall, which is known as the Phoenix Hall or Hoodo, was built in 1053, and is considered the most outstanding piece of religious architecture of the Heian period. The name was given to it due to the fact that the floor plan of the building resembles the shape of a bird, and a male and a female phoenix cast in bronze decorate the top of the central hall. Its main icon is a wooden image of the Buddha Amida, believed to have been carved by the most famous sculptor of the time, whose name was Jocho.

ABCDEFGHIJ KLMNOPQR STUVWXYZ

Cakra or **Chakra** A Sanskrit term meaning "wheel," which is used especially in reference to the Wheel of the Buddhist Law symbolizing the preaching of the Buddhist doctrine throughout the world. It is often represented in Buddhist art as a symbol of the Buddha and the spread of his doctrine.

Calendar In both China and Japan, the lunar calendar was employed until modern times, when the Western style Gregorian or solar calendar was introduced, first to Japan, in 1868, and then to China, in 1927. In it the year starts several weeks later, with New Year's Day falling somewhere between January 20 and February 19, and in consequence all other events also fall on a later date. The year is divided into twelve months which may consist of twenty-nine to thirty days, and it was therefore necessary to insert an intercalary month to make up for the extra days. The month itself was divided into three shorter periods of ten days each, and there were six such periods, making a sixty-day cycle. Six such cycles accounted for a year. In addition, there was the zodiacal calendar, in which one of the cycles of twelve years was named after an animal. (See Twelve Animals.) Five such cycles makes a series of sixty years, with the designation of the five twelve-year periods including the five elements, namely wood, fire, earth, metal and water. In traditional China and Japan, the years were designated either by their place in this sixty-year cycle, or would be listed as a certain year in the reign of an emperor or the period in which a significant event occurred in Chinese or Japanese history.

Calligraphy A Greek term referring to the art of beautiful writing, which has always played a major role in both China and Japan. It has often been said that only a good calligrapher could possibly be a good painter, and Far Eastern artists usually received training in calligraphy before they were taught painting. At the Imperial Academy in China, painting was regarded, in fact, as a subdivision of calligraphy, and most paintings contained inscriptions, poems, comments or signatures and seals in a beautiful writing. Many different styles of writing were employed, and to

23

this day thousands of Chinese and Japanese artists make calligraphy their profession. See entries under individual scripts: Bone writing, Ku-wên, Ta-chuan, Hsiao-chuan, Li-shu, K'ai-shu, Hsing-shu and Ts'ao-shu, and also Shodo and Kana.

Canton Chinese city located in Kwangtung province in southern China, on the banks of the Pearl River. It was a great center of China trade in the 18th and 19th centuries, and was the first Chinese port city where foreigners were permitted (at least to the outskirts of the walled city). Canton, therefore, served to introduce Europe to Chinese civilization. A type of porcelain especially made for foreign trade was exported from here, and was known as Canton ware in Europe and America.

Carp The carp, in traditional China, was thought of as an auspicious creature connected with marital happiness and many offspring; this probably derived, originally, from its male sexual connotations. To this day, the Japanese fly paper carps on Boys' Day to signify the presence of male offspring in the household. The carp is often represented in Chinese painting, and is considered one of the emblems of good luck in Chinese popular art.

Carpet The making of a pile carpets of wool from sheep or camels has existed in China for a long time, especially in the westernmost provinces, notably Kansu, Sinkiang and Inner Mongolia. It was probably introduced from the nomads of Central Asia and the Near East, who originated this art form in the pre-Christian era. The earliest examples found so far are fragments of pile carpets dating from the Han period which Sir Aurel Stein excavated in Chinese Turkestan along the old Silk Route. Fine examples of early Chinese rugs dating from T'ang times are also found in the Shosoin in Nara. Few of the existing specimens are older than the Ming period but literary accounts indicate that carpets were used in China for many centuries prior to that. Their colors are usually subdued, using cool blues and yellows, and their decorations consist of floral ornaments, abstract designs or embels of good luck and prosperity. The best of them were made in the western regions, especially around Ning Hsia.

Castiglione, Giuseppe Italian painter of the 18th century, known as Lang Shih-ning in China, who was born in Milan in 1688 and died in Peking in 1766. He was a Jesuit missionary who arrived in China in 1715 and became very popular at the Manchu court, serving both the emperor K'ang-hsi and the emperor Ch'ien-lung. His art combined Western and Chinese elements. It had little influence on the further development of Chinese painting. Although he was a remarkable man who was much admired, his paintings are little more than curiosities.

Castles Among the most important of Japanese architectural monuments are the numerous castles erected during the Momoyama and Early Edo periods. While some of the most grandiose, such as the Osaka Castle built by Hideyoshi, were destroyed, others, notably the Himeji Castle and the Nagoya Castle, are among the most impressive architectural monuments

of Japan. Their towering keeps, heavy walls, spacious halls and moats made them formidable military strongholds during the wars. It is believed that their construction owed a good deal to the influence of Western architecture which became known during the 16th century. See also entries under the names of specific castles.

Cat Although the cat is sometimes represented in Chinese and Japanese painting and sculpture, it never played a prominent role, either in the religious life, as it did in Egypt as a domestic pet, as it has done in the Western world. Cats were, however, often employed to protect the grain against rats. In Chinese and Japanese painting the cat is usually represented as a pet, with emphasis on its grace and beauty. In Japanese popular art the beckoning cat is a popular motif which, executed in clay, is sold at the Gotokuji Temple in Tokyo, since it is believed that it brings prosperity and good fortune.

Cedar The cedar, called sugi in Japanese, enjoys great popularity in Japan, both for its beauty and as a building material. Avenues of cedar trees and cedar groves are often planted at Shinto shrines, notably the Tokugawa mausoleum at Nikko. Cedar-wood, due to its beautiful grain and color, is a favorite medium of Japanese carpenters and builders, and is widely employed in construction throughout Japan.

Celadon A term employed by Western critics for a type of Chinese ware, which may be porcelain or porcelaneous stoneware, decorated with a greenish glaze. The word itself was derived from a character of a shepherd in a French 17th-century romance who always appeared wearing grey-green clothes. the term is very loosely employed, but usually refers to Yüeh ware, Lung-ch'üan ware and the so-called northern celadons. The earliest of the celadons were made by the Yüeh kilns during the Six Dynasties period, but the most typical celadons are those of the Lung-ch'üan variety. The so-called northern celadons tend to have a somewhat darker olive brown or olive green glaze, are somewhat coarser and were often decorated with carved, incised or molded designs. The most refined of all celadons were those of the Ju or Kuan type, which were probably made for imperial use.

Ch'a Ching or **Tea Classic** is a book which is traditionally attributed to the 8th-century author Lu Yü who is considered the father of tea drinking in China. It is particularly important for the history of Chinese ceramics in making references to the pale blue tea cups from the Yüeh-chou district which give a greenish tint to the yellow liquid, and are the ancestors of the celadons of the Sung period, and to the white wares from Hsing-chou which are said to give the tea a reddish tinge, and are the forerunners of the white Ting porcelains of later times.

Cha-ire Small container used to hold powdered green tea used in the cha-no-yu or tea ceremony. In Western literature it is usually referred to as a tea caddy. Made of stoneware with a brown glaze, which is sometimes decorated with a glaze of another color, it is usually about 2 to

3 inches high and has an ivory lid. When not in use it is stored in a silk brocade bag. Originally Chinese medicine jars were employed for this purpose, but beginning with the Muromachi period and continuing to the present day, many of the leading Japanese kilns have produced large quantities of such containers. The most famous of them have individual names, are considered to be of great value, and have been declared treasures of the Japanese nation.

Cha-no-yu Usually translated into English as "tea ceremony," is a term applied by the Japanese to a ceremonial way of drinking a thick, powdered green tea. It is usually done by a few friends who have gathered in a plain room, while contemplating a scroll or flower arrangement, and discussing the aesthetic merits of the utensils employed in this act. It is connected with Zen Buddhism and was introduced from China during the Muromachi period. The Japanese monk Shuko is credited with being the founder of cha-no-yu in its present form. The most famous of its practitioners was the tea master Sen-no-Rikyu, who lived during the Momoyama period and was patronized by Hideyoshi. To this day cha-no-yu has millions of followers throughout Japan, and plays an important role in the cultural life of the nation. The taste connected with it, referred to as the "tea taste," is a very important aspect of Japanese visual sensibility. The outstanding examples of tea bowls, tea caddles, water jars and bamboo spoons used during the tea ceremony are classed as national treasures and are thought of as being among the most beautiful and characteristic of Japanese art works.

Ch'a Shih-piao Chinese painter of the Ch'ing period who lived from 1615 to 1698. A native of Anhui province, he is regarded as one of the Four Masters of Anhui. In addition to being a skillful painter, he was also a well-known collector who possessed a great many paintings by the older masters. His own work is very eclectic, perhaps reflecting his close study of the famous painters in his extensive collection. His best work is in the style of the great Yuan painter Ni Tsan, showing his dry brush and melancholy feeling.

Chajin Literally, a "tea person," that is, a devotee and connoisseur of cha-no-yu or the tea ceremony. Ever since the introduction of this cult to Japan during the Muromachi period, the chajin have played a very important role in Japanese culture. They were the ones who formulated the tea taste which preferred subdued elegance to ostentation, understatement and a rustic feeling to display and over-refinement. In fact, the great tea masters, notably those of the Momoyama period, were largely responsible for developing and articulating the kind of aesthetic culture, described with terms such as shibui and wabi, which dominates much of Japanese artistic taste to this day.

Champlevé An enameling technique in which the design is hollowed out of the background metal and filled in with ceramic pastes. After firing, the object is rubbed down and polished, leaving an enameled design flush

with the metal background. The exposed metal surfaces are then gilt. Champlevé enameling differs from cloisonné, in which the enamel is raised above the surface, and can be distinguished from the latter by the irregular widths of the metal enclosing the colored areas. See also Enamels.

Ch'an Buddhism Chinese Buddhist sect which is known as Dhyani Buddhism in Sanskrit and Zen in Japanese. It is a mystic sect which teaches that mere good works, austerities, and the study of sutras are futile, and that true enlightenment can be achieved only by looking into one's own heart and discovering the Buddha nature within one. It is said that this doctrine was first introduced to China by the Indian monk Bodhidharma and became popular during the T'ang period. However, it was not until the Southern Sung period, when some of the finest of 13th-century ink paintings were done under Ch'an inspiration, that it played an important role in the arts. Some of the greatest painters of the time, such as Mu-ch'i, Lianga K'ai and Yü-chien, were associated with Ch'an monasteries. The doctrine first entered Japan during the Nara period but it was not until the 13th century that it achieved an important role, when the Buddhist monk Eisai founded the Rinzai sect of Zen Buddhism. It was particularly during the 15th century, under the Ashikaga rulers, that Zen profoundly influenced all of Japanese culture and art, especially ink painting, with some of the leading artists such as Shubun and Sesshu actual Zen monks. While it has ceased to play a significant role in China, Zen Buddhism continues to be one of the most important Buddhist sects in present-day Japan, and modern Japanese artists, such as the famous printmaker Munakata, are inspired by its teachings.

Ch'an painting A school of Chinese painting which flourished especially during the Southern Sung period, and which is better known in the West under the Japanese term of Zen painting. It is a type of Buddhist painting owing its inspiration to the mystic sect of Buddhism, known in Chinese as Ch'an and in Japanese as Zen, which had arisen during the T'ang period. Its most famous practitioners in China were Liang K'ai and Mu-ch'i, who worked in a very loose and free manner, reflecting the kind of sudden inspiration which the Ch'an doctrine taught led to enlightenment. Since the Chinese literati of later times had little use for this school of painting and considered it crude and vulgar, virtually no Ch'an paintings have survived in China, but magnificent examples of the work of these masters and several other Ch'an painters have survived in Japan, where the school has always been greatly admired. See also Liang K'ai, Mu-ch'i, Ch'an Buddhism and Zen.

Ch'ang Ancient Chinese jade form which is listed in the *Book of Rites* as one of the emblems of the six cosmic forces, representing the south. It takes the form of a semi-circle and is said to be usually red in color and connected with fire.

Ch'ang-an Chinese city in Shensi province, located by the Wei River near the modern city of Sian. It served as a capital of China first during the

Han period, and then again during the Sui and T'ang Dynasties. Under the T'ang rulers, it became a great cosmopolitan center and one of the largest cities in the world. It was laid out in a grid pattern, with streets running north-south and east-west, and the Imperial Palace in the northern section of the city. Little of the ancient city survives today, the most notable monument being the White Goose Pagoda, a brick structure which was built during the T'ang period.

Chang Ch'êng A Chinese lacquer master of the late Yuan period, who was active during the early 14th century in Chekiang province of southeastern China. His work was much esteemed in Japan, where it was often imitated and exerted a great influence. Judging from the surviving examples, largely in Japanese collections, he produced carved red lacquers decorated with flower and bird designs. In Japan he is referred to as Chosei.

Chang-chia-p'o Chinese archaeological site, located west of Sian in Shensi province. It is believed that the first Chou capital was located at this site, and excavations are presently being undertaken there.

Ch'ang Hsüan Chinese painter of the T'ang period who is believed to have been active between 713 and 742. He specialized in pictures depicting the elegant palace ladies, and served as a court painter in the capital at Ch'ang-an. He is today best known for his scroll painting showing "Ladies Preparing Newly Woven Silk," of which a 12th-century copy by the Sung emperor Hui-tsung is in the collection of the Boston Museum.

Chang Hung Chinese painter of the Late Ming period who was active during the second quarter of the 17th century. He was a characteristic exponent of the Su-chou school of painting, and enjoyed a considerable popularity during his lifetime. A traditional master, he primarily portrayed landscape in the style of the great masters of the Southern School, such as Shên Chou and Wên Chêng-ming. A very sensitive painter, he is known for the use of light washes of ink and strong dots which achieve an interesting pattern. Several important works by him are found in the National Palace Museum.

Chang Lu Chinese painter of the Ming period who was born c.1464 and died in 1538. He was a member of the Chê School. He was greatly influenced by the work of Tai Chin, the founder of the school, and even more by that of Wu Wei. He painted both landscapes and figure compositions, using a very loose ink style. An artist of no great originality, he nevertheless was, at his best, an accomplished practitioner of traditional Chinese painting. Good examples of his work may be seen in Japanese collections, and the National Palace Museum in Taipei has a striking painting of his representing "Lao-tzu Riding on a Water Buffalo."

Chang Sêng-yu Chinese painter of the Six Dynasties period, who was active during the 6th century. He enjoyed a great reputation as a Buddhist painter as well as for his portraits. Working under the Liang Dynasty, he decorated the walls of the great Buddhist temples at Nanking, and made

portraits of the Liang rulers which were said to be startling in their realism and in their use of light and shadow. Unfortunately, no original paintings by the artist have survived, but some copies, notably the "Constellation Scroll," formerly in the Abe Collection and now in the Osaka Municipal Art Museum, may give some idea of what his work looked like.

Ch'ang-sha City located in Hunan province which, during the Late Chou Dynasty, served as the capital of the Ch'u kingdom. Both before the Second World War and then again after 1951, excavations in the city and its surroundings brought to light some of the most interesting and valuable archaeological remains from the period between 600 and 200 B.C. The lacquer, which was well preserved, is the finest early Chinese lacquer work surviving today, and a silk painting is the earliest Chinese painting in existence. Among the treasures from this site, the last most outstanding are a pair of cranes and serpents in lacquered wood, now in the Cleveland Museum, and the silk painting now in the Sackler Collection in New York, but numerous other remains are found in the People's Republic of China and in many other collections in all parts of the world.

Chang Ta-ch'ien or **Tai-chien** Modern Chinese painter born in 1899 in Szechwan province. He is famous for the virtuosity with which he is able to work in a variety of styles based on the tradition of literati painting. However, his own work is highly eclectic, ranging from paintings based on the style of the great eccentric painters of the early Ch'ing period, notably Shih-t'ao and Pa-ta Shan-jên, to works executed in a modern Western idiom. He left China after the Communists came to power in 1949, and traveled widely in Japan, Taiwan, the United States, Europe and South America before finally settling in California. His work is represented in the Metropolitan Museum in New York, the Boston Museum and the Museum of Modern Art.

Chang Tse-tuan Chinese painter of the Sung period, who was a member of the Imperial Academy in K'ai-fêng during the last years of the Northern Sung role. In his day he was famous for his boundary paintings or chieh-tua, in which the outline of the objects is emphasized, depicting boats, carriages, bridges and market places. The most famous of his surviving works is a 17-foot-long scroll, now in the Palace Museum in Peking, which depicts the Ch'ing-ming Festival as it was celebrated along the banks of the Pien River, which flows through K'ai-fêng. The scroll, which is painted in a very linear and descriptive style, gives a vivid picture of Chinese life during that period, and is therefore not only an outstanding work of art but an important social document. In addition to this version, which is probably an original by the artist, many later versions of this scroll are in existence.

Chao Ch'ang Chinese painter of the Sung period, who flourished between 1000 and 1020. Serving at the imperial court during the early years of the Sung Dynasty, he was much admired for his delicate and detailed depiction of all kinds of flowers. He is thought of as one of the early

originators of the category of Chinese painting usually referred to as bird and flower painting, which was to play such a great role in the history of Chinese art, especially under the last of the Northern Sung rulers, Hui-tsung, who was himself an accomplished painter of this genre. Probably no originals by this master have survived, but a flower painting now in the National Palace Museum in Taipei may give some idea of the kind of work which he executed.

Chao Ling-jan, also known as **Chao Ta-hien** Chinese painter of the Sung period who is believed to have been active between 1070 and 1100. He was an instructor of the Sung emperor, Hui-tsung. He is best known for his landscape paintings, an example of which may be found in the Boston Museum. They are very soft in their brushwork and poetic in their inter-pretation of nature, with as low horizon and wide expanse of fields and lakes, over which the mist hovers. Their quiet and lyrical feeling differs markedly from the earlier type of Northern Sung landscape, which em-phasized the majesty and grandeur of the towering mountains.

Chao Mêng-chien Chinese painter of the Late Sung and Early Yuan periods, who was born in 1199 and died in 1295. He was related to the imperial family and had a career as an official, which ended with the fall of the Sung Dynasty in 1279. At that time he retired to Hsui-chou in Chekiang, and continued his artistic pursuits. He was considered one of the most cultured men of his time, and established a reputation as a calligrapher and poet, as well as being a fine painter. He specialized in painting flowers, particularly plum blossoms and narcissi, and bamboo, using light ink in the pai-miao style. Several scrolls believed to be by his hand have survived.

Chao Mêng-fu A famous Chinese painter of the Yuan period, who lived from 1254 to 1322. A court official under the Mongols, and an outstan-ding calligrapher, he was one of the few artists of his time who were will-ing to serve under the foreign rulers. He painted landscapes, figures, horses and flowers with equal skill, often employing bright colors in the manner of the T'ang painters. Among his most famous works are "Autumn Colors on the Ch'iao and Hua Mountains," now in the Na-tional Palace Museum in Taipei, and his "Horses crossing a River," and "A Sheep and a Goat," in the Freer Gallery in Washington.

Chao Po-chü Chinese painter of the Sung period who flourished during the middle of the 12th century. He was a direct descendant of the first Sung emperor, and had been a member of the art academy of Hui-tsung. After the fall of the Northern Sung Dynasty, he went to Hang-chou where he became the chief court painter under the emperor Kao-tsung. He was well known as an example of what later critics referred to as the Northern School of Chinese painting, employing detailed drawing and bright col-ors, notably blue and green, a style derived from the T'ang master Li Ssu-hsün. The most famous of his surviving scrolls, now in the collection of the Boston Museum, is one depicting the army of the first Han emperor making its victorious entry into Kuan-chung.

Chao Ta-nien See Chao Ling-jan.

Chao Tso Chinese painter of the Ming period who was active during the early years of the 17th century. He was a close friend of Tung Chi'i-ch'ang, and the author of a treatise on painting called *Hua yu lu*. His brushwork was based on that of his friend, and he also made copies of Tung Ch'i-ch'ang's work, which today are often confused with the work of the master. However, his original work is somewhat softer in execution in spite of the fact that it preserves much of the emphasis on formal pattern and abstract organization of forms. A good example of his art is found in the Stockholm Museum.

Chao Wu-chi See Zao Wou-ki.

Charms Charms of all kinds were widely used in both Chinese and Japanese folk culture to insure the wearer's good fortune, to protect houses and graves and to ward off evil spirits, sickness and accidents. They could be made of a wide variety of materials such as stone, metal, paper, animal and vegetable substances, but the most distinctive are the religious texts printed or written on pieces of paper, which may be worn on the person or else made into pellets or reduced to ashes and swallowed as spiritual medicine. In China they would be Buddhist or Taoist in nature, while in Japan they would be Shintoist or Buddhist. While no longer quite as common today, such charms and talismans may still be found in use in rural areas.

Chashaku Japanese term for a tea spoon, generally made of bamboo and used in the tea ceremony to transfer powdered tea from the tea caddy to the tea bowl. The finest of these, made by celebrated craftsmen, are regarded as great artistic treasures by tea enthusiasts.

Chashitsu A special room or a detached small structure used for the performance of the tea ceremony or cha-no-yu, often taking the form of a small rustic hut built in the garden of a temple, palace or private mansion. The earliest such buildings were constructed during the Momoyama period under the guidance of the great tea master Sen-no-Rikyu. They are small in scale, usually 4½ mats, but in some cases only 2 or 3 mats, have a small window and low entrance, and contain a sunken hearth for heating water, as well as an alcove for displaying paintings, calligraphies and flower arrangements, known as the tokonoma. The earliest of these is the Togudo found on the grounds of the Silver Pavilion in Kyoto. Other famous ones are in the garden of the Katsura Palace and in the Daitokuji Temple in Kyoto.

Chatsubo Large stoneware pot or urn used in Japan to store tea leaves. The correct Japanese term is actually hacha-tsubo, ha meaning "leaf" and cha meaning "tea."

Chawan Japanese term used for the tea bowls, especially those which are employed in cha-no-yu or the tea ceremony. They are usually made of stoneware, more rarely of porcelain or earthenware. The type most admired by the tea masters is a very plain, rustic kind of bowl which is derived from the rice bowls of humble Korean farmers of the Yi period. The

most celebrated of these early Korean and Japanese tea bowls are today regarded as national treasures and considered invaluable. The shapes, glazes and decorations of these chawan differ greatly depending on their use, the kiln in which they were made, and their date. The most famous potters specializing in tea bowls were those of the Raku family of Kyoto, but other fine tea bowls were made in the Mino, Bizen and Karatsu districts. See also Raku, Karatsu, Shino, Oribe.

Chê School School of Chinese painting which flourished in Chekiang province, and therefore took its name from the first character of the name of the region. The leading exponent of the school—who is credited with founding it—is the great 15th-century Ming painter Tai Chin. Members of the school were said to continue the academic tradition of the Southern Sung period, working in the style of the Ma-Hsia School. It continued into the 17th century, with Lan Ying considered the last master of this school.

Chekiang Chinese province located in the coastal area of Central China, south of the Yang-tze River. Its principal city is Hangchou, which, during the Southern Sung period, served as the capital of China, and was a great cultural center. This province is particularly well known for its production of ceramics, with the earliest types of green ware which preceded the celadon wares produced in the Yüeh district, and the finest celadons made at Lung-chu'üan. Chekiang was also a great center of silk production, and much of the silk exported to the West during the 18th century came from this region.

Ch'en Ch'i-k'uan Modern Chinese painter born in 1921 in Szechwan province, who was trained in architecture at Harvard, and taught at the Massachusetts Institute of Technology. He later settled in Taipei. His highly original paintings are characterized by a quality of delicacy and precision, and are both Chinese and contemporary in style. He often stresses verticality and height, or paints as if he were looking down on the scene from high above. He depicts a wide range of subject matter, including landscapes of hills covered with rice paddies, mountain cliffs, village scenes, and illustrations of the daily lives of farmers and village dwellers.

Ch'ên Hung Chinese painter of the T'ang Dynasty, who was active during the early and mid-8th century. Originally from Chekiang province, he was called to court during the K'ai-yuan period (713–742), where he became one of the principal imperial portraitists. His subjects included the emperors Hsüan-tsung and Su-tsung. He is also well known for his works depicting horses and other animnals, and, to a lesser extent, for his religious paintings. His style is characterized by the use of rich colors and a refined, but vigorous, handling of the brush. Some existing scrolls have been attributed to him.

Ch'ên Hung-shou Chinese figure painter of the Late Ming period, who lived from 1599 to 1652. A strange and eccentric person, he followed a very in-

dividual style which emphasized the linear aspect of painting. He was famous in his own day for his depiction of Taoist fairies, Buddhist Lohans, scholars, and strange ladies with attenuated figures and long faces rendered in a curious, mannered style. He was also known for the drawings he made for book illustrations, notably those for the famous Ming novel, *Shui Hu Chuan.* After the fall of the Ming Dynasty, he retired to a Buddhist monastery, where he spent the last years of his life. A good example of his art is to be found in the Honolulu Museum.

Ch'ên Jung Chinese painter of the Sung period who was active between 1235 and 1260. He is considered the greatest of all dragon painters and was also a poet and government official, known for his eccentric behavior. Among the many dragon paintings attributed to him, by far the most outstanding is the "Nine Dragon Scroll" in the Boston Museum, which was painted in 1244, and is almost universally regarded as the greatest dragon painting in existence.

Ch'ên Shu Chinese painter of the Ch'ing period, who was born in 1660 in Chekiang province, and died in 1736. One of several notable women painters of this period, she treated a large variety of subjects, including landscapes—executed in the manner of Wang Yüan-ch'i—figures, birds and flowers, insects, trees and Buddhist subjects as well. Twenty-three of her paintings are listed in the Imperial Catalogue. She was also renowned as a teacher.

Chêng Chinese term for a clapperless bronze bell made during the Shang and Early Chou periods. It is oval in shape, and the length exceeds the height of the bell. The decoration usually consists of t'ao-t'ieh masks. Unlike the chung bells, the surface of the chêng is without bosses.

Cheng-chou also sometimes spelled Cheng-chow. Important archaeological site in Honan province of northern China, where the Early Shang capital was located. Extensive archaeological excavations, which have shed new light on the early bronze culture of China, have been undertaken there in recent years. The earliest of the finds are believed to date from around 1600 B.C., and represent a phase of Shang culture preceding that of the An-yang finds. Both the forms and the decorations of the ritual vessels excavated here are cruder and simpler, and some of the tools and weapons are similar to prototypes from Siberia and the ancient Near East, suggesting a Western influence.

Ch'êng-hua Ming emperor who ruled from 1465 to 1487. His reign is particularly remembered for its ceramic production, especially its decorated polychrome porcelains with bold colorful designs executed in enamel colors over the glaze, among which the most outstanding are the tou-ts'ai wares. They were so popular that they were often copied as early as during the later Ming period, and during subsequent periods as well. See Tou-ts'ai.

Chêng Ssu-hsiao Chinese painter of the Southern Sung and Early Yuan periods, who specialized in painting orchids. His real name was Chêng

Mou, but upon the fall of the Sung Dynasty, he changed it to read Chêng Ssu-hsiao, which means "Chêng who thinks of Chao," Chao referring to the Sung rulers. Numbering himself among those artist-scholars who refused any association with the Mongol rulers, he settled in a small village in Kiangsu, where he continued his painting. The finest example of his exquisite brushwork is a small picture of two spring orchids, of which two versions exist, one presently in the Osaka Museum and the other in the Freer Gallery.

Ch'êng-tu Town in Szechwan province of western China, where an important provincial museum is located, in which a group of sculptures dating from the Han and Six Dynasties periods may be seen. The Han works are mainly pottery tiles with relief designs reflecting pictorial compositions of the time, while the Six Dynasties objects are largely Buddhist sculptures executed under the southern dynasties of the period. These works suggest that an important school of Buddhist sculpture, differing from the better-known northern school, existed in this part of the country, and may have been the source for much of the early Japanese Buddhist art.

Ch'eng-tzu-yai Archaeological site in Shantung province, located near Lung-shan, where the first prehistoric black pottery of China was found in 1928. This ware, which in shape and technique is far more sophisticated than the earlier painted ware from Yang-shao, resembles that of prehistoric Iran, and represents the latest and most sophisticated phase of Chinese prehistoric ceramics. See also Lung-shan.

Cherry This plant plays a very important role in the legend and art of Japan where, to this day, the cherry-viewing festival is one of the most popular in the Japanese calendar. The tree was admired for the beauty of its blossoms, which were likened to the life of a samurai, who, like the cherries in bloom, has a glorious but brief existence which may, at any moment, be cut short. Numerous legends about cherry trees are told in Japan, and the blooming cherry is a favorite motif representing spring in the pictorial arts.

Ch'i Name of a feudal state whose capital was Lin-tzu-hsien, located in Shantung in northeastern China. In recent decades, it has been the site of excavations which have uncovered a large city and many archaeological remains dating from the Late Chou period. For other dynasties by this name see also Northern and Southern Ch'i.

Ch'i Chinese term used to describe an axe with a broad blade, which originated in the form of a stone tool, but was commonly executed in bronze in Shang China, and was often decorated with symbolic sculptural designs. It may have been used in connection with ritual sacrifices, and ch'i shaped axes are often found in the tombs.

Chi-chou Pottery town, located in central Kiangsi province of southern China, where very pure white porcelains were made during the Southern Sung period. It is believed that these kilns were established by refugee

potters from Ting-chou in Hopei, who fled south after the fall of K'ai-fêng. Excavations carried out in 1957 have uncovered several kiln sites and large numbers of sherds.

Ch'i-lin or kirin in Japanese, is a fabulous creature sometimes referred to as the Chinese unicorn. Technically, it is the male that is called ch'i, and the female, lin. It is one of the four great mythical animals of China, along with the dragon, phoenix and tortoise. The ch'i-lin is considered to be a good omen, symbolizing longevity, grandeur, happiness, illustrious off-spring and wise administration. In appearance it is generally believed to be either leonine, with scales and horns, or else similar to a stag or horse, with or without scales, with a bushy mane and tail, and a horn or pair of horns. There are, however, countless variations. The ch'i-lin figures significantly in Chinese historical lore and in both Buddhist and Confucianist legend.

Ch'i Pai-shih The most famous of modern Chinese painters, who was born in 1861 and died in 1957. He was born into a very poor peasant family in Hunan province, and worked as a carpenter and wood carver before turning to painting. He acknowledged Wu Ch'ang-shih as his teacher, but was virtually self-taught. He developed a highly individual style which was influenced by the two great early Ch'ing Eccentric painters, Shih-t'ao and Pa-ta Shan-jên. Most of his work represents insects, shrimp, grasses, flowers and bamboo, and has enjoyed tremendous popularity and been widely copied by his followers and admirers. He lived most of his life in Peking, where he had settled in 1921. After the Communist Revolution, he became president of the Peking Institute of Chinese Painting, and head of the Union of Chinese Artists.

Ch'i-wên or **ch'i-shou** A Chinese term employed for the ornamental pottery figures placed at the end of the roof ridge, which served protective as well as decorative functions. Such figures, representing folk deities, were popular during the Ming period, and were executed in clay covered with bright, colorful glazes. They are, today, popular with collectors.

Chia Shape of ritual vessel found among the ancient bronzes of the Shang and Chou periods. It was used as a wine container, and usually had three, or at times four, legs, a wide flaring mouth, two bottle-shaped horns and a handle. The finest examples are among the great masterpieces of the metalworkers of ancient China.

Chia-ch'ing Ming emperor who ruled from 1522 to 1566. His reign is primarily remembered for the magnificent porcelains produced during that time, notably the monochromes in blue, yellow and red, and the colorful enamel, decorated wares.

Chia-hsing A city in Chekiang province, located south of Su-chou, which was famous for its gardens and also known as a center for lacquer production during the T'ang and Sung periods.

Ch'iang Ts'an Chinese painter of the Sung period who flourished during the first half of the 12th century. He was a member of the Northern Sung

Academy, and famous as a landscape painter. He is regarded as a follower of the great early Sung painters, Tung Yüan and Chü-jan, but developed a personal style which is far looser in its brushwork and less realistic in its representation of nature. His most famous surviving work is a long handscroll in the National Palace Museum in Taipei, representing a landscape, and another fine painting by his brush may be found in the collection of the Nelson Gallery in Kansas City.

Chieh-tzu-yüan hua-chuan Chinese title of the painting manual, the *Mustard Seed Garden*. See Mustard Seed Garden Painting Manual.

Chien Ancient Chinese bronze ritual vessel in the form of a deep, wide circular basin with two or more handles. The handles are frequently ornamented with animal heads and fitted with rings. It is believed that the vessel was either filled with water in order to serve as a mirror, or was filled with ice and used to store perishable food. It may also have been used for washing in, as was the p'an. Surviving examples date from the Late Chou period.

Chien A type of Chinese ware made at Chien-an in Fukien province, beginning with the 10th century. It has a dark stoneware body covered with a brown glaze, which is often so dark that it verges on black. The glaze is sometimes streaked with blue or steel grey, which is referred to as "hare's fur," or "oil spot." The shapes are usually tea bowls, which were immensely popular in Japan, where they were known as temmoku, the Japanese reading of T'ien-mu, a mountain near Hang-chou, whence these wares were shipped to Japan.

Ch'ien Hsüan Chinese painter of the Late Sung period, who is believed to have lived between c.1235 and 1290 or 1301. Since he died during the Yuan period, he is usually classed as a Yuan painter, in keeping with the Chinese custom of listing artists by the dynasty which ruled at the time of their death. He was particularly known for his graceful and charming bird and flower paintings, but also executed landscapes and figure paintings, some of which were in the blue and green manner of the T'ang period. Innumerable paintings are today attributed to him, but it is likely that very few of them were actually executed by the artist. In fact, the most famous work formerly ascribed to him, the "Early Autumn Scroll" in the Detroit Institute of Art, is no longer believed to be by his hand. However, other fine examples of his brush, which are believed to be authentic, are to be found in the Freer Gallery and the National Palace Museum in Taipei.

Ch'ien Ku Chinese painter of the Ming period who was born in 1508 and died in 1574. He lived in Su-chou and is classified as one of the pupils of Wên Chêng-ming, in whose house he is said to have studied painting and read the classics, but the greatest influence on him was the work of Shên Chou. He painted a wide variety of subjects, landscapes as well as bird and flower paintings, and especially narrative paintings with human figures, often illustrating popular stories or famous poems, such as the "Red Cliff" by Su Tung-p'o.

Ch'ien-lung A Chinese emperor of the Ch'ing Dynasty who reigned from 1736 to 1795. Although a Manchu, he was a great enthusiast for Chinese culture and art, and one of the most important imperial patrons of painting and ceramics. His collection of Chinese paintings of all periods was one of the greatest ever assembled, and forms the basis of the National Palace collection now in Taipei. His reign is usually regarded as the last truly creative period in the history of Chinese art.

Chigi A term used for scissor-shaped finials placed over the gables of Japanese Shinto shrines, which originally had the function of holding down the ridge-pole, but later became merely decorative forms. The earliest of these may be seen in the models of Japanese palaces found among the grave figures or haniwa in prehistoric Japanese tombs.

Chih-hua Chinese term for a technique known in the West as "finger painting" in which the fingers and nails are used in place of, or in addition to, the brush. It was a style of painting which became popular during the 18th century, and of which Kao Ch'i-pei, an accomplished landscape painter who was a Manchu by birth, was the most outstanding practitioner. He was so successful at this that he soon devoted himself wholly to finger painting, and had numerous followers who worked in this manner.

Chih-hua-ssu Name of a Ming period temple which is believed to have been completed around 1444, and is the most interesting early temple surviving in Peking. It consists of a series of courtyards of various sizes, flanked by buildings serving for religious worship and as living quarters for the monks.

Chikko Japanese Meiji carver of receptacles and netsuke, who was born in 1868 and died in 1911. His family name was Kusakawa. He lived in Tsu in Miwa prefecture. He was well known for the refinement of his carving, but few of his works exist today.

Chikuden Japanese painter of the Edo period whose real name was Tanamura. He was born in 1777 and died in 1835. In 1801 he went to Edo, present-day Tokyo, where he became a pupil of Tani Buncho, but most of his life was spent in his native province of Bungo. He as an outstanding exponent of the Chinese Nanga School, and specialized in painting landscapes as well as birds and flowers. He was also well known as a literary scholar.

Chikuzen Old name for that province of Japan which is now called Fukuoka prefecture.

Chimera Greek term for a legendary animal, which is sometimes employed in describing the monumental winged lion figures which occur in Chinese art of the Late Han and Six Dynasties periods. This type of creature, which is purely imaginary, is probably originally derived from ancient Near Eastern sources, for similar animal sculptures occur in Babylonian and Assyrian art. In China, they were usually placed at the roads leading to the tombs of rulers to serve as protective guardians, and the finest of them are among the true masterpieces of Chinese sculpture.

Ch'in Musical instrument resembling a small harp or zither, known as the koto in Japan. It enjoyed widespread popularity in traditional China, and Chinese scholars are often shown playing a tune on a ch'in or being followed by a servant who carries such a musical instrument for the use of his master.

Chin Dynasty also sometimes spelled Kin, was the Chinese name for a Barbarian empire which ruled northern China from 1115 to 1234. The chin were of Nuchen Tungus stock, but took over the Chinese civilization and institutions, and became gradually absorbed among the Chinese people. Under their rule, Sung culture continued to flourish, with thousands of painters, scholars, and artisans being active in their capital city of K'ai-fêng.

Ch'in Dynasty A brief but important period in Chinese history, which lasted from 221 to 207 B.C., during which China was unified under the emperor Shih Huang-ti. This reign is well known for its great construction projects, notably the Imperial Palace, which was far larger in scale and more splendid than anything China had known before, and for the building of the Great Wall. While nothing of the palace survives today, the Great Wall, which was built to protect China from the nomad barbarians of the steppes, is still standing and is one of the largest and most impressive architectural monuments existing in the world. The tomb of Shih Huang-ti was excavated in 1975, and thousands of huge grave figures in a very life like style, which are the most remarkable realistic large-scale sculptures so far recovered from ancient China, were found. See also Shih Huang-ti and Great Wall.

Chin Nung Chinese painter of the Ch'ing period who lived from 1687 to 1764. He was an eccentric who painted highly imaginative scrolls depicting landscapes, flowers, genre and religious subjects. He was considered one of the Eight Eccentrics of Yang-chou. Biographers record that he did not turn to painting until he was fifty, which may account for the somewhat amateurish quality of much of his work. It is also related that he turned to Buddhism late in life, and became a monk and recluse.

Chin P'ing Mei A Chinese novel of the Ming period which is a classic of Chinese erotic literature. Although it is not known with certainty who wrote it, it is believed to be the anonymous work of the celebrated 16th-century writer, Wang Shih-chên. It is the story of a Chinese beauty named Golden Lotus, whose amorous adventures, intrigues, and jealousies are related in a very vivid, and in portions almost pornographic, style. Scenes from it are sometimes represented in Chinese painting and wood-block prints.

Chincho Japanese printmaker of the Edo period whose family name was Hanakawa, and who lived from c.1679 to 1754. He was unique among Ukiyo-e artists for having come of samurai stock, instead of being a commoner, and for working as an artist only when the spirit moved him. He produced very few prints; however, they are of fine quality. A contem-

porary of Masanobu, he was very much influenced by the work of that master.

Ch'ing Chinese term used to designate a roughly L-shaped flat stone, usually of jade, which is used as a musical chime. It is suspended from a frame by means of a cord passed through a hole which has been drilled at the angle of the two arms.

Ch'ing-chou Site in Jehol province of northern China, where a large seven-storied pagoda, known as the White Pagoda or Pai-t'a-ssu, dating from the 11th or early 12th century, is located. It is one of the largest and best-preserved of all Chinese pagodas, and gives a good idea of the architectural style employed in China at that time. Since it is located near the mausolea of the Kitan rulers, it is believed to have been erected by them.

Ch'ing Dynasty The Ch'ing or Manchu Dynasty is the last of the traditional periods of Chinese art, lasting from 1644 to 1912, when the Republic was established. Although the Ch'ing rulers were not Chinese themselves, and based their power on the Manchu military and officials, they were, nevertheless, patrons of Chinese art, and in every way perpetuated the traditional institutions of Chinese society. The rules of the emperors K'ang-hsi (1662-1722) and Ch'ien-lung (1736-1795) were among the most glorious in the annals of Chinese art, with large numbers of outstanding works of art, notably in the realm of painting, porcelain, architecture and the decorative arts, dating from this period. In fact, the great bulk of Chinese art existing today, both in China and in the West, is probably of Ch'ing date, even if it is often ascribed to earlier periods. See also entries under the names of emperors, painters, and various types of porcelains.

Ching Hao Chinese painter of the Five Dynasties period, who is believed to have been active between c.900 and 960. He was well known for his contributions to the development of Chinese landscape painting, and a treatise on that subject, believed to have been written by him, called *Pi-fa chi*, or *Records of Brushwork*, has survived. However, no originals which can with certainty be assigned to his brush exist today, so that no very clear idea of the style of his painting can be formed any longer.

Ch'ing-ling Chinese tomb site in Mongolia, where the tombs belonging to emperors of the Liao Dynasty were found. They are of particular interest for their wall paintings which can be dated to 1031, and which represent landscapes in the four seasons, rendered in a colorful style. Reminiscent of the painting of the T'ang Dynasty and provincial in style, they are important documents for the study of the history and development of Chinese landscape painting.

Ch'ing-ming Festival An important festival in traditional China, held in early spring when the first green appears on the willows. At this time, the ancestors are worshipped and ceremonies are performed at their graves. Although the festival period lasts for thirty days, the first day, which falls in the early part of April, is the most important. The graves are swept and offerings of meats and vegetables are brought to the spirits. Gold and

silver paper is burned to supply the spirits with money during the coming year, and slips of red and white paper are secured to the corners of the grave as evidence of the rites having been performed. A famous painter of the Sung period by the name of Chang Tse-tuan painted a long scroll depicting this festival as it was celebrated in K'ai-fêng in the early 12th century. Many later versions of this scroll are in existence, the best-known being a long narrative scroll with a wealth of detail depicting Chinese life at the time which is now in the Metropolitan Museum in New York, and is believed to date from the Ch'ing period.

Ch'ing-pai A fine type of Chinese porcelain made during the Sung period, largely at Ching-tê-chên in Kiangsi province. It is particularly lovely for its shadowy blue color, and the name applied to it today, ch'ing-pai, means "bluish-white." In older Western books, it is often referred to as Ying-ch'ing, a term invented by Chinese art dealers but not found in the older literature. The shapes are primarily utilitarian, such as teapots, vases, cups and bowls, which often have delicate designs of dragons, flowers, birds and other such motifs incised or molded under the glaze. Many examples were exported to Southeast Asia, where this ware enjoyed great popularity.

Ch'ing porcelains The Chinese porcelains made under the Ch'ing Dynasty are probably technically the finest ever made. Under the patronage of the Manchu rulers, notably K'ang-hsi, who reigned from 1662 to 1722, and his grandson, Ch'ien-lung, who ruled from 1736 to 1795, the factories at Ching-tê-chên enjoyed imperial patronage on a scale never seen anywhere else in the world before or after. The models for these wares were the 15th-century Ming wares, but in some ways, the productions of the Ch'ing potters even surpassed the work of their predecessors, especially in regard to enamel-decorated porcelains and monochromes. A tremendous variety of types were made, varying from pure white porcelains and monochrome to blue-and-whites and wares decorated in many colors over the glaze. The shapes, too, showed a great variety, with large so-called imperial vases particularly admired by Europeans.

Ch'ing-t'ai-lan Name used to describe a particularly fine cloisonné enamel made during the Ming period under the special patronage of the emperor Ch'ing-t'ai, who ruled from 1450 to 1457. It is said that the high quality of these enamels was due to the arrival of Greek artisans who found refuge in China after Constantinople was taken by the Turks in 1453.

Ching-tê-chên The most famous and productive ceramic center of China, located near the town of Fou-liang in Kiangsi province in southern China. Its early history may be traced back to the Han period, but its golden age did not come until the Ming period, when the finest porcelains, notably the blue and white wares for which the dynasty became famous, were executed at this site. During the subsequent Ch'ing period, the output was even expanded, and this ceramic center became a large city devoted to the production of all kinds of wares, from the most refined porcelains intended

for the use of the imperial court to export ware made to be sold in Europe and America.

Chinju-sha Japanese term for the Shinto shrines which were built within the compounds of Buddhist monasteries. They were constructed after the synthesis of the Shinto and Buddhist religions had developed the theory of honji suijaku, according to which Shinto deities were regarded as manifestations of Buddhist divinities.

Chinkin-bori A technique of lacquer decoration in which the pattern cut in the lacquer is outlined with gold. It originated in China, where it was known as ts'ang-chin, and was introduced to Japan during the Ashikaga period. It was particularly popular in 18th-century Japan.

Chinoiserie Artistic movement which enjoyed great popularity in Europe and America, especially during the 18th century, when Chinese motifs were used in furniture, wallpaper, porcelains and lacquers, and even buildings were erected in the Chinese style. Sir William Chambers, the well-known 18th-century English architect, who had visited Canton in his youth, published a book of drawings of Chinese-style kiosks, pavilions and pagodas, and structures of that type were built in many English and European parks and gardens. Chippendale furniture was designed in an imaginary Chinese style which proved very popular, since it was believed to be quaint and exotic. The model for this art was found in the decorative arts of the Ch'ing Dynasty, notably the painted porcelains and the textiles which were exported in large quantities to Europe and America. This vogue, which at one time became a true craze, abated by the end of the 18th century under the influence of the Neo-classic movement.

Chinzo Type of Japanese portrait painting developed especially among the followers of the Zen sect of Buddhism, in which famous abbots and Zen teachers are portrayed either in painting or in sculpture. They are usually shown dressed in their ecclesiastical garments, posed in an official position and rendered in meticulous detail, with special emphasis upon the facial expression, attempting to mirror their inner spirit. A famous example of such a portrait is that of the national master, Shoichi, by Chodensu, in Tofukuji Temple in Kyoto.

Chion-in Main temple of the Jodo sect, founded by the famous priest Honen in 1211. It is located at the north end of the Maruyama Park in Kyoto. Its grounds cover some thirty acres and its buildings are among the largest and best known in all of Japan. However, fires have repeatedly destroyed them, so that few of them are actually very old. The most famous is the 80-foot-high, two-storied gate known as the Sammon. The temple also contains paintings by members of the Kano School, and a garden designed by Kobori Enshu.

Chishakuin Buddhist temple, located in Kyoto, which is the headquarters of the Chizan School of Shingon Buddhism. It was founded by Ieyasu at its present site in 1598. Unfortunately, the original buildings were

destroyed by fire in 1947. It is important today primarily for its magnificent screen paintings, depicting the seasons, which are attributed to Tohaku. It also has a fine garden, which is said to have been designed by Sen-no-Rikyu.

Ch'iu Ying Chinese painter of the Ming period who was active between 1522 and 1560. He was well known for his charming genre scenes, which were much admired by later critics. His style is meticulous and highly decorative, and was widely imitated by his numerous followers. Very few of the many paintings attributed to his brush are probably authentic, but several fine examples of his work may be found in the National Palace Museum in Taipei.

Cho Densu See Mincho.

Chojiro Japanese potter of Korean descent, who lived during the Momoyama period, from 1515 to 1592. He originally made roof tiles, but after 1572 turned to the making of tea utensils, notably tea bowls. He was a great favorite of the military dictator of the time, Toyotomi Hideyoshi, who honored him by letting him use the term Raku for his ware; this was derived from the name of one of his great palaces, the Jurakudai. The ware produced by Chojiro and his descendants is therefore referred to as Raku ware, and is much admired and valued by tea ceremony devotees to this day.

Choki Japanese painter and printmaker of the Edo period, who was active during the last decade of the 18th century. Little is known about his life, and it is not quite certain if he is the same artist who also called himself Shiko. He was celebrated for the elegance and charm of his portrayal of idealized women, rendered with great delicacy and sophistication. His triptychs of boating parties are especially outstanding for the quiet beauty of their color and the delicacy of their line. However, his output seems to have been small and uneven.

Chokuan Chokuan, whose family name was Soga, was a Japanese painter of the Momoyama period. He was well known for his paintings of birds and flowers, executed both in color and in black ink. Little is known of his life and work, and he is primarily remembered as the founder of the Soga School. See also Soga.

Chosei Japanese reading of Chang Ch'êng. See Chang Ch'êng.

Chosen Japanese term for Korea, a country with which Japan has had close cultural relations, especially during the Asuka and Momoyama periods. See also Chosen-garatsu.

Chosen-garatsu Type of tea ware, made in the neighborhood of Karatsu in northern Kyushu, which was profoundly influenced by Korean wares of the Yi Dynasty; it was therefore called Chosen, or Korean, Karatsu. These wares are usually rough stonewares, covered with a milk-white or dark brown glaze, which often show very subtle and beautiful color patterns achieved by letting various layers of colored glaze run freely down the side of the vessel. The finest of these wares date from the Momoyama and Early Edo periods, and are highly prized by the tea masters.

Choshu Old name of the province of western Japan which is today known as Yamaguchi prefecture. It was the home of several important families making sword guards, most of whom worked in Hagi, the provincial capital. They were collectively referred to as the Choshu Schools. Most of their work was made in iron with a rich black patina, and carefully modeled designs were embossed in low relief or cut out in elaborate detail. The low relief may have accents of actual incrustations. The schools were most active during the Edo period.

Choshun Japanese painter of the Edo period who lived from 1683 to 1753. He was trained in the Tosa School, but actually was closer to the Ukiyo-e School of painting. Although he never made any prints himself, he exerted an influence on the woodcut artists of the school. His painting consists largely of genre scenes depicting the life of the gay quarter and the theatre district, rendered in great detail and bright colors.

Chou Ch'ên Chinese painter of the Ming period who flourished between 1500 and 1535. Little is known about his life, and he is primarily famous for having probably been the teacher of two of the most famous of Ming painters, Ch'fu Ying and T'ang Yin. He was greatly influenced by the work of Li T'ang and Liu Sung-nien, and, like them, specialized in the painting of picturesque landscapes. While not a highly original or major painter, he nevertheless was a very accomplihed artist who continued the older tradition into the 16th century.

Chou Chi-ch'ang Chinese painter of the Sung period who was active during the late 12th century. Little is known about him, and his name is not recorded in the Chinese literature on painting, but he is known today for having been the painter responsible, together with Lin T'ing-kuei, for having executed a series of one hundred paintings depicting the five hundred Lohans, or Buddhist holy men. The bulk of these paintings are today in the great Zen temple of Daitokuji in Kyoto, but ten of them are in the collection of the Boston Museum, and two are in the Freer Gallery in Washington. They are executed in a very meticulous and colorful style, which, although skillful, is uninspired, and probably reflects very well the kind of conventional academic Buddhist painting which flourished in Sung China, in contrast to the more unconventional and inspired religious painting executed by the artists belonging to the Ch'an School.

Chou Dynasty The Chou Dynasty ruled China from c.1027 to 256 B.C. (The traditional Chinese chronology gives the date 1122 B.C., but this is no longer regarded as accurate by modern scholars.) This long period is usually broken up into Western and Eastern Chou, the first lasting from 1127 to 771 B.C., and the latter extending from 771 to 256 B.C. Eastern Chou in turn is broken down by Chinese historians into the period of the Spring and Autumn Annals and the period of the Warring States, the first dating from 722–481 B.C. and the latter from 481 to the end of the Chou period. However, for art historical purposes, it is far more meaningful to divide the period into three phases: the Early Chou, which lasts roughly to 900 B.C. and shows a continuation of the Late Shang artistic style; the

Middle Chou, which is a transitional stage during which the old symbols and forms lose their meaning and there is a growth of new artistic concepts; and, finally, the Late Chou, lasting from 650–256 B.C., when a new, vigorous artistic style reflecting the more rationalistic and humanistic values of the Late Chou society comes into being. This last phase of Chou is also very significant in terms of other aspects of Chinese culture, for it was at this time that Confucius, Lao-tzu, Mencius and other great thinkers of China lived.

Chou Fang Chinese painter of the T'ang period who was active between 780 and 810. He was primarily known as a figure painter, specializing in scenes from the lives of the elegant court ladies of the time. His paintings, worked in a colorful style, give a sophisticated and charming view of the life of the T'ang court. Outstanding examples of his art may be found in the Freer Gallery in Washington and the Nelson Gallery in Kansas City.

Chou-k'ou-tien Archaeological site in northern China, southwest of Peking, where the remains of the earliest humanoid known in China, who is believed to have lived half a million years ago, have been found. He is known as Sinanthropus pekinensis. In recent years the earliest traces of Homo sapiens in China, dating from about 20,000 to 10,000 B.C., were found in the same area. Along with the human remains, there were also found stone tools and finely fashioned microliths.

Chou Li A Late Chou text, re-edited during the Han period, in which the rites and ceremonies employed at the Chou court were recorded. Although it is probably not accurate in all respects, and represents an idealized version of what took place at the Chou court, the *Chou Li* is, nevertheless, one of our best sources for the ritual practices of feudal times.

Chou scroll Chinese term for the vertical hanging scroll, a type of painting which was probably first introduced into China by the Buddhist monks, who employed banners and hanging paintings in their religious services. However, it became the most popular format of painting, first in China and then also in Japan where it is known as kakemono. See Kakemono.

Chou Wên-ching Chinese painter of the Ming period who flourished during the middle of the 15th century. He was considered a member of the Chê School, and the foremost follower of Tai Chin. Working in the style derived from the great Southern Sung painters, Ma Yüan and Hsia Kuei, he portrayed picturesque landscapes with towering mountains, gnarled old trees, and misty atmospheres, but in keeping with the spirit of his age, he introduced far more realistic detail, and was more explicit in the rendering of the forms. He is a characteristic exponent of the so-called Northern School, which continued the tradition of the Southern Sung Academy. At his best he is a painter of great skill, and a fine draftsman, but basically a very eclectic artist. Good examples of his painting may be found in American as well as Far Eastern collections.

Chou Wên-chü Chinese painter of the Five Dynasties period who flourished during the 10th century. He was a painter connected with the Han-lin College, and a well-known figure painter who continued in the tradition of the great T'ang painter, Chou Fang. However, his work, in contrast to that of his predecessor, was more delicate and refined, showing more graceful figures and depicting more intimate aspects of the court life. The best-known of his surviving works are a group of album leaves in the shape of fan paintings, of which a charming example, showing "Ladies Bathing Children," is now in the Freer Gallery. A genre painting, it gives us a delightful glimpse into the domestic life of the time, and shows the artist's delicate use of line and color. Another fine example of his style is found in a picture, now in Chicago Art Institute, showing an all-girl orchestra, which may be an original of an early copy after his work.

Christian art Christianity had reached China as early as the T'ang period, when Nestorian Christians were prominent and Christian churches were built in many cities at the request of the emperor Kao-tsung. Some remnants of Christian art from this period still survive, but no vital artistic tradition connected with Christianity has ever evolved in China. In Japan, on the other hand, after the introduction of Christianity during the 16th century, a school of Christian art depicting the church's priests and worship services, and ritual objects used in connection with the Christian faith, became popular, and in spite of the destruction of many of these works during the ruthless persecution of all signs of Christianity during the 17th century, a fair number of these artifacts have survived. There has also been a flourishing school of Christian art during the last hundred years, when many Christian churches—usually built in the Western style—paintings and sculpture with Christian subject matter, and vestment and ritual objects used in religious services, were produced.

Chrysanthemum This flower plays a great role in the folklore and art of China and especially of Japan. The Chinese believed that chrysanthemums preserved health and prolonged life, and chrysanthemum flowers were, therefore, often used in tea or floated in wine. The same custom was introduced to Japan, where chrysanthemum sake was served at banquets. It is a flower which is associated with autumn, and is frequently represented in Japanese painting and the decorative arts as a symbol of the fall season. A stylized chrysanthemum flower forms the crest of the Japanese imperial family and decorates objects belonging to it.

Ch'u Name of the most southern of Chinese states during the Late Chou period, whose capital was Ch'ang-sha. Archaeological excavations in the Ch'ang-sha region have brought to light a wealth of magnificent works of art, some of them completely unique, reflecting a southern culture quite distinct from that of northern China. Particularly interesting are the wooden and lacquered cult objects, some of them in bizarre part-human, part-fantastic animal forms, with sprouting antlers and long extended

tongues. There were also found the earliest surviving Chinese paintings and many examples of the decorative arts, notably lacquer objects painted in red and yellow on a black ground.

Chü-fu a town in northern China, famous as the place where Confucius lived and taught. All the temples and monuments of the town were dedicated to him or to his disciples, and his descendants have lived here as its guardians and administrators right up to the 20th century. The house in which he lived, his tomb and the temple dedicated to his memory are still to be seen. Many of the monuments date from the Han period. However, the main temple, although reported to have been first erected a few years after the philosopher's death, and enlarged and expanded during subsequent centuries, dates from 1724. It was erected to replace the structure which had been hit by lightning and burned down. It is considered one of the finest examples of traditional Chinese architecture erected under the Ch'ing Dynasty. It is 84 feet high and 153 feet wide, and has a double roof and ten big marble columns decorated with carved dragons.

Chu Hsi A Chinese philosopher of the Sung period, who founded a school of thought known as Neo-Confucianism. His influence was very great on all later Chinese thought and his teaching became the orthodox official school of Confucianism during Ming times.

Chü-jan Chinese painter of the Sung period who was active in the second half of the 10th century. He was a Buddhist priest who resided in a temple in Nanking where he gained considerable fame as a painter. When the Sung rulers came to power, he went to K'ai-fêng, the Sung capital, and was well-received at court. It was reported that more than one hundred paintings by him were in the Imperial Collection. He is known for his landscapes, which portray towering mountains, built up with a series of smaller rounded shapes, and many ink dots which are supposed to suggest the vegetation. It is uncertain if any originals by this artist have actually survived, but a scroll called "Seeking Instruction in the Autumal Mountains," now in the National Palace Museum in Taipei, is attributed to him, and is believed to be either an original or a close copy.

Chu Ta Chinese painter of the Ch'ing period who was born in 1626 and died in 1705. A descendant of the Ming imperial family, he became a wandering monk at the fall of the Ming Dynasty in 1644 because he refused to collaborate with the Manchu invaders, and took on the name of Pa-ta Shan-jeñ. He is considered one of the Eccentrics of the Early Ch'ing period, and one of the most original and inspired of all Chinese painters. Leading a carefree life, he created only for his own pleasure and handed out his work freely. His style was very individual and expressive, using loose brushwork and striking contrasts between intense areas of black ink and the white paper. His subjects were usually taken from nature, especially birds, flowers, rocks and fish rendered in a very forceful and abstract manner. He has enjoyed a tremendous reputation, in his native country as well as the West, during the 20th century, because his style

seems to anticipate much of what we think of as characteristic of modern painting. He has exerted a powerful influence on many modern Chinese painters, notably Ch'i Pai-shih. Outstanding examples of his work may be found in many collections; these include a superb album by him in the Freer Gallery in Washington, and handscrolls in the Cleveland and Cincinnati Museums.

Chu Tuan Chinese painter of the Ming period who was active during the late 15th and early 16th centuries. He was a court painter during the time of the Ming emperor Hung-chih, who ruled from 1488 to 1505, and enjoyed a considerable reputation. He was considered a member of the Chê School, continuing the tradition of the Southern Sung Academic Painters. He is also included among the followers of Lü Chi, the famous Ming bird and flower painter, although his best-known works are landscapes, painted in an elegant and restrained manner, and revealing the realistic tendencies characteristic of the Ming period. A good example of his work is the "Scholar Seated in a Boat Contemplating a Landscape," which is now in the collection of the Boston Museum.

Chu Wei Name of a Chinese general of the Han period, whose shrine, erected about A.D. 50 near the present Chin-hsing in Shantung province, contains delicately incised designs showing figures in an interior setting. These designs are important documents for the study of the treatment of space in early Chinese paintings.

Chuang Chinese term for the high pillars often found in courtyards of Buddhist temples. They are decorated with low relief carvings and engraved Buddhist inscriptions.

Chuang-tzu A Chinese philosopher of the Late Chou period, who is believed to have lived from c.370 to 300 B.C. Along with Lao-tzu, he was one of the chief exponents of the Taoist school of thought, advocating a mystic nature philosophy in contrast to the more rational and moral teachings of Confucianism.

Chuban Japanese term referring to a standard size employed for colored woodblock prints, measuring approximately 29.3 cm. by 19 cm., or 11 in. by 8 in.

Chüeh Shape of ancient Chinese ritual vessel of the Shang period made of bronze and used for pouring wine in the rituals connected with the worship of the spirits. It is a cup resting on three blade-shaped legs, with an elongated spout on one side and a flat extended lip on the other; it also has two capped uprights and a handle.

Chuguji Buddhist nunnery located next to Horyuji on the outskirts of Nara. It is primarily famous for its wooden carving of the Bodhisattva Miroku, which is regarded by many as the finest Buddhist image of the Asuka period. It also contains the oldest Japanese embroidery, which represents the land of heavenly longevity and is known as the Tenjukoku Mandara.

Chumon Japanese term for the middle or central gate of Buddhist architectural complexes. It is located in the front or southern section of the

kairo, or peristyle, surrounding the central area of the temple precinct. The chumon of Horyuji Temple, built of Japanese cypress wood and decorated with clay images, is the oldest and one of the finest examples of this type of structure.

Chün Chinese ceramic ware produced from the Sung through the Ming periods at Chün-chou, a district of Honan province. The shapes were usually utilitarian, with flower pots and bulb bowls the most common. They were outstanding for the beauty of their glazes, which were blue to lavender, often with blotches of red and purple. The potting is usually heavy and tends to be stoneware or a porcelaneous ware. The finest of these date from the Sung period, beginning with the 10th century, but they continued to be made during Yuan and Ming times. However, the quality of these later wares was less good, from both a technical and an aesthetic point of view. Similar wares were made at other kilns as well, and are usually also referred to as Chun yao.

Ch'un Ch'iu See *Spring and Autumn Annals.*

Chung bell Chinese term for bronze bells made during the Chou period. They varied considerably in size, were oval in shape, and their outsides were usually ornamented with bosses or nipples. They were used in bell ceremonies, during which they were struck, since they had no clappers inside.

Chung K'uei or Shoki in Japanese, known as the "Demon Queller" or the "protector against Evil Spirits," is the subject of many legends in China. It is said that he first identified himself in a dream to the emperor Ming Huang of the T'ang Dynasty. In his mortal life he had passed the public examinations brilliantly, but was rejected in account of his extremely ugly features. Overwhelmed with shame, he committed suicide. He was then honored by the reigning emperor Kao-tsu, who ordered that he be buried in the green robe which was usually reserved for members of the imperial clan, and canonized him with the title of "Great Spiritual Chaser of Demons." He is usually represented in art as a large ugly man, wearing a scholar's hat, a green robe and large boots, and is usually shown either stabbing or trampling on demons.

Chushingura Name of a famous Japanese kabuki play which relates the story of the forty-seven ronin, who are held up as examples of loyalty to their feudal lord. The story is based on a real occurrence which took place in 1701, when the Lord of Ako, whose name was Asano Naganori, was ordered to take his own life for having committed the crime of drawing a sword in the shogun's palace. His retainers vowed to avenge their master, which they did on December 14th of the following year; they were subsequently ordered to commit suicide. The play dealing with this episode is one of the most popular in the kabuki repertoire and has formed the subject matter of some of the most famous Ukiyo-e prints, notably those of Shunsho and Sharaku.

Chusonji Famous Buddhist temple located in the town of Hiraizumi in the Tohoku region of northern Honshu. It was founded by the Fujiwara

family in 1105, and at that time contained forty buildings and housed three hundred priests. Most of the builidngs were later destroyed by Fire. However, the most famous one of them, the Konjikido, which is also known as the Golden or Glittering Hall, is still preserved, and is considered one of the masterpieces of Heian period architecture. It was originally lacquered and gilded, and decorated with mother-of-pearl inlay, which makes it one of the most splendid Buddhist temples in all of Japan.

Cicada The cicada, both as a larva and as a fully grown insect, plays a prominent role in the art of ancient China. Emerging out of the earth at harvest time and making a shrill noise with its wings, it is associated with late summer and fertility, and is therefore regarded as an auspicious insect. Jades in the form of cicadas were found placed in the mouths of corpses in tombs, especially those dating from the Han period, and were looked upon as symbols of rebirth, indicating that the dead person would rise again out of his grave, just as the cicada rose out of the earth.

Cintamani Sanskrit term for a precious jewel which grants men's wishes. It is often represented in the art of China, and especially Japan, being held in the hand of a Bodhisattva, notably Kuan-yin or Kannon. A special form of the Bodhisattva shown holding this jewel is called Cintamani-cakra-Avalokitesvara.

Cire Perdue See Lost wax.

Clair de lune A European term applied to Chinese porcelains of an exquisite pale lavender-blue, probably derived from the Chinese yüeh pai, meaning "moon white." The Chinese term was only used for the altar vessels of the altar of the moon while the French term is used much more broadly to apply much more broadly to apply to a whole range of porcelains of that type. It is said that the best of them were produced under the reign of the emperor Yung-chêng of the Ch'ing Dynasty.

Cloisonné An enameling technique in which thin filets of flattened wire, usually copper, are soldered on to a metal bsae, creating cells or cloisons. These are then filled in with color pastes, and the whole is fired. After firing, the rough, uneven surface is ground smooth and polished off flush with the wires. See also Enamel.

Cock The cock or rooster is prominent in the folklore of China and Japan, and is also often represented in the art of both countries. It is associated with fire and the sun, for the cry of the cock signifies the beginning of a new day. It is also one of the twelve animals in the duodenary cycle, and is often represented in this context. It was a popular custom among the common people of China to paste a red cock on the wall of the house, in the belief that it would protect the house from fire.

Coiled beast motif Decorative motif associated with the art of the nomadic tribes of the Ordos. It consists of a feline creature presented in profile, with its tail curled up to its head. This motif is sometimes repeated in miniature on the ears, feet and tail of the beast to enrich the design. The coiled animal figure is most frequently found on small objects intended for personal adornment or for use as harness ornaments. See also Ordos.

Color All kinds of colors were widely used in Chinese and Japanese art, not only for purely aesthetic reasons, but also for symbolical purposes. In China, for example, yellow, symbolizing the earth, was associated with the emperor and was, therefore, popular in works of art intended for the imperial court. Blue was associated with heaven, green with vegetation, and white in China signified a state of mourning. Red was the emblem of the south, and of joy and happiness, and as such was employed on festive occasions and used for the garments of brides. In Japan, the color red also played a very important role, and was often employed to decorate the woodwork of Buddhist temples and Shinto shrines. When used for garments, it was associated with courtesans as well as brides. More subdued colors, such as brown, grey and black, were customarily worn by older people, while pinks and light, gay colors were preferred for children.

Color printing Color printing was used extensively in both China and Japan. The earliest Chinese examples are found during the Ming period, with the *Ten Bamboo Hall* prints of 1619 the most famous example. The earliest Japanese color prints were made about 1741, for prior to that, color, if used at all, was added by hand. While color printing never played a major role in Chinese art in Japan the artists of the Ukiyo-e School produced most of their work in this medium; especially during the second half of the 18th century and the first half of the 19th century, they created some of the great masterpieces in the history of the graphic arts, not only of Japan, but of the world. See also Ukiyo-e, *Ten Bamboo Hall*, *Mustard Seed Garden* Painting Manual.

Confucius See K'ung-tzu.

Confucius Temple Many temples throughout China are dedicated to this great sage and philosopher who has played such an important role in the formation of traditional Chinese society and culture. The most famous of these is the great Confucius Temple located in his home town of Chü-fu. See Chü-fu.

Constellations The Chinese have, ever since Chou times, divided the celestial sphere into twenty-eight constellations, which were referred to as mansions, or resting places, of the sun and moon in their revolutions. Seven of these stellar mansions were allotted to each of the four quadrants of the vault of heaven, which were symbolized by four animals: the green dragon represented the eastern quadrant, the vermilion bird—the south, the white tiger—the west, and the tortoise and snake, referred to as the Somber Warrior—the north. These animals also represented the four directions and the four seasons. They are frequently seen in Chinese art. The constellations, although playing a great role in Chinese mythology and folklore, are rarely represented in the visual arts.

Contemporary Chinese and Japanese ceramics Both in China and in Japan, a vast amount of ceramic ware of all kinds is being produced at present. Most of it is mass-produced, industrial output of little artistic merit, in-

tended solely for purely commercial purposes within the country and for export. The higher quality, more artistic wares produced in China are largely imitations of traditional Chinese porcelains, especially those of the Sun, Ming and Ch'ing periods. In Japan, on the other hand, a vital ceramic tradition is still to be found, with a large number of artist-potters producing stonewares and porcelains comparable to the finest made in earlier times. They may be roughly divided into four major groups: those who make traditional tea wares in styles such as Bizen, Shino, Oribe and Karatsu; others who make fine porcelains in the Chinese tradition; still others who are influenced by Japanese or Korean folk art; and finally a group of largely younger potters who are profoundly influenced by the more avant-garde tendencies of modern Western art.

Copper Copper was widely used in both China and Japan in the making of works of art, as well as for coinage. In ancient China, it was usually used as an alloy with tine for the making of bronze, which was the most important artistic medium during the Shang and Chou periods. It was also used in metal glazes on ceramics, especially the green lead glazes of the Han and T'ang periods. Copper deposits in Japan were first discovered in 698; subsequently, copper was widely used in the making of Buddhist images and sword guards.

Copying The copying of paintings was widely practiced in both traditional China and Japan; much of it was, no doubt, intended to deceive the collector. However, many of the copies were clearly designated as such, and were intended as tributes to an old master who was admired by a later artist, or as exercises in schooling a young painter in the manners employed by celebrated older artists. While this practice has been a very vexing one in relation to modern scholarship, which has tried to determine which of the thousands of scrolls attributed to the well-known Chinese and Japanese artists are authentic works by the masters themselves, which are schoolpieces, which are merely in the style of a famous painter, and which are outright forgeries, the practice has nevertheless also meant that at least the subject matter and style of many older artists, of whom no originals survive, is known to us. In fact, some of the famous masterpieces of Chinese and Japanese painting survive today only in copies, and sometimes many versions of the same painting made over a number of centuries are in existence.

Coromandel lacquer A type of decorative Chinese lacquer screen, consisting of eight to twelve panels, which was exported to the West via the Coromandel coast of southwest India, and therefore received this name. It was actually a Chinese production of the K'ang-hsi period, executed with the use of several layers of lacquer on a wooden foundation, with designs cut through the lacquer showing birds, flowers, animals, landscapes and historical and legendary scenes, and painted in a variety of colors. This type of work became very popular with Westerners during the 18th and 19th centuries, and still enjoys widespread popularity today. It is

used for the decoration of cupboards and chests as well as for decorative screens.

Courtesan A euphemism employed in the literature discussing Japanese prints of the Ukiyo-e School, especially favored during the Victorian period, which was used to describe the licensed prostitutes of the Yoshiwara district, who were referred to as oiran in Japanese. See Oiran.

Cowry shells Cowry shells, which were probably ancient fertility symbols, since they resembled the female vulva, were used in ancient China as money, often shaped in bronze rather than made of its natural material. Cowry shell designs also often appear as decorative emblems on Shang and Chou bronzes, where they no doubt have magic significance connected with fertility and prosperity.

Crackle ware A type of ceramic ware, popular in China, in which a fine network of cracks on the surface of the glaze was brought about by unequal rates of contraction of the body and the glaze of the pot during the cooling period. It can be artificially induced by changes in the glaze formula or by the sudden chilling of the piece. It was first used during the Sung period, especially in the Kuan wares, but was later, notably during the Ch'ing period, used in a variety of monochromes.

Crane Next to the fêng-huang or phoenix, the crane is the most important bird in Chinese and Japanese legend and art. It is usually thought of as a symbol of long life and venerable old age, and cranes are usually shown in the Taoist Realm of the Immortals and in the company of the God of Long Life. In keeping with this, it is frequently represented in the painting or decorative arts of both countries, where it is always looked upon as an auspicious symbol, bringing a long life to those who pay it the proper respect. In Edo period Japan, flying cranes were often represented on the garments and chests of drawers of a bride, in order to grant her everlasting happiness, and paper cranes, symbols of good fortune, are still uncommonly made by Japanese children.

Crayfish or **Lobster** The crayfish, orebi in Japanese, is regarded as one of the symbols of longevity: it is to be hoped that a person will reach an age where his back becomes as bent as that of the crayfish. This animal figures among the symbolic decorations displayed at the New Year's celebrations. It was also used as a motif on crests of certain noble families of old Japan.

Crêpe de Chine A fine light-weight silk fabric, with crinkles or small folds, which is often decorated with stencilled designs. It was popular in both China and Japan, and also was exported to the West.

Crests or badges, known as mon in Japanese, were commonly used in Japan by noble families, and then also by others of prominence, as emblems of a particular clan. The most famous of these is the kiku-mon, consisting of a chrysanthemum of sixteen double petals, which was the personal emblem of the emperor of Japan. The paulownia, or kiri, was the imperial crest, and was also used by many of the leading daimyos of Japan. These crests,

which were often artistically very pleasing designs, of flowers, fans, arrows, mallets, insects, birds and animals, as well as geometric designs, of art, woven into clothing, and used for decorating weapons and armor. Thousands of different marks of this type were employed; these enable the student of Japanese heraldry to identify the families who originally owned these objects. Lists and reproductions of them may be found in several Japanese and Western publications. See also Mon.

Cricket This insect is very popular in both China and Japan, where it is caught and sold on the market in cages made of bamboo, so that the owners can enjoy the cricket's sound during the late summer. In keeping with this, crickets are also sometimes represented in painting and the decorative arts of China and especially Japan. There are cricket designs that often occur in the lacquers of the Edo period.

Crow In ancient China, the crow was an auspicious bird, the symbol of the sun and an example of filial piety. It was believed that a three-clawed crow was found in the sun, and it is represented in this manner in Chinese painting, notably that of the Late Chou and Han periods. Crows are also often represented in the painting and decorative arts of China and Japan, especially in Japanese screen paintings and lacquers.

Crystal Rock crystal of a pure glasslike appearance, resembling ice, is used in China and Japan for decorative carvings, especially during the later periods. The precious pearl that the dragon is believed to pursue is sometimes represented in this material.

Cult of the Dead In both China and Japan, the spirits of the dead were the subject of veneration, for it was felt that if proper respect was not paid to them, and offerings were not made, they would return as roaming, dissatisfied souls who would avenge themselves upon the living. At the same time it was also believed that if they were properly cared for, they would prove auspicious and bring good fortune to their descendants. In keeping with these ideas, both the Chinese and the Japanese have always placed great importance on the proper burial of the dead, with large tumuli erected over the graves of rulers and other important personages. These tombs, often containing large treasures, paintings, sculptures and tomb figures, are among the most valuable sources of our knowledge of ancient China and Japan. See also Grave, Tomb figures, and Ancestor worship.

ABCDEFGHIJ KLMNOPQR STUVWXYZ

Daggers Daggers were widely used in both China and Japan, and many of them were decorated with elaborate ornamental designs, executed in a great variety of materials. In China, the most interesting of these come from the Shang and especially the Late Chou periods, and have hilts which often consist of fantastic animal and bird designs, executed in bronze with gold and silver inlay and jade. In Japan, elaborately decorated daggers, referred to as tanto or kozuka, were produced, especially during the Edo period. See also Tanto, Kozuka, Hamidashi, Menuki and Kogai.

Dai-busshi Japanese term literally meaning "Great Buddhist Artist." It was the official title of sculptors of wooden Buddhist statues, who were associated with a particular monastery. The term first came into use during the Heian period, when monasteries began to employ sculptors for themselves. The designation may also be used to refer to a very highly skilled sculptor, who would be qualified to hold such a position. After the Kamakura period, the term dai-busshi was also used for Buddhist painters.

Dai-seishi Japanese name for the Bodhisattva Mahasthamaprapta. See Mahasthamaprapta.

Daibutsu Term referring to the giant statues of the Buddha in Japan, notably the one at Todaiji in Nara and the one at Kamakura. The Todaiji image, which is 53 feet high and contains over one million pounds of metal, was made between 747 and 749 and was dedicated in the so-called Eye-opening Ceremony in the year 752. This event was attended by ten thousand monks from throughout the Buddhist world, including representatives from China, Korea and even India. Unfortunately, this great image, which was one of the masterpieces of Nara period sculpture, was badly damaged during a fire and today is but a sad reminder of its original form. The Great Buddha at Kamakura is located in the Kotoku-in Temple and was made exactly five hundred years later, during the mid-

dle of the 13th century. It is probably today the single most popular and famous work of Japanese Buddhist sculpture. It measures 42 feet 6 inches, and is somewhat smaller than the Great Buddha at Nara. It was cast in 1252 by the well-known sculpture Ono Goroemon, and has been designated by the government as an important cultural property.

Daigo Japanese emperor of the Heian period who reigned from 885 to 930. The period of this rule, which is referred to as the Engi or Era of Enlightenment, was rich in literary and artistic production. Particularly famous was the *Kokin-Wakashu*, an anthology of Japanese poems, both old and modern, which was compiled at his command under the editorship of Ki-no-Tsurayuki. Next to the *Man-yo-shu*, it is the most famous collection of Japanese verse.

Daigoji Celebrated Buddhist temple of the Shingon sect, which was founded in 874 by the priest Shobo. Its most famous structure is the five-storied pagoda, which was built in 951, and is celebrated for its architecture and its paintings.

Daijingu One of the names of the Sun Goddess, Amaterasu. See Amaterasu.

Daikoku Shinto god of wealth who is one of the Seven Gods of Good Luck. He is usually represented as a good natured, cheerful deity, sitting on rice bales and holding a mallet with which he can grant the wishes of his worshippers. He is frequently represented in Japanese painting and sculpture, especially in the folk art of the country.

Daimon Japanese term literally meaning "great crest." It is used to refer to a type of dress decorated with large family crests. The garment was developed during the Muromachi period, and soon replaced the hitatare of the Kamakura period as the standard everyday dress of the members of the samurai class.

Daimyo Daimyo, or "great name," was a term applied to the great noble families of feudal Japan. There were, altogether, some two hundred and seventy such feudal lords, who, with their families, governed Japan. The most notable of them were the Tokugawa, who, during the Edo period, were the most powerful family, eclipsing even the emperor himself. Many of these daimyo were great patrons of the arts, and played an important role in the development of Japanese culture.

Daimyo-nuri Term used in Japan to designate the Japanese lacquer ware of a utilitarian type, intended for the use of the nobility. It was decorated with crests and floral and leaf designs against a shiny black ground.

Dainichi Japanese term for Vairocana, the great Cosmic Buddha, literally meaning the "Great Illuminator." He was seen as a representation of the absolute, and was worshipped as the Eternal Buddha by the followers of the Tendai, Shingon and Kegon sects. See Vairocana.

Dairi-sama Japanese name for the emperor and empress dolls which are used in the celebration of the Hina Matsuri or Dolls' Festival. The figures are dressed in elaborate costumes of rich silks and seated on the highest tier of the stand used to display the festival dolls. Surrounding them are dolls representing court ladies, attendants and musicians.

Daisen-in One of the sub-temples on the grounds of the famous Daitokuji Zen monastery in Kyoto. It is primarily famous for its small but exquisite rock garden, which was designed by Saomi. See Daitokuji.

Daisho Japanese name for the pair of swords, the wearing of which was the exclusive privilege of the samurai. Literally, dai means "large," referring to the katana, which usually measured 28-30 inches in length, and sho means "small," indicating the waki-zashi, which was about 18 inches long. The two swords were almost always fitted with matching mountings or else bore complementary motifs in the designs. They were carried in the sash of the samurai's dress.

Daito Kokushi One of the famous Japanese Zen priests who was a national master of Zen Buddhism and an abbot at Daitokuji Temple in Kyoto. A portrait of him painted in 1334, reflecting his spirituality and strong character, has come down to us.

Daitokuji Located in the northern part of Kyoto, it is one of the chief temples of the city, and one of the most famous of all Zen temples in Japan. It was founded in 1324, but most of the present-day buildings date from 1479, while other structures, notably the Karamon, were brought from Hideyoshi's castle during the Momoyama period. Its buildings are a rich repository of some of the most celebrated of Muromachi paintings and sculptures, and its tea room, designed by Kobori Enshu, and its gardens, designed by Soami, are among the most celebrated in Japan. In addition to the treasures of Japanese art, it also contains some famous Chinese paintings, notably Mu-chi'i's paintings of Kannon flanked by a crane and a monkey.

Dan-no-ura Name of a bay near Shimo-no-seki in Japan. It was here that the final sea battle between the great Minamoto and Taira clans took place in 1185, resulting in the ruin of the Taira family. On the shore are found small crabs which are popularly known as Heike-gani or "Taira clan crabs," and in the sea are found sea bream which shine with golden colors, and which are called koheike, for it was popularly believed that the Heike men, upon being killed or drowned, were turned into crabs and the women into these fish. This subject is often represented in Japanese art, notably in the prints of Kuniyoshi.

Dances Dances, both sacred and secular, played an important role in both China and Japan. Some of them were performed exclusively for the court and aristocracy, others were connected with temples and shrines, and still others were performed in connection with the popular festivals. From the point of view of the visual arts, the most interesting aspects of these performances were the costumes and especially the masks, often worn by the dancers. This was particularly true in Japan, where the garments and wooden masks used in the gigaku, bugaku, and noh dances were among the great masterpieces of textile-weaving and carving. Scenes taken from dances form a favorite subject in the pictorial art of both China and Japan, especially in Japanese prints of the Ukiyo-e School.

Danjuro Name of a number of kabuki actors, the first of whom, Iehikawa Danjuro I, lived from 1704 to 1760, while the most recent one is still active on the kabuki stage today. Several of these actors have been prominently represented in the Ukiyo-e prints, notably in the works of the masters of the Torii School, and the prints of Sharaku. They adopted as their crest three concentric squares which are prominently displayed on their garments, making it easy to recognize them.

Daruma Japanese name for the Indian monk Bodhidharma, who is said to have introduced Zen Buddhism into China during the 6th century. He is frequently represented in Japanese ink painting of the Zen school, particularly during the Muromachi period. The most famous of these representations is a painting of him by the great 15th-century master, Sesshu. He is also venerated as a popular deity, and is frequently represented in the folk art of Japan, notably in the Daruma dolls which are believed to bring good luck, and whose previously blank eyes are painted in after good fortune is bestowed upon the owner.

Death of Buddha The death or, as it is called in Sanskrit, Nirvana of Sakyamuni is often represented in Buddhist art. The most famous of these representations is a Japanese one dating from 1086, during the later Heian period, which is preserved in the Kongobuji on Koyasan. The scene, referred to as Nehan in Japanese, is painted in gold and bright colors, and shows the Bodhisattvas, Arhats, laymen and animals gathered around the golden body of the dead Buddha, lamenting his departure. Many later versions of this scene exist, in both Japanese and Western collections; they are however, artistically very inferior to this outstanding example of early Japanese Buddhist painting.

Deer Deer occur frequently in the art of both China and Japan. Since the Chinese believed that deer lived to a very great age, they became a symbol of long life, and the God of Longevity is often shown accompanied by a deer. It is said that it was the only animal which was able to find the sacred fungus which insured immortality. Parts of the horns of deer, dried and pulverized, were made into pills and taken as medicine. Imperial parks often contained herds of deer, as is depicted in a famous pair of paintings dating from the 10th century. In Japan, too, the deer was considered a sacred and auspicious animal, associated with Shinto shrines, notably the Kasuga Shrine in Nara, which was surrounded by a famous deer park. Many paintings depict these sacred deer, notably Sotatsu's "Deer Scroll."

Deme Name of Japanese carvers who specialized in the making of noh masks. The founders of the line were Jirozaemon Mitsuteru and Taikobo Koken. Their descendants, who were particularly active during the late 17th and 18th centuries, formed two celebrated schools of mask carving, known as the Echizen Deme and the Ono Deme. The most famous artists of the family were Deme Dohaku (d.1715), Deme Uman (18th c.), and Deme Joman (18th c.).

Demon All kinds of demons, spirits and ghosts play a very important role in both Chinese and Japanese folklore. The belief that the world is inhabited by such demonic creatures, often manifestations of the spirits of the dead, is current in the Far East even in modern times, and played an important role in traditional culture. While some of these demons might be auspicious, others were malevolent and wished to revenge themselves for injustices or neglect which they had suffered. They are frequently represented in paintings and prints, often in grotesque and strange forms, notably in the Japanese narrative scrolls of the Kamakura period and the woodblock prints of artists such as Hokusai and Kuniyoshi.

Dengyo Daishi Posthumous name of the Japanese Buddhist priest, Saicho. See Saicho.

Deva Sanskrit term applied to the gods of the ancient Vedic pantheon and to the Hindu male deities. These ancient Indian deities were sometimes taken over by Buddhism and entered the Buddhist pantheon as divine beings, inferior to the Buddhas, but above ordinary mortals. Among them the most popular during early times were the gods Indra and Brahma, who are shown as attendants of Sakyamuni Buddha. Others who occur are Shiva and Vishnu, who may be found represented in the wall paintings at Tun-huang. However, none of them play a very important role in the art of either China or Japan. See also Devi.

Devi Sanskrit term literally meaning "the goddess," which refers to the female deities of the Hindu pantheon. It can also be used more specifically to refer to the Devi, the great Mother Goddess who bestows fertility and is worshipped as the supreme deity by her devotees. The Devi most popular in the art of the Far East, especially Japan, is Lakshmi or Sridevi, the goddess of beauty and good luck, who appears in Japanese Buddhism as Kichijoten, and enjoyed a good deal of popularity from the Nara to the Kamakura period. See also Deva.

Devil The Buddhist equivalent of the Christian devil is Mara, the Evil One, who is said to have tempted the Buddha Sakyamuni, first by an army of demons, and then by his three shapely daughters who displayed their charms to him. This scene of the Buddha's temptation is frequently represented in both Chinese and Japanese art, into which it was introduced from older Indian sources. See also Demons and Oni.

Dharani Magic formula or player used in Esoteric Buddhism. The term itself is Sanskrit and the writing employed is a Sanskrit script known as Siddham. It is especially used in connection with Buddhist mandaras, but may also be found in Shinto devotional calligraphy.

Dharmacakra mudra A symbolic hand gesture found in Buddhist art of both China and Japan. It indicates teaching, or literally "turning of the wheel of law," from the Sanskrit cakra, meaning "wheel," and dharma meaning "law." Both hands are held against the chest, the right turned palm outward, the left showing the fingers counting off the noble eight-fold path.

Dharmapala Literally the "defenders of the law." Minor deities often represented in the Buddhist art of China and Japan. Although they appear to be ferocious, they are actually protective figures serving as guardians for the sacred precinct.

Dhyana Sanskrit term to describe the spiritual and mental concentration which is believed to lead to ultimate insight. The Chinese term derived from Dhyana is Ch'an, and the Japanese, Zen. Dhyana meditation in Buddhist images is conveyed by the Dhyana mudra, in which both hands are held flat with their palms upward, resting in the lap of the sacred figure.

Dhyana Buddhism See Ch'an Buddhism.

Dhyani Buddhas A Sanskrit term referring to the Five Buddhas representing the directions, with the Supreme Buddha, the Cosmic or Vairocana Buddha in the center, and the four others at the points of the compass. It is said that the four Dhyani Buddhas sprang from Vairocana through the power of his meditation. They can be distinguished from each other by their different hand gestures or mudras. This concept is often represented in the Buddhist mandalas or mandaras of the Esoteric sects. The best surviving examples, in both painted and sculptured forms, may be found in the Shingon temples of Japan.

Diamond Throne or Vajrasana in Sanskrit, is a term to describe the seat on which the Buddha is shown, symbolizing his position as the spiritual ruler of the universe. It is the center of the world, with the diamond a symbol of the ultimate and indestructible nature of his truth. The throne is often flanked by two lions, symbols of royal power and emblems of the Sakya clan to which the Historical Buddha, Sakyamuni, belonged. It is sometimes decorated with lotus leaves, symbols of the four areas, India, Central Asia, Iran and China, which in the traditional Hindu view, constitute the world over which the Buddha rules. It may also take the form of a small Mount Meru, the World Mountain on which the Buddha resides.

Diamond World in Sanskrit Vajradhatu. A term applied in Esoteric Buddhism to the idea of the absolute reality which is symbolized by the diamond mandara, and is often represented in the Buddhist art of the Shingon and Tendai sects of Japanese Buddhism, which it is known as Kongokai. See Mandara.

Divination With the help of tortoise shells, bones and yarrow sticks, and stars, divination was already practiced in China in Shang times and continues to play an important role in China and Japan right down to the present day. The most popular instrument for this is the *I Ching* or *Book of Changes*, which has been consulted for some 3,000 years, first by the Chinese, later also by the Japanese, and in recent times by many Westerners as well. In addition to that, great importance was placed on lucky and unlucky years, days and locations, with the utmost care being given to the choice of an auspicious year, lucky day and fortunate loca-

tion. On a popular level, fortune cookies, supposedly predicting the luck of the recipient, are still being handed out by Chinese restaurants.

Dofuku Japanese term used to describe a type of garment which was derived from a Buddhist priest's robe. It was a long, wide-sleeved version of the modern haori. Beginning with the Muromachi period, it was worn by men belonging to the upper classes of Japanese society.

Dog The dog played an important role in Chinese mythology and legend, and is one of the twelve animal symbols in the duodenary cycle of the lunar calendar. It is usually viewed as a symbol of fidelity and plays a role as a guardian. The heavenly dog is often represented in art, and is the subject of worship as a protector of the home. The Buddhist lions, originally imported from India and serving as protectors of the sanctuary, are in Ch'ing art falsely referred to as fu dogs, and are also often rendered in porcelain in Japan where the dog plays a lesser role; but here, too, the idea prevails that the dog is the protector and guardian, and is rendered as such, especially in folk art.

Dogen Famous Japanese Buddhist priest who lived from 1200 to 1253. He was educated at the Tendai monastery at Mount Hiei, and is credited with being one of those who first introduced the principles of Ch'an or Zen Buddhism into Japan.

Dohachi Name of Japanese pottery family which worked in the Awata district of Kyoto. The first of the ceramic artists of this name was Takahashi Dohachi I, who was active around 1800. He was followed by many other potters who used the same name. They made enamel-decorated wares in a variety of styles, some in the tradition of Ninsei and Kenzan, the two most famous Kyoto potters, while others were closer to the porcelains of Hizen and Owari.

Dohan See Kaigetsudo.

Dojojin One of the assistants of Emma-o, the King of the Underworld. He is the genius who hears all.

Dolls' Festival See Hina Matsuri.

Domejin One of the assistants of the Emma-o, the King of the Underworld. He is the genius who sees all.

Donsu Japanese name for the very fine damask cloth which was first developed by the weavers of Sakai during the Muromachi period. This cloth is among the fabrics collectively designated as meibutsu-gire, or "cloths for famous things," used by the tea masters. The various types of donsu are named in reference to their patterns or after their owners, for example the shukin-donsu of Kyoto was characterized by a pattern of floral medallions, and the Enshu-donsu was the donsu favored by Kobori Enshu.

Donyu Name assumed by the Raku potter Nonko, who lived from 1599 to 1656, at the time that he became a Buddhist monk. He was the grandson of the first Raku potter, Chojiro, and is regarded as one of the outstanding masters among the Raku potters. His output consisted largely of tea

bowls, which are highly valued by the tea masters and lovers of Japanese ceramics. See also Raku and Chojiro.

Door Gods or Mên-shên in Chinese are the protectors or guardians of doors, whose duty it is to keep out evil spirits and demons. The earliest door gods were Shên T'u and Yu Lü, who were said to guard the legendary Door of the Devils, through which ghosts from the world of the dead could enter the world of living men. But beginning in about the 13th or 14th century, they were supplanted in popular favor by Ch'in Shu-pao and Hu Ching-tê, two generals of the T'ang emperor T'ai-tsung, who had guarded the emperor's doors against demons when he had fallen seriously ill. They came to be represented on the doors of public buildings, palaces and private homes. The door guardians are shown with fierce, full-bearded faces, dressed in military costume and armed with sword and halberd. More rarely they are depicted in the dress of civilian mandarins.

Doshin See Kaigetsudo.

Doshu See Kaigetsudo.

Dosojin Japanese Shinto deities of the road and highways who are believed to protect travelers and keep them safe from evil spirits. It is said that they were created by Izanagi after a journey to the netherworld. Their emblem is a walking stick in reference to the stick that Izanagi threw across the path to bar the progress of the spirits pursuing him. They are often represented in the folk art of Japan, especially in the stone carvings erected at wayside shrines.

Dotaku Large bronze bells from prehistoric Japan which were found on the islands of Honshu and Shikoku. Their exact use is not known; it is believed that they were originally employed as percussion instruments, but may have been thought of later merely as precious ornamental objects to be placed in graves. They vary greatly in size, with the smallest 1 or 2 inches high, and the largest 3 feet tall. They are particularly interesting for the low-relief designs often decorating them, which show scenes from the lives of hunters and fishermen of early Japan, and their houses and animals, giving a vivid sense of life in Japan during the Early Bronze Age. Similar objects were found in Lo-yang, in North Korea and in Indo-China.

Dove The dove often occurs in Chinese art and was looked upon as a symbol of faithfulness and conjugal felicity. Pairs of doves are often shown in ornamental designs on porcelains and embroideries as symbols of a long and happy marriage. In ancient China, it was also thought of as an emblem of long life, and old people were presented with jade sceptres adorned with a dove or pigeon. It is also a popular subject in the bird and flower paintings of the Sung and Yuan periods, with a celebrated painting of doves traditionally attributed to the emperor Hui-tsung. The dove is also frequently represented in Japanese art, notably in the painting of the Edo period.

Dragon See Lung.

Dragon-boat Festival Important Chinese festival celebrated to this day in China, Southeast Asia, and the Chinese communities in the United States. It falls on the 15th day of the 5th lunar month, which corresponds to the end of May in the Western calendar. The name of the festival in Chinese is tuan wu or tuan yang, meaning the beginning of the sunny season. Many religious and folk traditions are connected with it, and a dragon-boat race was held in southern China on that occasion. The events connected with this festivity are often represented in Chinese painting.

Dragon robe A general term used for the dragon-decorated robes worn by the officials and nobles of the Chinese imperial court for official or festive occasions. The robe was a gown of a very simple cut, with straight lines, a narrow opening for the neck and tightly fitting sleeves. Its surface was almost completely covered with rich designs in bright colors. These designs were carefully prescribed and varied according to the status of the wearer. There are numerous dragon robes in both Chinese and Western collections today, largely dating from the Ch'ing period.

Dragonfly The dragonfly was looked upon in China as the emblem of summer and a symbol of instability and weakness. While not as popular as some insects, it is a motif which occurs in Chinese painting along with birds and other insects, and is used as an ornamental motif in the decorative arts of both China and Japan, where it is particularly popular in the lacquer wares of the Edo period.

Dream in the Red Chamber See *Hung Lou Meng.*

Drum and bell towers The compounds of many Chinese and Japanese Buddhist temples often contain small towers from which the drums and bells used to indicate the time, announce the hour of prayer or mark special occasions are suspended. The finest of these are remarkable for their wooden construction and for the artistic design of their bronze bells and drums.

Dry lacquer A technique of lacquer decoration which proved very popular in Japan, where it was known as kanshitsu. It was invented in China, where the earliest lacquer specimens date as far back as the Chou period. The finest examples of dry lacquer applied to a wooden base covered with hemp cloth, and used to decorate sculpture, are found in China during the T'ang period and in Japan during the Nara period. A type of image which proved particularly popular at the time was a hollow dry lacquer image, which lent itself to be carried easily in Buddhist processions. The dry lacquer technique is still being used in both countries for decorative purposes. See also Kanshitsu.

Dual Shinto Religious belief which sprang up during the Nara era in Japan, and became very popular during the Heian and Kamakura periods. According to this theory, the ancient Shinto gods are but manifestations of the Buddhas and Bodhisattvas. This cult exerted a great influence, especially during the 13th century, when a school of painting known as suijakuga developed, giving visual expression to Dual Shintoism. See Suijakuga and Shimbutsu-shugo.

Duck Ducks in China were regarded as emblems of felicity, and pairs of ducks were often rendered as symbols of conjugal fidelity, for it was said that they pine away and die when separated from their mates. They are also frequently represented in bird and flower painting, where they are usually associated with the lotus, a motif common in Sung painting and probably having some Buddhist connotation. Ducks were also represented in Chinese tomb figures as early as Han times, and are frequently shown in both Chinese and Japanese bird paintings.

Dvarapala A Sanskrit term meaning literally the "Guardians of the Gate." They are usually represented as two large, muscular, fierce-looking warriors, whose function it is to protect the sanctuary from any evil forces which might try to harm it. In both China and Japan, they are seen standing to the right and to the left of the temple entrance, turning back everything evil and demonic coming from the outside. It is believed that their Indian origin can be traced back to the Yaksha figures of pre-Buddhist India.

ABCDEFGHIJ KLMNOPQR STUVWXYZ

Earth Deity The deity Earth, representing the dark female Yin forces, was worshipped in China from the earliest times, and was symbolized by a jade emblem in the form of a square shape perforated with a circular tube. The name given to this principle was Ti, in contrast to its counterpart, T'ien, or heaven, which was looked upon as male. The altar of the deity Earth was located on the west side of the Imperial Palace, while the altar of the god of heaven was at the east. There was also a male deity called T'u, which represented the soil and worshipped by farmers as he who rules the earth, or Hou T'u. Many temples throughout China were dedicated to this deity.

Earth Demon An earth demon representing an ancient Indian concept predating Buddhism, in which the powers of the earth are represented by supernatural creatures who inhabit the earth and preside over its treasures, is frequently represented in Buddhist art. There is one particular gesture or mudra of the Buddha which is called the bhumisparsa mudra and which refers to calling upon the earth deity as a witness that Sakyamuni is the true Buddha. Earth demons are sometimes represented beneath the Buddhas' throne or supporting yaksha figures on their backs. They are represented as small, grotesque figures with strange features and curly hair, revealing their Indian, Western origin. The most famous examples are the bronze relief sculptures of such demons on the base of the throne of the Yakushi image in Yakushiji in Nara, Japan.

Earthenware Type of ceramic ware fired at a low temperature, with a soft, rather coarse body, as distinguished from stoneware and porcelain. All of the prehistoric wares of China, and many of those of the Shang, Chou and Han periods, were made of earthenware, sometimes decorated with painted, incised or impressed designs, and, during the later periods, also often covered with a glaze. The ceramic figures, notably the tomb figures, were also usually made of earthenware as were some of the fine glazed

and molded productions of the T'ang potters. In Japan, too, much of the ceramic production, especially during the prehistoric period—for example, Jomon and Yayoi pottery—consisted of earthenware. In both countries a good deal of the common wares are still being made in this medium.

Ebisu One of the Seven Gods of Good Luck in the popular religions of Japan who is the patron of the tradesmen and fishermen, and represents the virtue of hard work. He is usually represented with a fishing rod and a sea bream. He is frequently shown in Japanese sculpture and painting, notably in the folk art of the country.

Eccentric School of Painting School of Chinese painting which flourished during the 17th century, the very end of the Ming and beginning of the Ch'ing period. Among its most famous practitioners were Shih-t'ao, also known as Tao Chi, Chu Ta, also known as Pa-ta Shan-jên, K'un-ts'an and Kung Hsien. They were men who refused to serve at the court of the alien Manchu rulers of the Ch'ing Dynasty, and led the life of eccentric recluses, wandering around the countryside or dwelling in Buddhist or Taoist monasteries. Their style is a very free unconventional one, turning away from the orthodox tradition, and developing a highly individual manner of painting. Their work today is extremely popular in China, Japan and the West, and has exerted a great influence on modern Chinese painting. See also entries under individual painters' names.

Echizen Old name for a province of Japan, which is presently known as Fukui prefecture. It was well-known as a center of the silk industry. Its daimyo family was the Matsudaira clan, who were important patrons of art.

Edo Old name for the modern city of Tokyo, where a castle had been erected in 1457, and where the Tokugawa regime had its seat of government during the Edo period. The original building was largely destroyed during a fire, and only a few gates, towers and walls remain today. The city which grew up around it by the 18th century was already one of the largest in the world, and became a great center of art. After the Meiji Restoration, when the emperor moved his residence to Edo, it was renamed Tokyo, or Eastern Capital. See Tokyo.

Edo period The Edo, or, as it is sometimes referred to, Tokugawa period, extended from 1615 to 1868. It was very productive in all fields of art, notably architecture, painting, and the decorative arts, while sculpture, due to the decline of Buddhism, had already lost much of its vitality. In the West, the aspect of Edo period art which is probably best known is that of Ukiyo-e, a type of painting and above all printmaking, which, although not very highly esteemed in its native country, has been much admired and eagerly collected by Westerners ever since the late 19th century.

Eggshell porcelain A very fine, translucent type of porcelain, which was made in China ever since the Ming period, and became especially popular

under the Ch'ing Dynasty. It was much admired by Chinese and Western collectors, and was sometimes painted with famille rose designs. In Chinese this ware was called t'o-t'ai, or bodiless porcelain.

Ehon Literally "picture book," a term used in connection with the illustrated books, either hand-painted or printed, which were produced by Japanese artists throughout the ages. The most celebrated of these were made by artists of the Yamato-e or Tosa School, if they were hand-painted, and the Ukiyo-e School, if they were printed.

Eichin Japanese Buddhist monk who was also known as Genshin and who lived from 942 to 1017. In 984 he wrote a book called *Birth in the Land of Purity*, which proclaims a new type of Buddhist teaching in which it is said that the souls of the blessed are reborn in the Pure Land of the Buddha Amida, where they enjoy eternal peace and happiness in his paradise. These teachings gave rise to the Pure Land or Jodo sect of Buddhism, which to this day is one of the most popular and influential Buddhist sects of Japan. See also Jodo sect.

Eiga Japanese painter of the Early Muromachi period, who was a member of the Takuma School. He is primarily known for his Buddhist paintings which show the strong influence of Chinese Sung painting. Little is known about his life, but several works ascribed to him have survived.

Eight Buddhist Emblems also known as the Eight Auspicious Signs or Pa Chi-hsiang in Chinese. They are a collection of eight symbols associated with Buddhist doctrines. The emblems are: the Cakra or Wheel of the Law, the Conch Shell, the Umbrella, the Canopy, the Lotus, the Vase, the Paired Fish and the Entrails or Endless Knot. A bell is occasionally substituted for the Cakra. Wood and clay models of these objects were made to stand on the altar of Buddhist temples. The emblems also often appear on the later ceramic wares, lacquers and cloissonné as decorative elements.

Eight Immortals or Pa-hsien in Chinese. A group of Taoist holy personages who were seen as the protectors of Taoism. Their names are: Li T'ieh-kuai or Li of the Iron Crutch, Chung-li Ch'üan, Lan Ts'ai-ho, Chang-kuo Lao, Ho Hsien-ku, Lü Tung-pin, Han Hsiang-tzu, and Ts'ao Kuo-chiu. With the exception of Ho Hsien-ku, the Immortal Damsel who holds a peach of immortality and is female, they are all male figures, and their lives and attainments, often of a magical nature, are recorded in Chinese legend. They enjoyed widespread popularity as minor gods during the later periods of Chinese history, and are often represented in Chinese art.

Eight Masters of Nanking A group of Chinese painters who were working in the southern capital during the Early Ch'ing period. Among them, by far the most famous was Kung Hsien, one of the most admired and original of Chinese painters of the time, whose work is much admired and eagerly collected today. Among the others, Fan Ch'i, a charming but minor painter, is the best known. Most of them, while famous in their

day, are not much admired any longer, and few of their works have come down to us. The practice of listing artists in groups of four or eight was popular in China and is probably ultimately connected with the four main and four intermediary directions. See also Kung Hsien.

Eight Musical Instruments or in Chinese, pa yin. The eight musical instruments, which occur frequently as decorative motifs, are the ch'ing or stone chime, the chung or bell, the ch'in or lute, the ti or flute, the chu—a box with a metal hammer inside, the shêng or reed organ, and the hsüan or ocarina.

Eight Strange Masters of Yang-chou also the Eight Unusual Characters of Yang-chou. A group of artists who were active in the southern Chinese city of Yang-chou during the 18th century. They were celebrated both for their artistic merit and for their strange and highly individualistic behavior. By far the most famous of them was Hua Yen, a fine example of whose work is a series of album leaves depicting landscapes, now in the Freer Gallery. Others were Lo P'ing, Huang Shên, Ch'in Lung and Kao Fêng-han. See also Hua Yen.

Eight Treasures or pa pao in Chinese, are a collection of eight antique symbols: the jewel or pearl, the coin (a circle enclosing a square), the open lozenge with ribbons, the solid lozenge, also with ribbons, the stone chime, the pair of books, the pair of rhinoceros horns, and the artemisia leaf. The various objects symbolize victory, happiness, good augury, etc. They are often used as decorative motifs and occasionally, as in the case of the artemisia leaf as individual ceramic marks.

Eight Views of the Hsiao and Hsiang Rivers were a popular motif of Chinese painting beginning with the Sung period. It is said that it was originated by Sung Ti, a painter of this age. They are: wild geese alighting on a sandy beach, sailing towards home again, a mountain inn at twilight, snow on the banks of the lake, moonlit night in autumn, evening rain on the river, the tolling of a bell at eventide from a distant temple, and sunset glow over a fishing village. This subject was treated by many famous Chinese painters and also introduced to Japan, where is enjoyed great popularity. See also Hsiao and Hsiang Rivers and Hakkei.

Eighteen Lohan or **Arhats** A group of Buddhist holy men, disciples of the Buddha, who remained in the world to preach his doctrine and protect the law. There were originally sixteen such disciples, but in 10th-century China two more saints were added to that list. They are often represented in Chinese as well as in Japanese art, in both painted and sculptural form. They are always portrayed as Buddhist monks with shaven heads and monks' garments. See Arhat.

Eihoji Famous Buddhist temple of the Kinzai sect of Zen Buddhism, located at Tajimi in Gifu prefecture. It was founded by the famous priest Muso Kokushi in 1312. It is primarily famous for its architecture, notably the Kannon Hall and the Founder's Hall or Kaisando. It is also celebrated for its magnificent scenery with its mountains, deep valleys and swift streams.

Eiraku Japanese potter of the Edo period, who lived from 1795 to 1854. His artist's name was Hozen and he was one of th leading Kyoto potters of the early 19th century. He worked in a style derived from the Chinese three-color gilded porcelains of the Ming Dynasty, and from the blue and white wares of the Shonzui type. He also cleverly copied Ninsei's work. In fact, his copies were so good that they are often taken for originals by the master. He was followed by his son Wazen, who specialized in gilded porcelains and in a type of design that imitated the pattern of dyed cloth.

Eiri Japanese painter and printmaker of the Late Edo period, who belonged to the Ukiyo-e School and was one of the many pupils of Eishi. He was not, however, an artist of any distinction in his own right.

Eisai Famous Japanese Buddhist priest who lived from 1141 to 1215 He was educated at the Tendai monastery on Mount Hiei near Kyoto, and traveled and studied in China. He is usually credited with having been the first to have introduced the principles of Ch'an or Zen Buddhism to Japan, and he founded to Rinzai sect of meditative Buddhism shortly after 1200.

Eisen Japanese painter and printmaker of the Edo period who lived from 1790 to 1848. His family name was Ikeda, and his artist's name, Keisai. He studied painting under both Kano and Tosa masters, but his true teacher was the Ukiyo-e artist, Eiran. He is best known for his female figures, which, however, lack the elegance and refinement of those of Utamaro or Toyokuni. He often collaborated with Hiroshige and was responsible for several of the prints in the Kisokaido series of the master. His landscape prints reflect the influence of European painting.

Eisen Japanese potter of the Edo period who lived from 1753 to 1811. His family name was Okuda, and he was a wealthy man who made pottery and porcelain as a hobby. He was especially attracted by the Chinese porcelains of the Late Ming and Early Ch'ing periods, and made blue-and-white wares, as well as red and green ones, in the Chinese style. He is often credited with having been the founder of the Kiyomizu type of Kyoto porcelain, which was known as Kyo ware. Among his many pupils were Mokubei Dohachi and numerous other prominent potters of the Late Edo period.

Eishi Eishi, whose family name was Hosoda, and who also called himself Chobunsai, was a Japanese painter and printmaker of the Edo period. He lived from 1756 to 1829. He belonged to the samurai class, but gave up his social position to become an artist. He was first a member of the Kano School of painting, but his main contribution was made as a printmaker of the Ukiyo-e School. He is primarily known for his beautiful prints of courtesans, which combine a fragile elegance with a fine sense of design.

Eitoku Japanese painter of the Momorama period who lived from 1543 to 1590. A member of the Kano School, he was a grandson of Kano Montonobu. He was primarily known for his bold and decorative large-scale screen paintings, which were often painted in bright colors on a gold ground. He enjoyed the patronage of the two great military rulers of

Japan of that period, Oda Nobunaga, for whom he decorated the Azuchi Castle, and Toyotomi Hideyoshi, for whom he worked at the Osaka Castle and the Jurakudai Palace in Kyoto. His work, in its grandeur of scale and splendor, reflected the spirit of the age and exerted a powerful influence on the artists who followed him. He is usually regarded as the greatest and most original of Momorama period painters, and was a founder of a school of decorative painting which is typically Japanese and exerted a powerful influence on all later Japanese painting. Among the many works attributed to him, the two finest are the "Cypress Tree Screens" in the National Museum in Tokyo, and the "Lion Screens" in the Japanese Imperial Collection.

Eizan Japanese painter and printmaker of the Late Edo period who lived from 1787 to 1867. He belonged to the Ukiyo-e School and was a pupil of Hokukei, but was also associated with Toyokuni. He specialized in the portrayal of courtesans and kabuki actors.

Elephant The elephant, which today is found only in Yünnan, was believed to have existed all over China in ancient times, and was already represented in Shang bronzes. It is said to be the wisest of animals and, as such, plays a prominent role in Buddhism; for legend has it that a white elephant appeared to Maya, the mother of Sakyamuni, in a dream, to indicate that she would bear a son who would be a great sage, and the Bodhisattva of wisdom, Samanrabhadra, is always shown riding an elephant.

Eleven-headed Kannon See Juichimen Kannon.

Ema Japanese votice picture, literally "horse painting," since these paintings originally portrayed horses. Later on, however, they might portray any object relating to the prayers and wishes of the devotee. Although most of these pictures are true folk art executed by amateur artists in a primitive style, they often have a naive charm and simplicity which makes them very popular with modern folk art enthusiasts.

Emakimono A Japanese painting using the horizontal type of scroll, which enjoyed great popularity among the Yamato-e painters of the Heian and Kamakura periods. Although this art form had originally been imported from China, it played a greater role in Japan, and some of the masterpieces of Japanese painting were executed in this format. See also Makimono.

Emblems Emblems and symbols of all types are commonly found in the art of China and Japan of all periods. Some of them are associated with Buddhism, others with Taoism or Shintoism, and many of them with the traditional folklore of these countries. It is popular to combine them into groups of eight, ten, or twelve, such as the Eight Buddhist Emblems, the Ten Celestial Stems, and the Twelve Ornaments. The emblems may take many different forms, including animals, flowers, objects and diagrams, and are commonly represented in the decorative arts of both countries, notably China.

Emma-o Japanese name for the Buddhist god of death, Yama-raja. See Yama-raja.

Emperor and Empress dolls See Dairi-sama.

Enamel A usually opaque or semi-opaque vitreous composition, applied by fusion to the surface of metal, glass or pottery for ornamentation or protection, or as a basis for decoration. In China this technique was particularly popular for the decoration of metals, and often took the form of cloisonné and champleveé. The earliest enamels are found among the T'ang objects of decorative art stored in the Shosoin in Nara, Japan, and take the form of cloisonné, while painted enamel designs were only introduced during the Ming period. It is believed that these techniques were introduced from the West, probably Byzantium, and brought to China by Persian or Arab artisans. The technique of enamel decoration was particularly popular during the Yuan, Ming and Ch'ing periods, and was also introduced to Japan where, however, it never played as important a role in art as it did in China. Enamel decoration of all types continues to be used in both China and Japan right to the present day, but the objects made are usually of an inferior artistic quality. See also Champlevé and Cloisonné.

Engakuji Famous Zen temple located just to the north of Kamakura. It was founded by Hojo Tokimune in 1282, and is one of the oldest Zen temples. Its bell, cast in 1301, is the largest in Japan. While most of its original buildings were destroyed in the earthquake of 1923, its Shariden or Relic Hall, built in 1279, is one of the most famous of Zen structures built in a Chinese style, and reflects the kind of architectural innovation which was introduced into Japan by Zen monks during the Kamakura period.

Engi Japanese term employed to describe a series of pictures joined together in the form of a makimono or narrative scroll. They usually illustrate the lives of illustrious Japanese historical figures, or the history of various temples. The most famous of these is the Kitano Temman-gu engi, which illustrates the story of the famous Heian period nobleman, Tenjin-sama, to whom the Kitano Shrine is dedicated.

Eni Japanese painter of the Kamakura period, who is believed to have flourished during the 13th century. Nothing is known of his life, and the only surviving reference to him is found in an inscription on the famous Yamato-e scroll depicting the life of the priest Ippen, which was executed in 1299. It would appear, from this, that he was one of the outstanding Yamato-e painters of the Late Kamakura period.

Enku Japanese priest and sculptor of the Edo period, who was born in 1632 and died in 1695. A folk artist who worked in a very crude manner, he produced a large number of wooden images which are today greatly admired for their vigor and simple abstract style. He is regarded as the only truly creative and original Japanese Buddhist sculptor to have worked since the end of the Kamakura period.

Enlightenment Term applied in the Buddhist religion to the most important event in the earthly life of Sakyamuni. When seated in meditation under the Bodhi Tree in Bodhgaya in northern India, he perceived the true nature of the world and the cause of all suffering in desire, which had to be overcome in order to achieve true wisdom and inner peace. This scene is often represented in the art of China and Japan, and the Buddha is therefore referred to as the Enlightened One in Buddhist texts.

Ennin Japanese Buddhist priest who lived from 794 to 864. He is better known by his posthumous name of Jikaku Daishi. He was one of the patriarchs of the Tendai sect, the teachings of which he had studied in China, from whence he returned in 851. His account of Chinese Buddhism during its last florescence, just before the great Buddhist persecutions of the Late T'ang period, during which many of the temples were destroyed, metal images melted down, and hundreds of thousands of Buddhist monks and nuns forced to return to secular life, as it is recorded in his diary, is an invaluable source of our knowledge of Chinese Buddhism. After his return to his native country, he was active in spreading the Esoteric doctrines of the Tendai sect, and was connected with temples on Mount Hiei.

Enryakuji Famous Buddhist temple located on Mount Hiei, northeast of Kyoto, which is one of the most important temples of Japan. It was founded in 788 by Dengyo Daishi, the founder of the Tendai sect, and is the headquarters of that school of Buddhism. Its original buildings were destroyed by Nobunaga during the 16th century, but it was rebuilt later under Hideyoshi and the Tokugawa shogun, Iemitsu, and contains numerous temple halls and artistic treasures.

Enshu Japanese architect and garden designer of the Edo period, who lived from 1579 to 1647. His family name was Kobori, and he was a famous tea master and supervisor of construction at the court of the shogun. Many buildings and gardens in Kyoto are attributed to him; however, some of these were actually executed by his followers. His most famous garden is in the Koho-an at Daitokuji, the Zen temple in Kyoto. He also designed the gardens for the living quarters of the abbot of Nanzenji Temple in Kyoto.

Erh-li-kang Chinese archaeological site located near Chengchou, where remains from the late Neolithic and Shang periods have been excavated. It appears that this was the location of a large city, more than a mile square, with temples, palaces, bronze foundries, kilns and workshops. It is believed to have been the city known as Ao, the capital of the 10th Shang ruler. The graves at this site contained magnificent bronzes, jades, ivories and ceramic wares.

Erh-li-t'ou Archaeological site in Honan province, located on the Lo River. It dates from the Shang period, and it has been suggested that it might correspond to the site of Po, the first capital of the Shang rulers. Important archaeological remains, notably a bronze foundry and objects

made of bronze, jade, turquoise, shell and pottery, were excavated at this site.

Erotic prints In Japan, as well as in China, numerous paintings and prints depicting erotic scenes, which were thought of as guides to sexual enjoyment, were produced. While most of them were artistically on a very low level, Japanese Ukiyo-e prints depicting erotic scenes, referred to as shunga, were often executed by some of the leading masters of Japanese wood engraving. See Shunga.

Esoteric Buddhism A school of Buddhism which originated in India and was introduced to China during the T'ang period, where it was called Mit-sung. Esoteric Buddhism became particularly popular in Japan, where it was known as Mikkyo. See Mikkyo, Singon, and Tendai.

Export Ware Term applied to Chinese ceramics which were made specifically for export to foreign countries. As early as the T'ang period, Chinese ceramics were exported to the Near East, as is indicated by the Chinese wares excavated at Samarra in Mesopotamia. This exportation became even more important during the Sung and Yuan rule, when large quantities of Chinese porcelains were exported to Persia and other Near Eastern countries as well as Southeast Asia, which was one of the greatest markets for Chinese porcelains. In fact, some of the finest of early Chinese blue-and-whites, made during the Mongol rule, are to be found in Near Eastern collections. Due to the fact that the Mongols had an empire extending all the way from the coast of the China Sea to western Asia, the wares made for this trade often had shapes and decorative designs specifically made for the Islamic market. Chinese sources talk of a "Mohammedan blue," referring to a blue and white porcelain made during the Yuan and Ming periods. During the later periods, the export of Chinese porcelains to Europe became extremely important, and a large number of Ming and Ch'ing porcelains were made for the European market, where they were much admired and imitated at Delft and the various porcelain factories of Europe. The chief carriers of this trade were the Dutch, with Amsterdam the great European center for the auctioning and trading of Chinese porcelains, but soon others joined them, with the English East India Company playing a prominent role during the Ch'ing period. While some of the ware was specifically made for the European and American market, with shapes and pictorial designs prescribed by the Western buyers, a great deal of it was simply part of the huge Chinese production intended for the domestic market. In light of this, the quality of the export ware varies tremendously.

Ezo Old name for Hokkaido, the most northern island of the Japanese archipelago. The aborigines of Japan, a people of Caucasian stock known as the Ainu, were called the Ezojin in Japanese historical records. Small remnants of this ancient people may still be found in reservations on the island.

ABCDEFGHIJ KLMNOPQR STUVWXYZ

Fa-hsien Chinese Buddhist pilgrim who, during the Six Dynasties period, made the long and arduous trip across Central Asia to the homeland of Buddhism, in order to visit the sacred sites where Sakyamuni had lived and taught. He left China in 399 and went by way of Tun-huang and Khotan to the Gandhara province, and then to the sacred cities of Bodhgaya and Benares. From there, he journeyed to Ceylon, and returned to China by sea in 414. The account of his travels is one of the classics of Chinese travel literature, and his likeness is sometimes represented in Chinese art.

Falcon The falcon was employed by the nobility of China and Japan for hunting, and falcon banners were displayed in the chariots of feudal China as a sign of authority and power, for this bird was looked upon as an emblem of strength, boldness and keen vision. The falcon, and the closely related hawk and eagle were often represented on Japanese decorative screens, especially those of the Momoyama and Early Edo periods. Young noblemen holding hunting falcons are also a popular motif in the Japanese color prints of the Edo period.

Famille jaune Enamel-decorated Chinese porcelain of the Ch'ing period, similar to famille noire and famille verte, but here the background consists of a yellow glaze, instead of a black or green one.

Famille noire A type of Chinese porcelain decorated in enamel colors over the glaze, on a ground of black. The decorative designs, which generally depict birds, flowers, rocks and dragons, were painted by professional painters who specialized in this work. The most notable shapes are large club-shaped or four-sided vases, which were extremely popular in the West and brought very high prices. The finest examples date from the rule of the emperor K'ang-hsi and were made at Ching-tê-chên.

Famille rose Type of Chinese porcelain decorated in enamel color, with a rose glaze the dominant hue. The opaque rose-pink color was of foreign

origin and was introduced into China from Europe towards the close of the reign of the emperor K'ang-hsi. The Chinese therefore referred to these as yang-ts'ai, or foreign colors. Famille rose, which are delicately painted and beautifully potted, were made at Ching-tê-chên, and enjoyed a particular popularity in Europe, where they were eagerly collected during the 18th century.

Famille verte Type of Chinese porcelain decorated in enamel colors over the glaze against a green ground. The decorative designs usually consisted of flowers, birds, rocks and dragons which were skillfully painted by professional painters who specialized in this type of work. The most notable of these are the big vases of a club-shape or the four-sided type, which enjoyed tremendous popularity in the Western world, and brought enormous prices. The finest were made during the rule of the emperor K'ang-hsi at Ching-tê-chên.

Fan Fans were widely used in both China and Japan from very early times. It is believed that they originated in China, and were then introduced into Japan via Korea, when Chinese civilization became popular during the Asuka and Nara periods. The earliest fans were probably stiff ones made in imitation of palm leaves, while the folding fan was probably a Japanese invention, but became popular in China as well. While the purpose of fans was originally no doubt to cool oneself on hot days, and fans are still widely used for this purpose, they serve many other functions as well, such as being used in dances, during ceremonies, on the battlefield, and as gifts. There is even a whole category of painting known as fan painting, which does not necessarily imply that the pictorial composition were executed on surfaces intended to be used as fans, but that the format of a fan was employed by the painter for his pictures. The making of fans in both China and Japan was the province of highly skilled artisans, who specialized in this work and often produced true works of art, which have been eagerly collected in China and Japan, as well as in the West, for their aesthetic appeal. Although paper is the most common medium employed in the making of fans, other materials, such as bamboo, ivory, cloth, feathers and even metal, may be used as well.

Fan K'uan Chinese painter of the Sung period who is believed to have been active between 990 and 1010. He was a student of Li Ch'êng and further developed the style of monumental landscape painting of the Northern Sung period. He is well known for the grandeur of his mountain views, which reflect his Taoist philosophy and his ascetic life-style as a mountain dweller. He employed a great deal of detail, using precise brushwork as well as hatching and dots. The most outstanding work by his brush which survives is "Travelers on a Mountain Path" in the National Palace Museum in Taipei. Another scroll attributed to him is "Traveler in the Mist" in the Boston Museum.

Fan-lung Chinese painter of the Sung period who worked in the Ch'an style, and to whom a scroll of Arhas now in the Freer Gallery is attributed, but about whom little is otherwise known.

Fan-t'ao Chinese name for the legendary peach tree which is the Taoist symbol for longevity and marriage. According to popular legend, the tree grows in the palace gardens of Hsi Wang Mu, the Royal Lady or Queen Mother of the West. Its fruits are said to ripen only once every 3,000 years, and have the power to confer immortality upon those who eat them. The symbolical significance of the peach tree was carried over into Japan, where it became associated with several legendary figures and was often represented in art. In China, large boxes used to contain wedding gifts were often made in the form of a large peach.

Fang-i Chinse name for a rectangular bronze vessel in the shape of a square box with a slanted cover. It is believed to have served as a storage container for grain. The decoration is usually very elaborate, consisting of t'ao-t'ieh masks, k'uei dragons, and flanges. Surviving examples date only from the Shang and Early Chou periods.

Feast of the Dead This festival, which falls on the 15th day of the 3rd month, or, by the Western calendar, the beginning of April, was widely observed in traditional China, where it known as the Ch'ing-ming Festival. At this time people visited the tombs and presented offerings to the dead. It was connected with the worship of ancestors as well as Buddhism, and paper offerings in the form of money or flowers were burned at the graves. This festival is also celebrated widely in Japan, where it is known as Bon. See Bon Festival and Ch'ing-ming Festival.

Fei-po Chinese term literally meaning "flying white." It refers to an ink painting technique in which the brush is pulled quickly across the paper, allowing the hairs to separate so that the ink is broken and uneven, and streaks of white ground remain untouched. The resulting effect is a light, airy quality. The flying-white stroke was most frequently employed in bamboo and bird and flower painting.

Feng Name of the first Chou capital which is believed to have been at Chang-chia-p'o in Shensi. Excavations are now being undertaken to uncover the site.

Fêng-huang Chinese name for a mythical bird usually referred to as the phoenix in Western literature. It is called the ho or ho-o bird in Japanese. Along with the dragon, the tiger and the tortoise and snake, it is one of the four symbolical creatures that represent the directions. It presides over the southern quadrant of the heavens, and therefore symbolizes sun, warmth and summer. In appearance it is generally described as combining the characteristics of several birds and animals. It is believed that the fêng-huang will only appear in times of peace and prosperity. As a decorative motif on ceremonial costumes, it was the special emblem of the empress. It is often represented in the sculptural and pictorial arts of China.

Fêng-shui Chinese term literally referring to fêng—the direction of the winds, and shui—the direction of the water, but generally referring to a system of geomantic specifications, which was employed in traditional China in order to determine an auspicious site and orientation for a house, temple, or tomb.

Fêng-tai Chinese term to describe the two vertical strips made of paper or silk, which hang from the top of the vertical scrolls. Many ingenious explanations have been offered to describe their function and origin, such as that they scared away birds which might wish to settle on the picture. But there can be little doubt that their original function was that of tying the scroll when it was rolled up. Today the fêng-tai serve purely decorative purposes.

Fifty-three Stages of the Tokaido Road were the stops at which travelers making the journey from the Tokugawa capital in Edo to the ancient imperial city of Kyoto could rest and be served food and drink. These stages are particularly famous in terms of art due to the fact that the great 19th century printmaker, Hiroshige, portrayed them in his most celebrated series, known as the "Fifty-three Stages of the Tokaido Road," which was brought out in 1833 and has been reprinted innumerable times. See also Tokaido and Hiroshige.

Filial piety Filial piety, or a respect for one's parents, grandparents and ancestors, has always been a quality which was much admired in both China and Japan, and the *Book of Filial Piety* is one of the classics of Confucianist literature. The so-called paragons of filial piety who, through their exemplary behavior, demonstrated their filial devotion, are often respresented in art in order to inspire others by their noble example.

Finger painting See Chih-hua.

Fish Fish play a very important role in the life, legend and art of both China and Japan. In the very earliest art of China, fish were already represented as a symbol of water and fertility, and to this day the carp is thought of as an emblem of wealth, perseverance, and fertility, and is represented in the ornamental designs on the gifts given by the bride's family at a Chinese wedding. Fish of all types are frequently seen in both Chinese and Japanese painting of all periods, both for the beauty of their form and movement and for the auspicious associations which they have.

Five-color ware Type of Chinese porcelain decorated in enamel colors on a white body, which was invented by the potters of the Ming period, probably during the reign of the emperor Hsüan-tê, and brought to perfection under the rule of Ch'êng-hua. The colors are applied over the glaze or directly on to the body of the vessels. Sometimes cobalt blue was included under the glaze. The designs are chiefly flowers, flowering branches and vines, and are exquisitely painted with a fine sense of decorative design. This style of decoration continued to be popular during the later Ming and Ch'ing period with a great variety of shapes and designs being used by the potters.

Five Dynasties The period of Chinese history which falls between the end of the T'ang period in A.D. 907 and the beginning of the Sung period in 960. Five different dynasties, two of them Chinese and three Turkic, ruled at that time, none of them lasting for more than a few years. In terms of the history of art, this period is primarily important in that it brings the

beginning of the fully matured Chinese landscape painting which was to culminate in the magnificent landscape scrolls of the Sung period.

Five Great Buddhas of Meditation and Wisdom known in Chinese as Wu-chih-julai, and in Japanese as Go-chi-nyorai. In the symbolism of the Far East, these figures are the guardians of the five cardinal directions. Each also represents one of the five elements and corresponds to one of the five primary colors. Akshobhya represents the east, the earth, and the color green; Amitabha—the west, fire and red; Vairocana—the center, ether, and white; Ratnasambhava—the south, water and yellow; and finally Sakyamuni—the north, air and the color black. This concept is often represented in the Buddhist art of China and Japan, notably in Japanese sculpture and painting of the Shingon sect.

Five Great Vidyarajas called Godai Myo-o in Japanese. Deities who play an important role in Esoteric Buddhism and are looked upon as manifestations of the Five Buddhas of Wisdom. They are represented as fierce and powerful figures, surrounded by flames which symbolize their power to destroy the forces of evil. The most important of them is Acala (in Japanese—Fudo Myo-o), who is seen as a manifestation of the Cosmic Buddha Vairocana. The others are Yamantaka (Dai Itoku Myo-o), Kundali (Gund Myo-o), Vajra-jaksha (Kongo-yasha Myo-o), and Trailokya-vijaya-raja (Goanze Myo-o).

Flaming Jewel Buddhist symbol which is often represented as a finial on top of a pagoda, a lantern or a reliquary. It symbolizes the previous jewel of the Buddhist law, which spreads light wherever it reaches. It is a symbol which is particularly popular in Japanese Buddhist art, where it can be seen crowning the famous lantern in the courtyard of Todaiji Temple in Nara. It may also be represented separately as one of the sacred emblems of the Buddhist faith.

Flanges Term for the vertical rib-like projections used to decorate bronze vessels of the Shang and Early Chou periods. Flanges are often segmented, especially on pieces dating from the later period. Originally fairly simple and restrained in appearance, they were elaborated into large and spiky forms during Early Chou times, with animal motifs being used on the segments of the projecting ribs. In the Middle Chou period they occur only on li bronzes and are reduced to small fins. Flanges were originally introduced to mask the junctions of the casting molds.

Floating World One of the translations applied to the Japanese term Ukiyo, referring to the world of pleasure, the ephemeral world, in contrast to the world of religion and spiritual truth. First applied to literature in describing stories dealing with love, adventures and the life of the amusement district, it was later also applied to a school of painting, and especially printmaking, which specialized in the depicture of the life of the amusement district of Edo, with its theatres, courtesans and greenhouses.

Flower arrangement This art form, known as ikebana in Japan, plays a very important role in Japanese culture, and is looked upon as a major form of

aesthetic expression. Its origin is disputed, some sources suggesting that it originated in India with the custom of offering flowers to the Buddha, while others suggest that it is of Chinese origin and was introduced into Japan during the 15th century. However, there can be little doubt that it played a far more important role in Japan, and was here developed into a fine art. It is believed that the tea room of the Silver Pavilion in Kyoto was the birthplace of the Japanese floral art. It developed into many schools and became immensely popular during the Edo period. Today there are no less than three hundred different schools, which may be divided into the formal, the natural, and the modern schools. The work of this last school often resembles modern sculpture or assemblages more than traditional flower arrangement. These schools have millions of followers, and the great masters of flower arrangement are among the most esteemed and well-known of Japanese artists. Large exhibits of ikebana are shown all over Japan, and schools of flower arrangement may be found in every Japanese city or town.

Flower symbolism Flowers play a great role in the life, legend and art of both China and Japan. The beautiful arrangement of flowers is in itself looked upon as a major art form, especially in Japan, and has millions of devotees. Flowers were associated with the four seasons, with the peony representing spring, the lotus—summer, the chrysanthemum—autumn, and the prunus—winter. It is also thought that each month may be symbolized by a particular flower form or fruit blossom, with the first month, which fell somewhat later in the Chinese lunar calendar, represented by the prunus, the second by the peach; others are the peony, cherry, magnolia, pomegranate, lotus, pear, mallow, chrysanthemum, gardenia and poppy. Flowers of all sorts are also represented in both Chinese and Japanese paintings, with certain artists specializing in the representation of various kinds of flowers, such as the narcissus, lotus, iris and chrysanthemum. The most outstanding example of this genre is probably the iris screen by the 18th-century Japanese painter Korin. See also entries under individual flowers.

Fly Whisk or hossu in Japanese. An emblem held by Avalokitesvara (Kuan-yin in Chinese and Kannon in Japanese), the Bodhisattva of mercy and compassion, symbolizing his infinite love for all beings by indicating that he would not even kill an insect, but rather would wave it away with his whisk. The deity is often represented holding this instrument in the sculpture and painting of both China and Japan.

Flying white Chinese ink painting technique. See Fei-po.

Folk Art Folk art, which was an expression of the popular culture of the rural villages and small towns, played an important role in Chinese and especially in Japan. While the people who produced it, many of them farmers who built peasant houses and produced pots, textiles, crude paintings and carvings, and woodblock prints, did not think of themselves as artists, and were not thought of as such by the society of

their day, their productions are highly esteemed by modern critics as genuine artistic manifestations of the common people, in contrast to the self-conscious and refined output of the artists connected with the courts and the great urban centers. In modern China, especially since the establishment of the People's Republic, folk art, especially folk prints, is now collected and studied. In Japan, a very active folk art society has established many museums devoted to Japanese popular art, which is known as Mingei. See Mingei.

Footprints In the legends of Buddhism, there are references to sacred footprints of the Buddha and other transcendental beings, which symbolically represent the presence of the deity without portraying his human likeness. This motif is found frequently in the early Buddhist monuments of India, prior to the introduction of the Buddha in human form, notably in the sculptural decorations of the Great Stupa at Sanchi. The Buddha's footprints may also be found represented in the art of China and Japan.

Forbidden City A term applied to the central part of the old Imperial City of Peking, in which the Imperial Palace was located. It is also referred to as the Purple Forbidden City, since the color purple was associated with the North Star, and it was said that the imperial residence was, like the North Star, one of the main cosmic centers. After the Revolution of 1912, and the establishment of the Republic, the so-called Forbidden City was opened to the public and has been serving as a historical monument and museum since that time.

Four Accomplishments In traditional China, the four most important cultural accomplishments, based on Confucianist teaching, were believed to be music, games of skill art and scholarship. In the visual arts these were represented by the flute, the chess board, paintings and books.

Four Heavenly Kings See Lokapala.

Four Masters of Yuan Huang Kung-wang, Ni Tsan, Wêng Mêng and Wu Chên are often referred to as the Four Great Masters of the Yuan period, in keeping with the Chinese love for classifying artists, flowers etc. in groups of four, which probably originally derived from the cult of the four directions, already found in Shang inscriptions. See also entries under names of the artists.

Four Quarters or **Four Directions** played a great role in Far Eastern cosmology. Already the ancient Chinese of Shang times worshipped the deities of the four directions. In Han art they are often symbolized by four beasts, with the west represented by the White Tiger, the east by the Green Dragon, the south by the Vermilion Bird, and the north by a tortoise with a snake coiled around its body, known as the Somber or Dark Warrior. Sometimes the center too is considered one of the directions, bringing the total to five, which was considered an auspicious number in Chinese folklore. The same concept also exists in Buddhism, where a central Buddha is surrounded by Four Buddhas representing the Four Quarters. In both Chinese and Japanese art, there are also often found

four guardian deities, most frequently standing at the corners of a dais on which Buddhist images are located, where function it is to protect the sacred figures from evil forces. Another concept embodied in Buddhist art is that the worshippers come to worship the Buddha from all four directions, which is symbolized by the steps leading to the platform on which the temple is erected.

Four Seasons The year in the traditional calendar of China and Japan, as in the West, was usually divided into four seasons, although they fell a month or more later due to the lunar calendar which was employed. Each of these seasons was associated with various festivals, characterized and symbolized by four flowers, with the peony representing spring, the lotus—summer, the chrysanthemum—autumn, and the prunus—winter. The four seasons also were a favorite motif among Chinese and Japanese painters with some of the most celebrated of scrolls and screens, notably those of the great 15th-century master Sesshu, representing the characteristic activity and appearance of nature during the four seasons.

Four Treasures of the Literary Apartment In traditional China, the four treasures of literature were the brush, ink stick, paper and ink slab. These symbols are believed to owe their origin to Confucius, and are often represented in the arts of the later periods.

Four Wangs Since four of the most famous of early Ch'ing painters had the surname Wang, which is a very common family name in China, they are often referred to as the Four Wangs. The most famous of them were Wang Hui and Wang Yüan-ch'i. The others were Wang Chien and Wang Shih-min. See also entries under individual names.

Fox The fox plays an important role in the legend and art of both China and Japan, and many shrines dedicated to the fox deity are found in both countries. It is said that this animal has the power to transform himself into human shape and there are many stories telling of foxes emerging out of coffins and assuming the shape of old women or beautiful young girls. It is thought that these foxes represent the spirits of the deceased and many often haunt the living. Representations of these fox spirits may be found in the folk art of China and Japan, and fox images which are believed to have protective functions are frequently seen in Japan to the present day.

Frog See Toad.

Fu Chinese term used to describe a rectangular bronze good vessel resting on four angular feet. The cover is almost identical in form except for the addition, in some cases of two loops on the short sides to serve as handles; upon removal the cover could itself be used as a dish. This shape first came into use during the Middle Chou period.

Fu dog A term popularly applied to dog-like creatures seen in front of Buddhist temples or rendered in ceramics. They are actually lions which represent Buddhist guardians, even if in the later periods of Chinese art, when their original derivation and symbolism had been lost sight of, they

resemble dogs more closely than the majestic feline beasts found in the earlier periods. See Lion.

Fu Hsi Legendary Chinese ruler of prehistoric times, who is listed as one of the three sovereigns who ruled China in highest antiquity. He is usually represented with a human head and upper body, and a snake-like tail, notably on the low relief carvings of the Wu Liang-tz'u tombs in Shantung, which date from the Later Han period.

Fu Pao-shih Modern Chinese painter who was born in 1904 and died in 1965. He served as a professor of the history of art at Nanking University and enjoyed a great reputation as one of the most original of contemporary Chinese painters. His style is highly personal and very expressive, and owes a debt to the great early Ch'ing Eccentric painter, Shih-t'ao.

Fubako See Fumibako.

Fuchi Japanese term used to describe the collar or border of the hilt of the Japanese sword. It usually consists of a flat band of metal, up to half an inch wide, that encircles the hilt at the guard end. Its base has an oval plaque where the signature of the metal artist often is found.

Fudo Myo-o Japanese term for the Buddhist deity referred to as Acala or Achala in Sanskrit. He is regarded as a Bodhisattva and defender of the Buddhist law, and is one of the Five Great Myo-o. He is looked upon as a manifestation of Dainichi, or in Sanskirt, Vairocana, and enjoyed particular popularity among the followers of the Shingon sect of Esoteric or Mikkyo Buddhism of Japan. He is shown standing or seated on a rock, symbolizing his determination. He is almost grotesque in appearance, with a powerful body, bulging eyes, two fangs protruding from his mouth and a frightening facial expression. However, this fearsome appearance is only to scare off demons and fight the evil within the worshipper, for he is a protective, benevolent deity who, with the sword he holds in his hand, fights evil, and with a rope rescues the souls from purgatory. He is often represented in both painting and sculpture of the Heian as well as the Kamakura period, the most famous examples being the Red Fudo in the Myo-o-in on Koyasan, the Yellow Fudo in Onjoji, and the Blue Fudo in the Shore-in.

Fugen Bosatsu Japanese name for the Bodhisattva of wisdom and ethical perfection, Samantabhadra. See Samantabhadra.

Fujihime or Princess Fuji, is the goddess who dwells at the summit of Mount Fuji. She is the daughter of the god of mountains, O-yama-tsumi, and also bears the names Asama, Sengen, Konohana Sakuyahime (Princess who causes the trees to blossom). A temple on Mount Fuji is dedicated to her. She is often shown in Japanese art, holding a wistaria branch.

Fujin Japanese Shinto deity of wind who is frequently represented, in both the sculpture and painting of Japan, as a muscular figure holding a large bag over his shoulders, out of which he may release the winds if he so desires. He usually represented with the god of thunder, Raijin, who has

drums as a sign of his power. Both of them are worshipped by local people in the hope of avoiding catastropic storms and having a good harvest. His origin is probably derived from China, where he is known as Fêng Po, but he plays only a small role in the art of that country.

Fujisan or Mount Fuji, is the highest and most sacred mountain in Japan. It is a conical-shaped volcano, 12,397 feet high, the name of which is derived from the Ainu word for fire. However, the volcano has not been active for more than two hundred years. Since it is considered a sacred mountain, there is a Shinto shrine on its summit, and many people ascend its slopes each year. It is a common subject in Japanese art. The most famous example is a series of "Thirty-six Views of Mount Fuji," produced by the great woodblock artist, Hokusai, during the early 19th century, but numerous other painters and printmakers have immortalized this famous mountain, which is thought of as the symbol of the Japanese nation.

Fujishima Takeji Modern Japanese painter who lived from 1867 to 1943. He first trained in the Japanese style painting of the Shijo School, but soon switched to Western-style painting, which he studied under Kuroda. In 1905 he went to Europe for two years; there he discovered Impressionism, which was to have a profound influence on his own work. He specialized in the painting of landscapes, and is usually regarded as the most outstanding Japanese Western-style painter of the Taisho and early Showa periods.

Fujiwara One of the most important noble families of Japan, which was founded by Fujiwara Kamatari, who lived from 614 to 669. It played a very important role in Japanese history, especially during the Later Heian period, which is also often referred to as the Fujiwara period. Fujiwara Yoshifusa became prime minister under the emperor Montoku (827–858), and he and his descendants rose to the position of regent to the throne, placing them right next to the emperor and often making them even more powerful. The tutelary temple of the Fujiwara fammily was Kofukuji in Nara, which was established by the widow of the founder of the clan in 669. Their family crest is the wistaria.

Fuki-e Japanese term for a widely practiced process of dyeing which first became popular during the Tokugawa period. The term literally means "blown picture." An outline design is drawn on the cloth and a resist of rice paste is then selectively applied. Occasionally paper cutouts may be used instead of the paste. The dye is placed in a kind of metal funnel and sprayed onto the cloth by blowing through a tube. This process is still used in Japanese households.

Fukurokuju One of the Seven Gods of Good Luck in the popular religion of Japan, who is often represented in sculpture and painting. He can always be recognized by his short body and very tall and narrow head. He is said to combine wisdom with long life. His origin is derived from Chinese legend, where he is said to have been a Taoist sage and philosopher.

Fukusa Piece of cloth, either square of rectangular in shape, which was used in Japan as a wrapping for gifts. The fukusa were often richly decorated with plants, flowers, birds, and historical and legendary figures executed in embroidered or dyed designs.

Fukusuke Japanese dwarfs, believed to be the children of happiness. They are shown as young children with enormous heads, flat on top, which are completely out of proportion to the rest of their bodies. Fukusuke are given as toys to Japanese children. Artists have often represented them in netsuke, balancing on one foot or carrying a large box.

Fumibako or **Fubako** Japanese term literally meaning "letterbox." It refers to a long rectangular box, usually decorated with gold on a black lacquer ground, which was used for containing and delivering letters and documents. It was bound with a silken cord attached to the box by means of two metal rings.

Furisode Japanese term for a type of kimono, similar to the kosode or ordinary kimono, but which as considerably longer sleeves. It was during the Edo period that the Furisode came into fashion.

Furo Japanese term to describe a charcoal brazier, usually made of ceramics, and circular in shape. In traditional Japan it was used for the heating of houses and especially in connection with the tea ceremony, where it was employed for boiling the water. The finest of these may be works of art of considerable merit while the ordinary ones are purely utilitarian in character.

Furoshiki Japanese term to describe a square piece of cloth, which may vary in size, used to wrap around all kinds of objects which are being transported; they serve much the same function as a shopping bag would in Western civilization. All types of textiles from plain unadorned cotton or wool fabrics to highly decorated silks may be employed for that purpose, depending on the social status of the person using it and the purpose for which it is employed.

Furukawa Genchin 18th-century Japanese metalworker who specialized in sword guards in the katakiri style of engraving, which imitated brushstrokes in its design. He is regarded as one of the outstanding masters of the Edo School of sword furniture makers.

Fusenryo Japanese decorative motif consisting of a rosette, which may itself be composed of three or four smaller rosettes arranged in a circle. This motif, first employed during the Heian period, usually appears on embroidered cloth, but is also sometimes used on lacquered object. Originally the term was used as a generic designation for relief designs in figured silk.

Fushimi-ningyo Painted clay dolls made in the Fushimi district of Kyoto, which were extremely popular throughout Japan during the Edo period. There were altogether three hundred different types of dolls made here, with the gods of good fortune, famous historical personages, figures from myth and legend and others from contemporary life being represented. The best of them were small sculptures of considerable charm.

Fusuma Japanese term to describe the sliding partitions between rooms in a Japanese house. There are usually four separating an average-sized room, but they can be removed if a larger interior space is deemed desirable. They may also serve as doors for rooms and wall cupboards. They are usually 5 ft. 10 in. high, and about three feet wide. They are composed of a wooden frame with several layers of heavy paper glued to it on both sides. The surface is usually covered with a piece of decorative paper which is often painted. Some of the most famous pictorial compositions of Japanese art were executed in this format.

Futagawa Village in northern Kyushu where very fine folk pottery was produced during the Edo period. The wares made here were utilitarian in character, comprising bowls, jars, bottles, and plates made in stoneware and decorated with freely applied glazes, sometimes in the form of abstract pine tree designs.

Futon Japanese term to describe the mattress of wadded cotton which serves as a bed in a traditional Japanese houses. It is spread out over the tatami floor of the living room, and a pillow and quilted bed coverlet are placed on it. It generally measures an inch or so in thickness. When not in use it is kept in a wall cupboard.

ABCDEFGHIJ KLMNOPQR STUVWXYZ

Gaho Japanese painter of the Meiji period who lived from 1835 to 1908. His family name was Hashimoto and he belonged to the Kano School of painting, of which he was the last great practitioner. Discovered by the American scholar Ernest Fenollosa who had come to Japan during the Meiji period, and also much admired by Okakura Tenshin, he was, in 1887, made head of the Japanese painting department in the newly established Tokyo Fine Arts School, now the Tokyo University of the Arts. Later, he was also one of the founders of the Japanese artists' organization called Nihon Bijutsuin. In his work, he tried to combine the Oriental tradition of ink painting with certain elements derived from Western art, notably the use of perspective and shading—an endeavor in which he was not wholly successful—yet, at the time, he played a prominent role among the artists who were trying to keep alive the Japanese artistic tradition in a period when a craze for Western art swept the country. A good example of his painting may be seen in the Freer Gallery.

Gakko Bosatsu See Nikko Bosatsu.

Gaku Japanese term for a rectangular painting with pictorial or calligraphic subject matter, placed over the main entrance of a house, or high up on the wall over sliding doors.

Gakuo Zokyu Japanese painter of the Muromachi period who is believed to have flourished during the later half of the 15th century. He was a Zen priest and ink painter who was descended from Shubun, and was profoundly influenced by the Southern Sung painters such as Hsia Kuei. Several paintings bearing his signature have been preserved in Japan; these, while not very original or distinctive, do show him to have been an accomplished artist, especially in the use of varying tones of ink.

Gandhara Ancient name for the border province of northwestern India which now constitutes the most northern section of Pakistan and the southern section of Afghanistan. It played a great role in the history of Buddhism in giving birth to the first anthropomorphic representation of

the Buddha, in a style which is usually referred to a Greco-Buddhist since it combines late classical artistic conventions with Buddhist inspiration and iconography. The art of Gandhara spread through Central Asia and reached China, where it exerted a powerful influence on early Buddhist art of that country.

Gandharvas Minor deities who originally formed part of the pantheon of the ancient Vedic religion of India, but like so many other Brahmanic gods and sacred beings, found their way into Buddhism where they are thought of as heavenly musicians, not unlike the apsaras or angels. They are usually represented as part-human and part-bird creatures playing musical instruments.

Ganesha Hindu deity who is the child of the great Hindu gods Shiva and Parvati. He is shown in a form partially human and partially elephant, and is worshipped as the god of wisdom and learning, since the elephant is looked upon as the wisest of all animals. Like so many Hindu deities, he is sometimes represented in the Buddhist art of China and Japan, especially among the Esoteric sects.

Ganjin Japanese name for the Chinese priest Chien-chên. He was a T'ang period Chinese monk and teacher who, after many difficulties, including a shipwreck and losing his sight, reached Japan in 753. He was received with great honor and became a teacher of the Ritsu sect of Buddhism. The emperor himself had Toshodaiji Temple near Nara built for him; to this day his image, executed in papier-mâché and lacquer in a very realistic style, is preserved there. It is usually regarded as the greatest of all early Buddhist portrait sculptures made in Japan, and is believed to be a good likeness of this priest.

Ganku also known as Kishi Ku, a Japanese painter of the Edo period who lived from 1749 to 1838. He is believed to have been self-taught, and employed an eclectic manner derived from various sources, notably the realism of the school of the Chinese artist Shên Nan-p'in, who had worked in Nagasaki from 1771 to 1733, and above all the work of Maruyama Okyo, the great Japanese realistic painter of the 18th century. His most famous paintings were those representing tigers in a very detailed and lifelike manner.

Garaku Netsuke carver of the middle of the 18th century, who lived in Osaka. He is well known for his carvings of deer and turtles in ivory.

Garden architecture Landscape gardening is a very old art form in China and especially in Japan, and has played a prominent role in the culture of Eastern Asia. Arrangements of trees, bushes, moss, rocks and sand, sometimes combined with artificial hills and ponds, and provided with old stone lanterns and small pavilions, are often found represented in Chinese and Japanese paintings and prints. Beautiful examples of such gardens may be found in places like Su-chou and the Summer Palace outside of Peking in China, and all over Japan. The more outstanding of them were usually associated with palaces or Buddhist temples, but more

modest ones may be found even at the dwellnigs of ordinary people. The most famous of the Japanese gardens are looked upon today as among the most celebrated artistic treasures of Japan. Especially notable are the Zen-inspired gardens of the Muromachi period, such as the famous rock gardens at Ryoanji and Daitokuji in Kyoto. There are many different kinds of gardens—some hilly while others are flat, some dry while others feature lakes, some like large parks covering many acres while others are tiny plots of ground which are to be viewed, but not walked in. Famous garden architects are looked upon as great creative artists, and their work is much admired.

Garden pavilions A great variety of small pavilions, whose function it is to provide shelter for those who wish to contemplate the beauties of nature, are found in Chinese gardens. The buildings are often picturesque in form and may consist of a closed room, in which case they are referred to as ko or chai, or be open, in which case they are known as t'ing or hsieh. Similar pavilions are also found in Japan and have been imitated in Oriental-style gardens in Europe and America.

Garuda Mythological creature who is half human and half bird. He is a semi-divine being derived from Indian mthology, but later incorporated into Buddhism. The garuda is said to be the enemy of the snakes or nagas whom he attempts to devour. In Hindu mythology, a garuda is shown as the mount of Vishnu, and he is also particularly popular in the art of Cambodia. In China, where the garudas are known as Chin-ch'ih niao, and in Japan, the garudas sometimes occur as minor deities in Buddhist art.

Gautama or Ch'iao-ta-ma in Chinese and Kudon in Japanese. Family name of the Historical Buddha, Sakyamuni. See Sakyamuni.

Geiami Japanese painter of the Muromachi period who lived from 1431 to 1485. An outstanding member of the Suiboku school of Chinese ink painting, he was a son of Naomi with whom he studied, and the father of Saomi. In addition to being a painter of note, he also served as an art advisor and cataloguer of the painting collection of the Ashikaga shoguns. The most famous work of his which survives is a landscape called "Viewing a Waterfall," painted in 1480; it had been given to his pupil, Shokei, and is now in the Nezu Museum in Tokyo. Numerous other works are ascribed to him, including a charming painting of the Zen holy man Jittoku, now in the Boston Museum. However, it is not at all certain that these works were actually executed by his hand.

Geisha Japanese term to describe the high-class courtesans and entertainers who, to this day, play a prominent role in the amusement districts of Japanese cities. They were usually accomplished dancers, musicians and singers who had undergone years of training and were admired for their artistic accomplishments as well as their feminine charm. The most prominent of them were personages of real influence who were celebrated not only for their beauty, but for their social graces and, especially the

older ones, for their business acumen. The geisha houses were often important social centers, where social meetings took place and business arrangements were transacted. The geishas, and the establishments with which they were connected, were frequently represented in Japanese art, notably in the prints of the Ukiyo-e School. See also Ukiyo-e.

Gekkawo Poetic name for the god of marriage, Musubi no Kami, literally the "god who ties the knot." According to Taoist legends, he is the aged Yüeh Lao who dwells in the moon, and it is his principal duty to tie together the feet of lovers with a thread of red silk.

Geku Japanese term literally meaning "outer shrine." It refers to one of the main sanctuaries of the great Shinto shrine at Ise in Uji-Yamada. It is dedicated to Toyouke-Omikaull, the goddess of farms, crops, food and sericulture. It is said that it was erected in the year 478, but as is the custom at Ise, its buildings have been torn down and rebuilt every twenty years. It is also celebrated for its magnificent grounds which extend over some 214 acres. See Ise Shrine.

Genghis Khan also spelled Jenghis Khan, the most famous of Mongol rulers who conquered much of northern China as well as a vast empire extending all the way to Eastern Europe. Although a great general, he was a cruel and bloodthirsty ruler who destroyed Peking and butchered its inhabitants, and had a disastrous effect on the artistic culture of the part of China which he conquered.

Genji Monogatari or **Tale of Genji** A Heian period novel written in the early 11th century by Lady Murasaki. It is considered the greatest Japanese novel and one of the supreme masterpieces of Japanese literature. Scenes from the story were often represented in Japanese painting, especially that of the Yamato-e and Tosa Schools. The most famous of these is a series of scrolls executed during the 12th century containing the text and illustrations, which reflect, on the highest aesthetical level, the elegance and refinement of the Fujiwara period. It is believed that originally there was one illustration for each of the chapters of the novel, but only thirty-seven sheets of text and nineteen pictures survive; they are presently in the collections of the Tokugawa Museum in Nagoya and the Tokyo Museum.

Genkan A Japanese term to describe a vestibule through which one enters a Japanese house. It is here that the visitor removes his shoes and is traditionally welcomed by his hosts. It is sometimes, especially in hotels, decorated with screen paintings.

Genkei Japanese painter of the Edo period who was active during the late 18th century, and belonged to the Nagasaki School. His realistic style was influenced by Chinese painting of the Late Ming period and by European art. He was also well known as an interpreter of the Dutch language.

Gennai Japanese painter, writer and scientist of the Edo period who was born in 1723 and died in 1799. He was a native of Sanuka, and his true name was Hiraga Kokuin, while Gennai was his priest's name. He was a Yoga School painter, working in the Western style, inspired by Dutch

paintings and engravings which had entered Japan through the port of Nagasaki. He learned Dutch and studied Western science, notably botany, and is looked upon as one of the pioneers in the introduction of Western art and learning into Tokugawa Japan.

Genroku Name of a period in Japanese culture which is known for the gorgeousness of its art. It comprises the years 1688 to 1704, the end of the Early Edo period. The most representative artist of this era was Korin, whose screens, lacquers, and textile designs, with their bold compositions and bright colors, are thought of as being the very essence of the spirit of this age. It was also a period of outstanding literary production, during which the greatest of Haiku poets, Basho Matsuo, lived, as well as the famous playwright Chikamatsu Monzaemon, and the novelist Ihara Saikaku.

Gentlemen painters Both in China and in Japan, the idea of men of culture and learning who were also painters and calligraphers was a popular notion. In fact, in both countries emperors, famous statemen, high officials, and well-known scholars often distinguished themselves as artists as well. This preference for amateur painters, who were gentlemen and literati, over professional artists led the Chinese, and to a certain extent also the Japanese, to regard sculptors, architects, and all kinds of craftsmen as being not artists at all, but mere artisans and therefore of little artistic consequence. This idea probably goes back ultimately to Confucian teaching, which placed the scholar at the time of the social hierarchy. See also Amateur painter.

Geta Japanese footwear consisting of a wooden sole which was held to the foot by means of a leather thong passed between the first two toes. The geta was worn only outside the house.

Ghosts The belief that the ghosts of the dead return to haunt the living is widespread in both China and Japan. Numerous stories are told about how these ghosts would revenge themselves for the insults and wrongs they suffered, and appear in all kinds of forms such as beautiful maidens, grotesque monsters, animals and demons. The most famous of these in China is Chung K'uei, who, after being rejected for public office in spite of performing brilliantly on the examination, committed suicide and appeared as a ghost to the T'ang emperor Ming Huang. He is today venerated as a Demon Queller or Protector against Evil Spirits. In Japan, the most illustrious of these ghosts is that of the official Michizane, who was wrongly accused and sent into exile, but after death returned as an angry ghost and was worshipped, under the name of Tenjin, as a divinity of literary men. Both of these famous ghosts, and innumerable others of lesser stature, are frequently represented in the art of China and Japan.

Gifu City in central Japan and the seat of the governor of Gifu prefecture. It is today primarily known for its cormorant fishing, which is of very ancient origin and is often represented in Japanese painting. However, Gifu prefecture, especially the Mino district, is also famous for its ceramic pro-

duction which, since the Momoyama period, has included some of the finest tea ware made in Japan. The old name of what is now Gifu prefecture was the province of Mino.

Gigaku A type of drama and dance accompanied by music, which originated in China and was introduced to Japan during the Asuka period. It was performed at the temples and palaces of the time, with large wooden masks which are among the finest and oldest in the world. They were decorated with lacquer painting or metalwork and show vivid facial expressions, often comical or grotesque in nature. A large number of such masks are preserved at Horyuji, Todaiji, and the Shosoin.

Ginkakuji Buddhist temple in Kyoto which is better known among Westerners as the Silver Pavilion. It was originally built sometime between 1469 and 1486 as a country villa for the Ashikaga shogun Yoshimasa, and was converted after his death into a Buddhist temple known as Jishoji. Its architecture was modeled on that of the celebrated Golden Pavilion or Kinkakuji, but is is smaller in scale and was covered with silver leaf instead of gold. It is surrounded by a famous garden with beautiful trees, rocks and water, as well as a sand platform from which, it is said, the moon was viewed. The grounds of the temple also contain a small structure known as the Tolgudo, which has a tiny tea room where the first tea ceremony was said to have been performed.

Ginkgo The ginkgo is a great coniferous tree, known as icho in Japanese, which grows to a height of around eighty feet. Its leaves, which turn to a yellow-gold in autumn, are often used as a decorative motif in Japanese art, especially in association with the cicada who feeds of them. The triangular fruits of the ginkgo, when worn or carried, were believed to have some magical power that protected the bearer from attack by foxes. It was also said that these fruits would reveal the presence of poison in food or drink by making crackling sounds to warn the wearer.

Gion The Gion district or Gion Machi is a famous pleasure quarter of Kyoto, lying between the Shijo Bridge and Maruyama Park. It is here that the Gion Festival, featuring a parade of gorgeously decorated floats, is celebrated in July of each year, an event which dates back to 876, when it was inaugurated in order to protect the city from a pestilence which was raging at the time. It is in this district, too, that the Yasaka Shrine, more commonly called the Gion Shrine, is located. It is one of the important Shinto shrines of the city, and contains some famous sculptures attributed to the great Kamakura period sculpture Unkei. However, the present buildings date only from the 17th century.

Glazes Glazes were used very wisely by both Chinese and Japanese potters, both in order to make earthenware vessels less porous land therefore better able to hold liquids, and as decorations for stoneware and procelain. They consist either of silica in the form of sand or quartz, fused with the aid of a flux either alkaline or, more commonly, an oxide of lead, or a fusible earth or rock such as feldspar; the latter was a characteristic

Chinese discovery. The earliest and most natural type of glazing, already employed by the Chinese potters during the Shang period, was produced by wood ashes from the fire, but true glazes were developed only during the Chou period, and became a major element in ceramic decoration only with the Han period. Particularly beautiful were the lead glazes of greenish color which were widely used at that time. In Japan, glazes were introduced from Korea and China during the Asuka period, and have played an important role ever since that time.

Go Japanese term for the pseudonym or artist's name of Japanese painters and other artists, corresponding to the Chinese hao. These names were derived from the place where an artist worked, his personal characteristics, a special interest, appearance or religious affiliation, with some artists having as many as ten or more such go in the course of their career. See also Hao.

Go Japanese term for a game similar to Western checkers, which was imported from China during the Nara period and has enjoyed widespread popularity ever since. The board and playing pieces used in it are often works of decorative art of considerable merit, ornamented in lacquer, ivory and horn-colored wood and even gold and silver leaf. The most beautiful examples are found in the Shosoin in Nara, and are believed to have been brought from China during the 8th century.

Gobi Culture A prehistoric civilization found in the Gobi Desert north of the Great Wall. Excavations have been carried out in modern times and have brought to light stone tools and coarse pottery incised with geometric designs.

God of the Kitchen The god of the kitchen or hearth, called Tasao Chün in Chinese, was originally a Taoist invention, but he came to be worshipped by all traditional Chinese families. It was his chief duty to apportion to each member of the household in his charge the allotted number of days, and to bestow wealth or poverty at will. He also kept a record of all the actions of the household and made annual reports to the Jade Emperor or Supreme Being on the virtues and vices of the family. Special ceremonies with sacrifices of food were performed to see him off to heaven and then to welcome him upon his return. His picture, usually a simple colored drawing in which he is portrayed as an old man with a white beard in Mandarin costume, was placed in a niche over the kitchen stove, which served as his temple.

God of Literature See Wên Chang and K'uei Hsing.

God of Longevity See Shou Hsing and Jurojin.

God of War See Kuan-ti and Hachiman.

God of Wealth See Ts'ai Shên.

Godaigo Japanese emperor of the Kamakura period who lived from 1288 to 1339. His attempt to overthrow the feudal government of the Hojo family led to his exile on the island of Oki in the Japan Sea, but he was able to escape and, with the help of the nobles, to overthrow the Hojo clan and

restore imperial power. But his victory was short-lived, for he in turn was replaced, and Ashikaga Takauji assumed power. The emperor was forced to flee to the Yoshino Mountains in Nara prefecture, where he established his own court in competition with the court in Kyoto. Scenes from his dramatic life are sometimes depicted in Japanese art.

Gohei Japanese term literally meaning "august gifts," referring to the offerings presented to the Shinto deities by their worshippers. They take the form of twigs or wands bearing strips of paper which represent lengths of cloth, and are looked upon as symbolic offerings to the deity.

Gojo Bridge Famous bridge in Kyoto which is especially celebrated for its association with Benkei, who is said to have accosted travelers here, his purpose being to deprive them of their swords. It was at this bridge that the famous battle between Benkei and Yoshitsune was fought around 1175, an event which is frequently represented in Japanese art. See also Benkei.

Gold Leaf or kirigane in Japanese. Gold leaf consisting of very thin pieces of gold foil was widely used in Japanese art, especially for the gorgeous screen paintings of the Momoyama and Early Edo periods, and the decoration of lacquer boxes and kimonos. This technique was probably originally imported from China, but was used much more extensively and to greater advantage in Japan, where it is first found during the Heian period. However, in these early examples only small squares of gold are used, while the painters of the 17th century, notably Eitoku, Tohaku and Sotatsu covered the whole ground with gold leaf. Particularly outstanding was Korin, who used gold leaf extensively in screens, lacquers and textiles. See also Kirigane.

Golden Hall See Chusonji.

Golden Pavilion See Kinkakuji.

Gomoku-zogan A technique of decorating iron sword guards, in which the guard is covered with short pieces of fine wire, usually brass or copper, more rarely silver, which are brazed or soldered in place and then polished and pressed down so that they create a flat linear design resembling twigs or pine needles floating on water.

Gong A bronze plate with an upturned rim that produces a subdued but resonant sound when struck. In both China and Japan, it is often found in Buddhist temples, where it is usually hung on a rack in front of a Buddha image and struck by the priest with a mallet while reciting the sutras. It is often decorated with designs, executed in low relief, connected with Buddhism, notably lotus flowers and leaves.

Gongen Japanese term used by the Ryobu Shinto sect to designate Shinto divinities who, according to their religious doctrines, are considered to be mere manifestations of the great Buddhist deities.

Gongen-zukuri A Shinto structure of tripartite construction, with the honden or main sanctuary in the rear, the haiden or hall of worship in the front and a connecting corridor running between them.

Goose Geese play an important role in Chinese and Japanese life and legend, and are often represented in art. It is said that the goose is an emblem of the yang forces representing light and the masculine principle. Since geese were believed to never mate a second time, libations to the geese were poured out when the bridegroom fetched his bride from her father's house. The goose was also thought of as a harbinger of good news, and served as an emblem of the Chinese postal flag in memory of the goose which during the Han Dynasty, carried a message to the emperor from an official who had been captured by the Turkish tribes. A wild goose was also embroidered on the robes of civil officials of the third grade. Geese are frequently the subject of Chinese and Japanese art, notably in the form of painting and pottery and porcelain figures.

Goroeman Japanese sculptor of the Kamakura period whose family name was Ono. He is primarily remembered for being the artist responsible for casting the huge Buddha image in Kamakura. See Daibutsu.

Gosho Name applied to the Japanese Imperial Palace in Kyoto, which was originally erected by the emperor Kammu in 794. It has been repeatedly destroyed by fire, but has been rebuilt many times in the same style, most recently in 1855. It contains many buildings built of wood and covered with bark, erected in a very severe, dignified style and decorated with paintings and calligraphy.

Gosho-ningyo Japanese name for the wooden dolls which were produced in Kyoto during the Edo period. They represented babies or small children, usually boys, dressed only in a haragake, a piece of cloth covering the front of the body. These rather plump, round, white figures were shown in various poses such as crawling, sitting, standing and sometimes holding a musical instrument or some other object. They were not only popular as dolls, but were considered to be talismans which warded off evil spirits and prevented accidents from befalling the owner. The word gosho literally means "palace" and it is said that these dolls were used as gifts for members of the aristocracy. The finest of these dolls were carved from wood of the kiri or paulownia tree.

Goshun Artist's name of a famous Japanese painter who lived from 1752 to 1811. His family name was Matsumura and he was born in Owari, but lived largely in Settsu and Kyoto. He was the founder of the Shijo School of painting, and had studied under Buson and been associated with Okyo. His own work, and that of his school, tried to combine the best elements of Buson's literati-style painting and Okyo's realistic art. He produced landscapes, figures, and flower paintings. He played an important role in the art of the Late Edo period, and had numerous followers.

Goto The name of one of the leading schools of Japanese sword furniture makers established in Kyoto. The first master was Goto Yujo (1435–1512), who worked for the Ashikaga shogun Yoshimasa. The Goto style, which he established, became the official one, and continued to be used for court ceremonies until 1868. It consisted of a ground of an alloy

of copper with a small proportion of gold, referred to as shakudo, with raised decorations in gold or gilded metal. Later Goto artists differed from this classical style and founded schools of their own. A branch of the family settled in Mino province, the present Gifu prefecture, and produced work with larger and bolder designs. The line continued for sixteen generations, working through to the end of the 19th century. Authentic works of the first Goto are very rare. The influence of his work was tremendous, not only on artists of the Goto School, but also on later Japanese sword guard makers. While the school continued to be active through the 19th century, the work of the later period declined greatly.

Gourd The gourd in dry form was, in earliest times, used as a bottle, and is already found among the painted designs on the earliest Chinese pottery of Neolithic times. It continues to be used to contain liquid, and was also employed as a receptacle for medicine, and is, therefore, seen as a signboard in drugstores. In Taoism, it is looked upon as a symbol of long life, and is the emblem of Li T'ieh-kuai, one of the Eight Taoist Immortals. It is often represented as a decorative motif in the arts of both China and Japan, and is believed to have the function of a charm which will ward off pernicious influences. It is also sometimes represented with spirals of smoke ascending from it, indicating that the spirit is being set free from the body.

Goyo Japanese printmaker of the Taisho period whose family name was Hashigushi, and who lived from 1880 to 1921. He was trained at the Tokyo Academy of Fine Arts, where he specialized in Western-style painting, but he was also skilled in Japanese-style painting and wood engraving. His output was very small, consisting of fourteen color prints made between 1915 and 1921, mainly representing beautiful Japanese women. He is considered the finest printmaker of the early 20th century, and combined Western realism with the Japanese sense of line and pattern.

Goyunoto Japanese term which literally means "five-storied tower." It is used in reference to Buddhist pagodas. See Pagoda.

Grave Since the Chinese and Japanese venerated their ancestors, and felt that the proper burial of the dead was important so that the spirits of the deceased might not haunt the living, but instead prove protective and auspicious, graves played a great role in the culture of both civilizations. In fact, they are the source of the most valuable archaeological finds for both the prehistoric and the early historic periods in both countries, and continue to be a valuable source of information in China right into modern times. The imperial tombs, especially, often contained thousands of objects of all types, which have given us insights into the culture and customs of the period, and supply us with some of the outstanding works of art surviving today. The most spectacular Chinese grave site, with a tumulus larger than the Egyptian pyramids, is the tomb of the Ch'in emperor Shih Huang-ti, where no less than 6,000 life-sized clay figures

were excavated in 1975. The largest tomb of prehistoric Japan is that of the emperor Nintoku in the Yamato region of Japan.

Grave Pillar The approaches to the graves in ancient China were often lined by stone pillars, which were elaborately carved with relief designs representing symbolic animals and scenes taken from Chinese folklore. This was particularly true during the Han period, with some of the finest surviving Han artistic monuments originally serving this purpose. The most famous grave pillars from the Han period are those of the Shên family at Ch'ü-hsien in Szechuan province, which have magnificent relief carvings of the animals of the four directions. During later periods, under the impact of Buddhism, the grave pillars often showed lions or scenes from Buddhist legend.

Great Buddha See Daibutsu.

Great Wall A Chinese fortification and wall some 10,000 li long, extending over a distance of some 2,500 miles. Its origin goes back to the Late Chou period, but it was primarily the creation of the first Ch'in emperor, Shih Huang-ti, who ruled from 221 to 210 B.C. It was constructed with a huge expenditure of manpower and money in order to serve as a bulwark against the invasion of the barbarian nomads. It has been frequently rebuilt and enlarged, notably under the Ming Dynasty, when parts of it were reconstructed in brick and stone. Its height and width differ at different sections, but a paved road measuring an average of 16 feet wide is found along its top, and 13-foot-high towers were placed on it at irregular intervals. Gates were built at the points where it intersected major trade routes.

Greenhouses A term applied to the tea houses of the Yoshiwara district of Edo, in which the courtesans, who were referred to as beautiful flowers, entertained their customers. The life of these greenhouses formed the subject matter of many of the most outstanding of Japanese woodblock prints, notably those of Utamaro and his followers. The term is derived from Chinese use where the brothels were often painted green.

Guardian Guardian figures are popular in both Chinese and Japanese Buddhism, where they are thought of as the protectors of the temple or sacred precinct. They were originally Indian deities such as yakshas, or Hindu gods, but were incorporated into the Buddhist pantheon as protecting figures. The most common are the two guarding the gates of temples, which are known as Nio in Japanese art, where they are frequently represented, but others, like the Four Heavenly Kings or Shitenno, who were the Guardians of the Four Directions, and the Twelve Heavenly Generals or Junishinsho, who are usually represented in a circle around the Buddha Jakushi, are also popular. Another prominent guardian deity is Vajfapafi, the thunderbolt-bearing deity, who is a Buddhist version of the ancient Indian god Indra. In both Chinese and Japanese art, these guardian deities are represented as fierce warriors with bulging eyes, wild expressions and long curly hair to indicate their Western origin.

Guri Laquer The term guri literally means "in circles." It refers to a technique of lacquer decoration in which a series of usually black and red layers of lacquer are cut into with a V-shaped instrument so that the various levels become visible. This technique probably originated in China, and was introduced to Japan during the Ashikaga period, where it has remained in a very popular lacquer technique to the present day.

Gyo style Japanese term originally applied to calligraphy and Chinese-style ink painting in the Muromachi period. It refers to a style which is intermediary between the more stiff and conventional shin style and the more cursive so, or grass, style. It may also be employed in describing styles of gardens, flower arrangement and other art forms.

Gyokudo Japanese painter and calligrapher of the Edo period, who lived from 1745 to 1820. His family name was Uragami and he came from the military class, serving under Ideka Masaka, the lord of Bizen. However, at the death of his lord in 1798 he undertook a long journey through Japan, and eventually settled in Kyoto, where he took up the career of a painter. In addition to that, he was a Confucian scholar, a poet, a calligrapher, and a koto player. In fact he called himself Gyokudo-kinshi, or Gyokudo the koto-player. He was a member of the Nanga School, and a friend of Chikuden. His work follows the style of the Chinese painters of the Eccentric School, employing ink very effectively and often adding light touches of color. His subjects are usually landscapes based on Chinese models, which he interprets in a very expressive and highly individual style. Excellent examples of his work may be seen in the National Museum in Tokyo.

Gyokuso Modern netsuke carver born in 1879, who lived im Tokyo. He received numerous prizes and is regarded as one of the outstanding netsuke carvers of the contemporary period.

ABCDEFGHIJ KLMNOPQR STUVWXYZ

Habaki Japanese term for the blade socket found on all Japanese swords, daggers and spears. It is a stout metal collar usually made of copper, silver or gilt, whose purpose is to hold the blade firmly in place and to prevent rust.

Hachi-bu-shu Japanese term for the eight classes of supernatural beings that guard the Buddhas. They are: Ten (in Sanskrit, Deva), Ryu (Naga), Yasha (Yaksha), Kandaba (Gandharva), Ashura (Asura), Karura (Garuda), Kinnara (Kinnara), and Magoraka (Mahoraga). They often appear in Japanese sculpture in various groupings.

Hachiman Shinto god of war who is considered a divine manifestation of the emperor Ojin. Many famous shrines throughout Japan are dedicated to him, among which the Hachiman Shrine in Kamakura is the best known. His earliest shrine, founded in 725, is located in Kyushu near Beppu, and is therefore known as the Usa Hachiman-gu. The god is often represented in sculpture and painting, usually as a fierce warrior dressed in armor and holding a sword. But there is also a famous wooden statue of him in Yakushiji in Nara, which shows him as a Buddhist monk known as Sogyohachiman. It is an expression of the belief of Dual Shinto, that all the Shinto gods have their Buddhist counterparts.

Hagi A kiln site in Yamaguchi prefecture where, since the Momoyama period, a tea ware in the style of the Korean Yi Dynasty was manufactured. The early productions are covered with a transparent yellow-green ash glaze and milk-white glaze, but more characteristic is the loquat-colored glaze resembling that of the Korean Ido bowls, which became common during the later periods. Hagi ware was particularly valued by the tea masters, who regarded it secondly to Raku in suitability for the tea ceremony.

Haiden Japanese term used to designate the hall of public worship constructed in front of the main sanctuary, or honden, in a Shinto shrine.

The two structures may be either completely separate from one another or else may be connected along the roof.

Hakama Japanese term referring to the wide, full, almost skirtlike silk trousers which are worn by men over the kimono. The hakama as it is worn today is fastened about the waist with two long bands, and is usually made of high-quality dark silk with vertical stripes. The sides are open halfway to the bottom, and six deep, tapering pleats are sewn into the garment. The ancient origins of this article of clothing are indicated by their appearance in an early version on the clay Haniwa figurines. During the Nara period the hakama formed part of the official court dress, and it remained part of the standard costume of the nobles and samurai down through the Edo period. Members of other classes used the hakama only for marriages, funerals and the performance of ancestral rites. Today it is upon such ceremonial occasions that Japanese men wear this garment.

Hakata Japanese city located in northern Kyushu and today forming part of Fukuoka, the most prosperous city in Kyushu and the seat of the government of Fukuoka prefecture. It was one of the most important ports and trading centers of Japan, and played a prominent role during the time of the Mongol invasion, when it was the scene of fierce combat, and when its high walls and the courage of its defenders were able to beat off the invaders. It has a famous Hachiman shrine established in the 16th century, but little of the old Hakata has been preserved.

Hakkei Japanese term employed for the Eight Views of the Hsiao and Hsiang Rivers, a landscape motif popular in Sung painting, and introduced into Japan during the Muromachi period. While it was originally applied to the beautiful scenery of southern China, it was later also used for the Eight Beautiful Views of Lake Biwa, a large, picturesque lake located near Otsu, in Shiga prefecture. Other sets of eight views which were presented in woodblock prints, notably of Edo, were done by artists such as Hokusai, Harunobu and Hiroshige. See also Eight Views of the Hsaio and Hsiang Rivers.

Hakuho Name of a period in Japanese history strictly referring to the period A.D. 673 to 685, but in art history often used to describe the second half of the 7th century, more commonly referred to today as the Early Nara period. It was an age of political reform and artistic florescence, when Japanese art was under the influence of the T'ang art of the continent and made great advances.

Hakuin Japanese Zen priest and painter of the Edo period who lived from 1685 to 1768. His priest's name was Ekaku, but he is today best known under his artist's name, Hakuin. He was not only an outstanding painter of the Zen School, but also a well-known author and religious teacher. His work was executed in a rough, inspired Zen style, based on the works of the Chinese painters of the Ch'an School. The type of painting which he produced was referred to in Japan as Zenga, or Zen painting. He was particularly fond of representing subjects such as Daruma,

Hotei and others related to the Zen doctrine. Many works ascribed to him exist today; however, few of them are probably originals by the master.

Hakuryu Japanese netsuke carver of the 19th century whose family name was Miyasaka. He lived in Kyoto, and was well known for his ivory carvings of animals.

Hall of Annual Prayer or Ch'i-nien-tien in Chinese. Main structure of the Temple of Heaven, located south of Peking. It was here that the emperor prayed for a good harvest. See Temple of Heaven.

Halo A flat disc behind the head of a sacred being, which symbolizes holiness. It is a common feature found in the Buddhist art of both China and Japan, used in much the same way it is employed in Christian art to indicate sanctity. In both cases it is probably derived from much older Persian sources, where it represented the forces of the sun and light in contrast to those of night and darkness. In fact, both Buddha and Christ are often referred to as the light which illuminates the darkness, and the Buddha in some places is referred to as the Great Illuminator. While the halo is always a plain circle, similar meanings are intended in the larger nimbus or mandorla which is often surrounded with flames which make the solar symbolism even clearer. See also Nimbus.

Hamada Shoji Japanese potter of the contemporary period who was born in Kawasaki, a suburb of Tokyo, in 1894. He was trained at the Tokyo Institute of Technology, but did not take up ceramics until he saw the folk potters of Mashiko making traditional teapots. After four years in England, where he, together with Bernard Leach, set up a rural pottery at St. Ives in Cornwall, he returned to Japan and settled in Mashiko, where he has lived ever since. A great enthusiast of Japanese and Korean folk art, Hamada became one of the leading spirits of the folk art or Mingei movement, and was the greatest Japanese potter working in the Mingei style. In 1955, he was designated a living cultural treasure of the Japanese nation, and he was, in all likelihood, the most famous single artist working in pottery, not only in Japan, but in the world. He died in 1978.

Hamano School of Japanese metalworkers founded by Hamano Masayuki, also known as Shozui, who lived from 1695 to 1769. This school was a branch of the Nara School of metalworkers, and its work was marked by refinement and elaboration.

Hamidashi Japanese term for a dagger similar to the tanto, but with a far smaller, narrower guard. See Tanto.

Han Chinese term to describe a flat jade plaque found in Shang and Chou tombs, usually taking the shape of a cicada and placed in the mouth of the dead. It is believed that this object was used to seal the opening so that the body would be protected against evil influences. The cicada itself is believed to have been connected with rebirth. See Cicada.

Han Dynasty Chinese dynasty which lasted from 202 B.C. to A.D. 220. It is usually subdivided into Western or Early Han, dating from 202 B.C. to

A.D. 9, and Eastern or Later Han, lasting from A.D. 25 to 221. It is a period during which China was a great empire, extending all the way from Korea in the east to Central Asia in the west, Indochina in the south and Manchuria in the north. It was an age during which all the arts flourished, and while only a small fraction of the vast artistic output of the Han period has survived, even these remains suggest that the architecture, sculpture, painting and decorative arts enjoyed an unprecedented florescence. Among the sculptures, the first large-scale stone carvings and the numerous grave figurines are the most outstanding. While the surviving paintings are few in number, they show a sophistication and elegance which is remarkable indeed and indicates that it was during this age that the fully developed Chinese pictorial style was first evolved. In the decorative arts, it was above all the beautiful Han textiles, notably the silks, which enjoyed great popularity, even in the Roman Empire, and ceramic productiuon which made very great progress. Remains of Han art have been found not only all over China, but in Korea, Turkestan and North Vietnam.

Han-gonko Japanese term used to describe the spectral image of a woman which appears in the smoke produced by burning incense. It forms the subject of one of the episodes of a Japanese play entitled Sendai Hagi. According to the legend, the lord of Sendai, Date Masamune, fell in love with the beautiful courtesan Miuraya Takao, who in turn had pledged her love to the ronin Shimada Jusaburo. When Masamune purchased her to become his mistress she committed suicide, but her image continued to appear to Jusaburo in the smoke produced by the incense which she had given him before their separation. This theme is sometimes represented in Japanese woodblock prints.

Han Huang Chinese painter of the T'ang Dynasty who lived from 723 to 787. He had a successful official career, notably serving as governor of Chekiang province, and prime minister under the emperor Tê-tsung, and was created Duke of Chin. However, he devoted a great deal of time to painting and calligraphy, and established a reputation in both fields. He was particularly fond of illustrating the life of the countryside, and excelled in depicting genre scenes, farmhouses, water buffaloes, oxen and other domestic animals. It is not believed that any of the works attributed to him are actually by his hand.

Han Kan Chinese painter of the T'ang period who is believed to have lived between c. 720 and 780. He is considered the most outstanding horse painter in the entire history of Chinese painting. Although his reputation was immense, and his output great, very few, if any, of his paintings survive today. Most of the pictures attributed to him are, no doubt, the work of his numerous imitators. However, there is at least one outstanding scroll, now in the Sir Percival David Collection in London, which is believed to be an original by the master.

Han-lin Academy A Chinese institution founded by the T'ang emperor Ming Huang in 754, comprising scholars and artists. The academy has a long history and its organization and membership changed from reign to reign. However, its main function was that of maintaining standards of scholarship, education and artistic culture, and it played an important role in the cultural life of China. Its large collection of literary works was burned during the Boxer Rebellion of 1900.

Han-shan and Shih-tê or Kanzan and Jittoku in Japanese. Han-shan lived near a Ch'an monastery as a recluse and poet in 7th-century China. He was a friend of Shih-tê, a foundling who worked in the kitchen of the monastery, with whom he often discussed matters of literature and religion. They were looked upon as the very essence of Ch'an wisdom masked as foolishness, and they are often represented in both Chinese and Japanese ink painting, one with a blank sheet and a brush, the other with a kitchen broom. Both are laughing uproariously because they know that all ordinary learning and Buddhist ritual serve no purpose, for it is only discovering the Buddha within oneself which gives true insight and inner peace.

Hanaike Japanese word meaning flower vase. The vases, which are intended to be hung on the wall of the tokonoma during the celebration of the tea ceremony, are flat on one side, and are usually made of a fine basket-work.

Hand gestures The various positions of the hands of sacred images in Asian art, referred to as mudras in Sanskirt, are meaningful in terms of the function and qualities of the deities represented, especially in the Buddhist art of China and Japan. They are often the chief means of determining which particular deity is represented, or what aspect or manifestation of the Buddha or Bodhisattva is rendered. Characteristic gestures are those connected with preaching, teaching, meditation, fearlessness and charity. See Mudra and entries under individual hand gestures.

Hang-chou also spelled Hang-chew. City in Chekiang province located beautifully among hills on the banks of the West Lake and the estuary of the Ch'ien-t'ang River. It served as the capital of China during the Southern Sung period between 1127 and 1279. Marco Polo, the Venetian traveler, visited it in 1280 and described it as one of the most beautiful cities he had ever seen. Unfortunately, however, almost nothing of the old city survives today.

Hanga Japanese term applied to a group of modern creative print artists, who were deeply influenced by European ideals and practices, in contrast to the traditional Japanese Ukiyo-e prints. The term was first employed in the art magazine *Hosun* in 1907, but it did not come into general use until 1918, with the establishment of the Japan Creative Print Association, or Nippon Sosaku Hanga Kyokai. Its organizer was the wood engraver

Yamamoto Kanae, who had studied modern printmaking in Europe and had been particularly influenced by Gauguin. However, the most important of the early Hanga artists was Onchi Koshiro, who established this association as one of the most influential artistic groups of modern Japan.

Hanging blade Decorative motif used on Chinese bronzes of the Shang and Chou periods, consisting of long, narrow triangular or leaf-shaped figures, the tips of which are pointing downwards. The figure is usually decorated with a stylized cicada or a t'ao-t'ieh mask, and sometimes a background design of spirals as well. The motif was revived during the 18th and 19th centuries for use on bronzes and cloisonné.

Haniwa Prehistoric Japanese clay cylinders, often decorated with human or animal forms, which were placed around the tombs of Japanese rulers during the Grave Mound period. The tradition has it that the use of clay figures was introduced by Nomi no Sukune during the late 3rd century as a substitute for human sacrifice. The custom of making such figures continued until the introduction of Buddhism in the 6th century. Although crude in technique and primitive in style, these hollow clay figures are often works of charm and beauty, and have enjoyed great popularity with collectors during recent years. They are also one of the best sources for our knowledge of early Japan.

Hannya Female demon, represented with horns and a widely opened mouth showing long fangs, which occurs often in the noh drama. A special mask representing this figure, known as the Hannya mask, is one of the standard carved wooden masks employed in this dramatic art form.

Hanzan Japanese craftsmen of the Edo period who lived from 1743 to 1790. He was a follower of the famous lacquer maker Ritsuo, and had also studied with the potter Yosei. His work was marked by an emphasis on incrustation. He also make netsuke which were lacquered and inlaid.

Hao A Chinese term which refers to the brush name or pseudonym of an artist. It is usually connected with some special place, such as the study of the artist, some interest or function of his, for example—the "ch'in-player," or to describe his personality—the "man mad for painting." The Japanese equivalent is known as the go of the artist. See Go.

Hao Shih-chiu A Chinese potter of the Ming period who was active during the reign of the emperor Wan-li in the late 16th and early 17th centuries. He is one of the few Chinese potters known to us by name, which is probably due to the fact that he was not a mere artisan, but an educated man who also wrote verse. He used the mark the "Taoist hidden in a pot," and the "old man hidden in the teapots," which appears as a mark on some of his wares. He was known for his dawn-red wine cups of great thinness and delicacy, and his pale celadon teapots. Some of his works survive to the present day.

Haori Japanese term for a large cloak worn by men over the kimmono. It is a collarless garment which comes down just below the knee and is

fastened in front by means of braided silk cords. The haori for ordinary use may be of either black or patterned material. When a plain black ground is used, three to five family crests of nion are either embroidered or printed onto the dark material in a prescribed manner: one is placed high on the back, one on the back of the upper part of each sleeve, and, when five crests are used, one on the front of each sleeve. The haori first came into use during the Edo period and continues to form part of the traditional men's costume as it is used today.

Hare The hare in Chinese and Japanese art is associated with longevity and is one of the twelve animals of the duocenary cycle of the lunar calendar. It is believed that the moon is inhabited by a white hare, also sometimes referred to as a rabbit, which is shown pounding the drugs which compose the elixir of immortality. This image first occurs in Han art, and is frequently represented in the popular art of China and Japan in subsequent centuries. Hares and rabbits are also often represented in the painting of both China and Japan, and are looked upon as auspicious creatures who bring good fortune.

Hariti Originally an Indian demonic figure who devoured children and was an enemy of mankind, but who was converted by the Buddha and became the protectress of children and the goddess associated with childbirth. Her attribute is the pomegranate, which, with its numerous seeds, was looked upon in Chinese mythology as a symbol of numerous offspring. In China she is known as Kuei-tsi-mu and in Japan as Kishimo-jin or, among the Shingon Buddhists, Kariteimo. She is particularly popular with the Nichiren sect of Japanese Buddhism, and many temples are dedicated to her. She is usually shown holding a baby or surrounded by children, and Japanese mothers pray to her when their children are sick or epidemics threaten them.

Haritsu Personal name of the famous Edo period lacquer artist Ritsuo. See Ritsuo.

Harunobu Japanese painter and printmaker of the Edo period who lived from 1725 to 1770. One of the great masters of Ukiyo-e, he is regarded by many critics as the greatest of all Japanese printmakers. His most important contribution was the perfection of the multicolored print, referred to as nishiki-e or brocade prints. His family name was Suzuki and he was a pupil of Shigenaga, and was also greatly influenced by Toyonobu. Although his artistic career was brief, lasting less than one decade, since he died at an early age, his output was large and excellent. His work was outstanding for the variety and subtlety of its color, the delicacy of its line and the beauty of its design. His favorite subject was the portrayal of young girls, usually of middle-class families, rather than the courtesans of the Yoshiwara district who were favored as subjects by the other Ukiyo-e artists; they were shown against an interior or landscape setting. The delicacy of his doll-like, graceful and slender girls, the romantic mood of his young lovers, and the lyrical feeling of his figures made him immense-

ly popular, and he was widely imitated by later printmakers and much admired by Western collectors and connoisseurs as well.

Harushige See Kokan.

Hasegawa Family name of the famous Momoyama painter Tohaku, who was active during the second half of the 16th century and was one of the most important Japanese screen painters. His school was called the Hasegawa School and played an important role in the painting of the Edo period. Among the most prominent of his followers were his two sons Torin and Kyuzo. See also Tohaku.

Hashira-e Type of long, narrow woodcut print. It measures 66.7 cm. x 12.1 cm. or about 26.0 in. x 4.8 in. The term hashira-e means "pillar prints," and they were so called because they could easily be employed to decorate the pillars in a Japanese house. It is believed that this format was invented by Masanobu around 1746, and it is a form which has been used by most of the great printmakers of later times.

Hasui Modern Japanese printmaker who lived from 1883 to 1947. His family name was Kawase and he studied Japanese-style painting under Kiyokata. However, he soon turned to Western art, notably English 19th-century watercolors. His work consists mainly of woodblock prints, depicting the picturesque scenery of Japan in a realistic Western style, which have enjoyed great popularity among Western collectors.

Hawthorn Jar A Western term erroneously applied to the type of decoration on Chinese porcelains of the Ch'ing period, in which a flowering prunus, silhouetted in white against a blue background, is used as a symbol of winter. This type of design was favored for covered jars used to present sweetmeats, such as ginger, as a New Year's gift.

Hayashi Takeshi Japanese painter of the Showa period who lived from 1896 to 1975. One of the leading Western-style painters of contemporary Japan, he was profoundly influenced by modern French painting, and has often been referred to as a Japanese Fauvist. He was also an important influence on younger painters, and served for many years as a professor at the Tokyo University of Art.

Hazan Modern Japanese potter whose family name was Itaya. He was born in 1872 and died in 1963. One of the leading Japanese ceramic artists of the conservative school, he was outstanding for the elegance of his green celadon and the purity of his white porcelains, often decorated in enamel colors. Although a man of the Late Meiji period, he continued working actively during the Showa reign, and did some of his very finest work in the post war period.

Heaven or T'ien in Chinese, was worshipped in China since earliest times. Already in Shang inscriptions Heaven and Earth are mentioned as supreme deities who are looked upon as the great father and mother of the universe, with Heaven being thought of as the very essence of the Yang, light male forces, and the Earth symbolizing the Yin, dark female forces. The Chinese emperor was referred to as the Son of Heaven, and one of his duties was to worship the deity Heaven. Shang-ti, the supreme

god of the Shang pantheon, was believed to reside in Heaven, and a jade disc with a circular hole in its center, called pi, was used as a symbol of Heaven. The deity Heaven's birthday was celebrated on the ninth day of the first moon, at which time incense was burned towards Heaven in the open courts of the houses. In modern Chinese folklore, Yü Huang is thought to live in Heaven, and is in fact often referred to as Mr. Heaven or the Supreme August Jade Emperor, and is thought of as the supreme deity. He is portrayed as such in the folk prints and popular books of Ch'ing China. The most important sanctuary dedicated to Heaven is the Temple of Heaven in Peking, with its Hall of Annual Prayer and Altar of Heaven. See Temple of Heaven.

Heiankyo Old name for Kyoto meaning literally the "Capital of Peace." It was founded by the emperor Kammu in the year 794. Modeled on the T'ang period Chinese capital of Ch'ang-an, it was laid out in a grid pattern, with the streets meeting at right angles and the Imperial Palace at its center. The period of Japanese history during which Heiankyo was the great artistic and cultural center, lasting for 400 years from 794 to 1184, is therefore called the Heian period. It is considered one of the greatest and most characteristically Japanese periods in the history of Japanese art. See also Kyoto.

Heidatsu A technique of lacquer decoration which originated in China, where it was known as p'ing-t'o, and was already flourishing during the T'ang period. In Japan, it occurs as early as the Nara period, with examples preserved in the Shosoin, and has enjoyed great popularity ever since that time. It consists of gold or silver foil used in the ornamentation of the lacquer wares.

Heiji Monogatari Famous Japanese epic tale describing the long struggle between the Taira and Minamoto families at the end of the Heian period. It often forms the subject matter of Japanese painting, notably the so-called Heiji Monogatari Scroll, painted during the Kamakura period. It consists of three rolls, one of which is in the collection of the Boston Museum, while the other two are in the Tokyo National Museum and Seikado Foundation in Tokyo. The most famous episode depicted is the dramatic representation of the burning of the Sanjo Palace in the Boston painting. Its style is detailed and realistic, with a wonderful sense of the excitement and drama of the events portrayed. It is usually looked upon as one of the supreme masterpieces of 13th-century narrative scroll painting of the Yamato-e tradition.

Heike-gani Term applied to the small shore crabs found on the beach along the strait of Dan-no-ura. It literally means the "Taira clan crabs," since it is said that the creases of their shells resemble the angry faces of the Heike warriors who were drowned or killed and turned into crabs. This motif is sometimes represented in Japanese art. See also Dan-no-ura.

Heike Monogatari One of the famous tales of the Early Kamakura period in which the tragic final defeat of the Heike or Taira family by their great rivals, the Minamoro or Genji clan, is described in poetical

prose. Scenes from this popular story are often represented in Japanese art.

Hell Fire Scroll A type of Buddhist narrative scroll, popular during the Kamakura period, which portrays the various kinds of torments awaiting the damned in the eight hells and sixteen subsidiary hells of Buddhist theology. It is one of the most dramatic of Yamato-e paintings, and vividly portrays the anguish and terror of those who have not followed the path of Buddha. The scroll is today divided into many fragments, most of which are in the National Museum in Tokyo, but smaller ones may also be found in American collections, notably the Freer Gallery and the Seattle Museum.

Hibachi Japanese term for the portable charcoal burner or brazier used to heat the traditional Japanese house. It may be made of wood, ceramics or metal, and is either square, rectangular or round in shape.

Hida-ningyo Netsuke in the form of small figurines made by Matsuda Sukenaga of the province of Hida in the early 19th century. He usually employed wood of the yew tree for his carvings, and cleverly used the natural discolorations and knots to form the clothing of the small figures.

Hidari Jingoro Japanese sculptor of the Early Edo period who was born in 1594 and died in 1634. His name means left-handed Jingoro; it is said that a samurai had crippled his right hand. His work consisted largely of wooden carvings executed for Buddhist temples; these enjoyed great popularity at the time.

Hidemasu Mid-18th-century netsuke carver who adopted the pseudonym Chingendo. He lived in Kyoto, and later moved to Edo. He was well known for his work in wood and ivory.

Hideyori Japanese painter of the Muromachi period who died in 1557, but whose exact birth date is not known. He was a member of the Kano School and the son of Kano Motonobu, who was also his teacher. His primary importance stems from his being the first of the Kano masters to turn to the depiction of scenes taken from contemporary life, portraying the common man of 16th-century Japan rather than figures from Chinese history and legend. His most important work is a pair of screens depicting "Maple-viewing at Takao," rendered in a colorful and detailed manner, which is now in the Tokyo National Museum.

Hideyoshi whose family name was Toyotomi, was one of the most important figures in the history of Japan and a great patron of art. Born of peasant stock in 1536, he earned the status of samurai in the service of the military dictator Nobunaga. Through his great ability as a general, he succeeded his master and became the ruler of all Japan, with the title Kampaku, or Chief Minister of State, bestowed on him by the Imperial Court. After consolidating his power in Japan, he attempted to conquer Korea, an enterprise which, however, was cut short by his untimely death in 1598. As a patron of art he was particularly important as an enthusiastic follower of the tea ceremony, and for building the splendid

palaces and castles which were decorated with gorgeous screens. In fact, the entire period lasting from 1573 to 1614 is known as the Momoyama period, after the location of the Fusninil Castle which he built in the Momoyama district of Kyoto. The other famous castle which he built, and which after his death became the stronghold of the Toyotomi family, was Osaka Castle. His widow, in 1606, built Kodaiji Temple in Kyoto, where his mortuary chapel, a structure famous for its splendid lacquer decoration, is located. See also Momoyama period.

Hie Shrine Shinto shrine dedicated to Oyamakui-no-Mikoto, located in Tokyo. It was originally erected on the grounds of Edo Castle during the 15th century, but was removed to its present location in Nagatacho by Ieyasu, the founder of the Tokigawa shogunate. It was the most popular shrine in Edo during the Tokugawa period. It was entirely destroyed during the war, but its grounds were turned into a park, and its great festivals are still noteworthy.

Hieizan or Mount Hiei. A 2,782-foot-high mountain northeast of Kyoto, where Enryakuji Temple, the headquarters of the Tendai sect, is located. The purpose of situating the temple there was to protect the new capital, at that time Known as Heizankyo, from evil spirits which were believed to emanate from the northeastern direction. See Enryakuji.

Higashi Honganji Famous Kyoto temple and headquarters of the Jodo-Shinshu sect of Buddhism. It was founded in 1602, but the original buildings were repeatedly destroyed by fire, most recently in 1864. However, the modern structures which replaced them were built in the style of the earlier ones. Its Hondo, or Main Hall, and Daishido, or Founder's Hall, are large and impressive buildings containing famous images of Amida and of Shinran, the founder of the sect. It is also well known for its Gate of the Imperial Messengers, or Chokushimon, which is an exact replica of a gate originally located at Hideyoshi's Fushimi Castle, which had been destroyed in 1911, and for its noh stage. It has a collection of Japanese and Chinese paintings and sutra scrolls.

Higashiyama period An age of Japanese culture, roughly spanning the years 1480 to 1490, which is believed to be the high point of the Muromachi period. It is so called after the hill on the eastern outskirts of Kyoto, where the Ashikaga ruler Yoshimasa built his villa known as Ginkakuji, or the Silver Pavilion. It was an age when the arts flourished and when some of the greatest of Japanese ink painters, such as Sesshu and Kano Motonobu, were active, and especially when lacquerwork of the very finest quality was produced. It is also well known for its magnificent gardens, one of which was located on the grounds of Jishoji Temple in front of the Silver Pavilion. See Ginkakuji and Ashikaga.

Higo Schools of sword guard makers, so named after the old Higo province which is today Kumamoto prefecture. The schools owe their origin to the patronage of the local Hosokawa daimyo of the Early Edo period, who was himself a maker of sword guards. Among the outstand-

ing artists of the school were Hirata, Hikozo and Nishigaki Kanshiro, who founded subschools. The work of the school was original in its design and employed flat piercing, often with gold and silver inlay. The family continued to work through the 19th century.

-hiko Japanese term used as a component of a Shinto deity's name, meaning "lord."

Hill Jar or in Chinese, po-shan-lu. A Chinese bronze or ceramic vessel whose cover takes the shape of a hill often surrounded by water, and showing human figures and animals rendered in relief. These vessels are supposed to represent the Taoist Isles of the Blessed, and were very popular during the Han period.

-hime Japanese term used as a component of a Shinto goddess' name, meaning "lady."

Himeji Castle The finest and best preserved of old Japanese castles, located at Himeji in Okayama prefecture. It was founded during the 14th century, but in its present form was erected during the Momoyama period. It is a tall wooden structure with a large keep and magnificent tile roofs, surrounded by a moat with a stone wall.

Hina Matsuri Popular Japanese festival, usually referred to in English as the Dolls' Festival, which is celebrated on the 3rd day of the 3rd month, which in the traditional lunar calendar corresponded to the time when the peaches were in bloom. It was, therefore, also referred to as the Peach Blossom or Girls' Festival. To this day, Japanese girls bring out their array of dolls for this occasion, notably the emperor and empress dolls, or dairi-sama and those representing their attendants. Many of these dolls, which serve purely ceremonial functions and are handed down from generation to generation, are true works of art executed with great care by highly skilled craftsmen, and represent miniature replicas of the figures of the imperial court and their belongings.

Hinayana Literally the "Lesser Vehicle," is the original or Southern School of Buddhism, which is still practiced in Ceylon and much of Southeast Asia. In it the Buddha is seen primarily as a great teacher, and each individual, through spiritual perfection and leading a good life, can reach enlightenment. It stands in contrast to the Mahayana or Great Vehicle, a later form of Buddhism in which there are a wealth of Buddhas and Bodhisattvas, and the emphasis is more on faith rather than on leading an austere life. See also Mahayana.

Hirado The name of a Japanese porcelain produced at Mikawachi near Arita, under the patronage of the lord of Hirado, between 1751 and 1843. Its production consisted of a very pure, high-quality white porcelain, usually decorated in cobalt blue under the glaze. It was also well known for the making of porcelain figurines, often in the shape of animals or birds, decorated with blue or colored enamel.

Hirai Ikkan Celebrated chajin or tea master who originally came from China. He moved to Kyoto during the Kanei period (1624–1643), and

there became a famous tea master. He produced various wooden objects, which are characterized by an outer layer of lacquered paper, for use in the tea ceremony; some of his pieces were entirely of this paper. This ware was known by the name of Ikkan-bari. After Hirai's death in 1657, at the age of 80, twelve generations of his descendants continued to work in the same manner.

Hiraizumi Town in northern Japan which was, for four generations, between 1090 and 1181, the seat of a branch of the Fujiwara family. The reminder of that period is a famous temple by the name of Chusonji which contains the Konjikido or Golden Hall, one of the most celebrated examples of Heian period architecture. See Chusonji.

Hiramaki-e A technique of Japanese lacquer making which combines hira, meaning "flat relief," with maki-e, a technique of sprinkling fine gold dust onto the lacquer. This technique first occurs during the Heian period, was fully developed during the Kamakura period, and has remained popular to the present day.

Hirata A type of cloisonné enameling, called shippo in Japanese, which was introduced from Late Ming China. The first to use it for the decoration of sword furniture was Hirata Donin who died in 1646 and served with the shogun.

Hirata School School of metalworkers established in the middle of the 17th century in the old province of Awa, the present Chiba prefecture. The founder of the school was Hirata Tansai, who worked in iron covered with an overlay of gold leaf or wire, with sharply defined designs. His successors continued working through the 18th century.

Hiratsuka Modern Japanese printmaker who was born in 1895 in Matsue. He first studied oil painting in Tokyo, but soon became interested in printmaking and devoted his entire life to this artistic medium. He was one of the founders and guiding lights of the Japanese modern printmakers' association, and in 1935 was appointed a professor of woodblock engraving at the Tokyo Academy of Fine Arts. His output was vast and usually represented scenes such as Buddhist temples, old pagodas, and picturesque Japanese landscapes, in a style which combined Western with more traditionally Japanese elements.

Hiroshige whose family name was Ando, was a Japanese painter and printmaker of the Edo period, who lived from 1797 to 1858. He belonged to the Ukiyo-e School, and is looked upon as one of the outstanding printmakers of Japan. A native of Edo, he started his career as a fireman, his father's hereditary profession, but soon abandoned it for a career as an artist, studying under Utagawa Toyohiro. His early work consisted of pictures of actors and courtesans, but after his master's death in 1828 he turned to landscapes, under the inspiration of Hokusai. His prints are famous for their poetic interpretations of the Japanese landscape, with its picturesque mountain views, seascapes, towns and villages. He particularly excelled in rendering the various seasons, specializing in the depiction of

rain and mist. Among his numerous prints, numbering some five thousand different designs, the most famous are his "Fifty-three Stages of the Tokaido Road" of 1833, his "Eight Views of Omi" of 1853, and his "Hundred Views of Edo" of 1853–1856. There are two other artists by this name who called themselves Hiroshige II and Hiroshige III. The former treated similar subjects and worked in the same style as Hiroshige I, so that it is difficult to tell his work apart from that of the original artist. The latter, however, was a printmaker of the Meiji era, working in a new, more realistic, style.

Hisanobu Member of the Kano School who flourished during the 18th century, and became head of the Kano family in 1743. He was a son of Kano Chikanobu and worked in an eclectic style derived from the earlier Kano masters.

Hishida Japanese painter of the Meiji period who lived from 1874 to 1911. Trained in the Kano School at the Tokyo School of Fine Arts, where he studied under Okakura, he also was influenced by the more decorative aspects of the Japanese pictorial tradition, and evolved a synthesis of these various styles which resulted in a new modern Japanese painting of which he was one of the chief exponents. A premature death put an end to his career.

Hishikawa Family name of the founder of the Ukiyo-e tradition of printmaking. Hishikawa Moronobu. The Ukiyo-e painters and woodblock artists who followed him were therefore known as the Hishikawa School. See also Moronobu.

Hizen Name of a Japanese province located in western Kyushu, which is today referred to as Saga and Nagasaki prefectures. It played a very important role in the history of Japanese ceramics, with some of the most important pottery towns such as Karatsu and Arita located there. See Karatsu and Arita.

Ho Term used for an ancient Chinese bronze wine kettle resting on three or four legs. It is equipped with a straight spout, a large curved handle at the back, and a cover which is usually attached to the kettle itself by means of a short chain. The earliest examples date from Shang times, although pottery prototypes are already found in the prehistoric period. The shape continued to be used in Chinese art right through to modern times.

Ho or Ho-o Japanese form of the fêng-huang or phoenix. See Fêng-huang.

Ho Ch'ü-ping Name of a Chinese general of the Han Dynasty, whose tomb is located at Hsing-p'ing in Shensi province. It is the oldest piece of monumental stone sculpture we know of from ancient China and portrays a horse trampling a barbarian, commemorating the victories of this great cavalry general over the Hsiung-nu nomads of Central Asia. It is believed to have been executed around 117 B.C., shortly after the death of the general. Although its style is crude, it is an impressive piece of carv-

ing and anticipates the type of monumental stone sculpture which is found during later periods of Chinese art.

Hogai Japanese painter of the Meiji period who lived from 1828 to 1888. He belonged to the Kano School, and was a pupil of Kano Shosenin. Along with his friend and colleague Gaho, he was one of the leading painters of the group of artists who wished to revive Japanese style painting during the Meiji period when, after the opening of Japan, Western--style painting had become very popular. The American scholar Fenollosa was a great admirer of his and furthered his work. However, his premature death prevented him from playing the prominent role which he might have had. Like Gaho, he tried to combine the Eastern artistic tradition with elements derived from Western conventions, an attempt which was not wholly successful. His most famous work was a large painting of Kannon, now in the collection of the Tokyo University of Arts.

Hoichi Legendary blind priest who came to be known as Hoichi Miminashion, literally "Hoichi without ears." A tale tells how he was bewitched by ghosts of the dead Taira warriors who lured him night after night to the cemetery of Shimo-no-seki to play the biwa and sing of the epic battles between the Heike and Genji clans. On what was to be his last visit, his body was covered with texts from the sacred sutras in order to render him immune to the spells of the ghosts. Unfortunately, nothing was written on his ears; these alone being visible to the spirits, they pulled them off.

Hoitsu Hoitsu, whose family name was Sakai, was a Japanese painter of the Edo period who lived from 1761 to 1828. He was a younger brother of the lord of Himeji, and studied with various masters in both Kyoto and Edo. His mature work is based on the style of Ogata Korin, whose work he admired greatly and on whom he published a book called *Korin Hyajuzu*. His paintings are largely decorative screens, executed in a highly stylized manner with bright colors against a gold or silver ground. The most famous of these is a screen depicting autumn grasses.

Hojo The dwelling quarters of the abbot in a Zen monastery. They are generally rectangular in plan and divided, in a regular fashion, into several rooms, with the central room containing an image of the Buddha.

Hokkedo Famous Japanese Buddhist temple located in Nara which forms part of the great Nara period temple of Todaiji. It is named after Hokke, the Japanese term for the *Lotus Sutra,* and is also known as Sangatsudo, meaning Hall of the Month of March, since a ceremony based on this sutra was held here every March. It is one of the few Nara period structures surviving at Todaiji, having been built between between 733 and 746, with an enlargement in the form of an anteroom added in 1196. Although small, it is one of the most exquisitely designed and beautifully executed of all early Japanese temples, and is particularly noted for the splendid sculptural images which are found in its interior.

Hokkei Japanese painter and printmaker of the Late Edo period who lived from 1780 to 1850. He was a member of the Ukiyo-e School and a student of Hokusai's, whose figure style he imitated. His most remarkable works are a group of surimono, elaborately printed with gauffrage and gold and silver dust on silver paper.

Hokkekyo Japanese name for *Saddharmapundarika* or the *Lotus Sutra*. See *Lotus Sutra*.

Hokusai Hokusai, whose family name was Katsushika, taken from his birthplace located in a suburb of Tokyo, was a famous Japanese painter and printmaker of the Edo period. He was born in 1760 and died in 1849. He was a student of Katsukawa Shunsho, in whose studio he worked on actor portraits and book illustrations, which he signed with the name Shunro. He was also influenced by Western art, which he studied from Dutch engravings, and by traditional Chinese painting. His output was vast, comprising some 35,000 paintings, drawings and prints, and he used a great variety of signatures during his long creative life, the most picturesque of these being Gakyojin or the "old man mad for painting." Although much of his work consists of figure sketches, of which his *Manga*, a sketchbook published in fifteen volumes, is the most famous, his most outstanding work consists of landscape prints, of which his "Thirty-six Views of Mount Fuji" of 1825 to 1831 are the most famous. "Red Fuji" and "Fuji Among the Waves" are among the most celebrated of all Japanese prints, and were greatly admired by the French artists of the late 19th century. In particular, his use of flat decorative patterns and sharply defined color areas exerted a powerful influence on the post-impressionists, notably Van Gogh and Gauguin. His fame in the West is probably even greater than it was in his native country. Among his many pupils were Hokuju, Hokuba and, above all, Hokkei.

Homin Early 19th-century netsuke carver. He carved netsukes in ivory and signed his work with his name.

Hompa-shiki Japanese term literally meaning "rolling waves style." It refers to a manner of carving the drapery of wooden statues which is decorative, rather than realistic, in appearance. In this stylized drapery, parallel curves of high large round folds alternate with low ridged folds. The name refers to the fact that the folds resemble the alternating high and low waves that wash on the shores. The technique was used mainly in ichiboku statues of the Early Heian period, but it appears on works of later date as well.

Honami Famous Japanese artist family of the Edo period, which was established by the celebrated calligrapher, painter, lacquer artist and swordsmith, Koetsu, whose family name was Honami. Many of the most outstanding artists of the 17th and early 18th centuries were connected with this school, either by descent or through marriage. The most famous of these masters were Korin, Kenzan and Sotatsu. The works they produced were very typically Japanese, and tended towards the gorgeous and

decorative, in keeping with the spirit of the early Edo period. See also Koetsu, Sotatsu, Korin and Kenzan.

Honan Province of northern China which played a great role in the history of Chinese civilization. It was here in the valley of the Yellow River that some of the most significant early archaeological finds were made, notably at Yang-shao, and it was here that the heartland of the first historical civilization of China was found. The Shang capitals of Cheng-chou and An-yang were located in this province. Other important centers were Lo-yang, which, beginning with the Late Chou period, was one of the most important cities of China, and K'ai-fêng, the capital of the North ern Sung empire. Also in this area were Lung-mên, where the most magnificent sculptures of the Six Dynasties and T'ang periods were carved into the rock of the hillside, and pottery centers such as Chün-chou and Ju-chou.

Honan ware A term applied rather loosely to a stoneware with a blackish or brownish glaze, often painted in iron oxide with beautiful abstract floral or bird designs. The sites where these wares were made has not been satisfactorily established, and the term is also confusing since various other kilns made similar wares.

Honden Japanese term for the main hall or sanctuary of a Shinto shrine. It usually contains a bronze mirror symbolizing the spirit of the deity, but this may sometimes be replaced by a sculptural image of the god.

Hondo Japanese term for the main hall of a Buddhist sanctuary, which houses the principal object of worship. It is also called the kondo, or golden hall. See Kondo.

Honen Japanese Buddhist saint, also therefore called Honen Shonin. He was a Buddhist priest and teacher who lived from 1132 to 1212. A great evangelist, Honen was the founder of the Jodo or Paradise sect of Buddhism, which promised rebirth in the Western Paradise for all who called upon the name of Amida. His life and religious career form the subject of one of the most famous of Yamato-e paintings, which was pro-duced during the Kamakura period. It consists of forty-eight scrolls, which are preserved in the Chionin Temple in Kyoto. His teachings were based on the works of the Chinese priest Chên-tao, a T'ang period religious teacher who lived during the 17th century and is known in Japan as Zendo. He taught that he who repeats the name of Amida, with all his heart and complete faith, will be saved.

Hoodo or Phoenix Hall. Main Hall of Byodoin Temple in Uji. See Byodoin.

Hopei Province of northern China which was formerly known as Chihli. Its most important city is Peking, which has served as the capital and seat of imperial power during most of later Chinese history, and is presently the capital of the People's Republic as well. It was the center of important ceramics production, notably during the Sung period, when a beautiful white porcelain was made in the Ting-chou district and a decorated stoneware of the finest quality was produced at Tz'u-chou. The most im-

portant Buddhist monuments are the cave temples at Hsiang-t'ang Shan, dating from the Northern Ch'i period.

Horaisan Japanese name for the Chinese mountain, P'êng-lai Shan, the blessed land of the Taoists. See P'êng-lai Shan.

Horiguchi Japanese architect of the contemporary period, who was born in 1895. He was one of the pioneers in the development of modern international-style architecture, and his early work in particular, with its cubistic shapes, straight lines and plain surfaces, resembles that of Le Corbusier and the masters of the Bauhaus. In his later years, he returned to a more traditional type of Japanese architecture, trying to fuse the older ideals with modern conceptions. His most outstanding work in this style is the Hasshokan Inn in Nagoya.

Horimono Japanese term literally meaning "engraved or carved object." It is used to refer to designs which are either engraved, or executed in champlevé or pierced openwork, and used to decorate the surfaces of Japanese sword blades. The term may also be used for sword fittings such as the kozuka, menuki, and kogai.

Horse Horses played a great role in Chinese and Japanese life and legend, and are frequently represented in art. The horse is one of the twelve animals of the duodenary cycle of the lunar year, one of the Seven Treasures of Buddhism, and was connected with Chinese medicine. Horses are represented in Chinese art as early as the Shang period, and were particularly popular in the art of the Han Dynasty. Numerous horses are found among Chinese grave figures, notably those of the T'ang period, and celebrated Chinese painters such as Han Kan devoted themselves primarily to horse painting. In Japan, horses played a great role in religious life, with sacred horses being kept at the Ise Shrine and horse paintings, or ema, being used as votive offerings in Japanese shrines. Many Japanese painters portrayed horses of all kinds and in many different contexts, and horses fashioned of paper, wood and straw are frequently encountered in Japanese folk art.

Horse painting A category of Chinese painting which, ever since Han times, has played an important role in the pictorial arts of China. The most famous of all Chinese horse painters was a T'ang artist, Han Kan, of whom at least one genuine painting survives in the Sir Percival David Collection in London. other famous horsepainters were the Yuan artists Chao Mêng-fu and Jên Jên-fa, of whom numerous works survive and to whom many more, probably painted by their followers, are ascribed. The horse, which played an important role in Chinese life and was regarded as a noble animal by the Chinese, was also often represented in all kinds of genre and historical painting, and forms a favorite subject matter in the oeuvre of a great many Chinese painters.

Horyuji The most famous of early Japanese Buddhist temples, located near Nara and erected during the Asuka and Nara periods. It was first founded in 607, but a fire destroyed much of it in 670. In subsequent years it was, however, rebuilt in the same style. The Golden Hall or Kon-

do, the pagoda, and the Central Gate or Chumon, are believed to be the oldest wooden buildings existing in the world today. Other structures were added during the Nara, Heian and Kamakura periods, notably the Kodo, or Lecture Hall, and the Yumedono. The temple is also very famous for its wall paintings, most of which, unfortunately, perished in a fire in 1949, and for its magnificent sculptures, which are among the oldest and finest Buddhist works found in Japan.

Hosoban Small-format Japanese print which measures 30.3 cm. by 15.1 cm. or about 11.8 in. x 5.9 in. These figures are for the hosoban in its developed form, executed in the nishiki-e technique; during the earlier period of the hand-colored print and the early stages of printed woodblocks, it was slightly larger.

Hosokawa Name of one of the great feudal families of Japan. Their fief was the Higo province of Kyushu, which is now known as Kumamoto prefecture. They first came to prominence under the Ashikagas during the Muromachi period. In 1632 they were given the title of Prince of Higo, and played a prominent role during the Edo period. They were great patrons of art, and the Hosokawa collection is, to this day, one of the most outstanding collections of Chinese and Japanese art in Japan.

Hotei Japanese name of the Ch'an Buddhism monk, P'u-t'ai. See P'u-t'ai.

Hoto Japanese term for a treasure tope, a form of pagoda in which the building is surmounted by a high cupola with a roof and a metal spire, known as a sorin, on top. Such topes were usually of wood or stone construction. Miniature versions in gold were also produced and used as reliquaries. See also Tahoto.

Hours of the Day In traditional Japan, the twenty-four hours of the day were divided into twelve two-hour periods, each of which was symbolized by one of the twelve animals of the Chinese zodiacal cycle. The period from 11 p.m. to 1 a.m. was known as the Hour of the Rat, 1 a.m. to 3 a.m.—the Hour of the Ox, 3 a.m. to 5 a.m.—the Hour of the Tiger, 5 a.m. to 7 a.m.—the Hour of the Hare, 7 a.m. to 9 a.m.—the Hour of the Dragon, 9 a.m. to 11 a.m.—the Hour of the Snake, 11 a.m. to 1 p.m.—the Hour of the Horse, 1 p.m. to 3 p.m.—the Hour of the Goat or Sheep, 3 p.m. to 5 p.m.—the Hour of the Monkey, 5 p.m. to 7 p.m.—the Hour of the Cock, 7 p.m. to 9 p.m.—the Hour of the Dog, and finally, 9 p.m. to 11 p.m.—the Hour of the Boar or Pig. The theme of the hours is often the subject of Japanese prints, in which each of these periods is represented by the characteristic activities of that part of the day in the Yoshiwara district. In Japanese netsuke, the two animals representing the corresponding hours of the day and night were often shown grouped together; for example, the dragon and the dog symbolizing 7-9 a.m. and 7-9 p.m. respectively, and the tiger and the monkey representing 3-5 a.m. and 3-5 p.m.

Hsi ch'ing ku-chien Title of a Chinese publication which was issued in 1751 at the request of the Ch'ing emperor Ch'ien-lung. Additions to the work were subsequently made, but were printed only during the 20th cen-

tury. The publication contains a catalogue of the emperor's art collection, notably his bronzes, and is therefore one of the important sources for our knowledge of ancient Chinese ritual vessels.

Hsi Wang Mu The Royal Lady or Queen Mother of the West, who is a legendary figure believed to dwell in a magnificent palace upon the K'un Lun mountains. She was considered the guardian of the peaches of immortality which grew on the palace grounds. She is usually represented in Chinese art as a beautiful woman accompanied by girls known as Jade Maidens. One of her two principal attendants carries a large fan, and the other holds a large basket filled with the magical peaches. Hsi Wang Mu is often depicted riding on a crane in flight, escorted by azure-winged birds who serve as her messengers. She was of particular interest to Taoist writers.

Hsi Yû Chi Famous Chinese tale of the Ming period which, under the title *Journey to the West,* has been translated into English and has enjoyed considerable popularity among Western readers. Its author was the 16th-century writer Wu Ch'êng-ên. The hero of the story is a monkey who converted from Taoism to Buddhism, and who helped the famous T'ang pilgrim Hsüan-tsang on his journey, not to India, but to heaven. It abounds in descriptions of imaginary realms peopled by gods, demons and men. Scenes from this story have often been illustrated in Chinese paintings and prints.

Hsia Ch'ang Chinese painter of the Ming period who lived from 1388 to 1470. He was a follower of Wang Fu, and became one of the most celebrated of all Chinese bamboo painters. In addition to being an artist, he was a scholar and a government official. Among the bamboo painters of the Ming period, he is the most outstanding; his brushwork is excellent, and he brings a unique artistic sensibility to the depiction of this beautiful plant, which, to the Chinese, symbolized the Confucianist scholar who bends with the wind but does not break. A superb example of his work may be seen in the Nelson Gallery in Kansas City.

Hsia Dynasty Somewhat legendary Chinese dynasty which, according to the Chinese tradition, ruled China from 1994 to 1523 B.C. However, so far no archaeological evidence which can be linked successfully with this rule has been uncovered and modern scholars tend to believe that it never existed.

Hsia Kuei Chinese painter of the Sung period who was active between 1180 and 1230. A member of the Southern Sung Academy, he is generally regarded as one of the greatest masters of Chinese landscape painting. His work reflects the poetic interpretation of nature and the Taoist philosophy of the Southern Sung period, and was the inspiration for innumerable imitators in both China and Japan. His depiction of misty mountain tops, picturesque rock formations, gnarled trees, lakes with fishing boats and tiny figures of sages, fishermen or woodcutters are among the most characteristic of Chinese paintings. Together with Ma

Yüan, he was the founder of the Ma-Hsia School, which played a great role in later Chinese painting. Among the many works attributed to him, the finest examples are the handscroll in the Nelson Gallery in Kansas City, album leaves in Boston and New York, several magnificent landscape paintings in Japanese collections, and a long horizontal scroll called a "Pure and Remote View of Rivers and Mountains" in the National Palace Museum in Taipei.

Hsia Shên Minor Chinese painter of the Sung Dynasty, who is remembered primarily as being the son of the celebrated Sung artist Hsia Kuei. He is believed to have worked in his father's style. See Hsia Kuei.

Hsiang-kuo-ssu Name of Chinese temple located at K'ai-fêng in Honan province, which was the Northern Sung capital. It ws established during the Middle T'ang period, but most of its buildings are from the Sung age. Unfortunately, much of the architecture ws restored and enlarged during later times, and none of the paintings and sculptures, which no doubt originally were to be found at this sanctuary, survives today. Nevertheless, it remains one of the most important monuments of Chinese Buddhist architecture.

Hsiang Shêng-mo Chinese painter of the Late Ming and Early Ch'ing periods, who was born in 1597 and died in 1658. A native of Chekiang province, he was the grandson of the famous collector Hsiang Yüan-p'ien, and thus had ample opportunity to study the work of the great masters of previous ages. He is best known for his depiction of flowers, but was also a recognized landscape painter. While his work is competent and shows his skill in using the brush, it is eclectic in character and reflects his study of older masters, such as wên Chêng-ming, as well as the painters of the Sung and Yuan periods.

Hsiang-t'ang Shan A site on the border between Honan and Hopei provinces in northern China, where a series of cave temples was hollowed out of the rock during the second part of the 6th century under the Northern Ch'i Dynasty. These temples are regarded as being among the finest of the Chinese Buddhist carvings of that age, and reflect a renewal of the Indian influence which made itself felt at that time. Examples of such carvings may be seen in several American museums, notably the Freer Gallery in Washington and the University Museum in Philadephia.

Hsiao and Hsiang Rivers Names of two rivers, located in southern China, which were among the most popular motifs for Chinese painters, notably those of the Sung Dynasty. It was said that the scenery was highly picturesque and regarded as one of the great beauty spots of China. The Eight Views of the Hsiao and Hsiang Rivers were a favorite theme in both Chinese and Japanese painting. See Eight Views of the Hsiao and Hsiang Rivers.

Hsiao-chuan or "small seal" script, is a type of Chinese writing developed out of the ta-chuan script which has been employed during the Chiou Dynasty, and in which the earlier style was simplified and standardized.

The invention of this writing is usually credited to Li Ssu (221–207 B.C.), a chief minister under the Ch'in Dynasty. Examples of this script are preserved in bronze inscriptions.

Hsiao-t'un Chinese village located a few miles from An-yang in Honan province, where the first Shang oracle bones were discovered.

Hsiao Yün-tsung Chinese painter of the Ch'ing period who was born in 1596 and died in 1673. One of a group of painters referred to as the Four Masters of Anhui, he was principally known for his landscape paintings executed in an individualistic manner. While his early work shows the marked influence of the masters of the Yuan period, he later came to depend more on the Northern Sung artists such as Kuo Chung-shu and Kuo Hsi, making use of softer brushwork, but he never quite achieved the atmospheric beauty of the works of the old masters. Most of his paintings took the form of long handscrolls. He apparently enjoyed widespread popularity during his own time as many of his paintings were reproduced in stone or wood engravings. Some original works by his hand survive in both Far Eastern and Western collections.

Hsieh Ho Chinese painter of the Six Dynasties period who was active during the late 5th century. He enjoyed a great reputation during his lifetime; however, no works which can with any certainty be attributed to him have survived. Today he is chiefly remembered for his Six Canons of painting, which are always quoted as the guideposts of art criticism by Chinese scholars and artists. They are: to grasp the vital rhythm, to render the essential structure of features, to draw shapes in accordance with the object, to apply color according to the nature of the object, to organize the composition by disposing the elements in their proper places, and finally, in copying to find again and perpetuate the essence and methods of the great painters of the past.

Hsieh Shih-ch'ên Chinese painter of the Ming period who was born in 1487 and died in 1567. He was a follower of Shên Chou, but was also influenced by the professional painters of the Chê School, such as Tai Chin and Wu Wei. He was famed for his often large and long scrolls, one of them measuring over 10 feet, and screen paintings executed in a bold manner. While his work lacks the refinement of the best of the artists of the literati school, it is always vigorous, with powerful brushwork, and shows an original, individual style.

Hsien Also sometimes called ven, is the shape of an ancient Chinese bronze ritual vessel which was employed to steam food offerings to the spirits. The lower part of it resembles a li tripod, while the upper part is bowl-shaped with a grill at the bottom. The two parts may be separate or hinged. Vessels of this type may be found in the Shang and Chou periods, and similar shapes executed in ceramics were also found at Neolithic sites.

Hsien-yang Site in Shensi province where the tombs of some of the most famous T'ang emperors are located. The most celebrated of these is the tomb of the emperor Li Shih-min, the founder of the T'ang Dynasty whose posthumous name was T'ai-tsung, a monument which was commissioned in

637. Among the sculptures found here, the most famous are a series of six low relief carvings depicting horses in a very realistic style, two of which are now in American museums, while the other four are in the museum at Sian. Other outstanding sculptures are the monumental stone carvings, representing winged horses, lions and officials, flanking the spirit road of the emperor K'ao-tsung.

Hsin-cheng Chinese archaeological site located in Honan province where important remains dating from the 7th century B.C. were excavated. The recovered pieces play an important role in tracing the development of the ancient Chinese style of bronze decoration, since they form the transition from Middle to Late Chou and reflect the rather ornate baroque decoration characteristic of that age.

Hsing Type of Chinese porcelain or porcelaneous stoneware with a beautiful creamy white glaze, which is believed to have been made at a site named Hsing-jo in Chihli province in northern China during the T'ang period.

Hsing-shu or "running script." A style of Chinese writing which appeared under the Later Han Dynasty. The development of hsing-shu occurred parallel to that of the k'ai-shu or standard script. Both are derived from the earlier clerical writing known as li-shu, but the former style shows considerably greater movement and more freedom of handling than the more formal k'ai-shu writing. Hsing-shu has been recognized as one of the most artistic styles of writing, and many distinguished Chinese calligraphers have executed their finest work in this script.

Hsü Hsi Chinese painter of the Five Dynasties period who is believed to have worked during the middle of the 10th century. Chinese sources praise him very highly, and regard him as one of the great early masters and founders of a category of Chinese painting known as bird and flower painting. It is believed that he employed the p'o-mo technique in which, after the outlines were drawn, washes in ink and color were applied rather freely. However, we can no longer form any very clear idea of the style of his work, since no originals by his hand survive. Of those scrolls attributed to him, the best known are a pair of lotus-flower and bird paintings in the Chionin temple in Kyoto.

Hsü Pei-hung Modern Chinese painter who lived from 1896 to 1953. He is better known by the name Ju Peon. He is one of the best known of those Chinese painters who attempted to create a style which would combine traditional Chinese painting techniques with Western pictorial ideas. He spent almost a decade in Paris, where he studied Western art. After returning to China, he became professor of art at the National Central University in Nanking. He also was responsible for organizing major exhibits of Chinese art in Paris, Berlin and Milan. He is best known for his depiction of horses which combine Chinese-style brushwork with Western realism.

Hsü Tao-ning Chinese painter of the Sung period who was active during the early 11th century. He was a pupil of Li Ch'êng and was a celebrated artist in his own right, but very little is known about his life. He specialized in landscape painting, depicting tiny figures against a vast and mysterious space with

picturesque vistas of towering mountains, valleys, lakes and rivers. The best-known painting usually attributed to him is a horizontal scroll called "Fishing in a Mountain Stream," now in the collection of the Nelson Gallery in Kansas City.

Hsü Wei Chinese painter of the Ming period who lived from 1521 to 1593. He led an eccentric and disorderly life, but displayed remarkable talent as a painter, calligrapher and poet. His brushwork shows great vigor, employing ink in an energetic and spontaneous manner, which makes his best painting truly outstanding. He painted landscapes as well as flower paintings, but his finest works were his depictions of bamboo, of which an outstanding example is in the Freer Gallery in Washington.

Hsüan-chi Chinese term for an ancient jade shape which took the form of a perforated disc with teeth on the rim. It was current during the Shang and Chou periods, and it is believed that it may have been used, along with a long sighting tube, for astronomical observations.

Hsüan ho hua p'u Early 12th-century catalogue of the paintings in the Imperial Collection of the last Northern Sung emperor, Hui-tsung, who, in addition to being a painter of note, was also one of the greatest collectors of Chinese painting of all time. The catalogue, the preface of which is dated 1120, lists 6,396 paintings by 231 artists, starting with the Three Kingdoms or the 3rd century A.D. and ending with the emperor's own work; these paintings are listed under ten subject headings (see Ten Categories of Chinese painting). Several hundred of these works came from a period earlier than T'ang including nine works attributed to Ku K'ai-chih and over 1,000 Buddhist and Taoist paintings, many of them of very early date, and over 300 come from the T'ang period. Unfortunately, this collection was looted, destroyed and lost when the Northern Sung capital was sacked, and it is not known with certainty if any of the works belonging to it have survived to the present day.

Hsüan-tê Chinese emperor of the Ming period who reigned from 1426 to 1435. He was a great patron of art, as well as a noted painter in his own right. During his reign especially the decorative art of China reached its apogee, with the porcelains (notably those in blue and white), the lacquers, and the enamels considered among the finest ever produced in China. His own pictures depicted mainly birds, beasts and plants; among, these, an album leaf of 1427 depicting two hounds in a very detailed and graceful style, now in the Fogg Museum in Cambridge, is the most outstanding.

Hsüan Tsang A famous Chinese pilgrim who made an extensive trip through Central Asia and India, visiting the important Buddhist establishments and collecting works of art and Buddhist sutras. Leaving China in 629 during the Early T'ang period, he returned sixteen years later and devoted the rest of his life to translation of the Buddhist texts and to teaching. The account of his travels, which has been translated into English, is one of the best accounts of the state of Buddhism in the homeland of the Bud-

dha at that time. He is often represented in Chinese painting and a pagoda known as the Great Gander Pagoda or Ta-yen-t'a was built in his memory in Ch'ang-an.

Hu Ancient Chinese bronze ritual vessel in the shape of a large vase or jar which narrows at the foot and sometimes widens at its center. It is to be found in all periods of Chinese art, but was particularly popular during the Late Chou period, and appears often in ceramic form during the Han Dynasty.

Hu Chêng-yen Author of the famous manual of painting known as the *Pictures of the Ten Bamboo Hall*, or *Shih-chu-chai shu-hua-p'u*. Little is known about him otherwise, and the designs employed in his work are taken from a wide range of Chinese artists. See *Ten Bamboo Hall*.

Hua-ch'i A type of Chinese lacquer with a painted decoration on a flat surface. The base of it was usually wood, which was then covered with many thin layers of lacquer decorated in colors or gold and silver. A very laborious and lengthy process was used; this demanded great technical skill, and, in the best pieces, produced beautiful examples of the decorative arts.

Hua-piao A pair of white stone pillars with low relief carvings and a wing at the top, which are found standing on either side of an alley, a triumphal way, or an entrance.

Hua Yen Chinese painter of the Ch'ing period who lived from 1682 to 1765. He was known as one of the Eight Eccentrics of Yang-chou, a town in which he spent most of his life. He was a prolific artist who worked in a variety of styles and portrayed many subjects. He was also known by the name of Hsin-lo Shan-jên and enjoyed the reputation of being a very unconventional person. He painted landscapes in an academic style, recalling the work of painters such as Wang Hui; he also produced works in the blue and green manner of the T'ang masters, and misty mountain scenes in the style of Kao K'o-kung, as well as animals and flowers. A fine example of his work is an album of landscape sketches in the Freer Gallery.

Hua-yen-ssu Chinese temple located at Ta-t'ung in Shansi province, and dedicated in 1140 under the Chin Dynasty. The Buddha Hall at this monastery is one of the best preserved of all Chinese Buddhist sanctuaries; the original architecture, sculpture and painting have been preserved in good condition. While it does not compare to the finest of T'ang period Buddhist temples, it does give a good idea of what the great Buddhist sanctuaries of traditional China must have looked like.

Huai Style A term employed for Chinese bronzes of the Late Chou period (c.600 to c.200 B.C.). Many of these vessels were found in the Wei River basin of Anhoi province, southeastern Honan, and northeastern Shansi. They are marked by a design consisting of abstract bird and dragon forms, spirals and volutes, and also feature surfaces decorated with reliefs or inlaid with gold and silver.

Huan Chinese term to describe circular jade carvings which first occur at

Neolithic sites and continued to be popular also during the Shang and Chou periods. Although they were probably symbolical in meaning, their exact significance is not known today.

Huang Ch'üan Chinese painter of the 10th century. He was first a court painter in the Shu state in Szechwan and later, after the establishment of the Sung Dynasty, worked at the Sung court. It is related that he painted a wide variety of subjects, including Buddhist and Taoist deities, landscapes and dragons, although he is today best remembered as a bird and flower painter. In fact, he is considered one of the major artists of this genre. It is believed that these paintings were executed in color in a meticulous style, but no works which are generally accepted as being by his own hand have survived. Those which are ascribed to him are either later copies, or are so darkened and restored that they give no accurate idea of his style.

Huang Ho or Yellow River. The most important river of northern China, flowing through most of the provinces of the north, notably Shansi, Honan and Shantung. It was in this region that Chinese civilization originated, and some of the most important archaeological sites from the Neolithic, Shang and Chou periods are located here. Many important cities, such as Cheng-chou, Lo-yang and K'ai-fêng, are in the Yellow River valley.

Huang Kung-wang Chinese painter of the Yuan period who lived from 1269 to 1354. He is considered one of the four great masters of the Yuan Dynasty and exerted a powerful influence on all later Chinese painting, especially that of the Ming and Early Ch'ing periods. A scholar who ended his life as a Taoist hermit, living close to nature, he was the very essence of the scholar-painter the Chinese have always admired so much. He excelled in painting landscapes in a rather formal and simple style, in keeping with the pictorial ideals of his age. Few of his works survive today; one of the most famous of these is "Dwelling in the Fu-ch'un Mountains," now in the National Palace Museum in Taipei, which has often been copied and which is immensely admired by Chinese critics and artists.

Huang Pin-Hung Modern Chinese painter who was born in Anhui province in 1864 and died in 1955. A typical Chinese scholar-painter of the Southern School, he was an intellectual and antiquarian as well as an artist, and spent much of his life teaching and writing. He is well known for a valuable anthology of Chinese writings on painting called the *Mei-shu ts'ung-shu*. His own work, especially that of his later years, is very bold and highly expressive, reminding one of the artists of the Eccentric School of the Early Ch'ing period. He is widely regarded today as one of the outstanding Chinese painters of the 20th century.

Huang-ti or the Yellow Emperor, is the legendary first emperor of China from whom all subsequent kings and princes of ancient China claim descent. It is said that he was the founder of Chinese civilization and taught the hitherto barbarian people crafts and manners. He is the earliest ruler

recognized by the great Han historian Ssu-ma Ch'ien, who compiled the first general history in the 1st century B.C. He is sometimes represented in Chinese art, where he is shown as being fully human, in contrast to some of the more ancient rulers who are portrayed with snake-like lower bodies.

Huang T'ing-chien Chinese writer, poet and calligrapher of the Sung Dynasty who was born in 1045 in Kiangsi province and died in 1105. He and three close friends were known as the Four Pupils of Su Shih, where much of their activity was centered. A master of both the hsing-shu and ts'ao-shu styles of writing, he is famous for the firm, crisp, yet round strokes that characterize his calligraphy. Some of the finest examples of work by his hand are presently in the National Palace Museum in Taipei.

Hui-hsien Name of a region in the neighborhood of Lo-yang in Honan province where important archaeological finds dating from the Late Chou period were discovered. Among the most interesting were small clay figures of painted black pottery and miniature clay vessels similar to those executed in bronze. The figures, which are the prototypes for the Later Han grave figures, created a sensation and were immediately forged, so that the bulk of the so-called Hui-hsien figurines which exist today are no doubt modern, but the original finds are among the most charming small-scale sculptures from this period.

Hui-k'o Chinese Buddhist monk known as Eka in Japan, who was a follower of Bodhidharma and one of the early members of the Ch'an School of Buddhism in T'ang China. It is said that in order to demonstrate his total dedication, he cut off his arm and presented it to his master. There is a famous painting by the great Japanese Zen painter Sesshu which represents this scene.

Hui-tsung Chinese emperor and painter of the Sung Dynasty who lived from 1082 to 1135. While his rule was a most unsuccessful one, ending with his captivity in 1125, he is much admired as a patron and collector of art and an artist in his own right. His huge collection of scrolls was the most extensive and remarkable assembled in China up to that time, and the Imperial Academy of Painting flourished as never before. His own work consisted largely of bird and flower paintings, of which the five-colored parakeet in the collection of the Boston Museum of Fine Arts is the best-known example. Numerous works are attributed to him, but very few are probably by his own hand. A catalogue of his extensive art collection, which comprised no less than six thousand paintings as well as calligraphy, ceramics, bronzes and other works, was made. The part listing the titles of the paintings and the artist to whom they were attributed, as well as brief biographical notes on famous painters from the 3rd century through the Northern Sung period, exists, and is known by the name *Hsuan-ho hua-p'u.*

Hundred Views of Edo In both Cinese and Japanese art, it was customary to represent a hundred pictures of a certain species, or landscape, in art, probably since this represented 10 x 10, which was a lucky number. The

great T'ang period horse painter Han Kan is said to have painted a scroll of a hundred horses; other designs might show a hundred birds or flowers. In Japan, the most famous of such series is a set of prints which Hiroshige made late in his life between 1853 and 1856 representing a hundred views of Edo, the name by which Tokyo was known at that time, a set which contains some of his finest prints and gives a vivid picture of what the capital looked like during the middle of the 19th century.

Hung Jên Chinese painter of the Late Ming and Early Ch'ing period who lived from 1603 to 1663. After an early career as a scholar and painter, he withdrew from the world and became a Buddhist monk when the Ming Dynasty fell and was replaced by the Manchus in 1644. His work consisted largely of hanging scrolls representing mountain landscapes painted in a very austere and dry style, recalling the work of the great Yuan painter Ni Tsan. Employing an extraordinary economy of means and very abstract shapes, he achieved very pure and aesthetically pleasing effects which are greatly admired by modern critics.

Hung Lou Mêng Famous Chinese novel of the 18th century which, under the title *The Dream in the Red Chamber*, has been translated into English and has enjoyed considerable popularity with Western readers. It is believed that the first eighty chapters of the work were written by a man of prominent background by the name of Ts'ao Hsueh-ch'in, and the last forty by Kao Ou. It is also thought that it is largely autobiographical, dealing with the life and love affairs of a young man from a noble family. Scenes from it are often illustrated in Chinese paintings and prints.

Hyomon Japanese term meaning sheet design. It is a technique of laquer decoration which consists of cutting a design in a sheet of gold or silver and then applying it to the lacquered surface. Additional coats of lacquer are then added. After drying, the surface is carefully polished. This technique was imported from China during the Nara period.

ABCDEFGHIJ
KLMNOPQR
STUVWXYZ

I also often referred to as yi. Ancient Chinese bronze water ewer, resembling a Western gravy boat in form. Examples have been found dating from the Middle through the Late Chou periods. Earlier pieces rest on four ornamented legs, but in the mature Late Chou, they are either replaced by a ring foot or have disappeared entirely. The handle usually terminates in an animal head which bites the rim of the vessel. It was used to hold water for ceremonial hand washing. It differs from the kuang, which is similar in shape, in that it has no cover and none of the elaborate sculptural decoration in animal form characteristic of the kuang-shaped wine vessel.

I Ching or *Book of Changes* is a book of divination which is believed to be one of the very oldest of Chinese texts. It has been used by the Chinese for some three thousand years in order to predict the future and has in recent years also enjoyed widespread popularity in the West. The Japanese, as well, have employed this work for fortune-telling ever since it was first introduced during the Nara period. Numerous translations into English have been made over the years, the first one by the 19th-century scholar Legge. The most accurate and most widely read translation is that of the German scholar Richard Wilhelm with an introduction by Carl Jung.

I-hsing sometimes also called Yi-haing. Type of red and brown stoneware made at I-hsing in Kiangsu province of southern China. It probably dates back to the Ming period and is said to have been suitable for teapots because it was believed that it lent itself best for brewing tea. It is usually unglazed, and has a faint gloss over its hard reddish stoneware body. The Japanese have particularly admired them and many of them were exported to Europe along with the tea, where their shape was imitated by Western potters. The production of the I-hsing kiln continued right through the 19th century.

I-p'in Style of Chinese painting which is very spontaneous and completely unrestrained by rules. It is said that it was first used by the 10th-century Ch'an painter Shih K'o, who is reported to have been a wild and eccentric

individual. Although two paintings of Ch'an holy men in Japanese collections are attributed to him, it is most unlikly that they were painted this early, and at best reflect his style. However, the i-p'in manner of painting was employed by many artists of the Ch'an and Zen schools.

I Yüan-chi Chinese painter of the Sung period who is believed to have been active during the 11th century, although his exact dates are not known. In fact, little is known of his life and work in spite of the fact that he enjoyed a considerable reputation during his own lifetime. He was celebrated for his animal paintings, especially those of monkeys, rendered with great precision and feeling for humor. Among the works today attributed to him, the two most famous are "Monkey and Cats" in the National Palace Museum in Taipei, and "One Hundred Gibbons" in the Osaka Museum.

Ichijo One of the most brilliant metalworkers of the Goto family, who lived from 1789 to 1876. He was active first in Kyoto and then in Edo, and was well known for the technical mastery of his work and the variety of designs which often reflected the naturalism of the Shijo School of painting.

Ichikawa Name of an illustrious family of Japanese actors who have continued down to modern times. The first famous member of the family was Danjuro I. Many actors of this family have been represented playing various roles in the Ukiyo-e woodblock prints, notably in those of Torii Kiyonobu, Shunsho, and Kuniyoshi. See also Danjuro.

Ichinomiya School of metalworking founded by Ichinomiya Nagatsune who lived from 1719 to 1786. He belonged to a samurai family of Echizen province, but as a young man went to Kyoto, where he studied with one of the Goto masters. He also studied painting under Maruyama Okyo, whose art was often reflected in his designs. He usually employed the iro-e technique of relief incrustation, or a technique combining engraving with flat inlay.

Ieyasu Founder of the Tokugawa shogunate which ruled Japan during the Edo period. He was born in 1562 and died in 1616. He was made shogun in 1603 and after defeating the Toyotomi forces in 1615 became undisputed ruler of Japan, a position his descendants occupied until the Meiji Restoration of 1868. He was a statesman of considerable skill who established a repressive regime and favored learning and the arts. He is often portrayed in the company of the two other great rulers of the 16th-century early Japan, Nobunaga and Hideyoshi. His portraits usually represent him as a big powerful man, sometimes accompanied by his vassals. His mausoleum in Nikko is one of the celebrated masterpieces of Japanese architecture. See also Tokugawa and Nikko.

Iga Name of stoneware produced at the Iga kiln in Shiga prefecture, a type of ware which enjoyed tremendous popularity with the tea masters, and was particularly employed for flower vases used in the tokonoma of the tea houses. The best examples come from the Momoyama period

dating from the late 16th and the beginning of the 17th centuries. Its rather coarse hand-built shapes, the rough uneven texture and subtle glazes, varying all the way from a bluish tone to light pink, correspond to the kind of rustic taste much admired by the tea devotees.

Igarashi Family of lacquer artists who were active in Kanazawa during the Edo period. Its most important member was Igarashi Doho I, who was called to Kaga province by its daimyo Maeda Toshitsune, from Kyoto, and brought with him his adopted son and his student, Shimizu Kyubei. He established the school of kagamaki-e and died in 1678. His work was outstanding for the beauty of its decorative designs, using gold leaf, mother-of-pearl and tin. His work was contined by his son Doho II, but the school died out by the end of the 17th century.

Ikebana Japanese term for the art of flower arrangement which plays a prominent role in Japanese culture. See Flower arrangement.

Ikeda Matsuo Modern Japanese printmaker who was born in Nagano in 1935 and lived in Tokyo during the post war period. He was profoundly influenced by modern Western graphic art, notably the work of Klee, Miro and Dubuffet, and he employs etchings instead of the traditional Japanese woodblock as his main artistic medium. He has achieved widespread recognition both in Japan and in the West, and was given a one-man show at the Museum of Modern Art in New York, where in recent years he has made his home.

Ikkan whose family name was Hirai, lived from 1578 to 1657. He was a native of China, where his name was Pei-li I-hsien. He came to Kyoto during the 1620's and became well known as a tea master. He is said to have originated a type of technique in which lacquer covered an object made of papier-mâché; this process is therefore known as Ikkan-bari.

Ikkyu Famous Japanese Buddhist priest and tea master who lived from 1394 to 1481. He was associated with the Kyoto Zen temple of Daitokuji, and resided in the Shinyuan where his statue and a tablet of his writing are preserved. A portrait of him, which was painted in 1452 by Jasoku, is one of the most famous of Zen portraits.

Imado Kiln site located near Tokyo, established by a vassal of the daimyo of Chiba in the late 16th century. A great variety of wares were produced here varying all the way from crude pottery to refined porcelains. Its greatest period was during the 18th century when, under the influence of Kenzan, tea ceremony wares were made here. However, more characteristic for Imado-yaki were the 19th-century productions which were porcelains of a rather poor quality in imitation of the Arita wares.

Imari Seaport in northern Kyushu from which a great deal of the porcelain produced in Arita was shipped to other parts of Japan or exported to foreign countries. It was for this reason the the Arita wares are usually referred to as Imari wares, although none of them were actually produced in the town of this name. The earliest of them were blue-and-whites, but the most characteristic productions, starting with the Genroku period,

were lavishly decorated porcelains, with designs often derived from textile patterns, executed in brilliant red and gold enamel, known as aka-e, or red picture wares. However, other colors, such as blue, green, yellow, purple and black, were also employed. Although coarser than the more refined Kakiemon and Nabeshima wares, the Imari porcelain at its best was outstanding for the boldness and variety of the designs, sometimes representing actors, courtesans, genre scenes and red-headed foreigners arriving on the Dutch merchant ships, and for the decorative beauty of its colors. The best of these wares are the old or ko-imari, while the later production, starting with the 19th century, shows a marked decline.

Imbe Town in Okayama prefecture where Bizen ware is made. While the term Imbe ware is often employed interchangeably with Bizen ware, it is more correctly used for a type of ware which is thinner and more delicate, in contrast to ordinary Bizen, and employs more refined forms and a slight glazing. It is particularly associated with the tea ceremony and to this day is popular with the tea masters. See also Bizen ware.

Imperial Academy of Painting or Yü-hua-yüan in Chinese, was established in K'ai-fêng by the emperor Hui-tsung during the Northern Sung period in the early 12th century, and continued to play an important role in the Southern Sung period when the capital had been moved to Hang-chou. While it did provide imperial patronage and encourage the art of painting and calligraphy, it also tended to establish academic standards which, judging from the literary accounts, especially under Hui-tsung, were extremely narrow, tending towards the illustration of poems and a painstakingly detailed realism. Artists belonging to it were given official titles such as Tai-chao or Painter-in-attendance, Chih-hou or Painter-in-waiting, and beneath these, Scholars of Art and Students of Art. Artists of exceptional merit were given the golden girdle. The painting academy was revived by the Ming emperors, but never again played as important a role as during the Sung period.

Imperial Palace in Peking has served as the seat of the Chinese government for most of modern Chinese history. It was first erected at roughly the same location by the Mongol ruler of the Yuan Dynasty during the 14th century. However, when the Ming emperors established their capital in Peking in 1403, they completely rebuilt the entire palace complex, and it is this plan which forms the basis of the Imperial Palace to the present day. It has been enlarged and remodeled many times since, and most of the present-day buildings were erected during the 18th century under the Ch'ing emperors. It covers some 250 acres and is surrounded by a moat 54 yards wide and walls 35 feet high. Four towers stand at the corners and four gates, one from each direction, lead into the palace area. This consists of a large number of buildings organized on a north-south axis, with courtyards separating them. The structures themselves, erected on stone platforms with staircases leading up to them, are constructed of large wooden beams and covered with overhanging tile roofs. They are very im-

pressive and mirror the grandeur, wealth and harmony of the Middle Kingdom.

Imperial Regalia of Japan The sacred treasures associated with the Japanese imperial institution. See Sanshu-no-Shinki.

Inari Shinto god of rice who enjoys great popularity throughout Japan. He is venerated as the protector of food and the bringer of prosperity, who is said to be able to restore stolen objects and aid in all difficulties. His messenger is the fox, and in popular belief and in folk art, the god is often thought of as taking the shape of a fox. Many shrines have been erected to him, the most famous of which is the one founded in 711 at Fushimi near Kyoto. Numerous red painted torii or gates donated by faithful worshippers are characteristic of his shrines. His image in the form of a fox, executed in stone or wood, is commonly found in Japanese art.

Incense burners In both China and Japan, incense was often burned, especially in connection with religious rites and ceremonies. Incense burners used for that purpose were often works of art of aesthetic merit, usually made of metal or ceramics. The most distinctive Chinese incense burners were the hill jars, or po-shan-lu, while in Japan an incense burner, known as a koro, may be used in Buddhist rituals or in the incense ceremony which is referred to as kodo. This ceremony is an institution originally imported to Japan in connection with Buddhism during the 6th century, from China and Korea, and probably originated in India, where it is believed to have occured already in antiquity. Today the burning of incense to create mental tranquility is often employed in Japan for purely secular purposes, and is regarded as an elegant pasttime. See also Koro and Hill jar.

Indian influence on Chinese and Japanese art The art of India exerted a powerful influence on that of China and also, more indirectly, on that of Japan. This was particularly true of the Buddhist art, the iconography of which was wholly derived from Indian sources, since Buddhism was an Indian religion to which neither China nor Japan made any very significant contribution. The period of strongest Indian influence lasted from about 300 to 800 in China, covering most of the Six Dynasties and T'ang periods, and from 600 to 900 in Japan, corresponding to the Asuka, Nara and Early Heian reigns. While most of the subjects derived from Indian sources were connected with Buddhism and Buddhist deities, there are even some Hindu gods and goddesses represented in Chinese and Japanese art, such as Brahma, Shiva, Vishnu, Sridevi and Ganesha, who found their way into Far Eastern art as minor Buddhist divinities. While the stylistic influence of Indian art is less marked, there are certain phases of Chinese art, such as the early Buddhist sculptures which resemble those of the Greco-Buddhist school of northwestern India, and the Sui and Early T'ang images which resemble those of Gupta India. Their Japanese equivalents also show the marked influence of the Indian prototypes. In-

dian influence is less noticeable in the later phases of Chinese art, and when it does occur, it is largely of the Lamaist-Tibetan type.

Indra One of the great gods of the ancient Vedic religion of India, who as a storm and sky deity plays a great role in Indian mythology. His attribute is the thunderbolt and he is shown riding on an elephant. In Buddhist art he is often represented, together with Brahma, as an attendant to the Lord Buddha. This is particularly true in the early Buddhist art of Japan where he is known as Taishakuten. He also occurs frequently riding an elephant in the painting of the Shingon sect of Esoteric Japanese Buddhism.

Ink painting In both China and Japan, a great many of the finest paintings were executed in monochrome ink, a method referred to as shui-mo in Chinese and suiboku or sumi-e in Japanese. See Shui-mo, Suiboku, and Sumi.

Ink sticks The ink used in Chinese and Japanese painting consisted of a black carbon mixed with glue which was made from a variety of natural sources, notably petroleum derivatives in the early period, and at later times, wood soot, with pine soot traditionally being regarded as the best. The ratio of glue to carbon was usually 2:1, and it came in the form of sticks or cakes which were often decorated with elaborate ornamental designs. Beautiful old ink sticks were eagerly collected and considered works of art in themselves. The ink stick was ground on a hard surface, usually consisting of stone or pottery, and mixed with water. The proportions varied depending on what kind of ink was desired.

Inkstone Since the Chinese ink came in solid form, ink slabs, usually made of stone or sometimes pottery, quartz or jade, were used to grind the ink stick on their surface onto which some water had been poured. These inkstones are often works of art in their own right, made of beautiful material or engraved with attractive decorative designs.

Inro Small Japanese containers made in several sections which are fitted on top of each other so perfectly that the joints are hardly noticeable. Their shape varies greatly, but has mostly a longish oval crosscut. They were made of many materials, but wood decorated with lacquer is the most common. They were carried on the right hip, suspended from the obi with a double silk cord attached to a netsuke. A small bead known as the ojime held the cords together just below the obi. The earliest inro were probably made during the Momoyama period around 1600, and were used for containing seals. However, they did not become truly popular until the Edo period, when they were used as medicine boxes. The great bulk of the surviving inro come from the 18th and 19th centuries; many of them were executed by some of the most celebrated lacquer artists of that period.

Inubariko Japanese term referring to a box in the form of a reclining dog. According to popular superstition, the dog guards against attack by evil demons. Consequently, the inubariko was placed near the bedside of the mother or beside the newborn baby to insure their safety. The box

itself was used to hold various objects associated with the nursery such as cotton, powder, towels, brushes, etc. It was not uncommon for talismans to be included among these objects.

Inuyama Kiln site near Seto in Nagoya prefecture, where enameled pottery was produced during the Late Edo period. The specialties of this kiln were decorations representing brightly colored cherrry and maple designs, and floral patterns in red and green. The finest of these are among the outstanding Japanese decorated ceramics of the early 19th century.

Ippen Shonin Buddhist priest of the Kamakura period who lived from 1239 to 1289, and who spent his life traveling across Japan in order to popularize the teachings of the Jishu School of Buddhism. A set of twelve scrolls depicting his life and portraying the Japanese countryside, towns, villages and people of 13th century Japan was painted by an artist named En-i in 1299. This series of scrolls is considered one of the most outstanding examples of the Yamato-e painting of the Kamakura period. Sections of it are now in Tokyo National Museum and in the Freer Gallery.

Iris The iris is a very popular flower in Japan and plays an important role in the traditional life of the Japanese people. When the Boys' Festival, also called the Iris Festival, is celebrated on the 5th day of the 5th month, both the flower and leaves of the plant are used in the ceremonies. The sword-shaped leaves symbolize success, and are also believed to have the power to keep away evil spirits when hung from the eaves of houses. The leaves were steeped in wine to produce a drink which was considered an effective preventative against all kinds of disease, and which also insured a long life. The iris is often reproduced in Japanese decorative arts and painting. The most famous of such works is the "Iris Screen" by Korin.

Iro-e Literally "colored picture," a term employed to describe Japanese metalwork in which a variety of different metals or different alloys are employed for inlay. The term may also be used with regard to ceramic wares, in reference to the porcelains decorated with brilliant overglaze colors which were developed in the early 17th century.

Ise Monogatari Famous Japanese literary masterpiece of the Heian period which consists of a series of stories relating to a gay young nobleman of the Kyoto court, based on the life of a real personage by the name of Narihira. The author of the tale is not known. Episodes of the story are often represented in Japanese art, notably in a series of album leaves by Sotatsu.

Ise Shrine Most sacred of all Shinto shrines in Japan, this great sanctuary is dedicated to the sun goddess Amaterasu and is located in Ujiyamada. There are actually two shrines at Ise, the inner shrine—the Naigu or Naiku, dedicated to the Heaven-Great-Shining deity, Amaterasu-o-mi-kami; and the outer shrine—the Gegu or Geku, dedicated to the Plentiful-Food-August goddess, Toyo-uke-hime. These structures are located at some distance from each other, but are very similar in style. Both of the buildings are believed to go back to very early times, and have

been rebuilt in the same style every twenty years ever since the 7th century A.D. They consist of a simple rectangular wooded structure, covered with a heavy thatched roof, and are surrounded by beautiful large trees.

Ishiguro School of Japanese metalworking derived from the Goto and Yanagawa Schools, combining the formal, classical tradition of the former with the freer manner of the latter. It was named after the founder Ishiguro Masatsune who lived from 1760 to 1828, and flourished in Edo during the Edo period. The masters of the school excelled in the application of minute incrustations of gold, silver and bronze, and in delicate chiseling.

Ishikawa Family name of the famous Japanese printmaker Toyonobu. See Toyonobu.

Ishiyamadera A Buddhist temple located on Lake Biwa in the environs of Kyoto. It was founded in the 8th century, but rebuilt during the 12th and 16th centuries. In addition to its picturesque location, it is primarily known for its Hall of Genji or Genji-no-Ma, where it is said Lady Murasaki wrote her great literary classic, *The Tale of Genji.*

Isles of the Blessed The Isles of the Blessed were the island home of the Taoist immortals. The three islands, named P'êng-lai Shan, Fang-chang, and Ying-chou, were believed to be located in the Eastern Sea nearly opposite to the Kiangsu coast. In Chinese art they are depicted as a luxuriant landscape with lakes and rivers, birds and animals. The deer and crane, in particular, being symbols of immortality, were often represented.

Itcho Japanese painter of the Edo period whose true name was Taga Shinko, and who used Hanabusa for the school of painting which he founded. He lived from 1652 to 1724, first in his native Osaka, and then in the capital city of Edo, where he became a pupil of Kano Yasunobu. His work is often lively and amusing, and in 1698 he was exiled to the island of Miyake-jima for making satirical drawings alluding to the loves of the shogun. He was a very independent artist, but close in subject matter to the Ukiyo-e School in his preference for themes taken from the daily life of the common people.

Ito School of Japanese metalworkers named after Ito Masatsugo. It was originally centered in Odawara, but after one of the members of the school, Masatsune, was appointed sword guard maker to the shogun during the early 18th century, the school moved to Edo, where it continued to flourish to the middle of the 19th century. The work of this school, largely made of iron, was known for its fine pierced or modeled designs.

Itogiri The traces in the form of concentric or parallel lines left on the base of ceramic objects by the cord or metal wire used to detach the piece from the potter's wheel. The marks often resemble a series of concentric spirals which curve to the left or right, depending upon the manner in which the potter draws the wire. They are particularly prominent on the early cha-ire. Some scholars believe that this would help determine the provenance and age of the object.

Itsukushima Shrine Famous Shinto shrine located on an island of Miyajima off the coast near Hiroshima. It was dedicated by the Heike, or Taira family, and was, in its present form, erected during the Heian period in 1169. It is built right over the water, with its large torii at high tide actually surrounded by the sea, and was dedicated to the three Shinto goddesses, daughters of Susaro (the god of storms), the eldest of whom was Itsukushima-hime, after whom it was named. It is also famous for a set of thirty-three sutras donated by the Taira family, known as the Heike Sutras, which are among the most celebrated Buddhist scrolls of the Heian period.

Ittan Japanese netsuke carver of the 19th century who came from a noble family, but turned artist and lived in Nagoya. He specialized in carving both human figures and animals in wood.

Ivory Ivory was regarded as a very precious and beautiful material in China and was used for carvings as early as the Shang period. All kinds of ritual objects, tablets and small animal carvings were found at ancient Chinese sites indicating the popularity that this medium enjoyed in ancient China. It is said, in fact, that it was the extensive use of ivory which led to the extermination of the elephant in China and thus forced the Chinese to import ivory from Siam, Burma, Annam and India, and even as far away as Africa. Early pieces of ivory are very rare, but beginning with the Ming and Ch'ing periods, many ivory carvings depicting popular deities and serving practical purposes, such as combs, ornaments, brush holders, toilet articles, all kinds of boxes, screens and games, were produced in large quantities. The finest of these are works of art of real quality. In Japan, too, ivory carving became popular during the Edo period, and many picturesque carvings of legendary and popular Japanese figures were represented.

Iwamoto School of Japanese metalworkers founded by Iwamoto Konkan, who lived from 1743 to 1801. The work of the school was noted for its bold sculptured relief decorations, among which fish was the favorite subject.

Iwao Family name of several Japanese netsuke carvers, of whom the best known was Iwao I, who called himself Tomiharui. See Tomiharui.

Izanagi Literally the "male who invites," is one of the chief deities in the Shinto pantheon. He is said to have been responsible for forming the land mass which constitutes Japan out of the ocean, and is therefore looked upon as the creator god. Together with his sister Izanami, literally the "female who invites," he was also responsible for giving birth to the gods, notably the sun goddess—Amaterasu, the moon god—Tsukiyomi-no-kami, and the storm god—Susano-o. In the orthodox tradition of Japan, the imperial family are direct descendants of these creator gods through Amaterasu.

Izanami See Izanagi.

Izumo Japanese ceramic ware produced at Matsue in Shimane prefecture. It is also referred to as Rakuzan. It was developed by Hagi potters who

were called to Matsue by the Matsudaira lord in 1677. The early wares produced here were largely tea wares in the Korean style, but the kiln later came under Kyoto influence and its potters produced elaborate decorated enamels.

Izumo Shrine One of the most famous of Shinto shrines, located at Izumo in Shimane prefecture. This shrine is dedicated to the Shinto deity Onamochi, the nephew of the sun goddess Amaterasu. Although the present main structure dates from 1874, it is believed that this building goes back to very early times, perhaps to the very beginnings of present-day Japanese civilization. It is a plain wooden building on a raised platform, surrounded by a railing and covered with a thick thatched roof, not unlike the houses erected in Oceania to this day.

ABCDEFGHIJ
KLMNOPQR
STUVWXYZ

Jade or yü in Chinese. A type of semi-precious stone, usually nephrite imported from Turkestan, and later jadeite coming from Burma, which was considered very precious and auspicious by the Chinese people and was used for carving ritual objects, sculptures and works of the decorative arts from prehistoric to modern times. It occurs in many different shades of color, but especially in green when it is Burmese jadeite. It was carved with the help of abrasives and lapidary wheels, and, in more recent times, diamond drills and wire saws.

Jade carving Since jade is a very hard stone, it is very difficult to carve and requires a highly skilled craftsman who possesses the proper tools. In traditional China, the method of working jade was to first shape it with different types of saws and other implements and then smooth it down with polishing wheels before it is ready to be carved. The jade carver, working a treadle with his feet holds the jade against a tubular drill. A diamond drill is used to pierce the jade and a wire saw for the fine fretwork. The process is a very lengthy one requiring time, patience and skill, with several years often spent on completing a major carving.

Jakuchu Japanese painter of the Edo period who lived from c. 1713 to 1800. His family name was Ito, and he was a native and resident of Kyoto. He first studied under a Kano master, but soon turned to the style of Maruyama Okyo, whose realism greatly appealed to him. He is well known for his depiction of birds, and is said to have kept fowl in his study. He worked in a meticulous manner, using bright colors, and combined a sense of decoration with close naturalistic observation, reflecting the scientific ideas which were entering Japan from the West during the 18th century. His best-known work is a set of large paintings depicting plants, shells, fishes, flowers and birds, originally painted for Shokuji Temple in Kyoto, and now in the Imperial Household Collection.

Jakushi School of Japanese metalworking founded in the early 18th century by a Nagasaki painter by that name, who applied the painting technique

and design to metalwork by using gold overlay of various thickness on iron, giving the impression of painted designs. His favorite subjects were dragons and landscapes.

Jasoku Japanese painter of the Muromachi period who flourished late in the 15th century. He came from the samurai class. It is recorded that he was closely associated with the famous Zen teacher and tea master Ikkyu, who resided at the Daitokuji Temple in Kyoto. He worked in the suiboku style derived from Chinese painting of the Southern Sung period, and was a founder of the Soga School. The works by him which survive, most of them in the form of screen paintings in the Shinjuan in Daitokuji in Kyoto, represent landscapes as well as birds and flowers. They would suggest that he worked in the conventional style of the Zen ink painters of his day, but emphasized the contrasts between areas of dark and light ink more fully than most of his contemporaries. He is also known for having painted portraits, notably that of the 9th-century Chinese Zen priest, Lin-chi.

Jataka Traditional stories relating to the life of Sakyamuni Buddha and his previous incarnations. They often serve as inspiration for works of Buddhist art, among which the carvings at Sanchi in India are the most celebrated. Episodes from the jatakas also are portrayed in the Buddhist painting and sculpture of both China and Japan.

Jên Jên-fa Chinese painter of the Yuan period who lived during the first half of the 14th century. He was a high government official of the Mongol administration, and was also well known as a painter of horses. His style was very meticulous and detailed, showing the animals in a great variety of poses and activities. A good example of his art is the horizontal scroll entitled ''Feeding Horses,'' now in the Victoria and Albert Museum in London.

Jenghis Khan See Genghis Khan.

Jewelry Jewelry never played the role in China and especially Japan which it has played in the Western world. While it is true that the Chinese did employ fine gold and silver ornaments in the forms of crowns, earrings, belthooks, rings and pendants, they never used gold and silver very extensively, since jade was considered far more precious and beautiful. The work on this jewelry was usually extremely intricate and ornate, and was admired more for its skill than for its artistic excellence. The motifs were often symbolical, such as the phoenix bird, flowers, butterflies and other auspicious creatures. Pearls, coral, amber, lapis lazuli and jade were also often used along with precious metals. In Japan, jewelry was almost never used, with splended textiles instead of jewelry serving as indications of wealth and rank.

Jigoku Zoshi Japanese name for the Kamakura period scroll, traditionally attributed to Mitsunaga, which represents the torments of hell. See Hell Fire Scroll.

Jikaku Daishi Posthumous name of the Japanese Buddhist monk Ennin. See Ennin.

Jimpo Japanese metalworker of the Edo period who lived from 1720 to 1761. His family name was Tsu and he was trained in the Goto School. He was the teacher of Masachika of the Hirata family.

Jingu-ji Japanese term applied to a Buddhist temple which is located within the grounds of a Shinto shrine, as is particularly common among the sanctuaries of the Dual Shinto variety.

Jingu Shrines Shinto sanctuaries located in Ujiyamada. They consist of the Kodaijingu or the Naiku (Inner Shrine), and the Toyouke-daijingu or the Geku (Outer Shrine). The Naiku is dedicated to the sun goddess, Amaterasu-omikami, and the Geku to Toyouke-omikami, the goddess of farms, crops, food and sericulture.

Jinja Common term applied to ordinary Shinto shrines without special rank.

Jittoku Japanese name for the Zen figure Shih-tê. See Han-shan and Shih-tê.

Jizo Japanese name for the Bodhisativa Kshitigarbha. See Kshitigarbha.

Jo-an Tea House Name of a tea ceremony house or chashitsu built by Oda Urakusai during the Tensho era of the Momoyama period (1573–1592). It is one of the most famous of early examples of Japanese tea house architecture, assuming the shape of a peasant hut with a very severe and plain interior. It has today been removed to the grounds of the Mitsui estate at Oiso in Kanagawa prefecture.

Jocho Japanese sculptor of the Huan period who died in 1057. One of the most celebrated of Japanese carvers, he executed many commissions, both for Buddhist temples and for the imperial family, representing the various Buddhas and saints of the Buddhist pantheon. He was honored in 1022 with the Buddhist title of Hokkyo for his work at the Hojoji temple in Kyoto. However, his greatest work was the large gilded wooden statue which he made for the Phoenix Hall of the Byodoin Temple in Uji. His style, which combined a deeply spiritual feeling with a sense of decorative design, exerted a great influence on later sculptors, notably his son Kaku-jo and his pupil Chosei.

Jodo sect of Buddhism was founded by Honen, a great Buddhist teacher and saint who lived from 1133 to 1212. It is a doctrine which emphasizes absolute faith and trust in the saving power of the Buddha Amitabha. By repeating the formula "namu Amida Butsu"—"glory to Amida Buddha"—and believing in him, the faithful will enter the Paradise, or Jodo, of the Great Buddha Amida. It is to this day one of the most popular of Buddhist sects in Japan, and many of the great temples of the country belong to this sect. See also Honen and Sukhavati.

Jogahana A technique of painting in lacquer, using oil as a binding medium on a lacquer ground. It is named after a place in the province of

Etchu where this technique is said to have been used for the first time. It originated in China, where it was known as hua-ch'i, and was introduced into Japan during the late 16th century.

Jogan A Japanese term referring specifically to the period from 859 to 876; also used on occasion, in histories of art, to describe the art of the Early Heian period. It was an age during which new Buddhist sects, notably the Shingon sect, came into prominence and completely transformed Japanese Buddhist art. See Shingon and Heian.

Joi Celebrated Japanese sword guard maker, whose family name was Sugiura, who lived from 1700 to 1761. He was a member of the Nara School, which was the most influential in Edo, and is considered one of the three great masters of this school. He originated the technique of sunken relief known as shishiai-bori. Most of his work, and that of his school, is in red patinated copper. Authentic works by him are rare, for he was forged extensively.

Jokei Japanese sculptor of the Kamakura period who lived during the late 12th and early 13th centuries. Little is known about his life, but it is believed that he was a pupil of Kokei, the founder of the Kei School. His style is very vigorous and realistic; this is clearly seen in the works he made for the Kofukuji Temple in Nara, of which the portrait of Vimilakirti is the most celebrated.

Jomon Literally "rope impressed," referring to a prehistoric Japanese ware, from which the entire Neolithic civilization of prehistoric Japan is referred to as Jomon. The date of its beginning is a matter of great controversy among scholars. Some, basing their findings on carbon datings, suggest that the earliest Jomon pottery is as much as 10,000 years old, making it the oldest ceramic ware in the world, while the more traditional, conservative view is that it cannot be much older than 3,000 to 5,000 B.C. It is certainly among the most creative and remarkable of all early ceramic wares, and especially during the Middle Jomon period, takes the form of bold and fantastic sculptured and molded forms of great beauty and power. The Jomon potters also made small female figures which are believed to have been fertility idols. The latest phase of Jomon pottery is found in northern Honshu and dates as late as the beginning of the Christian era.

Josetsu Japanese painter of the Muromachi period who lived from 1394 to 1427. One of the leading early ink painters of Japan, he was a Zen Buddhist monk connected with Shokokuji Temple in Kyoto. Little is known about his life and few of his works survive, but there can be no doubt that he was one of the key figures in the development of suiboku, Chinese-style ink painting in Japan. Among his patrons were the leading Buddhist temples of Kyoto and the Ashikaga shoguns. His best-known painting today is one entitled "Catching a Catfish with a Gourd," believed to have been painted c.1410, and now preserved in Myoshinji Temple in Kyoto.

Journey to the West See *Hsi Yu Chi.*

Ju Type of very fine stoneware made for a short while during the Sung period, from 1107 to 1127, at the kilns in Ju-chou in Honan province. It is a buff or pinkish-yellow stoneware covered with a beautiful duck's-egg-blue glaze which is sometimes crackled. It is one of the rarest and most precious of all Chinese wares, outstanding for its form and the subtle beauty of its color.

Jui A Chinese term referring to a curved scepter-like emblem of rank used in court ceremonies. It also occurs in Buddhist iconography as a symbol of religious dialogue and is then held by Manjusri in his famous debate with Vimilakirti. It is usually made of jade or some other precious material.

Juichimen Kannon Ekadasamukha in Sanskrit. Form of Avalokitesvara Bodhisattva which became popular in T'ang China and especially Japan, in which this diety was shown with eleven heads, symbolizing that he was able to look in all directions simultaneously and to come to the help of those in need in all parts of the world.

Juni-hitoe Japanese term referring to the elaborate court dress for ladies which came into fashion during the Late Heian period. Literally meaning "twelve-fold dress," the costume consisted of many layers of kimono worn with each under-kimono slightly visible at the neck, sleeves and hem. A large, full pleated skirt was worn over these robes and spread trailing behind. The outermost garment and skirt were of a rich silk brocade fabric decorated with beautiful patterns created by brushwork painting, embroidery or tie-dyeing. The under-kimonos were usually slightly different shades of the same color to achieve a harmonious visual effect, and were decorated with small intricate designs. The men's equivalent of the juni-hitoe is called sokutai, and both have been used for great formal occasions in modern times.

Juni-shi See Twelve Animals.

Juni-shinsho Group of twelve guardian deities, represented as fierce warriors, who are grouped in a circle around the Buddha of Medicine, whose protectors they are. The most famous examples of such images executed in clay, are those found at the Nara period temple of Shin-Yakushiji.

Juni-ten or Twelve Deva A group of deities who were originally Indian gods connected with the ancient Vedic religion and Hinduism, but were incorporated into Buddhism. They enjoyed a particular popularity in Japan, where they were often represented in sculpture, painting, and illustrated books, especially during the Kamakura period; it is believed, however, that they occurred earlier in Chinese art, probably during the T'ang period. Most of them represent elements of nature such as fire, water, the sun and moon, and storms. The most popular among them were Emma, or in Sanskrit Yama, the god of the underworld and the dead; Bishamonten or Vaisravana in Sanskirt, the guardian of the north and the chief of the jakshas; Bonten or Brahma, and finally, Taishakuten

or Indra, who are often seen as attendants of the Buddha. See also separate entries under Deva, Brahma, Indra, Bishamonten and Emma.

Jurakudai A magnificent building erected by the Momoyama period military dictator Hideyoshi. It is famed for its screen paintings, which were executed by such famous artists as Kano Eitoku, Kano Sanraku and Kaihoku Yusho. Although the building has been destroyed, sections of it have been incorporated into Nishihonganji Temple in Kyoto, and many of the paintings have been preserved to the present day.

Jurojin One of the Seven Gods of Good Luck who is associated with long life. He is usually shown as an old man dressed as a scholar, holding a staff and in the company of a crane or stag, the symbol of old age. He originally was a Chinese Taoist deity named Shou-shên, and is the god of the star Canopus in the constellation Argo.

ABCDEFGHIJ
KLMNOPQR
STUVWXYZ

Kabuki Traditional Japanese drama which originated during the early 17th century and has continued to be the most popular form of stage entertainment in Japan to this day. Scenes from kabuki plays and portraits of celebrated actors form one of the main subjects represented in Ukiyo-e prints. Families of printmakers such as the Torii, specialized in making posters and series of prints dealing with the kabuki plays, and some of the greatest masterpieces of Ukiyo-e, such as the prints of Shunsho and his numerous followers and the celebrated woodcuts by Sharaku, depict scenes from the kabuki drama. Among later printmakers, it was Kunisada especially who made innumerable prints dealing with scenes from kabuki.

Kacho-e Bird and flower painting and printmaking popular in Japan in the Edo period.

Kaga School School of Japanese sword guard makers established by the Maeda daimyo of Kaga province, the present Ishikawa prefecture, who invited a number of metalworkers from Fushimi to come to Kanazawa, his provincial capital. They first worked in iron with flat inlay of soft metals, but later used copper and its alloys and elaborate inlay and engraving designs. The technique of incrustation employed by members of this school is called Kaga-zogan.

Kagamibuta Type of Japanese netsuke carving which consists of a bowl of ivory or horn fitted with a lid of metal, usually copper, silver, or an alloy of copper and gold. A cord is attached to the underside of the lid, which passes through a hole drilled in the bowl and is attached to the inro.

Kagetoshi Netsuke carver of the early 19th century who lived in Nagoya. He was best known for his minute carvings exhibiting great skill. He signed his work with his name.

Kagoshima City in southernmost Japan on the island of Kyushu, which is the seat of the government of Kagoshima prefecture, whose old name was Satsuma. It was the castle town of the Shimazu family which was famous for its association with the Restoration movement during the 19th

century, and supplied some of the famous leaders of the time such as Saigo, Takamori, and Okubo Toshimichi. From an artistic point of view, it is primarily known for its production of ceramics, notably the Satsuma ware and the fold pottery made in its environs. See Satsuma.

Kagura Traditional Japanese dance which is believed to be the oldest dramatic art form existing in Japan. A sacred dance accompanied by music, it is performed by masked dancers who impersonate the various deities. Its origins go back to prehistoric times, but it is still being performed today.

K'ai-fêng Chinese city in Honan province which, during the Northern Sung period (960–1126), served as the capital of the Chinese emperors. It is said that it was a dazzling city, comparable to the other great Chinese cities Ch'ang-an and Lo-yang. Among its major buildings was the Hsiang-kuo-ssu temple. The two most remarkable ancient buildings still surviving are the so-called Iron Pagoda, T'ieh-t'ao in Chinese, an octagonal brick structure thirteen stories high, dating from 1044; and the Fan-t'a or Fan Pagoda, which was first erected in 977 but reconstructed in 1384.

K'ai-shu The Chinese script which evolved during the Six Dynasties period and has remained the standard Chinese script to the present day. It is based on the li-shu writing of the Han Dynasty, but is more fluent and easily written. Many outstanding examples of Chinese calligraphy written in this script exist, beginning with the great 4th century calligrapher Wang Hsi-chih, who was particularly famous for his use of this type of writing.

Kaigetsudo A school of Japanese painters and printmakers active in Edo during the first half of the 18th century. The most famous among them was Kaigetsudo Ando, who lived from 1671 to 1743. He was famous for his bold and decorative portrayal of the proud and elegant courtesans of the amusement district of Edo, the Yoshiwara quarter. His painted designs and large black and white prints with their strong line and fine decorative design, which were also sometimes colored, were among the masterpieces of the early Ukiyo-e School. Among his many pupils who also used the Kaigetsudo name were Anchi, Doshin, Doshu, and Dohan.

Kaigyokusai Netsuke carver of the 19th century who lived from 1813 to 1892. A native of Osaka, he was one of the best known carvers of the Kansai district. He signed his work with a variety of signatures, depending on the period of his life during which the carving was made. He excelled in netsuke as well as okimono representing scenes from Japanese legend. Many of his works were exported.

Kaikei Japanese sculptor of the Kamakura period who was active during the late 12th and early 13th centuries. He was trained by Kokei, the father of the great Kamakura sculptor Unkei, but worked in a much quieter and gentler manner. His best-known work is a graceful and charming representation of Miroku, a gilded wooden statue made in 1198 which is now in the collection of the Boston Museum. A bolder and more realistic

aspect of his work is his depiction of Hachiman, the Shinto god of war, in Todaiji Temple in Nara.

Kairo Japanese term literally meaning "surrounding corridors." It is used to refer to the roofed passageways similar to medieval cloisters, which enclose the central part of a Buddhist or Shinto precinct.

Kaisando Japanese Zen temple at the Eihoji monastery near Nagoya. It was built during the 14th century, the Early Muromachi period, and is one of the oldest and most famous of Zen temples. It is dedicated to the founder of Eihoji, Buttoku Zenshi, a pupil of the great Zen master, Muso Soseki. The type of structure seen here was often copied by later Zen monasteries throughout Japan.

Kakemono Japanese term for a vertical hanging scroll suspended from two short wooden rods and containing paintings or calligraphy. When not on display, it is usually rolled up.

Kaki See Persimmon.

Kakiemon Type of Japanese porcelain made at the Nangawara kiln in Arita in Saga prefecture. The founder of this kiln was Sakaida Kizaemon, known as Kakiemon I, who lived from 1569 to 1666. It is believed that he invented the new method of enamel decoration employed by the Kakiemon potters during the middle of the 17th century. Based on the Chinese porcelains of the K'ang-hsi period, these refined and beautiful decorated wares are regarded as among the most excellent porcelains ever produced in Japan, and enjoyed a tremendous popularity in Europe, where they were imitated by the leading European porcelain manufacturers. This resulted in some of the finest early pieces being found today in Dresden, where they were collected by King August the Strong. The body of these wares is pure white porcelain and the colors are brilliant and clear. However, the most outstanding quality is the beauty of the painted designs showing birds and flowers, figures and landscapes in the Chinese style, but rendered with a marked Japanese flavor. Kakiemon ware continues to be produced by the Sakaida family to the present day, but the wares of the 17th and 18th centuries are regarded as the finest.

Kakihan Type of seal used by Japanese craftsmen, kaki literally meaning to write or sign, and han meaning seal. It is usually affixed to the finished piece after the signature of the artist. It is mainly used by metalworking artists, but may also appear on the work of lacquer makers and netsuke carvers. It was not uncommon for a single craftsman to use several different kakihan.

Kama Japanese term used for the iron kettles designed for boiling the water in the tea ceremony. The earliest mention of such objects is found in the records of the Nara period, and they were probably imported at that time from T'ang China. Their widespread use for the tea ceremony dates from the Late Kamakura period, and those of the Muromachi period especially are today considered great artistic treasures.

Kamakura City in Kanagawa prefecture south of Tokyo, which was the

seat of the military rulers of Japan between 1192 and 1333 and served as the *de facto* capital of the country. It was due to this fact that this period of Japanese history and art is known as the Kamakura period. Few of the artistic monuments of that time survive; among the most important are the Engakuji Zen temple and the Great Buddha. Other notable buildings are the Hachiman Shrine, a Shinto sanctuary, and the Kenchoji Buddhist temple.

Kamakura-bori A type of Japanese lacquer ware which consists of carved wood decorated with layers of black and red lacquer which are often rubbed down. It is said to have originated during the Kamakura period and was based on Chinese models. It is named after the town of Kamakura in Kanagawa prefecture, where it is still being produced today.

Kami Japanese Shinto term which describes the spirits or deities which, according to the native Japanese religion, inhabit all aspects of nature, such as the mountaintops, waterfalls, ancient trees and rock formations, and the heroes and rulers of Japan, whose spirits are deified and whose memory is venerated at Shinto shrines dedicated to them.

Kamman Netsuke carver of the late 18th century, who was a native of Iwami and a pupil of Tomiharu. He is well known for having made netsuke in the form of frogs in ebony and lobsters of wild boar tusk.

Kan-pi or "dry-brush" painting, a type of painting popular among the literati painters of China, notably those of the Yuan period, who were fond of using very little water with their ink. The result was a very delicate, refined type of brushwork which was imitated also by artists of the Ming and Ch'ing Dynasties and by Japanese painters of the Nanga School.

Kana A type of Japanese syllabic writing derived from Chinese ideographs and perhaps inspired by the Sanskrit alphabet. There are two main types of kana: katakana, which is traditionally said to have been invented during the 8th century by Kibi-no-Makibi, and hiragana, which is attributed to the Buddhist saint of the 9th century, Kobo Daishi. This writing is usually employed in conjunction with Chinese characters known as kanji, and is often employed in modern newspapers and magazines alongside Chinese ideographs to indicate the pronunciation or meaning. Kana is also often used in calligraphy, and enjoyed a particular vogue during the Heian period, when poems written in this style were executed by some of the outstanding artists of the day.

Kanaoka Japanese painter of the Early Heian period who is believed to have flourished during the second part of the 9th century. His family name was Kose, and he was the founder of a school of Japanese painters by that name. Although he was very famous in his own day, and is said to have painted a series of portraits of Chinese sages for the imperial palace in 892, none of his work remains today, and the few works associated with his name are, at best, school pieces painted by his numerous disciples.

Kaneie School of Japanese sword guard makers founded in the middle of the 17th century by Aoki Kaneie who worked in Fushimi, a suburb of Kyoto. The work of this school usually consists of iron sword-guards decorated with Chinese landscapes, occasionally touched up with gold or copper gilt.

K'ang-hsi Name of a Chinese emperor of the Manchu Dynasty who ruled from 1662 to 1722. He was particularly well known for his patronage of ceramics, and the K'ang-hsi porcelains enjoy great prestige throughout the world to this day. They are outstanding for their technical excellence, their pure white bodies and their varied color glazes. Among them are wares decorated in blue and white, in monochrome and in bright enamel colors.

Kannon Japanese name for the Bodhisattva Avalokitesvara. See Avalokitesvara.

Kano School School of Japanese painters founded by the Muromachi painter Kano Masanobu (1434–1530). Beginning with his son Motonobu, the Kano School became one of the most influential schools of painting in Japan, enjoying the official patronage of the shoguns during the Momoyama and Edo periods. Many of the outstanding Japanese artists, such as Eitoku, Koi, Masanobu, Minenobu, Mitsunobu, Motonobu, Naganobu, Naonobu, Sadanobu, Sanraku, Sansetsu, Shoei, Takanobu, Tanyu and Yasunobu, were members of this school. The last of the famous masters of the school was Kano Hogai, who lived during the Meiji period. For discussions of the life and work of the individual artists, see entries under their personal names.

Kanshitsu Japanese term for a technique of lacquer decoration which was employed in Japan beginning with the Nara period. In it the object, usually carved of wood, was covered with hemp cloth, which was then coated with liquid lacquer. Although this method of lacquer decoration was imported from China, where it was known as po-huan, the best examples of it are found among the Japanese Buddhist sculptures of the 8th century.

Kansu The westernmost province of northern China which links China proper with Sinkiang and Central Asia. It has therefore played a very important role in the history of Chinese civilization, and some of the most important of prehistoric finds were located in this area, notably the Neolithic grave site at Pan-shan. It also played a great role in Buddhist art, and some of the most important of all Buddhist sites, such as the Thousand Buddha Caves at Tun-huang, which contain the best preserved ancient Buddhist paintings of China, and the cave temples of Mai-chi-shan, are located in this province.

Kanzan Japanese name for the famous Zen figure, Han-shan. See Han-shan and Shih-tê.

Kanzashi Japanese term for the large ornamental hairpins worn by

Japanese women. The earliest ones were of wood, metal or shell and were very simple. Later on, especially during the Genroku period (1688–1703), the kanzashi were usually richly lacquered in gold or silver and inlaid. The number and types of kanzashi that a woman wore were an indication of her social and marital status.

Kao Ch'i-p'ei Chinese painter of the Ch'ing period who lived from 1672 to 1734. He was a high government official as well as a painter, and is primarily known today as a practitioner of finger painting, with which he achieved some highly original and extraordinary effects. A good example of his art is a series of album leaves, "Landscapes with Tall Peaks," in the Museum of Asian Art in Amsterdam.

Kao Chien-fu Modern Chinese painter who started an art school in Kwantung province in 1912 for the purpose of revitalizing traditional Chinese painting by infusing elements of modern Western art, notably perspective and shading, as well as the depiction of scenes from modern urban life. This movement was known as the Ling-nan P'ai or Cantonese School, and has exerted a strong influence on modern Chinese art, although the results are rather too self-conscious and aesthetically not very satisfactory.

Kao Fêng-han Chinese painter of the Ch'ing period who was born in 1683 and died in 1747. He was one of the group of painters referred to as the Eight Strange Masters of Yang-chou, and was known for his free brushwork and originality as a person. He worked in many different genres, painting landscapes, flowers, grasses, rocks and figure compositions which showed an individual style and expressive brushwork. Outstanding examples of his work are preserved in Japan, where he has enjoyed considerable popularity, and others are found in Chinese and American collections.

Kao K'o-kung Chinese painter of the Yuan period who lived from 1248 to 1310. He served as a high official in the Mongol Dynasty and also enjoyed great fame as an artist. His work consists largely of scrolls depicting misty landscapes in the style of Mi Fei. Numerous works are attributed to him, but only a few of them are probably by the brush of the master himself. Typical examples of his best work are such hanging scrolls, in the National Palace Museum in Taipei, as "Mists over Wooded Mountains," reflecting his very personal and expressive treatment of the majesty and mystery of nature.

Kao Sonen Japanese painter of the Muromachi period who was active during the first half of the 14th century, dying in 1345. He journeyed to China in 1320. His name appears on a seal and there can be little doubt that he was one of the pioneers in the development of Chinese-style Zen Buddhist painting in Japan. A good example of his type of painting is a picture of the Zen figure, Kanzan done in ink.

Kaolin A special kind of clay found in great quantities in China, but also in Japan, which is suitable for the production of porcelain since it

burns to a white color and lends itself to very refined ceramic productions. The term literally means "high ridge" from the place where it was found, and is referred to in England as "China clay." It is produced by the decay of feldspar. In China it is fired at the temperature of 1,300 degrees Celsius, together with the less-decayed and more fusible form of feldspardic material called petuntse, to produce a porcelain. Almost pure kaolin, fired at 1,000 degrees C., forming a very brittle stoneware, was also employed in Shang China for the production of a very fine white ware, of which only a few examples have survived.

Kappa Japanese monster of an amphibious nature that lives in the rivers of the island of Kyushu. In traditional legends, it is described as having the body of a tortoise, the legs of a frog, and the head of a monkey, with a short, strong beak. On its head is a kind of small bowl containg a liquid from which it draws its strength. The kappa attacks human beings and animals who venture near the river, luring them into the water and drowning them. It is often represented in Japanese netsuke and prints, and is the subject of a popular modern cartoon.

Kara-e Japanese term used to describe Chinese painting, especially those portraying secular subjects in contrast to Yamato-e pictures painted in a more truly Japanese style.

Kara-zuri Japanese term to describe a process of printmaking which consists of transferring the outlines of the print onto the paper by pressure on the matrix alone, rather than by color.

Karahitsu Japanese term for a chest constructed and decorated in the Chinese style. It stands on four legs and is used in temples to contain sacred texts.

Karakusa Decorative motif often found in Chinese and Japanese art, kara literally meaning Chinese, and kusa meaning grass. It consists of arabesques formed by tendrils and spirals of climbing plants, and is most commonly used in metalwork.

Karaori Japanese term literally meaning "Chinese weave." It refers to a rich brocade with was originally imported from Ming China during the Tensho era (1573–1591). The ground of the fabric is usually a twill weave, and the design, a satin weave. Beautiful effects are achieved through the use of gold, silver and colored threads. The term may also be used for the outer garment of the female costume used in noh plays. As such, it is the most decorative and florid of the costumes worn in this drama.

Karatsu Port city in northern Kyushu in Saga prefecture from which a type of ware known as Karatsu was exported throughout Japan. This ware was actually made at many local kilns in the neighborhood of Karatsu and therefore exhibits a great variety of ceramic styles. Some of it was highly sophisticated tea ware which was greatly esteemed by the tea masters, while other types of Karatsu consist of folk pottery of a rather crude but aesthetically pleasing type. The most famous is the Egaratsu or picture Karatsu, showing beautiful painted designs of grasses, reeds,

grapes, wistaria and geometric patterns executed in a free spontaneous style. While the finest of these works were produced during the Momoyama and Early Edo periods, Karatsu continues to be made to the present day and is highly valued by the tea masters.

Kare-sansui A Japanese term literally meaning "dry landscape," a type of landscape garden in which no water is used. Instead the sea is represented by a spread of white sand and waterfalls are suggested by large upright rocks. See also Garden architecture.

Kasuga Shrine Shinto shrine in Nara, founded by the Fujiwara family during the 8th century to house their four guardian gods. The present-day main building is a 19th-century structure, but is believed to reflect an older artistic style. In contrast to the Ise and Izumo Shrines, it is painted in bright red in the manner of Buddhist temples, and in other ways reflects the influence of Buddhist architecture. It is surrounded by a beautiful wooded park famous for its deer.

Kasuri Japanese term used to describe a type of fabric decorated with scattered patterns. The material is woven with threads that have been previously dyed in a mottled manner, a technique that was developed during the Momoyama period. Especially well known today are the Satsuma-gasuri still being produced at Kagoshima, and the fabrics woven in Okinawa.

Kasyapa or Chia-yeh-po in Chinese. One of the disciples of the Historical Buddha Sakyamuri, often depicted in both Chinese and Japanese art. He is shown along with Ananda in attendance on the Buddha.

Katana Japanese term which may be used as a generic term applied to all single-edged swords, or employed in a stricter sense to refer only to the longer of the daisho, or pair of swords, worn by the samurai. In the latter case the katana is a long, slightly curved blade, usually measuring 28 to 30 inches in length. It was worn in the sash of the samurai's costume with the blade edge upward. See also Daisho.

Kato Toshiro Japanese potter of the Kamakura period who is believed to have visited China in 1223, where he studied techniques of ceramic production. Upon his return to Japan he settled in Seto near Nagoya where he founded a kiln. Traditionally, it is said that he was a founder of the modern Japanese ceramic industry and produced excellent stoneware with a brownish or greenish glaze. Numerous tea wares, notably tea bowls and tea caddies, are ascribed to him, but modern scholars tend to doubt both his central position in the development of Japanese ceramic history and his authorship of these pieces. The Kato family has continued to play an important role in Japanese ceramic production, and numerous potters by that name have been active in and near Seto ever since that time.

Katsukawa School School of Japanese Ukiyo-e printmakers founded by Katsukawa Shunsho (1726–1792). It included such famous artists as Shunko, Shunjo, Shunei and Shunro, which is an early name used by the

great 19th-century printmaker Hokusai, who became the most famous member of this school.

Katsura Palace Katsura Palace, located on the western outskirts of Kyoto, is probably the most famous example of Japanese domestic architecture in existence. Originally, it was erected as a country villa for Prince Tomohito, who was the adopted son of Hideyoshi, after the estate had been given to the prince by the Tokugawa shoguns. It was probably started shortly after 1623 and completed about 1663. It represents the finest example of the simple and elegant type of Japanese architecture which modern Western architects, in particular, have admired so greatly. Both the exterior, with its use of plain wood, sliding screens and bark roof, and the interior, with its simple lines and severe decorations, represent the very essence of the wabi spirit which the tea masters treasured. It is also outstanding for its garden and the tea house located in it, known as the Shokin-tei or Pine Lute Pavilion.

Katsushika Family name of Hokusai. See Hokusai.

Kawabata Japanese painter of the Showa period who lived from 1885 to 1966. He was a native of Wakayama and started his career as a Western-style painter. But during a trip to the U.S. in 1912, he was so impressed with the Japanese paintings at the Boston Museum that he decided to take up Japanese-style painting. An artist of great power and originality, he used Japanese pigments as freely as if they were oil, and often worked in a large format. In addition to being an outstanding Japanese-style painter, he was also very influential in shaping the work of younger artists.

Kawai Gyokudo Modern Japanese painter who lived from 1873 to 1957. He was one of the outstanding masters of the Japanese-style contemporary school of painting, and enjoyed great popularity during his lifetime. He first studied Shijo-style painting in Kyoto, but then moved to Tokyo, where he studied Kano-type painting under Gaho. At the same time, he was also influenced by Western art, and was able to fuse the Oriental tradition with that of the West into a style which represented a synthesis of both artistic conventions.

Kawai Kanjiro Japanese potter of the contemporary period who was born in Shimane prefecture in 1890 and died in Kyoto in 1966. He was trained at the Tokyo Institute of Technology, and became a professional potter in 1917. He was early attracted to Korean pottery of the Yi Dynasty, which is reflected in his early work. His best work was done during the 30's and is outstanding for its glazes and painted designs. In his later years he turned to more experimental types of wares, showing the influence of modern abstract sculpture, which were closer to Picasso and Miro than to traditional Japanese ceramics. A clost friend of Hamada's and Yanagi's, he was one of the leading spirits of the Japanese folkart movement.

Kawakami Sumio Modern Japanese printmaker who was born in Yokohama in 1895. A prominent member of the Hanga group, he specialized in creating prints and illustrated books which depicted the first Westerners to arrive in Yokohama during the Meiji period. Treating these scenes of life in late 19th-century Japan with nostalgia, he evokes vividly the period when there was a craze for everything Western in Japan.

Kawanishi Hide Modern Japanese printmaker who was born in Kobe in 1894. He is one of the leading members of the Hanga movement and was inspired to turn to making prints after seeing the work of Yamamoto in an Osaka shop. Among his most important works are a series of one hundred views of Kobe, and his prints depicting the Western circuses which he had seen in his native city. His style is very colorful and decorative, and his subjects reflect the international atmosphere of the port city in which he grew up.

Kazan Japanese painter of the Edo period who lived from 1793 to 1841. His family name was Watanabe and he belonged to the military class. He studied with Tani Buncho, but was also greatly influenced by European painting, especially the Western manner of modeling in terms of light and shadow. His most striking works are his portraits which, in their realism and emphasis on the character of the person portrayed, seem almost Western. An enlightened man, who had been exposed to Dutch learning, he opposed the exclusion policy of the Tokugawas; this led to his confinement by the government and subsequent suicide.

Kegon Japanese name for a Buddhist sect which was known as the Avatamsaka School in Sanskrit, Hua-yen in Chinese and Hwa-om in Korea, where it played a particularly important role. It is one of the Mahayana schools of Buddhism which was founded in China in 630 and was introduced into Japan in 750. It belongs to the Esoteric schools in which all of the phenomenal world is viewed as but a manifestation of the world of the absolute, which finds its expression in the Buddha Vairocana. Todaiji Temple in Nara, one of the greatest of Japanese Buddhist temples, belonged to the Kegon sect.

Kei Japanese term for gong. See Gong.

Kei Shoki also known as Shokei. Japanese painter of the Muromachi period who died in 1523. He was a student of Geiami and worked in the suiboku style. He was a Zen priest connected with the Kenchoji Temple in Kamakura. His work consisted largely of either Zen subjects or landscapes of the picturesque scenery of sourthern China. His brushwork was very bold, employing striking contrasts between lights and darks. His most famous work is a powerful portrait of Daruma, the founder of Zen Buddhism, in Nanzenji Temple in Kyoto.

Keibun Japanese painter of the Edo period who lived from 1779 to 1843. His family name was Matsumura and he was the younger brother of the famous Shijo School painter Matsumura Goshun. He was also profoundly influenced by Chinese painting of the Ming and Ch'ing periods, and specialized in bird and flower painting.

Keman Decorative plaques used in the interior of Buddhist temples. Ori
ginally they consisted of flowers, but later were made of metal or various
other materials. They are hung on the walls of the temple.

Kengyu and Shokujo Legendary figures of the cowherd and weaver
representing the stars Altair and Vega, who are set apart on either side of
the Milky Way, and whose union takes place only one night each year.
While the story originated in China, it was particularly popular in Japan,
and gave rise to the Star Festival known as Tanabata. See Tanabata.

Kenjo tsuba Type of Japanese sword guard, richly decorated on both
surfaces in nunome-zogan, in which gold and silver are inlaid on an iron
surface in elaborate but delicate geometric patterns; or in hira-zogan, in
which gold and silver wires are hammered into grooves flush with the sur-
face. As the name indicates—kenjomono literally meaning a "present to
a superior"—these guards were among the objects which could be offered
as gifts to the shogun or other high-ranking officials.

Kensui Japanese term to describe the waste water jar which serves to
receive the water used for rinsing the tea bowl in the tea ceremony. These
are usually made of stoneware, and the finest of them are of considerable
artistic merit.

Kenya Japanese potter of the Meiji period who lived from 1821 to
1889, and whose family name was Miura. His kiln was located in the
Mukojima district of Tokyo. He regarded himself as one of the followers
of Kenzan, calling himself Kenzan V. He is usually regarded as the last
outstanding exponent of the Kenzan School.

Kenzan Japanese potter, painter and calligrapher of the Edo period who
lived from 1663 to 1743. He was the younger brother of Korin, with
whom he collaborated. He is considered the greatest ceramic artist that
Japan has ever produced. Since he lived in Kyoto and was connected
with the tea masters of the time, his pottery combined the simplicity of
the tea taste with a sense of decorative design derived from the Korin
School. His large output includes, in addition to a great variety of ceramic
wares which are outstanding for their colorful and spirited decorations,
paintings and calligraphy. His brushwork is always vigorous, using
natural forms rendered in an animated, abstract style. His work inspired,
even during his lifetime, numerous followers and disciples, and it is very
difficult even for the expert to distinguish between his own work and that
of his pupils. The situation is further confused by the fact that he had no
less than five followers, who called themselves Kenzan II, III, IV, V, and
VI, who used his seal and signature. The last of these artists, who worked
in a northern suburb of Tokyo, is primarily remembered for having been
the teacher of Bernard Leach, who therefore sometimes referred to
himself as the seventh Kenzan.

Kesa Japanese name for the ceremonial robe worn by Buddhist priests.
Pieces of different fabrics representing a variety of colors and textures are
stitched together so as to form a patchwork pattern.

Kiangsu Province in the coastal area of China, just south of Shantung

province. Its most important modern city is Shanghai. In terms of traditional Chinese culture, however, far more important are Nanking, a city which served as the southern capital during the Six Dynasties and Early Ming period and which has many important archaeological remains, and Su-chou in the Yang-tze River delta, which became the center of an important school of painters during the Ming period. Notable among them were the masters of the Wu School, named after a place called Wu-hsien in the Su-chou region, and the artist Shên Chou in particular. Another important center was the city of Yang-chou on the Grand Canal, which during the Ch'ing period was the home of a group of painters known as the Eight Strange Masters or Eight Eccentrics of Yang-chou, among whom Hua Yen was the most famous. It was also outstanding for ceramic production, with the I-hsing kilns, which produced a hard dark brown ware, being the most famous.

Kibi-no-Makibi A distinguished Japanese scholar and statesman of the 8th century. He is usually credited with the invention of the Japanese syllabic alphabet, although modern scholars have tended to doubt his prominent role in this important development. He is also well known for his two trips to China, which are represented in a famous scroll of the Kamakura period, now in the colleciton of the Boston Museum.

Kichijoten Sridevi in Sanskrit. Originally a Hindu goddess incorporated into the Buddhist pantheon, and worshipped in both China and Japan as a goddess of beauty and good fortune. She is often represented in Japanese art, the two most famous examples being a delicate ink painting from the Nara period in Yakushiji Temple in Nara, showing her as an elegant T'ang court lady; and a wooden sculpture in Joruriji Temple from the Heian period, representing her as a noblewoman from the Fujiwara court. In China, representations of her may be found among the wall paintings at Tun-huang. See also Lakshmi.

Kijimaki-e A technique in which the lacquer decoration is applied directly to the wooden surface, which remains unlacquered. It is said that it had originated already during the Heian period, but became popular during the 17th century and has been used ever since.

Kiku See Chrysanthemum.

Kimma-nuri Literally "Siamese lacquer," a type of bamboo ware, produced in Siam and Burma, which is decorated with colored lacquer. It enjoyed great popularity with the Japanese tea masters and was imitated in the province of Sanuki and called Sanuki-kimma.

Kimono A loose-fitting, robe-like garment which constitutes the traditional Japanese dress. It is worn folded over in front, and has wide sleeves. It may serve as either an outer or an under garment and is usually worn unlined in the summer, lined in the spring and autumn and padded in the winter. A variety of materials, ranging from the finest silk brocade to cotton, are used, depending on the season and occasion for which the kimono is intended. This type of garment was originally introduced from

China during the Nara period, but is used today primarily in Japan. See also Kosode, Furisode, Yukata, and Juni-hitoe.

Kimura Hyosai Japanese lacquer artist whose family name was Kimura, who lived from 1817 to 1885. He is regarded as the most outstanding lacquer artist in Kyoto during the Meiji period.

Kinai School of sword-guard makers established during the Early Edo period by Ishikawa Kinai in Echizen province, the present Fukui prefecture. The members of this school made sword-guards of iron, largely decorated with pierced relief designs, frequently representing dragons.

Kinji A type of lacquerware which uses a thickly applied gold ground. Its surface is often polished so that it truly looks like a gold object.

Kinkakuji better known as the Golden Pavilion, was originally a country villa built in 1397 on the outskirts of Kyoto for the Ashikaga shogun, Yoshimitsu. After the shogun's death, it was converted into a Zen monastery called Rokuonji. The original building was burned down by a disgruntled priest in 1950, but an exact replica decorated with gold leaf was erected in its place. It is surrounded by a beautiful garden with a lake and trees.

Kinkozan One of the kilns located in the Awata district of Kyoto which produced enamelled pottery in the Ninsei tradition from the 17th century. While the early wares produced here were of fine quality, the production declined greatly during the 19th century, when purely commercial mass-produced ceramics became the rule.

Kinran Type of Japanese silk fabric originally introduced from Ming China and first produced by Chinese weavers in Sakai near Osaka, but later also made in Kyoto, where it is being produced to the present day. A gold brocade which is woven with narrow strips of gold foil, it is valued for its gorgeous appearance.

Kinrande Type of Japanese porcelain decorated in red and gold in the manner of the Chinese porcelains of the Late Ming Dynasty. This style was developed at the Kutani kilns of Kanazawa in Ishikawa prefecture during the 19th century by a potter known as Iidaya Hachiroemon, and, was therefore known also as Hachiro-do. Due to their excellent technique and brilliant colors, these porcelains proved very popular in Japan as well as in the West.

Kintaro Kintaro or "Golden Boy," a figure of Japanese legend similar to a child Hercules. It is said that he was discovered by his foster mother, a forest demon or yama-uba, and raised among the wild beasts of the forest. The exploits of this wonder child are numerous, varying from wrestling with wild beasts to pulling out trees by their roots to catching a giant fish. Representations of him are often found in Japanese popular art, and Utamaro made several prints showing him with his foster mother.

Kiri See Paulownia.

Kirigane A form of decoration in which small rectangular pieces of gold

foil are used to decorate lacquer or sculptures and paintings. The technique originated during the Heian period, and has been popular throughout the history of Japanese art.

Kirikodoro Special lanterns used during the Bon Odori or Japanese Festival of the Dead. On this occasion, they are hung before the entrance to the house, or at the door leading to the room where the ancestral altar is located, to greet the souls of the dead members of the family. They are usually in the shape of a polyhedron, but may also be round or ribbed, and are always decorated with colored tassels and paper flowers.

Kirin Japanese term for the Chinese equivalent of the unicorn. See Ch'i-lin.

Kiseru Japanese term to describe a tobacco pipe used in Japan ever since the 16th century, when smoking was introduced by the Portuguese. It usually has a long stem and a small bowl which holds a tiny amount of tobacco, enough for only a few puffs. It was often decorated in beautiful metalwork, and the finest of these old pipes are valued today as works of art.

Kishimojin See Hariti.

Kisokaido A highway which is noted for its picturesque views, especially that of the Kiso Rapids, which is popularly known as the Rhine of Japan. It is primarily familiar in art due to a series of woodblock prints representing the "Sixty-nine Stages of the Kisokaido" which Hiroshige made.

Kitan Nomad people of Tungus stock who originally inhabited the Amur region of northern Manchuria. They conquered the territory north of the Great Wall and part of Hopei at the end of the T'ang Dynasty. They established the Liao realm in 907 and settled in Jehol and Chahar provinces. Their state, which lasted until 1125, was basically Chinese, with the bulk of the population of Chinese origin and the Kitan representing merely a small ruling class. From an artistic point of view, it is primarily significant for the rather crude but powerful ceramic tradition based on T'ang models. Numerous archaeological remains from the Liao Dynasty have come to light in recent years.

Kitano Shrine Well-known Kyoto Shinto shrine dedicated to the spirit of Sugawara Michizane, who was deified under the name of Tenjin. It is therefore also popularly referred to as Kitano-tenjin. The shrine was established in 947, but the present buildings were erected in 1607 by Hideyoshi. Among other works of art, it contains a series of nine scrolls illustrating the history of Kitano-tenjin, which are attributed to Fujiwara Nobuzane and are considered among the masterpieces of Kamakura period narrative scroll painting. It is also well known for its gardens with hundreds of apricot trees, and for its annual festival.

Kitao Studio name of Shigemasa, whose school, which produced such masters as Kitao Masanobu and Kitao Masayoshi, is therefore known as the Kitao School. See Shigemasa.

Kiyochika Japanese painter and printmaker of the Meiji period, who lived from 1847 to 1915. He first studied photography and then Japanese painting under Zeshin, and Western-style oil painting from the Englishman Charles Wirgman. He was fascinated by European prints and tried to introduce Western-style perspective and chiaroscuro into his own work. He therefore represents a marked break with traditional Japanese Ukiyo-e style prints and may be looked upon as the first of the more realistic printmakers, whose work is characteristic of the modern period in Japanese art.

Kiyohime Heroine of a popular Japanese love story involving the youthful monk Anchin and Kiyohime, the beautiful girl who fell in love with him. Upon being scorned, she turned herself into a dragon and went in pursuit of her lover. He in turn hid under the bell of Dojoji Temple, but she wound her dragon body around the bell until it became red hot, and then vanished into the Hidaka River not far from the temple. When the bell was lifted up, only Anchin's scorched bones were found. This story forms the basis of famous noh and kabuki plays, and is often represented in Japanese art.

Kiyohiro Japanese woodblock artist of the Edo period who belonged to the Torii School. He was active during the 1750's and modeled his work on that of Kiyomitsu and Toyonobu. Among his prints, the most outstanding are representations of nude figures, which are very exceptional for Japanese art.

Kiyokata Modern Japanese painter who lived from 1878 to 1972. He was a native of Tokyo and his family name was Kaburagi. He was trained in the Ukiyo-e tradition and started his life making illustrations for books, and drawings for newspapers and magazines. However, in his artistic maturity he specialized in depicting beautiful women, a type of painting which is known as bijinga in Japanese.

Kiyomasa Japanese painter and printmaker of the Edo period, who was active during the 1790's. He belonged to the Torii School and was a son and pupil of the famous 18th century master Kiyonaga. He showed considerable promise, but his career was a brief one since his father curtailed it in order not to interfere with the succession of Kiyomitsu's grandson, Kiyomine.

Kiyomasu Japanese printmaker of the Edo period who was active between 1690 and 1720. A member of the Torii school, he was a son of Kiyonobu. He specialized in the representation of courtesans and portrayals of kabuki actors. His work is outstanding for its bold line and dramatic sense of movement. His son-in-law, Kiyomasu II, who lived from 1706 to 1773, carried on his tradition, but was artistically inferior to the first Kiyomasu.

Kiyomine Japanese painter and woodblock artist of the Edo period, who is better known by the name of Kiyomitsu II, which he used in signing his

later prints. He lived from 1787 to 1868 and belonged to the Torii School. He was a student of Kiyonaga's and followed this master as his official successor. His work consists largely of scenes from the kabuki drama and actor portraits.

Kiyomitsu Japanese painter and woodblock artist of the Edo period who lived from 1735 to 1785. He belonged to the Torii family and was a son of Kiyomasu II. He was well known for his portrayal of actors and courtesans, and produced a large number of prints and illustrated books as well as some paintings. His work consisted largely of crimson prints.

Kiyomizu District of Kyoto where, to this day, the ceramic manufacturing of the ancient capital of Japan is concentrated. The best ware produced here is referred to today as old Kiyomizu or Ko-Kiyomizu, and was produced during the 18th century, following the tradition of the enameled pottery of the greatest potter of the Kyoto school, Ninsei. During the 19th century, the Kiyomizu kilns began to specialize in enameled porcelains decorated with designs taken from nature, such as cherry branches, bamboo, pine, and all sorts of grasses and flowers, executed in bright enamels or gold and silver over the glaze.

Kiyomori Japanese general of the Heian period who was the most illustrious member of the Taira family and lived from 1118 to 1181. He distinguished himself during the civil wars of the Late Heian period and became a prime minister of Japan, a post which enabled him to place many members of his family in positions of power. But after some twenty years of ascendancy, the Tairas were overthrown by Minamoto Yoritomo, who established the Kamakura rule. Kiyomori and the events relating to the story of the Taira clan are often represented in Japanese art.

Kiyonaga Japanese painter and printmaker of the Edo period, who lived from 1752 to 1815. A leading exponent of Ukiyo-e and the fourth master of the Torii line, the artist is usually regarded as one of the greatest of all Japanese printmakers. He was a pupil and adopted son of Torii Kiyomitsu (1735–1785), whose successor as head of the school he became in 1785. Early in his career, he made prints of kabuki actors, but later turned almost entirely to the portrayal of female beauties, especially the courtesans of the Yoshiwara district. His work enjoyed tremendous success during his lifetime, and was widely imitated by his pupils and followers. He created an ideal type of feminine beauty, with tall, slender body and delicate facial features, which has become associated with his name. His prints, which often take the form of diptychs and triptychs, are outstanding for their fine composition, the firmness and subtlety of their lines and the beauty of their colors.

Kiyonobu Japanese printmaker of the Edo period who lived from 1664 to 1729. A member of the Ukiyo-e School, he is looked upon as the founder of the Torii line. The son of an actor, he accompanied his father to Edo in 1687 and came under the influence of the founder of the Ukiyo-e School,

Hishikawa Moronobu. He was also influenced by the bold draughtsman-ship and the striking composition of the theatrical posters made by his father. His prints, the first one of which appeared in 1695, dealt primarily with kabuki actors.

Kiyoshige Japanese painter and printmaker of the Edo period who was active from the late twenties to the early sixties of the 18th century. He was a member of the Torii School and a pupil of Kiyonobu I. He por-trayed both actors and courtesans, and is primarily famous for his large pillar prints and book illustrations.

Kiyotada Japanese painter and printmaker of the Edo period who was active during the twenties and thirties of the 18th century. He belonged to the Torii School and is believed to have been a pupil of Kiyonobu, whose style his work reflects. He was a talented artist, but unfortunately very little of his work is known today. Most of his prints are executed in the beni-e and urushi-e techniques.

Kiyotsune Japanese painter and printmaker of the Edo period, who was ac-tive from the late fifties to the seventies of the 18th century. He belonged to the Torii School and was a pupil of Torii Kiyomitsu. His style was very much like that of his master, but he brought to it a delicacy and charm for which he is noted. He is best known for his actor prints and those showing the interior of the kabuki theatre, in which he employed Western-style perspective.

Ko Name of Chinese ceramic ware. See Kuan ware.

K'o Chinese term for a dagger axe, originally made in stone in pre-historic times, and later executed in bronze and iron, and jade. The finest examples of these from the Shang period have elaborately decorated bronze handles with animal designs and jade blades.

K'o Chiu-ssu Chinese painter of the Yuan period who was born in Chekiang province in 1312 and died in 1365. A gentleman scholar and painter, he specialized in the depiction of bamboo and landscapes. His best works are his pictures of bamboos, which are presented in sensitive compositions with stones and old trees. He was primarily admired for his fine brushwork, which emphasized the calligraphic quality and the ink tones rather than the presentation of the visual reality. Good examples of his work are found in Chinese collections.

K'o-ssu A Chinese term referring to a silk tapestry which is decorated with a pictorial design. The technique employed was probably introduced from the Turkish and Uigur peoples of Central Asia during the Sung period and became very popular during the Ming and Ch'ing Dynasties. Designs, often copied from paintings, were reproduced in bright colors and minute details, achieving pleasing decorative effects.

Koami Name of a celebrated family of lacquer makers which was estab-lished during the 15th century and has continued through nineteen generations to the modern period. The most famous artist of that school was the seventh master, who called himself by the artist's name

Nagayasu, and was also known as Choan. He lived from 1569 to 1610 and was employed by the great military ruler Hideyoshi. After Hideyoshi's death, he also worked for the first Tokugawa shogun, Ieyasu. It is said that many fo the finest of the Momoyama palace lacquers in the Kodaiji style were executed by him. The members of the Koami family continued to be employed by the Tokugawa shoguns, and artists such as Nagashige, the tenth in line, who lived from 1599 to 1651, are well known for the splendid gold lacquers produced for the shogun's court.

Koan Kung-an in Chinese. Riddle or mysterious saying which is used by Ch'an, or, in Japanese, Zen, Buddhist teachers as an object of meditation and a means of gaining enlightenment. Many of these sayings appear strange and paradoxical and are designed to open up, to the student of meditation, new realms of insight and awareness. One of the most famous of these is, "What is the sound made by one hand?"

Kobako or kogu. A small cabinet of lacquered wood, used in the tea and incense ceremonies. It is usually divided into three compartments which contain the incense, the talc squares or ginyo on which the burning incense will be set as it is passed among the guests during the incense ceremony, and the charred residue of the incense.

Koban Japanese term to describe the size of a Japanese woodblock print which measures 21.2 cm. by 15.1 cm., or 8.3 in. x 5.9 in.

Kobo Daishi Posthumous name for the famous Buddhist monk Kukai. See Kukai.

Kodaiji A small modest sanctuary erected in Kyoto by the widow of Hideyoshi, in memory of her late husband, in 1606. Its most outstanding buildings are the Kaisando or Founder's Hall, decorated with paintings by artists of the Kano and Tosa Schools, and its mortuary chapel, which contains some of the most splendid lacquer work of the Momoyama period.

Kodansu Small Japanese cabinet decorated with lacquer and furnished with interior drawers sometimes containing small boxes and a tray. It is often a very handsome piece with chased brass hinges and lock, and serves as a case for jewelry and other small personal items. The size of the average kodansu is about 13 in. x 15 in. x 12 in.

Kodo Japanese term for the lecture hall of a Buddhist monastery, usually located behind the kondo or main hall. It is here that the monks assemble to hear the prelate deliver lectures on the sutras.

Koetsu Japanese painter, calligrapher, lacquer artist and potter of the Edo period, who lived from 1558 to 1637. Although his father was Taga Muneharu, he was adopted by Honami Koshin, whose family name he took. The Honami family was a prominent Kyoto family of sword makers and art connoisseurs, and through this connection and his close collaboration with Sotatsu, he became one of the most influential and important artists of his time. The shogun Tokugawa Ieyasu presented him with a villa at Takagamine near Kyoto, where Koetsu founded an art col-

ony which attracted some of the best artists and artisans of that period. His work is characteristically Japanese with its strong sense of decorative design, its use of gold and silver, and its emphasis on calligraphic line. His lacquers, which use gold dust in the maki-e technique, and inlays of lead and mother of pearl, are considered among the great masterpieces of this art form, and his raku bowls are thought of as being among the supreme works by Japanese ceramic artists. His style was imitated by many later artists and has exerted a profound influence on the decorative arts of Japan. Outstanding examples of his work may be found in the National Museum in Tokyo, which has a famous writing box by him, and examples of his calligraphy may be found in many museums and galleries in both Japan and the United States.

Kogai Japanese term used to describe an implement shaped like a blunt knife or skewer, which is carried in slots in the sides of scabbards of certain swords. The hilts are exposed and rise above the surface of the guards, which are pierced to accommodate them. They are often decorated with low relief designs worked in the body of the kogai itself. It is believed that originally the function of the kogai was to smooth and part the hair under the helmet.

Kohosai Netsuke carver of the late 19th century. A native of Osaka, he is believed to have died around 1907. He is well known for his minute carvings of chrysanthemums in ivory.

Koi Japanese painter of the Edo period who lived from c.1569 to 1636. A member of the Kano School by adoption, he had been a pupil of Kano Mitsunobu, and is primarily remembered for having been the teacher of Kano Naonobu and Kano Yasunoba. Some sources also claim that Tanyu was trained by him, although this seems unlikely. He served the Kii branch of the Tokugawa family and was one of the artists who decorated the apartments of the Nijo Castle in Kyoto. His style was influenced by Chinese painting and that of the great Japanese ink painter Sesshu, but showed little originality.

Kojiki or *Record of Ancient Matters*, is the first written book of Japanese literature. It is our best early source for Japanese mythology, legends, customs and manners. It was gathered together at the request of the emperor Mommu, and was completed in the year 712. It was translated in 1882 by the British scholar Basil Chamberlain.

Kojiri Japanese term to describe the chape covering the butt of the sword scabbard. It was often decorated with embossed designs.

Kokan Japanese painter and printmaker of the Edo period who lived from 1738 to 1818. He first studied Kano School painting, but soon turned to Ukiyo-e models, entering the Studio of Harunobu, and made prints in the style of the master. For these he used the name Harushige, and it is said that after Harunobu's death, he also often falsified his teacher's signature on his own prints. However, he is even more important as the first Japanese artist to employ etching and to make prints using Western

perspective and shading. They are, however, more historical curiosities than works of art comparable to his best Ukiyo-e prints.

Kokechi also known today as shibori-zome, is the Japanese term for the tie-dying technique which was first used in Japan during the Nara period. The cloth is tied in knots and then placed in the dye, producing patterns of circles of varying size. The special technique of dyeing series of minute circles was called kanoko-shibori during the Edo period. The kokechi dyeing process was combined with hand painting during the Muromachi period to introduce the tsujigahana-zome method of design. See Tsujigahana.

Kokedera Literally "Moss Temple," name popularly given to Saihoji Temple. See Saihoji.

Kokei Netsuke carver of the late 18th century. He specialized in carving animals, especially tigers, in boxwood. He was a follower of the famous carver Minko who came from his native place of Ise and adopted his realistic style.

Kokei Japanese painter of the Showa period who lived from 1883 to 1958. He was a native of Gifu prefecture and his family name was Kobayashi. He had studied Yamato-e painting and continued working in a Japanese style throughout his life, although he showed a greater degree of realism than is usually found in traditional Japanese painting, which is probably due to Western influence. He painted Buddhist subjects and scenes from Japanese legend, and was one of the leading painters of the modern period working in the Japanese style.

Kokeshi-ningyo Japanese term used for the dolls which are made in the Tohoku region of northeastern Honshu. Originally intended as toys for the children of the area, they have become one of the most popular objects of Japanese folk art, and their production has continued to the present day. The bodies of the dolls are plain cylinders, rounded at the shoulders, with almost spherical heads. The facial features are painted on with thin delicate strokes, as are the decorative designs executed in two or three colors which ornament the body.

Kokusai Mid-19th century netsuke-carver whose family name was Ozaki. He was well known for his horn carving in a unique style which was called Kokusai-bori, and which became very popular. He was the father of the famous novelist Ozaki Koyo.

Kokushi An honorary title literally meaning "National Teacher," which was bestowed by the imperial court on certain great priests including Daito Kokushi and Muso Kokushi. The portraits of many of these religious figures were painted by Japanese portraitists.

Kokuzo Bosatsu Japanese name for the Bodhisattva Akashagharbha. See Akashagharbha.

Koma Famous family of Edo lacquer makers founded by Kyu-i during the 17th century. Among his many followers, the 18th-century masters Kyoryu and Kyuhaku are the best known, but other members of the

school continued working right through the 19th century. They excelled in maki-e with decorative designs executed in a sensitive realistic style.

Koma-inu Japanese term literally meaning "Korean dog," applied to the dog-like figures which are placed as guardians at the entrances to Shinto shrines. They are looked upon as messengers of the deities and protectors of the sacred precinct. One of them is usually shown with an open mouth, the other with a closed one. They are no doubt originally derived from the Chinese lion used in Buddhist art, and one of them in fact was originally referred to as Kari-shishi, meaning "Chinese lion."

Komachi whose full name is Ono-no-Komachi, was a beautiful court lady and famous poetess of 9th-century Japan. The story is told of her leaving the imperial court in search of her father, who had become a Buddhist priest. She fell ill far from the capital, but after a vision of the Buddha of Medicine came to her and told her to find the cure for her illness at the hot springs of the Azume River, she regained her health and found her father. She is regarded as one of the Thirty-six Great Poets of Japan and is frequently represented in Japanese painting.

Komuso Mendicant monk-soldiers who are recognizable by their curious headgear which consists of straw hats covering the entire head, with two holes pierced for the eyes. They are often represented in illustrated books and woodcuts.

Komyokogo Japanese empress of the Nara period who lived from 701 to 760. She was particularly noted for her piety and for her patronage of Buddhist art. In 747 she founded Shin Yakushiji Temple in order to effect a cure for her husband, the emperor Shomu, who was suffering from an eye disease. At his death she deposited all the art works he owned at Todaiji Temple, where they have been preserved in a storehouse known as the Shosoin ever since. See Shosoin.

Kondo or Golden Hall, is a Japanese term applied to the main hall of a Buddhist temple in which the image of the Buddha to whom the temple is dedicated is housed. The most famous of these kondos is the one at Horyuji, going back to the Asuka period, although the present-day building is an exact replica of the ancient temple which was destroyed by fire in 1949. See Horyuji.

Kongo or thunderbolt, is a symbol of power held by the Buddhist deities, notably Vajrapani—the Thunderbolt-bearing Deity. It is also widely used in Esoteric Buddhism as an emblem of magic power. Its origin goes back to ancient India where the thunderbolt was associated with the great god Indra, and symbolized him as a sky god who was in control of thunder and lightning.

Kongokai mandara or Vajradhatu mandala in Sanskrit. A magic diagram representing the Diamond World or the World of Ultimate Essences as conceived of by the Buddhists of the Esoteric sects. It represents the Buddha Vairocana in the center as the indestructible and eternal essence of all being, and the other Buddhas, Bodhisattvas, minor deities and sacred

symbols in eight squares which symbolize the Buddha world. This scheme is often represented in the sculpture and painting of Japan.

Kongorikishi or Vajra-vira in Sanskrit. Japanese term meaning the "strong men who hold the thunderbolt," referring to guardian figures often represented at the entrance of Buddhist temples. The most famous of these are at the gate of Todaiji Temple in Nara. See also Nio.

Korakuen Name of a park belonging to the prince Tokugawa, daimyo of Mito, located at Koishikawa in Edo. During the last years of the 18th century, it was the site of a pottery kiln which mainly produced utensils for the tea ceremony, intended for the exclusive use of the prince. The products, executed in the style of Raku ware, are marked with the name Korakuen or simply Koraku.

Korin Japanese painter, lacquer artist and textile designer of the Edo period who lived from 1659 to 1716. An artist of great brilliance and versatility, he was, next to Sotatsu, the most outstanding member of the Rimpa School of Japanese-style decorative painting, and one of the most famous and influential of all Japanese artists. The main influence on his work was that of Sotatsu, although he actually studied with masters of the Kano School. He worked both in Kyoto and in Edo, and enjoyed the patronage of the nobility and the wealthy merchants. His output was vast and, since he inspired many followers, there are a great number of works bearing his signature, of which probably only a fraction are by the artist himself. His most famous works are his screen paintings with their bold decorative design, brillant colors and wonderful sense of pattern. Among these the two most famous are the "Iris Screen" in the Nezu Museum in Tokyo, and the "White and Red Plum Trees Screen" in the Atami Museum. But other fine examples of his work are found in Boston, New York and Washington. Of his lacquers, a writing box with an iris design, now in the National Museum in Tokyo, is the most outstanding example.

Koro A Japanese term meaning "incense burner." They may be of a variety of material with metal, pottery and porcelain the most populer. The simpler ones consist of cylindrical vessels with an opening for the incense smoke at the top. However, others may take on more complex sculptural forms representing scenes from Chinese and Japanese mythology.

Koryusai Japanese painter and printmaker of the Edo period who was active between 1764 and 1788. He came from a military family by the name of Isoda, but turned to printmaking early in his career. Although his teacher was Shigenaga, he was primarily influenced by Harunobu, whose style and subject matter he imitated. The grace and charm of his prints of beautiful women rivals that found in the work of Harunobu himself. He is also well known for his depiction of birds and flowers and his book illustrations. It appears that he turned to painting in his later life and made no prints after 1780.

Kose Family name of a school of Japanese painters whose founder was Kose no Kanaoka, who was active during the second half of the 9th cen-

tury. He was followed by his sons Kimmochi, and Kintada, and they in turn were succeeded by Fukae and Hirotaka. All of them were famous artists in their day, but no works which can with certainty be attributed to them have survived. It is thought that the Kose School was the forerunner of the Yamato-e School of the Later Heian and Kamakura periods.

Kosetsu Japanese painter of the Edo period who lived from 1800 to 1853. His true name was Sakamoto Chokudai and he was a doctor for the Kii clan. He had studied painting under a Kano master and excelled in painting cherry blossoms and orchids.

Koshin Shinto god of the roads, whose companions are three monkeys who are also, therefore, often referred to as Koshin. The most famous depiction of them is the sculptural representation on the gate of the mausoleum of the first Tokugawa shogun, Ieyasu, at Nikko; they are shown covering their ears, mouth, and eyes to indicate that they hear no evil, speak no evil, and see no evil.

Kosobe A type of ceramic ware made in a district of that name in Osaka, which was related to the Seto kilns and produced tea wares derived from the Korean pottery of the Yi Dynasty. It was a thick stoneware with a dark brown glaze modulated with sections of brighter or darker color. It was sometimes covered with a second layer which was allowed to run down the sides of the vessels.

Kosode Japanese term for a lined, small-sleeved kimono made of silk which serves as the ordinary form of traditional Japanese dress. It was originally the innermost kimono of the voluminous twelve-layer court dress adopted during the Late Heian period, but in the Muromachi period, the various outer layers were eliminated from the costume until the kosode became the outside garment.

Koto A Japanese term for a musical instrument known as the ch'in in China, from where it was imported. It is a sort of horizontal miniature harp or zither, which is played by being plucked with a plectrum held in the right hand. The earliest example of such an instrument is found in the Shosoin. It has enjoyed widespread popularity in Japan throughout its history, and learning to play the koto even in present-day Japan, is considered one of the polite accomplishments of young ladies of culture, similar to learning the piano in the West. Koto players are often represented in Japanese painting and prints.

Koyasan Mountain, located south of Osaka in Wakayama prefecture, which is celebrated for its Shingon monastery. In spite of numerous fires the monastery still contains 120 buildings. It was founded by the famous priest Kobo Daishi in A.D. 816, and to this day is the most famous of all Shingon temples, being visited by over a million pilgrims each year. Among the many works of art found here is an image of Kobo Daishi and a celebrated Heian period painting representing the death of Buddha. Its great gate, or Daimon, has two guardian images which are attributed to the Kamakura sculptor Uncho. It also contains an extensive graveyard

with monuments for many illustrious Japanese, including the founder of the monastery.

Kozanji Buddhist temple located at Tagano-o near Kyoto at the foot of Mount Atago, on the banks of the Kiyotaki River, which is noted for its magnificent scenery. It is primarily famous for the narrative scrolls in its possession, especially those depicting animal caricatures, attributed to the Heian period abbot, Toba Soyo, and for the six scrolls illustrating the history of the Kegon sect.

Kozuka Small knife which is placed in a special section of the scabbard of a larger Japanese sword. Its hilt is always flat and passes through the sword guard, which has been pierced with an oval opening, allowing the small kozuka to be drawn without disturbing the larger weapon.

Kshitigarbha or Ti-tsang in Chinese, and Jizo in Japanese. Major Bodhisattva worshipped in China and Japan. He was looked upon as the protector of travelers and children, and the guardian of the earth, his name meaning "matrix of the earth." His symbols are the alarm staff or shakujo with which he warns the insects in his path so that he might not step on them, and the magic jewel. He is often represented in both the sculpture and the painting of China, and especially in Japan.

Ku Chinese bronze shape, found among the ritual vessels of the Shang period, in the form of a tall beaker with a wide flaring lip and a narrow circular body. It was, in later times, often imitated in porcelain and then thought of as a flower vase, but it originally was intended as a vessel for wine offerings to the spirits.

Ku An Chinese painter of the Yuan period who was active during the first half of the 14th century. He was a native of Yang-chou in Kiangsu. He is primarily known as a painter of bamboo, an artistic genre which was particularly popular during that age. His style was vigorous and simple, bringing out the beauty and quality of the bamboo. Two large paintings by him, representing bamboo in the wind, are in the National Palace Museum in Taipei.

Ku Chêng-i Chinese painter of the Ming period who was active during the 16th century. Few of his works survive today, but he was regarded in his time as one of the outstanding artists of the Southern School. His work is very much influenced by that of the masters of the Yuan period, notably Ni Tsan and Huang Kung-wang. He is traditionally regarded as the founder of the Hua-t'ing School.

Ku hua p'in lu Famous Chinese literary work on painting, written by the Chinese critic and painter Hsieh Ho, who was active in Nanking around A.D. 500 during the Six Dynasties period. His Six Principles or Six Canons have been cited by Chinese writers on painting for many centuries, and several translations of them have been attempted by Western writers. The first of the terms in particular has been a subject of much debate. See Hsieh Ho.

Ku Hung-chung Famous Chinese painter of the 10th century, who was active during the Five Dynasties period. He is primarily known for his portrait painting, notably a famous scroll entitled "Night Entertainment of Han Hsi-tsai;" which has been preserved in several versions; the earliest of these is in the Palace Museum in Peking. In it the social life of elegant Chinese society of his period is rendered in a realistic style in vivid detail.

Ku K'ai-chih Chinese painter of the Six Dynasties period who is believed to have been active during the second half of the 4th century. An artist who was already famous in his own lifetime and served at the Chin court at Nanking, he is particularly important for being the only early Chinese artist of note by whom originals or at least close copies exist today. Chinese records praise him for his religious paintings and his portraits, yet none of these survive. The two works on which his great fame depends are a long handscroll in the British Museum, known as the "Admonitions of the Instructress to the Court Ladies," and the "Nymph of the Lo River" scroll, of which one copy is in the Freer Gallery and another one in Peking. The later work, especially, seems to reflect the style we associate with the 4th century, and no doubt gives a good idea of the kind of painting which an artist such as Ku K'ai-chih would have produced. The dominant elements are the human figures, which are rendered in a very animated linear style, while the landscape setting and the treatment of trees are still rather archaic. The scroll in the British Museum is artistically of an even higher order, but does seem to be from a somewhat later date, perhaps a T'ang copy of an original by the master. Its theme is a typically Confucian one of portraying models of behavior. The characterization of the figures is excellent, and its treatment of line, subtle colors and delicate shading make it one of the masterpieces of Chinese painting.

Ku Kung Shu Hua Chi Catalogue of Chinese paintings in the Palace Museum in Peking, which was issued in many volumes beginning with 1931. Although not particularly well printed, it is still the most complete record of the former Imperial Collection, now housed in the National Palace Museum in Taipei, Taiwan. Many of these paintings have also, in more recent years, been published in a variety of publications issued by the National Palace Museum. This collection is not to be confused with the one now on display in Peking, which was formed after the establishment of the People's Republic, and is also often referred to as the Peking Palace Museum, or the Hui-hua kuan.

Ku-wên or "ancient script," is the style of Chinese writing developed after the shell-and-bone script of the Shang period, and was used extensively prior to the 3rd century B.C. It occurs in the inscriptions found on the bronze vessels of the Chou period (late 11th century B.C.). The characters are strong and of well-balanced construction. Many later

calligraphers have imitated the ku-wên style to train their eye and hand to reproduce these qualities in their own work. This script was eventually supplanted by the Ta-chuan or "Great Seal" style later in the Chou Dynasty.

Ku Yüeh-hsüan or "Ancient Moon Terrace," is a term found inscribed on certain fine porcelains which were made for the Chinese imperial court during the 18th century. The wares are rare and costly, usually small in size, delicately potted and decorated with enamel colors. The term is also found inscribed on inferior pieces of glass and porcelain, chiefly snuff bottles which are of later date, making the use of this designation somewhat confusing. It has therefore been suggested by some authorities that it would be more accurate to refer to these porcelains as fa-lang enamel ware.

Kuan-hsiu Chinese painter of the T'ang period who lived from 832 to 912. A monk and religious artist, he spent his youth in a Ch'an Buddhist monastery and visited temples throughout the country. He specialized in the depiction of Buddhist holy men or Lohan, rendered in a strange and powerful style, bordering on caricature. Although no originals by his brush exist today, numerous works reflecting his style, both in the form of paintings and of rubbings from stone engravings, survive. The most famous examples are a series of sixteen Lohan paintings in the Japanese Imperial Collection.

Kuan Tao-shêng Chinese painter of the Yuan period who was born in 1262 and died around 1315. One of the few female painters in the entire history of Chinese art whose name and career are recorded. She was the wife and pupil of the famous Yuan painter Chao Mêng-fu, and became a celebrated painter in her own right. She specialized in the painting of bamboo and orchids. Works of hers have survived to the present day and indicate that she was a skillful, although not highly original, artist.

Kuan-ti also referred to as Wu-ti, is the Chinese god of war. During his lifetime, he was the general Kuan Yü, a great military hero of the Three Kingdoms period. His exploits, along with those of his two sworn brothers Chang Fei and Liu Pei, are recorded in the famous Tale of the Three Kingdoms (*San Kuo chih ven i* in Chinese). Kuan Yü was taken prisoner and executed in A.D. 220, but even after his death was believed to have exerted a powerful influence for the protection of the nation. In 1594 he was awarded the title of Ti (emperor or god), and from then on was worshipped as Kuan-ti or Wu-ti, the god of war, and became one of the most popular deities of China. In art he is usually depicted as an ugly man dressed in full armor and brandishing a sword or halberd. He is, however, also worshipped as a secondary god of literature, having been able to recite the *Spring and Autumn Annals* and Tso's commentary from beginning to end. In this context, Kuan-ti appears as a bearded man holding a copy of the *Annals*.

Kuan T'ung Chinese painter of the Five Dynasties period who was active during the early years of the 10th century. One of the outstanding painters of his time, he was much admired for his landscapes, which portrayed the towering majesty of the mountains contrasted with the tiny figures seen against them. His work exerted a great influence on Sung and Yuan painting, and was wisely imitated, but very few, if any, originals by his brush survive today. An outstanding picture attributed to him, which may well be by his hand, is a hanging scroll called "Ford of a Mountain Stream," now in the National Palace Museum in Taipei.

Kuan ware or literally "official or imperial" ware. A type of porcelaneous stoneware which is outstanding for the subtle beauty of its glazes which vary in tone from a green to a pale bluish grey or lavender. The distinction is made between northern Kuan, made for the Northern Sung court at K'ai-fêng, and southern Kuan, made after the court was moved to the south to a suburb of Hang-chou. It is one of the most elegant of all Chinese wares and is particularly valued by collectors. It is believed today that a ware referred to as Ro ware was a variant of kuan ware, although of a somewhat coarser type.

Kuan-yin Chinese name for the Bodhisattva Avalokitesvara. See Avalokitesvara.

Kuang Chinese term for a bronze ceremonial vessel shaped not unlike the gravy boat in Western ceramics. It is one of the largest and most impressive of ritual bronzes. It may appear with or without a cover, and at times takes the shape of an animal or bird. It was probably employed for pouring sacred wine in ceremonies honoring the spirits.

Kuei Chinese term for the shape of an ancient bronze ritual vessel consisting of a large deep circular bowl, usually with two or four handles. There are many variations of this shape, some of which are mounted on a rectangular base, others on three small legs. The term kuei is a modern form of the character chiu found in ancient inscriptions.

Kuei Chinese term used to designate an ancient jade sceptre. There are two basic forms which the sceptre may take: one is that of an elongated flat tablet with a slight point at one end, while the other consists of a blade which, rather than coming to a point, widens and has an arc cut out of the end to form a concave edge. Both types were used as emblems of office or as insignia of the nobility. Their use and significance are described extensively in the ancient text, the *Chou-li*.

K'uei dragons Small dragon-like creatures used as decorative elements on ancient Chinese bronzes. They are represented in profile with widely opened mouths. Most strongly identified with the Shang and Early Chou styles, they also appear in modified forms on pieces dating from the Middle and Late Chou periods.

K'uei Hsing One of the gods of literature in Chinese mythology, he is regarded as the distributor of literary degrees and was invoked to obtain

success at the competitive public examinations. Images and temples dedicated to him are extremely numerous. K'uei Hsing is often represented standing on the left of Wên Ch'ang, the principal literary deity, in whose temples there is almost always a secondary altar consecrated to his worship. K'uei Hsing himself is represented as being of diminutive stature, but having a demonic face; he stands on his right leg with the left leg raised up behind. In his right hand he holds up a writing brush, and with his left, grasps a tou or official seal. See also Wên Ch'ang.

Kugikakushi Japanese term to describe the ornamental metal pieces used in traditional Japanese architecture to cover the wooden pegs where the lintel and uprights cross.

Kujaku Myo-o Japanese name for the Indian divinity Mahamayuri. See Mahamayuri.

Kukai Famous Japanese Buddhist priest who is better known by his post-humous name Kobo Daishi, or Kobo the Great Teacher. He went to China where he studied the Esoteric sects of Buddhism, and upon his return in 807, founded the Shingon or True Word sect, which was to play a tremendous role in the spiritual life of Japan and profoundly influence its religious art. In the doctrines of the sect, Dainichi, the Great Il-luminator and the Japanese form of the Cosmic Buddha Vairocana, was seen as the supreme Buddha of whom everything else is only an emana-tion. He was the founder of the great Shingon temple at Koyasan, where his tomb can still be seen. He was also important in giving Buddhism a strong Japanese bent by teaching that the Shinto deities were but manifestations of the various Buddhas and Bodhisattvas.

Kumano District on the Kii Peninsula of Wakayama prefecture, where three of the most venerated of Shinto shrines are located. The most famous of these is the Kumano-Nachi Shrine, built in the 4th century at the highest waterfall in Japan. It forms the subject of one of the most famous Japanese landscape paintings dating from the Kamakura period. The other shrines are the Kumano-Hayatama Shrine and the Kumano-ni-masu Shrine. All of them contain important cultural properties, are very an-cient and are often represented in mandara paintings dealing with Shinto shrines.

K'un-ts'an Chinese painter of the Ch'ing period who was active during the second half of the 17th century. He is believed to have lived from c.1612 to c.1697. He was a Buddhist priest and later in his life he became the ab-bot of the Bull Head Monastery in Nanking. As an artist, he used the pseudonym Shih-ch'i, and was a member of the Eccentric School of Chinese painting. Like many artists of this school, he was an amateur painter in the best sense of the word: a recluse who was not known as an artist outside of his own circle, and gave his works away to friends. But after his death, his reputation increased, and he is regarded today as one of the most original and interesting painters of the Early Ch'ing period. His towering and austere mountain landscapes, with their detailed and

powerful brushwork, are sombre and restless, and reflect his own highly individual view of nature. A good example of his work is the ''Autumn Landscape in Rain,'' now in the Ashmolean Museum in Oxford.

Kundaikan Sayu Choki A list of artists compiled by the famous Muromachi period painter, poet and art critic, Naomi. The text, first completed in 1476 and later revised and edited by Naomi's grandson Soami in 1511, contains a list of the artists represented in the collection of the Ashikaga shoguns.

Kung Hsien Chinese painter of the Ch'ing period who was active from about 1660 to 1689. A hermit and eccentric, he was regarded as one of the Eight Great Masters of Nanking, and one of the most original and expressive painters China has ever produced. Although he studied the old masters, he liked to declare, ''I am the first and the last of my sort.'' His somber expressionistic renderings of landscapes, mirroring a tragic view of life and devoid of human beings, are among the most impressive of 17th century paintings, and enjoy a great popularity with modern Chinese artists and collectors. He is also the author of a treatise on landscape painting which is called ''Secrets of Painting.'' Outstanding examples of his work may be found in the Nelson Gallery and in the Drenowitz Collection in Zürich.

Kung K'ai Chinese painter of the Late Sung and Early Yuan periods, whose active career lasted from 1260 to 1280; at that time, he went into retirement rather than serve the Mongel rules. A painter of the grotesque and fantastic, he specialized in the painting of scenes of demons and the supernatural, rendered in a very free and vigorous style. An outstanding example of his art is ''Ch'ung K'uei the Demon Queller on his Travels,'' now in the Freer Gallery in Washington, which in its wild imagination, robust humor and powerful brushwork, exemplifies the kind of work associated with the master.

K'ung-tzu Better known by his latinized name, Confucius, in the West, he is usually regarded as the greatest of all Chinese sages, and has been revered as a great philosopher and teacher both in China and Japan. He lived during the Late Chou period from 351 to 479 B.C. When he died at the age of seventy-three, he left one descendant, a grandson, through whom his family has descended to the present day. Numerous temples dedicated to him are found throughout the Far East, notably the one in his native town. His discourses, known as the *Analects*, were recorded by his disciples; he also edited several of the classics of Chinese literature, such as the *Book of Poetry* (*Shih Ching*), and is credited with the authorship of the *Spring and Autumn Annals (Ch'un Ch'iu)*, which was a history of his native state. The emphasis in his philosophy was upon filial piety, propriety in conduct and the performance of one's social obligations; he was not much interested in metaphysics and the world after death. His teachings have had a profound influence on both China and Japan, and to this day govern much of the behavior of these two peoples, even if the

individuals guided by his thought are not aware of it. His likeness has often been reproduced, in both sculptural and painted form, and some of the finest Chinese temples are dedicated to his memory.

Kunimasa Japanese painter and printmaker of the Edo period who lived from 1773 to 1810. He belonged to the Utagawa School, and was a student of Toyokuni's. He specialized in the actor prints, and tried to combine the dramatic intensity of Sharaku with the decorative style of Toyokuni. He emphasized the pageantry and drama of the kabui, but did not achieve the profound interpretation of the actor's personality found in Sharaku's prints, nor the aesthetic beauty of the best of his teacher's work.

Kuniyoshi Japanese painter and printmaker of the Edo period who lived from 1797 to 1861. A member of the Ukiyo-e School, he was a pupil of Toyokuni's, but developed a highly original style which reflected, in addition to the tradition of the Utagawa School of his master, whose name he took, the influence of the Kano and Ukiyo-e Schools, and also that of Western prints which were becoming known in Japan at that time. His best known works are his landscapes, and his depictions of scenes from Japanese history and legend, which emphasize the sense of drama in the events portrayed; in their rendering of space and shading, these reflect his study of Western art.

Kuo Hsi Chinese painter of the Sung period who was born in 1020, and is believed to have died around 1090. He was an outstanding landscape painter, and one of the most influential writers on Chinese painting; his essay on landscape painting is the best statement on the aims and philosophy of Sung landscape painting we have. A pupil of Li Chêng, he further developed the type of poetic and deeply spiritual landscape painting for which the Sung period is famous. Unfortunately, none of the wall paintings for which he was celebrated survived, but one of the finest Chinese paintings in existence, called "Autumn in a River Valley," now in the Freer Gallery in Washington, is generally believed to be an original by the master. In its subtle brushwork, its lyrical treatment of the landscape with its towering mountains, gnarled old pines and misty atmosphere, it relfects the kind of subject and the style associated with his work.

Kuo Jo-hsü Chinese art critic of the 11th century, whose discussion of Chinese painting is one of the most important reference books for factual information and contemporary opinion on the painters of the Northern Sung period. A translation of his work into English by Alexander Soper was issued in Washington in 1951, under the title *Experiences in Painting*.

Kuroda Seki Japanese painter of the Meiji period who lived from 1866 to 1924. He came from a noble family from Kagoshima. In 1884 he went to Paris to study law, but instead studied painting under Raphael Collin. He was one of the pioneers of Western-style oil painting in Japan. He founded a private art school and later became professor of Western-style painting

at the Tokyo School of Art, a member of the Imperial Art Committee, and President of the Imperial Art Academy. His work, although often representing Japanese subject matter, is wholly Western in style, and he is regarded as the most outstanding Meiji painter using the naturalist and impressionist styles.

Kuruma Japanese term used for a two-wheeled wagon, which is derived from the Japanese word for wheel. This vehicle is often represented in Japanese painting, both as a utilitarian cart and as a decorative design, notably in the form of the hana kuruma or "flower-carrying kuruma," which was looked upon as a symbol of happiness. The kuruma in the form of a flaming wheel may also be a symbol of Buddhism.

Kushida A type of decorative pattern consisting of parallel lines, used to decorate the base of porcelain dishes. These designs are found in the Nabeshima wares and resemble the teeth of a comb. They are usually executed in cobalt blue under the glaze.

Kutani Name of the kiln site located near Kanazawa in Ishikawa prefecture, where the finest porcelains of eastern Japan were produced during the Edo period. Japanese critics regard the products of these kilns as the most characteristically Japanese of all the porcelains produced in the country. The early history of the kiln is somewhat obscure, but it is believed that it was founded by the Lord Maeda who sent a potter to Arita to learn the closely guarded secret of making porcelains. The earliest of these wares, made between c.1660 and c.1690, are referred to as Ko-Kutani, or Old Kutani, and are today the most highly esteemed of all Japanese porcelains. Particularly fine are the Ao-Kutani, or Green Kutani wares, in which a rich dark-green color predominates. Others use a variety of enamel colors in which bird and flower designs, landscapes and decorative designs are drawn over the glaze. Yet other early Kutani are executed in blue and white. The Kutani kilns were revived during the 19th century by a rich merchant named Yoshidaya. These Late Edo-period wares resembled the early ones, but were less strong and spontaneous in drawing; they are known as Yoshidaya wares. During the later 19th century, highly decorated red and gold wares, referred to as Kinrande, were produced, which enjoyed wide popularity. Although ceramics are still being manufactured today in this district, none of them are of any great artistic merit.

Kuya Japanese Buddhist monk who lived from 903 to 972. He was famous for his evangelical zeal, which led him to wander all over Japan preaching the doctrine of salvation through the worship of Amida and the recitation of his sacred name, the so-called Nembutsu. He is, therefore, looked upon as one of the founders of Jodo Buddhism. His portrait by Kosho, the son of the famous Kamakura scupltor Unkei, showing him in a traveling costume with a staff tipped with a deer horn, a gong and striker, and with miniature images of Amida issuing forth from his mouth, is preserved in the Rokuharamitsuji Temple in Kyoto.

Kuzunoha In Japanese legend, Kuzunoha was the spirit of a white fox who appeared to Abe no Yasuna in the form of a woman and became his wife. She is often represented in Japanese art, notably in netsuke and prints, in her fox form, usually holding a child or using a brush held in her mouth to write a poem on the wall. See Abe-no-Yasuna.

Kwaten Mythological figure known as Agni Deva, the Deva of Fire, in Sanskrit. He belongs to the group of Twelve Deva Kings, or Juni-ten in Japanese, where he is sometimes represented in both sculpture and painting, notably of the Heian period. See Agni Deva.

Kyoyaki or Kyoto yaki.The term applied to the ceramic wares produced in the ancient capital city of Japan. The early history of Kyoyaki is uncertain, but the diary of an early 17th-century priest by the name of Horin indicates that potters from Seto, the oldest center of Japanese ceramic production, had come to Kyoto and established kilns in the Awata district in the eastern outskirts of the city, at the foot of Higashiyama. The earliest productions of the kiln can no longer be identified, but it is believed that they resembled the Chinese-style wares of Seto, and the tea bowls in the Korean style. But Kyoto only became important when the potters began to make wares decorated in overglaze enameling, reflecting the aristocratic culture of the city. Soon other kilns were set up in the Kiyomizu, Yasaka, Otowa and Mizoro districts, and Kyoyaki became famous throughout Japan. This development was furthered during the 17th century with the arrival of the famous potter Nonomura Ninsei, who produced gorgeously decorated pottery reflecting textile and lacquer patterns rendered in bright colors and in gold and silver. The culmination of Kyoyaki came with Ogata Kenzan, who is usually regarded as the greatest of all Japanese potters. He established his kiln in 1699 at Narutaki, in the northwestern outskirts of Kyoto. Kyoto continued to be an important ceramic center through the 19th century, and specialized in the production of ornately decorated pottery, with floral and leaf designs in bright enamel colors.

Kyogen Comic interlude used in connection with the noh drama. This art form is believed to date back to the Muromachi period and consists of short one-act humorous plays written in the colloquial Japanese of the time. There are some 280 such kyogen surviving, and they continue to be performed in Japan to this day. Wooden masks of humorous character are often worn by the actors in this drama.

Kyokechi Japanese term applied to a type of stencil dyeing which was imported from China during the Nara period. The oldest examples of this method are preserved in the Shosohn. In this method the cloth is folded in two and clamped between two boards with perforations arranged in a design. The design on one side is an exact reproduction of the design on the other, so that when the dye is poured on the perforations, the result is a symmetrical image.

Kyokusen Netsuke carver of the mid-18th century, who specialized in carving human figures in wood.

Kyoto Japanese city which served from 1794 to 1868 as the Imperial capital of Japan. It was originally called Heiankyo and was modeled on the Chinese capital of Ch'ang-an. Although much of the old city, notably the palace, was destroyed in the numerous wars which swept over it and in the fires which raged in its streets, many of the great temples, shrines and palaces of the Old Japan have still been preserved. Some of the most famous of these are Daitokuji—the great Buddhist Zen temple, Kiyomizudera, the Gold and Silver Pavilions, and the Nijo Palace. Today Kyoto is a big industrial city of over one million inhabitants. See also entries under names of temples and palaces.

Kyozutsu Buddhist ritual objects which take the form of bronze or ceramic cylinders, and were first used in Japan during the 11th century. Scrolls of sacred writing or prayers were ceremoniously placed in these containers, which were then buried on the temple grounds or on a nearby hill. It was believed that this procedure would produce the same results as the repeated recitation of lenghty prayers and the extensive reading of sacred texts which were required of priests in certain Buddhist sects.

Kyusai Netsuke carver of the modern period who was born in 1879 and died in 1938. His output was large, consisting of netsuke as well as tea utensils and okimono, executed in a variety of media such as wood, bamboo and ivory. He is considered one of the outstanding carvers of the modern period.

ABCDEFGHIJ KLMNOPQR STUVWXYZ

Lacquer A non-resinous sap produced by various plants belonging to the Rhus family. These trees are tapped and their sap is collected into cups, with one tree yielding six to seven ounces per season. The fresh sap is grey, translucent and somewhat viscious. When exposed to air and sunlight, it rapidly thickens and darkens. It has been employed since ancient times, both in China and Japan, for the decoration of objects made of wood, leather, papier mâché, ceramics and shell and stone.

Lacquer prints See Urushi-e.

Lakshmi also known as Sridevi, is the wife of Vishnu, and as goddess of beauty and good luck, one of the chief female deities of the Hindu pantheon. Like so many Hindu deities, she found her way into Buddhism and is represented as a goddess of good luck in the Buddhist art of China and Japan. It is especially in the latter country, under the name of Kichijoten, that she enjoys tremendous popularity, and is often represented in painting and sculpture. She is always shown as an elegant lady dressed in the manner of the court ladies of the T'ang period, and holds a precious jewel in her hand, which is said to bring good fortune. See Kichijoten.

Lamaism A type of Buddhist doctrine which originated in Tibet and which also exerted a powerful influence on China during the Mongol and the Manchu reigns. It developed out of the Tantric School of Buddhism, which had evolved in India during the 7th and 8th centuries, and reached Tibet via Nepal. While regarded as a form of Buddhism, it also contains many Hindu and older native Tibetan religious elements. It produced a very rich art with an extremely complex iconography which at times is reflected in Chinese Buddhist art as well. Numerous Lamaist temples were built in northern China, especially in Peking, during the Yuan and Ch'ing Dynasties, but the doctrine remained somewhat strange and foreign in the eyes of the Chinese people.

Lan Ying Chinese painter of the Ming period who lived from 1585 to 1660. He is considered the last important painter of the Chê School.

which had a kind of revival under his tutelage. He was a prolific artist and at his best a very facile skillful painter, but he showed no great originality. He painted landscapes, figures and bird and flower paintings. Numerous works of his may be found in American museums and private collections.

Landscape painting In both China and Japan, the painting of landscapes was one of the most popular and important artistic genres. In fact, beginning with the 10th century, and for the next thousand years, most of the great painters of China were landscape painters, and while the subject was never quite as popular in Japan, here too the painting of landscapes played a prominent role, especially among the ink painters working in the Chinese style. The landscape portrayed was not a realistic depiction of a specific scene which the artist was confronting while executing his work, but rather an ideal landscape which, to the Chinese, represented the awe-inspiring forces of nature as perceived in Taoist philosophy. This point of view is set forth very beautifully in an essay by the 11th-century painter Kuo Hsi, which, under the title "Essay on Landscape Painting" has been translated into English. In Japan, in addition to the Chinese-style land-scapers, there were others, notably those painted by artists of the Yamato-e, Sotatsu-Korin, and Ukiyo-e Schools, which are typically Japanese, both in the scenery which they portray and in the colorful decorative style which they employ. The depiction of landscape also plays an important role in Japanese prints, notably the works of Hokusai and Hiroshige.

Lang Chinese term to describe a covered passageway connecting two pavilions. They were very popular in palace architecture, notably in the Summer Palace outside of Peking, where these open, covered structures enabled the occupants of the building to enjoy a fine view of the landscape.

Lang A term employed for a Chinese monochrome porcelain of the Ch'ing period, decorated with a rich red produced from copper. It was probably named after the Lang family who lived in the neighborhood of Ching-tê-chên. However, it is not known with certainty which member of this prominent clan, which supplied several governors and other high officials, gave his name to this ware. In Europe it is usually referred to as sang de boeuf, or ox blood.

Lang Shih-ning See Castiglione, Guiseppe.

Lange Lijsen A Dutch term applied to a certain type of long, slender, blue and white Ch'ing porcelain jar which the English called long Elizas. The shape enjoyed a particular popularity in Europe with the Delft potters.

Lantern Lanterns of all kinds made of paper, cloth, metal, porcelain and stone, played a great role in both Chinese and Japanese life. In fact, in China, there was a lantern festival, and in Japan, lanterns are still lighted to commemorate the dead. The Deer Park at Nara has no less than 2,000 stone and 1,000 hanging metal lanterns, and old stone lanterns were

usually employed, shedding a very soft, subdued light and adding a great deal to the charm of the interior. Paper lanterns were also often suspended from poles or trees in parks and temples, especially during festival times, or were used for advertisements on the part of merchants and restaurant keepers. In Peking, there was a lantern street, where artisans making lanterns were housed and merchants selling them conducted their business. In Japan, the most famous center for lantern manufacture was the Gifu district, where, to this day, all kinds of lanterns, including modern ones designed by the well-known sculptor Noguchi, were produced mainly for export to the West.

Lao-tzu Chinese philosopher of the Late Chou period who is believed to have lived during the 4th century B.C. He is usually credited with being the author of the *Tao Tê Ching* and the founder of Taoism. However, modern scholarship tends to question his connection with this great classic of Chinese mystic literature. Many legendary accounts are related about him and his life; for example it is said that he was carried by his mother for eighty years before his birth, and therefore was born with white hair which gave him the nickname Lao-tzu, meaning "Aged Boy." He is also said to have been court librarian and a teacher. It is said that he departed for the west riding on a green ox, and before doing so, gave the book containing his teaching, known as the *Tao Tê Ching*, to a disciple. His teachings are the very opposite of those of the other great Chinese sage, Confucius, in saying that no action is the best action and that, instead of pursuing a public career in the service of society and the family, the best course is to withdraw from social life and strive for a mystic union with the eternal tao, which is the ultimate substance permeating all of life. His teachings were later debased into a popular religion given to alchemy, the search for pills of immortality and the elixir of life, and many other bizarre superstitions. He is often represented in art as a bald, bearded sage holding a scroll containing his teachings, or riding on an ox, or is shown, along with Confucius and Buddha, as one of the Three Great Sages.

Lei Term used to describe an ancient Chinese bronze vessel which was used to hold wine, or perhaps water. It had either a circular or a rectangular form. The lei has wide sloping shoulders fitted with rings hung from lugs ornamented with masks. The lower body of the vessel tapers down to a hollow foot, and is decorated with animal heads in relief. The covers of round-bodied lei are dome-shaped, while those of rectangular pieces resemble the fang-i lids. This shape occurs principally in the Shang and Early Chou periods, although some sources indicate that the round lei was also produced during the Middle Chou era.

Lei-wên or thunder pattern, a type of decorative design consisting of spirals which are used on the surface of Chinese bronze vessels of the Shang and Chou Dynasties, and are believed to symbolize storms, thunders, rain and fertility. See also Spiral.

Li Chinese bronze shape used in the ritual vessels of the Shang and Chou times for cooking meat offerings to the spirits. It consists of a deep bowl resting on three hollow legs. The prototype of this vessel, executed in ceramics, may be found among the Neolithic pottery of prehistoric China. See also Tripod.

Li An-chung Chinese painter of the Sung period who flourished during the 12th century. Although very little is known about him, he is believed to have been active at the imperial court both during the late Northern and early Southern Sung periods. He was an academic painter who specialized in bird and flower painting in the manner of Hui-tsung, portraying them in a very detailed meticulous style, using bright colors. Works traditionally attributed to him may be found in Japanese collections; they were much admired by Japanese critics, and exerted an influence on later Japanese painting.

Li Chao-tao Chinese painter of the T'ang period who is believed to have been active during the late 7th and early 8th centuries. He was a son of the well-known painter and official Li Ssu-hsün, and one of the main exponents of the Northern School of Chinese painting, which employed bright colors and detailed drawing. Although he was a much-admired artist and a court official, no works can be definitely proven to be by his hand exist today. However, modern scholarship believes that a scroll entitled "Travelers in a Mountain Landscape," now in the National Palace Museum, if not by the artist himself, certainly reflects his style. The colorful treatment of the mountains executed in green and blue, the vivid depiction of the travelers traversing the landscape on horseback, the rather primitive and awkward treatment of space and atmosphere, are all in keeping with what we know to have been the kind of painting flourishing during the Early T'ang period. All of this makes this landscape, which is usually assigned to his brush, one of the key works in the history of Chinese landscape painting.

Li Chên Chinese painter of the T'ang period, believed to have been active during the second half of the 8th century. He is virtually unknown in China, and no works of his are preserved in his native country. However, due to the fact that the great Buddhist teacher Kobo Daishi, the founder of the Shingon sect of Buddhism, brought some of his works back to Japan from China in 804, painting by him representing the five patriarchs of the Shingon sect are preserved in Toji Temple in Kyoto. They would suggest that a realistic style of portrait painting, depicting great religious teachers, flourished in China at that time.

Li Ch'êng Chinese painter of the Sung period who was active during the middle of the 10th century. He enjoyed a tremendous reputation, was often imitated by later artists, and is looked upon as one of the key figures in the development of Chinese landscape painting. He was particularly known for his melancholy fall and winter landscapes, creating a feeling of desolation, and his gnarled pines, employing monochrome ink very effec-

tively. He produced works of great power and aesthetic excellence. Although a great many paintings are attributed to him, it is doubtful if any of them are actually by the hand of the master himself. Of the examples in the United States, a hanging scroll portraying a "Buddhist Temple in the Mountains" in the Nelson Gallery collection and a scroll depicting "Travelers in the Mountains" in the Boston Museum are the best examples of works which are either by the artist himself or at least reflect his style accurately.

Li Chüeh Chinese painter of the Sung period, who belonged to the Ch'an School and was a close follower of Liang K'ai. He was known for his fine brushwork, with the ink flowing in beautifull controlled lines and touches. Two excellent examples of his style, representing the legandary monks Pu-tai and Fêng-kan, are to be found in the Myoshinji Temple in Kyoto. The former work is signed by the artist, and both have poems written by the monk Kuang-wên (1189–1236).

Li Jih-hua Chinese painter of the Ming period who lived from 1563 to 1635. He is primarily remembered today for his writing on art, rather than for his paintings, of which few seem to have survived. He was a man of letters who was admired for his learning and his skill as a poet and calligrapher, rather than for his genius as an artist. His theoretical writings on painting, and his inscriptions on scrolls in which he comments on earlier painters, and methods and ideals of painting, have been collected and are one of the best sources for our knowledge of the aesthetic ideas of the Late Ming period.

Li K'an Chinese painter of the Yuan period who lived from 1245 to 1320. He had a brilliant official career but was even better known for his bamboo painting. He wrote an essay on this branch of Chinese painting which also serves as a guideline for executing works of this type. His paintings of bamboo are very spirited, and show both his remarkable feeling for these plants and excellent brushwork. Several good examples of his work have survived, notably a handscroll in the Nelson Gallery in Kansas City.

Li Kung-lin See Li Lung-mien.

Li Liu-fang Chinese painter of the Ming period who lived from 1575 to 1629. He is usually considered one of the Four Masters of Chia-t'ing, a little town not far from Shanghai. After failing the examinations, he gave up the idea of government service and retired to this small country town, where he led the carefree life of a recluse poet and painter. He was particularly fond of the work of the Yuan painters Wu Chên and Ni Tsan, and modeled his own work on that of the Yuan artists. His style was very fresh and spontaneous, and at its best shows great expressive power.

Li Lung-mien Chinese painter of the Sung period, also known as Li Kung-lin, who lived from 1040 to 1106. He was not only an artist, but a scholar, government official and collector of paintings, ancient bronzes and jades. His output comprised Buddhist subjects, figure paintings, por-

traits, and horse paintings, as well as landscapes. His style is said to have been a very meticulous one, with heavy emphasis upon line. Although a great many works are attributed to him, it is doubtful if very many of them were actually executed by the aritst. Outstanding works associated with his name are a long handscroll entitled "Fairies in an Imaginary Landscape," now in the Freer Gallery in Washington, which in its fantastic quality and meticulous draftsmanship is in keeping with the sort of work we know that he had done, and a scroll of "Horses and Grooms," now in a private Japanese collection, which illustrates the more realistic and Academic style for which he was also well know.

Li Po Li Po is usually regarded as the greatest of all Chinese poets. He was born in Szechwan province in western China under the T'ang Dynasty, probably in the year 701. He studied Taoism and traveled widely in all parts of China. In 738 he met Tu Fu, the other great poet of the period with whom he became a lifelong friend. It was not until 742 that he came to the court in Ch'ang-an where the emperor Ming-Huang was ruling. For a time he became a court favorite and was one of a group of friends who called themselves the "Eight Immortals of the wine cup"; but he soon fell into disgrace and moved first to Shantung and then to Nanking in southern China. He died in 761 in An-hui, where he had found refuge with a relative who held office there. His poetry has often been translated into English and other European languages, and is generally regarded as the greatest to have come out of China. Li Po drinking with his friends is a favorite subject of Chinese painters, and has also been frequently illustrated in woodblock prints.

Li Shan Chinese painter of the Ch'ing period who was active during the 18th century in Yang-chou, where he served as a magistrate. He is well known for his bird and flower paintings executed in a free, quick manner which is referred to by some critics as being reckless. He excelled in painting lotuses, pumpkins and all kinds of winding, climbing plants, and enjoyed a considerable reputation for these pictures during his lifetime.

Li Shih-hsing Chinese painter of the Yuan period who lived from 1282 to 1328. His style shows the marked influence of his father, the artist Li K'an, who was famous for his bamboo painting. Good examples of Li Shih-hsing's work exist which depict pine trees against a background landscape shrouded in mist.

Li Shih-min whose posthumous name was T'ai-tsung, was the founder of the T'ang Dynasty, and one of the most remarkable rulers in the history of China. Although he died at the early age of forty-nine in 649, after ruling China for some twenty-two years, his influence was a lasting one and the dynasty he established ruled China for three centuries. He combined being a great general with being an excellent administrator and a fine scholar, under whose rule the arts and literature were fostered. The relief carvings of his favorite chargers which decorated his tomb at Sian—the ancient Ch'ang-an—and Shensi province are among the most

famous sculptures in the history of Chinese art; two of them are now in the University Museum of Philadelphia.

Li-shu or clerical script. A type of Chinese writing which was invented under the Ch'in Dynasty. Its most significant development took place during the Han period where it was adopted almost universally for official purposes. It was used on ritual vessels, stone monuments and government documents, some of which have survived to the present day. The construction of the characters and the forms of the individual brush strokes seem to have varied, probably depending on the taste of the writer and the nature of the writing.

Li Ssu-hsün Chinese painter of the T'ang period who lived from 651 to 716. He was referred to as General Li or Old Li in contrast to his son, Li Chao-tao, who was referred to as Young Li. He was considered the founder of the Northern School in the tradition of Chinese painting, which employed bright colors, notably blues and greens, and detailed, precise drawing. While he enjoyed a great reputation during his lifetime, and many references to him are found in Chinese art and literature, no work can be attributed to him with any degree of certainty. It is believed, however, that the type of subject he treated and the style he employed were similar to those of his son.

Li Sung Chinese painter of the Southern Sung period who was active during the 12th century. While he was not a highly original artist, he possessed a good sense of space and employed a fine rhythmic line. He is best known for his boundary paintings, which show the influence of Kuo Chung-shu and Chao Po-chü, and his seascapes, in which a more individual artistic style is displayed. One of the finest examples of his work in the latter category is an album leaf in the Nelson Gallery showing a small boat with four occupants being tossed about by waves which are rendered as long, swirling filaments. Other paintings by him are in the National Palace Museum collection.

Li T'ang Chinese painter of the Sung period who was active during the late 11th and early 12th centuries. A member of the Imperial Academy of Painting and, after the fall of the Northern Sung Dynasty, the director of the newly established Imperial Academy at Hang-chou, he followed in the great tradition of Northern Sung landscape painting. He depicted the majesty and grandeur of the picturesque mountain landscapes with their rocks and pines and tiny human figures. After the move of the imperial court to the south, he became the leading painter of the older generation and exerted a powerful influence on the later Academic painters of China, especially Ma Yüan and Hsia-Kuei. The finest paintings attributed to him are those in Japanese collections, notably a pair of magnificent landscapes in the Koto-in of Daitokuji in Kyoto.

Li Ti Chinese painter of the Sung period who was active during the 12th century. A disciple of Li T'ang and an admirer of the work of the emperor Hui-tsung, he painted birds and flowers, genre scenes and land-

scapes in a traditional Academic manner. A good example of his work is the picture depicting "Two Herd Boys Returning Home through a Storm," painted in 1174, now in the National Palace Museum in Taipei.

Lu Tsai Chinese painter of the Ming period who flourished during the middle of the 15th century. Little is known about his life, and he is primarily remembered today due to the fact that the great Japanese Zen ink painter, Sesshu, encountered him during a visit to China in 1468, and reported that he was one of the most famous painters of that time. Judging from the few works by him which have survived, he was a rather academic painter of the Northern School of Chinese painting, who derived his style from the masters of the Ma-Hsia School. The early work of Sesshu clearly reflects his influence.

Li Yin A noted Chinese woman artist from Chekiang province, who died in 1675 when she was over seventy years old. Although she painted many landscapes, her finest works are her flower paintings, which display considerable freshness and charm.

Li Yü Chinese ruler of the late T'ang Dynasty who lived from 937 to 978. His court was located at Nanking. He is primarily remembered as a patron of art, and is said to have encouraged the work of the great early Sung painters, Tung Yüan and Chü-jan.

Li-yü Chinese archaeological site located in Hopei province, where a group of excellent bronze vessels dating from the 6th century B.C. were excavated. These vessels are among the masterpieces of early Late Chou art, and helped trace the development of Chinese bronze style of the Eastern Chou period.

Liang Dynasty Chinese dynasty that ruled southern China from Nanking during the Six Dynasties period from 502 to 557. The Liang rulers were great patrons of Buddhism and Buddhist art, and had Chinese missions sent to India to bring back a sacred text and images from the homeland of Buddhism. The tombs of the Liang Dynasty near Nanking have magnificent large stone carvings of chimeras which are among the masterpieces of the sculpture of that age.

Liang K'ai Chinese painter of the Sung period who was active during the last 12th and early 13th centuries. He started out as an Academic painter, was a member of the Academy, and received the Golden Girdle. But later in life he turned his back on the official court life and joined the Ch'an Buddhist monastery of Lui-t'ung near Hang-chou. His best known work which was painted under Ch'an inspiration is, today, largely found in Japan, where it has been preserved and much admired in the great Zen establishments, while hardly any of his paintings survive in China, and his work has never received the acclaim in his native country which it has enjoyed ever since the Muromachi period in Japan. Employing a very abstract shorthand style with a few inspired brushstrokes, he painted some of the most evocative and profound paintings in the entire pictorial history of China. Outstanding examples are his portrayals of Zen patriarchs

and his celebrated picture of the great T'ang poet, Li Po, now in the collection of the Toyko National Museum.

Liao Dynasty A dynasty established by the Khitan people of Mongolia, who established a state in northern China which lasted from 907 to 1125. Although a barbaric nomad people who had come from the steppes, they adopted Chinese culture of the Late T'ang period and became patrons of art. Of the artifacts produced under their rule, the most notable are the ceramics, which, while lacking the refinement and elegance of Sung wares, have a primitive strength which is very appealing and has enjoyed popularity with modern collectors.

Liao-yang Tomb Tomb site in southern Manchuria near the modern city of Port Arthur, discovered by Japanese archaeologists during the 1930's. It is remarkable for its wall paintings, executed during the Later Han period, depicting chariots drawn by horses, riders and horses in profile and human figures. Although probably provincial in character, it nevertheless represents very valuable insights into what Chinese painting of the 2nd century A.D. looked like.

Lien Ancient Chinese bronze vessel of cylindrical shape, resting on three small feet which often taken the form of squatting bears. It is believed to have been used as a cosmetics container. While many liens are undecorated, others are gilt or beautifully inlaid with gold or other metals. The earliest examples of this type of vessel are from the Late Chou period.

Lin Liang Chinese painter of the Ming period who is believed to have been active during the 15th century. He is particularly famous for his numerous bird paintings executed in a fluent, spontaneous manner, often referred to as the hsieh-i manner. Numerous works attributed to him exist in Chinese and Japanese collections.

Lin T'ing-kuei See Chou Chi-ch'ang.

Ling-kuang Palace A Han period palace built by the brother of the emperor Wu Ti in Shantung province in northern China, not far from the Wu family tombs. The building no longer survives, but its wall paintings were famous and their subject matter is described in a poem by Wang Yen-shou which has survived, and which gives us an excellent idea of the type of subject matter treated by the painters of the time.

Lion The lion, although not traditionally portrayed in the art of China and Japan, was introduced along with Buddhism, since Sakyamuni was often referred to as a lion among men, speaking with the voice of a lion, and his throne was guarded by two lions. Due to this, numerous representations of lions, both in sculpture and in painting, are to be found in the art of the Far East. Lions are usually thought of as the symbols of power and protectors of the temples which they guard, or of the image or icon in which they are presented. The later, degenerate forms of these lions appearing in Chinese art of the Ch'ing period are also sometimes referred to by Western critics as fu dogs.

Lion dance See Shishi mai.

Literati painting or Literary Man's School, was the designation used for an important type of Chinese painting which was executed not by professional painters, but by scholar-painters who were amateurs in the best sense of the word. It was especially the Late Ming critic, Tung Ch'i-ch'ang, who was responsible for praising the work of this school over that of the professional painters, whom he regarded as being inferior. In China, this type of painting was referred to as wên-Jên hua, and in Japan it was known as bunjinga. See also Amateur paint, Gentleman paint, Wên-jên hua, Bunjinga.

Liu Chüeh Chinese painter of the Ming period who was born in 1410 and died in 1472. He was active in Su-chou and is looked upon as a member of the Wu School. He started his life as a government official, but at fifty retired and devoted himself to painting and to gardening at his country place. He was much influenced by Shên Chou and especially by the masters of the Yuan period, and employed a free, expressive style which was referred to in Chinese as i-p'in, or unrestrained manner. Several fine examples of his work have survived in China and Japan.

Liu Chün Chinese painter of the Ming period who was active during the late 15th century. He specialized in large figure paintings, often of Taoist or Buddhist personages, which were executed in a broad, rather coarse style. Most of his surviving works are in Japan, where he was much admired and where his work exerted a powerful influence on the Kano School.

Liu Sung-nien Chinese painter of the Sung period who flourished during the early decades of the 13th century. He was a contemporary of Ma Yüan and Hsia Kuei, and is usually listed with these two masters as one of the outstanding painters of the Southern Sung Academy. It is known that he worked at the court during the reign of the emperor Ming-tsung, who ruled from 1195 to 1224. He seems to have specialized in landscape paintings portraying the small figures of scholars against towering mountains and picturesque gnarled trees, as had the other two great masters. Liu Sung-nien's work, however, was more lyrical in mood, and at times employed color, instead of being restricted to black and white. A characteriostic work of his is "Conversing with Guests in a Stream Pavilion" in the National Palace Museum in Taipei.

Lo-lang Archaeological site near the modern Korean city of Pyong Yang where important Chinese art objects, dating from the Han dynasty, were found. Due to the expansion of Chinese power into northern Korea during that age, graves at this site yielded splendid examples of Chinese lacquer work with pictorial compositions reflecting Chinese painting of that time. These pieces were, no doubt, imported from China, but today they are largely in the National Museum in Seoul.

Lo P'ing Chinese painter of the Ch'ing Dynasty who lived from 1733 to 1799. He was a native of Yang-chou and is included among the Eight Ec-

centrics of Yang-chou. He was a pupil of Chin Nung, who also belonged to the group of eccentric Yang-chou painters. His specialty was the depiction of ghosts and demons, which he represented with great vividness and skill, for which he was much admired during his lifetime. Good examples of his work may be found in Japanese collections.

Lo-yang Chinese city in Honan province. It served as the imperial capital and played an important role in the political and cultural history of the country. Very little of the old architecture of this city remains today, and even the great pagoda of Pai-ma-ssu has been rebuilt in the T'ang manner under the Chin Tartars. The most notable artistic monuments in the vicinity of Lo-yan are the Buddhist caves at Lungmên, which are among the most remarkable carvings from the Six Dynasties and T'ang periods.

Lohan See Arhat.

Lokapala or T'ien-wang in Chinese and Shi-tenno in Japanese, are the four Buddhist guardians of the world who preside over the four directions and are believed to dwell on Mount Meru (Kailasa) at the gate of the Paradise of Sakra (Indra), acting as the protectors of Buddhism. They are frequently represented in both Chinese and Japanese sculpture and painting, usually in the form of warriors who, through their fierce expressions and powerful bodies, hope to protect the sanctuaries and sacred images from any evil forces which might disturb them.

Lost wax also known as cire perdue, is a process used in bronze casting, which, along with mold casting, was the most important means of making ritual bronzes in ancient China, and was also widely used in both China and Japan for making metal figures, especially in connection with the Buddhist religion. In it, the desired form is first fashioned in wax, often on a clay base, and then covered with clay, which forms a mold around the wax shape. The wax is thereupon melted, and the molten bronze poured into the area which had been occupied by the wax. The clay cover is then removed and the desired bronze shape emerges.

Lotus A flower which plays a great role in Buddhist art and which is looked upon as a symbol of the Buddha himself and of Buddhist purity, for it was said that just as the lotus grows from the mud at the bottom of the pond and emerges pure and beautiful, so the Buddha had walked through the corruption of this world and yet remained pure and holy. It is for this reason that Buddhist deities, notably Avalokitesvara, are depicted holding a lotus. The Buddha is often seen seated on a giant lotus. This symbolism is derived from ancient Vedic thought in which the world was looked upon as a giant lotus with India, Iran, Central Asia and China seen as its four petals and the Hilmalayas as its center. The image of the Buddha seated on top of the lotus therefore symbolizes his rule over all the world.

Lotus Sutra *Saddharmapundarika* in Sanskrit, *Miao-fa-lien hua-ching* in Chinese, and *Hokkekyo* in Japanese. One of the most sacred of Sanskrit texts of Mahayana Buddhism. It was originally written in India around

the first century A.D., and was translated into Chinese during the early Six Dynasties period. It enjoyed great popularity, both in China and, later on, in Japan. It often serves as an inspiration for the Buddhist art of both countries, and many copies of the text itself exist; one thousand executed by the priest Kumarajava were found in the great sealed library at Tunhuang alone. Among the Japanese versions, the most famous is found in the Itsukushima Shrine on Miyajima.

Lou A type of Chinese building, originally two stories high, built with a wooden framework. It became popular during the Han period, and was in use in all of Chinese architecture right into modern times. Its function was that of a tower within the building complexes of Chinese temples or palaces. In later times, these edifices were often high structures resembling Buddhist pagodas.

Lou-lan Archaeological sites located in the desert sands of Mongolia, where the British scholar Sir Aurel Stein found some interesting remains, notably magnificent textiles exported from Han China. They reflect the high development and popularity of this aspect of Chinese art during the period.

Lü Chi Chinese painter of the Ming period who was active during the late 15th and early 16th centuries. He worked at the court of the emperor Hsiao-tsung, and was much admired for his large decorative paintings, many of them as much as 5 to 6 feet in height and 3 to 4 feet in width. They were very popular as wall decorations in the Ming palaces. Employing brilliant colors and decorative designs, he achieved pleasing effects which enjoyed great popularity in China as well as in Japan, and later on among Westerners. They also inspired a large number of students and imitators, so that hundreds of such colorful bird and flower paintings are attributed to him. Probably only a few of them are originals by his brush, among which "Peonies and Wild Geese in Moonlight" and "Pheasant on a Snowy Tree," both in the National Palace Museum in Taipei, are outstanding examples.

Lu Chih Chinese painter, calligrapher and poet of the Ming period, who lived from 1496 to 1576. A follower of the great Ming painter Wên Chêng-ming and the masters of the Yuan period, he employed the same austere and pure manner of painting for which they were famous. His favorite subjects were landscapes, which he treated in a delicate manner with subdued colors, restrained brushwork and considerable emphasis on empty space. An outstanding example of his work is a horizontal scroll of 1554, entitled "Autumn Colors at Hsün-yung," now in the Freer Gallery.

Lu Lêng-chia Chinese painter of the T'ang period who was active between A.D. 730 and 760. He was well known as a follower of the great T'ang master, Wu Tao-tze, and was noted for his Buddhist paintings. A series of Arhat paintings discovered some years ago under the cushion of a throne in the Imperial Palace in Peking is attributed to him; this, while perhaps not an original, may very well reflect his style and give us some

idea of what the Buddhist painting of the T'ang period must have looked like.

Lung usually translated in English as dragon, is an auspicious and very significant creature who plays an important role in the mythology and art of China. The concept of such a large, winged reptile, connected with water, clouds, rain, heaven and fertility, may be derived from ancient Mesopotamia, where it occurs many centureis before it is found in China, and may ultimately reflect even older memories of a giant winged lizard which we know existed in very early times and which might have survived in the collective subconscious of prehistoric man. In China, the dragon became the symbol of heaven and the emperor, and was particularly connected with clouds, rain, rivers and lakes. It is said that the emperor sits on the dragon throne and has the face of a dragon. Numerous legends tell of dragons appearing to the emperors to announce auspicious events. Beginning with the Shang period around 1500 B.C., the dragon motif is one of the most common symbolical forms in Chinese art, first on the bronze vessels and jades, later in painting, sculpture and ceramic decoration. Dragon robes were worn at the Chinese court by the emperor and high court officials, and dragon emblems served as signs of rank. The dragon festival is celebrated in Chinese communities throughout the world to the present day, and in the duodenary cycle, the year of the dragon is regarded as a particularly auspicious one; those born in the year of the dragon are looked upon as being very fortunate.

Lung-ch'üan Pottery site located in Chekiang province where the finest of celadon wares were produced. It was called green porcelain or ch'ing-tzu by the Chinese, and has a light grey body which burns yellowish on exposure in the kiln, and an iron glaze ranging from a warm leaf-green to a cool bluish green, and is sometimes crackled. Some of these wares have, in addition to the green glaze, brown iron spots, and still others have molded designs. A great variety of shapes of all kinds was used, some of them derived from ancient bronze vessels. The finest of these Lung-ch'üan wares were made during the Sung period, but the kiln continued to produce a large quantity of porcelain during the Yuan and Ming Dynasties. A large portion of this production was apparently exported, for examples of this ware have been found in considerable quantities in Japan, Indochina, Borneo, the Philipines, Malaya and Indonesia as well as in the Arab world.

Lung-ma or ryuma in Japanese, is a horse-dragon of Chinese legend. It is said to have appeared to the emperor Fu-hsi in 2852 B.C. The creature took the shape of a horse's body, with a dragon's head, similar to the Ch'i-lin or kirin. It is frequently represented in the popular art of both China and Japan.

Lung-mên Literally "Dragon Gate," the site of a group of Buddhist caves located south of Lo-yang in Honan province. The sculptures for which this monument is famous were started under the Wei Dynasty in 494 and

continued under the T'ang rulers. There are altogether forty caves, of which the Pin-yang cave, made during the first quarter of the 6th century under the Northern Wei Dynasty, is generally regarded as the best. The central image there is that of a large Buddha flanked by Bodhisattvas and disciples, with the emperor and his attendants, and the empress and her ladies, doing homage to him. The relief carvings representing them are now in the Nelson Gallery in Kansas City and the Metropolitan Museum in New York. Among the T'ang carvings, the most impressive is a huge 50-foot-high image of the Cosmic Buddha Vairocana, flanked by Bodhisattvas and guardians. It was carved between 670 and 675, and reflects the full-bodied and dramatic style of the T'ang period.

Lung-nü A minor Chinese popular deity who is the daughter of the dragon king Lung Wang, and is often shown as an attendant of Kuanyin in her female form as a giver of children. In this capacity, she is represented as holding a precious pearl, which was a gift from the dragon king to this deity. This scene is sometimes shown in Chinese art of the Ch'ing period.

Lung-shan Site in Shantung province where a prehistoric blackware, made during the first half of the second millenium B.C., was first discovered. The term Lung-shan ware is employed today, therefore, as a generic term for this type of ware, which is now known to have been produced at other sites as well. It is the most developed pottery of China's Neolithic Age, and immediately precedes the first historical period of Chinese art—the Shang period. See also Ch'eng-tzu-yai.

ABCDEFGHIJ KLMNOPQR STUVWXYZ

Ma Ch'ang Site in Kansu province of western China where the Swedish engineer and archaeologist J. G. Anderson found some of the most beautiful prehistoric pottery ever discovered in China. It is known today to have been a rather late phase of the Neolithic Chinese pottery culture, following earlier phases of this art form which were native to Honan, Shensi, and Shansi, such as the Yang-shao pottery. The shapes of these wares are strong, beautifully curved jars and bowls, and urns decorated with geometric designs painted on the bodies of the vessels.

Ma-chia-yao Chinese archaeological site located in Kansu in western China where examples of beautifully painted Neolithic ceramics, dating from around 2,000 B.C., have been excavated. They are similar to the Yang-shao pottery, but are believed to date about 1,000 years later.

Ma Ch'üan Chinese painter who lived in the late 18th century. Originally from Kaingsu, she and her husband, who was also an artist, later moved to Peking, where they enjoyed considerable success. It was thought that Ma Ch'üan's work was superior to that of her husband. She was particularly known for her find bird and flower paintings. He father was the noted artist Ma Yüan-yü, also known as Fu-hsi, who was active c.1690 to 1720.

Ma Fên Chinese painter of the Sung period who was active during the early 12th century. He was a member of the painting academy and enjoyed a considerable reputation as an artist especially for his scrolls in which he rendered a hundred animals of a certain species, for example, a hundred monkeys, a hundred horses, a hundred birds, etc. He is also important for having been the founder of the Ma family of painters, which produced such eminent masters as Ma Kung-hsien, Ma Yüan and Ma Lin. Among the works attributed to him today, the most outstanding is the long horizontal scroll representing a hundred geese which is now in the Honolulu Academy of Art. The vivid way in which the birds are depicted, the variety of poses and positions, the inspired brushwork of this painting

would all suggest that this work must indeed be an original by the master.

Ma Ho-chih Chinese painter of the Sung period who lived during the 12th century. He was a native of Chekiang and had a successful official career. His output consisted mainly of ink drawings, the most famous of which were the illustrations of the *Odes* from Shih-ching, executed at the request of the emperor Kao-tsung who copied the text in his own hand. While these illustrations have come down to us only in the form of later copies, evidence of the charm and intimacy of his airy, fluttering manner can be seen. He also painted landscapes, birds and trees of which a few examples still exist.

Ma-Hsia School A school of Chinese painting whose two leading masters were the Southern Sung Academic painters of the 13th century, Ma Yüan and Hsia Kuei. The term is usually employed to describe the work of those artists who in subject matter and style, followed in the footsteps of these great masters. See entries under individual names of painters.

Ma Kung-phsien Chinese painter of the Sung period who was active during the middle of the 12th century. He was the grandson of the founder of the Ma School, the painter Ma Fên, and the uncle of the most celebrated master of this school, Ma Yüan. Like the other members of the school, he was a member of the Imperial Academy of Painting and enjoyed considerable success during his lifetime. Judging from the works which are ascribed to him, his style was very similar to that of the other members of this family, favoring a poetic interpretation of nature and the use of loosely applied ink. However, it would seem that his work is less inspired and somewhat drier than that of his famous nephew. A good example of his work may be found in Nanzenji Temple in Kyoto.

Ma Lin Chinese painter of the late Sung period who is believed to have been active duirng the mid 13th century. Following in the footsteps of his father, Ma Yüan, he painted landscapes and bird and flower paintings in the traditional Southern Sung style. Although he does not achieve the artistic excellence and expressive power of his father's work, there is a charm and poetry in his painting which is nevertheless very attractive. A large number of paintings have traditionally been attributed to him, but it is not at all certain how many were actually by his hand. The best of these are a group of charming album leaves depicting birds and flowers, which are found in numerous Chinese and American collections.

Ma Tsu P'o The Taoist Queen of Heaven who is the patron deity of sailors. Temples and shrines were erected in her honor along the coast of China and images of her are found in many Chinese junks. It is said that she was the daughter of a Fu-chou fisherman by the name of Lin, who due to her filial behavior was elevated to a divine position and was credited with having cured an emperor of a disease which no physician had been able to do. She is sometimes represented in Chinese popular art of the Ch'ing period, seated on a throne dressed in a splendid garment with a crown on her head and an emblem of power in her hands.

Ma Yüan Chinese painter of the Sung period who was active between 1190 and 1230. He was a member of the Ma family and the great-grandson of its founder, Ma Fên. Together with Hsia Kuei, he was considered the leading Academic painter of the Southern Sung period and the co-founder of the Ma-Hsia School. His paintings, with their poetic interpretation of nature, their subtle use of space and misty atmosphere, their one-corner compositions and their fine brushwork, represent the culmination of the development of Chinese painting of the Sung period. The Chinese themselves, as well as the Japanese, and in modern times also Western critics, have admired his work very much, and see him as one of the greatest artists of his age. A large number of paintings, many of them album leaves, but also hanging scrolls and handscrolls, are attributed to him, some of which are no doubt by the master while a great many others are imitations of his style executed during the Yuan and Ming periods. Among the finest paintings by him in America is an album leaf entitled "Landscape with Willows" in the Boston Museum of Fine Arts, while the most outstanding of his works in Japan is a picture showing an "Angler on a Wintry Lake" in the Tokyo National Museum.

Machiai Japanese name for a small pavilion containing a single bench. It is here that the guest for the cha-no-yu gather together before beginning the ceremony.

Maekawa Kunio Modern Japanese architect born in Niigata in 1905. He studied at the architectural school of Tokyo University, and then worked under Le Corbusier in Paris. He set himself up as an independent architect in Tokyo in 1935, and was soon recognized as one of the leading exponents of the international style of architecture in Japan. While employing steel and concrete and clearly revealing the influence of Le Corbusier, he nevertheless attempted to combine modern building techniques and artistic ideas with architectural principles derived from traditional Japanese domestic architecture. During the postwar period, he built some of the most remarkable and original structures erected in Japan, such as the Community Center at Setagaya and the Harumi apartments, both erected in 1957 in Tokyo, and the Fukushima Town Hall of 1958. Together with Tange, he is regarded today as the leading contemporary Japanese architect.

Maekawa Sempan Modern Japanese printmaker who lived from 1888 to 1960. One of the leading members of the Hanga group of creative printmakers, he is famous for his woodblock prints, both in black and white and in color, of typically Japanese scenes such as hotspring spas, country inns and folk festivals. Although a native of Kyoto, he spent most of his life in Tokyo and was closely associated with the Sosaku Hanga movement.

Magatama Japanese term to describe the comma-shaped curved jewels found in the prehistoric graves of ancient Japan. They are believed to

have been magic emblems which served as jewels and protective charms. The most famous of them, known as the yasakani-no-magatama, form part of the imperial regalia.

Mahamayuri A Buddhist deity who is one of the myo-o, but not rendered in an awe-inspiring, terrible aspect. He is always shown seated on a peacock—hence his name, Kujaku, which means peacock in Japanese. He dwells in the Tushita heaven and is sometimes seated on a large lotus. According to the tradition of the Esoteric sects, he is a manifestation of Sakyamuni and is looked upon as the protector against calamities and the giver of rain in times of drought. He is often shown in Japanese sculpture and painting but only rarely in Chinese art.

Maharajalila Position or pose of a Buddhist deity, usually Avalokitesvara. It is often seen in Chinese images of Kuan-yin, especially during the T'ang and Sung periods. It is characterized by one leg being raised or pendant, while the other one is placed horizontally at right angles to it.

Mahasthamaprapta Ta Shih-chih in Chinese, and Dai-seishi in Japanese. One of the chief Bodhisattvas who belongs to the retinue of the Buddha Amitabha. Along with the Bodhisattva Avalokitesvara, he is often shown as part of a Buddhist trinity in which Amitabha forms the center. He can be recognized by the sacred vessel he has in his crown.

Mahayana or Great Vehicle, the Northern School of Buddhism, which stands in contrast to the Southern School, the Hinayana or Lesser Vehicle. Growing up during the last centuries of the pre-Christian era, it represents a teaching in which the Buddha is no longer seen as merely a great teacher, but as a god, and one in a series of Buddhas who extend into the past and into the future. There is also a great emphasis on Buddhist saints or Bodhisattvas—sacred beings who have reached perfection, but have chosen to remain in the world to help suffering mankind. There is also in Mahayana, less emphasis on good works and asceticism, and more on faith and the transfer of merit. While both Hinayana and Mahayana Buddhism are known in China and Japan, it was Mahayana which played the dominant role in the Buddhism of the Far East.

Mai-chi Shan Site of important cave temples located in Kansu province of western China. They were first visited by a group of scholars in 1941, but serious work in studying and restoring them was not undertaken until 1953. Although somewhat provincial in style compared to the finest works produced at the capital, the sculpture and paintings at this site are valuable remains of Chinese Buddhist art dating from the Six Dynasties through the T'ang period. Particularly interesting are the clay figures and stone stele.

Maidama A branch of either bamboo or willow to which various emblems of wealth and happiness are attached, including gold paper money and rice cakes in the form of cocoons. They are connected with the celebration of the New Year in Japan.

Maiko Japanese term for the young girls who assist the geishas and who are being trained in dancing, singing and the art of entertaining men. They are often represented in the woodcut prints of the Ukiyo-e School.

Maitreya Mi-lo in Chinese and Miroku in Japanese. The Future Buddha who is said to come into the world five thousand years after the Historical Buddha Sakyamuni. Pending his rebirth, he is said to dwell in the Tushita heaven in the form of a Bodhisattva. He enjoyed great popularity both in China and Japan and is depicted in the Buddhist sculpture and painting of these countries, both in the form of a Buddha and in that of a Bodhisattva. Particularly lovely are his representations as a Bodhisattva, showing him seated in meditation, of which the most famous example is the Miroku in Chuguji nunnery in Nara.

Maki-e A technique of lacquer decoration which has been very popular in Japan. A picture is made by sprinkling either gold or silver powder on a moist lacquer ground. It originated during the Nara period, but the oldest dated work is a box made in the early 10th century. Many masterpieces of Japanese lacquer throughout the ages have been executed in this technique.

Makimono Japanese term for a horizontal handscroll with painting or calligraphy. An art form originally imported from China, where it had been widely used for many centuries before its introduction to Japan, it became very popular, especially among the artists of the Yamato-e School who produced some of their masterpieces in this art form. This type of painting is also referred to as e-makimono or e-maki.

Mampukuji Famous Zen temple located near Kyoto, which is the headquarters of the Obaku sect of Buddhism. It was founded in 1659 by Ingen, a famous Chinese priest of the Ming Dynasty who had come to spread the teachings of this sect in Japan. It is particularly notable for its buildings, which are in a purely Chinese style, differing greatly from the traditional Japanese Buddhist architecture.

Man-ch'eng Chinese archaeological site located in Hopei province where, in 1968, the tombs of a Han prince and princess, who were totally encased in jade suits and masks consisting of two thousand thin jade plaques sewn together with gold thread, were uncovered. These unique remains of the ancient Chinese jade Carver's skill were shown in Europe and North America in the great Chinese archaeological show which circulated in those countries in 1973–1974, and are now on display in Peking.

Manchu A nomad people of Central Asia who had established themselves north of the Great Wall during the latter part of the 16th century. Their capital was established in Mukden—in what is today Manchuria—in 1625. In 1636 they founded the Ch'ing Dynasty which conquered Peking in 1644 and made itself the ruler of all China. Although they were not of Chinese stock, they adopted Chinese civilization, became great patrons of art and brought a long period of peace and prosperity to the country. See also Ch'ing Dynasty.

Manchuria Region of north China extending north of Korea and the Gulf of Chihli, east of Mongolia, and south of Siberia. It derived its name from the fact that the Manchus had established themselves there with their capital in Mukdeh. Although the Japanese tried to detach it from China, Manchuria has been inhabited by Chinese people for many centuries, and archaeological excavations have brought to light many fine remains of a basically Chinese artistic culture.

Mandara In Sanskrit, mandala meaning "circle." A magic diagram developed in Vajrajana Buddhism in which the Buddhist world is represented in terms of paintings, sculpture or architectural forms. It was used widely in China and Japan by the members of the Tantric or Esoteric sects of Buddhism, although few of the Chinese examples survive today. In its painted form, the concept usually consists of two pictures, one representing the Diamond World or the world of ultimate essences, the other, the Womb World or the world of phenomena. Mandara paintings were particularly popular among the members of the Shingon and Tendai sects, or in Chinese Chên-yên and T'ien-t'ai.

Manga Sketch book by the famous Japanese woodcut printer Hokusai. The title literally means "random drawings" and it consists of a large number of sketches of all aspects of Japanese life, legend and nature. The first volume came out in 1814, when Hokusai was 54 years old, and the last one, the fifteenth, was published after his death in 1878. These sets have been reprinted, and volumes from the original edition are extremely rare.

Manju Type of netsuke, so called after the Japanese rice cake whose shape it resembles. It consists of a flat round piece of ivory, horn, wood or bamboo, and has no lid.

Manjusri or Wên-shu in Chinese and Monju in Japanese. One of the most important of Bodhisattvas, he is looked upon as the embodiment of wisdom and the guardian of the sacred doctrines. He enjoyed great popularity in both China and Japan, and is often represented in sculpture and painting. He may be recognized by the fact that he rides on a lion and often holds a sacred book. He and Samantabhadra, who is shown riding on an elephant, are often represented as a sacred pair flanking a central Buddha image.

Mantra Sanskrit term for mystic syllables which played a great role in the meditations and religious rites of Tantric Buddhism. They were particularly important in the school of the True Word or Chên-yên in Chinese, and Shingon in Japanese.

Manyoshu One of the classics of Japanese literature consisting of a collection of some 4,500 poems, some of them going back to the 4th century, but most of them probably dating from the 8th century. The title itself means *Collection of a Myriad Leaves*. The compilation is attributed to the poet Otomo-no-Yakamochi. However, it includes poems by a large number of people, all the way from emperors and empresses to

farmers and hermits. This book has been translated into English several times.

Mao I Chinese painter of the Sung period who is believed to have been active during the latter part of the 12th century. He was a son of Mao Sung with whom he studied painting. A member of the Southern Sung Academy, he continued the tradition of bird and flower, and especially animal, painting which had been established by Hui-tsung. His manner was very detailed, portraying the animals and birds in a lifelike and colorful style. He was particularly fond of cats and dogs. Although decidedly a minor artist, he nevertheless excelled within the genre of his specialization. The best examples of his work are preserved today in Japanese collections.

Mao Sung Chinese painter of the Sung period who was active during the first half of the 12th century. He is known to have been a member of the Imperial Academy of Painting under the last of the Northern Sung emperors, Hui-tsung, who was an all accomplished painter in his own right. According to the Chinese literature, he was celebrated as a painter of monkeys, which he portrayed in a very vivid, lifelike style, using a wealth of detail and subtle colors in depicting them. A charming painting of such a subject in the Manjuin Temple in Kyoto has for many years been attributed to him. If this attribution can be accepted, it would suggest that he was a very skillful artist working in the realistic style which flourished at the Academy. His son, Mao I, continued this tradition of animal painting. See Mao I.

Maples Maple trees, called "momiji" in Japanese, are greatly admired for the beauty of their foilage, which changes color with the seasons. In the autumn, special parties known as momijigari are organized with the sole purpose of going to view these trees in their full splendor. Autumn landscapes with deep red maples have served as a source of inspiration for many Japanese poets and painters. The leaves of the maple in association with the deer are emblems of autumn, and often occur in Japanese art.

Mara The evil spirit or devil in Buddhist theology, who is reported to have tempted the Buddha during his meditation prior to his Enlightenment under the Bodhi Tree at Bodhgaya. Although Mara sent demons and his beautiful daughters to prevent the Buddha from reaching Enlightenment, he failed in this enterprise. This event is often portrayed in sculpture and painting.

Marco Polo A Venetian traveler of the 13th century who went to China and served under the Mongol emperor Kublai Khan at the imperial court in Peking. He wrote an account of his experiences in China which has become a classic of travel literature and which made China well known in the West. He praised the cosmopolitan nature of the great Khan's administration and drew a very favorable picture of China, which at that time was probably the most civilized and wealthy country in the world.

Marks Marks and monograms of all types are widely used in both

China and Japan, especially on works of ceramics, indicating the period, place, and date, and in Japan often the maker of the object as well. They may be painted, incised, or stamped, and may consist merely of one character or of a whole group of them, depending on the usage of the particular potter or kiln. While they are helpful in determining where and when a piece of ceramic ware was made, caution must prevail in placing too much emphasis on these marks, since the Chinese often copied earlier marks during the later periods, and the Japanese not only copied the monograms of earlier Japanese artists, but even used Chinese reign names on their porcelains.

Maruyama See Okyo.

Masanao Name of several famous Japanese netsuke carvers, of whom Masanao Suzuki, who lived from 1815 to 1890, was the most famous. He was a native of Ise and lived in Uji-yamada. He carved largely in wood, in minute detail, with very sharp chiseling. He treated a large variety of subjects, especially toads, all kinds of animals, birds, flowers, and landscapes.

Masanobu Japanese painter of the Muromachi period who lived from 1434 to 1530. The founder of the Kano School, he was the son of the amateur painter, Kano Kagenobu, and the father of Kano Motonobu. The Ashikaga shogun Yoshimasa appointed him chief court painter and gave him the title of Hogen, the highest rank among scholars and artists. His style followed the Chinese pictorial tradition, especially that of the masters of the Southern Sung period and of the Japanese Zen painter, Shubun. A large number of works have been attributed to him; however, it is uncertain which of them are actually by his hand. Many of them are Buddhist figures, others landscapes, and yet others, birds and flowers. One of the works believed to have actually been executed by him is "Hotei Under a Cliff" in a private collection in Tokyo.

Masanobu Japanese painter and printmaker of the Edo period who lived from 1686 to 1764. His family name was Okumura, and he was a member of the Ukiyo-e School. His early work was strongly influenced by Kiyonobu, and he had also studied the work of Moronobu. He was a very productive and many-sided artist who treated a variety of subjects and experimented with a wide range of new techniques. He is therefore regarded as an important figure in the development of the Japanese print. He treated courtesans, kabuki actors, scenes from the Yoshiwara, historic legends, and parodies of classic themes. The invention of the narrow form of pillar print is attributed to him. Some authorities believe that he was also responsible for the development of urushi-e lacquer prints, although this is by no means certain. He was also the first Ukiyo-e artist to use Western-style perspective. He was followed by his pupil, Okumura Toshinobu, who lived from 1717 to 1750.

Masasada Celebrated Japanese sword guard maker who flourished in Kyoto in the middle of the 18th century. His family name was Hashinobe.

He was trained by a master of the Goto School, the leading school of metalworking of the time, and excelled in cut-out designs executed in the technique known as ito-zukashi.

Masatoshi Name of several netsuke carvers, of whom Sawaki Toshizo was the most famous. He lived from 1835 to 1884 in Nagoya. He carved netsuke and tea ceremony articles, as well as Chinese-style musical instruments—a craft which he had studied for several years in China.

Mask The Japanese have used wooden carved masks in connection with religious dances and theatre performances ever since ancient times; it was felt that the mask would help transform its wearer into the character he was impersonating. The oldest of these masks, coming from the Asuka and Nara periods, were used in conjunction with the gigaku dance performed in the courtyards of Buddhist temples. A somewhat later group of masks was connected with the bugaku, a dance-drama imported from China. Bugaku performances became popular at the imperial court as well as in Buddhist temples and Shinto shrines. The finest of these masks were made during the Heian and Kamakura periods. Finally, the most important and varied group of masks was composed of those connected with the noh drama and the comic interludes associated with it known as kyogen. The oldest of these masks were made during the Muromachi period, notably in the 15th and 16th centuries, but fine noh masks are still being produced today, and accomplished craftsmen in this field enjoy a great artistic reputation. See also Gigaku, Bugaku, and Noh.

Matabei Japanese painter of the Edo period who lived from 1578 to 1650. His family name was Iwasa, which he derived from his mother's family, by whom he was brought up. While he was trained under the Kano master Shigesato, he really is far closer to the tradition of the Tosa School. He has traditionally been credited with having been the creator of Ukiyo-e, but modern scholarships has disproved this contention. His subjects were usually taken from traditional sources, such as the Tales of Genji and Ise, the Thirty-six Poets, and scenes from Chinese legend. He was employed by the Lord of Fukui, and was commissioned late in life to do a series of paintings for the Tokugawa shogun Iemitsu. He died in Edo. A large number of works are attributed to him, some executed in the Chinese ink style, for example his Daruma in the Atami Museum, while others are closer to the narrative tradition of the Japanese Tosa school, such as his paintings of the Thirty-six Poets, painted in 1640 for Toshugu Temple in Kawagoe.

Matsuda Gonroku Modern Japanese lacquer artist who was born in 1896. He is generally regarded as the most outstanding of modern Japanese lacquer makers. He has spent his life in Tokyo and has been a teacher at the Tokyo University of Arts. He is best known for his work in maki-e, decorated with pictorial designs.

Matsudaira Village in Aichi prefecture which was the birthplace of the Tokugawa shogun family. This name was bestowed as an honorary title

upon several leading daimyo families, the most famous of which had its seat in Shirakawa, where a park that was built by Matsudaira Sadunobu (1758–1828), an important political and literary figure of the Tokugawa regime, is still to be found. The Matsudaira family were great patrons of art, and the Matsudaira collection contained some of the masterpieces of both Chinese and Japanese painting.

Matsuri Japanese term used for festivals connected with Shinto shrines and religion. They often form the subject matter of Japanese genre painting, and continue to play a prominent role in the religious life of modern Japan. See also Bon Matsuri, Hina Matsuri.

Matsushima or the Pine Islands, is one of the famous beauty spots of Japan. It is located in the Tohoku district not far from Sendai, and is visited by millions of Japanese travelers each year. Its picturesque rocky islands, covered with pines, have been frequently represented in art. Two of the most famous of these paintings are a pair of screens by Sotatsu, now in the Freer Gallery, and another one by his follower Korin, in the Boston Museum.

Maya Name of the mother of the Historical Buddha Sakyamuni, who is said to have given birth to her great son in the Lumbini Garden outside of the city of Kapilavastu. This scene is often represented in Buddhist art, and although Maya is said to have died seven days aftr her son's birth, she is venerated by the Buddhists and likenesses of her occur in the Buddhist art of China and Japan.

Mel Ch'ing Chinese painter of the Ch'ing period who was born in 1623 in Anhui province and died in 1697. The youngest and one of the most gifted of the Anhui painters, and a close friend of Shih-t'ao, he worked in a highly original and personal style. He was particularly famous for his paintings of pine trees and mountain landscapes which he interpreted in a poetic manner, emphasizing the fantastic qualities of the trees, mountains, water and mist. Many works by his hand survive, particularly in Japanese collections.

Mei-p'ing A ceramic shape, literally meaning "plum blossom vase," which was commonly employed by Chinese potters beginning with the Sung period. It is a tall vase with a very small mouth, no neck, high wide shoulders, and a tapering body which has a very graceful silhouette. It is said to have lent itself particularly well to the display of plum blossoms.

Meibutsu Literally "objects of fame." A Japanese term used to describe celebrated works of art, specifically a group of tea ceremony utensils dating from the late 16th century, the time of the tea master Rikyu.

Meibutsu-gire Japanese term literally meaning "cloths for famous objects." This collective designation refers to the rich fabrics which were used to make coverings for the utensils employed in the tea ceremony or to mount the hanging scrolls of painting or calligraphy. The favored cloths were of Chinese origin dating from the Sung, Yuan and Ming periods, and included kinran or gold brocade, donsu, an exquisite damask, and inkin, a cloth

with patterns in gold leaf. The designation first came into widespread use during the Muromachi period with the growth of the tea cult.

Meiji period Phase of Japanese art and history which lasted from 1868 to 1912. It was named after the Emperor Meiji, who ruled Japan at that time. It was marked by the opening of the country to Western influence, with the result that much of the architecture, sculpture and, above all, painting produced at that time was based on European models. In fact, artists from England, France and Italy came to Japan, some of them at the invitation of the Japanese government, to teach the young Japanese artists.

Meiji Shrine Shinto shrine located in Tokyo, dedicated to the memory of the emperor Meiji. In addition to his shrine, the grounds contain a treasure house and a large garden which is famous for its irises. The torii are the largest in Japan and its sanctuary attracts huge numbers of worshippers each year.

Meisho literally meaning "famous scenes," are Japanese travel guides or itineraries which describe the points of interest of cities and the surrounding countryside. They are illustrated for the most part with views of temples and shrines, although the more modern ones also contain scenes from Japanese life. The illustrations were often executed in woodblock prints. A famous early example of such a book is the *Yamato Meisho*, a work in seven volumes published in 1792, which describes famous sites in Japan.

Mencius See Meng-tzu.

Meng-tzu Chinese philosopher of the Late Chou period who is better known in the West under his Latinized name, Mencius. He lived from 372 to 289 B.C. and was the most important disciple of Confucius; his writing forms the Fourth Book of the Chinese classics. He held the position of minister in the state of Ch'i, but later devoted himself entirely to his literary pursuits. His particular interest was the study of human nature in relationship to society. His tablet is usually placed in Confucian temples, and his likeness is sometimes rendered in paintings depicting the Chinese sages.

Menuki Japanese term for a pair of small ornaments placed on either side of the hilt of a sword. They served to strengthen the grip, as well as to adorn the sword. They are often decorated with pictorial designs, usually engraved or executed in répoussé.

Meru or Sumeru. Hsü-mi Lou in Chinese. Sacred mountain occurring in Indian mythology and probably going back to yet earlier ancient Near Eastern sources. This concept also occurs in Buddhism, where the platform on which the Buddha is seated is often rendered in the form of a step pyramid, symbolizing Mount Meru—the World Mountain. The concept of the pagoda, too, can ultimately be connected with the idea of the seven-storied Mount Meru, which, in some of the earlier Chinese pagodas, is clearly represented as such.

Mi Fei also called Mi Fu. Chinese painter of the Sung period who lived from 1051 to 1107. Besides being a painter of note, Mi Fei was also a writer, whose book on painting called *Hua Shih* is considered a classic in its field, a poet, a calligrapher, a discriminating collector of painting and a government official. He is said to have been an inividualist who developed a very personal way of painting and an eccentric way of life. The style he employed is said to have been a very blurred one, and his interpretation of the landscape, showing mountains hidden by mist and clouds, a very lyrical one. Although there are many pictures reflecting his style, since he was much admired and often imitated during later periods, it is uncertain if any originals by his hand survive today. Two fine pictures usually associated with his name are a small colored painting entitled "Auspicious Pine Trees in the Spring Mountains" in the National Palace Museum in Taipei, and "Tower of the Rising Clouds," a beautiful hanging scroll showing mountaintops emerging out of the mist, in the Freer Gallery.

Mi Yu-jên Chinese painter of the Sung period who lived from 1086 to 1165. The son of Mi Fei, the famous Northern Sung painter, his style reflects that of his father. However, his activity falls largely into the Southern Sung period, after the capital had been moved to Hang-chou. While he too specialized in misty mountain views, his manner of painting is even softer and more diffuse than that of the elder Mi. Numerous works are attributed to his brush; of these, a horizontal landscape scroll in the Freer Gallery and one in the Cleveland Museum are the best examples.

Miao A Chinese term to describe a temple or shrine dedicated to the ancestors, such as the Grand Ancestral Shrine at the Peking Palace, which is referred to as the T'ai-miao, or the Confucius Temple, which is called the Kung-miao.

Mica A mineral with a shiny surface, which in powdered form is often employed as a background in Japanese woodcut prints, notably those of Utamaro and Sharaku.

Michizane Japanese statesman of the Heian period who lived from 845 to 903. His full name was Sugawara no Michizane and he was a nobleman at the imperial court who was falsely accused by his enemies of plotting against the emperor. He was consequently sent into exile, where he died. It is said that his angry ghost caused all kinds of misfortune; this led to his reinstitution in 903, and his elevation to the position of a Shinto deity under the name of Tenjin, the god of literary men. The Kitano Shrine in Kyoto was dedicated to him, and scenes from his life are often represented in Japanese painting, notably in the Kitano Tenjin scrolls. See Kitano Shrine.

Middle Kingdom or Chung Juo in Chinese. Term employed by the Chinese for their country, implying that China was the center of the universe and that all other people were barbarians. This concept arose during the Late

Chou period, and was not unlike that prevailing in the Greek city-states of classical times.

Miidera Buddhist temple located near Otsu on Lake Biwa, not far from Kyoto. It was founded in 686 and is the headquarters of the Jimon branch of the Tendai sect. In its heyday it contained 859 buildings, but only sixty of them are standing today. It is particularly famous for its melodious bell, which was cast in 1602, and for the so-called Benkei bell, famed in Japanese legend. The temple grounds contain the grave of Professor Fenollosa, the famous American scholar who was a pioneer in the study of Japanese art.

Mikado Title of the emperor of Japan, literally meaning "sublime gateway." It is a term used mainly by foreigners; the Japanese themselves refer to the ruler as Tenshi, meaning "Celestial Emperor," or Tenno, meaning "Son of Heaven."

Mikawachi Village located near Arita in Kyushu, where very fine porcelain was made under the patronage of the Matsu-ura princes. Since these productions were exported through the port of Hirado, they are usually referred to as Hirado ware. See Hirado.

Mikkyo or Mi-tsung in Chinese. Japanese term for the teachings of the Tantric or Esoteric sects of Buddhism. The words literally mean secret teachings, which suggests that these were mysterious doctrines consisting of magic spells and formulas. It was a doctrine introduced from India to China during the 4th century, but did not really become popular until the T'ang period. From China the Esoteric teachings were introduced to Japan in 816 by the monk Kukei, better known as Kobo Daishi, the founder of the Shingon sect. While it influenced the art of both China and Japan, due to the great Buddhist persecutions of the 9th century, almost no Chinese examples of Tantric art have survived. In Japan, beginning with the Early Heian period, much of the Buddhist art was inspired by Mikkyo; this was particularly true of the architecture, sculpture and painting of the Shingon and Tendai sects.

Mikoshi Japanese term to describe the sacred palanquin, carried on the shoulders of worshippers, which is used to transport the kami or divine spirits of Shintoism during festivals. These palanquins are often elaborately carved and brightly painted, and continue to play a prominent role in the popular religious festivals of contemporary Japan.

Mikoto Japanese term, used as a component in the name of Shinto deities, meaning "the august one."

Mimpei Japanese potter of the 19th century who was instrumental in establishing the Awaji kilns. See Awaji.

Minamoto The family name of one of the great feudal clans of Japan. They are also often referred to as the Genji. This illustrious, powerful family was established during the Early Heian period by one of the sons of the Japanese emperor Saga. They were the rivals of the Fujiwara and later of the Taira, the other two powerful feudal families of the age. The most famous member of the Minamoto was Yoritomo, who became the

all-powerful ruler of Japan in 1185, at the beginning of the Kamakura period. The Minamoto lords were great patrons of art. A portrait of their most important ruler, Yoritomo, painted by Takanobu, is usually considered one of the masterpieces of Japanese portraiture, and scenes from the story of the Minamoto clan are often represented in Japanese painting.

Mincho Japanese painter of the Muromachi period who lived from 1350 to 1431. He is considered one of the founders of the Suiboku School of Chinese style ink painting, and together with Josetsu is the artist most responsible for popularizing Chinese Buddhist painting of the Sung and Yuan Dynasties in Japan. He worked at the Tofukuji Temple in Kyoto under the name of Cho Densu. His most famous works are a depiction of the Five Hundred Arhats, and a portrait of the great Zen master Shoichi, both preserved in the Tofukuji Temple.

Ming-ch'i Chinese term employed to describe the grave figures in tombs, placed there as substitutes for the real people and gifts which were originally interred with the dead in ancient China. This custom originated during the Chou periods, when first wooden and, later clay images of people, horses and all kinds of objects belonging to the dead were placed in the tombs. These figures, notably those of the Han, Six Dynasties and T'ang periods, are highly valued today as works of art and are eagerly collected by art-lovers both in the Far East and in the West. The most notable group of such objects was the six thousand life-sized pottery figures of warriors and horses excavated at the tomb of the first Chinese emperor, Shih Huang-ti, in 1975. This custom became less prevalent after the end of the T'ang Dynasty, and ceased after the Ming period.

Ming Dynasty Major period in the history of Chinese culture and art, which lasted from 1368 to 1644. It was an era outstanding for its architecture, painting, porcelain, lacquer, textiles and enamels. Much of the surviving Chinese architecture, notably the palaces, gates and temples of Peking, was erected during this age, and many of the most famous of Chinese painters, notably Shên Chou, Wên Chêng-ming, T'ang Yin and Ch'ui Ying—the so-called four great masters of the Ming period—lived during this age. Being a period of material splendor, it was also outstanding in all the fields of decorative art, and to this day Ming porcelains, especially blue-and-white, are admired throughout Asia and the West and have often been imitated.

Ming Huang T'ang emperor who ruled China from 712 to 756. It was under his rule that some of the greatest of Chinese poets and some of the most famous painters were active. He is, however, best known for his love affair with the famous beauty Yang Kuei-fei, which ultimately cost him his throne. The scene of his flight to Western China, after the rebellion of the Turkish official An Lu-shan, is often portrayed in Chinese painting, but it is really his patronage of the arts and the prosperity of his regime that is far more important for the history of Chinese art and culture.

Ming tombs The Ming tombs, where all but the first two of the Ming

emperors were buried, are located in a hilly forested area in the neighborhood of Peking. It is here that thirteen of the rulers of this illustrious dynasty, which ruled China from 1368 to 1644, are buried. The area was forbidden ground for all but the official entrusted with taking charge of it; no tree could be cut down, no stone removed, and the soil could not be tilled. A sacred way led to the entrance of the chief tomb, which was that of the third Ming emperor, Yung-lo, with the other tombs built around this one. Each tomb consists of three parts; the building in which sacrifices were prepared and offered, the tower for the stele, and the tumulus itself, erected over the underground vault in which the body was buried. The sacred way leading to the tombs is flanked by a series of stone carvings dating from the 15th century, representing men and animals which are meant to serve the dead in the other world. The tombs have been excavated in recent years and may now be visited by the public.

Mingei Japanese term for folk art, literally meaning "people's craft," which has been produced in Japanese villages and rural towns during the Edo and modern periods. The discovery of the unique beauty of this art form was largely due to the efforts of Dr. Yanagi, the founder and guiding spirit of the folk art or Mingei movement, and an untiring writer and lecturer on the special beauty of this form of art. He established a folk art museum devoted to this type of art in Tokyo, and stimulated collectors and museums throughout Japan to acquire examples of traditional Japanese folk art. From Japan the enthusiasm for Mingei spread to America and, to a lesser extent, to Europe as well, and fine collections of Japanese Mingei have been formed. Although the best of this folk art dates from the Edo period, the folk art tradition is still a vital one in the more isolated rural areas of Japan, and has been encouraged and maintained by by Mingei enthusiasts. Among the types of works still being produced are objects made of ceramics, wood, lacquer, papier-Mâché metal, grasses and straw, some of which are true artistic masterpieces.

Minko A well-known netsuke carver of the Edo period who lived from 1735 to 1816. He was born in Iga, but lived most of his life in Ise where he worked for the Lord Todo. His specialty was the carving of animals and fruits in various kinds of wood. He also made tobacco cases of wood inlaid with ivory and shell. Even during his lifetime, many copies of his work were already being made.

Minkoku Netsuke carver of the late 18th century who assumed the pseudonym Genryosai. He lived in Tokyo and excelled in the carving of figures in both wood and ivory.

Mino The old name of the province of Japan which today is known as Gifu prefecture. It is a district in which some of the most celebrated of Japanese tea wares, known collectively as the Mino wares, were produced. Among them, the most outstanding are Shino and Oribe, which the Japanese tea masters regard as among the finest of all Japanese ceramics. Shino are heavy, coarse wares covered with a thick, creamy glaze, often

decorated with freely rendered designs of flowers, plants and landscapes executed in a brownish iron glaze, while Oribe wares are known for their bold designs executed with lovely green glazes which cover half the surface of the vessel. The finest of these Mino wares were produced during the Momoyama and Early Edo periods, but the Mino kilns continued to be active down to the modern period, with the leading Shino potter, whose name is Arakawa, an artist who was designated as a living cultural treasure of the Japanese nation, making his home in the Mino district.

Mino coat Cloak woven from grass, hemp or straw, which is worn by Japanese peasants and farmers as protection against rain or snow.

Miroku Japanese name for Maitreya Buddha. See Maitreya.

Mirror Circular metal mirrors, with decorative designs on one side and a highly polished smooth surface on the other, were widely employed in both China and Japan. The finest of these, dating from the Late Chou and Han periods, as well as those of the T'ang period, are outstanding works of art. The ornamental designs on their backs, executed in bronze in low relief, or more rarely inlaid with precious metals, usually represent the animals of the four directions, magic diagrams symbolizing the universe. Taoist scenes of the celestial realm or purely ornamental designs. The T'ang mirrors also frequently represent motifs taken from late Classical art, such as erotes and grape designs. In Japan, the mirror also served as a symbol of the sun goddess, and a sacred mirror serving as her emblem is preserved at the Ise Shrine.

Mito School School of sword-guard makers active in Mito in Ibaraki prefecture beginning with the late 17th century. Their style is derived from that of the Nara and Yokoya masters of Edo. There are also several sub-schools which enjoyed popularity during the later Edo period. The products of this school were noted for their fine technique and imaginative designs.

Mitsuda-e Japanese term for a category of painting executed with oil paint produced from lead oxide. Works of this type appeared in China beginning with the T'ang Dynasty, and in Japan during the Muromachi and Early Edo periods. The term itself is ultimately derived from the Persian term for lead oxide—mirdasang.

Mitsuhiro Netsuke carver of the Edo period who lived from 1810 to 1875. A native of Onomichi, he went to Osaka, where he became an apprentice to an ivory-carver. He is well known for his fine realistic carvings of figures, birds, bees, insects and plants.

Mitsunaga Japanese painter of the Helan period who is known to have been active during the 1170's. His family name was Tokiwa. He was attached to the court painting office and worked in Kyoto as a pictorial recorder of the ceremonies at the imperial processions. At about the same time, he executed his most ambitious work, a series of sixty scrolls depicting the annual rites and ceremonies which, unfortunately, are today known only in copies. Of the extant works, the most celebrated associated with his name

is the Ban Dainagon scroll, which, with its vivid depiction of tense crowds, dramatic presentation of burning buildings, and striking facial expressions, is one of the masterpieces of Japanese narrative painting of the Yamato-e School. Whether this work is actually by his hand is not certain, but it reflects the subject matter and style associated with this master.

Mitsunobu Japanese painter of the Muromachi period who lived from 1435 to 1525. He was a member of the Tosa School, the son of Tosa Mitsuhiro, and became the chief painter at the imperial court in 1469. He also served as head of the painting office of the shogun and deputy minister of justice. He was an outstanding exponent of the type of narrative scroll painting which was derived from the Yamato-e tradition, and stood in striking contrast to the Chinese-style ink painting which had become popular during that period. His most famous works are the long handscrolls depicting the story of the Kitano Tenjin Shrine and the origin of the Kiyomizudera, both of them executed in a detailed, colorful manner, with emphasis on the telling of the story.

Mitsuoki Japanese painter of the Edo period who lived from 1617 to 1691. The son of Tosa Mitsunori, he was the outstanding artist of the Tosa School during the Tokugawa rule, and was appointed chief court painter, receiving the rank of Hogen, the highest distinction for scholars and artists. Although he was a member of the typically Japanese school, he actually often worked in a Chinese manner, and his best work, such as the "Quails and Millet Screen" in the Atami Museum, combines the Japanese decorative tradition with the close observation of nature derived from Chinese Sung prototypes. More typically Japanese were his screens and album leaves depicting scenes from the Tale of Genji, which established a tradition continuing into the 19th century.

Miwa Netsuke carver of the late 18th century who lived in Edo and is regarded as the originator of the Edo School of netsuke carving. He worked largely in cherry or sandalwood, and fitted pieces of dyed ivory or horn for the running of the cords. He was a very skillful artist who depicted scenes from Japanese life.

Miya Japanese term to describe a Shinto shrine: it is often used in compounds, for example Miyajima. It is the equivalent of the other term used to describe Shinto sanctuaries—jinja.

Miyajima See Itsukushima Shrine.

Miyamoto Musashi Japanese painter of the Edo period who is better known as an artist under the name Niten. See Niten.

Mizu-e Literally "water prints." A type of Japanese print in which the outline block is faintly printed in color, giving an effect of extreme delicacy. The technique was employed by Harunobu around 1760.

Mizu-enogu Japanese term meaning water colors.

Mizu-ire Small vessels which hold the water needed to dilute the ink used for writing or painting. They take on a variety of forms including animals, fruits, plants and various objects.

Mizu-sashi Japanese term employed to describe the water jars used in the tea ceremony or cha-no-yu. These usually consist of coarsely made pottery jars which serve as receptacles for fresh water used while making the tea. The finest of these water jars are among the great masterpieces of Japanese ceramics and have been classed as national treasures. While some of the earlier ones may have been produced by the traditional folk kilns, the later ones, especially those made at the Mino kilns, are highly sophisticated wares produced by the most skilled Japanese potters under the direction of the tea masters. A large number of such mizu-sashi intended for use in the tea ceremony are still being made in Japan.

Mo or sumi in Japanese. The Chinese term for the black ink used for painting and calligraphy. It is made from carbon, usually in the form of wood soot, which is mixed with a glue and fashioned into sticks or cakes. When in use, the solid stick is ground to produce a powder, which is then diluted with varying amounts of water to obtain tonal gradations. This medium was extremely popular with Chinese artists, and many of the masterpieces of Chinese painting were executed in monochrome ink. See also Ink stick, Shui-mo, Sumi.

Mokkei Japanese reading of the name of the Chinese painter Mu-ch'i. See Mu-ch'i.

Mokuan Japanese painter of the Kamakura period who was active during the first half of the 14th century. He was a Zen monk and in the year 1333 went to China, where he died around 1345. He was praised as a reincarnation of the great Chinese Ch'an painter Mu-ch'i, and for many years his work was confused with that of the older master. In fact, many of the paintings in Japanese collections which are attributed today to Mu-ch'i may actually be by the hand of Mokuan. Both his subject matter and style are very definitely Zen-inspired, and were much admired in Japan, where many examples of his work are preserved. Particularly fine are his portrayals of the eccentric figures from Zen and Taoist legends, such as the charming picture of the fat-bellied and laughing Hotei, now in the Sumitomo Collection, and his renderings of the Zen figures Jittoku and Kanzan.

Mokubei Japanese painter and potter of the Edo period who lived from 1767 to 1833. His family name was Aoki nad he was a native of Kyoto. As a painter he was a member of the Nanga or Southern School, basing his work on the Chinese painters of the Ming and Ch'ing periods and on the great Japanese master of the literati school, Ike no Taiga. However, he is even more important as a potter, and founded the Awatagama pottery in 1808. His work in this field was very much in the Kyoto tradition, and was primarily intended for use in the tea ceremony.

Momotaro Literally meaning "peach boy," the name of the hero of a Japanese fairy tale, who was found inside a peach by his woodcutter foster-parents. This story enjoyed great popularity, especially with children, and has often been represented in Japanese painting, illustrated books, and decorative arts.

Momoyama period A period of Japanese history and art named after the site at which the great military dictator Hideyoshi built his castle; the term literally means "peach hill." It lasted from 1573 to 1615 (some authorities give 1603 as the end of the period). It was marked by splendor, with some of the grandest palaces and castles of Japan erected by the military dictators Nobunaga and Hideyoshi, and by magnificent, colorful decorative screen paintings which were used in the great audience halls of these structures. At the same time, it was also the great age of cha-no-uy, or the tea ceremony, during which the finest of Japanese tea wares were produced. It was also during this period that Japan first came into contact with the West, a development which is reflected in a school of art known as Namban or, literally, "southern barbarian" art.

Mon A Japanese term applied to crests, heraldic badges or coats of arms. Although this custom was at first restricted to warriors, the mon were later worn by all members of the nobility, and this fashion eventually spread to the rest of the population. To regulate the use of mon, laws were enacted ordering the daimyo and samurai to register at least two crests for their family. But these laws were not strictly observed, and by the Edo period all members of the nobility and many others were wearing their mon. They usually take the form of symbolic motifs, contained within a circle, representing plants or, more rarely, birds, animals and insects, and objects such as fans, arrows and mallets, as well as purely geometric designs. The designs of the mon are often aesthetically pleasing, and enable one to determine for which noble family an object decorated with it was made.

Monasteries Monasteries and nunneries played a very important role in the Buddhist religion, and, to a lesser extent, are also found in Taoism. Many of the most important religious establishments of China and Japan took the form of monasteries in which thousands of monks lived a life of meditation, prayer and charity. Some of the oldest of architectural monuments in both countries, such as the great cave temples at Tunhuang, Yün-kang, and Lung-mên in China, and Horyuji, Shitennoji, and Todaiji in Japan, were established as Buddhist monasteries. These institutions were not only centers of religious life, but also great centers of art, with many of the most important Chinese painters, notably those of the Ch'an sect, living as residents in such monasteries. The most famous of Japanese ink painters, the Zen artist Sesshu, was a monk connected with one of the great Zen establishments of Kyoto. Today, many of these monasteries are art museums, containing some of the most important examples of the religious architecture, sculpture and painting of China and Japan.

Mongols A nomad people who roamed across the steppes of Central Asia, and were well known for their military prowess and their cruelty. Under Genghis Khan, who was one of the greatest military geniuses of history, they established an empire which extended all the way from Mesopotamia

in the West to China in the East, and at one point included Hungary as well. During the Yuan or Mongol period, which lasted from 1279 to 1368, it also included China; it was during this period that the famous traveler Marco Polo visited the country. However, his favorable account has been questioned by modern historians, who have pointed out that the Mongol rule was one of oppression and impoverishment, and ended with the hated barbarians being driven out of the country. Today, the Mongols live largely in Sinkiang province, where they pursue their traditional life. See also Yuan Dynasty.

Monju Japanese name for the Bodhisattva Manjusri. See Manjusri.

Monkey The monkey plays a great role in Chinese and Japanese legend, and is often represented in art. It is one of the twelve animals of the duodenary cycle of the lunar calendar, and is believed to be very tricky and, therefore, able to bestow success, protection, and health by keeping away malicious spirits and goblins. A monkey-god plays a prominent role in Hinduism, and this concert is sometimes encountered in Buddhism as well. It is said that the monkey performed important services for the Chinese emissary who, during the T'ang Dynasty, went to India to obtain the sacred books of the Buddhist religion. The emperor, therefore, conferred the august title of "Great Sage Equal to Heaven" upon the monkey, and his festival was celebrated on the 23rd day of the 2nd month of the Chinese calendar. Monkeys are frequently represented in Chinese and Japanese painting and sculpture. The most famous paintings are those of Mori Sosen, and among the sculptures, that of the three monkeys at the gate to the Tokugawa Shrine at Nikko is the best-known.

Monogatari Japanese term to describe the ancient historical narratives of Japanese literature. Many of these, notably the *Genji Monogatari* and the *Heiji Monogatari*, have been the subject of Yamato-e School paintings.

Monster Monsters, supernatural creatures, ghosts and apparitions of all types, both in human and in animal form, abound in Chinese and Japanese legend, and are frequently represented in the art of both countries. The popular art in particular revels in the depiction of weird creatures taking on strange forms, often said to embody the spirit of some restless soul who is avenging himself for past neglect or unfilial behavior. In popular folklore derived from older Buddhist, Taoist and Shinto sources, weird creatures punishing the sinners in hell, or haunting the living in their dreams, form a favorite subject. This is particularly true of the popular woodblock prints of China and the Buddhist painting and Ukiyo-e prints of Japan, with artists such as Hokusai portraying a vast array of fanciful monsters, ghosts and apparitions.

Months Since the traditional Chinese followed the lunar calender, the months played a great role in China: special names were assigned to them, animals were associated with them and floral names were given to them. As the lunar year did not correspond to the solar year, an intercalary month was interposed every 3rd year to make up for the extra days. The

first day of each month was arranged to correspond to the new moon, while the 15th day corresponded to the full moon. Activities appropriate to the various months are often represented in Chinese and Japanese paintings and woodblock prints.

Moon The moon as a heavenly body and a deity played an important role in the religion and artistic life of both China and Japan. Lunar worship is believed to be among the oldest of religious cults, and the moon was associated with the Yin, or female, forces, in contrast to the sun, which was thought of as Yang. Legend had it that it was inhabited by a hare producing the drugs of immortality and a three-legged toad. Both of these are frequently represented in Chinese art beginning with the Han Dynasty. In Buddhism, too, the moon was worshipped as a deity, and the Bodhisattva of the moon enjoyed great popularity in Chinese and, especially, Japanese religious art. In Shintoism, the moon was worshipped in the form of the god Tsukiyomi who, in contrast to the sun deity Amaterasu, who was female, was a male deity. Temples were erected to him, and he was symbolized by a mirror. His sacred days were August 15th and September 13th. The moon is also represented as a decorative motif in Japanese art.

Mori One of the great feudal families of Japan whose seat was located in the castle town of Hagi in Yamaguchi prefecture. They were great patrons of art, and it was for a member of this family that Sesshu painted his most important scroll. It was also under their patronage that the famous tea-ceremony ware was produced at Hagi.

Mori Sosen Famous Japanese painter of the Edo period. See Sosen.

Morofusa Japanese printmaker and textile designer who was the son of Moronobu. He followed in his father's footsteps for a brief time as one of the early masters of the Ukiyo-e, but soon gave this up to return to the family's traditional dyeing and kimono-design business.

Moromasa Japanese painter and printmaker who was a member of the Furuyama School and a pupil of Moroshige. He specialized in the representation of female figures and in illustrating books.

Moronobu Japanese painter and printmaker of the Edo period who is believed to have been born c.1625 and died in 1694. He is considered to be the founder of the Ukiyo-e School of woodblock printing, and was responsible for translating what had originally been a type of genre painting depicting the life of the common people and the Yoshiwara district into wood engravings which were printed in book form. Both as a painter of the amusement district of Edo, with its courtesans and actors, and as a designer of prints and books, Moronobu was very productive, and exerted a great influence on the popular painters and printmakers of later times. With this inexpensive form of artistic expression. Moronobu opened a whole new audience to the appreciation and collecting of art; this was to have a lasting influence on the development of Japanese painting and, especially, prints.

Moroshige Japanese painter and printmaker who was a pupil of Moronobu and one of the outstanding artists of the early Ukiyo-e School. He is primarily known as a book illustrator and as the founder of the Furuyama School, named after his studio.

Moss Temple or Kokedera. The name popularly given to Saihoji Temple. See Saihoji.

Motonobu Japanese painter of the Muromachi period who lived from 1476 to 1559. The son and pupil of Kano Masunobu, he was the outstanding Kano artist of the Muromachi period. He was appointed chief painter by the Ashikaga shoguns and was dignified by the title of Lord of Echizen. He married the daughter of Tosa Mitsunobu and learned, in addition to the Chinese-style painting for which his father was famous, the Japanese style of the Tosa masters. Due to this, he combined, in his best work, the decorative tradition of Japanese painting with the more calligraphic ink style of the Chinese painter. A large number of works, depicting a great variety of subjects, and exhibiting a very eclectic style based on different Chinese and Japanese painters, is attributed to him, but much of it was probably executed by his students. Among his best-known works are the sliding screens from the Daisenin of Daitokuji, and the Reiunin of Myoshinji, both Buddhist establishmetns in Kyoto.

Mu-ch'i Chinese painter of the Sung period who was active during the 13th century. Unfortunately, very little is known about his life, since the Chinese art critics and scholars had little appreciation for the kind of painting which he produced. It was only due to the Japanese Zen monks admiring it and bringing it with them to Japan that his work survives, and that his reputation as one of the great masters of religious painting of China can be substantiated. His family name was Fa-ch'ang, but he adopted the name Mu-ch'i when he joined the Ch'an monastery of Liut'ung-ssu near Hang-chou, where he became a Buddhist monk. His greatest paintings, produced in what the Chinese call an "untrammeled" style with their economy of means, inspired brushwork and deep spirituality, are among the masterpieces of Chinese painting. Most famous is perhaps the "Six Persimmons" preserved in Daitokuji Temple in Kyoto, but other exceptional works are his scrolls of the "Eight Views of the Hsiao and Hsiang Rivers," his Kuan-yin, and his "Monkeys and Crane."

Mudra Sanskrit term to describe the various symbolical hand gestures employed in Buddhist art. Each one of them is associated with some particular quality, state or action, and is also often connected with a particular deity. Among the most important are the dhyani mudra—indicating meditation, the dharmacakra mudra—indicating teaching, the vajra mudra—indicating charity, the abhaya mudra—symbolizing fearlessness, and the vitarka mudra—representing the exposition of the laws. See also entries under different mudras.

Mukade Technique of Japanese sword guard decoration in which a fine wire

outlining the guard is held down by numerous little staples of iron or brass, the ends of which are set into the iron ground. The term literally means "centipede incrustation."

Munakata Shiko Japanese painter and printmaker of the modern period, who was born in Aomori prefecture in northern Japan in 1905 and died in 1975. He is regarded as the most outstanding of contemporary Japanese printmakers. Although he started by studying Western-style oil painting, under the influence of the great modern Hanga artist Onchi, he turned to the making of woodblocks depicting subjects taken largely from Buddhism. A member of the folk art society, he was particularly interested in Japanese Buddhist folk prints of the Heian and Kamakura periods, and Central Asian wall paintings from sites like Turfan and Kyzil. However, he combines this Eastern heritage with a style and sensibility reflecting his exposure to modern Western art, notably to the woodcut prints of the German expressionists. The result is an art of great power and emotional expression, which successfully fuses East and West into a new artistic style all his own. This is best seen in a series of ten large woodcuts representing the disciples of Buddha.

Murasaki Shikibu Japanese author who lived from 975 to 1031. Her most famous work is the *Tale of Genji*, which is not only the greatest of Japanese novels, but one of the masterpieces of world literature. She was the widow of a nobleman, and served at the imperial court as a lady-in-waiting to Jotomonin, the consort of the emperor Ichijo of the Heian period. Several painters and printmakers of later Japan have given us imaginary portraits of this famous writer.

Muroji A small but exquisite Buddhist temple of the Shingon sect, located in an isolated rural area in the Nara district. It was founded in 681, but its present buildings were largely erected by Kobo Daishi in 824. Its main hall and pagoda are among the most authentic and best-preserved structures from the Early Haian period, and its wooden sculptures are considered among the masterpieces of Buddhist art of the 9th century

Musashi Old name of the province in which Edo was located, now now compromising Tokyo and parts of Saitama and Kanagawa prefectures. Scenes from Musashi, notably the autumn grasses of this region, were often represented in decorative Japanese painting. This historical term is sometimes still applied to the Tokyo region with nostalgic associations.

Mushroom The mushroom occurs frequently in both Chinese and Japanese art, especially that connected with Taoism, in which it is said that the Immortals live off magic mushrooms that insure their everlasting life. In keeping with this, the mushroom is looked upon as an emblem of longevity, happiness and prosperity, and forms a frequent motif in the decorative arts of both China and Japan.

Musokukushi Japanese Buddhist priest of the Zen sect who played an important role during the Muromachi period in advocating trade and cultural contact with China. This resulted in the importation of many of the great Ch'an Buddhist paintings, by the outstanding Chinese painters of this school, into Japan. In 1344, the Ashikaga shogun Takauji founded the Tenryuji monastery for him, where he taught the Zen doctrines. An excellent painting of him by Muto Shui is preserved in the Myochi-in in Kyoto, and a sculpture representing him can be seen in the founder's hall of Zuisenji Temple in Kamakura.

Mustard Seed Garden Painting Manual Most famous and most important of the manuals of painting instruction ever published in China. It is illustrated with black-and-white and colored woodcuts which are considered among the masterpieces of this art form in China. The Chinese title for this book is *Chieh-tzu-yüan hua-chuan*. It had no less than twenty editions, the first of which was issued in 1679; it was often reprinted in China and Japan, with additions published in 1701. Its editors were Li Yü, a well-known writer, and Wang Kai, who was assisted by his brothers Wang Shih and Wang Nieh, and by the painters Chu Shêng and Wang Yün-an. It was basically conceived of as a book of instruction, showing how to paint various standard subjects such as mountains, trees, rocks, animals, birds, flowers, bamboo, buildings, bridges and furniture. The illustrations showed compositions freely adapted from the pictures of old masters and contemporary artists.

Muto Shui Japanese painter of the Muromachi period who flourished around the middle of the 14th century. A Zen priest who lived in Kyoto, he was one of the first Chinese-style ink painters in Japan. Judging from his few surviving works he specialized in painting portraits of Zen priests.

Myo-o Ming-wang in Chinese and Vidya-raja in Sanskrit. Buddhist deities represented in fierce and terrifying forms, and looked upon as aspects of the Five Great Buddhas of Wisdom. They are known as the Go Dai Myo-o, or Five Great Kings. The most important of them is Fudo Myo-o, who is a Buddhist manifestation of the Cosmic Buddha Dainichi, and is one of the most popular of all Shingon deities as the protector against evil forces. See Fudo Myo-o.

Myochin Leading family of Japanese armorers who trace their ancestry back to the Heian period. Beginning with the 16th century, they also made sword guards, a practice probably established by Myochin Nobuie. Their work is always in iron and shows great power and dignity. They continued working through the 19th century.

ABCDEFGHIJ KLMNOPQR STUVWXYZ

Nabeshima A type of Japanese porcelain made at the Okawachi kilns of Saga prefecture. It was originally produced exclusively for the Nabeshima daimyo and his family, the feudal lords of the area. Only after the Meiji Restoration of 1868 was it sold on the open market. The older productions of the Nabeshima kiln are considered technically the best porcelain ever made in Japan. The kiln was founded in 1722 and flourished during the 18th and early 19th centuries; it is generally felt that after 1830 the quality of the production declined. Nabeshima ware is still being made today by the twelfth generation of the Imaemon family, who originated this kiln. The most characteristic of the Nabeshima wares are the so-called Iro-Nabeshima or colored Nabeshima wares, but blue and white wares, celadons and plain white wares were also made. Most of the output consists of table wares, notably plates, but flower vases, water bottles and other such utensils were also produced by the Nabeshima potters. Their most outstanding feature was the painted designs, which were very Japanese in character, and were often derived from textile patterns. Typical of these wares is the comb pattern around the base which enables one to distinguish the Nabeshima productions from those of other kilns. Next to the Kutani porcelains, it is the Nabeshima ones which enjoy the greatest popularity among Japanese collectors.

Naeshirogawa Name of a Japanese village near Kagoshima in southernmost Japan, where traditional Japanese folk kilns are located. Originally established by Korean potters, these kilns produce excellent utilitarian wares which are much admired by modern folk pottery enthusiasts. The shapes are strong and simple, and the glazes are usually brown, green or white. This ware is one of the finest and most traditional of the folk pottery being produced in Japan today.

Nagaban or Naga-e Format of Japanese woodcut prints which measure 65.6 cm. x 16.8 cm. or 25.5 in. x 6.5 in., when executed in the benizuri-e

technique; and 67.0 cm. x 13.6 cm. or 26.1 in. x 5.3 in., in the later prints produced in the nishiki-e manner.

Nagaoka Name of the ancient Japanese capital which was situated near the present-day station of Mukomachi. For a brief time between 784 and 794, the capital of Japan was located here, before being moved to a site to the northeast where the present-day Kyoto was built.

Nagare Masayuki Contemporary Japanese sculptor who was born in Nagasaki in 1923. He is usually regarded as the most outstanding and original of modern Japanese sculptors, who combines a sensibility deeply steeped in Zen Buddhism and Japanese folk sculpture with modern abstract art. In addition to many smaller works which use strong, simple shapes and beautiful materials and textures, he has also undertaken several larger commissions, notably the walls of the Japanese pavilion at the New York World's Fair of 1964, and the cement and stone floor and mural decorations for the Zenkyoren Building in Tokyo.

Nagasaki A port city, located on the west coast of Kyushu, which is the oldest open port in Japan. It played a great role during the Edo period, when the Japanese empire conducted its outside trade with the Chinese and Dutch entirely through this port. Unfortunately, most of the old buildings were destroyed during the Second World War, but a few of them survive and others have been reconstructed, notably the Urakami Catholic Cathedral, which was the most famous Catholic church in Japan and the site of the martyrdom of many early Japanese Christians. The island of Dejima, located in the harbor of Nagasaki, was the seat of the Dutch trading mission, and was often represented in the art of the time. See also Nagasaki prints.

Nagasaki prints Type of Japanese woodblock print produced in Nagasaki during the late 18th and early 19th centuries. They represented scenes from the life of the foreigners, notably the Dutch and Chinese, who were permitted to trade with the Japanese in this port city. Particularly interesting are those showing the Dutch ships and the exotic Hollanders portrayed with red hair and grotesquely large noses.

Nagata Yuji Kyoto lacquer artist of the early 19th century who worked in style of Korin, and who is known for a technique named after him, called Yuji-age, in which tin powder was used for the lower layers when the maki-e technique was being employed.

Nagoya One of the largest cities of Japan, and the site of one of the main Japanese castles. It was the seat first of the Oda family and later of Tokugawa Yoshinao, the son of Ieyasu. The castle was five stories high and its donjon stood 140 ft., topped by a pair of dolphins made of gold. Although it was destroyed during the bombing of the Second World War, it has been reconstructed and serves as a museum which contains many objects of artistic and historic importance. Nagoya is also a great center of ceramic production, with extensive porcelain factories located in the city and its environs.

Naijin Japanese term meaning "inner sanctuary." It is the inner sanctum of a shrine or temple building and contains the principal object of worship.

Nakayama Komin Well-known Japanese lacquer master of the Late Edo period, who lived from 1808 to 1870. He was highly skilled in the traditional lacquer techniques and was famous for his copies of lacquers from earlier periods.

Namazu Giant fish of Japanese legend, described as having a large, smooth black body with a flat head and long feelers. He was believed to carry the islands of Japan on his back, and to cause earthquakes by his thrashing about. The Japanese appealed to Kadori Myojin for help against Namazu; the two adversaries are often represented together in prints and netsuke.

Namban Japanese term, used for Westerners, which literally means "southern barbarians." It was first employed for the Portuguese and Spaniards who arrived in Japan during the 16th century. It is also used to refer to the screen paintings representing Westerners or painted in a Western style, which were produced during the Momoyama period, and for the decorative arts executed to suit the European taste or using imported materials.

Nambokucho Japanese term sometimes applied to the beginning of the Muromachi period, when two rival claimants to the Japanese imperial throne were competing against each other. It lasted from 1336 to 1392, and was a period during which Zen Buddhism began to make a strong impact on Japanese culture.

Namikawa School of Japanese enamelers which flourished in Kyoto during the late 19th century. Its founder was Namikawa Yasuyuki, a highly skilled craftsman whose work was technically accomplished and decorated with brilliant colors. This school has branches in Nagoya, Tokyo and Yokohama. The leading artist of the Tokyo School was Namikawa Sosuke. His work was distinctive in that the metal partitions were concealed or even entirely omitted, thereby achieving a more unified pictorial design. See also Yasuyuki.

Nanako Japanese term literally meaning "fish roe." It is used to describe a technique of decorating metal with a close assemblage of tiny granules. Each of the grains is formed by a blow from a cup-headed punch, guided solely by the hand and eye. It originated with the Goto masters of the 15th or 16th century, but was later also used by artists of many other schools.

Nandaimon Japanese term, literally meaning "great southern gate", used to refer to the main gateway at the entrance to the precinct of a Buddhist temple. The nandaimon of the Todaiji Temple in Nara is one of the most famous of Japanese architectural monuments. It was erected during the Kamakura period between 1196 and 1203 to replace the original main gate, dating from the Nara period, which had been destroyed during the civil war at the end of the Heian period. It is outstanding for its huge size

and its complex bracketing system, executed in what is known as the Ten-jikyo or Indian style, but is actually a type of construction imported from southern China. At both sides of the central gateway are huge guardian figures, carved in wood by the workshop of Unkei, which are among the most celebrated of all Japanese sculptures.

Nanga School A school of Japanese painting which is also known as Bunjinga or literary man's school of painting. The terms are derived from the Chinese Nan-hua or Southern School, and Wên-jên hua which means literati men's painting. It stands in contrast to the so-called Northern School or Hokuga of Academic or professional painters. This distinction was first made by the famous Ming painter and critic Tung Ch'i-ch'ang, and was widely used in the classification of painters both in China and Japan. This terminology was introduced to Japan by Nankei, an 18th century artist, and played an important role in Japanese art criticism of the Edo period. Artists such as Taiga, Buncho, Chikuden, Gyokudo, and Tessai were considered outstanding masters of the Nanga School.

Nanking Chinese city located on the south bank of the Yangtze in Kiangsu province. Its name literally means "southern capital," and it did indeed serve as the capital of China during several periods. Under the Liang Dynasty, one of the Southern States during the Six Dynasties period, it became an important political and artistic center. Magnificent large stone carvings of chimeras, which flanked the road to the imperial tombs of that period, are among the masterpieces of early Chinese sculpture. Many of these are found today in Western museums, notably those of the United States. During the T'ang and Sung periods, Nanking declined in importance, but it was still an intellectual and artistic center, and the most famous of Chinese poets, Li Po, spent several years there towards the end of his life. It once more became the capital of China at the beginning of the Ming Dynasty, and most of the present-day old city owes its aspect to this period. It was here that the great encyclopedia of the emperor Yung-lo was compiled and an imperial college was located. While the capital was later moved to Peking, Nanking continued to be an important cultural center during the Ming and Ch'ing periods, and many painters of prominence were among its inhabitants. It again played a significant role during the years of the republic, and it was here that a magnificent mausoleum was built for Sun Yat-sen in 1929.

Nanzenji Japanese Buddhist temple of the Rinzai sect of Zen Buddhism, located in Kyoto. It was founded in 1293, but the original buildings were all destroyed by fire. The earliest existing structures date from the 17th century, but the main hall is modern. It is well known for its paintings of tigers on gold leaf by Kano Tanyu.

Naohabu Japanese painter of the Edo period who lived from 1607 to 1650. Son of Kano Takanobu and younger brother of Kano Tanyu, he was one of the leading masters of the Kano School. At the age of twenty-three he was called to Edo in order to serve as the official painter of the

shogun. He was recognized as having talent equal to that of his more famous brother, and enjoyed considerable success. His work was profoundly influenced by the Chinese painters of the Sung and Yuan Dynasties, as is clearly seen from the few surviving examples. The most famous among them is a pair of landscape screens, in the National Museum in Tokyo, which exemplifies his subtle and masterful use of brush and ink.

Nara City in Japan, which from 710 to 784 served as the capital of the country. It was modeled after the T'ang capital of Ch'ang-an, and was famous for its seven great Buddhist temples, Shinto shrines and the imperial palace. After the removal of the capital to Heiankyo—present-day Kyoto—it declined in importance and became a provincial town. Due to circumstances, however, it has become a veritable museum of ancient Japanese Buddhist art. Some of the most famous of the Nara temples are Todaiji and Kofukuji in the center of the town, and Horyuji and Yakushiji located somewhat outside of the modern city. These temples contain some of the most celebrated of early Japanese sculptures and paintings, as well as a magnificent collection of decorative arts preserved in the Shosoin on the grounds of Todaiji.

Nara-ningyo A type of Japanese wooden doll representing noh actors in various characteristic roles taken from this form of drama. The finest of these figures are characterized by sharp, deep and vigorous carving, and skillful and selective application of color. It is believed that the first of these dolls were made during the Early Edo period by a craftsman of the Kasuga Shrine, who drew his inspiration from small netsuke carvings in the form of noh and kyogen performers.

Nara School Leading school of Japanese sword guard makers established by Nara Toshiteru in Edo during the first half of the 17th century. It was one of the most influential schools of metalworking, and exerted a profound influence on sword makers of later times. It gave rise to many subschools, and continued to flourish right through the 19th century. Its leading master was Nara Toshinaga (1667-1737), who introduced greater refinement into the art of making sword-guards, and employed many new materials and designs. Among the other leading masters who were trained in the Nara School were Sugiura Joi (1700-1761), who invented the shishiai-bori technique, and Tsuchiya Yasuchika (1670-1744), who was also known as Tou, and employed decorative designs based on the style of Korin.

Narihira Japanese poet of the 9th century who was famed for his verses as well as for his handsome appearance. It is said that he paid court to the famous poetess Komachi, with whom he is often represented in art.

Nashiji A type of Japanese lacquer technique in which a moist black lacquer ground is strewn with particles of pure gold or silver, or an alloy of the two. This is then covered with a thick layer of nashiji-urushi, a reddish-yellow transparent lacquer. The best works of this type were pro-

duced during the 15th century, but it is believed that it originated in the Heian period.

National Palace Museum Official name of the museum of Chinese art and archaeology in Taipei, Taiwan, which houses the great collection of Chinese art which originally was located at the Imperial Palace in Peking and included the former imperial collection. It comprises some of the finest examples of Chinese painting and ceramics of the T'ang, Sung, Ming and Ch'ing periods, and outstanding archaeological specimens from the Shang and Chon Dynasties.

Natsume Small lacquered box of cylindrical shape which is used to contain the powdered tea used in the tea ceremony. The natsume were only used during the summer season; in the winter, they were replaced by ceramic cha-ire.

Natsuo Sword guard maker who lived from 1828 to 1898, whose family name was Kano, and who is usually looked upon as the last great master of the art of sword decoration in 19th-century Japan. He belonged to the Otsuki School, which had been established by the 18th-century metal artist Otsuki Mitsuoki. He was well known for his technical skill in the surface treatment and coloring of his metal ground and the delicate modeling of his designs. He served as a professor at the Tokyo School of Fine Arts, and was the author of a book dealing with the history of Japanese metalworkers.

Negoro-ningyo A kind of netsuke carving in the Negoro style, with a wooden base coated with black lacquer and then covered with red lacquer which is partially rubbed off. See Negoro-nuri.

Negoro-nuri A type of lacquer ware named after the Negoro Temple in Wakayama prefecture, where it is reported to have first been made. It consists of wooden objects decorated with a highly polished red lacquer beneath which the black ground sometimes appears. The oldest pieces come from the Kamakura period, but the ware enjoyed widespread popularity only in the 15th century. To this day it is one of the most admired types of lacquer to be found in Japan.

Nehan See Nirvana.

Nekogaki Literally "cat scratches," a Japanese term used to describe a technique in which the surface of metal objects is decorated with oblique burred striations.

Nengo Japanese equivalent of the Chinese term nien-hao, used to designate a particular era which may vary in length from a couple of years to several decades. They are usually connected with the reigns of certain emperors, although more than one nengo may be employed in the course of the rule of a single emperor. See Nien-hao.

Neolithic The Neolithic or New Stone Age played a very important role in the art of both China and Japan. The exact beginnings of Neolithic art cannot be determined with certainty in either country, but there can be little doubt that by 5,000 B.C. magnificent large Neolithic pottery vessels were

being made in both countries. In China, the Neolithic period lasted until the beginning of the 2nd millennium, when it was replaced by a bronze culture; in more provincial places, however, the Neolithic pottery culture continued for several centuries. In Japan, the Neolithic Jomon culture lasted to the end of the 1st millennium B.C., particularly in the northern part of the country, and produced a rich and varied art.

Netsuke Japanese miniature carving made of a large variety of materials, notably all kinds of wood, ivory and bone, which serves as a button or catch to hold the string attached to the inro, or tobacco pouch, between the girdle and the garment. They became popular during the Genroku period, when elaborately carved netsuke were produced. Their high point was reached during the Edo period, notably the 18th century, and they began declining during the middle of the 19th century, when they were no longer widely used, but were produced mainly as curios for collectors. However, it was at this point that Westerners developed a great liking for them, which stimulated manufacture for export. Many Japanese carvers specialized in making them, and some of the best sculpture of Edo-period Japan was produced in this form.

Ni Tsan Chinese painter of the Yuan period who lived from 1301 to 1374. He is considered one of the Four Great Masters of the Yuan Dynasty and the very essence of the kind of scholar-painter the Chinese have always admired above all. As a young man, he led a carefree life as a scholar, collector of paintings and eccentric. But then, at thirty-five, he took up the life of a wanderer and artist, sailing up and down the rivers and lakes of Kiangsu and giving his pictures to friends. His work is very restrained, employing a dry brush and sparse forms. His subject is almost invariably a landscape with mountains, a body of water, a few trees and rocks, rendered in a very austere style, giving a rather cold, silent, and somewhat melancholy feeling. His fame was great even during his lifetime and inspired many followers during the Ming and Ch'ing periods. Outstanding examples of his art may be found in several collections, notably the National Palace Museum in Taipei.

Ni Yüan-lu Chinese painter of the Ming period who was born in 1593 and died by his own hand in 1644, when the rebel Li Tzu-ch'êng entered Peking. He was highly esteemed as a poet, literary writer and calligrapher as well as a painter, and was a member of the Han-lin Academy. He also served in many official capacities. He is best remembered today for his paintings of rocks and trees, which are often fantastic and reveal a fine sense of structure. Excellent examples of his work may be seen in Japanese collections.

Nichiren Japanese Buddhist priest who lived from 1222 to 1282. He was trained in the Tendai sect on Mount Hiei, but rebelled against the teachings of the school and founded his own sect, known as Nichiren Buddhism, based on a new emphasis on the Lotus Sutra. His strong personality, Japanese nationalism, and prophetic statements about the

Mongol invasion gained him many followers, especially among the military, but he had little influence on art.

Nien-hao Generic term used for the names of the various eras or periods of Chinese history. Literally translated, nien means year and hao means name. Originally the nien-hao might be changed any number of times in the course of any one emperor's reign. But beginning with the Ming Dynasty, the nien-hao corresponds exactly to the reign of each emperor. This term is also used to designate the date or reign marks incised, painted or otherwise affixed to the surface of an object—usually porcelain and sometimes bronze—which give the title of the period during which the object was purportedly made. On porcelain objects, these inscriptions are usually in blue under the glaze, but may also be executed in overglaze red or blue enamel. Such marks are usually composed of either six or four characters. They are not normally found on objects dating from before the 15th century.

Nihon-shoki or *Chronicles of Japan.* One of the classics of Japanese literature. Together with the *Kojien,* or *Record of Ancient Matters,* the *Nihon-shoki* is the most valuable source for our knowledge of early Japanese history, legend and culture. It was compiled under the empress Gensho during the Nara period in the first half of the 8th century, and has played an important role in traditional Japanese culture ever since that time. It was translated into English in 1896 by W. G. Aston.

Nihonga Literally "Japanese painting," a term often employed to describe painting in the Japanese style in contrast to Chinese painting, which is known as kara-e, and Western-style painting, which is known as yoga. In modern Japanese painting, especially, the term nihonga is applied to those artists who continue to use traditional Japanese painting materials, styles and subject matter, as opposed to those who have embraced Western-style painting.

Nihongi Abbreviated form of *Nihon-shoki,* the classic of Japanese history. See *Nihon-shoki.*

Nijo Castle The most famous and best-preserved of the Kyoto palaces. It was erected between 1601 and 1603 as a residence for the Tokugawa shogun Ieyasu, during his stays in the ancient capital. It was enlarged in 1626, at the time of an imperial visit. It is a characteristic example of shoin architecture, and is outstanding for its painted decorations executed by Kano Tanyu and other members of the Kano School. It also has a magnificent garden.

Nikko A Japanese town, located ninety miles north of Tokyo, which is well known for containing the Tokugawa Family mausoleum, called the Toshogu, and a magnificient national park, extending over some 206 acres and including some of the most beautiful mountain scenery in all of Japan. See Toshogu.

Nikko Bosatsu Buddhist deity who is the Bodhisattva of the sun. He appears frequently in Japanese art alongside his companion Gakko, who

is the Bodhisattva of the moon. They are represented as typical Bodhisatt-vas, wearing the crown, jewels, scarves and skirt characteristic of these sacred beings. The most famous examples of such representations are the large bronze figures standing at the sides of the great seated Yakushi figure in the Yakushi Temple in Nara, which dates from the Nara period.

Nimbus Radiant emanation surrounding the head or the entire figure of a deity, indicating its sanctity. It was probably originally derived from the solar disc in ancient Persian art. It occurs often in both Christian and Buddhist iconography. In Japan, a large oval nimbus is often referred to as funagoko, meaning "boat-shaped halo." See also Halo.

Nine Dragon Screen The most famous of all of the spirit screens in China. It is located at the northern shore of the Northern Lake or Peihai, north-west of the Imperial Palace in Peking. It was erected in 1417 during the Ming Dynasty to protect the temple, which no longer exists today. It is 87 ft. long and 15 ft. high, and is made of glazed tiles of different colors, representing the nine heavenly dragons playing with balls among the waves. See also Spirit screens.

Ning Hsia A province of modern China comprising the territory north of the great bend of the Yellow River. It was formerly part of Inner Mongolia. From an artistic point of view, it is particularly important for its woven rugs made from sheep or camel wool by the nomad people of this region.

Ning-po Name of Chinese city, located in Chekiang province, which is the port city of Hang-chou, and played an important role in Chinese overseas trade. It was here that the Portuguese were first permitted to trade in 1542, but after a brief time, during which it is said that some 3,000 Por-tuguese settled there, they were evicted due to their arrogant behavior. It also was a center for Moslems and Jews, who lived here in large numbers.

Ningyo Japanese term applied to dolls of all kinds, literally meaning a "figure of human shape." It may be used for dolls used as children's playthings, figures used in connection with the Dolls' Festival, or small ornamental figures, such as netsuke carvings in human form. Dolls were already made during the Heian period at which time they were called hina and were used as playthings for the children of noble families. However, the finest dolls were made during the Edo period (1615–1867), when magnificent dolls, often dressed in beautiful costumes, were produced not only for the nobility, but for the well-to-do city people as well. The most celebrated of these are the emperor and empress dolls, and those of their attendants which were made for display on the Girls' or Dolls' Festival day. See also Dairi-sarpa, Gosho-ningyo, Nara-ningyo, Saga-ningyo, Ukiyo-ningyo, and Kokeshi-ningyo.

Ninnami Dohachi Japanese potter of the Edo period who lived from 1783 to 1855. A leading member of the Kyoto School of potters during the 19th century, he worked in a characteristically Japanese style, im-itating the work of Ninsei, Koetsu, and Kenzan, often using bold

decorative designs. He had numerous followers who also employed the name Dohachi. See Dohachi.

Ninsei whose family name was Nonomura, was one of the most famous and influential of all Japanese potters. Although his exact dates are not known, it is recorded that he was most active during the 5th and 6th decades of the 17th century. He was a native of Tamba, a district famous for its ceramic production since ancient times. He studied in Seto, the traditional Japanese pottery center, and then settled in Kyoto, where he spent the remainder of his life. He was a painter as well as a potter, and was greatly interested in enamel decoration, of the type employed by the Chinese ceramic artists of the Ming and Ch'ing periods, and the Japanese ones of the Arita district. His greatest contribution was that of applying to pottery the gorgeous color enameling previously only used for porcelain, an innovation which was much admired at the time and exerted a great influence on later Japanese potters, notably Kenzan. Best known of his works is the group of large tea jars, with brilliant color designs of flowers and trees, as well as landscapes, which reflect the tradition of splendid decorative arts of the Momoyama period. He was the leading artist of the Kyoto School of ceramics during the 17th century. His tea jars and tea bowls are regarded today among the national treasures of the Japanese people.

Nintoku Ancient emperor of Japan who is said to have been the sixteenth in the imperial line, and to have lived in the 4th century A.D. His grave mound, or misasagi located not far from Osaka, is the largest in Japan. It is 100 ft. high and 1,700 ft. long, and is surrounded by a moat. It is considered one of the most important artistic monuments of prehistoric Japan.

Nio or "two kings," is the Japanese term for the two guardian deities who appear at the gates of Buddhist temples. They are thought of as protectors of the Buddhist sanctuary, and are usually represented as muscular warriors holding vajras, or clubs, and scaring off any evil demons who might wish to invade the sacred precincts. Among the most famous of these are the clay figures at Horyuji, which date from the Nara period, and the large wooden carvings at Todaiji, which come from the Kamakura age.

Nioibin Japanese term for a small perfume flask, usually of metal or lacquer, which is shaped to resemble a gourd and is worn hanging from the belt. They became popular in the early part of the 19th century.

Nirvana or Nehan in Japanese. Sanskrit term to describe the Death of the Buddha, and the ultimate reality which the Buddha himself and his followers may reach after their earthly life, when they have achieved moral and spiritual perfection. It is usually conceived of as the ultimate nothingness in which all striving, pain and anguish have ceased after the soul is no longer subject to rebirth.

Nisai Modern netsuke carver who was born in 1880 in Yamatoshimachi.

He studied in Tokyo, and lived mainly in Kyoto and Osaka. He is well known for his carving of netsuke and tea-ceremony articles of boxwood.

Nishi Honganji Famous Kyoto temple which is the main headquarters of the Lodo-Shinshu sect of Buddhism. The temple was established in Kyoto by order of Hideyoshi in the late 16th century, but after a fire destroyed it in 1617, it was reconstructed, and sections of Hideyoshi's famous Juraku Palace were added to the temple buildings. It is particularly well known for its Hondo, or Main Hall, which contains magnificent screen paintings executed by masters of the Kano School, and the portraits of Shinran and Honen, the two most outstanding priests of the sect. Among the structures transferred from the Juraku Palace, the most famous are the Hilnkaku and the Seimon Gate. Paintings by some of the most famous of Japanese painters, notably masters of the Kano School such as Eitoku, Sanraku and Tanyu, may be found among the numerous artistic treasures contained in the apartments of this great temple.

Nishijin District in the northwestern part of Kyoto, known as a leading center of the weaving industry since the Momoyama period, when it almost completely monopolized the production of all textiles of high quality. It was during this time that the magnificent brocade known as Nishijin-ori came into existence. Silk weaving is still carried on as a home industry in this district. In 1915 the Nishijin Textile Museum was established at Imadegawa Omiya; it contains a large number of exhibits of all the Nishijin products.

Nishikawa Family name of the woodcut artist and illustrator, Sukenobu. See Sukenobu.

Nishiki Japanese term applied to the exquisite brocades woven with designs in many colors. The earliest examples of the nishiki are found in the Shosoin and date from the Nara period. Several different kinds of nishiki can be distinguished, such as kinran-nishiki—a rich silk brocade interwoven with thin strips of gold; foil; ginran-nishiki—the same brocade but using silver foil; tsuzure-no-nishiki—a kind of tapestry weave similar to the Gobelin weave, with shading and details applied with a brush; and orimono—a silk cloth with woven designs.

Nishiki-e Japanese term literally meaning "brocade pictures." It is used to describe the fully developed technique of color printing which is likened to the varied and fine colors of a beautiful fabric. The earliest of these prints appeared on the market in 1765, and are therefore believed to have been made in 1764. The first major artist to work in that technique was Harunobu.

Niten Japanese painter of the Edo period who lived from 1584 to 1645. He was well known as a swordsman as well as an artist, and belonged to the nobility. His true name was Miyamoto Musashi. He was trained in the Kano School, and also studied the work of the Chinese painters of the Sung period. However, he developed a highly individual style which combined vigorous brushwork with great simplicity of form. His finest work,

mostly representing birds, is among the best ink painting produced in Japan during the Edo period.

Noami Japanese painter of the Muromachi period who lived from 1397 to 1471. A pupil of Shubun's, he was one of the outstanding ink painters of the time as well as a poet, a tea master, and an art collector who became the director of the Ashikaga shogun's collection of Chinese painting. Together with his son, Geiami, and his grandson, Soami, he formed the so-called Sonami Group. His works followed Chinese Sung inspiration both in subject matter and style, but were somewhat softer and more decorative, in keeping with Japanese taste. Numerous works are attributed to him; however, it is very uncertain if any of these are actually by his hand.

Nobunaga Oda Military dictator of Momoyama period Japan who lived from 1534 to 1582. He originally had been the daimyo of Owari province, today's Aichi prefecture, but, in a series of military campaigns, enlarged his fief, conquered Kyoto, and was on the verge of uniting the whole country, when he was assassinated by one of his generals in 1582. In addition to being a great soldier and statesman, he was also a great patron of the arts and an enthusiastic practitioner of the tea ceremony. His castle at Azuchi on Lake Biwa was one of the most splendid structures ever erected in Japan, and was decorated with screen paintings by some of the greatest of contemporary painters. See Azuchi.

Nobuzane Japanese painter of the Kamakura period who was active during the first half of the 13th century. His family name was Fujiwara, and he was the son of Takanobu. Little is known about his life, but he was a courtier and a poet as well as being an artist. He enjoyed a reputation as a realistic portrait painter, and a scroll depicting the Thirty-six Poets is attributed to him. If this is actually by his hand, it would suggest that he employed a detailed, colorful, decorative style, in keeping with the Yamato-e tradition, which was the dominant school of that time. Another work often ascribed to him is the scroll illustrating the diary of Lady Murasaki, but this attribution is even more uncertain.

Nodachi Outsized Japanese sword, sometimes as long as 7 ft., carried by certain stalwarts during the civil wars of the 14th century. It was worn on the back of the warrior with the hilt emerging over the left shoulder.

Noh Type of Japanese drama which was develped during the Muromachi period and continues to play an important role in the traditional Japanese theatre of the present day in connection with the drama, masks and garments which were often works of art of a very high order were worn. Several families specialized in the making of noh masks, and have continued that tradition to the present day. Fine examples of such masks from the 15th and 16th centuries are preserved in the Shinto shrines of the Nara area and in the collections of the great families of noh performers. There were several types of masks, each one associated with a particular character appearing in the noh drama or the comic interludes connected

with them, known as kyogen. Equally fine were the splendid garments worn by the actors. Those fabricated during the Momoyama period, which are regarded as among the finest of all Japanese textiles are outstanding for the boldness of their designs and the beauty of their colors.

Noin Ula Archaeological site in Mongolia, seventy miles north of Urga. It was at this site that Russian archaeological expedition under Kozlov found fine examples of Han textiles with animal, bird, tree and landscape designs, indicating the popularity which Chinese silks and other materials enjoyed among the nomads.

Nonko Alternate name of the great Raku family potter Donyu, who is regarded by some critics as the finest of all the Raku artists. His glossy black Raku glaze is especially prized by the tea masters and is referred to as Nonko-guro. See also Raku and Donyu.

Northern Ch'i Short-lived Chinese dynasty that ruled parts of northern China from A.D. 550 to 577, and is primarily important as a patron of Buddhist art. Some of the finest 6th-century sculptures were made during this reign.

Northern Chou A short-lived Chinese dynasty that ruled part of northern China from 557 to 581. It is particularly known for its Buddhist sculpture, which reflects the strong Indian influences that were felt in the Chinese Buddhist art of that period.

Northern School Pei-hua in Chinese and Hokuga in Japanese. School of Chinese painting which stood in contrast to the Southern School, and was believed to derive from the great T'ang painter, Li Ssu-hsün, and was traced through Chao Po-chü, and the Academic painters of the Southern Sung court at Hang-chou, to the members of the Chê School of the Ming Dynasty. This division, which was a somewhat arbitrary one, had nothing to do with geography, but was based on the supposed distinction between the two schools of Ch'an Buddhism, formulated by the Ming critic Tung'Ch'i-ch'ang. In theory, at least, the painters of the Northern School were professionals who worked in a meticulous manner, often using color, while the members of the Southern School were literati painters who worked in ink and were amateurs in the best sense of the word.

Northern Wei A Tartar dynasty that ruled much of northern China from A.D. 386 to 535. It is particularly noted for its patronage of Buddhist art, with the two most celebrated artistic monuments executed under its rule: the cave temples at Lung-mên and those at Yün-kang. Many of the finest Chinese Buddhist bronzes of the Six Dynasties period were also executed under its rule.

Noshi Colored paper folded to form a cover for a gift traditionally of awabi fish, but now used widely for wrapping gifts presented at New Year's, weddings, and other festivals. The form is also used today as a common decorative motif, especially in textiles.

Nü Kua Legendary ruler of China in highest antiquity, the sister of the emperor Fu Hsi. According to Chinese tradition, they are believed to

have ruled China together at the beginning of the 3rd millennium B.C. She is usually represented with a human head and torso, but the tail of a snake, and is believed to have brought civilization to China. Representations of her and her brother are found in Han art, notably the Wu family tomb reliefs in Shantung.

Nuihaku A Japanese textile-design technique which was perfected during Momoyama period. It combines embroidery, or nui, and gold leaf, or haku, to create detailed designs of brilliant yet refined effect. Among the finest surviving examples of fabric worked in this technique are the noh robes in the collection of the Tokyo National Museum.

Nuri Japanese term referring to the outer layer of lacquer covering an object. It is used in conjunction with other terms to describe various types of lacquer ware, for example ro-iro-nuri, or black lacquer ground, shu-nuri, or red lacquer ground, Tsugaru-nuri, a type of specially decorated lacquer produced in the Tsugaru district, etc. Other commonly used terms are nuri-shi, or "lacquer master," and nuri-mono, or "lacquered object."

Nyoirin Kannon In Sanskrit, Cintamanicakra Avalokitesvara. Japanese name for a form of Kannon shown holding a magic jewel or nyoirin in the right hand.

Nyorai Tathagata in Sanskrit, is one of the names applied to the Buddha: nyo (in Sanskrit Dharmakaya) indicating that he has received the state of absolute existence, and rai (Sambhogakaya) indicating that although he has reached Nirvana, he continues to have an existence of his own in order to be able to enter into relationships with Bodhisattvas. It is one of the forms in which the Buddha manifests himself in order to save the human race.

ABCDEFGHIJ KLMNOPQR STUVWXYZ

Oban Term used to describe the standard format of Japanese woodblock print, which in the case of the fully developed color print of the nishiki-e type usually measures 75.7 cm. x 45.4 cm. or 29.5 in. x 17.7 in. Variations, referred to as onishiki-e oban, measuring 39.3 cm. x 26.3 cm. or 15.3 in. x 10.3 in., and onishiki-e baiban, which measures 53.0 cm. x 37.8 cm. or 20.7 in. x 14.7 in., also occur. In the earlier periods of Japanese printmaking, a great variety of measurements among the oban are to be found.

Obi The belt or sash used to fasten the Japanese kimono. The obi worn by women are about 2 ft. wide and 11 ft. long. They are folded double, woundaround the waist twice and tied behind. Obi used by men generally measure only 4 in. in width and are shorter than those intended for women. They are usually made of elegant, heavy silk material.

Octopus The octopus, commonly found along the coasts of the Japanese archipelago, plays an important role in the life and legend of Japan, and is often represented in art. Its strange appearance and the almost human aspect of its eyes and nose have long made the octopus a popular subject in Japanese folklore, where it is variously presented as the physician or messenger of Ryujin—the King of the Sea, a peaceable temple guardian, or a terrifying monster that frightens peasants and children and lures young women into the sea. The octopus has long served as a source of food for the poor people of the Japanese islands. It is frequently used as the subject for netsuke and okimono, and also occurs as a decorative motif on lacquer ware and metal objects, illustrating the many legends in which it plays a role.

Oda Family name of the Japanese military ruler Nobunaga. See Nobunaga.

Odori Japanese term used to describe popular dances of all kinds which are still being performed on festival days throughout Japan. The best known of these is the Bon Odori, a community dance usually held on the last night of the Bon Festival or Bon Matsuri. It is a very rhythmic dance, with

the participants both singing and dancing, and clapping their hands and stamping their feet.

Oei Japanese painter and printmaker of the Edo period who was active from about 1810 to 1840. She was the daughter of Hokusai, and worked in his studio, where she assisted him, but she was also known for her independent work, consisting of book illustrations and paintings of young girls. Little is known about her life, and few of her works are preserved.

Ohara Village north of Kyoto, at the foot of Mount Hiei, which is well known for the handsome peasant women who carry bundles of wood on their heads. They are dressed in special garments that feature white cotton cloth covering the legs and arms, and kerchiefs over the head. Women of this village are often represented in Japanese painting and decorative arts, and are referred to as Oharame.

Ohi Type of Raku ware made at Ohi, in Ishikawa prefecture, which is well-known for its tea bowls with an amber-colored glaze; in addition, in later times, enamels decorated with green and red colors were also made. The kiln was established by a Kyoto potter by the name of Chozaemon in the 17th century, and has continued into modern times.

Ohisa Celebrated beauty of the Japanese tea house Takashima in Edo. She has been made famous by the prints of Utamaro, and can be recognized by the mon that she wears on her garments or in her hair—three oak leaves arranged in a circle.

Oil spot A silvery grey spotting on a black glaze, derived from iron, which results from excesses of the metallic compound being deposited on the surface during the oxidizing firing. This decorative effect introduced under the Sung Dynasty, occurs in the Honan black wares and the Chien wares, called temmoku in Japanese. Highly skilled potters were able to control the markings, bringing the grey crystals together to form a regular pattern of dots. The oil spot glaze was greatly admired by the tea masters of Japan.

Oiran Japanese term for the licensed prostitutes of the red-light districts of traditional Japan, usually referred to as courtesans in Western literature. They played a prominent role in the life of the Japanese cities, especially Edo. The most outstanding of them were known for their beauty, bearing and elegant attire. They form one of the main subjects treated by the Japanese artists of the Ukiyo-e School, and the most popular of them have achieved immortality in the depictions of such masters as Harunobu, Kiyonaga and Utamaro.

Ojime A small sliding bead through which are passed the silken cords used to suspend the inro, tobacco pouches and money purses. These beads, which may be made out of a variety of material such as bone, wood, lacquer, jade, and ivory, are often carved with intricate designs or in the shape of animals or human figures.

Okada Kenzo Modern Japanese painter who was born in Kanagawa prefecture in 1902. He studied Western-style painting at the Toyko School of

Art in Paris, and became one of the pioneers among abstract painters in Japan. In 1950 he moved to New York, where he has done his best work, combining the vitality of the New York school with a typically Japanese sensibility. He is often thought of today as an American rather than a Japanese painter.

Okame See Uzume.

Okatomo Netsuke carver of the mid-18th century who lived in Kyoto. He worked in ivory and Japanese oak, specializing in the carving of flowers, birds and monkeys. He often represented quail with millet seeds.

Okawachi Site near Arita where a beautiful type of fine porcelain, known as Nabeshima ware, was produced for the house of Nabeshima, the lords of Saga. See Nabeshima.

Okimono Generic name for all Japanese decorative objects which have no utilitarian function, but are merely created to distract or please the eye. They are usually of ceramic or metal, and most frequently represent human figures, animals and birds. Literally translated, oki means to place or to put, and mono means object or thing.

Okumura Family name of a famous 18th-century printmaker, Okumura Masanobu. See Masanobu.

Okuni Famous Japanese dancer of the Momoyama period who is credited with helping to establish kabuki as a popular art form. She had started her life as a dancing girl at the Shinto shrine at Izumo, and then went to Kyoto, where she performed sacred dances and married the hyogen dancer, Sanjuro. With him, she erected a stage in the Kamo river where, accompanied by other women, they performed bugaku dances and kabuki plays. This proved so successful that she went to Edo, where her performances were much admired. Her dancing is often represented in Japanese art.

Okyo Japanese painter of the Edo period who lived from 1733 to 1795. His family name was Maruyama and he originally came from Tamba, but at seventeen he went to Kyoto, where he spent most of his life. His early training was received in the Kano School, but far more important for his artistic development was his encounter with Chinese painting of the Ming period, and above all the influence of Shên Nan-p'in, a Chinese artist who had lived in Nagasaki during the 1730's and employed a rather detailed and realistic style. Also significant was his discovery of European engravings, which had reached Japan during that period, and which exposed him to Western-style perspective and shading. As a result of these influences, he developed a more realistic style of painting based on the meticulous examination of nature, making numerous sketches of the objects he depicted. His output was large, consisting of landscapes, trees, flowers, human figures, and animals in the form of screens, wall paintings and scrolls, and his influence on later artists was immense. The Maruyama School, of which he was the founder, was one of the domi-

nant schools of Japanese painting throughout the later Edo period, and several important artists, such as Sosen and Genki, were among his followers. Outstanding examples of his work may be found in the Tokyo National Museum.

Omori School of Japanese metalworkers founded by Omori Shigemitsu (1693-1726), who had studied with the Nara School in Edo. The most outstanding master of this school was Omori Teruhide (1729-1798), who is credited with the invention of the so-called Omori waves, with their curling, undercut crest and gold powder inlay. He had many followers, who continued to work in his style into the 19th century.

Onchi Koshiro Japanese printmaker of the modern period who lived from 1891 to 1955. A native of Tokyo, he studied Western art at the Tokyo Fine Arts Academy. One of the leading members of the school of modern woodcut prints known as Hanga, he was a pioneer in introducing abstract art to Japan. In contrast to the traditional Ukiyo-e printmakers, he made his prints himself rather than having them cut, engraved and printed by professional artisans. He was profoundly influenced by such Western graphic artists as Munch and Kandinsky. He was also a designer and writer who exerted a powerful influence on contemporary Japanese art.

Oni Japanese term applied to demons which were believed to inhabit both the lower regions and the celestial realm. The oni of the nether regions are believed to have red or green bodies and, often, the heads of oxen and horses, and are said to come to fetch sinners to take them before the god of death, called Emma-o in Japan. Related to them are the humorous Buddhist figures representing oni, still showing grotesque features and horns, but converted to Buddhism and dressed as mendicant monks. Oni are frequently represented in Japanese painting and sculpture, notably that of the Heian and Kamakura periods.

Onin Name of an era of Japanese history which started with the year 1467. It is best known for the Onin War, a civil conflict between two of the most powerful families of Japan—the Hosokawa and the Yamana—which lasted from 1467 to 1477 and reduced Kyoto to ashes.

Oracle bones Oracle bones played a great role in the culture of ancient China, notably the Shang period, when animal bones and the shell of the tortoise were used for purposes of divination. The questions and answers asked of the oracle were inscribed on the bone, constituting the earliest body of Chinese writing, which has helped modern scholars trace the development fo the Chinese script and to reconstruct many aspects of ancient Chinese civilizations. The discovery of these inscribed bones, and the recognition of the fact that they dated from Shang times, led to the excavations at An-yang, and are modern scientific archaeological evidence for ancient Chinese culture. See also Bone writing.

Oranda Japanese term for Holland, which is applied to a doll made at Koga, not far from Nagasaki in Kyushu. The doll represents a Dutch sea captain

holding a gun in his hand. The term, however, may be more generally applied to any objects that have a connection with Holland.

Ordos Desert region of China just north of the Great Wall, where numerous bronzes decorated with animal motifs in a nomad style were found. Due to this, a category of small-scale Chinese bronze objects, largely dating from the Han period, are referred to as Ordos bronzes. Among the animals represented are reindeer, oxen and horses, often in combat with tigers and eagles. The style employed here is usually referred to as the animal style, which can ultimately be derived from ancient Iranian sources. It enjoyed great popularity among the nomad tribes of Mongolia and Siberia, and is also sometimes found in Chinese art.

Oribe Name of a Japanese ceramic ware connected with the tea ceremony. It derived its name from the distinguished tea master Furuta Oribe, who lived from 1543 to 1615. Oribe, who was born the son of a priest in Mino, became a samurai and later daimyo, but his fame today rests upon his having become a pupil of Sen-no-Rikyu, the great tea master. Oribe ware is noted for the beautiful deep-green glazes that usually cover only part of the surface of the vessels. They are also often painted with abstract stylized designs of grasses and flowers. The shapes are usually intended for the tea ceremony, and are asymmetrical in shape and bold in manner. Although Oribe ware continues to be made in the Mino district and Seto today, the finest of these wares date from the Momoyama or Early Edo period.

Orihon Album containing Japanese prints or drawings. Rather than being bound like a book, however, the pages are folded in zigzag fashion, like the leaves of a screen.

Orikami Certificate or document, accompanying Japanese objects of art and antiques which identifies the artist and gives the date, provenance, history and value of the work.

Osaka Second largest city of Japan, originally called Naniwa or "rapid waves." It has a very long history, and it is said that, as early as the 4th century, the emperor Nintoku built a palace at the site where Hireyoshi was to build his great castle. Ever since Momoyama times, it has been one of the great commercial centers of Japan, and contains several important temples and shrines, notably Shitennoji, founded by Prince Shotokutaishi, and the Sumiyoshi Shrine, and important Shinto sanctuary. It also contains a famous art museum, built in 1936, which has a large collection of paintings, Buddhist sculptures, ceramics, lacquer and metalwork.

Osen Tea house waitress of the Kasamori in Edo who lived during the Edo period. She was celebrated for her charm and beauty, and was represented in the prints of Harunobu.

Ota Name of a suburb of Yokohama, where, during the 19th century, decorated faience, in imitation of Satsuma ware, was produced, notably in the kiln of Miyagawa Kozan, also known as Makuzu.

Otoman Netsuke carver of the early 19th century who came from Hakata. He had originally been an obi dealer, but became a famous netsuke carver who worked in wood and ivory, specializing in the depiction of tigers.

Otsu Town near Kyoto, located on the shores of Lake Biwa, which is the capital of Shiga prefecture. It contains the tomb of Basho, the greatest Haiku poet, and served as the residence of the imperial court during the 2nd and 7th centuries. A type of popular painting, known as otsu-e, was produced here during the Edo period. See Otsu-e.

Otsu-e Japanese folk paintings that were executed during the Edo period in the town of Otsu, on Lake Biwa, and were sold for a few pennies near the gate of the Miidera temple. Although crude and inexpensively mass-produced, they have considerable charm, and portray the figures from popular religion and legend of the time in a vivid and colorful manner. While originally produced to sell to the travelers who passed by, along with dolls, towels and other souvenirs, they are highly valued today by folk art enthusiasts and are eagerly collected in both Japan and the West.

Otsuki School of Japanese metalworkers established in Kyoto by Otsuki Mitsuoki (1766–1834), who was a pupil of the painter Ganku. He is well known for his great skill in working in a variety of techniques, notably katakiri engraving. His favorite subjects were from the animal world—stags, storks, crabs, fish and octopi. He had a large number of pupils, among whom Kawarabayashi Hideoki, Sasayama Tokuoki and Tenkodo Hidekuni were the most notable.

Ou-yang Hsün Chinese scholar and calligrapher who lived from 557 to 641. He developed an individual style of k'ai-shu writing, distinguished by strongly constructed and well-designed characters and sharp, powerful strokes. He is also known for the thirty-six rules of composition which are set forth in his widely read book on calligraphy.

Owari Old name for the section of Japan now called Aichi prefecture, in which Nagoya is located. It was famed for its production of ceramics and swords.

Owl The owl is often represented in the art of ancient China where it probably was seen as a symbol of darkness and night, in contrast to the pheasant, who was associated with light and the sun. In later China, the owl was thought of as an evil bird, for it was said that the young owls eat their mother. The voice of the owl was dreaded, for it was thought that it indicated that a death would occur in the neighborhood. The finest representations of owls in Chinese art occur among the ceremonial bronze vessels and jade carvings of the Shang Dynasty—being considered an unfilial bird of ill omen, the owl is not much represented in later Chinese and Japanese art.

Ox The ox plays an important role in the life and legend of China and Japan, and is frequently represented in art. It is thought of as an emblem of spring and agriculture, and is one of the twelve animals of the duodenary cycle

of the lunar calendar. It was originally associated with the lunar forces, probably due to the shape of its horns. It occurs among the bronze ceremonial vessels and jades of ancient China, and is frequently represented in both Chinese and Japanese art of later times as well. Oxen and water buffaloes often occur in Chinese painting, some of them no doubt purely descriptive, but some of them also connected with Zen Buddhism. The ox also occurs in Esoteric Buddhism, where Daitoku Myo-o is seen seated on an ox.

ABCDEFGHIJ
KLMNOPQR
STUVWXYZ

Pa Chi'hsiang See Eight Buddhist Emblems.

Pa-hsten See Eight Immortals.

Pa kua or Eight Trigrams, are eight groups of lines, each group consisting of various combinations of broken and unbroken lines arranged in three ranks. They formed the basis of an ancient system of philosophy and divination in which they figuratively denoted the evolution of nature and its cyclical changes; in this context, they are often associated with the yin-yang device. They are said to have been invented by the legendary emperor, Fu Hsi. Beginning with the 14th century, the pa kua came to be used as a decorative motif in ceramics, metalwork and other media.

Pa pao See Eight Treasures.

Pa-ta Shan-jên See Chu Ta.

Pa yin See Eight Musical Instruments.

Padmapani Literally meaning "lotus-bearing," from the Sanskrit padma, meaning lotus, a term also used in padmasana, meaning the lotus seat or throne, on which the Buddha is often shown. The term is usually applied to a particular manifestation of the Bodhisattva Avalokitesvara, who is then referred to as the Padmapani Avalokitesvara, or Lien-huashou Kuan-yin in Chinese and Sho Kannon in Japanese. The lotus which he holds is the symbol of purity and is derived from older Indian sources.

Pagoda A Western term, originally coined by Portuguese traders to describe the towers connected with Buddhist monasteries, which may be found in China and Japan. In China the term t'a is usually applied to them, whereas in Japan they are referred to as to, with gojunoto designating a five-storied tower, and tahoto referring to a pagoda of precious jewels when it takes on a form more closely resembling the Indian stupa, from which it is ultimately derived. The Chinese form probably represents a fusion of the stupa, conceived of as a monument to the Buddha's death in Nirvana, the Mahabodhi Temple erected at Bodhgaya, and the ancient Chinese watch towers. They usually contained some kind

of reliquary in their interior, and were crowned with a series of umbrellas and a jewel which symbolized the rule of the Buddha and his precious doctrine over all the world. The various stories of the pagoda were thought to represent the stories of Mount Meru, the sacred mountain on which the gods dwelled. Forming an integral part of the Buddhist temples, they, like the towers on Christian cathedrals, also served to indicate the presence of a Buddhist sanctuary. The oldest surviving Chinese examples of pagodas are built of brick and stone and date from the Six Dynasties and T'ang periods, while the Japanese ones are usually made of wood. The five-storied pagoda at Horyuji and the three-storied one at Yakushiji are among the oldest and most famous Japanese examples.

Pai-hua Literally "painting in white." Chinese term to describe a painting executed in ink using only chalk color. In Japanese it is called shira-e.

P'ai-lou Chinese memorial gateway erected in memory of a ruler or distinguished personage. It is built of either stone or wood, and consists of a series of posts supporting a horizontal member. The larger ones usually have three openings while the smaller ones may have only one. Both the vertical and the horizontal members are often decorated with sculptural carvings, and sometimes a projecting ornamental roof may also be employed. Their function was much the same as that of the great Roman triumphal arches.

Pai-miao Chinese term for outline drawing, a special category in Chinese painting which was used especially for the depiction of architectural designs and sometimes for the representation of Buddhist iconography. It never played as important a role in Chinese art as did drawing in the art of the West; however, some important pictures by artists such as the great Sung painter, Li Lung-mien, were executed in this style.

Palace Museum Museum of Chinese art located in Peking, which contained some of the most important artistic treasures of China, and is particularly rich in its paintings and ceramics. Most of its original holdings were removed at the time of the Japanese conquest of northern China, and are on display today at the National Palace Museum in Taipei.

P'an Chinese term applied to a low open basin, usually made of bronze but also executed in clay, which was made for ritual purposes during the Shang and Chou periods. It is often decorated with beautiful low relief and incised designs depicting symbolic animals, birds and fish.

P'an Fei A celebrated Chinese dancer of the 5th century who became the concubine of the Ch'i emperor, Tung-hun Hou. She is said to have created several dances with poetic names such as "dawn of day," "waves," the "cherry blossom," etc. It is said that Tung-hun Hou had water lilies made of gold-leaf strewn upon the ground for P'an Fei to dance upon, and in reference to this she is sometimes shown in art in a field of lilies.

P'an Ku Legendary figure who is often referred to as as the great architect of the universe, and has also been called the Adam of Chinese

mythology. It is said that his efforts continued for some 18,000 years, and that it was he who was responsible for creating the world as we know it today. He is sometimes represented in Chinese popular art, where he is associated with the dragon and the phoenix.

Pan-p'o-ts'un Archaeological site in Shensi province where a group of early Neolithic villages was discovered in 1953. It is believed that the site was occupied from 4,000 to 2,000 B.C., and it contained the remains of human settlements as well as six pottery kilns. A museum devoted to early Chinese civilization has now been erected at this site.

Pan-shan Site in Kansu province in western China where excellent examples of Chinese Neolithic pottery from the Middle Yang-shao period, probably the latter half of the 2nd millennium B.C., were found by the Swedish engineer and archaeologist J. G. Anderson. A large variety of shapes, such as bowls, basins, cups, beakers and jars, were found here, many painted with beautiful designs executed with free brushwork, probably representing magic ideas connected with fertility.

P'an Yü-liang Modern Chinese painter born in Anhui province in 1905. She studied with Liu Hai-su in Shanghai before going to Europe in 1921. She remained there until 1928, when she returned to China and taught at the National Central University. In 1935, the artist returned to Paris to take up permanent residence. She has worked in oils and Chinese ink, and has mastered both the Eastern and Western techniques.

P'ang Hsün-ch'in Modern Chinese painter who was born in 1903 in Kiangsu province. He was a medical student before going to Paris to study music and, later, painting. In 1929, he returned to Shanghai and opened his own studio. He became particulary well known for his drawings and paintings of the Kweichow countryside, where he traveled extensively, and of the M'iao aborigines who lived there. One of the prime leaders of the early 20th century modern movement, P'ang is also known as a writer and critic, and has been on the faculty of several of the leading art academies of China.

Paper Paper was used very extensively in both China and Japan as a ground for painting and calligraphy. It is believed that this material, which was usually made of vegetable fibers, was invented in China during the Han period. The official date given in Chinese annals for this event is A.D. 105, and is credited to the eunuch Ts'ai Lun. However, it is believed today that, in a crude form, it may actually have existed earlier. The paper employed in painting, such as rice paper, is usually of an absorbent nature, while, for Japanese prints, the inner bark of the mulberry tree was preferred. Beautiful examples of handmade paper were treasured for their own sake, and high-quality paper has been much sought after by artists of all periods. In Japan, paper was used for many other purposes as well, for example the sliding screens in Japanese houses, folk toys, and as wall paper. Today, outstanding craftsmen specializing in making beautiful handmade paper are among those individuals designated as living cultural treasures of the Japanese nation.

Patriarchs A term often employed to describe the great teachers of Buddhism in India, as well as in China and Japan. Among the Indian patriarchs, Nagarjuna, Asanga, and Vasubhandu are the most important, and are sometimes represented in Buddhist art. In both Chinese and Japanese art, sculptural and painted portraits of such great teachers were often made as a memorial to them. Those that have come down to us are among the finest portraits in the art of the Far East. Particularly famous are the numerous representations of the Indian monk Bodhidharma, who introduced Ch'an Buddhism into China and who, under his Japanese name Daruma, is frequently represented in the art of Japan.

Paulownia The paulownia, or kiri in Japanese, is a tree native to Japan, which grows to a height of about 50 to 65 feet. In April, it produces blossoms of a pale violet shade which grow in clusters. The imperial crest of Japan, known as the kiri-mon, is composed of three leaves and three clusters of blossoms of the kiri tree. The light wood of the tree is used in the manufacture of lacquered objects.

Peach In Chinese legend, the peach is associated with long life and good fortune, especially in the eyes of the Taoists, for it was said that the sacred peach tree grew in the gardens of the palace of Hsi Wang Mu, the Royal Lady of the West; the peaches ripened but once in 1,000 years, and bestowed immortality on those who ate it. The peach blossom was considered a flower of spring, and felicitous at the time of marriage. In Japan the peach is particularly associated with the Girl's Festival, which occurs on the third day of the third month.

Peacock The peacock has long been admired and respected by the Chinese, who regard the bird as an emblem of beauty and dignity. The magnificent tail feathers were used to indicate official rank beginning with the Ming Dynasty, a practice that continued through the Ch'ing period. In the Buddhist religion the peacock is closely associated with the deity Mahamayuri, or in Japanese Kujaku Myo-o (kujaku meaning peacock). In art, he is invariably shown seated on one of these birds.

Pearl The pearl, in Chinese—chu and in Japanese—tama, plays a great role in both Chinese and Japanese legend and art. It is regarded as one of the Eight Treasures and is believed to be a magic, wonder-working object. The pearl is believed to be a charm against fire, and dragons pursuing the precious pearl are often represented in Chinese art. In Japanese popular art, Hotei, the god of good luck, has a pearl in his bag as a symbol of good fortune, and the pearl emblem appears as a popular motif in the decorative arts of China and Japan. The pearl is also very important in Buddhism, where it is referred to as cintamani, and is seen as an emblem of the Bodhisattva Kshitigarbha (better known as Jizo, his Japanese name), who holds a precious pearl. A flaming pearl as a symbol of the Buddhist doctrine is found on the tops of pagodas and Buddhist reliquaries.

Peking Capital city of China located on the North China plains of Hopei province. The site itself had already been occupied in ancient

times, but it only became the imperial city when the Ming emperor Yung-lo moved his residence to this city in 1420. Prior to this, the Khitan and Mongol rulers had already had palaces constructed here, and the Yuan ruler Kublai Khan had his capital, which was visited by Marco Polo, on this site. It was during the Ming rule that most of the great architectural monuments seen in Peking today were erected, including the Imperial Palace, the great walls, and the Temple of Heaven. During the Ch'ing Dynasty, when the Manchus were in control of China, many changes and additions were made, notably the distinction between the northern, or Tartar, city, where the palace was located, and the southern, or Chinese, city. Much of the Imperial Palace, located in the so-called Forbidden City, while going back to Ming beginnings, actually dates from the Manchu rule, having been erected during the 18th century. Outside the city proper, there are a number of other important architectural monuments, notably the Temple and Altar of Heaven, the Temple of Agriculture, and Imperial Summer Palace and the Northern Lake. Peking presently serves, as it has for many centuries, as a great center of Chinese culture and art.

P'êng-lai Shan Taoist Isles of the Blessed, located in the east. This is the home of the Immortals, who live here in houses made of gold and silver, with pearl and coral trees growing in great profusion. The flowers and seeds have a sweet taste, and those who eat them neither grow old nor die. These eastern isles are surrounded by water, and can be approached only by supernatural means. Reaching these islands was the goal of many devout Taoists, and they are also often described in Chinese and Japanese literature and depicted in art. The most famous depictions occur on bronze mirrors and incense burners made during the Han period.

P'êng-niao A legenday bird of enormous size, capable of flying tremendous distances. It is the Chinese equivalent of the Roc of Western and Islamic legend. The flight of this mythical bird is considered a symbol of rapid advancement in study and general success in life. It is sometimes represented in Chinese painting.

Peony The peony enjoys great popularity in both China and Japan, and is often represented in the decorative arts. It was looked upon as a symbol of spring among the flowers representing the four seasons. It was also thought of as an emblem of love and affection, and an omen of good fortune. In China, it was given the title of hua wang, or king of the flowers, indicating the high esteem in which it was held. It was a popular decorative motif employed on the enameled vases of the K'ang-hsi period.

Persimmon or kaki in Japanese. The fruits of this tree, which are yellow-gold in color, with several stones, are often represented in Japanese art, especially in association with monkeys, who are particularly fond of eating them. The dried fruits of the kaki are strung together on a thin bamboo stalk and offered to the domestic gods at the New Year. The wood, which is extremely hard, is used in the production of lacquered objects.

Perspective prints See Uki-e.

Petuntse or more correctly in Chinese—pai-tun-tzu, literally meaning little white blocks. A type of clay, referred to in England as China stone, consisting of a fusible form of feldspar which is used together with kaolin to form porcelain. The Chinese speak of these two ingredients as the bone and flesh of porcelain ware.

Pheasant The pheasant is frequently represented in Chinese and, less commonly, in Japanese art. It is looked upon as an emblem of beauty and good fortune. It already occurs in the art of Shang and Chou times, where it is probably connected with light and sun, in contrast to the owl, representing darkness and night. In later times, a golden pheasant was embroidered on the robes of civil officers of the second grade, and a silver pheasant on those of the fifth. The bird was represented standing on a rock in the sea, looking to the sun, the symbol of imperial authority. It is also often confused with the mythical fêng-huang bird, usually referred to as the phoenix in Western writing on Chinese art.

Phoenix Greek term which Western writers erroneously apply to the legendary fêng-huang of Chinese myth and art. The bird plays an important role in the painting and decorative arts of China and Japan. See Fêng-huang.

Phoenix Hall or Hoodo in Japanese. The main hall of the Byodoin Temple in Uji. See Byodoin.

Pi Chinese term for a jade ritual object consisting of a flat disc, perforated by a circular opening in its center, and often decorated with sculptural carvings, particularly representations of dragons. The earliest of these come from prehistoric times, but the finest date from the Shang and Chou periods. Chinese texts refer to them as symbols of heaven, and they were employed as such in ceremonies and in the tombs. Their original meaning, however, may have been that of sun discs, since the archaic character for sun takes the same shape.

Pi-hua Chinese term for wall painting, an art form which, no doubt, played a very important role in China beginning with the Shang period. Although there are many literary references to magnificent wall paintings that decorated the walls of palaces and temples, often executed by famous artists, very few early examples of such pictorial compositions have come down to us. Since they were also executed by professional artists, whom the critics of later times looked down upon, they have never been suffi- ·ciently appreciated and studied in China, but there can be little doubt that, at least through the T'ang period, they were one of the most important forms of Chinese painting.

Pien-ho The god of jewellers in Chinese mythology. He was an official who lived during the 8th century in the state of Ch'u. He had found an extraordinary precious stone which he offered successively to three kings of the state. In each case, the royal advisors pronounced the stone a fake, and Pien-ho had his legs amputated as punishment for the insult. Finally,

however, the king Wên Wang heard of the matter, had the stone re-examined and found it to be of great value. Pien Ho was well rewarded, and after his death became the patron deity of jewellers.

Pien Wên-chin Chinese painter of the Ming period, who was active during the 15th century, and worked at the court of the emperors Yung-lo and Hsüan-tê. He was a man of culture, as well as a poet and painter who specialized in bird and flower pictures executed in a meticulous manner based on the tradition of Hui-tsung and the Northern Sung Academy. Several fine examples of such paintings of birds have come down to us.

Pilgrim To make a pilgrimage to sacred sites connected with the life and teachings of the Buddha in the homeland of Buddhism itself, or to visit sacred temples or monasteries, played a great role in both Chinese and Japanese Buddhism, and, to a lesser extent, in Japanese Shintoism. The most famous of these early pilgrims were Fa-hsien, who in the 5th century visited India and Ceylon and Hsüan-tsang, the 7th-century pilgrim who visited the religious establishment of Central Asia and India during the T'ang period. Hsüan-tsang wrote a long account of his travels which has become a classic of Buddhist literature and is an invaluable source for our knowledge of the Buddhist establishment and doctrines of the time. He and other such pilgrims are often represented in Buddhist painting.

Pilgrim bottle Chinese ceramic shape which evolved during the T'ang period. It was probably derived from a flask carried by travelers. Bottles of a similar type are represented on the saddles of camels in T'ang mortuary figures. They are usually decorated with low relief designs of a Western character, such as dancing and piping figures and birds among vine scrolls and other floral elements derived from the Late Classical art of the Near East. Once introduced, this shape continued to be used in Chinese ceramics through the Ch'ing period.

Pillar Print See Hashira-e.

Pillow screen Small, low two-panel screens, which were used in a Japanese house to set apart a small section of the floor where the pillows were located, indicating that this area was designated for lovers or newlyweds. These screens were often decorated with beautiful pictorial designs.

Pin-yang Caves Name of one of the finest Chinese Buddhist caves, located at Lung-mên, ten miles south of Lo-yang in Honan province. It is particularly well known for its stone carvings representing a Buddha attended by Bodhisattvas and two disciples, with representations of the emperor and empress, in the form of relief sculptures, flanking the central figures. The carvings showing the empress and her ladies are now in the Nelson Gallery in Kansas City, and constitute one of the finest examples of Chinese stone sculpture in America. See also Lung-mên.

Pine The pine is one of the most popular of all trees in both China and Japan, and plays a prominent role in legend, literature and art. It is referred to as one of the three friends of the cold season, since it endures during the winter, and is thought of as an emblem of longevity. Old, gnarled

pines are one of the favorite motifs in both Chinese and Japanese painting, where they are looked upon as symbols of venerable old age and endurance. Some of the most famous Chinese scrolls and Japanese screen paintings represent this tree as a main subject, and famous old pines are much admired in the gardens and temple enclosures of Japan.

Pipe After the introduction of tobacco through the Westerners, who in turn had learned the use of tobacco from the Indians of America; pipes became popular in both China and Japan. The Japanese, especially, often turn them into exquisite little works of art, combining a wood or bamboo stem and a small metal cup made of copper, bronze or sometimes silver.

Plum The plum tree or prunus, especially when it is in bloom, is much admired in both China and Japan. It represents winter among the four flowers symbolizing the seasons, since it is the first flower to appear, while the rest of the vegetation is still dormant. It is thought of as a very auspicious plant, the harbinger of spring. Plum blossoms are a frequest decorative motif on blue and white porcelain jars, which are given as New Year's presents, and they also occur often in Chinese and Japanese painting.

Po Chü-i Chinese poet of the Late T'ang period, who was born in Shansi province in 772, and died in 847. Unlike the other two great T'ang period poets, Li Po and Tu Fu, he had a brilliant official career that ended with his obtaining the governorship of Honan province. His most famous work is the long narrative poem called "The Everlasting Wrong," which is a romantic account of the tragic love of the emperor Ming Huang and the beauty Yang Kuei-fei. The bulk of his work was more moral in tone and owed its inspiration to Confucianism, but it never enjoyed the same popularity. His work has been translated into English, and has also enjoyed great popularity in Korea and Japan, where he became the hero of a noh play. It is believed that his poetry had the distinction of being the first to have been printed. Scenes from his long poem have been represented in Chinese painting and prints.

P'o-mo A Chinese term literally meaning "broken ink," or, when written with a different character for the term p'o, it is translated as "spilled" or "splashed" ink. The term broken ink refers to a technique of Chinese painting, in which the effect of modeling and texturing is obtained with ink alone, without the use of colored pigments or an emphasis on pure line. It is associated with the work of the great T'ang painter, Wang Wei. P'o-mo, translated as splashed or spilled ink, is a technique in which the ink is very broadly and freely applied, with no emphasis on outline, and is associated with the work of the Ch'an painters of the 13th century, notably Liang K'ai and Yü-chien, and their Japanese imitators.

Po-shan-lu See Hill Jar.

Poetry Chinese poetry is closely connected with the painting of the country. There is a traditional Chinese saying that a poem is a picture expressed in words and a painting is a poem without words. Many Chinese scrolls are inscribed with the poems that inspired them or are believed to

be related to them, and colophons on Chinese scrolls often contain poems. Poets also are a favorite subject in Chinese painting, especially the famous T'ang poet, Li Po. See also Thirty-six Poets.

Pomegranate The fruit of the pomegranate is cultivated in both China and Japan, and is sometimes represented in art. Since it has numerous seeds, it is thought of as a symbol of fertility and many offspring, and is therefore looked upon as being very auspicious. In Chinese popular art, figures holding bursting pomegranates revealing their seeds are often shown as an omen for many children. The fruit also occurs in Buddhist art, where again it is thought of as being a representation of the essence of favorable influences.

Porcelain A variety of ceramic ware made of a pure white body fired at a very high temperature, which when broken has sharp breaks, when potted thinly is translucent and, when struck, produces a musical sound. It consists of kaolin and petuntse, called China clay and China stone in English, which are fused into a material which has the qualities associated with true porcelain. The exact definition of the term varies somewhat among different critics, notably those of China and the West, and the borderline between true porcelain and porcelaneous stoneware is difficult to draw. The exact time when porcelain was invented is also a matter of debate, but most critics agree that it is the white wares of the T'ang period that are the first ceramics that can be considered fully developed porcelains. In Japan, porcelains were not made until the 17th century, fully one thousand years after the process had been invented in China, and the earliest European porcelains, made in Meissen, in Saxony, are of 18th-century date.

Portraits Portrait-painting played a prominent role in both Chinese and Japanese art. The earliest Chinese portraits can be found among the remains of Han painting, and this genre becomes particularly popular during the T'ang period, with celebrated scrolls, such as the Yen Li-pên scroll of the "Thirteen Emperors," now in the Boston Museum, portraying the Chinese rulers of the Six Dynasties and Sui period. Many other portraits of emperors, officials, Buddhist masters, artists and literary figures have also been preserved, and ancestor portraits enjoyed great popularity, especially during the Ming and Ch'ing periods. However, they were never accurate likenesses or psychological interpretations of human personality, such as are found in European portraits, but rather idealized interpretations of what these great rulers, teachers, sages, artists or honored ancestors should look like. In Japan, too, ever since the Nara period, when a famous portrait of the Prince Regent Shotoku Taishi was painted, portrait painting played a prominent role. But here again, it is unlikely that the numerous portraits of rulers, noblemen, priests, artists and literary men are more than approximations of what the people looked like, in spite of the fact that they seem more realistic and individualized than their Chinese counterparts.

Potala The residence of the Dalai Lama, located in Lhasa in Tibet. It is so named after Mount Potala, on which it is built. Although the original structure goes back to the 7th century, according to tradition, the present edifice dates from the 17th century. The Red Palace and the White Palace were erected by the 5th and 13th Dalai Lamas, and have served as a residence for the spiritual rulers of Tibetan Lamaism until modern times. Elaborately decorated halls with gilded bronze statues, lamps, ritual vessels and banners were found here. Many of them are now on exhibit in the Lhasa Museum.

Pottery Generic term used in English to describe a large variety of ceramic wares of all kinds, made of fired clay. The three most common subdivisions are earthenware, stoneware and porcelain. The art of making pottery existed in both China and Japan from very early times, certainly from the beginning of the Neolithic period, which is usually dated around 5,000 B.C.; however, recent readings from carbon dates suggest that the earliest Jomon pottery of Japan may go back to as early as 8,000 to 10,000 B.C., and some scholars have suggested equally early dates for the most primitive phases of Neolithic Chinese pottery as well. See also separate entries under Earthenware, Stoneware and Porcelain.

Prabhutaratna To-pao in Chinese and Ta-ho in Japanese. Buddha of the Past who is prominently mentioned in the Lotus Sutra. He is often portrayed in Chinese Buddhist art, seated next to the Historical Buddha Sakyamuni, listening to the teachings of the Historical Buddha.

P'u Hsien Chinese name for Samantabhadra, the Bodhisattva of Wisdom. See Samantabhadra.

P'u-ming Chinese painter of the Yuan period who was active during the middle of the 14th century. He served briefly at the imperial court of the Mongol rulers, but early in life he became a Ch'an Buddhist monk and lived at one of the Buddhist temples in Su-chou. He was well known as a painter of orchids, which he often portrayed together with picturesque weathered rocks, bamboo and grasses, which are rendered with great skill and elegance. Although he is little known in his native country today, he was much admired in Japan, and influenced Japanese ink painters of the Muromachi period. His best-known paintings are a set of four hanging scrolls representing orchids which are in the Imperial Household Collection of Japan.

P'u-sa Chinese term for Bodhisattva. See Bodhisattva.

P'u-t'ai Chinese Ch'an monk of the Late T'ang period who regarded himself as a latter-day manifestation of Maitreya; the Chinese, therefore, also refer to him often as Mi-lo. In Japan, he is known as Hotei, and is frequently called the Laughing Buddha as well. He is usually represented as a fat, pot-bellied, half-naked figure, carrying a large sack. He is laughing since he has overcome all the anxieties and cares that trouble most people, and is carefree and happy. To the Zen Buddhists, he is a saintly figure, embodying their unconventional attitude towards tradi-

tional Buddhist ideas, and the unconcern and joyousness of those who have discovered the Buddha within themselves. Many representations of P'u-t'ai may be found in the Ch'an painting of China and the Zen painting of Japan.

Pure Land or Jodo. A religious concept that was introduced by the Japanese Buddhist priest Eshin (942–1017), who was also called Genshin. In 984 he wrote a book called *Ojo Yoshu* or *Birth in the Land of Purity*, in which he describes how the souls of the faithful are reborn in a land of purity, where the Buddha Amida welcomes them surrounded by saints and angels. This concept became particularly popular during the Kamakura period after Honen founded the Jodo sect of Buddhism. See Sukhavati and Jodo sect.

ABCDEFGHIJ
KLMNOPQR
STUVWXYZ

Queen of Heaven See Ma Tsu P'o.

ABCDEFGHIJ KLMNOPQR STUVWXYZ

Rabbit See Hare.

Raden Japanese term for a method of decorating the surface of lacquer ware with mother-of-pearl or nacre inlay. It consists of cutting out the iridescent lining of certain nacreous sea shells in units which will form a design, and inlaying them on a hardwood base, usually of red sandalwood. Sometimes, fragments or pewter and gold or silver foil may be added to enrich the design. The whole is then coated with lacquer and later polished with a piece of charcoal. The technique was first developed to a high degree of sophistication in T'ang China, and then imported to Japan during the 8th century. The Shosoin in Nara contains the finest examples from this period.

Raiden Shinto god of thunder. He is represented as a devil with red skin, a demonic face with two small horns, and two claws on each foot. His characteristic attribute is a drum, sometimes an entire wheel of drums. He is frequently shown in Japanese art, the most famous representations being those found in the paintings of Sotatsu and Korin.

Raigo Japanese term referring to the descent of the Buddha Amida, accompanied by his Bodhisattvas and angels, in order to receive the soul of the dying worshipper into the realm of eternal bliss. It is a theme commonly portrayed in the Buddhist painting of Japan, and was particularly popular during the Heian and Kamakura periods. The most celebrated example of the treatment of this theme is found in a 12th-century version from the Later Heian period, preserved in the Reihokan on Koyasan, showing Amida painted in brilliant gold surrounded by thirty-one Bodhisattvas, some playing musical instruments, others in gestures of adoration. Many other versions of the raigo theme may be found among Kamakura paintings, usually showing only Amida and two accompanying figures.

Rakan See Arhat.

Raku The name of a Japanese ceramic ware produced by a family of Kyoto potters, who specialized in the production of tea bowls intended for the cha-no-yu. The name Raku derives from a golden seal presented by Hideyoshi, the great military dictator of the Momoyama period, to Jokei—the second potter of the line—in memory of his father, Chojiro. Raku ware reached its highest point under Donyu, the third potter of the line, who lived from 1599 to 1656 and was popularly known as Nonko. The production of Raku ware has continued right to the present day over a period of some four hundred years, with the fifteenth generation of Raku potters now active in Kyoto. The wares produced by the family were shaped by hand, fired at very low temperatures, and decorated with a glaze which was applied in many thin layers. The walls of the bowl are usually thick, and the rim of the mouth and base irregular. These qualities were esteemed by the tea masters for whose use the Raku ware was intended. The color was usually a dark brown or black, but red and white Raku are also known. While the bulk of the production consisted of tea bowls or chawan, other shapes such as flower vases, tea jars, water jars and incense containers were also produced. The most famous of these bowls have individual names and are today designated as national treasures of Japan. Among these are Mellow Persimmon, Gold Moon, Five Mountains, and Fujisan. See also Chojiro.

Rakuzan Ceramic kiln located at Matsue in Shimane prefecture, where tea-ceremony wares in imitation of Yi Dynasty Korean wares, similar to those of Hagi, were produced. In later times, the potters turned to the manufacturing of Kyoto-type decorated enamel wares. They were produced during the Early and Middle Edo period.

Ramma Japanese architectural term referring to a wooden lattice above the sliding screens and beneath the ceiling of a room. These lattices, particularly those found in the large reception rooms of the momoyama and Edo periods, are often decorated with low relief carvings which are sometimes gilded or painted in bright colors.

Rankeito Japanese stone lantern which is usually placed near running water in parks and gardens. It usually has a large roof and is mounted on a single arched foot, extending out over the water.

Rantei Netsuke carver of the late 18th century who came from Izumo province, but who lived largely in Kyoto. He worked in ivory, for the most part, and was noted for his masterful technique in rendering forms in such minute detail that they could not be seen by the unaided eye. He was best at figure carving, but also carved animals, flowers, birds and landscapes.

Rat The rat, which occurs quite frequently in Chinese and Japanese legend and art, had a positive connotation in traditional China. It is one of the twelve animals of the duodenary cycle, and is thought of as a symbol of industry and prosperity due to its ability to locate, acquire and hoard abundant supplies of food. At the same time, it is looked upon as

an emblem of timidity and meanness. It is sometimes represented in painting and in the decorative arts of both countries.

Realistic School While most Chinese and Japanese painting is highly conventionalized and rather abstract in character, there are, particularly in modern times, several schools of painting which can well be described as realistic. The most prominent of these is the Maruyama Okyo School, established by a Japanese artist of the 18th century, which played an important role during the second half of the Edo period. Western-type realism is particularly noticeable in the Japanese painting of the Meiji period, which attempts to imitate European realistic painting of the 19th century, and in Chinese painting under the People's Republic.

Reliquary Sacred reliquaries play an important role in the Buddhist faith, and are often deposited in the stupas, in memory of the deities or saints which they are associated. Some of them consist of remains believed to have belonged to the Buddha or to one of his saints, such as a tooth, a begging bowl, or a part of a garment, while others take the form of miniature stupas, precious jewels, bronze urns and receptacles of all kinds. They are often works of art of a high order, made of gold, silver, bronze, copper, and jewels or stone.

Rhinoceros horn The rhinoceros, which is now extinct in China, used to exist there in ancient times, and is represented in Shang and Chou art. The horns of the rhinoceros are considered to be among the Eight Treasures, and symbolize happiness. They are often carved with intricate designs, and are used for ornamental purposes. It is also said that when they are employed as drinking vessels, they reveal the presence of poison by sweating. Powdered rhinoceros horns are used as medicine, and are believed to restore male potency.

Ri Sampei Korean potter who is primarily important for having discovered porcelain clay near Arita, in Saga prefecture, in 1605. He thereby contributed to the development of the Japanese porcelain industry which, prior to that time, had been dependent on the importation of kaolin and petuntse from China.

Rice grain pattern A decorative lacework pattern, used on 18th-century and later porcelains, in which the openings of a pierced design have been filled in with a semi-transparent glaze. The name "rice grain" derives from the size and shape of the pierced holes. The technique was apparently copied from the so-called Gombroon wares of Persia.

Rihaku Japanese reading of the name of the great Chinese T'ang poet, Li Po. See Li Po.

Rikyu The most famous of all Japanese tea masters, who lived from 1521 to 1591. His true name was Sen-no-Soeki, but he is better known by his court name, Rikyu. He was one of the most important cultural figures of the Momoyama period, and served as a tea master to the military dictator Hideyoshi. He reformed cha-no-yu, omitting all excesses and extravagances, and set up new rules and etiquette which are still enforced

today. What he emphasized was simplicity and restraint, the spirit of wabi, which still prevails in this art form in modern times. All the arts connected with the tea ceremony—the tea house architecture, the gardens, the flower arrangements and the utensils—bear the imprint of Rikyu's taste and teaching. He ended his life by suicide at the request of his patron, Hideyoshi, as the penalty for having displeased him.

Rimpa Japanese term, derived from the second character of the name of the Edo-period painter Korin, which was originally used to describe the artists of the Korin School. Today, it is usually employed more broadly for the decorative painters of the Sotatsu-Korin School, among whom are Koetsu and Hoitsu. Japanese subject matter and style were emphasized by members of this school. While it flourished primarily during the Edo period, it can ultimately be traced to the Yamato-e paintings of the Heian period and the screen paintings of the Momoyama period. See also Hoitsu, Koetsu, Korin and Sotatsu.

Rishi Japanese term for the Taoist immortals. See Sennin.

Ritsuo Artist's name of the famous Japanese lacquer maker, Ogawa Haritsu, who was born in 1663 and died in 1747. A contemporary of Korin, he was, next to that master, the most famous lacquer artist of the time. A native of Ise, he went to Edo, where he studied poetry under Basho, painting under Itcho, and ceramics. However, his main field of interest was lacquer. He is particularly famous for his lacquers employing extraneous materials such as mother-of-pearl and lead against a black ground. He often achieves very original and unconventional effects by also using ivory-colored ceramics and red carved lacquer in the Chinese manner. Outstanding examples of his work may be found in the National Museum in Tokyo.

Ritual vessels Bronze ritual vessels played a very important role in Chinese art, notably that of the Shang and Chou periods. They usually took the form of food or wine vessels in which offerings, intended for the spirits of nature or the spirits of the ancestors, were placed in the temples and tombs. While the earliest ones were plain, by the mature Shang period they were usually decorated with animal symbols and magic emblems often executed in high relief, sometimes even assuming fully sculptural form. They constitute the most important artifacts produced in ancient China, and are valued today among the great masterpieces of the bronzemaker's art of all times and civilizations. See also Bronze and entries under the names of the individual shapes of such vessels.

Roben Japanese Buddhist priest who was the founder of the Kegon sect of Buddhism in 740. He was associated with the chief Kegon temple of Nara, Todaiji, where the Hokkedo was built for him in 733. A sculptured portrait of him, which is one of the celebrated early Japanese priest portraits, survives.

Rock gardens In both China and Japan, rocks represented a very important element in garden architecture along with sand, water, and bushes and

trees. Picturesque rocks were set up like pieces of sculpture and much admired for their shape, texture, and appearance. Placed along the edges of pools and pathways, and on hills, these rocks suggested landscapes with mountains, or served as bridges or stepping-stones leading from one section of the garden to the other. Rock gardens were particularly popular among the Zen Buddhists of Japan, and some of the most famous of the Japanese gardens, such as the dry garden at Ryoanji and Daisenin of the Daitokuji Temple in Kyoto, depend largely upon their beautiful rocks for their effectiveness. See Ryoanji, Daitokuji, Katsura, and Kare-sansui.

Rokechi A Japanese term for a type of textile decoration employing wax-resist dyeing, usually referred to as batik in Western literature. It has been used very widely in Japan ever since the Nara period, and is still used today, especially among the textile artists of the folk art movement. See Batik.

Rokubei Name of a potter of the Shimizu family who took on the name of Rokubei in 1765. His descendants have been active in Kyoto ever since, with Shimizu Rokubei VI being one of the outstanding modern Japanese potters. Their ware consisted of fine porcelain, decorated in blue and white, and artistic waves in the Kenzan tradition.

Rokudo-e Japanese term literally meaning "picture of the six paths." In Japanese Buddhism, the rokudo are the six realms to which the soul can transmigrate. They include the hells and the realms of hungry ghosts, of beasts, of demons, of men and of the deities. This theme is frequently represented in Japanese Buddhist painting.

Rokuonji Name of Kyoto Buddhist temple, on the grounds of which is located the Kinkakuji or Golden Pavilion. See Kinkakuji.

Romance of the Three Kingdoms See *San kuo chih yen i.*

Ronin Japanese term to describe vassals who had lost their master and led a life of restless wandering. The most famous of these were the forty-seven ronin who avenged the death of their lord, Asano Naganori of Ako, an event dramatically told in the famous kabuki play called Chushingura. Scenes of these tales are often represented in Ukiyo-e prints. See Chushingura.

Roof ridge figures In addition to the ceramic tiles covering the roofs of buildings in both China and Japan, there were often decorative end pieces with human or animal designs, and glazed ceramic figures used in the decoration of the roofs. This was particularly true during the Ming period in China, when all kinds of human and animal forms, either in monochrome or glazed in yellow, green, blue, purple and black, were employed as decorations and as protective charms guarding the houses against evil spirits. The finest of these are works of sculpture of considerable merit and are among the best ceramic figures from their period. See also Ch'i-wên.

Rosanjin Modern Japanese potter who lived from 1881 to 1959. His family name was Kitaoji, and he was trained as a seal engraver and

calligrapher. In his early life, he intended to become a Japanese-style painter. In 1915, when he was already 34 years old, he decided to become a potter, and studied ceramics under Suda Seika in Kanazawa. In 1920, he opened an art shop in Tokyo which he called Taigado, and in 1925 he settled in Kitakamakura, where he built a kiln; it was there that he had his first one-man show. His work was shown widely in Japan, Europe and the United States, and he had a large retrospective at the Japan House gallery in New York in 1972. He worked in a wide variety of styles, notably in those of the traditional Japanese wares such as Bizen, Shino and Oribe, as well as in the manner of Kenzan and his school, Korean wares of the Yi Dynasty, and Chinese ceramics of the Sung and Ming periods. Many critics regard him as the greatest of modern Japanese potters.

Rosary The rosary, known as mala in Sanskrit, plays an important role in Buddhism, as it does in Christianity. Buddhist priests used rosaries to help them in their prayers and meditation, and they are often represented in Buddhist art. A great variety of materials such as pearls, bone, wood, gold, jade, crystal and precious stones could be used for making them. The small rosaries usually had eighteen beads, symbolizing the eighteen Lohans, while the larger ones had one hundred and eight beads to insure that the worshipper would repeat the sacred name of the Buddha at least one hundred times.

Rosetsu Japanese painter of the Okyo School who lived from 1755 to 1799. His family name was Nagasawa, and he came from a samurai family. He studied under Okyo, but developed his own highly original style, which, although based on the work of his teacher, was very personal and unrestrained. At his best, he is an artist of real power, although his work is rather uneven. His most characteristic work consists of spirited ink paintings representing birds and animals, but he also dealt with Buddhist subjects, since he was a lay Zen student. Several fine examples of his work may be found in American public and private collections.

Roshana See Vairocana.

Roshi Japanese name for the Chinese philosopher Lao-tzu. See Lao-tzu.

Royal Ease position See Maharajalila.

Rubbing A technique of reproduction traditionally used in China to make copies of works of art particularly designs incised or cut into stone. It consists of pressing a moist, absorbent rice paper into the areas which have been incised, or on the projecting areas which have been covered with a black coloring, resulting in a bold black and white pattern. This technique lends itself very well to the duplication of written characters or ornamental and pictorial designs. The finest of these, the celebrated rubbing of the low relief sculptures of the Wu Liang-tz'u funerary stones are outstanding in their own right.

Ryoanji Buddhist temple of the Zen sect, located in the Western part of Kyoto. It was founded in 1473 by Hosokawa Katsumoto, whose tomb is

on the temple grounds. It is primarily known for its magnificent rock garden, designed by Soami, using only white sand, some oddly shaped stones and a bit of moss, which in its simplicity and beauty expresses the very essence of the Zen spirit.

Ryobu Shinto See Dual Shinto.

Ryogoku Bridge Famous bridge across the Sumida River in Tokyo, which formerly joined the provinces of Musashi and Shimosa. It is primarily famous for its fireworks display held in the latter part of July in connection with the river festival. This occasion is very popular, and has often been represented in Japanese art, notably in the prints of Hiroshige.

Ryoshibako Japanese term to describe a box which is used to contain writing utensils, paper and sometimes manuscripts as well. It often forms a set with the writing-boy, or suzuribako.

Ryozen Japanese painter of the Muromachi period who is believed to have lived during the late 14th and early 15th centuries. He was one of the early masters of the Zen school of Chinese-style ink paintings in Japan, and worked in the manner of the great Chinese Ch'an painter, Mu-ch'i. Today, however, very few works can be attributed to him with certainty.

Ryu Japanese term for dragon called lung in Chinese. It is used in connection with many other words, such as Ryujin or Ryu-o, referring to the dragon king; Ryugu, the Palace of the Dragon; Ryuko, a Taoist magician. It forms part of the names of countless Japanese painters and netsuke carvers. See Lung.

Ryukei Netsuke carver of the middle of the 19th century. A native of Edo, he became a famous artist who had a great many students. He specialized in the use of ivory, which he often tinted. His work is marked by sharp chiseling and graceful designs.

Ryumonji The name of the Japanese folk kiln located in southernmost Japan, in the neighborhood of Kagoshima. Established by Korean potters in the 17th century, these kilns produce simple, unpretentious utilitarian pots to this day, which are highly regarded by folk art enthusiasts. Their most outstanding products are low, dark brown pots with spout and cover, which are used for a gin-like drink made from sweet potatoes.

ABCDEFGHIJ KLMNOPQR STUVWXYZ

Sabi Japanese term employed by the tea masters, literally meaning "mellowed by age," which is closely related to wabi, and is especially applied to the tea gardens, or chaniwa built for the tea enthusiasts. It suggests that these gardens should give the feeling of solitude, of rustic simplicity and detachment from the world, and employ moss-covered stones, old stone lanterns and clumps of trees cutting off the garden from public view. See also Wabi.

Sadanobu Japanese painter of the Edo period who lived from 1597 to 1623. He was a member of the Kano School and was trained by his father, Kano Mitsunobu. He was called to the court by the shogun, Tokugawa Hidetada, and appointed official painter of the Nagoya Castle, where some of his work can still be seen. His promising career was cut short when he died prematurely at the age of twenty-six. He was a typical exponent of the Kano School but, in spite of considerable gifts, he did not live long enough to develop an individual style.

Saga-ningyo Japanese term for the wooden dolls which represent subjects taken from the daily life of the Edo period, as well as mythical and legendary personages. The figures were intended for ornamental purposes with their fine carving and beautifully and meticulously painted costumes, the designs of which were copied from fine silks. Rich colors and gold leaf were used to simulate the appearance of brocade. It is said that the name is derived from the Western district of Kyoto, known as Saga, where the first of these dolls are believed to have been made.

Sagemono also sometimes referred to as koshisage, literally meaning "hanging things," are any pendant objects suspended from the girdle, such as inro, money purses, cases for pipes or brushes, and tobacco pouches. They were suspended by means of a cord held in place with a netsuke or carved toggle. See also Inro and Netsuke.

Saicho Japanese Buddhist priest, founder of the Tendai sect, who lived from 767 to 822. He went to China, where he studied Buddhism at Mount

T'ien-t'ai (Tendai in Japanese), and brought with him, upon his return in 805, new teachings that were based on the Lotus Sutra and emphasized the identity of the Buddha and the eternal Buddha nature existing in all people and beings. The chief monastery of the sect was located on Mount Hiei near Kyoto; it played an important role as a spiritual center of Japanese Buddhism. Saicho was known posthumously as Dengyo Daishi, and the Tendai sect, which he founded, exerted a great influence on Japanese art.

Saigyo Japanese priest and poet who lived form 1118 to 1190. He is regarded as one of the greatest of Japanese poets, and his work expressed the evanescent. He loved nature and travelled around the countryside, celebrating the beauty of the mountains, rivers and trees. A famous Kamakura-period narrative scroll is devoted to the depiction of his life and tales.

Saihoji Temple of the Rinzai sect of Zen Buddhism, located in the neighborhood of Kyoto. It is primarily famous for its garden, which was designed by the priest Muso Kokushi during the early 14th century. Its outstanding feature is its thick moss, along with its beautiful trees and ponds. It is, therefore, popularly known as the Kokedera, or Moss Temple.

Saito Kiyoshi Modern Japanese printmaker born in 1907. One of the outstanding and most popular of all contemporary Japanese printmakers, who integrates, in a very effective way, a style derived from modern abstract art with subjects taken from traditional Japan. His representations of the Buddhist temples and Shinto shrines and their gardens, especially, are works which combine beauty of color and pattern with the nostalgic evocation of traditional Japan.

Sakai Ancient Japanese port city located close to Osaka in Osaka prefecture. During the 15th to 16th centuries it was an important port for trade with China and other countries, especially in connection with the importation of Chinese silks. It was often portrayed in Japanese screen-paintings of the Momoyama period, notably those dealing with foreigners. It declined when foreign trade was forbidden in 1635 and never regained its importance. A few of its old buildings have survived and today form part of the larger Osaka urban complex.

Sakakura Junzo Modern Japanese architect born in 1904. One of the leading architects of contemporary Japan, he studied in Paris under Le Corbusier. After returning to his native country, he became a pioneer in the introduction of modern International style architecture to Japan. While clearly reflecting modern Western architecture in his style and use of materials, he has also attempted to preserve, as much as possible, a characteristically Japanese sensibility. Among his most outstanding works are the Museum of Modern Art in Kamakura, the Museum of Modern Art in Tokyo, the Cultural Center in Ueno Park in Tokyo, and the Senri New Town Neighborhood Center in Osaka.

Sakura See Cherry.

Sakyamuni also spelled Shakyamuni. Literally meaning the "Sage of the Sakya Clan," the name given to the Historical Buddha, who as a royal prince is known as Siddhartha, and as a monk—Gautama. Other names applied to him are the Enlightened One, the Blessed One, the Great Being, the Cakravarti or World Ruler. He was born as a royal prince at Kapilavastu in northern India in 567 B.C. He was protected by his royal parents and brought up with all the luxury and sensuous enjoyment afforded by the princely household. However, upon departing from the palace, he discovered the suffering of mankind by encountering a beggar, a cripple, a dying man and finally an ascetic. He subsequently renounced his princely life and became an ascetic, devoting himself to meditation and a life of austerity. After some time, however, he found this mode of existence unsatisfactory, and embraced what he called the Middle Way, based on the four noble truths of the nature of suffering, its cause, and how to overcome it. This insight was achieved under the Bodhi Tree at Bodhgaya, and is referred to as the Enlightment. He thereupon entered a life of religious devotions and preaching, gathering disciples around him and establishing the Buddhist community. The first of his sermons was preached in the deer park outside Benares in northern India, an event referred to as the Setting of the Wheel in Motion. After a long and fruitful life dedicated to spreading the gospel of Buddhism, Sakyamuni died in 488 B.C. and entered the Nirvana—the ultimate realm in which all suffering and desire ceases. The cardinal events of his life are frequently represented in the painting and sculpture of both China and Japan.

Samantabhadra P'u-hsien in Chinese and Fugen in Japanese. The Bodhisattva of wisdom and ethical perfection who is usually shown together with Manjusri, often forming a trinity with Sakyamuni Buddha between them. In China and Japan, he can be clearly recognized by being shown riding on an elephant, the symbol of wisdom, since the elephant is regarded as the wisest of all animals—an iconography derived from the *Lotus Sutra*. He is also often shown with a magic jewel in one hand and a lotus at his left shoulder. Many representations of this deity may be found in the sculpture and painting of both China and Japan.

Sambo Japanese term used to describe a small wooden table or tray which is used to present offerings to the domestic gods on the occasion of certain festivals or, in a non-religious context, to serve sake to the daimyos. It is sometimes triangular in shape, and rests on a base in the form of a truncated pyramid. The term sambo literally means "three directions."

Samboin One of the chief temples of the Shingon sect, located in the environs of Kyoto. It was established in 1115 by the abbot Shokaku, but its present buildings were constructed by order of Hideyoshi during the 16th century. It is primarily known for its magnificent garden, which is considered to be one of the finest in Japan; it contains a large cherry tree that is very popular with visitors. It also contains a large collection of paintings and calligraphy, and has wall paintings by Kano Sanraku.

Same-nuri Japanese term literally meaning "sharkskin lacquer." The skin of the shark, which was very rare in feudal Japan, was used for ornamental purposes in the decorative arts. It was particularly popular as a covering for sword hilts and scabbards. The sharkskin itself is white in color and partly covered with small bumps, which are filed down. The hollow areas are then filled with black lacquer, and a final grinding and polishing produced a smooth surface, resembling tiny ivory discs set in black lacquer.

Samurai Japanese term used to describe the military nobility which played a very important role in the feudal society of Japan. Beginning with the Kamakura period, they became the dominant class, and their code of behavior, known as businde, played a prominent role in Japanese ethics. Many of them were important patrons of art, and a few members of the samurai class actually became artists. Their military exploits, their impressive appearance when dressed in their armor and swords, and their amorous adventures are often subjects of Japanese art.

San kuo chih yen i Famous Chinese novel which, under the title *Romance of the Three Kingdoms*, has been translated into English. It is attributed to the early Ming author Lo Kuan-chung, but appeared in several enlarged versions during later periods as well. It deals with the wars of the Three Kingdoms period, the age falling between the end of the Han Empire in A.D. 221 and the beginning of the Six Dynasties period. Although this period was one of bloodshed and turmoil, it is portrayed in the stories as a golden age of chivalry and romance. Scenes from it are often shown in Chinese painting, and episodes from the novel have been made into plays.

San-ta-shih or Three Great Beings, referring to the three great Bodhisattvas: Avalokitesvara or Kuan-yin in Chinese—The Bodhisattva of mercy and compassion; Manjusri or Wên Shu—the Bodhisattva of wisdom, usually seen riding a lion; and Samantabhadra, or in Chinese P'u-hsien—the Bodhisattva of learning, who is usually seen on an elephant. They are sometimes shown as a Buddhist trinity in the popular art of China.

San-ts'ai See Three-color ware.

Sanda Name of a Japanese porcelain produced at the town of Sanda in Hyogo. The kiln was established during the 18th century by the prince of Settsu, and initially specialized in producing blue-and-whites and celadons in imitation of Chinese wares. In 1836, under the influence of Matsudaira Kikusaburo, the kiln also turned to making porcelain decorated in red, the early examples of which were considered very fine. However, the production declined during the latter part of the 19th century and became purely commercial.

Sang de boeuf A type of Chinese Ch'ing porcelain developed during the K'ang-hsi period. It has a deep, blood-red glaze, and is therefore referred to as ox-blood or sang de boeuf ware. The finest of these wares, made for the imperial court, are beautifully controlled and remarkable for their

color; but this type of ware continued to be made right through the 19th century, and many of these later wares are of indifferent quality.

Sanjurokkasen Literally "Thirty-six Poets," famous in Japanese literature. They are often represented in Japanese painting and the decorative arts. This list, comprising thirty-six poets, the earliest of whom was from the Nara period and the last of whom worked during the Heian period, was first compiled by the 11th-century nobleman Dainagon Shijo Kinto. The most famous of these writers are the poetess Ono no Komachi, the poets Ariwara no Narihira, and Minamoto no Kintada. Scrolls representing these poets, executed in the Yamato-e style, may go back as early as the 11th century, but the oldest surviving one, now cut up into sections, is one from the Kamakura period which is traditionally attributed to the famous 13th-century artist, Nobuzane. In addition to this version, which was formerly in the collection of the Marquis Satake, there are several other versions, for this subject enjoyed great popularity in Japanese art.

Sankei The three most celebrated landscapes of Japan: Matsushima, Miya-jima or Itsukushima, and Ama-no-hashidate. These beauty spots are often represented in Japanese art. See individual entries.

Sanraku Japanese painter of the Momoyama and early Edo periods who lived from 1559 to 1635. He was a student of Kano Eitoku, and impressed his master so greatly that he adopted him as his son. He enjoyed the patronage of the military ruler of the time, Toyotomi Hideyoshi, who made him his official court painter and commissioned him to decorate the Momoyama Castle. He employed the bold decorative style of his master, Eitoku, but did not show his originality or vigor. In fact, he represents the brilliant style of the Momoyama-period screen painting in its last and somewhat decadent phase. Unfortunately, many of the artist's most important works, painted for the great palaces and castles of the time, were destroyed, so that we can gain only an incomplete picture of the true stature and contribution of the artist; but those works which do survive, notably at the Tenkyuin Temple of Myoshinji and the Daikakuji Temple, both in Kyoto, reveal him to be a very colorful and highly decorative artist.

Sansetsu Japanese painter of the Edo period who lived from 1590 to 1651. He was the adopted son of Kano Sanraku, and succeeded his master. He is believed to have collaborated with his teacher in the wall paintings at the Tenkyuin at Myoshinji Temple in Kyoto, and it is often difficult to be certain which paintings are by the elder and which by the younger Kano master. His style was rich in coloring and elegant in execution, but rather eclectic, and lacked the strength of that of his master.

Sansho Modern netsuke carver who was born in 1871 and died in 1936. He lived in Osaka, and was pupil of Dosho. He excelled in wood and ivory netsuke, and also made carvings inlaid with shell and jade.

Sanshu-no-Shinki or Three Sacred Treasures, constitute the most sacred emblems of Shintoism and the Japanese imperial institution. They are the mirror which is enshrined at the Daijingu Shinto Shrine at Ise; the sacred

necklace of jewels preserved at the Imperial Palace at Tokyo; and the sword venerated at the Atsuta Shrine at Nagoya.

Sanzu-no-kawa Literally, "River of the Three Roads," the Styx of the Buddhist underworld. This river can be crossed at three points. The first ford, or Sensuise, where the water comes up to the knees, is used by those who have committed minor misdeeds during their previous life. The second point of crossing, at the Kyodo, is a bridge of gold, silver, and precious stones, which has been constructed for the use of the virtuous souls. The third passage, the Goshindo, is that reserved for criminals and evildoers; the water is deep and turbulent and filled with treacherous rocks, serpents and demons.

Sashinabe Vessel in the form of a bowl equipped with a spout and a long handle. It is used in Japan to warm sake. A particular type of sashinabe, decorated with flowers and noshi, is used for wedding ceremonies.

Satsuma Old name for what is today Kagoshima prefecture.

Satsuma ware Type of Japanese ceramic ware which was produced in Satsuma province, now called Kagoshima prefecture, the most southern one of the Japanese archipelago. It is today best known for the highly decorated enameled pottery produced during the 19th century, which enjoyed a great popularity in Europe at the time. However, its original productions, which are more highly valued in Japan, are the tea wares in the Korean style. In fact, the Satsuma kilns were originally founded by Korean potters, and some of them preserve their Korean character to the present day. The most outstanding products were the tea bowls, especially those with a white glaze, known as Shiro-Satsuma, and the black ones, known as Karo-Satsuma. Other works consisted of folk pottery of a plain but sturdy and beautiful type, and purely utilitarian wares. The modern wares were highly decorated, often in gaudy enamel colors, in a style derived from the Kyoto tradition, and are referred to as Nishikide Satsuma. They were exported in large quantities to Europe and America, and were imitated, during the Meiji period, in Tokyo factories as well.

Seals Seals engraved in wood, stone, metal or ivory have been widely used since ancient times, both in China and in Japan. They supplement or, in many cases, replace the written signature, and are attached to documents and books of all kinds as well as to works of art. They are usually written in archaic characters which are illegible to the ordinary reader and require a special study to be read. In order to print them, the seals are pressed in a damp red paste, which serves as an inking pad. The designs of these seals may often be artistically very beautiful, and in the case of paintings may actually contribute to the visual appeal of the scroll, although in some cases the numerous large seals applied all over the surface of the picture may definitely be detrimental to the work of art. For the art historian, the seals are invaluable in determining the authorship of works of art and tracing their history and ownership. Collections of such seals have been

assembled in China, Japan and the West, and are frequently employed in the study of Chinese and Japanese paintings.

Seasons The seasons of the year played a great role in both Chinese and Japanese life and art, and often were the occasions for popular festivals. They provided motifs for paintings and the decorative arts. See Four Seasons.

Sei-shonagon Japanese poet and prose writer of the Heian period who, next to Lady Murasaki, was the most famous writer of this age. Her best-known work is *Makura-no-Soshi*, or *Miscellany*, which, under the title of *Pillow Book*, has been translated into English. It consists of notes and observations on the people she met and the events at court, which are amazingly modern in their revelation of the personality of the author herself and in her sharp and caustic comments. Representations of this celebrated writer occur in Japanese painting and the decorative arts.

Seishi Bosatsu See Dai-seishi.

Seitaka and Kongara In Sanskrit, Chetaka and Kinkara. The acolytes of Fudo Myo-o, who are often represented as young boys standing at his side in the Fudo paintings of Heian period Japan.

Sekkei Japanese painter of the Edo period who lived from 1644 to 1732. His family name was Yamaguchi. He studied first under one of the Kano masters, but was subsequently strongly influenced by the work of Sesshu and the Chinese Sung painter Mu-ch'i. He lived in Kyoto, and in his own day was highly regarded as an ink painter in the Chinese style, but few of his works survive today.

Sen-no-Rikyu Famous Japanese tea master. See Rikyu.

Sengai Japanese painter of the Edo period who lived from 1751 to 1837. He was a Zen priest of the Seifukuji Temple in Chikuzen, and was the most outstanding Zen painter of the Late Edo period. Using a very simple ink style, he produced a huge body of work, usually connected with Zen thought and often humorous in content.

Sengakuji Buddhist temple, located off Shiba Park in Tokyo, which is primarily famous for containing the tombs of the forty-seven ronin, celebrated in Japanese literature as outstanding examples of loyalty in the service of a feudal lord. Their story is the subject of one of the most celebrated of all kabuki dramas, called *Chushingura*. To this day, it is one of the most popular of all Japanese plays. See *Chushingura*.

Senju Kannon In Sanskrit, Sahasrabhuja Avalokitesvara. Japanese name for the thousand-armed Kannon, sometimes represented in Japanese art, notably in the Kyoto Sanju-sangen-do Temple, where the deity is shown with literally one thousand hands.

Sennin or Rishi in Japanese, are Taoist holy men who had reached immortality. The most famous of them were the Eight Immortals or Pahsien, but many others were believed to have reached the stage and are thought to dwell either in heaven or in mountains and hills remote from human habitation. They are often represented in Taoist paintings, and many famous scrolls depict the immortals dwelling in imaginary landscapes.

Seppa Japanese term used to describe a pair of oval metal plates or washers encircling the tang on either side of the sword guard. They are made of copper which is either plain or decorated in gold or silver. The function of the seppa is to protect the fuchi, or collar, of the hilt and thus prevent the sword guard from being damaged.

Sessai Japanese netsuke carver who lived from 1821 to 1879. He came from Echizen, the modern Fukui prefecture, where he served the local lord. He was a skilled carver who specialized in the representation of snakes.

Sesshu Japanese painter of the Muromachi period who lived from 1420 to 1506. He is usually regarded as the greatest of all Japanese ink painters and is, in the eyes of some critics', looked upon as the greatest master in the entire history of Japanese painting. Like many outstanding artists of his day, he became a Zen monk, taking on the name Toyo, and joined the Shokukuji Monastery in Kyoto, which was a great spiritual and artistic center. In 1467, he was sent on a trade mission to China, where he visited Peking and was reportedly asked to paint some pictures, and was received as an honored guest at the great Ch'an temples. After his return to Japan, he settled first in Oita and later in Yamaguchi, where he enjoyed the patronage of the Mori family. His style was derived from that of the great Chinese painters of the Southern Sung period, notably Ma Yüan. Hsia Kuei and Yü-ohion. However, basing his approach on theirs, he developed a highly individual and more Japanese style which formed the basis for all later Japanese suiboku. His influence was immense and he had many followers, some of whom, in fact, used his name and seal. A great many paintings are attributed to him today, but it is most unlikely that the bulk of them are actually by his brush. Of those which are generally accepted as authentic, the two most outstanding are the long handscroll representing a landscape in various seasons, painted in 1486, now in the Mori collection, and the inspired hanging scroll of 1495, representing a landscape executed in the splashed ink style, and now kept in the Tokyo National Museum.

Sesson Japanese painter of the Muromachi period who lived from c.1504 to 1589. Little is known about his life. He was, in addition to being an artist, a Buddhist monk, and combined an artistic and religious life, as did many artists of that time. He worked in the tradition of Sesshu, and is usually regarded as the last of the great suiboku painters of the Muromachi period. He is not particularly original, either in his subject matter or in its execution, but continues the tradition of the Chinese-inspired ink painting so popular at the time. His finest work, such as his small but powerful painting of a "Sailboat in a Storm" in the Nomura Collection in Kyoto, is among the masterpieces of suiboku painting.

Seto A town near Nagoya, in Aichi prefecture, which became the center of Japanese ceramic manufacture during the Kamakura period. The history of the Seto kiln is a very old one, but it did not become truly important until the Seto potters began making celadons in imitation of the Chinese wares of the Sung Dynasty. This development is usually attributed to a

potter by the name of Toshiro, who is traditionally credited with the establishment of this industry during the 13th century. Although modern scholars tend to doubt the accuracy of this account, there can be no doubt that, at that time, Seto became the leading center of ceramic production in Japan, and that the oldest of these works, which are stonewares decorated with green, brown and blackish-brown glazes, sometimes incised with floral designs, and referred to as Ko-Seto or Old Seto, are among the most outstanding of early Japanese ceramics. The Ki-Seto, or Yellow Seto, is particularly admired, and imitations of it are still being made to-day. Much of the Seto production was intended for the tea ceremony; especially the Seto tea caddies, or cha-ire, were admired. After the 15th century, when other ceramic centers began to evolve, the importance of Seto declined, but it continues to be a huge manufacturing center for ceramics right to the present day, when it has become part of the Nagoya urban area where the center of Japanese ceramic manufacture is located. Just about every type of ceramic ware, from refined porcelain to crude folk pottery and purely commercial industrial wares, has been produced here, varying tremendously in style and aesthetic quality.

Seven Gods of Good Luck See Shichi Fukujin.

Seven Sages of the Bamboo Grove A group of famous literary men of the third century A.D. who were reputed to have met regularly in a bamboo grove, where they proceeded to drink wine and discuss literature. The men usually named as members of this group are Hsiang Hsiu, Chi K'ang, Liu Ling, Shan T'ao, Yüan Chi, Yüan Hsiao and Wang Jung, although they were not all living at the same time. The Seven Sages are frequently depicted in Chinese paintings, where they are shown drinking wine in the midst of a rocky landscape shaded by sprays of bamboo.

Shaka Japanese name for Sakyamuni. See Sakyamuni.

Shakti A Sanskrit term describing the consort or female counterpart of a male deity. Although Hindu in origin, this concept also enters Buddhism, and is particularly popular in Tibetan and Nepalese Buddhist teachings. It is not important in the traditional Buddhist schools of either China or Japan, but female Bodhisattvas are encountered in Chinese art under Tibetan inspiration.

Shaku Japanese term used to describe a flat, elongated wooden sceptre, a symbol of dignity and authority. According to tradition, it was first used under Kotoku (645–654) and later replaced by ceremonial court fans. It was originally derived from a Chinese emblem of rank known as a hu, and is frequently represented in the art of both China and Japan.

Shakujo Staff carried by mendicant Buddhist priests. The upper end is deco-rated with a set of six rings, whose sound was intended to warn the smallest living creatures of the monk's approach, so that he would not in-advertently step on them. It is frequently represented in Japanese Bud-dhist art in paintings depicting Jizo Bosatsu.

Shan Chinese term for a category of painting which is executed on a fan, which may actually be employed in that capacity or merely be a convenient and attractive shape used within an album or mounted as a scroll. This format was particularly popular among the painters of album leaves, taking the shape of the traditional Chinese stiff oval fan, or in later examples, the folding fan. This format also enjoyed great popularity with Japanese painters. See Fan.

Shan-jên Chinese term literally meaning "mountain man," a term often used by Chinese painters who had withdrawn from the court life, become wandering hermits and dwelled among the mountains, to refer to themselves. The most famous of these was Chu Ta, who called himself Pa-ta Shan-jên—the Eighth Great Mountain Man.

Shan-shui Chinese term literally meaning "mountain and water," which is employed for Chinese landscape painting. See Landscape painting.

Shan-t'ao Chinese Buddhist priest of the T'ang period who lived from 1613 to 1681. He is primarily important for his preaching of faith in Amida; for he said, only repeat the name of Amida with all your heart, and you will be saved. His teachings had a great influence not only in China, but also in Japan where, especially among the followers of the Pure Land sect, salvation through faith in Amida became the cardinal doctrine.

Shang Dynasty The first of the historical Chinese dynasties, (also known as the Yin Dynasty). The Shang ruled China from 1523 to 1028 B.C. It was during this period that bronze casting was introduced into China and that the magnificent ceremonial vessels with symbolical animal decorations were produced. Among the many Shang sites which have been excavated, and where superb artistic remains have been brought to light, the two most notable are Cheng-chou, the early Shang capital, and An-yang, the later Shang capital which is the single most important archaeological site in all of China. See also Bronze, Jade, Pottery, Symbolism.

Shang-ti Chinese term, employed in ancient Chinese texts to describe the supreme deity of the Shang pantheon, which may be rendered as supreme Ancestor or Emperor on High. It has also been used by some Protestant missionaries as a translation for God; this usage, however, is incorrect and misleading. In ancient Chinese cosmology, he was looked upon as a heavenly ruler to whom the Chinese owed their existence, and whom they therefore worshipped, bringing offerings to him. It may be that some of the human figures appearing in Shang art are representations of this deity.

Shanghai With over 10,000,000 inhabitants, Shanghai is the largest city in China, and a center of industry and commerce, It is located on the left bank of the Huang-p'u River, just south of the mouth of the Yang-tze. Although its beginnings date to the Sung period, it only emerged as a major commercial center in the 19th century, when much of the foreign trade was channeled through its port. From an artistic point of view, it is primarily important for its museum of art and history, founded in 1952

and containing one of the best and most complete collections of Chinese art from prehistoric times to their modern period.

Shansi Province of northern China, north of Honan and east of Hopei, which played an important role in the early history of Chinese civilization. Many of the most important archaeological finds were made in this area, notably in the valley of the Yellow River, which was the heartland of ancient Chinese civilization. It is also very important for its Buddhist monuments, among which are the 5th century cave temples at Yün-kang and the great T'ang period caves at T'ien-lung Shan. The Northern Wei capital at Ta-t'ung was also located in Shansi. See Yün-kang, T'ien-lung Shan.

Shantung Coastal province of northern China, which played an important role in the history of Chinese civilizaton. It was here that the black ware from the Late Neolithic period was first discovered at Ling-shan, and that some of the most important Han remains were found. It is also the site of one of the most sacred of Chinese mountains, T'ai Shan, where numerous temples are located, dedicated to the great Emperor of the Eastern Peak. See Lung-shan T'ai Shan.

Shao Mi Chinese painter of the Late Ming and Early Ch'ing period, who was active during the middle of the 17th century. A member of the Suchou School, he worked in the southern tradition, and was particularly close to the artists of the Yuan period, such as Ni Tsan. It is said that he was a strange and withdrawn person who preferred a solitary life away from the world. His work reflected a sense of melancholy and loneliness combined with delicacy and sensitivity. Several of his works are found in the National Palace Museum in Taipei.

Sharaku Japanese printmaker of the Edo period who was active from 1794 to 1795. He is one of the most mysterious figures in the entire history of art, and virtually nothing is known about his life. His entire creative period lasted for less than one year, from May of 1794 to February of 1795, during which he made 140 color prints. What he had done up to that time and what happened to him afterwards, in spite of extensive research on the part of Japanese and Western scholars, is not known. Tradition had it that he may have been a noh actor named Saito Jurobei, but this could not be confirmed. His oeuvre consists entirely of actor prints in the tradition of Shunsho. His specialty was close-ups of actors' faces against a mica background which, for boldness of design and power of expression, have no equals. While the Japanese apparently did not much appreciate his work, which may explain the brevity of his artistic career, he was much admired by Western collectors, and is regarded today as one of the great masters of Ukiyo-e by both Japanese and Western critics.

Shari See Sharira.

Shariden or Relic Hall, located on the grounds of Engakuji Temple in Kamakura. See Engakuji.

Sharira Sanskrit term to describe Buddhist relics which consisted of the earthly remains of the historical Buddhist holy men and the legendary Buddhas of the past. They were often placed in stupas or pagodas, and were venerated as precious treasures which were believed to have supernatural powers. In Japan, where they are known as shari, they were often made of small semi-precious stones, and were kept in reliquaries, called sharito, which usually took the form of small pagodas.

Sheep The sheep or ram played a great role in Chinese life and was the source of wool. It is frequently represented in Chinese and to a lesser extent in Japanese art. It was one of the twelve animals of the duodenary cycle of the lunar calendar, and was looked upon as an emblem of filial piety and a life of retirement and leisure. In the form of a ram, it was a popular motif in the art of the Shang and Chou periods, where it may well have been connected with the lunar forces due to the shape of its crescent horns. It is also sometimes represented in Chinese and Japanese animal painting.

Shên Chou Chinese painter of the Ming period who lived from 1427 to 1509. He is considered the founder of the Wu School of Chinese painting, the greatest master of the Ming period, and the very essence of the kind of artist the Chinese critics have always admired most of all. He was a native of Su-chou, where he lived in retirement as a recluse, scholar and painter most of his life. His output was large, and of high quality. While his work is clearly based on that of the Northern Sung and, above all, the Yuan masters, he developed a highly individual style that exerted a powerful influence on all later Chinese painting. His brushwork was vigorous and very expressive, and much of his work shows greater realism than that of his models, in keeping with the spirit of his age. Numerous fine examples of his work may be found in the National Palace Museum, and splendid examples are also to be seen in the Boston Museum and the Nelson Gallery in Kansas City.

Shên Nan-p'ing Also known as Shên Ch'üan. Chinese painter of the Ch'ing period who was active from 1725 to 1780. A bird and flower painter who used a meticulous, colorful style, he did not play a great role in China, but was invited by an admiring patron to come to Japan in 1731. Spending three years in Nagasaki, he was much admired by the Japanese and exerted a great influence on Japanese artists, especially those of the Okyo School. His realism was highly esteemed and his colorful decorative manner appealed to the Japanese artistic taste. In consequence, most of the best examples of his art are to be found in Japanese collections.

Shên Nung A legendary figure in Chinese mythology, who is believed to have been one of the divine ancestors of the Chinese people and is credited with having invented agriculture and discovering the use of medicinal herbs. He is sometimes represented in Han art, where he is shown as having a human head and torso and a serpent's tail.

Shên-tao Literally "spirit road," the way leading up to a grave mound,

which was often lined with double rows of statues of men or animals, stele and pillars. The most famous of these are the roads leading to the tombs of the T'ang and Ming emperors.

Shêng Mao-hua Chinese painter of the Late Ming period, who was active during the first half of the 17th century. His oeuvre is very extensive, but rather eclectic in character, combining elements of the Southern School, particularly Wên Chêng-ming, with those of the Northern School, notably Ma Yüan. Many examples of his work are preserved in Japanese collections.

Shêng Mou Chinese painter of the Yuan period, who was active during the first half of the 14th century. A traditional and rather eclectic painter, he enjoyed great popularity during his lifetime, but is not particularly highly regarded today. His painting consists mainly of landscapes dealing with the traditional themes of towering mountains, picturesque old trees, and the scholar sitting in his hut contemplating nature. In contrast to the Sung painters, upon whom he modeled his work, his forms are rather more detailed and often employ touches of color. Good examples of his work may be found in the National Palace Museum in Taipei and the Nelson Gallery in Kansas City.

Shensi Province of northern China located west of Shansi and east of Kansu. Its most important city is Sian, which in ancient times was known as Ch'ang-an and served as the capital of the Han and T'ang empires. There are numerous important archaeological sites located near the Yellow River valley, of which Pan-p'o, where an entire Neolithic village was excavated, is the most important. See Pan-p'o-ts'un, Ch'ang-an.

Shiba Section of Tokyo where there was formerly a palace, but is today the grounds of a public park. It contains the Zojoji Temple, which is the headquarters of the Jodo sect in the Tokyo area, and was formerly the family temple of the Tokugawa shoguns.

Shiba Kokan Name of an Edo period painter and printmaker who is better known under his artist's name—Kokan. See Kokan.

Shibayama School of netsuke makers who produced pieces inlaid with shell and ivory, a type of technique invented by Shibayama Senzo in the 1770's.

Shibui A Japanese term for which there is no exact equivalent in English. It is commonly employed in a discussion of aesthetic matters and may best be translated as subdued elegance, describing an aesthetic sensibility that avoids ostentation, but at the same time conveys a feeling of refinement.

Shichi Fukujin The Seven Gods of Good Luck, who play a great role in Japanese popular religion. They are probably originally Chinese, but they enjoyed particular popularity in Japan, where they are often represented in art. The most prominent of them is Hotei, originally a Buddhist deity, who is represented with a huge stomach and symbolizes good nature and contentment. The others are: Jurojin, who is shown as an old man holding a staff, accompanied by a crane, tortoise or stag, identifying him as the god of longevity; Fukurokuju, who is shown with a long narrow

head and short body, and combines longevity with wisdom; Bishamon, who was originally a Buddhist deity, is the guardian of wealth and is shown as a warrior holding a miniature pagoda; Daikoku, the god of prosperity and good harvest, who is shown with bags of rice; Ebisu, the patron of tradesmen and fishermen, representing honest labor, who is usually shown carrying a fishing rod and sea bream; and finally Benten, the only female among them, who is the goddess of music and is connected with the sea. She is usually shown as a beautiful woman carrying a biwa, a Japanese musical instrument similar to a mandolin. See also entries under individual deities.

Shidoro The name of a pottery produced in the village of Shidoro in Shizuoka prefecture. The kiln is one of the traditional ones whose origins go back to early times, but it was particularly outstanding only after a group of Seto potters migrated here during the 17th century and began making stonewares in the Seto manner, decorated with a reddish brown or blackish glaze. In later times, tea wares inspired by Kobori Enshu, the celebrated tea master, were also produced at this site.

Shigajiku Japanese term literally meaning "poem picture hanging scroll." These were kakemono with one or more related poems inscribed above the painting, a form particularly favored by Zen priests of the Muromachi period.

Shigaraki Type of Japanese pottery made in a village of that name in Shiga prefecture. It is one of the traditional Japanese folk wares which was originally made for the local people of the district, and the place has continued to be a center of folk pottery to the present day. However, after the sturdy and rustic appeal of this ware was discovered by the great tea masters of the 17th century, notably Kobori Enshu, the Shigaraki kilns also made tea wares of great strength and beauty. The forms of this ware are crude, the walls of its body thick, and it is decorated with crudely incised designs and covered with a bluish green glaze which is allowed to run down the side of the vessel in a very spontaneous manner. It was particularly popular for water jars and tea bowls used in the tea ceremony although the great bulk of the production of the Shigaraki kilns consisted of purely utilitarian wares such as storage jars and tea jars which, especially in the early examples, with their interesting surface patterns, are among the masterpieces of Japanese folk pottery.

Shiegemasa Japanese painter and printmaker of the Edo period who lived from 1739 to 1820. His studio name was Kitao, and he was a son of the publisher Suharaya Saburobei. A member of the Ukioy-e School, he was initially a follower of Harunobu, but developed a more individual style in his maturity. He specialized in the representation of courtesans, emphasizing the elegance of their garments and their grace and beauty. His sense of design and color was excellent, although he never reached the artistic height of such contemporaries as Utamaro and Kiyonaga. In addition to his prints, he also illustrated a large number of books.

Shigenaga Japanese painter and printmaker of the Edo period who lived

from about 1695 to 1756. His family name was Nishimura, and it is believed that he was trained by Kiuyonobu in the Torii School. Although not a major figure in his own right, he was very important as a teacher, with such outstanding artists as Shigenobu, Toyonobu and Harunobu numbering among his students. His work was varied, and included prints of courtesans, landscapes, actors and birds and flowers.

Shih-chai-shan Archaeological site located twenty miles south of Kunming in Yünnan province. A large number of interesting objects made of bronze, gold and jade were excavated in the tombs at this site, which are believed to come from the 3rd and 2nd centuries B.C. Most striking are the drum-shaped containers that show figures, rendered in sculptural form on their tops, performing a sacrificial rite.

Shih Chi or *Historical Memoirs*, is one of the great classics of Chinese scholarly literature. Its author was the Han period scholar Ssu-ma Ch'ien, who wrote it around 100 B.C. It is the first factual account based on actual records of the history of China, and has served as a model for all later Chinese historical scholarship. It has been translated into English and into French, and has supplied valuable source material for all later historians of China.

Shih Ching or the *Book of Poetry*, is a collection of poems, hymns and songs of ancient China, which has been traditionally attributed to Confucius and is considered one of the Chinese classics. Actually, it is probably older, and reflects the customs and beliefs of the Late Shang period, and is therefore one of the oldest sources of our knowledge of early China. References to deities worshipped, ceremonial rites, and sacrifices are of great value for our knowledge of the art and culture of early China. An excellent English translation by Arthur Waley has been published.

Shih Chung Chinese painter of the Ming Dynasty who lived from 1437 to 1517. He was a friend of Shên Chou and formed part of the group of painters based in Su-chou. Since he was eccentric in his behavior, he was nicknamed "the fool from Nanking" or "the immortal fool." He painted largely landscapes in a free, inspired ink style which was remarkable for its brushwork. Among his surviving works, one of the most outstanding is a horizontal scroll depicting a winter landscape, now in the Boston Museum.

Shih Huang-ti Chinese emperor who established the Ch'in Dynasty which, after a period of civil war, united all of China and laid the foundation for the Han empire. Due to the repressive measures of his regime, especially regarding the persecution of Confucianist scholars, his rule was a brief one, lasting only from 221 to 207 B.C., but it had profound effects on Chinese history. His tomb, located near the modern city of Sian in northwest China, was excavated in 1975, and brought to light, among other archaeological treasures, some six thousand life-sized clay figures of warriors and horses, the most impressive and extensive find of this type ever to have been made. The monument from his reign which is best remembered today is the Great Wall of China.

Shih K'o Chinese painter of the 10th century who, according to literary accounts, was a very eccentric and unconventional person. He is usually credited with a manner of very spontaneous, unrestrained painting known as i-p'in in Chinese art criticism. The only surviving works which can be connected with his name are two scrolls of Ch'an holy men in Japanese collections which, however, are probably, at best, later copies of his work. See I-p'in.

Shih-t'ao Chinese painter of the Ch'ing period who lived from 1630 to 1717. His true name was Tao-eni, but he is best-known under the pseudonym Shih-t'ao. A painter, calligrapher, poet, art critic and author of a treatise on painting, he was one of the outstanding figures of the early Ch'ing period. Related to the Ming emperor, he, like Chu Ta, became a Buddhist monk at the fall of the Ming dynasty and spent much of his life traveling throughout the country. However, in his old age, he retired to Yang-chou. A member of the Eccentric School of painting, he developed a highly original style and, as he himself said, "I am beholden to no school, but paint in my own style with nature my only master." In employing ink and pale colors in a very forceful and unconventional manner, he produced works that reflect a very personal vision of nature. His work, not much appreciated in his own day, has become very popular in modern times, with Japanese and Western critics especially regarding him as one of the true giants in the history of Chinese painting. He has been much imitated and forged in the 20th century, but excellent and original examples of his work may be found in many collection.s

Shih-tê or Jittoku in Japanese. See Han-shan.

Shijo School School of Japanese painting which played an important role during the Edo period. It took its name from Shijo or the fourth street of Kyoto, where its founder, Maisumura Goshun (1752–1811) lived. It was an offshoot of the Maruyama School, for Goshun had studied with Okyo; but he combined the naturalistic principles of this school with a softer, more poetic interpretation of nature which was derived from the Nanga School. Among the important members of this school were Keibun, Shibata Zeshin, Kono Bairei, and Okamoto Toyohiko. See also Goshun, Zeshin, Keibun.

Shikishi Japanese term for a small square of thick paper, which usually measures about 5 in. x 6 in. It is decorated with patterns executed in colors or in gold and silver, and is used as a ground for painting or for poem-writing. These papers were traditionally stored in lacquer boxes, known as shikishibako, especially made for that purpose.

Shiko Japanese painter of the Edo period who lived from 1684 to 1785. His family name was Watanabe and he lived in Kyoto, where he first studied under a Kano master; later he studied with Korin, who had a profound influence on his work. In fact, he has been called the greatest of the artists who continued the decorative tradition of Japanese painting into the 18th century.

Shimbutsu-shugo Japanese term for the fusion of Shinto gods and Buddhas,

a theory according to which Buddhist gods are original forms (honji) and Shinto deities their incarnations (suijaku or gongen). It is also called the honji-suijaku theory. See also Dual Shinto.

Shime-kazari Japanese term used to describe the ornamental and symbolic arrangement of two pines, known as kadomatsu, joined by a cord of rice straw, and set up before temples and houses for the New Year's festival. Various symbols of longevity and happiness, including food items, are hung from the cord.

Shime-nawa Japanese word for the cord of rice straw which is hung as ornament before altars and over the entrances of temples and private houses for various festivals, especially the celebration of the New Year. It is twisted from right to left and adorned at regular intervals with small straw bouquets, bands of colored paper, etc.

Shimpo Japanese term literally meaning "divine treasure." It is applied to the gifts and offerings given to Shinto shrines for the use of the kami. These may include furnishings, clothing, arms, or simple cloth or paper offerings.

Shin style Japanese term to describe a type of calligraphy and painting which is formal, regular and traditional, in contrast to the gyo and so styles. While the term originated with calligraphy, it is also applied today to other art forms, such as gardens and flower arrangement. See also Gyo and So styles.

Shinden-zukuri A type of Japanese residential architecture which was developed during the Heian period and reflected the sophisticated taste of the court aristocracy. Although no actual examples of such architecture from this period have survived, Japanese literature and painted scrolls illustrate what it was like. It consists of a group of buildings surrounded by a garden, with the central hall, the Shinden, in which the master lived, opening into the southern garden. Veranda-like corridors, connecting the central section with the side wings, served as subsidiary living quarters. The construction was wholly of wood, with cypress bark used for the roofing and reed matting, known as tatami, used as a floor covering. This type of building has exerted a powerful influence on all later Japanese domestic architecture.

Shingon Japanese term for a Tantric Buddhist sect which is known in Chinese as Chên-yên, meaning True Word sect. It was introduced to Japan by the priest Kukai (744–836), who had studied in China under the priest Hui-ko, who in turn was a disciple of the Indian monk Amoghavajra. jra. Its teachings were very esoteric and mysterious, with Vairocana Buddha, the great Cosmic Buddha, known in Japanese as Dainichi, looked upon as the supreme deity of whom all the world was but a manifestation. In it, magic diagrams in both painted and sculptural forms, known as mandaras, were employed, as well as representations of often grotesque and strange deities, such as the Myo-o, many of them derived from Hindu sources. See Kukai, Mandara.

Shino Type of Japanese ceramic named after the famous tea master, Shino Shoshin. It is a coarse, heavy pottery, covered with a thick, creamy-white glaze and often decorated with freely rendered abstract designs of flowers, plants and landscapes. The decorated wares are known as e-Shino, or painted Shino. Other types of Shino are known as Nezumi, or Grey Shino, and Beni-Shino, or Red Shino. The finest of these were produced during the Momoyama and Early Edo periods, but they continue to be made to the present day, with the leading modern Shino artist, whose name is Arakawa, considered one of the living cultural treasures of Japan. A great variety of shapes are found among the Shino wares, most of them connected with the tea ceremony, such as tea bowls, water jars, cake dishes, flower vases and incense containers. The most outstanding of the Shino wares are among the most celebrated of all Japanese ceramics.

Shinran Famous Japanese Buddhist priest who lived from 1173 to 1262. He was, at first, associated with the Tendai sect, and taught on Mount Hiei, but then became a follower of Honen, and turned to the teachings of the Pure Land, or Jodo, school. His appeal was broad and popular, and his teaching emphasized faith in the Buddha Amida, upon whose mercy the faithful could depend for salvation. He founded his own sect, known as Shin Buddhism, which enjoyed great popularity and which is still one of the largest Buddhist sects in Japan.

Shinsui Japanese painter and printmaker of the Showa period, who lived from 1898 to 1974. Although he had travelled in Europe, he remained a purely Japanese-style painter who specialized in bijinga, or the representation of beautiful women. He was one of the most popular of contemporary traditional Japanese artists, and also enjoyed a considerable reputation as a printmaker.

Shinto Native Japanese religion which predates the introduction of Buddhism, and is still a vital religious force in Japanese life today. Shinto, or, as it has been called, the "way of the gods," basically consists of the veneration of the spirits of the dead, especially those of the ancestors and heroes of the Japanese nation. The Shintoists believe that all of nature is filled with divine spirits, known as kami, to whom proper respect must be given, and to whom the numerous Shinto shrines found throughout the Japanese isles are dedicated. While the term "gods" is often applied to the Shinto deities, it would probably be more accurate to think of the kami as divine spirits that inhabit the universe. While Shintoism never developed a rich and varied art as did Buddhism, the numerous Shinto shrines, notably those at Ise and Izumo, are noble expressions of the Shinto philosophy, which emphasizes closeness to nature and simplicity. Under the influence of Buddhism, Shintoism also developed sculpture and painting which represent the Shinto deities and sacred shrines. However, the most venerated and sacred of all Shinto emblems is the bronze mirror, the symbol of the Sun Goddess, which is kept at the Ise Shrine, See Ise, Izumo, Kami, Dual Shinto.

Shiomi Masanari Japanese lacquer master from Kyoto, who was active around 1700 and is usually regarded as an outstanding master of the togidashi technique. In fact, he became so well known for this work that the term Shiomi-makie was applied to high-class togidashi lacquers. His most famous work is a hirasan writing-box representing a scene from Lake Biwa, now in the Tokyo National Museum, which reveals him to have been a subtle painter and an outstanding technician.

Shippo Japanese term used to describe cloisonné enamel, which was introduced into Japan from China during the 16th century. The word itself literally means the ''seven precious objects'' or ''seven treasures'' mentioned in Buddhist sutras, namely gold, silver, agate, amber, coral, emerald and tortoise shell. Cloisonné was used extensively during the Edo period for the decoration of objects of art, notably metal containers, jars and dishes. See also Cloisonné and Enamel.

Shira-e Japanese term for the painting technique known as pai-hua in Chinese. See Pai-hua.

Shishi Japanese term for the Chinese lion, also referred to as Karashishi. See Lion.

Shishimai One of the most popular traditional dances in Japan, in which the dancer, wearing a lion mask is representing the shishi, or lion, who plays a prominent role in both Chinese and Japanese mythology. It was probably derived from China, and appears in the gigaku dances performed in the courtyard of Buddhist temples and noble mansions as early as the Asuka and Nara periods. It is particularly popular on the kabuki stage, where the lion dance is featured in one of the best-known plays. It also is often performed by the ordinary people in folk dances and processions. It is frequently the subject of art, especially in popular painting and woodcut prints. In China, too, a common amusement is the game of the lion, in which two men, dressed in the garment of a cloth or paper lion, perform dances, while a third one postures in front of them with a large colored ball which is said to represent the sun.

Shishinden Name of famous structure at the Imperial Palace in Kyoto. It serves as the inner throne room, where the emperor was located when he appeared in his official function as the ruler of the Japanese empire. It is ultimately based on Chinese prototypes, and it was believed that this type of architecture was introduced from the mainland in the 9th century. It consists of a rectangular throne-chamber, which is ramed on each side by oblong rooms, known as hisashi.

Shitenno See Lokapala.

Shitennoji Buddhist temple in Osaka founded in A.D. 593 by Prince Shotoku Taishi. It is one of the oldest temples in all of Japan. The original buildings were repeatedly destroyed by fire, most recently during an air raid in 1945. The temple has, however, been reconstructed since the war and contains several treasures of Buddhist art, notably a Heian period scroll of the *Lotus Sutra* and various objects which belonged to Prince Shotoku Taishi.

Shoami School of Japanese sword guard makers founded in the early 17th century by Shoami Masanori of the Nishijin district of Kyoto. The last master of the school was Shoami Katsuhoshi, who died in 1909. The school established many branches throughout the country, especially in Matsuyama, and in other places or Shikoku. Members of the schools worked in a great variety of styles, especially a low relief decorated with incrustations of gold and silver.

Shobu-no-sekku Japanese term for the Boys' Festival. See Boys' Festival.

Shodo Japanese term used for the art of beautiful writing or calligraphy, which in Japan, as in traditional China, was regarded as one of the major forms of artistic expression, and thought of as being equal to painting. To this day, thousands of accomplished artists are devoted to this art form, and hundreds of organizations whose members practice and study calligraphy exist throughout the country. They vary from very traditional ones to extremely abstract and modern ones, whose members practice what is known as Zenei Shodo, or literally "avant-garde shodo." See also Calligraphy.

Shoei Japanese printer of the Momoyama period who lived from 1519 to 1592. A member of the Kano school, he was the son of Kano Motonobu and the father of Kano Eitoku. He studied with his father and developed a style based on Chinese ink painting. While not nearly as original or distinguished as his son, he is nevertheless an accomplished artist, whose work is pleasing and shows excellent brushwork. Of the works ascribed to him, the best known is a series of panel paintings representing tigers and bamboo, now in the Jukoin of Daitokuji Temple in Kyoto.

Shoga Japanese painter of the Kamakura period who is believed to have flourished in the late 12th and early 13th centuries. He was a son of Takuma Tameto, the founder of the Takuma School of Buddhist painting. His only surviving work is a set of twelve paintings, representing the Devas, which is found in the Toji Temple in Kyoto. It was painted in 1191 and clearly reflects the influence of Sung painting, emphasizing line rather than color or pattern, and employing a new type of iconography which had not been found in Japanese Buddhist art prior to this.

Shogun A title first conferred upon the military ruler Yoritomo by the emperor of Japan in 1192. The full name of the office was Sei-i-Taishogun, meaning "generalissimo for the subjugation of eastern barbarians." This office, which really amounted to being a military dictator of Japan, was passed on to other Japanese ruling houses, such as the Ashikaga and the Tokugawa families, so that all-powerful rulers, referred to as shoguns, dominated Japan for some seven centuries, until the abolition of the shogunate and the re-establishment of imperial power at the time of the Meiji Restoration in 1868.

Shohaku Japanese painter of the Edo period who lived from 1730 to 1781. He was trained in the Kano School, but called himself the 10th generation of the Jasoku, a famous ink painter of the 15th century. In keeping with this, he turned for inspiration, not to his own contemporaries, but to the

much more powerful and expressive ink painting of the Muromachi period. His brush stroke is very powerful and his style unconventional; he is one of the most original and interesting painters of 18th-century Japan. A good example of his art is found in the Boston Museum in the form of a pair of six panel screens, representing the "Four Sages of Mount Shang," which reflects the explosiveness and eccentric nature of his art very well.

Shoin-zukuri A Japanese architectural term for a certain type of residential building which first occurs during the Muromachi period. The term shoin itself refers to the study in a priest's house, in which a window supplied additional illumination, but later on was used more broadly to describe a type of house which also had a tokonoma and tatami, and a series of rooms separated by sliding screens in the form of shoji and fusuma.

Shoji Sliding screens in the form of panels of translucent rice paper, held in place by wooden frames and gridwork of slender wooden supports. They are used very extensively in Japanese architecture as movable outer walls.

Shokado Japanese calligrapher and painter of the Edo period who lived from 1584 to 1639. His real name was Nakanuma Shojo, and he was a priest of the Shingon sect. He was regarded as one of the great calligraphers of the time, and was particularly interested in the type of calligraphy which the founder of the Shingon sect, Kobo Daishi, had employed during the Heian period. He was also a distinguished painter, and was particularly known for the type of painting executed by the Chinese artists of the Ch'an School, notably Mu-ch'i and Yin-t'o-lo. He also painted birds and flowers in a more decorative style, in keeping with the artistic spirit of his own age, in which the influence of Kano Sanraku, who had been his teacher, was reflected.

Shoki Japanese name of the Chinese demon queller, Chung K'uei. See Chung K'uei.

Shoko Modern netsuke carver born in Tokyo in 1915. A pupil of Morita Soko, he became an independent artistan 1943 and is considered one of the best of contemporary carvers.

Shokokuji Temple in Kyoto founded by Ashikaga Yoshimitsu.

Shonai Town of northern Japan in the province of Uzen, now Yamagata prefecture. A number of schools of sword guard makers were located here, the most prominent of which was founded in the early 18th century by Funada Zaisai, a pupil of Shoami. The other notable Shonai school was the Katsurano School, founded by Katsurano Akabumi, a samurai, around 1750. Shanai work is characterized by great strength and boldness of design.

Shonin An honorary title appended to the names of great priests, for example—Myoe Shonin, Honen Shonin and Ippen Shonin. It is roughly equivalent to the Christian designation "saint."

Shonsui A type of early Japanese blue and white ware, based on Chinese Ming models, which has been traditionally attributed to the 16th-century potter Gorodayu Shonsui. It was said that he had gone to China and had

imported the tools, clay, glaze and color from that country, but modern scholars tend to be very skeptical about this tradition. Today the term is used in a more general sense to describe the early Japanese porcelains made with a white porcelain clay and decorated in cobalt blue under the glaze.

Shoryobune Japanese term for the small ships made of rice- or barley-straw which are used on the occasion of the Bon Matsuri, or Festival of the Dead. They take the form of small junks 2–4 feet in length, with sails of white paper on which the names of the dead are inscribed, and are decorated with lanterns and small banners bearing symbolic emblems. Incense is burned on the miniature decks. On the evening of the last day of the festival, the 16th of July, the remaining offerings are taken from the altars and placed in the boats, which are then set asail on the rivers, taking the spirits back to the realm of the dead.

Shosoin Storehouse, built in a style resembling an American Western block-house, but raised from the ground on stilts and covered with a tile roof, which is attached to Todaiji Temple in Nara. It was built by the widow of the emperor Shomu in order to house the treasures from his palace, which he bequeathed to the temple in 756. Since it comprises a collection of thousands of works of the decorative arts, including painted screens, furniture, musical instruments, ceramics, metalwork, lacquers, weapons, textiles and many other such craft items which have been kept together there for over twelve centuries, it constitutes the single most important source for our knowledge of the history of Japanese decorative arts of the Nara period. Furthermore, since many of these objects were imported from China, they are also invaluable for dating Chinese crafts of the T'ang period.

Shotoku Taishi Prince Regent of Japan during the rule of the empress Suiko, and a patron of Japanese Buddhism. His real name was Umayodo, but he was better known by his posthumous name, Shotoku, meaning "sage virtue." He lived from 572 to 621 and was a great ruler. He has often been referred to as the Constantine of Japanese Buddhism, and it is true that he played a vital role in establishing the new religion in Japan. He gave lectures on Buddhist doctrine and wrote comments on Buddhist sutras. He was also interested in Chinese political theory and had a great influence on the structuring of Japanese society along Chinese lines. He was the founder of Shitennoji Temple of Osaka and Horyuji temple in Nara, and an enthusiastic supporter of Buddhist art. A portrait in the collection of Horyuji Temple is believed to be a good likeness, as well as the first portrait-painting in the history of Japanese art.

Shou-chou Chinese archaeological site at the Huai River in Anhui province. During the Late Chou period, it was the capital of the Ch'u state, and even after the conquest of Ch'u by the Ch'in in 223 B.C., it continued to be an artistic center. It is particularly important for the ceramics which were excavated there: grey stoneware with a thin olive-green glaze, which

are probably the immediate ancestors of the Yüeh wares of the Han Dynasty and the celadons of later times.

Shou-chüan A Chinese term for the horizontal handscroll which, at least since Han times, has been one of the most popular formats in Chinese painting. These may vary from a few inches to many feet, and are unrolled from right to left, section by section, so that they can be examined closely and at leisure. This format is particularly popular for representing narrative scenes and landscape scrolls depicting the various seasons as they are experienced by the viewer. It was also introduced to Japan during the Nara period, where it was known as makimono, and enjoyed great popularity, especially among the artists of the Yamato-e School.

Shou Hsing Shou Hsing, the god of longevity in popular Chinese mythology, is also known as the Old Man or the Spirit of the South Pole. From his original identity as a stellar deity, the god of the star Canopus in the constellation Argo, he evolved into a domestic god with the task of deciding the date of every man's death. He is represented as an old man with an extremely high bald skull and a bulging forehead, and is often accompanied by a stag and a bat, both symbols of happiness. In one hand Shou Hsing bears a peach, the fruit of immortality, and in the other he holds a knotted staff to which are attached a gourd and a scroll, emblems of long life. A mushroom or tortoise, also symbolizing longevity, is sometimes placed at his feet. He is frequently represented with the god of happiness and the god of emoluments as a trinity known as the "Three Stars" or San hsing.

Shu Ching or *Book of History*, is the oldest collection of Chinese documents, speeches and records. Although it goes back to the beginning of the Chou period, its present version was put together during Han times after every effort had been made to destroy it during the Ch'in period. Many of the facts mentioned in it have been corroborated by recent archaeological finds and by the study of inscriptions on ancient Chinese bronzes.

Shu-fu A type of pottery, made in Kiansi province in the Ching-tê-chên district, which is marked with the characters shu and fu, meaning central palace, and which has, therefore, been identified as an official ware of the Yuan period. Only a few specimens of this ware have survived, but they are of fine quality, with a thick pale blue or greenish blue glaze. These wares may also have low relief designs decorating either the inside or the outside of the vessels. It is believed that they continued to be made during the Early Ming period and may be related to both the Ying-ch'ing and early blue-and-white.

Shubun Japanese painter of the Muromachi period who flourished from the 1430's through the early 1460's. A Zen monk who was connected with Shokokuji Temple in Kyoto, he was one of the most influential and important of all Japanese artists. He followed Josetsu as the official painter of the shogun, and was regarded as the greatest ink painter of his time. In addition, he was the teacher of Sesshu. In 1423, he joined a Japanese mission to Korea, where he studied the art and religious doctrines of the

country. His style was derived from that of the Southern Sung masters, notably Ma Yüan and Hsia Kuei. A large number of paintings, mostly landscapes in the Chinese manner, are attributed to him today, but the problem of determining which of these are originals by his hand is a very complex one, and we cannot be certain that any of them are more than Muromachi paintings executed in his style. The work which is most generally accepted as being authentic is the scroll in the Tokyo National Museum.

Shugetsu Japanese painter of the Muromachi period who was active during the late years of the 15th and the early years of the 16th century. He was a pupil of Sesshu, whom he visited in Kyushu, in order to study with him, around 1490, and he also made a trip to China around 1496. He painted both in ink and in color, employing a style which was influenced by the Ming painting which he had seen during his visit to the Chinese mainland. In contrast to the earlier Japanese ink painters, his style was rather more detailed and naturalistic, showing little of the spiritual quality associated with the greatest masters of Japanese suiboku.

Shui Hu Chuan A Chinese novel of the Ming period, the title of which has been literally translated as the *Water Margin*, but is better known in the West under the title *All Men are Brothers*, which Pearl Buck gave to her English translation of the story. It is attributed to the late 14th-century author Shih Nai-an, but additions were made two centuries later. It is a picaresque novel centering around the bandit leader Sung Ching, who lived in Shantung province during the last years of the Northern Sung Dynasty and is portrayed as a kind of Robin Hood. Episodes from it are sometimes portrayed in Chinese painting and prints.

Shui-mo Chinese term, literally meaning "water and ink," which is applied to paintings executed in monochrome. Much of the finest of Chinese and Japanese painting is executed not in color, but in monochrome ink, in which the tonal gradations of the ink itself are employed in lieu of the different hues. In fact, many Chinese and Japanese artists prefer this manner of painting, thinking of it as being more refined and elegant. In China, this tradition is usually credited to the T'ang painter Wang Wei, who was therefore looked upon as the founder of the Southern School of literati painting. It became the favored type of painting with the Sung Dynasty, and continued to be the preferred medium of artistic expression of the painters of the Yuan, Ming and Ch'ing periods, notably among the literati painters and those of the Eccentric School. It continues to be used by traditional Chinese painters even during modern times. In Japan, this type of painting was introduced by the Zen monks during the Late Kamakura period, and became the dominant art form during the Muromachi period, especially among the Zen painters. To this day, monochrome painting is widely practiced in both countries, and is felt to be particularly suitable for certain subjects such as landscapes, bamboo, and sometimes also bird and flower paintings. See also Suiboku, Sumi-e.

Shummei Celebrated metalworker of the Edo period who was born in 1786

and died in 1859. His real name was Kono Haruaki. His art was influenced by that of the Goto School with subjects executed in low relief in a realistic style. He usually represented scenes or themes from Japanese legend and everyday life, and often included lines of verse and other inscriptions.

Shuncho Japanese painter and printmaker of the Edo period, who was active during the last quarter of the 18th century. He was trained in the Katsukawa School, but was primarily influenced by the work of Kiyonaga. He specialized particularly in the depiction of women, whose grace and elegance he portrayed with great mastery. He was particularly adept in the making of pillar prints and diptychs and triptychs. In his old age he gave up painting and printmaking and turned to the writing of novels.

Shunei Japanese painter and woodcut artist of the Edo period who lived from 1762 to 1819. His family name was Isoda, and he was a member of the Ukiyo-e School. He was a pupil of Katsukawa Shunsho and a member of the Katsukawa School. Like his master, he specialized in actor portraits, usually showing them in full length, as they were performing on the stage, or as large portrait heads. His style is very close to that of Shunsho, combining beauty of color and design with a vivid representation of facial and body expression. He was also well known for his representations of sumo wrestlers, an artistic genre of which he was one of the pioneers and in which he excelled.

Shunga Literally "spring pictures," a term referring to the erotic paintings and books produced in Japan, which were particularly popular during the Edo period. The early Ukiyo-e book illustrators and virtually all of the major printmakers, such as Harunobu, Utamaro, Hokusai and many others, in addition to their courtesan, actor and landscape prints, made books and individual prints which were very explicit and were intended as sex manuals and stimulants to erotic curiosity.

Shunko Japanese painter and printmaker of the Edo period who lived from 1743 to 1812. He belonged to the Katsukawa School, and was a pupil of Shunsho. Like his master, he devoted himself largely to the depiction of scenes of actors from the kabuki, with his best work equaling that of his teacher. His main contribution to this subject was the portrayal of large actors' heads. He is also known for his portrayal of courtesans and wrestlers.

Shunman Japanese painter and printmaker of the Edo period who lived from 1757 to 1820. A member of the Ukiyo-e School whose family name was Kubo, he became a pupil of Shigemasa, but was primarily influenced by the work of Kiyonaga. In addition to being an artist, he was also a poet, and in his lifetime had more success as a writer than as a printmaker and painter. His best work consisted of the representation of elegant and beautiful women, especially courtesans, rendered against a landscape setting. His colors, which were subtle and subdued, were particularly lovely,

and while a minor master, he nevertheless was one of the outstanding printmakers of his age. In later life, he turned to the surimono form, elaborately printed small works with short poems by literary men, which were printed on special paper with great care and elegance.

Shunsho Japanese painter and printmaker of the Edo period who lived from 1726 to 1792. He was a Ukiyo-e artist and the founder of the Katsukawa School, other members of which were such artists as Shunei, Shunko, Shunjo and Shunro. He was primarily known for his prints of kabuki actors, whom he showed with a keen psychological insight not to be found in this type of print prior to his work. He also portrayed them in close-up, concentrating on their heads and facial expressions, a type of print which Sharaku was to bring to perfection after Shunso's death. In paintings, he also portrayed courtesans, whose beauty and activities he recorded with great skill. He was a fine colorist, using bright and vivid colors to good advantage, and was outstanding for his vigorous line and beautiful sense of design. His most gifted pupil was Katsukawa Shunko, who continued this tradition of actor printmaking.

Shunsho A family of Japanese lacquer makers which was founded by Shunsho Yamamoto during the early 17th century. After studying literature, he turned to lacquer, and became one of the best-known and most highly esteemed masters of the early Edo period. He excelled particularly in works executed in the togidashi and hiramaki-e techniques, employing a style which continued the Momoyama tradition of highly decorative gold lacquer. This school continued through ten generations to the 19th century, with Shunsho Kagemasa, who died in 1707, the most famous master next to the founder.

Shuzan Netsuke carver of the 18th century. His birth date is unknown, but he died in 1776. He studied painting under a master of the Kano School, and made netsuke as a hobby. He carved chiefly hermits in hinoki wood, decorated in colors. He never signed his work and was frequently copied, so that it is difficult to identify his originals.

Sian Today the capital of Shensi province, and at one point the imperial capital, it is one of the oldest and most important of Chinese cities. Excavations have revealed that there were human settlements here during the Neolithic period, and during the Han period the Chinese capital of Ch'ang-an was located slightly north of the modern city of Sian. After the fall of the T'ang Dynasty, Sian went into a decline, from which it did not emerge until the beginning of the Ming period, when a palace was built at this site. It also flourished during the Ch'ing Dynasty, when it was described by a European traveler as one of the largest and most beautiful towns in China. In recent years it has become an important industrial center, and has very much expanded its population. In 1953, one of the most significant of all Chinese archaeological finds—the Neolithic pottery village of Pan-p'o, which has now been turned into a museum—was discovered six miles from Sian. See Ch'ang-an.

Siddham script Special kind of Indian sacred script employed to write Sanskrit phrases or magic formulas in Esoteric Buddhism.

Siddhartha Hsi-ta-to in Chinese and Shitta Taishi in Japanese. The name of the Historical Buddha Sakyamuni as a royal Indian prince, before he had renounced his heritage and turned to the life of an ascetic. He is often represented, in both Chinese and Japanese sculpture and painting, as Prince Siddhartha, shown dressed in the garments of a royal Indian prince and wearing a crown and jewels. A particularly lovely representation in sculptural form is found at Lung-mên and is now in the collection of the Boston Museum, while the most charming representation in Japanese art is to be found in the Nara period scrolls representing the Sutra of the Past and Present Incarnations of the Buddha, the so-called Inga-Kyo Scroll.

Silk A type of delicate textile made from the softened cocoon of the mulberry silkworm. The cultivation of silkworms for the making of such fibers was begun in ancient China and flourished especially during the Han period, when Chinese silk was exported as far afield as the Roman Empire, where it enjoyed great favor. Some of the finest Chinese and Japanese textiles, often outstanding for their colors and woven or dyed designs, were made in this artistic medium. Masterpieces of early Chinese silk have been excavated in Central Asia, are to be found in the Shosoin in Nara, and have survived in the cathedral treasuries of medieval Europe. It is also often used, along with paper, as a ground for painting.

Silk Road Name applied to the route leading from China across Central Asia to the West, because it was traveled by the caravans which brought chinese silks to the Near East and the Roman Empire. Some of the finest examples of Chinese textiles of the Han period, illustrating the many techniques and designs employed by the Chinese weavers of the time, were found at archaeological sites along the way, and new excavations, notably in Sinkiang province, have brought valuable material to light in recent years, mainly in the region around Turfan.

Silver Pavilion See Ginkakuji.

Sinkiang Westernmost province of modern China, located in Central Asia beyond the Great Wall. Inhabited by nomad tribes of Turkish and Mongol racial stock, it nevertheless played an important role in the history of Chinese art; for it was through this territory that the so-called Silk Route, conveying the trade from China to Western Asia, was located, and there that some of the most important Buddhist establishments of the Six Dynasties and T'ang periods were excavated. Well-preserved examples of Chinese textiles, dating from the Han through the T'ang periods, have been found at numerous sites, notably in the region around Turfan, by modern archaeologists of the People's Republic. The bulk of the Buddhist remains, which were brought light by German archaeologists, are now in the Berlin Museum.

Six Canons See Hsieh Ho.

Six Dynasties The period of Chinese history, lasting from A.D. 265 to 589, during which China was divided, with the north being ruled by foreign Tartar and Turkish dynasties, while the south was ruled from Nanking by six successive native Chinese dynasties, among which the Liang Dynasty was the most notable. It was during this period that Buddhism was introduced to China and that some of the finest of Chinese Buddhist art was produced. Among the most notable monuments of this art surviving today are the great cave temples at Yün-kang and Lung-mên with their sculptural carvings, and the Thousand Buddha Caves at Tun-huang with their wall paintings. The age was also well-known for its secular painting, with the 4th-century master Ku K'ai-chih, to whom several surviving scrolls are attributed, being one of the most famous artists. See Yün-kang, Lung-mên, Tun-huang, Ku K'ai-chih.

Snake The snake plays a prominent role in both Chinese and Japanese legend and art, and is one of the twelve animals of the duodenary cycle. Its associations are twofold, for on the one hand, along with the dragon, it is looked upon as a powerful supernatural creature, regarded with awe and veneration, while, on the other hand, it is considered the emblem of sycophancy, cunning and evil. It is said that it is very unlucky to injure a snake who has made its domicile beneath one's house, and to release a captured snake is regarded as a good deed. Snakes already occur in the art of the Shang and Chou periods, where they were thought of as symbol of water and fertility. Snake deities are often shown in Chinese and Japanese popular art and the earliest ancestors of the Chinese race are traditionally shown with human heads and bodies and snake tails.

Snuff bottle Snuff bottles of all types played a great role in later Chinese art. The earliest of these probably go back to Sung times, and were used as medicine bottles, but, by the Late Ming period, they were widely used for snuff, and enjoyed vast popularity during the Ch'ing period. All kinds of materials, such as jade, crystal, onyx, turquoise, amber, coral, glass, silver, bronze, lacquer, enamel, tortoise shell, ivory and all kinds of ceramic wares, were used for this purpose. The bottles were often elaborately carved or painted with designs of fruits, flowers, animals, insects and human or legendary figures. They are eagerly collected today by both Chinese and Westerners.

So style A Japanese term applied to a certain style of calligraphy which is the running, or grass, style. The term may also be used to describe ink paintings which are executed in a very free, broad manner, such as may be found in some of the works of Sesshu and, especially, in the work of Kano Naonobu, as well as that of their many followers. This term may also be applied to other art forms and flower arrangement. See also Ts'ao-shu.

Soami Japanese painter of the Muromachi period who lived from c.1472 to 1525. The son of Gerami and the grandson of Noami, he was the most famous member of the Ami family, which was one of the prominent ar-

tistic families of Kyoto. In addition to being an outstanding painter, he worked as an artistic advisor to the shogun, and was one of the authors of a book called *Kundai-kan Sochoki*, the first book of art criticism in Japan. His work followed Chinese models of the Sung period, and was executed in suiboku. While many works are attributed to him today, very few of these can be accepted as by his own hand. The best known of these are the ones he painted for the Daisenin at the Daitokuji monastery in Kyote. In America, the best work attributed to him is a pair of screens in the Metropolitan Museum in New York.

Soft paste Western term for a type of fine white Chinese porcelain of the Ch'ing period which, in China, is referred to as chiang-t'ai, or paste-bodied ware. It is opaque, but fine-grained, with a very smooth surface and faint glazing. It is extremely delicate and light in weight, and was largely used for small objects, which were often also decorated with blue paint.

Soga School of Japanese painting which traces its origin back to the ink painters of the Muromachi period, but was actually established by the Momoyama-period painter, Soga Chokuan. His son, Chokuan II, called himself the sixth generation both from Shubun and Jasoku in order to strengthen the family prestige. The painters of this school were rather conventional Chinese-style ink painters who specialized in the painting of birds, notably rocs and eagles, as well as landscapes and scenes from Chinese mythology, in a style recalling that of the minor masters of the Kano School. See Chokuan.

Sogyohachiman See Hachiman.

Soken Japanese painter of the Edo period who lived from 1759 to 1818. His true name was Yamaguchi Soken, and he lived in Kyoto. A pupil of Maruyama Okyo, he belonged to the Maruyama School and specialized in the painting of female figures.

Soko Modern netsuke carver, born in 1879, whose family name was Morita. A native of Tokyo, he is one of the leaders of the modern Tokyo School of netsuke carving, which combines realism with minute detail.

Soko Modern netsuke carver who lived from 1868 to 1935. His family name was Toshiyama. Born in Kanazawa city, he spent most of his life in Osaka. He worked largely in wood, depicting stories from Japanese history and legend.

Soma Name of a Japanese ceramic ware produced at a kiln located at Nakamura in Fukushima prefecture. It was established by the local prince, whose name was Soma, and the earliest examples bear his crest. It is best known for the decoration showing a horse tied to a stake, based on a design executed during the 17th century by Kano Naonobu.

Sombre Warrior also called the Dark Warrior, is the guardian of the northern quarter of the heavens in Chinese cosmology, and also symbolizes the winter season. The "warrior" is actually a tortoise with a snake coiled around its body, always represented in black. This figure is often shown in Chinese art, especially that of the Han period. See also Four Quarters.

Sometsuke Japanese term, meaning blue and white, used to describe a type of porcelain decorated in cobalt blue under the glaze in the Chinese manner. Ever since the 17th century, this type of ware has been extremely popular in Japan. See also Blue and white.

Somin Famous Japanese sword guard maker who lived from 1670 to 1733. He was a member of the Yokoya School of metalworkers in Edo. His most important contribution was a new style of engraving, called katakiri, which imitated brush strokes. His designs were often taken from the work of his friend, the famous painter Itcho.

Soochow Chinese city which was a great artistic center. It is usually spelled Su-chou. See Su-chou.

Sosen Japanese painter of the Edo period who was born in 1749 and died in 1821. His true name was Mori Shusho; however, he used the artist's name Sosen, by which he is best known. Although he was trained by a Kano master, he was primarily influenced by Okyo, and became one of the leading exponents of the Maruyama School. He is particuarly well known for his depiction of animals, notably monkeys, in a very detailed, realistic style based on a close study of nature, instead of that of older artistic models. Due to the great popularity which his monkey paintings enjoyed, virtually every Japanese painting of the Edo period depicting the animal is today attributed to him. However, only a fraction of these are by his own hand. At his best, he is an artist of great vitality and artistic skill, exemplifying the realistic trend in Japanese painting at its best.

Soshu Japanese painter of the Momoyama period who lived from 1551 to 1601. He was a member of the Kano School and studied with his father, Kano Shoei, and his elder brother, Eitoku. He worked with them on several important artistic projects in the Kyoto area.

Sotan Japanese painter of the Muromachi period who lived from 1413 to 1481. He studied with Shubun, and succeeded his teacher as the official court painter of the Ashikaga shoguns. He was a Zen priest connected with the Shokokuji monastery, and belonged to that prominent school of Chinese-style ink painters which flourished in Kyoto at that time. Although his name is often mentioned in the temple records, no certain works of his survive today. Some of the screen paintings in Kyoto temples have been attributed to him, and it would appear that his work consisted largely of landscapes rendered in suiboku, in the Chinese manner.

Sotatsu Japanese painter of the Edo period whose birth date is not known, but who was active during the first half of the 17th century, and who died in 1643. He is thought of by many critics as the greatest and most characteristically Japanese of all of the painters of the Edo period. He has enjoyed tremendous popularity among artists, scholars and critics, both in Japan and in the West, during the 20th century. Very little is known about his life, but it is believed that his family name was Nonomura and that he was connected with the Tawaraya establishment of weavers and decorative artists in Kyoto, and was related by marriage to Koetsu and the other members of the Honnami family. His style was based

on the Yamato-e tradition of the Heian period, and on the decorative screens of the Monioyama age. He was the very essence of the Japanese artistic sensibility, employing bright colors, flat decorative shapes and gold backgrounds. His subject matter, too, was largely taken from Japanese life, legend and literature, portraying such typically Japanese themes as the *Tale of Genji,* the *Tale of Ise*, and the Matsushima Islands of northern Japan, in contrast to many of his fellow artists who preferred scenes taken from Chinese history or landscape. Among his most famous works are his ''Genji Screen,'' now in the collection of the Seikado, the ''Gods of Thunder and Wind'' in the Kenninji monastery in Kyoto, and the ''Bugaku Dancers'' in Daigoji Temple near Kyoto. In America, outstanding examples of his work may be found at the Freer Gallery, which owns the famous ''Matsushima Screen'' and at the Seattle Museun, which has a celebrated deer scroll.

Soten School of Japanese sword-guard makers founded, during the late 17th century, by Kitagawa Soten at Hikone, in Shiga prefecture. He developed a style of decoration, called marubori, in which the forms were represented completely in the round, often decorated with overlay or inlay of gold, silver and copper. The subjects were usually taken from Chinese and Japanese history. This type of work, referred to as Hikonebori, was very popular and, therefore, frequently imitated.

Southern Ch'i Short-lived Chinese dynasty which ruled southern China from its capital in Nanking from A.D. 479 to 501. It is said that its court was an artistic center; however, little of the artistic output of that time survived.

Spilled ink See P'o-mo.

Spiral A very common motif, in the early art of many civilizations, is a spiral or volute pattern. In China it is known as the thunder pattern or lei-wên, and resembles the archaic character for cloud, thunder and to revolve, and was, therefore, connected with thunder, clouds, rain and fertility. It frequently occurs as the main decorative motif on Chinese wares of the prehistoric period and, in a somewhat more stylized form, in Shang and Chou bronzes. In Japan too, the spiral motif is frequently encountered on Jomon vessels of the prehistoric age. See also Lei-wên.

Spirit screens or in Chinese ying-pi. A screen, placed at the main door of a Chinese house or at the entrance of a temple or important building, which is believed to protect the structure by turning back evil spirits that might be approaching. The most famous of these is the Nine Dragon Wall, with its magnificent colored-tile dragons, in Peking. See Nine Dragon Screen.

Spring and Autumn Annals This classical text, known as *Ch'un Ch'iu* in Chinese, is an account of Chinese history chronicling the feudal state of Lu during the period from 722 to 481 B.C. Orthodox tradition attributed this text to Confucius himself, but modern scholars tend not to accept this. The period covered is often referred to as the Age of the Spring and

Autumn Annals; however, in terms of the history of artistic development, it is more meaningfully referred to as the Late Chou period, since stylistic changes occurring in the art of this time do not coincide with these dates.

Spring Festival Traditional Chinese festival which marks the beginning of the lunar year. The exact date varies, but falls somewhere between the end of January and the beginning of February. It is the day of celebration and family reunions, with large and noisy parties and, usually, a four-day holiday. Houses are decorated with New Year's pictures in the form of colored woodcuts representing the folk deities of traditional China. This event is often represented in Chinese paintings and prints.

Sridevi See Lakshmi.

Ssu A Chinese term to describe a Buddhist monastery, which in some cases may also refer to an Islamic mosque. For example, the White Pagoda Monastery at Ch'ing-chou near Jehol is referred to as Pai-t'a-ssu.

Stag See Deer.

Stele The Greek term stele is often employed to describe the upright stones, decorated with sculptural carvings or engraved inscriptions, which are found frequently in China, and more rarely in Japan. The finest of these are the Buddhist steles of the Six Dynasties period, notably those made during the Northern Wei reign, which usually show scenes from Buddhist legend together with the donors who commissioned the work. It was the custom to use them as memorials to honor the dead, to pay homage to the deitie and to commemorate important events. While the stele of later times are not on such a high artistic level, they nonetheless continue to be used to the present day.

Stone lanterns are frequently found in the temples, cemeteries and gardens of Japan. They vary in size and may be of various types of stone and of different shapes, and may either serve religious purposes or be purely decorative in function. Their original purpose was probably to be lighted in connection with the festival of the dead, a custom that still prevails in some places, but today they are more frequently primarily thought of as picturesque shapes suitable for the decoration of gardens, and are very popular in modern Japan. See also Rankeito, Yukimidoro.

Stone printing A technique of reproduction which preceded woodblock printing and was used in ancient China, particularly for the reproduction of texts which were cut into stone tablets. The characters were engraved into the stone, which was then covered with a black substance from which a rubbing was taken, resulting in the words showing up in white against a black background. See also Rubbing and Woodblock prints.

Stones Stones of all types and sizes, varying from small round pebbles to huge rocks, were much admired in both China and Japan, and were used extensively in the construction of rock gardens. Old, moss-covered stones, and others in picturesque forms, with openings and interesting shapes, were eagerly collected and highly treasured, with special stone markets and shops catering to those who wish to acquire them. Often,

special stones needed for the construction of a garden were brought from distant places and installed with great care by garden architects who had carefully selected them. Among the most highly valued monumental garden stones were those known as t'ai-hu. These have been modeled by water, and are taken from the lake beds of the T'ai-hu and other lakes. Scholars often kept particularly beautiful examples of fantastically shaped stones on their desks, and pieces of auspicious stones, such as jade, were carried around for the beauty of their color, surface and texture.

Stoneware A type of ceramic ware in distinction to the softer earthenware, which is fired at a lower temperature, and the harder porcelain, which is fired at a higher temperature. When the firing of the clay is carried to a point at which it no longer remains porous, but becomes a vitrified mass impervious to liquids, it becomes stoneware. The earliest Chinese stoneware was made during the Late Chou period, and beginning with the Han period, and especially during the Sung period, many of the finest of Chinese wares were stonewares, which, while not possessing the purity and refinement of porcelains, have a strength and simple beauty which many critics greatly admire. In Japan, stoneware was first introduced during the Asuka period, and has continued to be the favorite artistic medium for Japanese potters throughout the history of the Japanese ceramic industry. In particular, the tea masters and their devotees much referred pottery to porcelain on account of its honesty and rustic quality, and many of the greatest Japanese potters worked exclusively in this medium. The borderline between earthenware and stoneware, and between porcelaneous stonework and true porcelain, is difficult to draw, and even experts may disagree at times on how to classify a given piece of Oriental ceramic ware.

Su-chou also spelled Soochow. One of the most ancient and picturesque towns in China, located west of Shanghai in Kiangsi province, in the Yang-tze River basin. It served as the capital of the kingdom of Wu during the Late Chou period, and continued to play a prominent role during subsequent dynasties. However, it was not until the Southern Sung period that it became truly important, and the Venetian traveler Marco Polo extolled its glories and beauty in the account of his Chinese travels. It was a great center of silk production, and during the Ming period it became the center of the painters and literati of the Wu School, among whom Shên Chou was the most outstanding. It is primarily famed today for its magnificent gardens, many of which go back to the Sung period, and the art of Chinese garden design can be studied here better than in any other place.

Su Han-ch'en Chinese painter of the Sung period who was active during the first half of the 12th century. A member of the Imperial Academy of Painting before the fall of the Northern Sung Dynasty, he settled in Hang-chou, where he became a celebrated painter. In his own day he was famous for his Buddhist and Taoist paintings, but he is known today

primarily for his genre scenes, which combine an interesting depiction of the daily life of the China of his day with a charming depiction of Chinese women and children. Several examples of his work have come down to us, among them the "Toy Seller" and "Children at Play in a Garden," in the National Palace Museum in Taipei.

Su Shih See Su Tung-p'o.

Su Tung-p'o Chinese painter of the Sung period who lived from 1036 to 1101. A poet, government official, philosopher and calligrapher in addition to being an artist, he has always been looked upon as the very ideal of a gentleman scholar-painter, of the type the Chinese literati have always admired so much. His painting was largely devoted to the depiction of bamboo, a motif which greatly appealed to him, for the bamboo was thought of as the very essence of the Confucian scholar who bends with the wind but does not break. However, as a true member of the Wên-jên hua, or school of literary man's painting, he felt that the subject matter itself, and the likeness to nature in the depiction of the object represented, was of little consequence, and the quality of the brushwork and the sensibility displayed by the artist were all-important. Good examples of his art are found in the National Palace Museum in Taipei.

Sue Type of prehistoric Japanese pottery made in imitation of the Korean wares of the Silla Dynasty. It is named after the Suebe people, who came from Korea during the 8th century. It is also called Iwaibe, meaning sacred ware, and was used for festivals. It has a hard, grey body, and is sometimes decorated with a greenish natural-ash glaze. All kinds of shapes, such as jars, bottles, dishes, cups and pots, were produced by the Sue potters. However, the most distinctive are the dishes with a high, hollow foot and vessels that have sculptural decorations, in the form of human and animal figures, around their shoulders.

Sugimura Jihei Japanese painter and printmaker of the Edo period who was active during the '80's and '90's of the 17th century. A member of the Ukiyo-e School, he was a chief rival of Moronobu, whose pupil he probably was. He was primarily famous for the erotic work which comprises two-thirds of his entire output. His work is very suggestive and elegant, showing lovers in intimate situations. Although his prints are executed in black and white, they are often hand-colored. His work was popular in his lifetime, but later he was almost forgotten, only to be rediscovered in recent years.

Sui Dynasty A brief but important rule which lasted from 589 to 618. It was primarily important in seeing China united under one emperor again, after centuries of division and strife. It was also significant in being a great age of Buddhism, during which thousands of temples and monasteries were erected and the emperors were great patrons of Buddhist art. Of the surviving artistic monuments, the most notable are the Buddhist sculptures executed in stone or bronze, which are generally thought of as being among the finest ever produced in China.

Suiboku Japanese term for Chinese-style ink painting, first developed

in Sung China and introduced to Japan by the Zen monks during the Late Kamakura period, but only fully developed during the Muromachi period, notably in the 15th century. The term literally means "water and ink." The technique employs black Chinese ink, diluted by water, applied to paper or silk. Its most famous Japanese practitioners were Shubun, Sesshu, the members of the Kano School, notably Motonobu, and the painters of the Bunjinga School. See also Shui-mo, Sumi.

Suijakuga School of Japanese painting which gives visual expression to the idea that the Shinto gods are manifestations of the Buddhist deities. The paintings usually represent one of the famous Shinto shrines, or a symbol standing for the shrine, with the Buddhist deities associated with them hovering over the site. The most characteristic are those representing the Kasuga Shrine in Nura and the Nachi Waterfall. They are also frequently referred to as mandara paintings, since they show assemblies of Buddhist deities, but this term is not applicable, strictly speaking.

Suijin The Shinto god of wells, also called Mizuhanome no Mikoto. He protects wells, and often appears in the form of a serpent.

Suiko Name of a Japanese empress who lived from 554 to 628. The period of Japanese art which is usually referred to today as the Asuka period, lasting from 552 to 645, is also often referred to as the Suiko period. It was a period during which Buddhism and Buddhist art were introduced to Japan, largely due to the efforts of the prince Shotoku Taishi, who was the regent under the empress Suiko. The finest works from this period are preserved today at Horyuji Temple. See also Asuka, Shotoku Taishi, Horyuji.

Sukenobu Japanese painter and printmaker of the Edo period, who was born in 1671 and died in 1751. His family name was Nishikawa. Although he had been trained under Kano and Tosa masters, he was primarily influenced by Moronobu and the Hishikawa School but, unlike these artists, he lived in Kyoto. He is regarded today as one of the most important members of the Ukiyo-e School, and is particularly famous for his illustrated books such as the *Yamato-kiji,* many of them representing courtesans and erotic tales. In addition to his prints and illustrations, he was also known for his genre painting.

Sukhavati Term literally meaning Pure Land; Ching-t'u in Chinese and Jodo in Japanese. It is applied to the paradise of the Buddha Amitabha, which was believed to be located in the western quarter. The souls of the faithful were reborn into his paradise after death. It is frequently represented in the art of both China and Japan, notably in the cave paintings at Tun-huang and in the Japanese mandaras. It is envisaged as a splendid palatial place, where the Buddha, seated on a giant lotus and surrounded by Bodhisattvas, Arhats and apsaras, is preaching to the multitudes of the reborn.

Sumeru pedestal or Shumiza in Japanese. A dais consisting of a base, a box-like column and a top platform. It is usually employed for the

display of Buddhist images, and is intended to represent Mount Sumeru, the center of the universe in Buddhist cosmology. See also Meru.

Sumi Japanese term employed to describe the black ink used for calligraphy and painting. It usually comes in the form of an ink stick which is made by solidfying soot with a kind of glue. Its color is a black which at times, however, tends towards bluish or brownish. It originated in China in very early times, but the earliest ink sticks probably do not date from earlier than the T'ang period. It was introduced into Japan during the Asuka period, where it was employed for both writing and painting. Painting executed in monochrome ink is known as sumi-e, and became popular in Japan in the middle of the Kamakura period. It was particularly favored by the Zen artists of the Muromachi period, during which this kind of painting became the dominant art form. It has continued to be a major medium of artistic expression to the present day. See also Shui-mo, Suiboku.

Sumiyoshi School of Japanese-painting which flourished during the Edo period. It was founded by Jokei who, in 1666, broke away from the traditional Tosa School, of which he had been a member, in order to establish his own school, in Edo, which enjoyed the patronage of the shogunate. It specialized in narrative scrolls, representing genre scenes in the manner of the Yamato-e and Tosa traditions, but was closer in subject matter to the Ukiyo-e School. The most outstanding painter of this school was Jokusan Gulei (1631–1705). Later artists, such as Hiromori and Hirotsura, continued this school right into the 19th century.

Summer Palace of the Chinese emperors Located about twelve miles northwest of the city of Peking in the picturesque mountain scenery of the Western Hills, the Summer Palace, especially during the Ming and Ch'ing Dynasties, became the official residence of the Chinese emperors during the summer months—palaces, temples, monasteries and Mandarin houses were erected here. The first palace at this site was built in 1153 uner the Chin Dynasty, and was called the Garden of Golden Waters, since it was surrounded by beautiful lakes and gardens. It was enlarged during the Yuan period, and a good deal was also added during the Ming and Ch'ing reigns. The lake at this site was renamed several times, being called the Big Lake, the Western Lake and the Western Sea. The most spectacular addition was a Western-style palace, built during the 18th century by the emperor Ch'ien-lung, and known as the Yüan-ming-yüan. Along with the other palaces, it was sacked by European troops in 1860. The gardens were opened to the public in 1924 and were restored in 1949; they now serve as a public park.

Sun The sun plays a very important role in the legend and life of both China and Japan. In China, the sun was looked upon as a great deity and the very essence of the Yang or male principle in creation. It is said that a three-clawed raven inhabited the sun, a motif often represented in art, particularly of the Han period. The ancient character for sun formed a

circle with a dot in the center and it is believed that the pi-shaped jade, now looked upon as a symbol of heaven, may have originally been a solar disc. In Japan, the sun goddess, Amaterasu was the supreme deity in the Shinto pantheon, and was looked upon as the ancestress of the imperial family. Her emblem was a disc-shaped mirror, now preserved in the shrines dedicated to her, notably the Ise Shrine, which was her most sacred sanctuary. In Buddhism, too, the sun was worshipped in the form of a Bodhisattva, who is sometimes represented in the art of China and Japan. The most famous of these images are the bronzesculptures in the Yakushiji Temple in Nara. See Amaterasu, Pi.

Sun bird The bird usually conceived of as a crow or raven is believed to inhabit the sun, and is often represented doing so in Chinese art, especially of the Han period. The bird usually referred to as the phoenix is also thought of as an emblem of the south, sun, and light, and is often represented in this capacity in Chinese wall paintings and relief sculptures, and on mirrors. The idea of associating the solar forces with the sun bird is probably a very ancient one, certainly going back to Shang times, where the pheasant is commonly represented in art, and may indeed be derived from yet older Near Eastern sources.

Sun Chün-tse Chinese painter who was active in Hang-chou during the early 14th century. He was a close follower of Ma Yüan, and his works often show a decorative treatment of buildings and costumes, which produces a pleasing effect; however, they completely lack the expressive qualities so apparent in the painting of the great master. Surviving examples are to be found almost entirely in Japanese collections.

Sun Wei Chinese painter of the Five Dynasties period, who was active during the late 9th century. He was from Chekiang province and worked at Ch'ang-an during the early part of his career. In 880, he followed the imperial court to Shu, where he established a reputation as the finest of the Shu masters. He was commissioned to execute the wall paintings of dragons and water, and secular and divine figures, executed in an intense, bold and vigorous style. However, it was said that in works depicting pine trees, stoves and bamboo, he was also able to demonstrate refined and delicate brushwork. Only one work is attributed to him today, and even that is not generally accepted.

Sung period Lasting from 960 to 1279, the Sung period, while politically and militarily an era of great weakness, during which Chinese emperors first lost control of much of the north of China and ultimately were replaced by the Mongol Yuan Dynasty, was an age of great artistic flourescence, during which painting and ceramics, in particular, attained a height never achieved before or since. Chinese landscape painting of the Sung period, inspired by Taoist philosophy, is thought of by many critics, both Chinese and Western, as the supreme manifestation of the Chinese artistic genius. Sung porcelains are generally thought to be the most ex-

quisite and refined ceramic wares ever made. See entries under painters' names and types of Chinese ceramic ware, also Sung ware.

Sung ware The Sung period, which lasted from 960 to 1279, was a particularly creative one in regard to the production of ceramics. Numerous kiln sites in both northern and southern China produced a large quantity of wares, varying all the way from highly refined porcelains, made exclusively for the imperial court, to coarse stoneware, made for the daily use of the common people. During the earlier Sung period, when the capital was located at K'ai-fêng, the most important kilns were located in northern provinces, notably Hopei, Shansi and Honan, while during the late or Southern Sung period, when the capital was moved to Hang-chou, the most important kilns were located in the southern part of the country. Both the shapes and the decorations of the Sung ware have a classical purity, which critics in both China and the West have admired greatly. In fact, in the eyes of many connoisseurs, Chinese Sung wares are the finest ceramics ever made.

Sung-yüeh-ssu Chinese temple of the Six Dynasties period, located on Mount Sung in Honan, from which a famous early twelve-sided brick pagoda with fifteen stories has survived. It is believed to have been built around 520 and to be the earliest such monument surviving in the Far East today. Its model was probably found in Buddhist India, for it closely resembles the prototypes for such structures in the homeland of all architectural monuments in China.

Surimono Type of small Japanese woodblock prints which were printed on special paper in delicate colors, sometimes employing imitation gold and silver dust, with poems by literary men of the day. They were usually printed in small editions and sent to friends as gifts, rather than being commercially sold on a wide scale. Many of the leading printmakers, such as Shumman, Hokusai and his pupil Hokkei, were well known for their surimono.

Susano-o Shinto storm god whose name literally means the "impetuous male" or the "swift, impetuous deity." He is the brother of the sun goddess Amaterasu, and played a great role in early Shinto mythology. He was banished by his sister from the celestial country and went to Izumo, where he is still worshipped today. He is usually represented as a heavily bearded figure, who may be related to the hairy Ainu. The episode which is the most important in his later life is his defeat of the eight-headed dragon, in whose belly he found the sacred sword which he presented to his sister Amaterasu.

Sutra Sanskrit term literally meaning "thread" or "string," but used today to describe a religious text, primarily one embodying Buddhist doctrines. The sacred sutras were often copied, usually by hand, but sometimes by woodblocks or in the form of rubbings in China and Japan. The finest of these are outstanding works of calligraphy which are admired not only for

their religious, but also for their artistic, significance. The copies were often decorated with painted designs and line drawings illuminating the text. Outstanding examples of such sacred texts have been found in the library at Tun-huang, and other fine examples, some with beautiful illustrations, are to be seen in Japanese temples.

Suzuki Family name of the 18th century Ukiyo-e painter and printmaker Harunobu. See Harunobu.

Suzuribako A Japanese willing-box. The terms, literally translated, mean: suzuri—inkstone, and bako—box. The boxes usually contain an inkstone, a small bowl (mizu-ire) for the water which is used to dilute the ink, trays for brushes, and a lacquer or metal case for the ink. The finest of them are considered major works of art, with those by Koetsu and Korin designated as Japanese National Treasures.

Swatow A Chinese ceramic ware, popular in Japan and the West, which was named after a port city in southern China which played an important role for the export trade during the Ming and Ch'ing periods. Although no pottery was made in the town itself, it was from here that a rough and vigorous porcelain, made up the river at Chao-chou, was exported to Southeast Asia and the Western world.

Swords Swords of all types were employed in both China and Japan throughout their history. The bronze swords of the Shang and Chou periods were often decorated with beautiful ornamental designs of symbolical or abstract patterns, and Japanese swords, especially, were regarded as being far more than mere weapons. In fact, a sword was one of the three sacred treasures of the ancient Shinto faith. However, the true emergence of the sword as the chief attribute of the samurai was a development of the Kamakura period; ever since that time, the Japanese have regarded the swordsmith as foremost among craftsmen. There are no less than 20,000 names of skilled swordsmiths on record, among whom Yoshimitsu Masamune and Yoshihiro are the most famous. Even in modern times, the most celebrated contemporary Japanese swordsmiths have been designated as living cultural treasures of the Japanese nation. Various parts of the sword, especially the swordguards, were artistically ornamented and are widely collected today by Japanese and Westerners. See Daisho, Katana, Tachi, Tsuba, Goto School.

Symbolism Symbolism of all kinds plays a very imortant role in both Chinese and Japanese art. Religious art, in particular, employs a varied and profound symbolism derived from many sources, and exhibits a complex iconography. Best known is the Buddhist symbolism, which is ultimately derived from India, but the Taoists, Confucianists and Shintoists, too, employ many symbols. While the meaning of the various decorative motifs used by the artists of prehistorical China and Japan, and of Shang and Chou China, is not always clear to us, there can be no doubt that this art is symbolical in nature, probably connected with fertility magic. In modern times, the importance of symbolism has diminshed but, especially

in popular art, all kinds of symbols connected with folk religion and magic superstition may still be found. See also Buddha, Taoism. Shinto, and entries under specific motifs.

Szechwan The largest and most populous province of China, located west of the Great Plains and somewhat isolated from the remainder of the country. Its capital is Ch'eng-tu, a town which is regarded as one of the most beautiful in China. Its history goes back some two thousand years, and splendid tomb tiles, with narrative scenes of hunters and harvesters dating from the Late Han period, were found here. Other important works of art from Szechwan province are the Han memorial pillar of the Shên family in Ch'ü-nisch, and the stone chimera from the tome of Kao-i at Ya-chou.

ABCDEFGHIJ KLMNOPQR STUVWXYZ

Ta-chuan or "great seal" script, was a style of writing developed during the Chou Dynasty and used in the inscriptions found on bronze ritual vessels and other subjects of the period. It was invented by a recorder at the Chou court, and described in a book entitled *Fifteen Essays on the Great Seal*. The ta-chuan did not, in fact, differ greatly from th earlier ku-wên (ancient script), but was rather a synthesis of the variants of that style. The most famous examples of this script are the so-called Stone Drum Inscriptions, which were discovered in Shensi province. Countless rubbings of these characters have been made by scholars, in order to be studied and imitated.

Tachi Type of long Japanese sword. The first single-edged sword to be developed by the Japanese, it came into use during the 8th century It was eventually replaced by the katana as a fighting weapon, however, and became a court sword, restricted in use to ceremonial functions. It is worn suspended from the sash by two cords, with the blade edge downward.

Tachi Gasui An early 19th-century lacquer master of Wajima on the Noto peninsula. He had studied painting in Kyoto, but was primarily famous for his lacquers in the chinkinbori technique. It was through his work that the Wajima School of lacquer-making first became known throughout Japan.

Tachibana Miniature shrine dedicated to Lady Tachibana, the consort of the emperor Shomu, which is now in the Kondo of Horyuji Temple in Nara. It represents the Buddha Amida flanked by Kannon and Seishi, on lotuses cast in bronze. It is considered one of the finest examples of early Nara period Buddhist sculpture.

Tahoto A special kind of Japanese Buddhist pagoda, literally "pagoda of many tiers," which was imported from China by the Buddhist priests of the Shingon or Tendai sect. It is ultimately based on the Indian stupa, and consists of a platform from which there arises a domed structure sur-

mounted by a wide roof, with a finial consisting of umbrellas and a precious jewel. The most famous example of such a structure is the Ishiyamadera Pagoda in Otsu near Kyoto, erected in 1154. See also Hoto.

T'ai Chinese term referring to towers built on a high base, and often of considerable height, which form part of a palace complex, such as the Phoenix Tower at the Ch'ien-chang Palace, said to have been 200 Han feet high. They served purely practical as well as magical purposes, and it is said that one such structure was used to communicate with heaven.

T'ai Chi Chinese term for the creative principle, which is thought of as the origin of all things. It is usually represented as a circle divided by a curved line separating it into the Yang and Yin, the male and female elements, which represent the duality underlying all existence. See also Yin and Yang.

Tai Chin Chinese painter of the Ming period who was active during the first half of the 15th century. Little is known about his life, and he enjoyed no great success. In fact, due to attacks by official artists, he was unsuccessful in winning imperial favor and retired to his native Chekiang where he spent most of his life wholly devoted to art. He is much admired today, and is thought of as the founder of the Chê School. His early work was based on that of the Ma-Hsia School, but his mature work introduced a great deal more of the realism characteristic of so much of Ming painting; this quality is evident in the remarkable long handscroll in the Freer Gallery called "Life on the River," which combines vigorous brushwork with the vivid depiction of the activities of the fishermen against a landscape background. He had many followers and imitators, and the Chê School became one of the two leading schools of painting of the Ming period.

T'ai-ho-tien Name of the great front throne hall at the Imperial Palace in Peking, one of the largest and most impressive examples of Chinese palace architecture in existence. It goes back to Ming designs, but the present-day structure is from th Ch'ing period. See also Imperial Palace in Peking.

T'ai Shan One of the most famous and sacred of all the mountains of China, and the highest peak of the Shantung peninsula. From ancient times, this area played an important role in the religious life of China, and numerous temples and monuments are located here even now. It was believed that this mountain was inhabited by spirits of great power, and that T'ai Shan itself was a great deity. Countless prayers were addressed to T'ai Shan itself was a great deity. Countless prayers were addressed to T'ai Shan by the emperors of various dynasties, and are engraved on the stele located there. T'ai Shan was known as the Eastern Peak, and its deity presided over the East, where the sun rises and all life originates. It therefore played a very important role in the life of traditional China. There are no less than 252 temples and monuments in the town of T'ai-an, located at the foot of the mountain. At the peak of the mountain,

which is referred to as the Summit of the Celestial Pillar, there is a temple dedicated to the Taoist deity, the Jade Emperor. An image of this deity containing the inscription "Image of the Jade Sovereign, Emperor of Heaven" is located there is a small shrine.

Tai Sung Chinese painter of the T'ang Dynasty who was active during the 8th century. He served as a magistrate under Han Huang, when the latter was governor of Chekiang, and also studied painting under him. Like his master, Tai Sung was especially skilled in painting rustic marshlands, secular figures such as woodcutters and shepherds, and farmhouses and domesticated animals. He specialized in the depiction of water buffaloes, the most famous example of which is the painting of two fighting buffaloes in the National Palace Museum Collection. His work showed a remarkable technical mastery of ink and brush, and succeeded in capturing the character and movement of his animal subjects.

T'ai-tsung Posthumous name of the first T'ang emperor, Li Shih-min. See Li Shih-min.

Taiga Japanese painter of the Edo period who lived from 1723 to 1776. The artist, whose name was Ikeno, was a native of Kyoto, where he also spent most of his life. He was a distinguished calligrapher and literary man, and a student of Zen Buddhism. He was a fiend of Buson and a member of the Bunjinga, the literary men's school of painting. Like them, he admired, above all, Chinese painting of the Southern School, called Nanga in Japan, and the work of the Eccentric painters of the Early Ch'ing period. His output was large, but uneven. At his best, he is one of the most original and expressive of Japanese painters. His most ambitious works were large screen paintings representing "Sages in a Mountain Retreat," painted for the Henjokoin Temple on Koyasan, and a pair of landscape screens in the Tokyo National Museum. His masterpiece, however, was an album depicting the "Ten Advantages and the Ten Pleasures of Rural Life," on which he collaborated with his friend Buson, and which is now in the Kawabata Collection.

Taira One of the two main military families of Heian period Japan, who are also known as the Heike. The family descended from the Kamma, and were given the name Taira in 889 by the emperor Uda. Their greatest period of power came during the Late Heian period, when, under Taira-no-Kiyomori (1118–1181), they defeated the Minamoto or Genji clan, and became military rulers of the Japanese empire. However, in 1185 they were overthrown by the Minamoto under Yoritomo, and ceased to play an important role. Portraits of the leading figures of the family, and scenes from the war they fought with the Minamoto, are commonly represented in Japanese painting. The most famous of these is the Heiji Monogatari scroll, one roll of which is in the Boston Museum. It was the Taira family that dedicated the illuminated sutras to the Itsukishima Shrine. See also Heike, Itsikushina, Heiji Monogatari, Dan-no-ura.

Taisha Name of a locality in Shimane prefecture, where the Izumo Taisha Shrine, which, together with the Ise Shrine, is the most ancient and sacred of Shinto sanctuary is located. The type of architecture employed in the erection of this building is referred to as Taisha style, and was imitated by many later structures erected to honor the Shinto deities. See Izumo.

Taishakuten Japanese name for the Hindu god Indra. See Indra.

Taizokai Japanese term for the mandara representing the Womb World or Garbhadhatu,, the world of appearances, in contrast to the Diamond World, or the world of ultimate essences, known as Kongokai in Japanese or Vajradhatu in Sanskrit. In its center is a lotus flower with Vairocana seated on it. From the middle of the flower emanate eight petals on which other Buddhas and Bodhisattvas are seated, and surrounding the is a magic diagram representing the world. This scheme is often represented in the sculpture and painting of Japan.

Takanobu Japanese painter of the Heian period who was born in 1142 and is believed to have died in 1205. A nobleman and poet as well as an artist, he came from the Fujiwara family, which was prominent in Kyoto. He was principally known for his portraits, the most famous of which are those of Minamoto Yoritomo and Taira-no-Shigemori in the Jingojo Temple in Kyoto; they are among the most celebrated portrait paintings in the entire pictorial tradition of Japan. They are rendered in the Yamato-e style, and combine vivid characterization of the individual depicted with a fine sense of flat decorative design. He is also said to have collaborated with Mitsunaga in decorating the walls of the Imperial Palace in Heiankyo, as the modern Kyoto was called at that time. His style and artistic tradition were carried on by his son, Fujiwara Nobuzane, who was active during the Kamakura period.

Takarabune Japanese term literally meaning "ship laden with treasures." It is a phantom ship which is said to arrive in Japan on New Year's Eve with a cargo of precious objects, or in Japanese, takaramono. Sometimes the Seven Gods of Happiness are also on board, and it is they who distribute the gifts to the people. Representations of the boat are carried in processions through the streets of Japan on January 1. It is also sometimes represented in art in a humorous fashion. See also Takaramono.

Takaramono Japanese term meaning "precious things," a collection of various objects, each of which has its own emblematical significance for happiness or wealth. They often form the cargo of the ship of good fortune known as takarabune, or are carried in the bag of Hotei, one of the gods of happiness. The objects include items such as the sacred jewels, gold and silver money, bohs of brocade, the cap and cloak of invisibility, etc. They are often represented in Japanese decorative arts. See also Takarabune.

Takatori One of the ceramic kilns located in northern Kyushu in Fukuoka

prefecture. It was well-known for its Korean-style tea wares, which resemble those of the Karatsu kilns. Particularly fine were the water containers and tea bowls of the 17th century, which had heavy forms and were covered with a thick, creamy, whitish glaze. It is also well known for its tea jars, caddies and bowls, covered with a beautiful black-brown or a combination of a white and dark glaze. Its production continued into modern times, but declined markedly during the 19th century.

Takuma School of Japanese Buddhist painting, which flourished during the late Heian and Early Kamakura periods. It reflected the influence of the Sung style in its brushwork. The best known member of the school, and its last prominent exponent, was Takuma Eiga, who lived during the very end of the Kamkura and the beginning of the Muromachi period.

Tama Sanskrit term referring to a precious jewel considered by Buddhists as a symbol of purity which has the power to grant wishes to the faithful. It is often seen represented in Buddhist painting and sculpture; in particular, Jiuzo, the Japanese form of Kshitigarbha, is often shown holding such a precious pearl in his hand.

Tasmagawa Name of a picturesque river in a suburb of Tokyo, maintained today as a recreation park. It was often represented in the print Hiroshige.

Tamamushi-no-Zushi A small Buddhist shrine called the Golden Beetle Miniature Shrine due to the fact that it was originally decorated with multicolored beetle wings. It is kept in the Golden Hall or Kondo of Horyuji Temple, and is considered a national treasure. It originally belong to the empress Suiko, and dates from the 7th century. It is important primarily for its paintings of Buddhist scenes, executed in oil paints on wood, and constituting the earliest Japanese paintings which have survived.

Tamba One of the best-known of traditional Japanese ceramic kilns, located in the Tamba district in the hills north of Osaka. It was established during the Kamakura period, and continues to be active to the present day. It is well known for its coarse, heavy stoneware, usually dark brown, but in later times also white in color, and decorated with different-colored glazes. The wares are usually uitilitarian in character, such as jars, bottles, bowls and dishes, much of the putput falling into the category of folk pottery. However, since the rustic quality of this ware appealed to the tea masters, some of the finer products of the kilns were also used in connection with cha-no-yu.

Tametaka Netsuke carver of the mid-18th century, who lived in Nagoya. He originated an embossing technique for rendering the dress figures, and worked primarily in wood.

Tan-an Japanese painter of the Muromachi period who is believed to have been active c.1500. He was a Zen priest and one of the leading Chinese-style ink painters of his day. Little is known about his life and few of his works have survived.

Tan-e Literally "orange prints." A type of early Ukiyo-e print, popular during the second half of the 17th century. They were colored by hand with an organge-colored red lead pigment. They are very rare today and enjoy great popularity with collectors.

Tanabata Matsuri The popular name for the Star Festival or Hoshi Matsuri, which is now usually celebrated on July 7th. It is particularly popular in Sendai in northern Japan, where it is observed with a great display of parades, floats and gay decorations. It commemorates the union of the cowherd star Kengyu with the weaver star Shokujo, which is believed to take place only one night each year. The custom was to pray to the cowherd for a good harvest and to the weaver for skill in this art. Today, however, it has become merely a joyous occasion on which crowds participate in a summer festival.

Tanaka School of Japanese metalworkers founded by Tanaka Toryusai Kiyonaga, a 19th-century Edo metalworker who was self-taught. He is credited with having introduced the Y-shaped punch, used to roughen the ground for gold overlay. He had many pupils, of whom Morikawa Nagakage was the most outstanding.

T'ang A period in Chinese history and art which lasted from 618 to 906. During this period, China enjoyed great power and prosperity, and the Chinese have always looked upon this as a golden age of their art and literature. It was also during this period that Buddhism achieved its great flourescence in China, although the Buddhist persecutions of the middle of the 9th century led to the destruction of the Buddhist temples and monasteries. The T'ang rulers were great patrons of the arts, and architecutre, sculpture, painting and the decorative arts flourished as never before. While almost no T'ang buildings have survived, and, with the exception of the wall paintings at Tun-huang, few T'ang paintings have come down to us, these, and the existing examples of T'ang sculpture, ceramics, metalwork, lacquer wares and textiles, testify to the brilliant artistic culture of that time.

T'ang grave figures Ceramic figures made in large quantities in order to accompany the dead into the spirit world. Although usually small in scale, they are among the finest sculptures surviving from the T'ang period and represent many aspects of the life of the time. Court ladies, officials, musicians and dancers, merchants—often markedly Near Eastern appearance—horses and camels, as well as buildings, are rendered in both unglazed and glazed pottery. While originally mass-produced with the help of molds, and intended solely for burial, today they enjoy great popularity among both Far Eastern and Western collectors.

T'ang ware The T'ang period, was one of the most productive and creative eras in the history of Chinese ceramics. It was noted especially for the strength and beauty of the ceramic shapes evolved, for the development of colored glazes—notably blue and green ones as well as yellow and brown—and for the perfection of white porcelain. A large number of dif-

ferent shapes—some of them derived from the Near East—were employed, and many different decorations, all the way from one-color glazes to brilliant three-color decorations, some of them with pictorial designs, were employed. While the most original contributions of the age were the porcelains, many of the finest T'ang wares were executed in earthenware decorated in colorful glazes, or in stoneware. The T'ang potters sometimes included designs in low relief, or sculptured handles or spouts.

T'ang Yin Chinese painter of the Ming period who was born in 1470 and died in 1523. A native of Su-chou, he belonged to the same group as Shén Chou and Wén Chéng-ming, and was a calligrapher and poet as well as a painter. His work, however, was rather conventional, based on the manner of the Southern Sung period, but showing far greater detail, meticulousness and realism, in keeping with the spirit of the Ming age. Few genuine examples of his work survive today. An outstanding work by his hand is a scroll, dated 1505 called "Voyage to the South," now in the Freer Gallery, which exemplifies his somewhat labored manner and his interest in realistic detail. He was also a figure painter of note, as is seen in his "Poet and the Courtesan" in the collection of the National Palace Museum in Taipei.

T'ang Ying Director of the imperial porcelain kilns at Ching-tê-chên from 1727 to 1749. It was under his regime that some of the finest of Chinese porcelains were produced both in a modern style including all kinds of monochromes and the famille rose-type wares, and imitations of older Sung and Ming type porcelains. His account of office, descriptions of the process of porcelain manufacture and comments on ceramics are among the most valuable sources for our knowledge of Chinese porcelain manufacture during the Yung-chêng and early Ch'ien-lung periods.

Tange Kenzo Modern Japanese architect who was born in 1913 in Imabari. He was educated first in Hiroshima and then at the Tokyo Imperial University between 1935 and 1938. After that, he worked in the office of the well-known architect Maekawa Kunio and won the first prize in a competition sponsored by the Japanese Institute of Architecture. His first building was a pavilion he erected for the Kobe Fair of 1950, but it was not until 1954 that the began to emerge as a leading architect of postwar Japan. Such works as the Shimizu Town Hall, the Ehime Convention Center at Matsuyama, the Tsuda College Library in Tokyo, the Peace Center in Hiroshima and the Prefectural Hall in Kagawa, all built during th 1950's, established his reputation, first in Japan and then also abroad. A visit to the United States, where he taught for a time at the Massachusetts Institute of Technology, and above all his design for the buildings for the Olympic games of 1964 in Tokyo and bold plans for the rebuilding of Tokyo, brought him to world attention and made him the best-known modern Japanese architect of the present day.

Tanida Chubei Edo lacquer master who was strongly influenced by Chinese-style painted lacquers. He specialized in painting decorations in gold and

colors on a red lacquer ground. He was called by the daimyo of Awa to the island of Shikoku, where he was employed in making lacquers in the Chinese style for this ruler during the middle of the 18th century.

Tanka Term employed for hanging scrolls depicting Buddhist scenes which are used in the religious ceremonies of the Lamaist sect of Buddhism. They are particularly important in Tibet, where they played a central role in the religious and artistic life of the people, but they also occur in China in connection with the Lamaist cult which, especially under Mongol and Manchu patronage, enjoyed a certain popularity.

Tanto A Japanese sword or dagger with a curved blade measuring about 12 inches in length, which was worn by the samurai. It was fitted with a small guard, and the hilt and scabbard were usually mounted with all the fittings used on a full-length sword. It was on these daggers that Japanese artists and lacquer-masters often produced designs showing talent and taste, taking great pains in the execution of the decoration.

Tantra Sanskrit term meaning ''rule'' or ''ritual.'' It is a term connected with a late school of Buddhism which reflects strong Hindu influence and in which esoteric writings and magical formulas play a dominant role. The Tantric deities are often grotesque in form and possess multiple arms, and comprise female as well as male forms. Tantric Buddhism also occurs in China, where it is known as Mi-lo, and in Japan, where it is called Mik-kyo. See Mikkyo and Shingon.

Tanyu Japanese painter of the Edo period who lived from 1602 to 1674. A member of the Kano School, he was the son of Kano Takanobu and the grandson of Kano Eitoku. At the death of his father, he became head of the Kyoto branch of the Kano School, and was the most famous member of the Kano family during the Edo period. At an early age he became court painter to the shogun and, together with his brother Naonobu, decorated the halls of the Nijo Castle, and in the suiboku style based on Chinese models, as interpreted by Japanese painters of the Muromachi period, as is well illustrated by his ''Sages,'' which he painted for the Imperial Palace in Kyoto. At the age of thirty-four he became a monk and, along with the work he did for the shogun, executed many paintings for the monasteries of Kyoto. Although a very skillful and productive artist who enjoyed a great reputation, he is somewhat academic and ultimately a rather eclectic artist.

Tanzakuban Type of Japanese woodblock print in a narrow format, which is usually 38 cm. x 13 cm. or about 15 in. x 5 in. It includes a poem written beside the picture.

Tao A term used in Chinese philosophy to describe the ultimate reality which is the source of all being and permeates all of life. It is particularly emphasized as a philosophical concept in the Taoist philosophy, but the term itself is probably older and is frequently also used in connection with other systems of thought, notably Ch'an Buddhism. Much of Chinese landscape painting is said to represent the eternal tao, and the literature

on Chinese painting often refers to the tao as the very essence of what the artists are striving after. See also Taoism and Lao-tzu.

Tao-chi See Shih't-ao.

T'ao Shuo or *Description of Chinese Pottery and Porcelain,* is a Chinese publication dealing with ceramics written by the 18th-century author Chu Yen. It was published in 1774 and was translated into English by Bushnell in 1910. This work, consisting of six volumes, is one of the chief literary sources for our knowledge of Ch'ing pottery and porcelain. The author was a government official in Chekiang province and had ample opportunity to observe the ceramic production at Ching-tê-chên.

T'ao-t'ieh Chinese term literally meaning "glutton," which was employed by later Chinese authors for the fantastic animal masks decorating the Shang and Chou vessels; however, the explanation that this design was intended as a warning against overindulgence is obviously a late and erroneous interpreation. It is far more likely that the t'ao-t'ieh was actually a tiger mask of magical import, representing one of the great deities of the Shang pantheon.

Taoism One of the three great religions of China, along with Confucianism and Buddhism, and in more recent Chinese popular religion, often combined with them. Originally, however, Taoism was a school of philosphy, believed to have been founded by Lao-tzu during the Late Chou period, which emphasized a mystical, quietistic type of approach to life. Beginning with the Han period, it began to be corrupted and became a popular religion filled with all kinds of superstitions, in which discovering the elixir of immortality and practicing alchemy was far more important than the philosophical and sages are represented in Chinese and, to a lesser extent, in Japanese art. See also Lao-tzu, Tao, Eight Immortals.

Tara Female deity who is believed to represent the feminine energy of the Bodhisattva Avalokitesvara. She is referred to as the Saviour, the Giver of Favor who is filled with mercy and compassion towards all beings. She occurs primarily among the Tantric schools of Buddhism and enjoyed great popularity in Tibetan and Nepalese art. She is shown as a beautiful young woman who forms the counterpart of her male consort.

Tartar sometimes also spelled Tatar. A term employed in Western literature, especially that of earlier times, to describe the nomadic tribes of Central Asia who repeatedly invaded northern China, and at times established foreign dynasties such as the Wei Dynasty, during the Six Dynasties period, and the Chin Dynasty, during the Sung period. Strictly speaking, the Tartars are a Turkish-speaking people inhabiting western Central Asia and parts of Russia, with the bulk of the population forming one of the republics of the Soviet Union. However, the term, ever since medieval times, has also been more loosely applied to the people of Turkic and Mongol stock who, under Genghis Khan, established a great empire stretching all the way from China to Eastern Europe. See also T'o-pa.

Tartar City A term traditionally employed to describe the Inner City of Peking, in contrast to the Outer City. This appellation is derived from the fact that during the Ch'ing Dynasty, the Manchus lived here, while the Chinese lived in the Outer City, which was also known as the Southern City since it was located to the south of both the Forbidden City and the Tartar City. See also Forbidden City.

Tatami Japanese term for the mats used as floor coverings in houses. They are made of rice straw faced with rushes and have a cloth binding at the long ends. They are usually 3 ft. x 6 ft., and Japanese rooms are measured by the tatami length which they have. The custom of covering the entire floor with tatami matting dates from the 15th century, but straw mats of this type were used prior to that.

Tathagata One of the terms applied to the Buddha. See Nyorai.

Tatsuke Chobel One of the leading lacquer artists of the Early Edo period, who worked in a conservative style based on the lacquers of the Higashiyama period. Little is known about his life, other than the fact that he was active in Edo around 1667. A fine writing-box by his hand, decorated with plant designs, is in the National Museum in Tokyo.

Tawaraya Name of a Kyoto establishment of weavers and other artisans, which is primarily famous because the great Early Edo-period painter Sotatsu was associated with it. See Sotatsu.

Tê-hua Town in Fukien province of southern China, where a very pure white porcelain, in the West referred to as blanc de Chine, was made. It flourished particularly in the 17th and 18th centuries, when it became the greatest manufacturing center next to Ching-tê-chên, although it had actually been in operation as early as the Sung period, and had produced both porcelain vessels and figurines with a luminous, warm white glaze during the Ming period. See Blanc de Chine.

Tea ceremony See Cha-no-yu.

Tea Classic See *Ch'a Ching*.

Teiji Netsuke carver of the mid-19th century. Originally a potter, he made unique works by inlaying lacquer ware with clay.

Temmoku Japanese term for the Sung period tea ware known as Chien-yao in China. See Chien ware.

Temple of Heaven Most famous of all surviving Chinese temples, located in the suburbs of Peking and dedicated to the deity Heaven, or T'ien, who was worshipped by the Confucianist Chinese. Originally built during the Ming period in 1420, it was burned down in 1889 and in its present form dates from 1890. Its main structure, the Hall of Annual Prayer, is circular in shape for the symbol of heaven was a circular disc. It stands on a circular platform surrounded by three levels of marble balustrades, with marble staircases leading up to the platform on which the temple is erected. Its most striking feature is a series of three circular roofs which are made of blue tiles. Its interior is 50 ft. high, and is surrounded by

twelve tall columns supporting the upper structure. Several other buildings surround it and gateways lead up to it. Close to it is also the Altar of Heaven, a circular platform where ceremonies honoring the deity Heaven were performed.

Tempyo Term applied to a period of Japanese art, lasting from 710 to 794, which is more commonly referred to today as the Later Nara period. It was an age during which Japan was in close contact with China, and in which the arts reflected very clearly the ideals and artistic style of the T'ang Dynasty. See also Nara and T'ang.

Ten Bamboo Hall Name of a famous album of Chinese colored woodblock prints, whose Chinese name is *Shih-chu-chai shu-hau-p'u,* which literally translated means *Collection of Paintings and Writings from the Ten Bamboo Studio.* The author of the work is Hu Chêng-yen. It was published beginning in 1619, and had many new additions and reprintings in subsequent years. It was intended as a manual for the instruction of painters, and reproduced examples of birds, flowers, fruit, bamboo and garden stones as well as a selection of poetry. In addition to Hu Chêng-yen, several painters, among whom were Kao Yang, Wei Chih-huang and Kao Ya, were instrumental in producing these volumes. It is similar to the *Mustard Seed Garden Painting Manual,* but is on a somewhat higher artistic level, especially as regards the quality of color printing.

Ten Categories of Chinese painting Classification of painting used during the early 12th century in listing the great collection of more than 6,000 scrolls owned by the emperor Hui-tsung, which was known as the collection of the Hsüan Ho Hua P'u. The ten categories are: tao-shih, or Taoist and Buddhist paintings; Jên-wu, or human figures; Kung-shih—palaces and buildings; Fan-tsu—barbarians and foreigners; Lung-yu—dragons and fishes; Shan-shui—landscapes; Ch'u—shou—domestic and wild animals; Hua-niao—flowers and birds; Mo-chu—bamboos; and finally, Su-kuo, or vegetables and fruits.

Ten Disciples of Buddha Group of Buddhist holy men represented as monks with shaven heads and dressed in monks' garments. They are often shown in the art of Japan and also in the art of China, although far fewer examples survive in that country. The most famous set is that coming from the Nara period, which was made originally for Kofukuji Temple in Nara. Another celebrated group of such disciples is the ten woodcut prints made by the modern Japanese artist Munakata.

Tendai Japanese name of a Buddhist sect known in Chinese as T'ien-t'ai. It was introduced to Japan in 805 by the priest Saicho, better known by his posthumous name of Dengyo Dashi. Its center was the Enryakuji monastery on Mount Hiei, northeast of Kyoto. Its emphasis was on the teachings of the Lotus Sutra and the esoteric practices of Mikkyo Buddhism. It inspired a great deal of Buddhist art, notably during the Heian and Kamakura periods.

Tengu Mischievous creatures of Japanese legend who are believed to inhabit the forests and mountains of the Japanese countryside. There are two main types, one with a grotesquely long nose and the other with a bird's beak. In addition, both types are usually shown with wings. Their origin is believed to go back to Buddhism, and it is said that they are related to the garudas of Buddhist legend. Many stories are told about their exploits, which are frequently represented in Japanese art. The most famous examples are the Tengu Scroll of the Kamakura period, and the representations of their activities in Ukiyo-e prints, as well as in lacquer and netsuke designs.

Tenjin Posthumous name of the Heian-period statesman Sugawara no Michizane who, after his death, was elevated to the position of Shinto god of literary men, called Tenjin. See Michizane.

Tennin Japanese term for the heavenly beings known in Sanskrit as apsaras. See Apsara.

Tessai Japanese painter of the modern period who lived from 1836 to 1924. His family name was Tomioka. He was the last great exponent of the typically Japanese tradition of Chinese-style ink painting and, although living into the 20th century and producing much of his best work during the last years of his life, when he was already a very old man, adhered to the ideals of the Nanga or Southern School of Chinese painting. A literary man who was steeped in Confucianist thought and Buddhist philosophy, he remained completely oblivious to the currents of Western thought and European realistic painting which swept Japan during his lifetime. A painter of great power and originality, he is much admired today by both Japanese and Western critics. His output was immense, and he has been frequently imitated. At his best, he is an artist of vigor and individuality. His work was shown in a large exhibition in the United States in 1957, where he was much admired by contemporary Western critics and artists, who felt that it had an affinity to modern Western painting.

Tetsugendo School of Japanese sword-guard artists founded by Okamoto Naoshige, an artist from Choshu who came to Kyoto around 1750, where he studied under Tetsuya Kuniharu of the Nara School. His work, and that of his followers, is almost entirely in iron of a rich brown patina, with figures rendered in bold relief.

Thirty-six Poets Group of famous Japanese poets who are often represented in art. See Sanjurokkasen.

Thirty-six Views of Fuji The most important and famous set of woodblock prints, was made by Hokusai between 1823 and 1829. There are actually forty-six prints in the series, since some extra scenes were added. Made by the artist when he was already in his sixties, this set is regarded by most critics as the culmination of his artistic career. The "Red Fuji," with its striking contrast of the silhouette of the sacred mountain against the sky, and the "Wave," which shows Fuji in the distance, with dramatically

treated waves and fishermen in the foreground, are looked upon as masterpieces of Japanese printmaking. They enjoyed great popularity in 19th-century Europe, where they influenced artists such as Van Gogh and Gauguin. Other scenes in the series are particularly interesting for their depiction of Japanese popular life of the time.

Thousand Buddha Caves or in Chinese, Ch'ien-fo-tung. Name applied to the cave temples located at the most western outpost of Chinese civilization at Tun-huang, due to the innumerable Buddha images which are found there. They are said to have first appeared as a vision to the Monk Lo Tsun. See Tun-huang.

Three-color ware or San-ts'ai, is a type of Chinese stoneware or porcelain which was decorated in three colors, notably turquoise, dark blue and aubergine. However, the number three was not strictly adhered to, and in some examples turquoise glaze is used alone, or additional colors are added. The most characteristic three-color wares were made during the Ming period, and are decorated with thickly applied, bold floral and bird motifs, separated by ridges which perform the same function as do the cloisons in Ming enamels. Shapes which were particularly favored are jars, flower pots, and bowls with strong shapes and richly colored glazes closer in spirit to the T'ang era than the more refined wares of the Sung period. A less characteristic, but more refined type of three-color ware was also made in porcelain, notably at Ching-tê-chên.

Three Kingdoms or San Juo in Chinese. A brief period in Chinese history, lasting from 221 to 265, between the end of the Han and the beginning of the Six Dynasties period. It was a period of strife and turmoil, but due to the fact that it was the subject of a famous cycle of stories, it has become, in Chinese eyes, an age of chivalry and romance. One of the generals of this time, Kuan Yü, has now been canonized as Kuan Ti, the god of war in popular Chinese religion. He is also often represented in the folk sculpture and painting of later China.

Three Sacred Beings or in Chinese, San Ch'ing, are the deities of the Taoist trinity. Supreme among these is the Jade Emperor, Yü Huang. The second sacred being is Tao Chün, who dwells beyond the North Pole and is believed to control the relations of the Yin and Yang. Lao-tzu is the third member of the group. The three figures are represented in art as dignified gentlemen with beards, and are seated on thrones. The concept of a Taoist trinity was apparently introduced to counter the Buddhist trinity of the Buddha and two Bodhisattvas.

Three Sacred Treasures See Sanshu-no-Shinki.

Thunder God In Japanese Shinto mythology the god of thunder was Raiden. See Raiden.

Thunder pattern See Lei-wên.

Ti-tsang Chinese name for the Bodhisattva Kshitigarbha. See Kshitigarbha.

Tiao-ch'i Chinese term for carved lacquers, which were very popular during the Ming and Ch'ing periods. Although they might be made in green,

buff, brown, black or purple, the most popular ones were the red carved lacquers, with elaborate designs taken from mythological and historical subjects or purely decorative floral or landscape motifs. The process of making these was a very difficult and laborious one, sometimes requiring over one hundred coats of lacquer, each of which had to be left to dry, so that the execution of a major piece might take several years.

Tie-dyeing Textile dyeing technique that was first developed in China. It was introduced to Japan, where it was called kokechi, during the Nara period. See Kokechi.

Tien Chinese term used to designate the dots used in ink or color painting to accentuate or more clearly delineate planes and contours. They are also used on rocks and trees to suggest lichens and to represent foliage.

Tien Chinese term usually translated as ''hall'' in English, which refers to the large, rectangular structures, separated by courtyards, that form the temple and palace complexes employed by Chinese architects. They are usually erected in wood on a stone platform, with a large overhanging tile roof which dominates the architectural composition, and are arranged along a north-south axis.

T'ien See Heaven.

T'ien-an mên or Gate of Heavenly Peace, is the largest and most impressive of the many gates found in Peking. It lies south of the Imperial City in the very center of Peking, and is surrounded today by a large square. When the emperor traveled from his palace to the Temple of Heaven, he passed through the gate with great pomp, and when he made a journey, sacrifices were performed in front of the gate. Imperial edicts were let down from the top of the gate. It is a massive stone building, painted purple, with five passages leading through it, surmounted by a wooden structure with a double yellow tile roof. Along the foot of the gate runs the Golden Waters Spring with five bridges leading across it. The square in front of the great gate plays a very important role today in the political life of the People's Republic.

T'ien-lung Shan Buddhist cave temples, located in Shansi province, which are well-known for their magnificent sculptures dating from the Northern Ch'i (520–577) and T'ang (618–906) periods. A large number of stone carvings, representing Buddhas and Bodhisattavas, are found here, carved in a full-bodied and sensuous style which reflects the strong influence from Gupta India which was prevalent at that time. Many of the images have been removed and may now be found in American museums and private collections.

Tiger The tiger plays an important role in the legend and art of both China and Japan. It is one of the twelve animals of the duodenary cycle of the lunar calendar, where it symbolizes strength and courage. It is looked upon as the ruler of the beasts of the earth, in contrast to the dragon, who is the chief animal of the sky. As early as the Shang and Chou eras, the tiger is frequently represented as a decorative emblem on the ritual

bronzes or in sculptural form. In fact, the so-called t'ao-t'ieh motif is widely believed to be, basically, a tiger mask. Tiger headdresses, which were believed to be protective, were worn by ancient Chinese warriors, tigers appeared on banners as emblems of power and valor, and tiger images were embroidered on the court robes of military officers. The tiger was also seen as a symbol of the west and, as such, is often represented in Chinese art, notably that of the Han period. In Buddhist art, the tiger is also sometimes represented, particularly in Zen painting. It is one of the most popular of all motifs in the pictorial and decorative arts of both countries, and many outstanding painters depicted this animal in their works.

Ting Term applied to a shape of Chinese ritual vessel of the Shang and Chou periods. It is a round or rectangular container resting on three or four legs. Its prototype in ceramic form may be found among Neolithic pottery.

Ting Type of Chinese porcelain made in several places, notably at Ting-chou in Hopei province. The ware is a very refined white porcelain with a purity of form and decoration which is rarely matched in any other Chinese wares. The finest of the early Ting wares were produced for the imperial court at K'ai-fêng. After the defeat of the Northern Sung ruler, Ting-type wares were made at Chi-chou in Kiangsi, in southern China. The shapes are usually bowls, dishes, plates, and wine pots, some of which are decorated with molded or engraved designs beneath the glaze.

T'ing Chinese term employed to describe small, open pavilions which are popular in Chinese garden architecture, enabling the visitor to linger and enjoy the view.

T'o-pa Name of a nomad tribe, of Tungusic or Tartar stock, which invaded northern China during the 4th century and established the Wei Dynsasty. In terms of art history, it is particularly notable for its partronage of Buddhist art, with some of the finest surviving Buddhist monuments of the Six Dynasties period being produced under their sponsorship. See also Wei Dynasty.

T'o-t'ai Chinese name for a type of ceramic ware, translated as "bodiless porcelain." See Bodiless porcelain.

Toad The Chinese do not clearly distinguish between toads and frogs. They both play a prominent role in Chinese legend and art. It is believed that a three-legged toad inhabits the moon, and it is thought to be an emblem of good fortune and financial success. However, in ancient Chinese art, the toad and frog were probably primarily connected with water, rain and fertility. Chang-kuo Lao, one of the Eight Immortals of Taoism, is often shown riding on a large toad, and the toad is particularly popular with followers of this religion. While not as frequent a motif in the art of China and Japan as some of the other animals, it is, nevertheless, sometimes represented, and was a favorite motif of the great modern Chinese painter, Shih Pai-chih.

Toba Sojo Japanese painter of the Heian period who lived from 1053 to 1140. He was a monk, under the name of Kakuyu, and became the abbot of Kozanji Monastery near kyoto. The works for which he is famous today are a series of scrolls, representing animal and human caricatures, preserved in the temple with which he was associated. Executed in a very vigorour and fluid style, they make fun of the clergy and people of his time in the guise of rabbits, monkeys, foxes and other animals. Modern scholars have tended to question this attribution, and while some of the earliest paintings of this series, which were painted during the Heian period, may well be by his hand, others, notably the human caricatures, which were executed during the Kamakura period, must have been painted by a later follower. Fragments from these later scrolls may now be found in the Cleveland and Seattle Museums.

Todaiji The largest and most famous of Japanese temples, which is located in Nara and was built between 745 and 752. Although the original building was burned twice, and the present building was constructed in 1709 on a smaller scale than the original, it is still the largest wooden building in the world. Its main icon was a huge image of the Buddha, standing 53 feet high, known as the Daibutsu. Unfortunately, this was damaged during a fire, and presents today only a sad reminder of its original appearance. other famous buildings on the grounds of Todaiji are the Hokkedo, the Shosoin and the great Nandaimon, or South Gate.

Toen A 19th-century netsuke carver who lived from 1820 to 1894. A native of Nara, he was one of the most celebrated of Nara-ningyo makers, and also produced wooden netsuke which were much admired during the Meiji period.

Tofukuji Buddhist temple in Kyoto which was founded in 1236 and erected largely during the 13th century. However, the original buildings were destroyed by fire and were reconstructed in modern times. It contains many masterpieces of Japanese art, such as the sculpture by Jocho—a famous artist of the Heian period—ceiling paintings by Mincho, and works attributed to the great Muromachi painter, Sesshu.

Togan Japanese painter of the Momoyama period who lived from 1547 to 1618. The most prominent of Sesshu's pupils, he called himself Sesshu of the third generation and restored Sesshu's studio in Yamaguchi as his own place of work, and called himself Unkoku after its traditional name. Like Sesshu, he was also employed by the Lord Mori. A conservative artist, using the ink style of the Muromachi period, he nevertheless reflected the tendencies of the Momoyama age by introducing gold and a flatter, more decorative use of shapes and space into his painting. He was the founder of the Unkoku School. Good examples of his work may be found in the Tokyo National Museum and in the Boston Museum of Fine Arts.

Togidashi Term applied to certain kinds of Japanese lacquers, in which the image is painted on the same level with the lacquer ground and then covered with additional, usually black, layers. These top layers are then

rubbed away to make the image appear. This techinique was first employed in the Heian period, and has continued to be popular in subsequent centuries.

Togudo Small structure found on the grounds of Jishoji Temple, where the Silver Pavilion is also located, in which there is an image of Yoshimasa in the garb of a priest. This building is primarily famous for its tiny tea room, measuring no larger than 4½ mats, where the first tea ceremony was performed; this room served as the model for all later tea rooms.

Tohaku Japanese painter of the Momoyama period who lived from 1539 to 1610. A leading artist of his time, he was the founder of the Hasagawa School, which was a rival to the Kano School during that age. He worked both in the ink style of the suiboku tradition, referring to himself as Sesshu of the fifth generation, and, more importantly, in the colorful decorative style so characteristic of the Momoyama period. His masterpieces in the latter style were the magnificent screen paintings representing the flowers of the various seasons, executed in 1592 and now in the Chishakuin in Kyoto. Other outstanding works in this style were the various versions of the bridge at Uji, which, with their bold decorative design pattern and use of rich gold leaf, are among the great masterpieces of Japanese painting. In his ink style, his most outstanding work was, without question, the "Pines and Mist" screen, now in the National Museum in Tokyo. In America, the best works by him are a monkey screen, in a very subtle ink style derived from the work of Much'i, and the versions of the Uji Bridge, rendered in a more characteristically Japanese manner.

Toji or Eastern Temple. Popular name for a Kyoto Buddhist temple whose true name is Kyo-ogokokuji. It was founded in 823 by Kobo Daishi, the famous Buddhist monk and founder of the Shingon sect. The original buildings were largely destroyed during the civil war which raged in Japan during the 15th century, but they were reconstructed later, with the main hall, built under Hideyoshi, being one of the largest structures from the Momoyama period now standing. The five-storied pagoda erected under the third Tokugawa shogun, Iemitsu, is the tallest in Japan. Its collection of Buddhist paintings, sculptures and illustrated books is one of the finest and most extensive in all of Japan.

Tokaido Road leading from the ancient imperial capital of Kyoto to the seat of the Tokugawas in Edo. It was traveled by many Japanese, and is often depicted in art, notably in Hiroshige's celebrated series of the "Fifty-three Stages of the Tokaido Road." See Fifty-three Stages of the Tokaido Road.

Tokoku Netsuke carver of the middle of the 19th century, who lived in Edo. He employed a large number of materials, such as ivory, horn, metal, stone and wood. He enjoyed great popularity and had many pupils.

Tokoname Type of Japanese pottery made in a town of that name located in Aichi prefecture south of Nagoya. An artless folk pottery of crude

stoneware decorated with a natural ash glaze, it is one of the traditional Japanese wares which traces its history to the Heian period. Its best production was during the Kamakura period, when very strong and often aesthetically beautiful large water jars, with a broad mouth decorated with a drip glaze, were produced here. They are much admired today by the chajin and the folk art enthusiasts.

Tokonoma Japanese term for a niche or alcove built into a Japanese room, with the floor elevated a little higher than that of the main room. It is believed that it was originally derived from a priest's private chapel, but is now one of the standard features of a Japanese private house. It is used to display paintings or calligraphy, a flower arrangement, or some bronze or ceramic object.

Tokugawa Name of the most powerful and important daimyo family of feudal Japan, who were undisputed rulers of the Japanese empire between 1615 and 1868. In fact, this period of Japanese history is referred to as the Edo or Tokugawa period. They are descendants of the Minamoto clan, but became prominent only during the 17th century, when Tokugawa Ieyasu succeeded Hideyoshi upon the latter's death. In 1603, Ieyasu became the military dictator of the country, a position that he handed down to this descendants for some 250 years, until the Tokugawa were overthrown during the Meiji Restoration of 1868. The most important artistic monument associated with this family is the great Toshogu shrine at Nikko, dedicated to the spirit of Ieyasu. Also famous are their castles at Edo, now Tokyo, and at Nagoya; the Nijo Palace in Kyoto and numerouis shrines dedicated to the spirits of the Tokugawa rulers. All the arts were partonized by the Tokugawa rulers during their long reign, notably painting and the decorative arts. See also Ieyasu, Nikko and Edo period.

Tokyo Modern name of the ancient city of Edo, meaning Eastern Capital, which has been employed since it became the seat of government of the Japanese nation in 1868. Now the largest city in the world, it was twice destroyed, first in the earthquake of 1923, and then during the bombing of Japan during the Second World War. Because of this, few examples of traditional Japanese architecture may be found there, but it is a great cultural center and contains some of the finest examples of modern Japanese architecture and some of the greatest museums in Japan. See also Edo.

Tomb figures Both the Chinese and the Japanese, especially during the early phases of their civilization, often placed clay figures in or around the tombs of the dead. This custom no doubt arose as a substitute for the burial of the wives, concubines, servants and other attendants which was customary in early times. In China, these figurines, first carved in wood but later made of clay, were interred with the dead, whereas in Japan they were usually placed in a circle around the tumulus or on top of it. The latter were known as haniwa, and were in use during the so-called Grave

Mound period, between the 3rd and 7th centuries A.D. See Haniwa, T'ang grave figures.

Tombs See Grave.

Tomiharui Netsuke carver of the Edo period who lived from 1733 to 1810. He was born in Izumo and studied carving in Edo, but later returned to his native town where he devoted himself to carving, Buddhism, and writing poetry. He used many different signatures such as Seiyodo, Namie, and Iwami.

Tomimoto Kenkichi Leading contemporary Japanese potter who was born in 1886 and died in 1963. He was originally trained as an architect, and spent three years in England, where he took up ceramics instead. His early work was very much influenced by the Korean folk tradition, and used crude shapes and simple abstract designs. As a mature artist, however, he broke with the Mingei tradition and turned to making fine porcelains in the Chinese manner, which are outstanding for their pure white bodies and beautiful painted designs. He was designated as a living cultural treasure of the Japanese nation, and is regarded today as the finest of modern Japanese potters who worked in porcelain.

Tomochika Netsuke carver of the 19th century who was born in 1800 and died in 1873. He lived in Edo, and carved mainly in ivory. He represented many subjects taken from Hokusai's Manga which were remarkable for the uniqueness of their design rather than for their elaborate workmanship. The same name was used by two of his followers known as Tomochika II and III.

Tomokazu Netsuke carver of the early 19th century who was born in Kajimachi in Gifu prefecture but lived largely in Kyoto. He excelled in the carving of animals in the realistic style, usually in boxwood, his specialty being tortoises and monkeys.

Tomotada Early 19th century netsuke carver who was trained in metalworking, but is primarily known for his exquisitely carved wooden netsuke.

Tori Busshi Japanese sculptor of the Asuka period. He is believed to have been active between 605 and 623. He was the grandson of a Chinese immigrant who had come to Japan to introduce Chinese-style Buddhist sculpture. The only work which can be attributed to him with certainty is the gilded bronze Shaka Trinity in Horyuji Temple in Nara. It is believed, however, that other works which are very similar in style were also made by him. He was patronized by the empress Suiko and the prince regent, Shotoku Taishi, who was a great patron of Buddhism. The iconography and style of his work follow Chinese models very closely, and indicate that by the early 6th century, the Japanese sculptors had learned the technique of bronze casting and had mastered the artistic conventions of the religious sculpture of the mainland. How many other works came from his workshop can no longer be determined with certainty, but there can be no doubt that he overted a powerful influence on the development of Japanese religious art.

Torii Japanese term for the gateways leading into Shinto shrines, which consist of two uprights with two horizontal beams above them. In the older shrines, for example those at Ise and Izumo, they are made of plain wood, but some of the later gates are painted a bright red, which is probably the result of Buddhist influence. The most famous of them is the great Torii at the Itsukushima Shrine in Miyajima.

Torii family School of Japanese printmakers who specialized in making billboards for the kabuki theatre and prints portraying famous actors and scenes from the traditional drama, as well as depicting the courtesans of the Yoshiwara district. It was founded by Torii Kiyomoto in the 17th century, and continued by his son, Kiyonobu, and many other masters in subsequent generations. Most of these later artists used the character "Kiyo" in their names; the most illustrious of all ws the late 18th century artist, Kiyonaga.

Tortoise The tortoise or turtle plays a prominent role in Chinese and Japanese legend and art. An ancient Chinese *Record of Science* tells that the turtle lives a thousand years, and it was looked upon, therefore, as a symbol of longevity, strength and endurance. In ancient China, the turtle, together with the snake which was entwined around it, was referred to as the Sombre or Black Warrior, and was believed to preside over the northern quarter, symbolizing cold and winter. It is frequently represented in this role in the painting, sculpture and decorative arts of the Han and later periods. The shell of the tortoise was employed in ancient China for divination. Tortoises are also often shown as supports carrying columns or stele on their back, due to the belief that they would provide a lasting foundation for whatever they were supporting.

Tosa School School of Japanese painting which continued the tradition of Yamato-e right into the modern period. Although it claims its descent from the Heian period, the historical Tosa School only started with the 15th-century painter Tosa Yukihiro, who worked as an official painter at the imperial court in Kyoto. It declined during the later 16th century, but had a resurgence during the Edo period, in connection with the movement to re-emphasize the importance of the imperial institution. The artists of this school used subject matter taken from Japanese history and literature, and employed a colorful and decorative style.

Toshinaga Leading metalworker of the Edo period who lived from 1667 to 1733. He was one of the foremost masters of the Nara School of Edo. He was well-known for the technical refinement of his work and the variety and originality of his designs.

Toshinobu Japanese painter and printmaker of the Edo period who worked from about 1717 to the 1740's. He belonged to the Okamura School, and was a pupil, and perhaps adopted son, of Masanobu. He specialized in small lacquer prints representing actors or courtesans. At his best his work equals that of his master, and is highly regarded among modern collectors.

Toshiro Artist's name of a famous Japanese potter whose true name

was Kato Shirozaemon Kagemasa. He is traditionally credited with having gone to China in 1223, in the retinue of the priest Dogen, and to have stayed there for six years, during which he visited several kiln sites, notably Ch'üan-chou, where Chien ware, or, as the Japanese called it, Temmoku, was made. After his return to Japan, he is said to have settled in Seto and established the Japanese porcelain industry. Modern scholarship has tended to discredit this story and to believe that Toshiro, if he existed at all, lived at a later date. However, there can be no doubt that members of the Kato family worked in Seto for many generations and made a significant contribution to the development of the Japanese ceramic industry.

Toshodaiji Buddhist temple in Nara, founded in 759 by the Chinese priest, Chien-chên, better known by his Japanese name, Ganjin. It is one of the finest examples of Nara-period architecture surviving in Japan today, and has a magnificent sculpture representing its founder which dates from the 8th century.

Toshogu Shrine The mortuary shrine dedicated to Ieyasu, the founder of the Tokugawa Dynasty, located in Nikko, and considered by the Japanese to be one of the outstanding architectural monuments of the country. It was built in accordance with the instructions of Ieyasu himself, but not completed until 1636, twenty years after his death. There was an old Japanese saying, "Never say kekko (magnificent) until you have seen Nikko." The elaborate buildings, gorgeously decorated with intricate carvings and covered with gold leaf, are indeed impressive, but somewhat on the gaudy side for modern taste, which tends to prefer the severe and elegant beauty of the Katsura Palace, built at approximately the same time. The buildings are also surrounded by spacious grounds with magnificent trees and picturesque scenery. A colorful festival is celebrated at the Toshogu Shrine every year on May 17th.

Tou Chinese term for the shape of a ritual bronze vessel chiefly found during the Late Chou period. It takes the form of a spherical bowl on a high stem with a spreading foot. It frequently has a cover as well. Prototypes of this shape may be found among the Neolithic pottery forms of the prehistoric Chinese civilizations.

Tou-ts'ai or, literally, "painting in contrasted colors," is the Chinese term used for a characteristic style of decoration used on porcelains of the Ming and Ch'ing Dynasties. The main parts of the design are outlined in a soft underglaze blue over which shining red, yellow, apple-green and other enamels are then applied in thin translucent washes. The technique was introduced during the Ch'êng-hua period.

Toyo Japanese potter of the contemporary period who lived from 1896 to 1967. He is regarded as the most outstanding of modern Bizen potters, and was honored by being declared a living national treasure. His work follows in the line of the traditional pottery made since the Kamakura period at Imbe, in Okayama prefecture, in the Bizen style, using no glaze,

only the characteristic Bizen reddish-brown clay with a high iron content. His work had a particular appeal for the Japanese tea masters, and is much admired for its subdued elegance.

Toyoharu Japanese painter and printmaker of the Edo period who lived from 1735 to 1814. He studied under Toriyama Sekien, and worked in the Ukiyo-e style. He was important as the founder of the Utagawa School and the teacher of Toyohiro and Toyokuni. As far as his own work is concerned, his most interesting prints were those inspired by Dutch engravings which employed Western-style linear perspective in the portrayal of interiors and landscapes. He was also a painter of note who specialized in the depiction of courtesans.

Toyokuni Japanese painter and printmaker of the Edo period who lived from 1769 to 1825. An Ukiyo-e artist who belonged to the Utagawa School, which had been founded by his teacher, Toyoharu, his subjects were primarily the actors of the kabuki stage, but he also portrayed courtesans and scenes from the Yoshiwara. His fame was great and his influence immense. However, his output, which was large, was extremely uneven. At his best, especially in some of his large triptychs, he is equal to his great contemporaries, men like Utamaro and Kiyonaga, but his later work was produced carelessly, in huge quantities, and is often very inferior. He had many followers, of whom Toyokuni III, better known as Kunisada, is the most famous.

Toyomasa Netsuke carver of the Late Edo period who was born in 1773 and died in 1856. A native of the Tamba district, he was primarily a seal engraver, but as a sideline he also produced wooden netsuke and okimono which were outstanding for their minute carving.

Toyonobu Japanese painter and printmaker of the Edo period who lived from 1717 to 1785. He belonged to the Ukiyo-e School, and played an important role in the development of the color print. His family name was Ishikawa, and he also called himself, during the earlier phase of his career, Nishimura Shigenobu. He was a student of Shigenaga, and specialized in the depiction of female figures. His early work was hand-colored, in the urushi-e technique, but his mature work shows two printed colors—a delicate green and a salmon pink of great subtlety and beauty—and, later, a third color block was added to this. This type of color print was called benizuri-e in Japanese. While not a major master, Toyonobu was an artist of great charm, whose best work is among the most delightful produced during the early phase of the Ukiyo-e prints.

Transcription of Chinese characters A number of systems to transcribe Chinese characters into Western languages have been evolved over the years. The most commonly employed method in the English-speaking world is the Wade system, which is also used in the standard Chinese-English dictionary compiled by Dr. N. Giles. Although the romanization employed by Wade is, in some respects, inconsistent and misleading, it is

used so generally that it seemed best to follow it in this dictionary. Among the letters which need some explanation. these are the most important:

ai = y as in why	ê, ên, êng = short u, as in flung
ao = ow as in how	hs = sh
ch = j as in jam	j = nearly initial r or z
ch' = ch as in church	k = initial g
k' = initial k	t = initial d
ou = long o as in Joseph	t' = initial t
p = initial b	tz = dz
p' = initial p	u = oo as in too
	ü = French "u"

In the People's Republic of China, a new, revised system of romanizing Chinese, known as pin yin, has been developed, modifying the Wade system, and it is, in some ways, more accurate in transcribing the Chinese sounds. The differences between the two systems are as follows:

Wade	Pin Yin	Wade	Pin Yin
p	b	ê	e
p'	p	eh	ê
t	d	êm	er
t'	t	ih	i
k	g	ên	en
k'	k	êng	eng
ch	j	ieh	ie
ch'	q	oen	ian
hs	x	uei, ui	ui
ch	zh	ung	ong
ch'	ch	üeh	üe
j	r	iung	iong
ts, tx	z		
ts', tz'	c		
s,ss,sz	s		

Trinity The concept of the trinity which occurs in many religions, is also found in Buddhism, in the form of the "Three Precious Jewels," a group consisting of the person of the Buddha, the law of the Buddha, and the community of the monks. The Sanskrit term for this concept is Triratna or the Three Holies, while in China, the term San-pao is used to refer to the Three Precious Objects. In Buddhist sculpture and painting, a Buddhist trinity, usually consisting of a central Buddha flanked by two Bodhisattvas, is also often represented.

Tripod Vessels with three legs are commonly found in Chinese art, and already appear in the prehistoric ceramic wares of the Yang-shao and Lung-shan type. They become particularly popular during the Shang and Chou periods, where they are usually executed in bronze and serve for

bringing offerings of food to the spirits. While many tripods take the shape of the li, others of a slightly different shape are referred to as ting or chia. See also Li, Ting and Chia.

Triratna Sanskrit term to describe the three treasures of Buddhism: the person of the Buddha; the Buddhist law, or dharma; and the Buddhist church, or Sangha.

Ts'ai Shên Ts'ai Shên, the god of wealth, occupied an important place in the popular religion of traditional China. He is usually accompanied by two attendants, is worshipped on the 20th day of the 7th moon, and is particularly popular with the poor people and gamblers. His shrine is to be found in nearly every home, and temples dedicated to him are found in every town and village. His worshippers burn sticks of incense before his image. Tradition has it that he is the deified spirit of Pi Kan, a sage of the 12th century B.C. who reproved the last Shang emperor for his wickedness and was executed by having his heart cut out.

Ts'ao Chih-po Chinese painter of the Yuan period who was born in 1272 in Kiangsu province and died in 1355. A close friend of Huang Kung-wang, he followed a similar path, resigning his position as a government official to devote himself to Taoist studies and painting. Although he did not receive much recognition during his lifetime, later critics have placed him on a par with the Four Great Masters of the period. His landscapes show the marked influence, on his style, of Li Ch'êng and Kuo Hsi. One of his favorite motifs consists of two or three gnarled pines or cedars growing on a rocky river bank, with mist-covered mountains appearing in the background. Several fine examples of his work can be found in the National Palace Museum and private Far Eastern collections.

Tsao-ching Architectural term used in China in referring to the coffered ceilings of temples and palaces, made of wood and usually decorated with painted designs. In the case of Buddhist caves, they may be executed in stone, and often have beautiful relief carvings representing the celestial realm.

Ts'ao Pu-hsing Chinese painted of the 3rd century A.D. He is identified by Chang Yen-yüan as one of the earliest painters to demonstrate a definite individual character in his work. He was associated with the court of the prince of Wu, and was renowned for the life like quality of his paintings. Several charming legends are connected with this artist, among them one relating how, in a time of severe drought, a dragon painted by his hand brought on a great storm as though it were the living creature itself.

Ts'ao-shu or grass script, in Japanese called "so." One of the most popular forms of Chinese writing, which is particularly favored for poems and poetic inscriptions on paintings. It was invented during the Han Dynasty. It was, however, fully developed only during the T'ang Dynasty and has continued to enjoy great favor with the literati ever since. It is

marked by a very rapid execution, producing characters of a sketchy, carefree, almost careless appearance. Many of the great masterpieces of Chinese calligraphy are written in this style.

Tseng Yu-ho Modern Chinese painter born in Peking in 1923. She was a pupil of P'u Chin, and was trained in the traditional Chinese manner. However, after leaving her native country in 1949 and settling in Honolulu, she became interested in modern art as well, and evolved a style which represents a fusion of traditional Chinese artistic materials and sensibility with the influence of modern abstract art. She is regarded today as one of the leading modern Chinese artists, and her work is well represented in both public and private collections in America and Europe.

Tso-chuan One of the classics of Chinese literature, which is attributed to a scholar by the name of Tso Shih, but is probably a compendium from a variety of sources, put together around 300 B.C. It is a lively chronicle of the feudal history of Late Chou China, including a commentary on the *Ch'un Ch'iu,* or *Spring and Autumn Anals,* which are traditionally attributed to Confucius.

Tsuba Japanese term for the sword guards, the most important of the fittings of the samurai sword, normally taking the form of a flat disc. They are usually decorated with cutout, inlaid, engraved or raised designs, which are often of great artistic quality. The finest of these tsuba are treasured today among the masterpieces of the art of Japanese metalwork and their makers are among the most celebrated of Japanese craftsmen. The earliest of these were produced in the 15th century, but they can be ultimately traced back to the sword-decorations found in tombs of prehistoric times. There are no less than three thousand makers of such sword-guards whose names have been recorded. They may be divided into some sixty schools, each of which has its own style and technical peculiarities.

Tsuchidu Soetsu Kyoto lacquer master of the middle Edo period who lived from 1660 to 1742. He was a contemporary and follower of Korin. He often worked in lacquer with lead and mother-of-pearl inlay, and was well-known for his beautiful inro. He had several pupils who worked in the same style.

Tsugaru-nuri A technique of Japanese lacquer, named after the town of Tsugaru in Aomori prefecture, in northern Honshu. It consists of a lacquer decoration in several colors, usually green, red, yellow and brown, which are applied to an uneven ground and then rubbed down to reveal a marbled pattern. It is believed that this technique, which appears in Japan in the 18th century, originated in China during the Ming period.

Ts'ui Po Chinese painter of the Sung period who was active during the second half of the 11th century. He was a member of the Imperial Academy of Painting, and decorated many of the palaces and temples in K'ai-fêng. He specialized in the painting of birds and flowers which were much admired by Chinese art critics. They were executed in a meticulous

manner, reflecting the kind of detailed depiction of various kinds of birds, animals, plants and bamboo which was popular during the Northern Sung period. Many works have been attributed to him, but only a few are actually by his own brush. The best of these are now in the National Palace Museum in Taipei.

Tsuishu Literally, "carved lacquer," a term applied to the work of a family of lacquer masters who can be traced back to the Muromachi period. Little is known about the work of the early masters of the school, but the 8th artist in the line, Tsuishu Heijiro, who was known as Choshu, worked for the first Tokugawa shogun, Icyasu, and is said to have died in 1654. The Tsuishu lacquers resemble those of Ming and Early Ch'ing China, using carved designs with red lacquer decoration. The 20th master of this line, who, like his predecessors, called himself Yosei, died in 1952.

Tsuitate Type of Japanese screen which usually had only one panel and resembled the type of screen placed in front of fireplaces in the West. It might be executed on a large scale, and then used to set apart a section of a room, or on a small scale, in which case it was placed in front of the inkstone in order to avoid splashing by drops of ink. While the larger ones were usually executed in wood with cloth or paper, the smaller ones might be made of wood, ivory, porcelain, metal or lacquer.

Tsujigahana A Japanese design technique which was developed during the Muromachi and Momoyama periods. It is a type of tie-dyeing in which a brush is used to paint black lines and colors inside the circles formed by the dyeing process. The hand-painting allowed a certain freedom of expression in the decoration, and the finished products showed a characteristically Japanese elegance and restraint.

Tsun Term applied to a Chinese ritual bronze vessel which is similar to a ku, but broader and heavier. It was probably used for containing wine intended for offerings. The term is also applied to wine vessels in animal or bird form which, instead of taking a vase shape, are more sculptural in character.

Ts'un Chinese term used to designate certain types of brush strokes, in the form of lines and dots, traditionally used by Chinese artists in order to indicate wrinkles, markings and modeling on mountains, rocks, trees and stones in their paintings.

Tsunenobu Japanese painter of the Edo period who lived from 1636 to 1713. He was the son of Kano Naonobu and a pupil, after his father's early death, of his uncle, Kano Tanya. He was one of the most distinguished Kano School painters of the Early Edo period, and was honored by being commissioned to paint a group of sliding screens for the imperial palace. His work reflects the subject matter and style developed by the Kano masters of the early 17th century, but lacks their vitality and expressive power. Many of his works survive, the best example in America being a pair of six-panel screens, representing the seasons, now in the Boston Museum.

Tsung Chinese term to describe jade ritual objects in the form of a square or upright rectangular block which is perforated with a circular tube. The earliest of these occur in prehistoric sites, but the finest date from the Shang and Chou periods. Chinese texts refer to them as symbols of the earth and, along with the pi, which symbolizes heaven, they are often found in tombs and used in ceremonies. Their original meaning is somewhat obscure, but it has been suggested that they might have been female fertility emblems encasing a male phallus.

Tsushima Name of an island, located between the Japanese mainland and Korea, where ceramics were produced during the Edo period. The style of these wares was purely Korean, consisting of pieces of a very fine grey paste, covered with a finely crackled enamel of a creamy white color, under which very simple motifs, such as pine branches, bamboo and plum blossoms, have been drawn in blue.

Tu Fu Chinese poet who lived from 713 to 768. Next to Li Po, he is regarded as the greatest poet of China. Although a close friend of Li Po's, he was a rather different poet, being more scholarly and conventional in his forms and therefore appealing particularly to the literati class of Chinese critics and scholars. His poetry has been translated into English, but has never enjoyed the same widespread popularity among Western readers as that of Li Po.

Tui Chinese term used to designate a roughly spherical bronze vessel, cast in two identical halves. Both the base and the cover are equipped with three lugs, or rings, on which they stand. The tui were, apparently, often decorated with inlaid materials. Vessels of this shape first occurred during the Middle Chou period.

Tun-huang Name of a group of Buddhist caves, also known as the Thousand Buddha Caves, in Kansu province in northwestern China. It is located at the westernmost edge of China, just before the beginning of the roads which lead across the deserts of Central Asia to India and the Near East. The caves were begun during the Six Dynasties period in the 4th century, but the most important ones date from between the 6th and 10th centuries, when Tun-huang was a great center of Buddhist worship. They are primarily famous today for their numerous wall paintings, which are the best-preserved examples of early Chinese Buddhist paintings in existence today. Although beyond doubt provincial works, they nevertheless reflect the kind of pictorial composition and style which would have been found in the Buddhist temples of the cities of China. In addition to the wall paintings, large quantities of painted scrolls and Buddhist texts were recovered in a walled-up library which was discovered by modern scholars. Today there is a Tun-huang Research Institute which studies these works. Some of these scroll paintings may now be seen at the Musée Guimet in Paris, the British Museum in London, and the National Museum of India in New Delhi.

Tung Ch'i-ch'ang Chinese painter of the Ming period who was born in 1555 and died in 1636. A scholar as well as a painter, and an art critic whose ideas exerted a tremendous influence on all later Chinese art criticism, he was a person of considerable erudition and great learning. His approach towards art was an essentially intellectual one; this was also reflected in his own work which, although very skillful, tended to be dry and somewhat stilted. Yet, due to his prominence as a critic, and the esteem the Chinese have always accorded the literati, his paintings have been much admired, and exerted a great influence on later Chinese painting. It was he who was responsible for dividing all Chinese paintings into two major traditions; the Northern one, derived from Li Ssu-hsün of the T'ang Dynasty and Ma Yüan and Hsia Kuei of the Southern Sung period, and the Southern School, derived from Wang Wei, the Northern Sung masters and, above all, the painters of the Yuan period. In his eyes the artists of the Southern School were much more profound in expressions and also preferable for having been gentlemen painters rather than professionals.

Tung-t'ing Island An island in Lake T'ai which is considered one of the beauty spots of China. It is listed as one of the Eight Views of the Hsiao and Hsiang Rivers, a favorite subject among both Chinese and Japanese ink painters.

Tung Wang Kung The Royal Lord of the East, a Taoist deity who presides over the eastern realm of heaven and is consort of Hsi Wang Mu, the Royal Lady of the West. He is believed to reside on the K'un Lun mountains, where trees of precious stones are found and where the Immortals dwell. Both of these deities are frequently represented in the art of China, notably that of the Han Dynasty.

Tung Yüan Chinese painter of the Five Dynasties period who lived from 907 to 960. Although little is known about the artist's life, there can be no doubt that he was considered by his contemporaries, and by the artists of the Sung and Yuan periods, as a great innovator and one of the most outstanding painters of his time. He was especially praised for his rendering of space and atmosphere, and for his profound and beautiful interpretation of mountains and river valleys. While today several paintings are attributed to him, it is unlikely that any of them are actually by the master himself. What confuses the picture we have even more is the fact that the works attributed to him vary greatly in style. Some, like the landscape in the National Palace Museum in Taipei and another in the Palace Museum in Peking, recall the work of the late T'ang period, while the best-known and finest painting attributed to him, the ''Clear Weather in the Valley'' scroll in the Boston Museum, shows a much more advanced and sophisticated style. Be this a work by his hand, as the famous Ming critic Tung Ch'i-ch'ang claims, or not, it is certainly one of the great masterpieces of Chinese landscape painting.

Turfan Site in Sinkiang province of western China where important Buddhist remains, in the form of wall paintings and sculptures, were found. They were executed in a style combining Indian, Central Asian and Chinese characteristics, and are one of our most valuable sources for the study of early Buddhist painting.

Turkestan A term loosely applied to the vast regions of Central Asia traditionally inhabited by nomad people of Turkish and related origin, and therefore referred to as the Land of the Turks. Today much of it is a part of the Soviet Union, but during the Middle Ages it belonged to the Islamic world, and played a significant role in the cultural history of the times. The Chinese first came into contact with it during the Han period, when Chinese armies expanded the power of the empire into Turkestan. While never a part of China itself, this region, during subsequent centuries, was often under Chinese control.

Turquoise Semi-precious hard stone used by the Chinese and especially by the Tibetans, who valued it very highly for ornaments and carvings. In China, snuff bottles were often carved in turquoise, for it was much admired for its beautiful blue color. In Tibet, turquoises were used as propitiatory offerings to the gods and demons, and decorated the thrones and vestments of the kings and lamas. It was considered to be an effective remedy against poison.

Twelve Animals referred to as Shih-erh-shu in Chinese, and Juni-shi in Japanese. In the lunar calendar traditionally employed by the people of Eastern Asia, the twelve years in the duodenary cycle are symbolized by animals, and it is believed that a person born in the year presided over by one of these animals bears its characteristics. The twelve animals employed are the rat, ox, tiger, rabbit or hare, dragon, snake, horse, sheep or goat, monkey, rooster, dog and boar or pig. In accordance with this, the years are referred to as the Year of the Dragon, the Year of the Tiger, the Year of the Sheep, etc., and those who are born under a certain sign are believed to be favored during the years that their emblem occurs. Greeting cards showing the animals of the year are sent out at New Year's, and all of these animals are frequently represented in art. Since the year 1976 is the Year of the Dragon, it follows that the snake would stand for 1977, the horse for 1978, the sheep for 1979, etc.

Twelve Heavenly Generals See Juni-shinsho.

Twelve Ornaments also known as the Twelve Symbols, are mainly associated with the ornamentation of imperial robes, but may sometimes occur alone and in other media, notably porcelain. The ornaments, which are among the most ancient of Chinese symbols, are as follows: the Sun with a three-legged or three-clawed raven in it; the Moon with a hare pounding the elixir of life; the Stars or Constellations; the Mountains; the Dragon; the Pheasant; the Bronze Sacrificial Cups; a spray of Water Weed; grains of Rice; Fire; an Ax; and Fu, meaning bat and good fortune. The Sun, Moon and Constellations are symbols of enlightenment and of heaven;

the Mountains, of protection, and earth. The Dragon, because of its ability to transform itself, symbolizes adaptability, while the Pheasant is associated with literary refinement. Together, they represent animate nature. The Bronze Cups symbolize filial piety; the Water Weed, purity; the Grains, plentiful food for the people; and Fire, brilliance. These last four, together with the Mountains, represent the Five elements: metal, water, fire, plant life and earth. The Axe and Fu symbol are special emblems of the emperor's authority, symbololizing, respectively, the power to punish and the power to judge. Only the emperor was entitled to wear the complete set of Twelve Symbols painted or embroidered on his ceremonial robes. In their unity, the Twelve Ornaments became the symbolic interpretation of the universe.

Tz'u-chou Name of a kiln site in Hopei province of northern China where, over a period of 1,000 years, starting with the Sung Dynasty, utilitarian stonewares decorated with free brush painting were produced. The body of this ware is a buff, heavy stoneware covered with a white slip, on which bold decorative designs are painted or, occasionally, incised or carved. The motifs represented are usually flowers, leaves, fishes or dragons, rendered in a spontaneous style which, at its best, produces drawings of great beauty. The Chinese themselves have not, traditionally, valued these popular wares very highly but, among Western collectors, the Tz'u-chou wares, especially those of the Sung Dynasty, are much admired and eagerly collected. Apparently, similar wares were also made at other kilns, so that it is probably more correct to speak of Tz'u-chou-type wares. There are other types of Tz'u-chou ware which employ a dark brown glaze, often incised with pictorial designs; more rarely, a colored ware painted in red, green and yellow, which is believed to be the forerunner of the Ming colored wares, was produced.

ABCDEFGHIJ KLMNOPQR STUVWXYZ

Uchikake Japanese term for the outer garment, or cloak, worn by a court lady over the kosode as part of the ceremonial costume. It is usually draped loosely over the shoulders and tied about the waist.

Ueno Section of Tokyo which is well known for its park, which contains the National Museum, the Metropolitan Fine Arts Gallery, the Tokyo University of the Arts, Lake Shinobazu with the Benzaiten Temple, and the Toshogu Shrine of Edo. It is often represented in Japanese art.

Uji Town located south of Kyoto where several famous temples are located, the most important of which are the Byodoin, a Buddhist temple which, with its celebrated Phoenix Hall, or Hoodo, containing an image oif Amida by Jocho, is the most famous of all Heian temples, and the Mampukuji Temple, founded in 1659 and built in a wholly Chinese style.

Uki-e Type of Japanese woodblock print which employs Western-style perspective, derived from foreign books which began to reach Japan during the 1720's and 1730's through the port of Nagasaki. The artist primarily responsible for this innovation was Okumura Masanobu, who made this type of print popular during the '30s of the 18th century. At first a mere curiosity, this type of spatial representation influenced all later Japanese landscape prints, notably the work of Hokusai, Hiroshige and Kuniyoshi.

Ukiyo-e School of Japanese painting and woodblock printing, which specialized in the representation of genre scenes, notably those taken from the life of the Yoshiwara district of Edo. The term Ukiyo itself means the "floating world" or "world of pleasure" in contrast to the world of Buddhism. While it was originally a school of painting, it later became primarily famous for its woodcut prints, first executed in black and white, or hand-colored, and later printed in many colors by the use of various blocks. The founder of this school of printing was Moronobu, who worked in the late 17th century, or Early Edo period. The artist who perfected the color print was Harunobu, who was active in the mid-18th

century. The six great masters of Ukiyo-e are usually regarded to be Harunobu, Kiyonaga, Utamaro, Sharaku, Hokusai and Hiroshige.

Ukiyo-ningyo Japanese term to describe the costumed dolls which realistically portrayed the people of the everyday life of Edo, particularly the courtesans, kabuki actors, noh performers and others of Yoshiwara amusement district. The head and hands of the figures were made of wood, while the body might be of either rice straw or wood. The costumes, usually of crepe or brocade, were sewn as miniature garments, or else consisted of small pieces of fabric pasted onto the wooden body.

Umehara Ryuzaburo Japanese painter of the modern period who was born in Kyoto in 1888. He is regarded today as the greatest of all contemporary Western-style Japanese oil painters, and is considered the grand old man of modern Japanese painting. He studied under Renoir in Paris, and his early work clearly reflects his French training. In his later work, however, although he continued to use the oil medium, he attempted to fuse Western artistic ideas with the traditional Japanese sensibility, especially in regard to the use of color and flat decorative patterns. Among his outstanding works are landscapes, usually of the Japanese countryside, but some also portraying scenes observed during his trips to China, others representing nudes and still lifes, all rendered in brilliant colors and in a bold and expressive style.

Umetada A school of Japanese swordsmiths which can be traced back to the Kamakura period. Beginning with the 25th generation of Myoju, who lived from 1558 to 1632, they also began making sword fittings. This school, centered in Kyoto, continued to be active throughout the 19th century. Their work was marked by a skillful combination of chiseling and incrustation.

Unicorn See Ch'i-lin.

Unkei Japanese sculptor of the Kamakura period who was active during the late 12th and early 13th centuries. The son of the famous sculptor Kokei, and father of Tantei Koban and Kosho, he was the founder of the most important school of Japanese Buddhist sculpture. His earliest dated work comes from 1175 and his latest from 1218. He headed a large workshop which produced much of the important religious carving of the Kamakura period, and he himself was the single most famous and outstanding sculptor Japan has produced. His most famous works are the two giant guardian figures at the Great South Gate of Todaiji Temple in Nara, carved in wood jointly with Kaikei, another famous sculptor of the time, and a group of assistants, in 1203. These works exemplify the vigor and expressive power of his best work. Two of his other carvings which are very famous are the portraits of the Buddhist patriarchs Seshin and Mujaku, which he carved for the Kofukuji Temple in Nara in 1208. These pieces illustrate the striking realism which is the other outstanding feature of Kamakura art.

Unkok'i School of Japanese painting founded by Unkoku Togan in the

Momoyama period and continued by his sons, Tooku and Toeki, during the Edo period. Based on the work of Sesshu, of whom Togan regarded himself a follower, his paintings never equaled the work of the older master, and tended to be dull and conventional, continuing to depict the same kind of subject matter in the ink style associated with Sesshu, but lacking his force or creativity. See also Togan.

Urashima Taro Hero of one of the most popular of Japanese legends. It is said that, upon catching a large tortoise, he released it, thereby putting the Dragon King of the Sea in his debt, since the animal was sacred to this deity. He was married to Otohimo, the daughter of the Dragon King, and took up residence beneath the sea. After three years, he wished to return to the world of men to see his family again. His wife presented him with a magic box to ensure his safe return, making him promise not to open it. However, he disobeyed her after returning to his native village, and immediately aged to become an old man of 300 years, the actual time which had passed on earth. Scenes from his adventures are frequently represented in Japanese art, especially in netsuke and lacquer.

Urna Sanskrit term to describe the third eye appearing on the forehead of the Buddha, which symbolizes the fact that the Enlightened One is omniscient and sees all that goes on in the universe. It is sometimes represented by a protuberance, painted as a golden dot, or inlaid with crystal or a precious stone.

Urushi-e Literally "lacquer print," a type of hand-colored early Ukiyo-e print, in which the color is thickened and made glossy with a glue in imitation of a lacquer surface. The technique was especially popular among the early masters of the Tori School.

Ushnisha Protuberance on the head of the Buddha, indicating his superior wisdom. It is one of the thirty-two marks of the Buddha.

Utagawa School of Japanese painters and printmakers of the Edo period. It was founded by Utagawa Toyoharu, who lived from 1735 to 1814. It was one of the leading branches of the Ukiyo-e School of printmaking, to which some of the most distinguished of Japanese printmakers, in the realm of both figure prints and landscape prints, belonged. Among them were Toyohiro, Toyokuni, Hiroshige, Kunisada and Kuniyoshi. See entries under individual artists' names.

Utamaro Japanese painter and printmaker of the Edo period who lived from 1753 to 1806. His family name was Kitagawa. A native of Edo, he was a member of the Ukiyo-e School. His early work was influenced by Kiyonaga, but he soon developed a personal style which was outstanding for the use of close-ups of the faces and busts of the figures. He specialized in the portrayal of beautiful women, a kind of art which is referred to in Japan as bijinga. In the eyes of many critics, his prints of the elegant and sophisticated courtesans of the Yoshiwara district are the finest of all Japanese woodcuts. For beauty of line, color and design, he has few, if any equals, and he enjoyed tremendous popularity both in the Japan of

his day and in the West. In addition to paintings and prints of beautiful women, he also made albums of flowers, birds and fish which are outstanding examples of their artistic genre. His work had a marked influence on later Japanese artists, but he was not equalled by any of his many followers.

Utsutsugawa Kiln site in Nagasazi prefecture, where a type of ceramic ware, belonging to the Karatsu family and influenced by Korean pottery, was produced, beginning with the 17th century. It is particularly known for its painted designs, executed in a white slip and copper green or brown iron glaze, representing flowering trees, plants and fruit. The best of these wares come from the early part of the Edo period.

Uzume Literally "terrible female," the name of the Shinto goddess of mirth, whose complete name is Ame-no-Usume and who is commonly referred to as Okame. According to ancient legend, it was she who, through her comical and lewd dance, lured the sun goddess Amaterasu out of her cave and restored the proper order of nature. She is frequently represented in Japanese popular art, notably in netsuke carving, as a humurous, full-faced and plump figure who, as the goddess of mirth and dance, enjoys considerable popularity.

ABCDEFGHIJ KLMNOPQR STUVWXYZ

Vairocana P'i-lu-fo in Chinese, and Dainichi or Roshana in Japanese. The great Cosmic Buddha, or Great Illuminator, the first of the Five Dhyani Buddhas and the supreme deity in the Tantric or Esoteric Buddhism of China and Japan. He is prominently shown in mandara paintings, and is also frequently represented in sculptural form. His characteristic hand gesture is that of teaching, or the dharmacakra mudra, and, especially in the images of Japan, he is shown with his right hand closed in a fist around the index finger of the left, symbolizing the union of the Diamond World with the Womb World.

Vajra A Sanskrit term applied to an emblem which originally represented a thunderbolt, trident or bundle of arrows connected with storm, thunder, and lightning—the attribute of the sky deity in the ancient Vedic religion of India and many other mythologies. In Buddhism, particularly among the Esoteric Tantric sects, it was interpreted as a diamond, symbol of the absolute and ultimate reality. It is usually a metal object of bronze which is shaped as a short club with one, three, or five prongs at both ends. It is a symbol which represents the indestructible substance which overcomes all others, as the power of the absolute and supreme wisdom overcomes all obstacles in its path.

Vajra Bell The Vajra Bell, in contrast to the Vajra itself, which represented the Diamond World or the World of Ultimate Reality, represented the Womb World or the World of Phenomena. It is a female symbol, as opposed to the Vajra, which is seen as a male emblem. It is said that as the sound of the bell dies away quickly, so the phenomenal world has no permanence. The Vajra Bell is usually made of bronze, and consists of a bell-shape with a Vajra decoration on its top. It plays an important role in the religious ceremonies and rites performed by the Tantric sects of Buddhism.

Vajrapani Shitsu gongojin in Japanese. Literally, the "Thunderbolt Bearer," a Buddhist form of the Hindu god Indra, who is looked upon as one of

the great Dhyani Bodhisattvas. He is usually thought of as a protective deity, rendered as a fierce, muscular warrior who scares off evil forces. The most impressive representation of him is a Japanese one, dating from the Nara period, located in the Hokkedo of Todaiji Temple; made of clay which has been painted, it portrays him as a powerful warrior with a fierce expression, holding a thunderbolt in his hand.

Vara mudra One of the gestures in Buddhist art, symbolizing charity. The arm is lowered with the palm facing the worshipper and the fingers are pointing to the ground.

Vimalakirti Wei-no-chi in Chinese, and Yuima in Japanese. Central figure in a sutra devoted to him, he was a learned layman who became a disciple of the Buddha and conducted a famous debate with Manjusri. He became extremely popular with Chinese and Japanese scholars since he was not a monk, but rather a man of secular learning, and, therefore, he is often represented in Far Eastern Buddhist art. A famous painting depicting him is traditionally attributed to Li Lung-mien, and he is also often shown in sculpture, usually in the course of his debate with Manjusri.

Vishnu One of the great Hindu gods and a member of the Hindu trinity. He is also represented in Buddhist art on occasion, notably in the wall paintings at Tun-huang, but he is primarily a figure associated solely with the Hindu art of India.

ABCDEFGHIJ KLMNOPQR STUVWXYZ

Wabi A Japanese term, employed by the tea masters, which has no exact English equivalent. It describes a quality of rustic simplicity, naturalness and subdued elegance which they valued above all in the objects they used in the cha-no-yu and in the tea houses and gardens in which the tea ceremony was performed. This type of sensitivity, and the use of the term wabi itself, has deeply influenced all of Japanese culture, and has led to an admiration of folk pottery, old rustic buildings, and picturesque moss-covered stones, in contrast to more showy and decorative types of art.

Wade System of transcribing Chinese sounds into English evolved by the 19th-century scholar Sir James Wade, and widely used in the English-speaking world. See Transcription of Chinese characters.

Wakasa-nuri Lacquer technique named after Wakasa, the old name for what is today Fukui perfecture. It resembles the type of marbled lacquer decoration developed at Tsugaru, but it also uses gold and silver foil and emphasizes the yellow and brown tones. The technique was first used in Japan during the Early Edo period, and is said to have been derived from Chinese sources.

Wan-li Chinese emperor of the Ming period who ruled from 1573 to 1620. His tomb, located in the Western Hills outside of Peking, was excavated between 1956 and 1958 bringing to light rich artistic treasures. The term Wan-li, as used today, refers primarily to the kind of porcelains produced at the imperial kilns at Ching-tê-chên during his reign. Most outstanding among them are the blue and white porcelains and the enamel-decorated wares.

Wang-ch'eng Capital of the Eastern Chou Dynasty, located near Lo-yang in Honan province. It was discovered in the 1950s and is now in the process of being excavated.

Wang Chi-chuan Modern Chinese painter who was born in Su-chou in 1907. He studied in Shanghai under Wu Hu-fan. Like so many Chinese

artists of the literati school, he has combined being a painter and calligrapher with being an outstanding collector and expert in the field of Chinese painting. After the establishment of the People's Republic, he left his native country, and has settled in New York, where he has become a well-known figure in the Chinese art world. Under the impact of his American experience, his own work has turned from a purely traditional Chinese style to one aiming at a synthesis between native Chinese traditions and some Western elements.

Wang Chien Chinese painter of the Ch'ing period who lived from 1598 to 1677. He is regarded as one of the six great masters of the Ch'ing Dynasty and one of the four great painters of that period by the name of Wang. An Academic painter who held a high government position, he handled the brush with great skill and showed ability in copying the old masters. However, he brought little that was original to the development of Chinese painting. Good examples of his work may be seen in the National Palace Museum in Taipei.

Wang Fu Chinese painter of the Ming period who lived from 1362 to 1416. A transitional figure between the end of the Yuan and the beginning of the Ming period, he followed in the footsteps of the great Yuan masters and excelled especially in the painting of bamboo. Well known as a calligrapher and poet, he served as a minor official in the Han-lin Academy. He is also known as the teacher of Hsia Ch'ang, the greatest of Ming-period bamboo painters. Good examples of his work may be found in the National Palace Museum in Taipei.

Wang Hsi-chih Chinese calligrapher of the Eastern Chin Dynasty who is believed to have been born c.307 and to have died c.365. A native of K'uai-chi, he held a succession of high military offices during his lifetime. The most famous of all Chinese calligraphers, he was—even in his own time—very highly regarded, particularly for his k'ai-shu, or standard script, and his hsing-shu, or semi-cursive writing. His work gained great prominence during the T'ang Dynasty, when the emperor T'ai-tsung (627–650) became a devoted admirer of his writing and spared no effort to collect works by his hand. His most celebrated work, the "Preface to Poems Composed at the Orchid Pavilion," written in 353, survives only in the form of later copies, the earliest dating from the T'ang period. His style serves as a favorite model for calligraphers to this day.

Wang Hui Chinese painter of the Ch'ing period who lived from 1632 to 1717. He was one of a group of outstanding Early Ch'ing painters by the name of Wang who were known as the Four Wangs of the Ch'ing Dynasty. He was a pupil of Wang Shih-min, and was also very much influenced by the great masters of the Yuan period. His early work is very eclectic but, after mastering the traditional styles of the old masters, he developed a mature style which combined the inspiration he derived from earlier models with the new artistic ideals of the Ch'ing period. He had a great reputation in his own day, and is regarded as one of the outstanding

Academic masters of the 17th century. His output was very large and very uneven; at his best, he is an accomplished, although not highly original, artist. Outstanding examples of his art may be found in the National Palace Museum in Taipei and in the Morse Collection in New York City.

Wang Mêng Chinese painter of the Yuan period who is believed to have been born around 1310 and died in 1385. A grandson of the famous painter Chao Mêng-fu, he is regarded as one of the Four Great Masters of the Yuan Dynasty. Early in life, he held an official position, but later devoted himself entirely to painting. He ended his life in prison, where he was confined for political reasons. He was a powerful and highly original painter, whose brushwork was very forceful and mirrored his own restless personality. Specializing in towering mountain scenes inspired by the painters of the Northern Sung period, he brought to them an expressive quality and intensity which was uniquely his own. Outstanding examples of his work may be found in the National Palace Museum in Taipei.

Wang Mien Chinese painter of the Yuan period who lived from 1335 to 1414. He was particularly famous for his depiction of plum trees, which were represented in a vigorous and spontaneous style. He was also notorious for his eccentric and highly individual behavior. In fact, some Chinese sources report that people thought him quite mad.

Wang Shih-min Chinese painter of the Ch'ing period who lived from 1592 to 1680. He belonged to a group of painters by the name of Wang who are known as the Four Wangs of the Ch'ing Dynasty. Coming from a distinguished family of scholars, he had originally been an official, but he retired when the Manchus came into power. He was a student and follower of Tung Ch'i-ch'ang, and also very much admired the painters of the Yuan period. He developed a style which relied on excellent brushwork, color, and complex pictorial elements, rather than on simple lines and atmospheric effects. He enjoyed a great deal of fame during his own lifetime, and is usually looked upon as one of the outstanding Chinese painters of the 17th century. Good examples of his work may be found in the National Palace Museum and in the collection of C. C. Wang in New York.

Wang-tu A town in Hopei province where, in 1952, two large princely tombs of the Han period were discovered which were important both for their architecture and, especially, for the wall paintings depicting human figures and animals, and the numerous engraved gifts made of pottery, clay, jade and bronze. The paintings are executed in a very vivid, fluent and realistic style, and form one of the most important surviving documents of early Chinese painting.

Wang Wei Chinese painter of the T'ang period who lived from 699 to 759. One of the most famous artists in the entire history of Chinese painting, he is usually looked upon as the originator of monochrome landscape painting and the founder of the Southern School of painting. Although he started his life as an official, and was a dintisguished scholar and poet

as well as a painter, he withdrew from court society, and lived the life of a recluse beneath towering mountains at the side of a river, in a small hut surrounded by trees—a type of existence that was taken up by innumerable other artists in later years. Although there are many references to his work in Chinese texts, and he is always referred to as one of the great masters of Chinese painting, we really do not have a very good idea of what his work looked like. The copies after him which have survived were executed many centuries after his death, and probably give only a very inadequate idea of his art. The two best-known of these works are in the Ogawa Collection in Kyoto and the National Palace Museum in Taipei.

Wang Yüan-ch'i Chinese painter of the Ch'ing period who lived from 1642 to 1715. A grandson and pupil of Wang Shih-min, he is regarded as one of the Four Wangs of the Ch'ing Dynasty. He is well known as a connoisseur and scholar, as well as a painter, and was the keeper of the Imperial Collection under the emperor K'ang-hsi. He published an encyclopedia of painters and calligraphers in one hundred volumes. Although he was profoundly influenced by the painters of the Yuan Dynasty, whom he greatly admired, he nevertheless developed a highly original style, in which the purely formal elements of the landscape and the brushwork itself were far more important than the depiction of nature or the rendering of space and atmosphere, which had played such a great role in older Chinese painting. Outstanding examples of his work may be seen in the National Palace Museum in Taipei.

Warring States period This age, which lasted from 481 to 221 B.C., was the final phase of China's feudal era during which various states were fighting for supremacy, a struggle which was won by the Ch'in Dynasty. In artistic terms, it represents the late phase of the Late Chou period, and is outstanding for its magnificent bronze vessels and beautiful jade carvings, which reflect the more humanistic and decorative spirit of this age.

Water buffalo The water buffalo played a prominent role in Chinese agriculture and is also frequently represented in Chinese art. As early as the Shang period, the water buffalo which, due to its crescent-shaped horns, was probably connected with the lunar forces and fertility, may be found in sculptures and ceremonial vessels. In later Chinese art, the water buffalo forms a popular motif in painting, with the various activities of the animal presented in long narrative scrolls, or with a single figure leading or riding a water buffalo shown in the form of album leaves. Many Chinese painters, notably the Sung painter Li-T'ang, were famous for their depictions of this animal. In Japan, this motif never enjoyed quite the same popularity, but it does occur, especially in Chinese-inspired ink painting.

Waterfall The waterfall as a symbol of the eternal tao, the everlasting change in the universe and the ability of the weakest element to wear down the strongest rock, is a favorite motif in Taoist thought and art.

Some of the most celebrated Chinese landscape paintings feature a water-fall, and hardly any landscape scroll would omit including at least one in the scene depicted. In Japan too, waterfalls played a great role, and deities inhabiting them were venerated by the Shintoists. Famous water-falls, such as that at Nachi, form the subject of celebrated paintings, and Japanese printmakers, including Hokusai, chose waterfalls as the motifs for some of their finest works.

Wei Dynasty The most important of the foreign barbarian dynasties ruling China during much of the Six Dynasties period. The Wei rulers were nomad tribesmen who had come from Central Asia and conquered most of China north of the Yang-tze. They were known as the T'o-pa people, and they were of Tungusic or Tartar stock, but they soon adopted Chinese customs and culture, and became great patrons of Buddhist art. Their rule lasted from A.D. 386 to 557, with the so-called Northern Wei period, from 386 to 532, being the most important. Many of the finest and most typically Chinese works of Buddhist art were produced during this age, notably the cave temples at Yün-kang and Lung-mên.

Wên Ch'ang The principal god of literature in Chinese mythology. His-torically, he is believed to be Chang Ya, who was born during the T'ang Dynasty in what is now Chekiang province but later moved to Szechwan. A brilliant writer in his lifetime, he eventually disappeared suddenly or was killed in battle. He was later canonized and worshipped as a god. A more mythological account of his origins states that Wên Ch'ang was the god of a constellation by that name, forming part of the Great Bear, who came down several times to live among men. It was after the ninth of his existences, when he had been Chang Ya, that the Jade Emperor charged him with the task of distinguishing between good and bad literati. In Chinese art, Wên Ch'ang is depicted as a dignified figure in official dress, wearing a broad-brimmed hat, and either seated on a throne or riding on a mule. He is almost invariably accompanied by K'uei Hsing on his left and Chu I, better known as Red Coat, on his right. See also K'uei Hsing.

Wên Chêng-ming Chinese painter of the Ming period who lived from 1470 to 1559. Early in life he held a position at the Han-lin Academy of Painting, but retired from it in order to devote himself entirely to paint-ing, calligraphy and poetry. He was the very essence of the kind of literati painter who was a scholar as well as an artist, the type the Chinese have always admired so much. He was a student of Shên Chou, and was also profoundly influenced by the artists of the Yuan period. He is looked upon as one of the leading exponents of the Southern School of Chinese painting, and has always been vastly admired by Chinese artists and critics. His brushwork is vigorous yet subtle, his drawing firm and ex-pressive, and at his best he is an artist of great power and sensitivity. He was particularly good in the painting of bamboo, trees and flowers, as well as the more traditional landscapes. Outstanding examples of his work are found in the Honolulu Museum of Art and the National Palace

Museum in Taipei. He was the teacher of his son, Wên Chia, and his nephew, Wên Po-jên, who followed in his footsteps.

Wên-chi Chinese noble lady who was captured by the Tartars in 195 and carried off to Mongolia, where she was forced to marry a chieftain, to whom she bore two children. After twelve years of exile, she was ransomed and was able to return to her native country, but was sad at having to leave her children behind. These events are recounted in eighteen poems traditionally ascribed to Lady Wên-chi herself, and have been the subject of several paintings. The most famous series is the first, dating from the Sung period, which is now in the Boston Museum. A somewhat later version which, although inferior artistically, is more complete, is found in the Metropolitan Museum in New York.

Wên-jên hua or bunjinga in Japanese. Literati painting, or literally "painting executed by men of letters or cultured men." This school of painting played a very important role in both China and Japan, and was closely associated with the so-called Southern School, which emphasized the superiority of the type of painting produced by gentlemen scholars as opposed to that of professional artists who painted for a living. While it is probably primarily a social distinction, indicating that the gentlemen painters of the intelligentsia considered themselves superior to men they regarded as mere artisans, it is also said that their style is a looser, freer one, relying more on the play of ink in contrast to the more detailed and linear manner of the artists of the Northern School, who often worked in color. The first great exponent of the wên-jên hua was Su Tung-p'o (1036–1101), who combined being a leading artist, poet and intellectual.

Wên Po-jên Chinese painter of the Ming period who lived from 1502 to c.1580. He was a nephew of Wên Chêng-ming, and became the most prominent member of his family after the death of his uncle. His work was profoundly influenced by that of the Yuan masters, notably Wang Mêng. He was much admired as a landscape painter, and worked largely in a tall, narrow format, with emphasis on the awe-inspiring, loftly form of the mountains he portrayed. Good examples of his work are found in the National Palace Museum in Taipei.

Wên Shu Chinese artist of the Ming Dynasty who was born in 1595 and died in 1634. She is considered by many to be the second finest woman painter in the history of Chinese art, with only Kuan Tao-shêng of the Yuan Dynasty being more highly regarded. She specialized in painting album leaves of rare flowers and plants, insects and butterflies in a delicate style.

Wên T'ung Chinese painter of the Sung period who lived from c.1020 to 1079. A friend of the Famous poet and artist, Su Tung-p'o, he is usually regarded as the greatest bamboo painter of the Sung period—an artistic genre which has always enjoyed great popularity in China, and in which many outstanding artists specialized. The bamboo was not only admired for its beauty and the delicate pattern formed by its leaves, but was looked

upon as a symbol of the Confucian gentleman who bends with the wind but does not break. In rendering the bamboo, the artist is said to have achieved a freshness and purity which was extraordinary, and to have caught the very essence of the growth and life-quality of the plant. Outstanding examples of his work may be found in the National Palace Museum in Taipei.

Western influence on Chinese and Japanese art The art of China and Japan was profoundly influenced by Buddhism and Buddhist art which, being located to the west of China, constituted a Western, although non-European, influence. However, since Indian Buddhist art, in turn, was strongly influenced in its early forms by Late Classical art, there was already, in this phase of Far Eastern art, a certain Western influence. A more immediate Classical influence was experienced during the T'ang period, when ceramic wares and metalwork showed Late Classical Byzantine and Greek shapes and motifs. In Japan, there was also a marked Western influence during the Momoyama period, when Western pictorial conventions and subject matter were imitated in the Namban art of the late 16th and early 17th centuries. In both countries, there has been a very strong Western influence in modern times, especially in the late 19th and 20th centuries, when the art of both China and Japan, in considerable measure turned to Western styles and aesthetic ideals. This would be particularly true of Chinese art under the People's Republic and Japanese art during the postwar period.

Western Lake The Western Lake, located near Hang-chou in Chekiang province, is one of the most famous of all the beauty spots of China, and has often been represented in Chinese painting and celebrated in Chinese poetry. Its mountain scenery, beautiful trees and flowers, monasteries, pagodas, and towers, not to mention to lake itself, provided picturesque views which were famed throughout the country.

Western Paradise The paradise of the Buddha Amitabha, into which the souls of the blessed are reborn. It is often represented, in both Chinese and Japanese painting, as a splendid celestial realm, in which the Buddha, surrounded by his followers, is seen preaching to the faithful. See Sukhavati.

Westerners in Chinese and Japanese art Both the Chinese and Japanese civilizations, at various times, came into contact with Westerners who, being foreign and exotic people, were represented in the art of the time. In China this was particularly true during the T'ang period, when Ch'ang-an was a truly cosmopolitan city harboring Nestorian Christians, Jews and Mohammedans among its inhabitants. The grave figures of the time often represent figures of Syrian, Armenian, Jewish and Turkish merchants who could be observed in the streets of the T'ang capital. In Japan, where Portuguese and Spanish priests and merchants had arrived during the 16th century, a whole school of art, known as the Namban school, literally meaning "southern barbarian," was devoted to representing these

strange Westerners. In both centuries, in modern times, when the contact with Westerners became closer, Europeans and Americans were frequently represented in all forms of art—in China, most commonly in the decoration of porcelain wares, and in Japan, especially in woodblock prints of the Nagasaki and Yokohama type. See also Namban, Nagasaki prints, Yokohama prints and Export Ware.

Wheel of the Law See Cakra.

Willow The willow is one of the most popular trees in Chinese and Japanese legend and art, and is looked upon as a symbol of melancholy and humility. It was thought of as a very beautiful tree, supple and frail, and therefore became an emblem of the female sex. Chinese poets often talk of the beauties of a willow-like waist, and even in modern China, women are praised for their willowy figures, implying that they are slender and graceful. The willow is a popular motif in Chinese painting, especially of the Sung period, and became a favorite pattern employed by Chinese potters, and copied by English porcelain factories.

Wind god The wind god of Japanese Shinto mythology is Fujin. See Fujin.

Wire line Term often applied to the type of a very even line used in Chinese and Japanese drawing and painting, notably that of the T'ang period. The best examples of this type of drawing are the wall paintings at the Kondo at Horyuji.

Womb World Garbhakoshadhatu in Sanskrit. A term employed to describe the world of appearances or phenomena, in contrast to the world of ultimate reality, the Diamond World. It is often represented in the Buddhist art of the Shingon and Tendai sects of Japanese Buddhism, where it is known as Taizokai. See also Mandara.

Woodblock prints Woodblock printing was used in both China and Japan since early times, when this technique was employed for making Buddhist images. The earliest Chinese examples probably date from the T'ang period, while the earliest Japanese ones come from the Heian age. Their purpose, no doubt, was to make inexpensive reproductions of painted designs which would serve as religious icons and aid the worshippers in their meditations. While the early prints were largely in black and white, some of them were very likely hand-colored, and in China, by the Ming period, and in Japan, during the Edo period, the multicolor print was developed and brought to a high degree of sophistication by the masters of the Ukiyo-e School. In modern times, the woodcut print with a definite political and social message has enjoyed great popularity among the Chinese Communists both before and after the establishment of the People's Republic, and a modern Western-style print, often abstract character, has proven very popular in Japan. See *Ten Bamboo Hall, Mustard Seed Garden,* Ukiyo-e and Hanga.

Writing See Calligraphy.

Wu Chên Chinese painter of the Yuan Dynasty who lived from 1280

to 1354. He is regarded as one of the Four Great Masters of the Yuan Dynasty, and has been much admired by later Chinese critics and artists. During his own lifetime, he was little appreciated and lived the life of a recluse, bartering his paintings as a means of subsistence. His paintings are very simple and restrained, emphasizing the forms of nature and the quality of the brushwork far more than the philosophical and poetic aspects of landscapes, as the Sung masters had done. He was also a distinguished painter of bamboo. Outstanding examples of his works may be seen in the Freer Gallery and the National Palace Museum in Taipei.

Wu Li Chinese painter of the Ch'ing period who lived from 1632 to 1718. He is unique among Chinese painters, not so much for his work, but for having converted to Christianity and becoming a Jesuit priest. However, this in no way affected his painting, based on the artistic concepts of the Yuan and Ming masters and his own teacher, Wang Shih-min. His brushwork is rather dry and uninspired, and he was a conventional Academic painter of the Early Ch'ing period. Although he was considered one of the six great masters of the Ch'ing period, his work is not comparable, in quality or originality, to either the great conventional or the great Eccentric painters of that period. Good examples of his work may be seen in the Cleveland Museum and the National Palace Museum in Taipei.

Wu Liang tombs Famous tombs of the Wu family, dating from the Han period, located near Chia-shiang in Shantung province. The relief carvings which were excavated at this site originally formed the walls of the shrine of Wu Liang, or the Wu Liang-tzu. The low relief compositions decorating the slabs are of great importance for the study of early Chinese painting, for they are drawn from Chinese folklore, history, and Confucianist teaching, and indicate the kind of subjects and the styles of the artists of the second century. Rubbings made from them have been widely distributed, and are major works of art in their own right.

Wu School Name applied to a group of Chinese painters who were active during the late 15th and first half of the 16th centuries at a place by the name of Wu Hsien, in the region of Su-chou in the Yang-tze delta. They were primarily literati who were equally at home in poetry, calligraphy and painting, and came from well-to-do families so that they could paint for their own pleasure and self-expression. The most famous of them was Shên Chou, who is regarded by many as the greatest of all painters of the Ming period. He is usually thought of as the founder of the Wu School. Among his followers, the most celebrated and outstanding was Wên Chêng-ming. Other painters who are associated with the Wu School were Wên Chia, son of Wên Chêng-ming, and his nephew, Wên Po-jên. These artists were looked upon as the very embodiment of the Chinese ideal of gentlemen painters of the Southern School.

Wu-t'ai Shan or Five-terrace Fountain, located in Shansi province in northern China, is one of the most sacred of all Chinese Buddhist centers,

and has been visited by Buddhist pilgrims from all over the country ever since the Six Dynasties period. It rises some 9,483 feet above sea level, and is famed for its beautiful mountain scenery, cool climate and clear springs. It is traditionally believed that the Bodhisattva Manjusri lived and taught here, and it is his worship which is particularly emphasized. The famous Japanese traveler, Ennin, visited this site under the T'ang Dynasty in the 9th century, and described its splendid temples and monasteries in his diary. The Mongols, too, venerated this place, and a large lamasery was erected on the mountaintop. Most of the present-day temples date from the Ming and Ch'ing periods, but many of them are believed to go back to much earlier beginnings.

Wu Tao-tzu Chinese painter of the T'ang period who lived from 699 to 757. He is traditionally regarded by Chinese critics as the greatest of T'ang painters and one of the true giants in the history of Chinese painting, but it is very difficult today to form any clear picture of his style, for none of his original works has survived. According to the records he was, in his lifetime, primarily admired for his Buddhist paintings, which decorated the walls of the great temples in Ch'ang-an and Lo-yang. It is said that he worked in a very vigorous and inspired style, and he was particularly praised for his brushwork. Subjects such as the Buddha, Kuan-yin, Confucius and demons are reported to have been treated by him, but only the faintest of echoes, in the form of stone engravings and very late and poor copies, survive today. It is believed that a sketch of a Bodhisattva painted on hemp cloth in the Shosoin in Nara, Japan, reflects, in a provincial version, the style which he employed.

Wu-ti Chinese emperor of the Han Dynasty who ruled from 141 to 87 B.C. His reign was one of the most glorious of the Han Dynasty, and consolidated Chinese power and prestige. In 136 B.C., he founded the Imperial Academy, in which scholars and officials were trained in the Confucian classics and prepared for careers in the imperial civil service. He also was responsible for sending a mission to the Western regions to establish contact with the nomad tribes of Central Asia. His capital city of Ch'ang-an was one of the largest cities in the world, and boasted magnificent palaces and temples, none of which has survived. Only the rich decorative arts of this time, such as the silks, ceramics, metalwork and lacquers, give some idea of artistic culture under his rule.

Wu-ts'ai See Five-color Ware.

Wu Wei Chinese painter of the Ming period who lived from 1459 to 1508. A member of the Chê School of Chinese painting, he was a follower of Tai Chin and ultimately traces his art back to the Ma-Hsia School of the Southern Sung period. He specialized in the painting of figures, notably sages and scholars seen against a landscape background. Although not a profound or highly original artist, he was a skillful painter who was admired for his excellent brushwork and became a court painter of the Ming Dynasty. Good examples of his work may be found in the National Palace Museum in Taipei and the Boston Museum of Fine Arts.

ABCDEFGHIJ KLMNOPQR STUVWX**YZ**

Ya-hsing Chinese term used for a square shape surrounding an inscription employed on Shang Dynasty ritual vessels. Its name is derived from the fact that the shape resembles the character "ya," but its original meaning is not known. The characters inside the ya-hsing are usually limited to two or three, and may represent a clan name.

Yaki Japanese term, literally meaning "baked wares." It is the generic term employed for all types of ceramics, including earthenware, stoneware and porcelain. It can designate wares made by a certain family, such as Raku-yaki or Raku ware; of a certain type, like Sino-yaki or Shino ware; or coming from a certain locality, for example Kyoto-yaki, meaning ceramics produced in Kyoto. It is used in much the same way that the Chinese term yao is employed.

Yaksha Ancient Indian fertility deity who represented the forces of nature and was the protector of the treasures of the earth. He was taken over into the Buddhist faith, where he and his female counterpart, the Yakshi, play a prominent role as minor deities and are often represented in art. The most famous early examples are those found at the stupas at Bharhut and Sanchi in northern India, but numerous representations of yakshas and yakshis, usually as guardian deities, are also found in Chinese and Japanese art.

Yakshi Female form of Yaksha, a fertility deity frequently rendered in Indian art, notably at Sanchi, as the very incarnation of female beauty and fertility. See Yaksha.

Yakushi Japanese name for the Buddha of Medicine, who in Sanskrit, is called Bhaishajyaguru. He is rarely represented in the art of China, but is often found in Japan, and can be recognized by the medicine jar which he holds in his hand. The most famous example of such a figure is the large bronze in the Yakushiji Temple in Nara.

Yakushiji Japanese Buddhist temple in Nara which was founded in the late 7th century, but which, in its present form, was built on the outskirts of

338

Nara in 718. It is dedicated to Yakushi Buddha, the Buddha of Medicine, as a thank-offering for his having healed the emperor. It is famed for its three-story pagoda and its large bronze trinity representing Yakushi flanked by Gakko and Nikko, the Bodhisattvas of the moon and the sun. It also has a painting of Kichijoten which is one of the early masterpieces of Japanese painting.

Yama or mountain in Japanese. The character, which can also be read san or, in Chinese, shan, is usually employed as a compound, for example: Fujiyama or Fujisan.

Yama-raja Yen-mo-lo-shih, or simply Yen-lo, in Chinese and Emma-o in Japanese. The god of death who, as the reigning deity of the underworld, plays a great role in both Chinese and Japanese Buddhism. He is often represented in Buddhist painting as a fierce-looking high government official, dressed with all the insigna of office and surrounded by his attendants, some of whom are shown as bureaucrats presenting the registers of good and bad deeds of those who appear before him, while others are demonic creatures ready to torture and throw the condemned into the fires of hell. He is also numbered among the Twelve Devas. See Juni-ten.

Yama-uba Japanese term which is the generic name of the aged female creature-spirits who dwell in the mountains. Literally translated, yama means "mountain" and uba means "old woman." They are usually not malevolent, but well disposed towards humans,whom they will guide through the forest. The best-known member of this tribe is the adoptive mother of the Japanese here Kintaro. They are often represented in Japanese decorative arts, particularly in prints, sword guards and netsuke.

Yamada Joka Name of a lacquer master who worked during the Genroku period. He was the founder of a school of lacquer-makers which continued through the 19th century. All of the masters of this school used the name Joka. They were well known for their inro and incense boxes which were decorated in gold lacquer. They also sometimes decorated sword guards and mountings with lacquer.

Yamagoshi Type of Japanese Buddhist painting, which became popular during the Heian period, representing the Buddha Amida appearing with a golden nimbus amidst the mountains of Japan. This type of picture is believed to have originated with the famous Buddhist priest, Genshin, around the year 1000, but the same motif was used by many other artists as well.

Yamato ancient province of Japan, known today as Nara prefecture, which was regarded as the heartland of Japanese civilization, and was the seat of the Japanese court and the location of many of Japan's famous Shinto shrines and Buddhist temples. The most characteristically Japanese school of painting is referred to, therefore, as Yamato-e, and the Japanese people are often referred to as the Yamato race. See Yamato-e.

Yamato-e School of Japanese painting which was believed to be charac-

teristically Japanese, in contrast to Kara-e, the Chinese style of painting. It originated during the 9th century, but began to play an important role only during the Heian period, when some of the most important Japanese paintings, such as the Genju Monogatari Scroll, the Shigisan Engi Scroll, and the Bandninagon Scroll, were painted in this manner. It continued to play a great role during the Kamakura period, notably the 13th century, with many famous paintings of the time, notably the Heiji Monogatari Scroll, executed in this tradition. In contrast to the painters who used Chinese-style ink painting, the Yamato-e artists employed a colorful narrative-type painting, with subjects usually taken from Japanese history, literature and legend, or deities associated with Buddhist temples and Shinto shrines. This tradition was continued by the Tosa School artists of the Muromachi and later ages.

Yamato Kanae Modern Japanese printmaker who lived from 1882 to 1946. He is primarily important as a pioneer in the development of the modern creative Japanese print, known as Hanga. The earliest of these prints was made in 1904, but it was not until he went to Paris, where he lived from 1912 to 1916, and was inspired by modern European prints, that he developed his mature style. In 1918, he established the Japan Creative Print Association, and in 1919 he organized the first Hanga show at a Tokyo department store. However, soon thereafter, he turned to other pursuits and ceased being a major figure in the modern print movement.

Yanagawa One of the most important schools of Japanese metalworking, founded by Yanagawa Naomasa, who lived from 1691 to 1757. He had been a pupil of the Yokoya and Yoshioka Schools, but established his own school in Edo, and had a great many pupils, who in turn established branch schools. The work of the school shows great variety in the materials used, the techniques, and the designs. The subjects are generally taken from the animal and vegetable realm.

Yang See Yin and Yang.

Yang-chou Town located on the Grand Canal in Kiangsu province of southern China, which became a center of intellectual and artistic life during the Ming and Ch'ing periods. The most famous of the artists working here were the so-called Eight Eccentrics of Yang-chou, who were active during the 18th century. They all differed in style and outlook, and were highly individual and independent artists who are usually thought of as the last truly creative masters before the modern period.

Yang Kuei-fei Famous Chinese beauty of the T'ang period who is celebrated in Chinese literature and art as the very ideal of the captivating, beautiful female. The great T'ang emperor, Ming Huang, lost his head over her in his old age, an infatuation which eventually cost him his throne. It was said that she established the norm of feminine beauty as represented in T'ang art, showing a rather plump body, a flat, round, so-called moon face, and heavy black hair made up in an intricate coiffure. Although she gained great power, she was, in the end, strangled by

soldiers, who blamed her for the rebellion of her favorite, An Lushan, and for the plight of the emperor. Many paintings depicting her beauty and her flight have been made throughout the history of Chinese painting, from T'ang to modern times.

Yang Mao Chinese lacquer master of the Late Yuan period, whose work was highly esteemed in Japan, where he was known as Yomo. Judging from the work surviving in Japanese collections, he excelled in carved red lacquers with decorative bird and floral designs, which were apparently produced in a large workshop and exported to Japan.

Yang-shao An archaeological site in Honan province of northern China where, in 1921, the Swedish archaeologist J. G. Andersson and his assistants located many remains of the Neolithic period, notably magnificent large earthenware jars decorated with painted designs. While such Neolithic wares have been found at many other locations as well, the term Yang-shao ware is now applied as a generic term to describe this type of painted red ware, which was made as far west as Kansu during the prehistoric period. Recent excavations conducted by Chinese archaeologists, notably at Pan-p'o in Shensi, suggest that this pottery culture was very ancient and widespread, probably originating during the 5th millennium and continuing to the beginning of the Bronze Age during the Shang period. The Yang-shao pottery is outstanding not only for the robustness and beauty of its shape, but also for its painted designs, consisting of spirals, gourds, flowers, leaves, circles, triangles, and wavy and other kinds of linear designs, and, more rarely, stylized human and animal figures, all of which were, no doubt, symbolical in meaning. Many of these bear a striking resemblance to the Neolithic pottery of Central and Western Asis and Eastern Europe.

Yang-ts'ai See Famille rose.

Yao Chinese word meaning "ware," which is the generic term employed for all types of ceramics, including earthenware, stoneware and porcelain. The term is usually employed in conjunction with a placename or type of ware, such as Tz'u-chou yao or San-ts'ai Yao. See also Yaki.

Yao Legendary figure of Chinese mythology. He is said to have been one of the early rulers of China, and apparently was born of the union between a dragon and a woman.

Yasuchika One of the leading sword-guard makers of the Nara School, who lived from 1670 to 1744. His family name was Tsuchiya, and he was also known by the name Tou. He was first a pupil of a Shoami master of Shonai in Dewa, but later went to Edo and studied under Tokimasa Chuzaemon of the Nara School. He was noted for the decorative effect of his designs, which treated a great variety of subjects, especially animals, birds and scenes from legends.

Yasui Sotaro Modern Japanese painter who lived from 1888 to 1955. Regarded as one of the leading modern Japanese Western-style painters, he studied in Paris, in 1907, and was greatly influenced by the French

painters of the post-Impressionist school, notably Cézanne. His style is colorful, bold and decorative, in keeping with the tenets of modern European art, but also has a certain Japanese flavor. He was particularly outstanding for his portraits and landscape paintings.

Yasuyuki Japanese enamel artist of the Meiji period who lived from 1848 to 1927. His family name was Namikawsa. Working in Kyoto, he founded one of the three schools of enameling that developed in the latter part of the 19th century. The Kyoto school of Naimawa has become renowned for the beauty of the elegant and harmonious decoration which usually covers the entire surface of its pieces, as well as for its unequalled technical accomplishments. It was Namikawa Yasuyuki who first developed a process for creating transparent cloisonné. He also worked with Namikawa Sosuke in Tokyo to produce the first wireless cloisonné.

Yatsubashi A legendary bridge of eight planks placed in a zigzag arrangement over a bed of irises, which is said to have existed in Mikawa province and is celebrated in the *Tale of Ise*. It was often depicted in Japanese art, especially in the work of Korin and his school, and was a favorite subject for the lacquer makers of the Edo period. Bridges of this type have been built in other sections of Japan as well, and are represented in woodblock prints, notably those of Hokusai.

Yatsushiro Ceramic ware produced at a kiln site of that name in Kumamoto prefecture. It was originally founded by Agano potters from northern Kyushu, but soon developed its own artistic style. It was noted for its Korean-style ceramics of the Mishima type, which were decorated in white inlay against a grey ground. The designs, representing flying storks and floral patterns, are often of great beauty and elegance, resembling those of the Korean potters and equalling them in quality. The finest are from the Middle Edo period or the 18th century, the later wares being somewhat hard and dry. The early Yatsushiro ware, a celadon prized by tea devotees, is sometimes referred to as Unkaku ware.

Yayoi Type of prehistoric Japanese pottery named after a district of Tokyo where the first such wares were excavated. The term itself is employed today to describe an entire period of Japanese culture which extended from about the 2nd century B.C. to the 2nd century A.D. The ceramic ware is a reddish or sometimes yellowish earthenware, produced with the help of a potter's wheel, and fired at a much higher temperature than had been employed in the Jomon ware which preceded it. It was probably derived from the prehistoric wares of Korea to which it bears a marked resemblance. The shapes are varied and utilitarian in character. Their surface is sometimes decorated with incised geometric design patterns. At their best, they have an elegance and beauty which has made them popular with modern collectors.

Yedo Old-fashioned way of spelling Edo, particularly in Meiji-period literature. See Edo.

Yellow Emperor See Huang-ti.

Yellow River See Huang Ho.

Yen One of the dukedoms of the feudal period of Chinese history. It comprised the region around Peking which Is Hopei province today, and was known as Chihli in earlier times. Its capital, located at I-hsien, has been discovered in recent years. The excavations undertaken there have brought to light the remains of an ancient city and works of art dating from the Late Chou period.

Yen Chên-ch'ing Chinese calligrapher of the T'ang Dynasty who was born in 709 and died in 785. A statesman and high military official by profession, he developed a reputation for his extensive learning and great skill as a calligrapher. His k'ai-shu style represented a radical departure from the elegant, slender strokes created by Wang Hsi-chih, and instead made use of broad, strong, rigid and energetic strokes. He is recognized as one of the finest masters of both the k'ai-shu and ts'ao-shu styles of writing, and has exercised an enormous influence on later calligraphers. To this day, his k'ai-shu is one of the primary models used in the training of young calligraphers.

Yen Hui Chinese painter of the Yuan period who flourished during the first half of the 14th century. He was primarily a painter of Buddhist and Taoist subjects, which were executed in a very expressive and highly original style, often employing grotesque imagery. Little is recorded about him in Chinese artistic literature. He is primarily known today for his religious paintings preserved in Japanese collections. There is also an interesting painting by him, representing Chung K'uei, in the Cleveland Museum.

Yen Li-pên Chinese painter of the T'ang period who died in 673. He was celebrated as a court painter, and came from an artistic family; his father and brother were both painters of note. He rose to a high position in the court hierarchy, occupying the offices of Senior Secretary of the Peerage Bureau, Grand Architect, and President of the Board of Works, and was finally, in 666, made a state minister. As a painter, he was particularly admired for his portraits, but he is also known to have painted Buddhist subjects. His most famous surviving work is the Emperor Scroll in the Boston Museum, which depicts the Chinese emperors from the Han through the Sui periods. It is believed that only part of the painting is by the master himself, with the rest being a later copy painted by a lesser artist of the Sung period. The style of the picture is realistic, employing a firm and even line, a variety of colors, and some shading, in keeping with artistic conventions of the T'ang period.

Yen Tz'u-p'ing Chinese painter of the Sung period who was active during the latter part of the 12th century. He was the son of the painter, Yen Chung, one of the old members of Hui-tsung's Academy who had reestablished himself in the Hang-chou. Yen Tz'u-p'ing entered the Academy in the Lung-hsing era (1163–1164), and received several awards. He painted mainly landscapes, in a manner similar to that of Li T'ang,

but also represented water buffaloes, following in his father's tradition. A good example of his work is a large landscape showing innovations in composition and the treatment of the mountains, now in the collection of the National Palace Museum.

Yen Wên-kuei Chinese painter of the Sung period who was active during the late 10th and early 11th centuries. He is regarded as one of the great masters of early Chinese landscape painting; unfortunately, however, no works which can with certainty be attributed to him have survived. A hanging scroll depicting temples amid mountains and streams, now in the National Palace Museum in Taipei, is traditionally ascribed to him, but is probably, at best, a later work reflecting his style.

Yi Alternate transliteration of the character which is usually spelled "i" in Western literature. See I.

Yi-hsing See I-hsing.

Yin Name of a place on the banks of the Huan River in northern Honan province, in what is known today as the An-yang district, where the capital of the later Shang Dynasty was established. For this reason, the Shang period is also referred to, in some of the older writings, as the Shang-Yin period or the Yin period, but this is neither strictly accurate nor widely used any longer.

Yin and Yang The Chinese, ever since ancient times, have seen two basic principles at work in the universe: yang, the masculine, active principle, representing light and heaven, and yin, the female, passive one, representing darkness and earth. It is the interrelationship between these two principles which, in the eyes of the Chinese, makes life possible, with the two complementing each other and being essential to one another. This principle of the dual forces controlling the universe is symbolized by a circle equally divided by a curved line, and by the worship of the two supreme dieties, of heaven and of earth, whose temples and altars were found throughout China.

Yin-t'o-lo Chinese painter of Indian origin who was active in the second half of the 13th century. A monk who worked in the Ch'an tradition, he lived in temples near K'an-fêng and Hang-chou after coming to China. His paintings, mostly of eccentric Buddhist figures, were executed in the characteristic, untrammeled ink style of the Ch'an painters, and almost always had some symbolic and didactic significance. Several examples of his work survive in Japanese collections.

Ying-ch'ing ware See Ch'ing-pai.

Ying-tsao Fa Shih Chinese manual on architecture, written by the state architect, Li Chiai, in 1100. It has survived in several manuscript copies made from a printed edition of 1145, and also exists in a handsome modern reprint which is illustrated with many pictures. It is an important source for our knowledge of Chinese architectural practices of the Sung period, and is filled with technical information.

Ying Yü-chien See Yü-chien.

Yokohama Port city located near Tokyo on the west side of Tokyo Bay. It

was a small fishing village with merely eighty-seven houses when Commodore Perry landed there to deliver a letter from the President of the United States to the ruler of Japan. But after it was opened to foreign residence in 1859, it grew into an important port, and was the center of trade with the Western world. However, most of the old buildings were destroyed during the great earthquake of 1923 and the bombing of 1945, so that the best picture of Meiji-period Yokohama can be gained from Yokohama prints showing the exotic foreigners and the Western-style buildings. See Yokohama prints.

Yokohama prints Type of Japanese print which came into existence in the Meiji period. They specialized in depicting scenes from the port city of Yokohama, which seemed exotic to the Japanese with the many foreigners, the Western-style buildings, railroads, steam engines, and Japanese dressed in modern Western clothing. While neglected for a long time, these prints have been, in recent years, discovered to be one of the most interesting artistic documents of late 19th-century Japan, and are now eagerly collected in both Japan and the West.

Yokoya School of Japanese sword-guard makers founded by Yokoya Soyo, who lived from 1633 to 1691. He worked at the court of the shogun in Edo in the classic Goto style. It was not really until his successor, Somin, that the Yokoya style was developed, establishing the Yokoya School as an independent artistic entity. Somin introduced a new engraving technique, known as katakiri-bori, which imitated brushstrokes. In the work of the Yokoya School, this technique was usually applied to designs inspired by Ukiyo-e drawings.

Yokoyama Taikan Japanese painter of the modern period who lived from 1868 to 1959. Trained by Gaho, and greatly influenced by Okakura, the famous Meiji-period art critic, he became one of the leading Japanese-style painters of the modern period. A prolific artist, who lived a very long and creative life, he was much admired by his contemporaries, and played a prominent role in the artistic life of modern Japan. His work is rather uneven, but the best of it, as represented by a long landscape scroll executed in ink, carries on the suiboku tradition of Japanese painting with remarkable vigor.

Yomeimon Literally, "Gate of Sunlight," the main gate of the Toshogu Shrine at Nikko, which is the most elaborately carved gate in all of Japan and has been designated a national treasure. A two-storied structure with twelve columns, and gables at the ends and sides, it is decorated with hundreds of wooden sculptures, representing animals, birds, monkeys, flowers and legendary Chinese figures, which are painted in bright colors or gilded Particularly strking are the numerous carvings of dragons, which were believed to have an auspicious character and were associated with the emperor, clouds, rain and fertility. This monument was greatly admired during the 19th century, but its intricate carving and gaudy coloring do not generally appeal to contemporary artistic taste. See Toshogu.

Yomo Japanese reading of Yang Mao. See Yang Mao.

Yoritomo One of the leading military figures and statesmen of Japan, who lived from 1147 to 1199. The most illustrious member of the Minamoto family, he estalbished the Kamakura regime in 1185, moving the seat of government from Kyoto to the seaside town of Kamakura, not far from present day Tokyo. A portrait of him attributed to Takanobu has come down to us, and episodes from his life and military campaigns are often represented in Japanese painting. See Kamakura and Minamoto.

Yosakura-nuri Japanese lacquer technique that employs a dark, transparent lacquer, beneath which a painting of cherry blossoms, or sakura, is dimly visible. This type of decoration was the specialty of a Kyoto lacquer artist name Nakamura Sotetsu, who lived from 1617 to 1695.

Yosei Artist's name adopted by the lacquer masters of the Tsuishu family, which was derived from the Japanese reading of the names of the two most famous Chinese lacquer artists—Yang Mao, who in Japanese is called Yomo, and Chang Ch'êng, known as Chosei in Japan. It was first used by the 17th-century artist Heijiro, and all subsequent members of that school continued the tradition.

Yoshimasa One of the outstanding figures of the Ashikaga family, who lived from 1435 to 1490. He ruled Japan during the middle of the Muromachi period, from 1449 to 1474, at which time he resigned his position, shaved his head, and became a monk. While not a very effective statesman, he was a great patron of the arts, and his reign—referred to as the Higashiyama age in art history—is thought of as one of the most splendid. This period was so named after the eastern district of Kyoto, where Yoshimasa built his villa, known as the Ginkakuji, or Silver Pavilion. With his encouragement, all the arts fourished, especially Chinese-style ink painting, the lacquer art, architecture, garden designing, and other art forms connected with the tea ceremony. See also Ashikaga, Ginkakuji, and Higashiyama.

Yoshimitsu The third and greatest of the Ashikaga shoguns, who lived from 1358 to 1408. It was under his rule, in 1393, that the two courts which had split the country for over fifty years were united, and the Ashikaga shoguns occupied their most powerful position. He was also a great patron of the arts and an enthusiast of Chinese ink painting, particularly that of the Southern Sung period, which he eagerly collected; as a result, some of the finest such paintings are found today in Japan. On the outskirts of western Kyoto, he constructed the famous three-storied, gilded structure known as the Golden Pavilion, or Kinkakuji, which today forms part of a Buddhist temple. He retired from office in 1394 to become a Buddhist monk. See Ashikaga, Kinkakuji.

Yoshino Small mountain town south of Osaka, in Wakayama prefecture, which is the site of a Shinto shrine dedicated to the emperor Godaigo. The surrounding area is famous for its cherry-tree groves, which have often been depicted in Japanese art.

Yoshitoshi Japanese printmaker of the Meiji period who lived from 1839 to 1892. He was a pupil of the famous Late Edo period printmaker, Kuniyoshi, and produced many woodblock prints, as well as illustrations for books and newspapers. He is today highly regarded, eagerly collected and regarded as the greatest of the Meiji period printmakers. He had numerous pupils, among whom Toshikata and Toshihide were the most prominent. See also Yokohama prints.

Yoshitsune A member of the Minamoto family, and the younger half-brother of Yoritomo, who lived from 1159 to 1189. After a successful military campaign, Yoshitsune had a falling out with Yoritomo and was forced to flee to northern Japan, accompanied by his faithful retainer, Benkei. During his flight, his brother had Yoshitsune's mistress—the dancer Shizuka—arrested, in the hope of learning his whereabouts. Although she would not divulge his secret, Yoshitsune was, nevertheless, eventually discovered, and, along with Benkei, met his end in 1189. The events of this romantic story have often been retold in Japanese literature, and have frequently been represented in Japanese art. See also Benkei.

Yü Chinese term for the shape of a bronze ritual vessel in the form of a wine bucket, with a tightly fitting lid and a handle for carrying. It is commonly found among the bronzes of the Shang and Early Chou Dynasties.

Yü Chinese term for jade. See Jade.

Yü the Great Legendary figure of an ideal ruler who is credited with having established the Hsia Dynasty. There is some question as to whether this dynasty actually existed and such a person as Yü actually lived The veneration of Yü as one of the divine ancestors began during the Chou period.

Yü-chien Chinese painter of the Sung period who was active during the 13th century. Little is known about the life of the artist, and there is even some question as to his exact identity. However, today most scholars believe that he was a Ch'an monk, by the name of Ying Yü-chien, who was connected with a Buddhist temple in Hang-chou. Chinese critics have never paid him much attention, and he apparently achieved little success during his lifetime; but, like many other Ch'an painters, he was greatly admired in Japan, where his works have been preserved in the great Zen monasteries and in famous private collections. Among the most celebrated of these is "Mountain Village in Mist," painted in a very free, inspired Zen style employing the spilled-ink technique, in which the forms are dissolved into broad splashes of ink applied spontaneously to the white paper. His work exerted a great influence on Japanese ink painters, notably Sesshu and some of the masters of the Kano School.

Yuan Dynasty Name of the Mongol Dynasty which ruled China from 1279 to 1368. Although the Yuan rulers were cruel and oppressive and were hated by the Chinese people, many of whom refused to cooperate with the conquerors, this period was, nevertheless, a significant one in the

history of Chinese art. The imperial palace built by the Yuan emperors at their capital in Peking was the model for all of the later palace structures, and it was during this period that the making of blue and white porcelains, which were to play such a great role in the history of Chinese ceramics, was begun. This was also a great age of Chinese painting, in which a group of scholar-painters, most of whom refused to deal with the Mongol court, produced monochrome landscape paintings in a very austere style executed with dry brushwork. The Chinese of later times have always looked upon these works as among the greatest of Chinese paintings. Notable artists of this period were Huang Kung-wang, Ni Tsan, and Chao Mêng-fu. See also entries under the painters' names, Blue and whiteware, and Porcelain.

Yüan-ming-yüan Name of a Western-type palace, built in the Rococo style by the Ch'ing emperor, Ch'ien-lung, during the 18th century. It is located at a lake near the Summer Palace, twelve miles outside of Peking. It was, for many years, the most perfect example of European architecture to be found in the Far East, but was, unfortunately, destroyed by Western troops in 1860, so that only fragments of these buildings survive today.

Yüan Yeh Title of a Chinese treatise on gardening which was written during the Late Ming period. It combines a practical guide for the laying-out of gardens with a discussion of the aesthetic aims and function of the garden as conceived of by the Chinese. It is our most valuable source of information on Chinese gardens. Sections of it have been translated and published by Osvald Siren in his *Gardens of China.*

Yüeh Name of the Chinese ceramic ware which come from a district in Chekiang province known as Yüeh-chou. It is proto-procelain which is believed to be the ancestor of the green porcelain of later times known in Western literature as celadon. The earliest of these yüeh wares date from the 3rd century A.D., the very beginning of the Six Dynasties period. It is a hard stoneware, sometimes porcelaneous in character, with a green glaze over a grey body. The glaze is often impure, and tends towards darker yellowish or brownish tones. The shapes are strong, utilitarian ones, sometimes with molded or incised decoration. This type of ornamentation is referred to as secret or private color, or pi-sê in Chinese.

Yuima Japanese name for Vimalakirti. See Vimalakirti.

Yuji-age Japanese technique of employing tin powder as a ground for gold lacquer decoration. The process was invented by Nagata Yuji during the late 18th century, and was named after him.

Yukata Japanese term used for the light, comfortable kimonos worn in the summer, particularly in the house, after bathing or while strolling in the evening. They are of cotton fabric, and are decorated with a great variety of ornamental designs, usually executed in a blue dye or a stencil design on a white ground.

Yukimidoro Japanese name for a stone lantern which is often found in parks and gardens. It is of a squat construction, surmounted by a large,

flat roof and supported by four or six arched legs. Yuki literally means "snow," mi means "view" and doro is "lantern," and the lantern was so named because it enabled one to contemplate the fallen snow.

Yujimitsu Japanese painter of the Muromachi period who was active between 1360 and 1371. He is primarily known, together with his son Yukihiro, as the founder of the Tosa School, which produced a large number of artists tghrough the 19th century and supplied the imperial court in Kyoto with its official painters. While the school has been traced back to Yamatoi-e painting of the Heian period, it actually started only with these two 14th-century artists. Yukimitsu is believed to have specialized in religious paintings of Buddhist and Shintoist subject matter. He executed a number of illustrations for a six-volume work, devoted to the Bodhisattva Jizo, which was printed in 1362. It was also formerly believed that he was connected with the Kitano-Tenjin-Enji School, but this is no longer believed today. His son, Yukihiro, and his grandson, Yukihide, continued the Tosa School during the late 14th and early 15th centuries.

Yumedono or, literally, the "Hall of Dreams." The main building in the eastern section of Horyuji Temple in Nara. It was built during the Nara period, and is considered to be the most beautiful octagonal building in all of Japan. It derives its name from the fact that the Prince Shotoku used to meditate and study in this hall, which is, therefore, dedicated to him. It contains a six-foot-high gilded wooden statue of Kannon which is one of the most famous Buddhist images in Japan and has been designated a national treasure. A famous dry-lacquer image of the founder of this temple, the priest Gyoshin, has also been preserved in the Yumedono.

Yumeji Takehisa Japanese printmaker of the Taisho period who lived from 1884 to 1934. A native of Okayama, he studied oil painting in Tokyo, but soon turned to printmaking and book and magazine illustrating. His prints, especially those of young girls, are admired today as typical expressions of the Taisho era.

Yün-kang Buddhist cave temples located near Ta-t'ung in Shansi, the capital of the Northern Wei Dynasty. Work began there in 460 and continued until the end of the 5th century, when the Wei capital moved to Lo-yang in Honan province. Thousands of Buddhist images were carved out of the living rock of the hillside. The most impressive of these is a seated statue of the Buddha, which is 45 feet high and is based on the colossal Buddha at Bamiyan in Afghanistan. Many of the images from this site have been removed during the 20th century, and may now be found in the collections of museums in the United States, Europe and Japan.

Yün Shou-p'ing Chinese painter of the Ch'ing Dynasty who lived from 1633 to 1690. Coming from an impoverished family, and never having held a high government office, he was less esteemed than some of his contemporaries, who came from the scholar class; but he is, nevertheless, usually considered to be among the outstanding painters of the Ch'ing

period. He is best known for bird and flower paintings done in a detailed and colorful manner, which are regarded as the last important pictures of this genre in the history of Chinese painting.

Yung-lo Chinese emperor of the Ming period who ruled from 1403 to 1424. A remarkable ruler, who brought peace and prosperity to China, he also put scholars to work compiling anthologies of Chinese lituerature and philosophy. He sent naval expeditions to foreign countries and broadened China's contacts with Southeast Asia. From the point of view of art history, he is best remembered for moving the capital from Nanking to Peking, and there building the Imperial Palace. Although enlarged and reconstructed in later times, the present-day buildings still go back to the structures erected during Yung-lo's reign. The term Yung-lo, as it is used today, usually refers to the magnificent porcelains produced under his rule, especially the blue-and-whites, which are considered to be among the finest ever made.

Yusho Japanese painter of the Momoyama period who lived from 1533 to 1615. His family name was Kaiho, and he was the founder of the Kaiho School. He studied with Kano Motonobu, but an even greater influence on his work was provided by the painting of Liang K'ai, the great Chinese Ch'an painter of the Southern Sung period. In keeping with these models, he executed some very fine ink paintings in the suiboku style, representing landscapes, trees, and flowers, tigers and dragons. However, even more original were his screen paintings, rendered in the more colorful manner and bold decorative style of the Momoyama period. It is believed that he was employed by the great military dictator, Hideyoshi, to decorate his Jurakudai Palace in 1587. Outstanding examples of his work are found in the Tokyo National Museum, the Brooklyn Museum and several leading Zen temples of Kyoto.

Yuzen Japanese term for a type of beautiful dyed silk produced in Kyoto. The process for making this fabric, which involves the dyeing of elaborate multi-colored graphic designs, was invented during the Genroku era (1688-1704), and is usually credited to a priest named Fukae Yuzen. In the yuzen method, or yuzen-zome, a detailed design is drawn on the silk with a rice paste resist, applied with the aid of a small stick. The process became the most important and popular one of the Edo period because of the great freedom of design and color that it permitted. It is still widely practiced today.

ABCDEFGHIJ KLMNOPQR STUVWXYZ

Zao Gongen Shinto deity who is the tutelary god of Mount Kimpu and the special guardian of the Shugendo sect. He is frequently represented in Japanese sculpture and painting.

Zao Wou-ki Modern Chinese painter born in Peking in 1921. Educated at the National School of Fine Arts in Hang-chou, he also served on its faculty. In 1948, he went to Paris, where he has taken up permanent residence. His work combines the delicate color and calligraphic quality of traditional Chinese painting with the conventions and artistic ideas of modern abstract art, particularly as it is expressed in the work of Paul Klee. In fact, his later work is far closer to the Ecole de Paris than it is to the Chinese artistic tradition. At his best, he is able to integrate these two artistic trends into paintings that possess a great sensitivity of feeling and have a spontaneous, expressive quality.

Zen The Japanese term for a sect of Buddhism which is known as Ch'an. in Chinese, and Dhyani, in Sanskrit. While this teaching originated in China, and represents a fusion between Indian Buddhist mysticism and Chinese Taoism, it played an especially important role in the history of Japanese culture. Many of the great temples, gardens and paintings of Japan were created under Zen inspiration, and popular cultural institutions, such as flower arrangement, the tea ceremony and the noh drama, are connected with Zen Buddhism. Some of the leading Japanese artists, notably Sesshu and Hakuin, were Zen monks, and the Zen monasteries, particularly during the Muromachi period, were great centers of learning and artistic culture. See also Ch'an Buddhism.

Zendo Japanese name of the famous Chinese priest, Shan-t'ao. See Shan-t'ao.

Zendo Japanese term employed for the meditation hall which was the spiritual center of the Zen temple. Its Chinese name was Ch'an-t'ang, after the place where this type of hall was first constructed. It usually oc-

351

cupies a central location in the Zen Buddhist complex, and is considered more important than the Buddha Hall, where the images are preserved, and which had been the focal point in traditional Buddhist monasteries.

Zenga School of Japanese painting, devoted to the depiction of Zen subjects whose practitioners were usually Zen monks. It flourished primarily in the Edo period. The most outstanding artists of this school were the 18-century painter and Zen priest, Hakuin, and the 19th-century artist, Sengai.

Zeshin Japanese lacquer artist who lived from 1807 to 1891. His family name was Shihata. He was trained in his youth by a lacquer master of the Kano School, and also studied painting in the realistic Shijo style. He worked primarily with colored lacquers, and achieved subtle contrasts between different colors and between the decoration and the ground. His designs were often taken from nature, representing various birds and plants, and reflected the realistic tendencies of the art of his day. In his old age, he also did lacquer paintings on paper in which his pictorial gifts are clearly manifested. He is usually regarded as the last of the great traditional lacquer masters of Japan.

Zeze A town near Lake Biwa, in Shiga prefecture, which is well known for its ceramic production. It was established during the Early Edo period, and specialized in the manufacture of tea utensils. It is particularly noted for its tea caddies, which have a fine white paste and are covered with a brown iron glaze of a soft, warm color. The oldest of these are highly valued today by the Japanese tea masters. The production has continued into modern times, but the quality has declined greatly.

Zodiac For the Chinese equivalent of the Western signs of the zodiac, see Twelve Animals.

Zogan Japanese term, meaning "inlay," which is applied to decorative designs on metalwork. A great variety of techniques are used, such as hon-zogan, in which metal wires, usually of gold and silver, are hammered into grooves; gomoku-zogan, which uses short lengths of fine brass or copper wire inlaid on an iron ground to suggest pine needless floating on water; sumi-zogan, or "ink inlaying," which creates a design that appears to have been painted on the metal with ink; and kiribame-zogan, in which a design is chiseled in pierced openwork and then outlined with a contrasting metal for emphasis.

Zogan-nuri Japanese lacquer technique in which the moist lacquer is inlaid with gold or silver wire in the manner of cloisonné. It is then covered with several layers of black lacquer which are rubbed down to reveal the metal.

Zokoku Japanese lacquer master who lived from 1805 to 1869. His family name was Tamakaji, and he worked in Takamatsu in Shikoku. He was the best-known master of carved lacquer during the Late Edo period. He employed the kimma technique of lacquer engraving derived from Thailand and Burma, and also produced carved lacquers in the Chinese style. His subject matter, however, was invariably taken from Japanese sources.

BIBLIOGRAPHY OF REFERENCE BOOKS
ON CHINESE AND JAPANESE ART

Beurdeley, Cécile and Michel. *A Connoisseur's Guide to Chinese Ceramics.* Translated from the French edition of 1974. New York, 1974.

Binyon, Laurence and Sexton, J. J. O'Brien. *Japanese Colour Prints.* London and New York, 1923. 2nd edition, ed. Basil Gray, London, 1960.

Edmunds, William. *Pointers and Clues to the Subjects of Chinese and Japanese Art.* London, 1934.

Encyclopedia of World Art. New York, 1959-1968. Original Italian edition, Rome, 1958.

Gulik, Robert Hans van. *Chinese Pictorial Art.* Rome, 1958.

Hackin, Joseph, et al. *Asiatic Mythology.* Translated from the French edition of 1928. London and New York, 1932.

Index of Japanese Painters. Yukio Yashiro (ed.). Tokyo, 1941.

Japan: the Official Guide. Edited by the Tourist Industry Bureau. 7th revised edition, Tokyo, 1959.

Joly, Henri. *Legend in Japanese Art.* London, 1908. Reprinted Rutland, Vermont, and Tokyo, 1967.

Lane, Richard. *Images from the Floating World, the Japanese Print.* New York, 1978.

McGraw-Hill Dictionary of Art. Bernard S. Myers (ed.), Shirley D. Myers (asst. ed.). London and New York, 1969.

March, Benjamin. *Some Technical Terms of Chinese Painting.* Baltimore, 1935.

Medley, Margaret. *A Handbook of Chinese Art.* London, 1964; New York, 1965. 2nd edition, London, 1973.

Munsterberg, Hugo. *The Ceramic Art of Japan.* Rutland, Vermont, and Tokyo, 1964.

Nagel's China. English version by Anne L. Destenay. 3rd edition, Geneva, 1973.

Praeger Encyclopedia of Art. New York, 1971. Original French edition, Paris, 1967.

Ragué, Beatrix von. *Geschichte der japanischen Lackkunst.* Berlin, 1967. English edition, University of Toronto Press, 1976.

Roberts, Laurance P. *A Dictionary of Japanese Artists.* Tokyo and New York, 1976.

Robinson, Basil William. *The Arts of the Japanese Sword.* London, 1961.

Ueda, Reikichi. *The Netsuke Handbook of Ueda Reikichi.* Adapted from the 2nd Japanese edition of 1943 by Raymond Bushell. Rutland, Vermont, and Toyko, 1961.

Waley, Arthur. *An Index of Chinese Artists.* London, 1922.

Weber, Victor Frédéric. *Ko-ji Ho-ten.* Paris, 1923. Reprinted by Hacker, New York, 1976.

Werner, Edward T.C. *A Dictionary of Chinese Mythology.* Shanghai, 1932. Reprinted New York, 1961.

Williams, C.A.S. *Outlines of Chinese Symbolism and Art Motives,* 3rd revised edition, Shanghai, 1941. Reprinted Rutland, Vermont, and Tokyo, 1974.